BERNARDO BELLOTTO

and the
CAPITALS of EUROPE

BERNARDO BELLOTTO
and the
CAPITALS of EUROPE

Edited by
Edgar Peters Bowron

With contributions by
Irina Artemieva
Charles Beddington
Edgar Peters Bowron
Martina Frank
Bożena Anna Kowalczyk
Andrzej Rottermund
Gregor J. M. Weber

Yale University Press ~ New Haven & London

This catalogue was first published
by Electa on the occasion
of the exhibition
Bernardo Bellotto 1722-1780,
edited by Bożena Anna Kowalczyk
and Monica da Cortà Fumei

Museo Correr, Venice
10 February-27 June 2001

The Museum of Fine Arts, Houston
29 July-21 October 2001

In collaboration with the
Fondazione Giorgio Cini, Venice

Comune di Venezia
Assessore alla Cultura
Marino Cortese

**Direzione Beni e Attività Culturali
Musei Civici Veneziani**
Direttore
Giandomenico Romanelli

The Museum of Fine Arts, Houston
Director
Peter C. Marzio

Organizing Committee
Alessandro Bettagno
Edgar Peters Bowron
Bozena Anna Kowalczyk
Giovanna Nepi Scirè
Giandomenico Romanelli
Andrzej Rottermund
Gregor J.M. Weber

Translation from the Italian by
Studio Globe, Foligno

Directors' Foreword

*Among the topographical view painters who flourished in eighteenth-century Europe,
none did more to enrich the conventions of the painted veduta, or possessed a wider range
than Bernardo Bellotto (1722-80). Often dismissed as an acolyte of his famous uncle,
Canaletto, Bellotto surprises with the breadth of his interests.*

*His quest for fresh topographical material led him to visit half a dozen cities in northern
and central Italy in the 1740s, and at twenty-five he left Venice for northern Europe, never
to return. There he spent the remainder of his life working for royal
and aristocratic patrons in Dresden, Vienna, Munich, and Warsaw, and left
us an unparalleled record of the capitals of Europe in the Age of Enlightenment.*

*Bellotto's paintings have never lacked admirers, and as an artist he is fortunate
to have received the attention of many gifted scholars over the past century,
notably Stefan Kozakiewicz, who have devoted great effort to the appreciation
and understanding of his art. His paintings have been shown in countless exhibitions
throughout Europe. The topographical views of Dresden and Warsaw, in particular, have
been the focus of major exhibitions in London, Liverpool, York, and Rotterdam (1957),
Dresden (1963-64), Essen, Vienna, and Warsaw (1965), and Venice (1986).*

In 1990 an exhibition at the Museo di Castelvecchio, Verona, Bernardo Bellotto: Verona e
le città europee, *celebrated the artist's Italian views and capricci painted before
his departure in 1747 for the Saxon court in Dresden. Of course, Bellotto's paintings
are obligatory for any exhibition devoted to the Italian veduta or Venetian eighteenth-
century art and culture, and his art has been featured in many shows such as the recent
surveys of Venetian art,* The Glory of Venice *(London and Washington, 1994-95)
and* Splendori del Settecento veneziano *(Venice, 1995).*

*The 1990s witnessed a remarkable expansion of interest in Bellotto's art that resulted
in new articles, catalogues, and the publication of documents pertaining to his life
and work and newly attributed and newly discovered paintings, in many cases by younger
scholars with a fresh approach to the material. Much of this interest has centered on
Bellotto's early relations with Canaletto and the task of identifying his paintings from
the Venetian period that reflect his assimilation of his uncle's style and technique.*

*For these reasons, the moment seemed ripe to launch another effort to demonstrate
Bellotto's pictorial interests and ambitions and to reveal him as the great and imaginative
painter that he was. It should be noted that the exhibition at the Museum of Fine Arts,
Houston, is the first devoted to the painter in the United States.*

*The goal of the exhibition is to present Bellotto's career and development,
from the beginning of his career as a painter of conventional views of Venice
in the manner of Canaletto, to his work for the last king of Poland, Stanislaus II Augustus
Poniatowski, through a wide selection of paintings of the highest quality.*

*Although the exhibition represents a relatively small selection of the hundreds of paintings
Bellotto created in his forty-year career, the range is comprehensive.*

*His progression from Venice, Florence, Rome, Milan, Turin, and Verona
to the new landscape and buildings and northern light of Dresden, Munich, Vienna,
and, finally, Warsaw, can be measured in this exhibition.*

*Over the years Bellotto expanded his range beyond traditional view painting, venturing
into genre, portraiture, allegory, and history painting, and we have attempted to present
these aspects of his art as well. One notable feature of the exhibition is the presentation
of nine paintings of the Warsaw period from collections of the Royal Castle,*

seven of them cleaned and reframed especially for the exhibition. Bellotto's interest
in nature deepened considerably in this last period of his career, and these late landscapes
and views enable us to see Bellotto even more clearly as a precursor of the Romantic
and nineteenth-century landscape painting. The sensibility and technique of his landscapes
prefigure a variety of later developments in European painting, and it is not surprising
that frequent comparisions have been made of his landscapes to the work of Corot,
Daubigny, and the painters of the Barbizon School.

This exhibition placed exceptional demands upon many lenders, public and private,
and we offer them heartfelt thanks for their generosity. Early in the planning
of the exhibition we received a commitment of support from the Staatliche
Kunstsammlungen, Dresden, and we wish to acknowledge the help and generosity
of Frau Dr. Sybille Ebert-Schifferer, general director, and Professor Dr. Harald Marx,
director, and Dr. Gregor J.M. Weber, curator of Italian painting, Gemäldegalerie Alte
Meister, Dresden. Similarly, Prof. Dr. Andrzej Rottermund, director, The Royal Castle,
Warsaw, promised early on the support of the resources of that institution, and we are
pleased to acknowledge his generous participation from the inception of the project.

As always, an exhibition such as this cannot take place without generous sponsorship.
In Venice, the exhibition is supported by the Soprintendenza ai Beni Artistici e Storici
di Venezia and Musei Civici Veneziani with contributions from Ras (Riunione Adriatica
di Sicurtà), Club La Repubblica, and Piccin Trasporti d'Arte. In Houston, the exhibition
is supported by Fayez Sarofim & Co., Continental Airlines, Eni Group (Agip Petroleum,
EniChem America, Snamprogetti USA), Ferrari of Houston and Vespa of Houston,
and The Interfin Companies LP. In Houston the exhibition is held under
the Honorary High Patronage of His Excellency Ferdinando Salleo, Ambassador
of Italy to the United States.

The burden of the organization and presentation of the exhibition in Venice
and Houston has fallen on the shoulders of Dr. Monica da Cortà Fumei
and Dr. Edgar Peters Bowron, respectively, and to both we offer our sincere thanks.

Peter C. Marzio
Director, The Museum of Fine Arts, Houston

Giandomenico Romanelli
Director, Musei Civici Veneziani, Venice

Lenders to the Exhibition

The numbers in the following list refer to works in the catalogue

Public Institutions

Austria
Vienna, Kunsthistorisches Museum 66, 67, 68

Canada
Ottawa, The National Gallery of Canada 9, 10

Germany
Dessau, Kulturstiftung Dessau Wörlitz 79, 80

Dresden, Staatliche Kunstsammlungen, Gemäldegalerie Alte Meister 38, 39, 42, 43, 44, 46, 48, 49, 53, 56, 57, 58, 59, 60, 62, 63, 72, 73, 75, 86

Düsseldorf, Kunstmuseum im Ehrenhof 21

Hamburg, Hamburger Kunsthalle 74

Hannover, Niedersächsisches Landesmuseum, Landesgalerie 6

Munich, Bayerische Staategemäldesammlungen 70

Munich, Bayerische Verwaltung des Staatlichen Schlösser, Gärten und Seen, Residenzmuseum 69

Schwerin, Staatliches Museum 77, 78

Great Britain
Cambridge, Fitzwilliam Museum 15, 16

London, The National Gallery 1

Petworth House, The Egremont Collection (The National Trust) 20

Powis Castle, The Powis Collection (The National Trust) 37

York, The Castle Howard Collection 3, 4

York, York City Art Gallery 17

Hungary
Budapest, Szépmüvészeti Múzeum 13, 14

Italy
Asolo, Museo Civico 27, 28

Milan, Pinacoteca di Brera 31

Parma, Galleria Nazionale 35

Turin, Galleria Sabauda 33, 34

Venice, Gallerie dell'Accademia 5

Poland
Warsaw, The Royal Castle in Warsaw 84, 85, 87, 88, 89, 90, 91, 92, 93

Russia
St. Petersburg, State Hermitage Museum 45, 47, 50, 51, 52, 54, 61, 64

United States of America
Columbia, Columbia Museum of Art 32

Detroit, The Detroit Institute of Arts 25

El Paso, Museum of Art 76

Hartford, The Wadsworth Atheneum 81

Los Angeles, The J. Paul Getty Museum 8

Raleigh, North Carolina Museum of Art 40, 41

San Diego, San Diego Museum of Art 82

Springfield, Museum of Fine Arts 7

Toledo, Museum of Art 24

Washington, National Gallery of Art 65

Other Collections
Verona, Fondazione Cassa di Risparmio di Verona Vicenza Belluno e Ancona 36

Anonymous lenders
2, 11, 12, 18, 19 22, 23, 26, 29, 30, 55, 71, 83

Bernardo Bellotto 1722-1780: biographical register

Bibliographic note
Studies by various scholars have been dedicated to the artist's Venetian and Italian period, the earliest being by Fabio Mauroner, whose notes and transcriptions of archival documents, preserved in the Library of the Museo Correr, Venice (Mauroner, without date [before 1948], have been transcribed and published by Giorgio Marini (1993). Other studies include those by Bozena Anna Kowalczyk (1995 and 1999). The publication of the documents relative to his stay in Dresden owes a great deal to Moritz von Stübel (1911) and to Hellmuth Allwill Fritzsche (1936), while the notes on the Warsaw period come principally from Sebastiano Ciampi (1830 and 1839), Barbara Kròl-Kaczorowska (1966), Stefan Kozakiewicz (1972) and Elena Bassi (1979).

1722

20 May, Bernardo Francesco Paulo Ernesto Bellotto was born in Venice, in the parish of Santa Margherita, son of Lorenzo Antonio Bellotto, administrator of the assets of the Procurator of San Marco, Marc'Antonio Giustinian, and of Fiorenza Domenica Canal, sister of Canaletto.

1736

Bellotto has already been a pupil in Canaletto's workshop for some time. Before June, he executes a drawing depicting the Canale di Santa Chiara looking southeast toward the Fondamenta della Croce (Hessisches Landesmuseum, Darmstadt, AE 2208) and writes a letter to his father in verse.

1738

Starting in this year, up to 1743, Bellotto is enrolled in the *Fraglia dei pittori* (Guild of painters).

1739

Probable start of his relationship with Henry Howard, 4th Duke of Carlisle, for whom he was to paint between 1739 and 1741 a series of paintings, four still preserved at Castle Howard in Yorkshire.

1740

He paints the *Grand Canal from the Palazzo Foscari and Moro Lin to the Carità* (Nationalmuseum, Stockholm), commissioned to commemorate the visit to Venice of Prince Frederick Christian, son of the Elector of Saxony and King of Poland, Augustus III, a guest at Palazzo Foscari from December 1739 to June 1740.
20 November, the secretary of Field Marshal von der Schulenburg is reimbursed with 9 sequins for the purchase of four views of Venice by the "nephew of Canaletto".
8 December, he signs the drawing *Campo Santi Giovanni e Paolo* (Hessisches Landesmuseum, Darmstadt, AE 2218).

1741

5 October, marriage contract between the painter and his father-in-law Giambattista Pizzorno, executed on *2 November*.
5 November, marriage to Elisabetta Pizzorno, daughter of Giambattista quondam Zorzi, celebrated in the church of the Redeemer, witness Count Bonomo Algarotti; investment of part of his wife's dowry (850 ducats) in the Scuola Grande della Misericordia; his mother

Fiorenza drafts a document to protect the painter, in which she declares that the family has been abandoned by her husband Lorenzo and that its only assets have been provided by Bernardo, who with his work maintained her and his brother Pietro, putting them up in his own house; his brother Pietro Bellotto (landscape artist in Toulouse and Nantes) asserts before the same notary that he had learned painting from Bernardo. In order to continue living with his brother and improving his knowledge of the profession, he undertakes to pay him one hundred and twenty ducats a year.

1742

Spring, probable date of the trip to Rome, with stops in Florence, Lucca, and Livorno.
25 July, Bernardo is back in Venice, where the contract with his brother Pietro is dissolved.
2 August, will of his mother Fiorenza, which nominates Bernardo as her heir and entrusts to his care his sister, a Franciscan tertiary at San Francesco della Vigna.
15 October, Bernardo's first son, Lorenzo Francesco, is born in Venice, in the parish of Santa Marina.

1743

16 August, Bellotto exhibits two views in the annual San Rocco exhibition, one of the *Campidoglio* (The National Trust, Petworth House, cat. no. 20), and the other of the *Chiovere di San Giovanni Evangelista* (lost).

1744

Travels to Milan, where he executes two views for Archbishop Giuseppe Pozzobonelli; in Vaprio he executes two paintings for Count Antonio Simonetta (Metropolitan Museum of Art, New York, and private collection, Italy), as attested to by the inscription on the preparatory sketches (Hessisches Landesmuseum, Darmstadt, AE 2215 and 2216). In Gazzada he paints the town and the villa of the Perabò brothers (see cat. no. 31).
July, a daughter, Fiorenza, is born.

1745

Bernardo is documented among the inhabitants of the parish of Santa Marina, on the Fondamenta Nuove, where he rents for 60 ducats an apartment for his family, consisting of his mother, wife and two children.
He executes two views of Turin (cat. nos. 33, 34), for which he is paid in the summer.
12 August, his daughter Fiorenza dies in Venice.

29 November, a daughter, Francesca Elisabetta, is born, godfather Pietro Guarienti.

1746

2 December, a son, Giambattista Francesco, is born, godfather Giuseppe Camerata.

Probable date of the two large views of Verona (see cat. no. 37).

1747

5 April, power of attorney in the name of his father-in-law, Giambattista Pizzorno, to manage the investment of his wife's dowry. Shortly afterwards he leaves for Dresden.

8 May, his son Giambattista Francesco dies in Venice. He signs various paintings and etchings in Dresden.

1748

Frederick Augustus II, King of Poland and Elector of Saxony with the name of Augustus III, bestows on Bellotto the title of court painter, with an annual salary of 1750 thalers and gives him a gold snuff-box studded with diamonds, containing 300 gold louis.

During his eleven years in Dresden, before the outbreak of the Seven Years War, the artist paints for the Royal Gallery the series of fourteen views of Dresden and eleven of Pirna, in large format, and repeats the same subjects for the prime minister Count Heinrich Brühl with thirteen views of Dresden and eight of Pirna, without ever being paid by the latter.

He produces etchings of his paintings.

July, he is recorded among those "who live in Sta Marina and can pay tax for Festivals", even though he is already living in Dresden.

24 September, his daughter Maria Anna is baptised, the godparents are Count Heinrich Brühl and his wife.

1750

4 March, his daughter Maria Anna dies.

4 August, a daughter, Maria Josepha Friedrica, is baptised.

1752

26 August, a daughter, Christiana Xaveria, is baptised.

27 November, his daughter Antonia Federica dies.

1753

26 April, he receives a warrant from Augustus III, addressed to the bailiff Crusius in Pirna, to facilitate his work in this town.

1754

16 November, his father Lorenzo Bellotto, residing in Dresden, sends Count Brühl a letter in which he complains about Bernardo's character and behaviour.

1756

March, Augustus III issues a warrant to facilitate the painter with his paintings of the fortress of Königstein.

Between 1756 and 1758 he paints five large views of the fortress.

1757

2 November, his daughter Theresia Francisca Florentia is baptised.

1758

5 December, the painter is granted a passport to Bayreuth.

1759

January, the artist arrives in Vienna with his son Lorenzo, where he remains for two years, painting on commission of the Empress Maria Theresa a series of large views of the imperial residences, a panoramic view of the city and several medium-sized city views; for Count Wenzel Anton von Kaunitz-Rietberg and Prince Joseph Wenzel Liechtenstein he executes views of their palaces and gardens.

1760

July, during a Prussian bombardment the painter's house in Dresden, situated in the suburb of Pirna, is destroyed, and the losses, including furnishings, works of art and etching plates, amount to 50,000 thalers.

1761

4 January, Empress Maria Theresa writes a letter recommending the painter to Princess Maria Antonia, who was in Munich at the court of her brother Maximilian III Joseph, together with her husband Frederick Christian.

14 January, Bellotto arrives in Munich with six other court painters of the House of Saxony – probably including his son Lorenzo – and takes lodgings at the best hotel in the city, the Black Eagle in Kauffingergasse.

He stays in Munich less than a year but in that time paints a view of the city and two of Nyphenburg (cat. nos. 69, 70) for the Elector Maximilian III Joseph of Bavaria.

1762

Before 13 January, Bellotto is back in Dresden: Count Brühl sends a letter to the painter from Warsaw, addressing it to this city.

He executes two *Allegories* (cat. nos. 72, 73) of the political situation in Saxony at the end of the Seven Years War.

1763

October, death of Bellotto's two patrons, Augustus III and Count Brühl.

1764

Upon the foundation of the Academy of Fine Arts of Dresden, directed by Christian Ludwig Hagedorn (1712-80), and the new influence at court of neoclassical ideas, the painter is shunted aside and suffers a loss of professional prestige. It is only due to residual support from the court that he is nominated an "associate member for perspective" (teacher of perspective) with an annual salary of 600 thalers.

Inititates litigation in vain against the heirs of Count Brühl, demanding payment for the paintings commissioned years before, whose price was agreed upon at 200 thalers each. He is called upon to settle the debts of his son Lorenzo.

1765

Bellotto paints his *morceau de reception* for admission to the Academy, a view of the Frauenkirche, Brühl Palace, Augustusbrücke, and the Hofkirche (Staatliche Kunsthalle, Karlsruhe), which was exhibited in the second Academy exhibition in 1766.

1766

20 December, he asks Hagedorn for nine months' leave to visit St. Petersburg.

1767

26 January, a letter sent from Dresden by the painter Giuseppe Rosa to his colleague Marcello Bacciarelli, first artist of the Polish court, announces the imminent arrival of Bellotto in Warsaw.

Bacciarelli presents Bellotto to King Stanislaus II Augustus Poniatowski.

May, the painter and his son are engaged on the fresco decoration of the castle of Ujazdòw.

27 August, he sends the Dresden Academy a request to extend his leave, which is granted to him until 31 January 1768.

He then decides to remain in Warsaw, where he arranges for his family to join him.

1768

The king of Poland bestows on Bellotto the title of court painter, with an annual salary of 400 ducats, with an additional 150 for lodgings, 120 for his carriage, 40 for firewood and 120 for the theatre. In Warsaw the painter's principal work is the series of 26 views of the city and of Wilanòw intended for the "Canaletto room" in the Royal Castle.

20 April, in Venice, Bernardo is nominated together with his brothers Michiel and Pietro in the documents relating to the hereditary issues resulting from the death of Canaletto.

1 March, in a letter to Bacciarelli, the painter Giuseppe Rosa describes Bernardo's moody personality.

1769

He signs, together with his son, two paintings in the series of Roman views taken from Piranesi's prints and intended for the castle of Ujazdòw.

His eldest daughter, Maria Josepha Friedrica, marries the court geographer Hermann Karl Perthées, a native of Dresden.

1770

In a view of Warsaw and the Vistula seen from Praga (cat. no. 88) Bellotto portrays himself together with the king, his son and son-in-law.

20 October, his son Lorenzo dies; the funeral is paid for by the king and the burial takes place in Warsaw, in the Reformate church.

1779

He executes for Count Jòzef Ossolinski the painting representing the *Entry into Rome of the Polish Envoy Jerzy Ossolinski* (Silesian Museum, Wroclaw), the only documented painting of the Polish period commissioned by a non-royal source.

1780

He draws up a list of works executed in the period 1771-80, indicating prices and dates of execution.

17 November, he dies in Warsaw; his death is announced that same day by his son-in-law de Perthées and the following day he is buried in the Capuchin church in Miodowa Street.

Contents

Bernardo Bellotto: The Formation of an Original Style

Bożena Anna Kowalczyk

If the Italian years of Bellotto close in some mystery, it is nothing in comparison to the vagueness surrounding his formation and development. The clues to this period are largely stylistic and the first task must be to attempt to distinguish Bellotto's early style, particularly in painting, from his uncle's.
Michael Levey[1]

It seemed an impossible task. W.G. Constable saw Bellotto as Canaletto's "black shadow;" J.G. Links believed that no Venetian view could be confirmed as by his hand, and Stefan Kozakiewicz expressed uncertainty about the authenticity of a number of early paintings attributed to the artist.[2] Today, however, the path of Bellotto's early development is better understood and his early paintings and drawings can now often be distinguished from those of Canaletto and other Venetian *vedutisti*. Moreover, the documentary silence surrounding this period has been broken: Bernardo Bellotto is now one of the best-documented painters of the eighteenth century with respect to his early career. His emergence from an apparently simple emulator of his uncle into a "rival to be feared"[3] and a talented and successful artist have encouraged scholars to search the archives in an attempt to document his artistic development. Although until recently only the identity of Bellotto's mother, Canaletto's sister, Fiorenza Domenica Canal, was known, now the story of his difficult family history and early years in Venice have been traced through a series of deeds and contracts, down to a final Venetian document, the power of attorney in his father-in-law's name, dated 5 April 1747, shortly before he departed for Dresden. His Venetian friends and acquaintances were not limited to those "inherited" from Canaletto – the Algarotti brothers, Bonomo and Francesco, Joseph Smith and Anton Maria Zanetti the Elder – but in fact included his godfather, Francesco Perabò, who came from a noble Lombard family, the *quadernier* of the Procuratia de Supra (Procuratorship of the Republic), and the Procurator Marc'Antonio Giustinian di San Barnaba, his father's patron.[4]

In Venice Bellotto painted not only well-known building and monuments previously depicted by Canaletto, but also many areas unknown to tourists, the churches of Santa Maria Nuova and dei Miracoli, the Rio dei Mendicanti, and Campo San Stin. He made sketches of buildings and churches and drew the Venetians going about their everyday business, both for his own work and for the use of others in Canaletto's workshop, until he departed for Lombardy in 1744.[5] The date of Bellotto's enrollment in the Fraglia (guild of Venetian painters) informs us that in 1738 he was already a fully enrolled practising artist. Indeed, there are paintings and drawings that can be dated with some certainty to this initial period through comparison with the pieces executed in 1740, a critical year in which his career was launched. Not only can the well-known drawing in Darmstadt depicting the Campo di SS. Giovanni e Paolo, dated 8 December 1740, be placed with certainty in this year, but also a painting in the Nationalmuseum, Stockhom (Fig. 1), discussed below.[6] The attribution of two views executed for the German military commander, patron and collector, Johann Matthias Graf von der Schulenburg (1661-1747), completes the information on that year's activities and provides a basis upon which to make stylistic and technical comparisons to other works.

Bellotto learned from Canaletto techniques to evoke the play of light and shade on buildings, the cracks and irregularities on their surfaces, the precise description of architectural detail, and the brilliance and mutability of water. His growing ability to emulate Canaletto's methods and techniques and the gradual development his own manner of painting provides the criteria for the attribution and chronology of Bellotto's earliest works. By 1740 the artist was interpreting Canaletto's manner with such mastery that even his early works gave rise to doubts about their authenticity or were attributed mistakenly to Canaletto, as is known by a remark from a contemporary writer, Pietro Guarienti.[7] No other Venetian painter seems to have managed to appropriate Canaletto's technique with the same

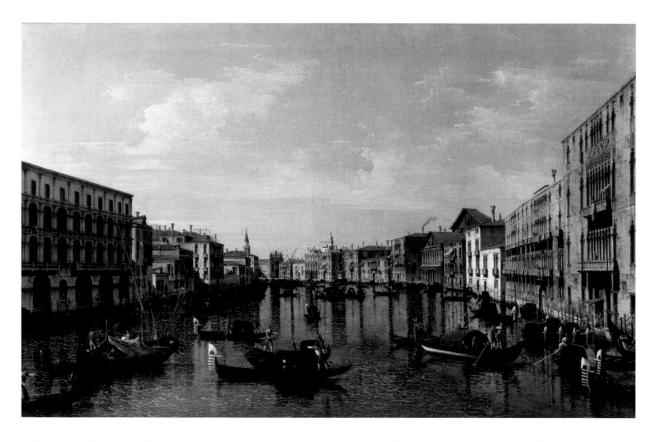

skill as Bellotto, although one assumes there must have been other collaborators in the master's workshop with talent commensurate to his nephew's, even if there is no way of identifying their works.

Bellotto's view of *The Grand Canal from the Church of Santa Croce and the Convent of Corpus Domini* in the National Gallery, London (cat. no. 1), is clearly a painting created in Canaletto's workshop.[8] A comparison with an autograph drawing in Darmstadt enables us to attribute it to the artist's early years in about 1738-39. The rigid perspective and the evident uncertainties and errors in the alignment of the church of Santa Lucia and the church of the Scalzi, the elementary methods of description (the heavy black lines outlining the shapes and the architectural details, the graphic shorthand indicating the irregularities in the walls, similar to those in the drawing), the manner of indicating reflections on the water (in the manner of Canaletto), and the roundish figures (much like the figures painted by Canaletto in the first half of the 1730s in a series of Venetian views painted for John, 4th Duke of Bedford, now at Woburn Abbey)[9] suggest a very early date for the National Gallery painting, close to that of the drawing. Examination of the painting clearly reveals that the young Bellotto followed the technical procedures of his master; for example, the use of a ruler to cut grooves in the wet paint. (The deep groove he marked to establish the line of the horizon is at exactly the same height as the mark in pencil in the drawing, but only for half its length.)

A view of the Grand Canal in the Nationalmuseum, Stockholm (Fig. 1), demonstrates clearly the progress Bellotto had made as a painter in his early years in Venice. Although still very young, the artist had undertaken an ambitious project to execute a large painting commemorating the visit to Venice from December 1739 to June 1740 of Prince Frederick Christian (1722-64), the eldest son of August III, King of Poland and Elector of Saxony.[10] The commission can presumably be dated to the beginning of 1740 since in March of that year Rosalba Carriera (1675-1757) was already at work on the young prince's portrait.[11] Bellotto has produced in the Stockholm painting a carefully considered and executed work, although in some passages he seems unsure of how to apply the techniques he learned from Canaletto; the perspective, for instance, is correct if rather rigid and geometrical, and the approach to handling the play of light in the scene is quite sophisticated for a young painter.

More complete documentation is available for the two paintings made for Schulenburg, one of the greatest collectors in eighteenth-century

Venice. On 20 November 1740 the marshall's secretary acquired for his employer for nine zecchini "*quattro vedute di quadri due di S. Marco e due del Arsenale*". These are the paintings that were subsequently listed in related documents as "Four Prospects of the Nephew of Canaletto" and "Prospects of Venice by the nephew of Canaletto," for which a purchase price of twenty-four ducats was declared.[12] Among the known works of Bellotto executed in 1740 or just before, there is no known pair of views of San Marco or of the Arsenal. But the existence of a series of four paintings – three of the Piazzetta from different angles and one of the *campo* of the Arsenal – has suggested to scholars that they may have been the paintings in the Schulenburg collection.[13] Leaving aside the fact that these four views of the Piazzetta and the Campo dell'Arsenale in the National Gallery of Canada, Ottawa (cat. nos. 9, 10) and of the Piazzetta and the entrance to the Grand Canal from the Piazzetta in the collection of Major John Mills, Ringwood, Hampshire, already belonged to two different collections in 1760 and may never have constituted a true series, the handling in the four paintings is much more sophisticated than the young artist's skills appear to have been in 1740.[14]

The paintings executed for marshall Schulenburg are therefore still missing. By a fortunate coincidence, however, the important Schulenburg archive is a significant source of information for appreciating Bellotto's early development. The lost Schulenburg *vedute* by Bellotto have a different history than the that of the paintings proposed above. They were executed in the early stages of the painter's career but appear to have disappeared without trace immediately after their existence was noted, although they were at one stage recognized as by Bellotto. In our opinion, two of these lost Schulenberg works may be identified with a pair of paintings, the *Bacino di San Marco from the Piazzetta* (Fig. 2) and the *Piazzetta looking towards the Doge's Palace* (Fig. 3), once in the Paris collection of the Austrian collector, Baron Fédéric Spitzer (1815-90). Executed in a technique obviously emulative of Canaletto's, but so close to Bellotto's manner in the "cool tone, cold grey shadows, china-blue sky, with diagonal brush-strokes in upper part and horizontal in lower," W.G. Constable – who had the opportunity of examining the pictures in the original in New York in 1946 – was per-

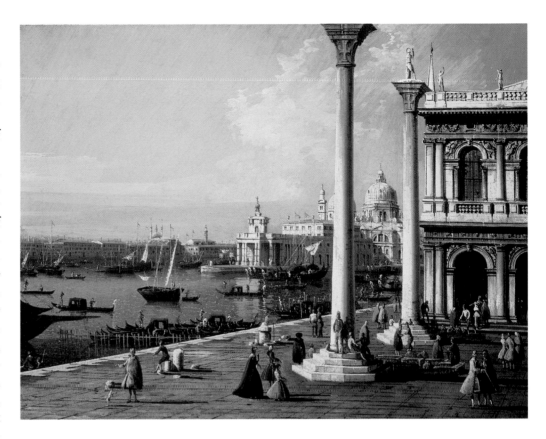

2. *Bernardo Bellotto,* The Piazzetta looking towards the Bacino di San Marco with the Dogana and Santa Maria della Salute, c. *1739-40 (Private Collection)*

suaded to set aside a previous attribution to Canaletto and to assign the paintings, with some hesitation, to Bellotto. Stefan Kozakiewicz accepted the ascription to Bellotto, but from a photo of the view of Bacino di San Marco from the Piazzetta he deduced that the artist "may at most have collaborated" on the painting, whereas J.G. Links was convinced that "Bellotto may have played a considerable part in the execution".[15]

The notion that Bellotto could emulate Canaletto while at the same time forge a personal style of his own has not been sufficiently appreciated until recently – there has not been enough relevant data, pictorial and otherwise, to make such a case. This should neither surprise nor scandalize us since a firm knowledge of Bellotto's early manner has only recently been acquired, as indeed, strange as it may seem, has a similar understanding of the evolution of Canaletto's style and technique. The sophisticated handling and almost obsessive attention to detail that characterizes the two small views illustrated in Figs. 2 and 3 provide new perceptions and insights about the young Bernardo Bellotto each time they are examined. The young painter's competence at this stage of his career is undeniable, even if his style is characterized by a slight coarseness in the handling and by uncertainty

5

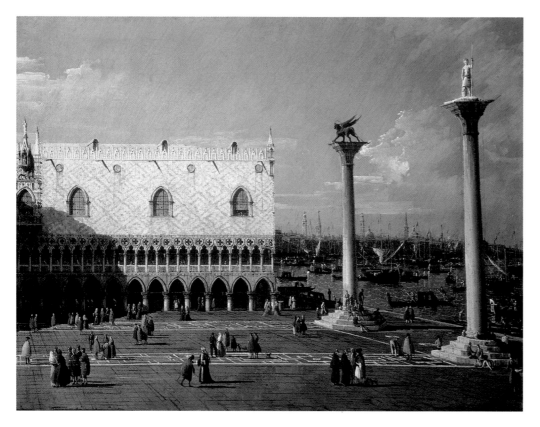

3. *Bernardo Bellotto,*
The Piazzetta looking
towards Palazzo
Ducale, *c. 1739-40
(Private Collection)*

here and there in establishing the perspective of the scene and describing individual architectural details, as is confirmed by several passages of visible *pentimenti.* The artist's first compositional thoughts can be seen to have been outlined in the wet paint, marking the larger outline of the columns, the almost invisible taller outline of the dragon at the feet of St. Theodore, and the decoration on the façade of the Doge's Palace.

There is no precise reference to the iconography of the two views in Canaletto's existing repertory, but the view of the Piazzetta looking towards the Palazzo Ducale was clearly based on an etching by Luca Carlevaris (Fig. 4).[16] This utilization of an earlier composition was of course a new technique for Bellotto, but Canaletto had often

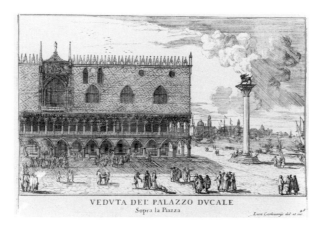

VEDVTA DEL PALAZZO DVCALE
Sopra la Piazza

4. *Luca Carlevaris,*
The Piazzetta looking
towards the Palazzo
Ducale, *c. 1703-04,
etching*

made use of Carlevaris' etchings as an aid in his work. It should be noted how Bellotto improves the compositional balance of his source – he has shifted the "frame" of the view to the right, not going beyond the main window of the Doge's Palace surmounted by the statue of Justice by Alessandro Vittoria, and extends the line of vision further to the right, encompassing more of the Riva degli Schiavoni and the Bacino. By increasing the distance from the Palazzo Ducale and exaggerating the depth of the Piazzetta, Bellotto can include the column of St. Teodoro. But is it above all the way in which the light is handled, with dramatic effects and constrasts, that gives this painting its exceptional originality. The contrast between the dark shadow of the campanile falling with an irregular outline onto the bright façade of the Doge's Palace and the columns in full light at the right of the composition provides spectacular proof of Bellotto's abilities at this stage of his career.

The view looking toward the Bacino with the entrance to the Grand Canal, the Dogana and the Salute, on the other hand, is a rather strange composition that seems to have no precedent and was not repeated in Bellotto's topographical repertory. Both columns rise up before the Salute and the convent of the Somaschi in the distance; St. Mark's column is shown without the lion, cropped at the top of the capital. Did Bellotto employ this device (Fig. 5) to create a greater depth of field, emphasizing the receding perspective and highlighting the variations in the fall of light upon the church? Nothing remains of this compositional tension and manipulated perspective in a subsequent view of the Bacino from the Piazzetta, formerly in the collection of Paxton House,[17] a painting that is stylistically more advanced and in which the space is organized into strict parallel planes and the ambiguities of the earlier work are resolved.

The style of the paintings in Figs. 2 and 3 can be specifically linked to Canaletto's works of the 1730s. The basic technique is the one developed by the older painter in the series of views painted for the Duke of Bedford, but Bellotto's intensity of application, accuracy of description, and manner of working the wet paint, "engraving" it and twisting his brush, evokes the very complicated handling of a Canaletto view of *The Campo Santi Giovanni e Paolo* painted for Joseph Smith some time between 1735 and 1738 and now at Windsor Castle.[18] In the description of

the Libreria exactly the same techniques employed by Canaletto has been adopted by Bellotto: a grid is marked out with a ruler, arches are drawn with a compass, and lines of perspective and proportion are indicated by incisions in the ground. To create the sensation of relief in the sculptural parts, various overlapping layers of thick paint are applied, from the darkest to the lightest, and topped with touches of white and yellow. The light reflected in the windows is marked with touches of blue-grey, a technique of Canaletto's, and in the shadows beneath the porticoes very fine grooves have been cut in the wet paint using a ruler that provide glimpses of the pale preparatory colour.

But Bellotto's tendency to accentuate the procedures undoubtedly learned in Canaletto's workshop is already evident here in every brushstroke, which are thicker than Canaletto's. In the plastic, "sculpted" description of the church of the Salute, highlighted by the outline of the two columns – the most evocative and personal section (Fig. 5) of the painting – Bellotto's experiments with light and shade carry him beyond his teacher's practices. In order to emphasize the illuminated parts of the baskets containing birds in the Piazzetta, he applies thick layers of cadmium yellow that were to become characteristic of his subsequent technique.[19] The façade of the Doge's Palace in the companion painting is described using an impasto style with irregular brushstrokes, "dragged up" here and there to augment the rich thickness of the paint layer, in the manner of Canaletto. The grooves in the paint – not always well calculated, as also may be observed in the master's work[20] – trace the outline of the lozenge-shaped decoration. But the windows and the sculptural decoration are outlined in very fine black lines with a precision not encountered in Canaletto and the depth of the porticoes in shadow is suggested with marks of varying intensity that can be found in later paintings by Bellotto, such as the view of the Piazzetta in the National Gallery of Canada (cat. no. 10). Bellotto's personal style is also very much evident in the treatment of the sky and the water, and also contributes much to defining the overall sense of atmosphere of the two paintings. After his return from Rome he changed his way of painting – the two capriccios in Asolo from about 1742-43 (cat. nos. 27, 28) reflect his later techniques. Nonetheless, in certain paintings such as the *Arch of Titus* in the Accademia Car-

rara, Bergamo, which possess great descriptive maturity, there is evidence of the use of this same early technique in the handling of the clouds, with irregular brush-work and thick horizontal strokes over a dense diagonal preparatory layer.[21]

Bellotto has paid particular to the figures in the two views – these are not just decorative *staffage* but carefully delineated types. Some have been portrayed with great delicacy, others are less carefully finished. The manner in which he makes these characters real and convincing by carefully describing their clothes, displaying a great deal of variety and originality in his use of color, is typical of the artist and will become an increasingly important feature of his work, culminating in the views of Warsaw. In the view of the Piazzetta looking towards the Dogana and the Salute, one group near the base of the column stands out in particular (Fig. 6). This well-to-do, fashionably dressed family going about its business presents an unusual sight: the woman in her full-skirted black dress and fichu; the man with clearly defined features seen in profile to show off his *catogan* and the braided edges of his elegant frock-coat; the child in a light blue dress with lace decoration and white shoes. They

could be foreigners, so different do they appear from the Venetians wrapped in their cloaks beneath which they wore fleece-lined frock-coats.[22] The attribution of the two former Spitzer paintings to Bellotto and the fact that they are the only known pair of *vedute* of San Marco ascribed to the artist makes it extremely probable that both originally belonged in the Schulenburg collection; their modest dimensions and quality, moreover, justify the low valuation indicated in the archival documents. Bellotto's use of Carlevaris's print of the Ducal Palace and the Riva degli Schiavoni as far as the Arsenale for one of the compositions suggests that he intended an allusion not only to the political power of the Republic but also to its military and naval power, in which Schulenburg played such a glorious role. In the companion painting, as we have seen,

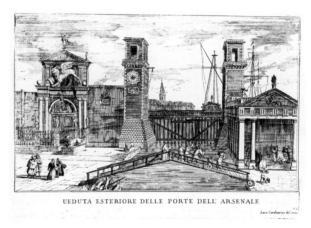

UEDUTA ESTERIORE DELLE PORTE DELL' ARSENALE

6. *Bernardo Bellotto,* The Piazzetta looking towards the Bacino di San Marco with the Dogana and Santa Maria della Salute *(detail), c. 1739-40 (Private Collection)*

7. *Luca Carlevaris,* View of the Exterior of the Arsenal, *c. 1703-4, etching*

the position of the columns in the Piazzetta have been manipulated to "frame" the Salute, the symbol of Venice's salvation. It is quite possible that the lost views of the Arsenale that completed the Schulenburg set may also have been derived from compositions by Carlevaris such as the etchings reproduced in Figs. 7 and 8.[23] Thus Bellotto could have conceived a series of topographically complementary views that would have conveyed a coherent allegorical message to their owner, and if this supposition is correct, the choices and anomalies of the two existing compositions may be explained.

Bellotto did in fact produce a view of the Arsenal and the Campo dell'Arsenale a few years later that is now in the National Gallery of Canada (cat. no. 9). Nothing is known about another view of the same site, "The Entrance to the Arsenal at Venice, with Lions," described by Waagen in the William Roscoe collection in Liverpool as "a good picture by Bernardo Bellotto, and not by

Canaletto".[24] Two drawings by Bellotto of the gates of the Arsenal are known, executed between 1738 and 1740; one is in the Hessisches Landesmuseum, Darmstadt (Fig. 9), the other is in the Fondazione Custodia, Paris, where it is attributed to Canaletto.[25]

In tracing Bellotto's early development, it is important to consider four works painted for Henry Howard, 4th Duke of Carlisle (1694-1758), in the collection at Castle Howard.[26] Stylistic evidence suggests that these were painted shortly after the views we have identified as two of the missing Schulenburg paintings. One, the Bucintoro on Ascension Day, clearly derives from Canaletto's manner of painting in the first half of the 1730s. Several other views formerly in the Castle Howard collection are pertinent in this discussion such as a view of the entrance to the Grand Canal with the Salute and another of the Ponte di Rialto, now in the Musée du Louvre, Paris, that also reveal the strong influence of Bellotto's master.[27] A view of the *Bacino di San Marco with the Church of San Giorgio,* (Fig. 10) once in the collection of Sir Michael Sobell, London, contemporary version of a lost Castle Howard painting, suggests Bellotto's rapidly increasing mastery as a painter of *vedute.*[28]

Bellotto's paintings continued to reveal ever more sophisticated refinements of Canaletto's methods of the 1730s through the early 1740s, and he continued to evolve an individual style of his own, demonstrating an increasing skill in establishing compositional harmony and balance, the description of light and shade, architectural exactitude, and individualization and conviction in the figures. In a view of *The Piazza di San Martino with the Cathedral, Lucca* (cat. no. 17), his handling reveals an extraordinary sophistication, he has attained great mastery in his powers

of description, and there is no longer any evidence of hesitancy in establishing his composition. The dating of this picture to the latter part of 1742 establishes a significant point of reference in Bellotto's early chronology.

A view of *The Grand Canal from Palazzo Flangini to San Geremia*, now in an American private collection (Fig. 11), which I have had identified as by Bellotto, certainly predates this single view of Lucca and at the same time is definitely later than the two former Spitzer views.[29] If, as has been suggested, its origins lie in the Castle Howard collection, it is the last painting in the series.[30] It is a version of the analagous painting by Canaletto in the Harvey series, formerly at Langley Park, now in the Wrightsman collection, having the same composition and revealing a similar technique.[31] The expression of the char-

the waves and the reflections). It may be that Bellotto's transformation of the lighting effects in Canaletto's composition was first studied in a drawing, now lost, similar to that of *The Grand Canal with the Salute from Campo Santa Maria del Giglio* in Darmstadt from 1740-41, which has the same atmospheric density as this painting and the same attention to the fall of light and shade.[33] In this changeable light no detail of the architecture has been neglected, but these are clearly accentuated with black lines made with the tip of the brush, while other less deep impressions made with a blunter point vary the reflections of the light. This technique greatly enriches the painted surface and surpasses Bellotto's rather "didactic" search for perfection in the *View of the Campo Santi Giovanni e Paolo* exhibited here (cat. no. 7). The handling anticipates

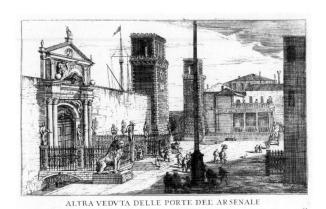

ALTRA VEDVTA DELLE PORTE DEL ARSENALE

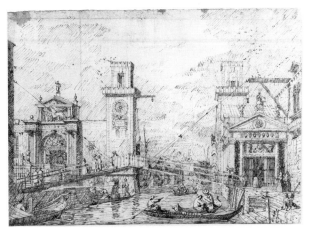

8. *Luca Carlevaris, View of the Arsenal and the Campo dell'Arsenale, c. 1703-4, etching*

9. *Bernardo Bellotto, View of the Arsenale, c. 1738-40, drawing (Hessisches Landesmuseum, Darmstadt)*

acteristics so typical of Bellotto is so highly evolved here that all doubts as to its attribution can now be set aside. This painting was not known to Stefan Kozakiewicz and is therefore not mentioned in his book; W. G. Constable, who studied it at an exhibition at Tooth's in London in 1968, classified it as by Canaletto, even though of "replica quality". But he perceived in the figures some elements that were foreign to his style.[32] In his great fidelity to Canaletto's composition, Bellotto's efforts to "personalize" the work are very evident in the choice of green tones, in the grey sky full of large clouds, and in the highly elaborate treatment of the water (a true proof of the artist's creativity in varying the colour and the size of the strokes that describe

the lucidity of description and the strong contrasts of light and shade in every detail that characterize the *View of the Arno from Ponte della Trinità to the Carraia* in Budapest (cat. no. 14), painted in 1742. The absence of the statue of St. John Nepomuk, carved by Giovanni Marchiori and formally erected at the Fondamenta di San Geremia on 12 May 1742, when the artist had already been gone some months from Venice, supports a date for the painting before (perhaps only shortly before) Bellotto's departure for Rome.[34] Ironically, at the very moment when Canaletto was beginning to simplify his own painting technique,[35] Bellotto was employing every trick he learned in the studio of the master in his own works.

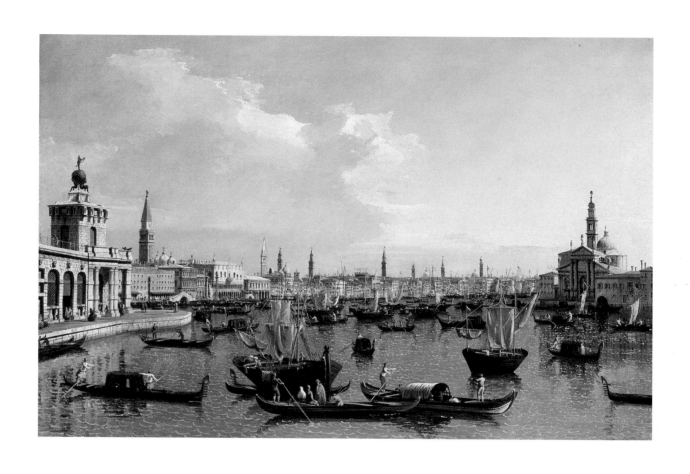

10. *Bernardo Bellotto,*
The Bacino di San
Marco from the Canal
of the Giudecca,
c. 1740-41
(formerly Sir Michael
Sobell, London)

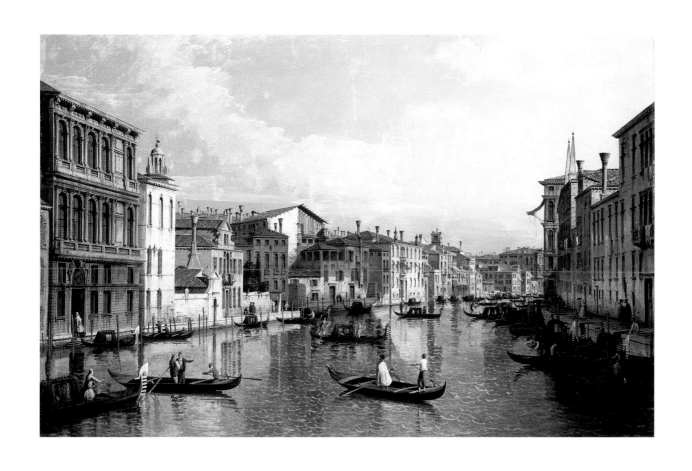

11. *Bernardo Bellotto,*
The Grand Canal
from the Palazzo
Flangini to the Palazzo
Vendramin Calergi,
c. 1740-41 (detail)
(Private collection)

[1] Levey 1973, p. 616.

[2] Constable 1962; Constable and Links 1976 and 1989; Links 1998; Kozakiewicz 1972.

[3] De Vesme, *Le Peintre Graveur italien*, Milan 1906, pp. 488-89.

[4] Kowalczyk 1999, pp. 189-218. In 1732 Antonio Visentini dedicated an etching to Marc'Antonio Giustinian (1676-1756) – one of the outstanding figures in the Venetian Government from 1717, the year he was appointed "*procuratore de Supra*" – to commemorate the transferral of the relics of St. Peter Orseolus, Doge of Venice from 976 to 997, to San Marco (Succi, in Venice and London 1986, p. 216).

[5] Kozakiewicz had already surmised Bellotto's role as chronicler for the workshop, but the similarity of style and technique between Bellotto's drawings and his contemporaries was an insuperable obstacle at the time. The studies of the drawings have now yielded very significant results. In addition to preparing sketches for compositions, Bellotto (and Canaletto, too) kept architectural sketches of Venetian sites and studies of figures for the use of the workshop in an album with numbered pages. Various drawings, now held in public and private collections in Berlin, Rotterdam, and elsewhere should be attributed to the younger artist and not to Canaletto. Fortunately, the succession of such sheets on the art market has accelerated the process of attribution. See for example, a double-sided drawing, a sketch of houses in the Campo San Basso and studies of groups of figures (sale, Sotheby's, New York, 26 January 2000, lot 43); a *Group of Spectators Around an Acrobat* (sale, Christie's, London, 4 July 2000, lot 46); and another drawing sold at Sotheby's, London, 5 July 2000, lot 67) with sketches on both sides of the sheet.

[6] For the Darmstadt drawing, see Kozakiewicz 1972, vol. 2, no. 25.

[7] Orlandi and Guarienti, 1753, p. 101.

[8] The painting has been studied and recognized as Bellotto's in two separate essays written about the same time but in very different critical contexts (Kowalczyk 1998, pp. 84-85, 88, and Succi 1999, pp. 33-37). Dario Succi, the only scholar to have understood the importance of my discovery of the artist's date of birth (Kowalczyk 1995, pp. 66-77), maintains a date for the National Gallery painting of 1740, and therefore to the series of paintings that should comprise the painter's first years of production. In order to execute this painting and another equally simple *View of the Bacino di San Marco looking towards the Riva degli Schiavoni*, formerly with the Walpole Gallery, dated by Succi to the end of 1740 (London 1990, no. 42; Kowalczyk 1996, no. 4; Succi 1999, pp. 24, 27, fig. 1), Bellotto, according to Succi, would have had to execute a substantial number of paintings which, in my view, bear no relation to one another and are stylistically quite unconnected. For example, both anonymous paintings in Ca' Rezzonico, Venice (Succi 1999, pp. 30, 32, figs. 11 and 12) and a *View of the Campo Santi Giovanni e Paolo* in a private collection in Montecarlo (p. 28, fig. 6), and an even more stylistically remote, colorless version, now in a private Italian collection (p. 62, fig. 45), of *The Grand Canal from Palazzo Flangini,* should be excluded from Bellotto's catalogue. Moreover, the artist's Venetian drawings should not simply be used as illustrations of one site or another and then cited to make attributions to paintings, the dates of which are determined on the basis of their usefulness in making a particular attribution. (Succi's erroneous spelling of both the city of Darmstadt, which holds the largest collection of Bellotto's graphic work, and the author of an accurate catalogue of the collection, Matthias Bleyl, is rather a mystery). As far as the history of the Castle Howard collection of *vedute* is concerned, the relevant documents in the collection's archives have been accurately transcribed and put in order by the archivist Christopher Ridgway and for so-

me time made available to scholars. The publication of the two valuable photographs of the "Canaletto Room" at the beginning of the century clearly reveals the prominence of Bellotto's work in the collection and Dario Succi correctly analysed it in some detail; but the number of paintings attributed to the artist (seventeen) should be reduced by at least two. I would prefer to eliminate as by Bellotto the two mainland views, a town on the Venetian mainland (62 × 88.9 cm; decribed as a "View across a canal; a domed church in a campo, filled with boats and crowded with figures and cattle, a palace on the right") and a view of Mira (62 × 88.9 cm; described as "A Canal with a church standing on a quay; along which a procession escorting an image of the Virgin is passing, on the left the machinery of the sluices lock"), which this scholar sought in vain among Bellotto's known paintings. Valued by Sotheby's on 10 May 1922 at £100 and sold in 1923 by Barbizon House for £70 each, the subjects and measurements suggest that they are the pair of paintings of Giovanni Battista Cimaroli exhibited by Succi in 1994 in Palazzo della Ragione in Padova (*Luca Carlevaris e la veduta veneziana del Settecento*, Milan 1994, p. 277, nos. 92 e 93). That Cimaroli is represented among the works of the *vedutisti* in Castle Howard, alongside Canaletto, Bellotto and Marieschi, is a surprise for scholars. One of his best paintings, the *Locks at Dolo* (Staatsgalerie, Stuttgart), has never been previously attributed to him and is still thought to be by Canaletto. But this really does comprise a completely new element, in particular for the history of the collection, which is still far from being solved.

[9] See Russell 1988, pp. 401-406.

[10] Kowalczyk 1999, pp. 199-204.

[11] Sani 1988, p. 320, no. 326.

[12] Binion, in Verona 1990, pp. 27-29 (Niedersächsisches Staatsarchiv, Hannover-Pattensen, NS 82 III 61); Binion 1990, pp. 119-20.

[13] Binion 1990, p. 29.

[14] For the discussion of the four paintings, see Pantazzi, in Ottawa 1987, pp. 19-24, and Kowalczyk 1995, p. 76, n. 47.

[15] For discussions of these pictures, see Constable and Links 1989, vol. 2, nos. 76 and 129 (b); Kozakiewicz 1972, vol. 2, pp. 404-405 and 415, nos. Z 45 and Z 101; Links 1998, pp. 9, 14, nos. 75* and 129*; my entry in *Important Old Master Paintings*, Christie's, New York, 25 May 1999, lot 146, pp. 168-69; Succi 1999, pp. 37, 39, 71, fig. 19.

[16] Carlevaris 1703-4, no. 48 (*Veduta del Palazzo Ducale Sopra la Piazza*).

[17] Constable and Links 1989, vol. 2, no. 129 (a); Kowalczyk 1996, p. 80; Succi 1999, p. 37, fig. 17

[18] Constable and Links 1989, vol. 2, no. 308; Puppi 1968, no. 193A; Corboz 1985, vol. 2, no. P 308. For the date, see Oliver Millar, in London 1980, p. 52, and in Venice 1982, p. 67.

I believe that a later date, around 1738, when Canaletto started working on the Harvey paintings, formerly at Langley Park, can be accepted. This series of 21 paintings (see Constable and Links 1989, vol. 2, no. 188) was executed in my opinion between 1738 and 1740; there exist preparatory drawings by Bellotto whose dates would accord with this period for some of these canvases.

[19] Pignatti 1966, pp. 222, 227.

[20] Viola Pemberton-Pigott, "The Development of Canaletto's Painting Technique," in New York 1989-90, p. 58.

[21] Kozakiewicz, vol. 2, no. 73; Marini, in Verona 1990, p. 70.

[22] The small figures in these paintings, which are decidedly elongated, frozen in their actions, and executed with abundant touches of colour, turn up again with minor differences in paintings executed shortly after this such as the views of *The Rio dei Mendicanti and the Scuola di San Marco, Venice* (cat. no. 5) and *The Campo Santo Stefano* (cat. no. 4). The two gentlemen at the right in the

view of *The Bacino di San Marco from the Piazzetta* undoubtedly served as the prototype for a similar group in the foreground of *The Piazza della Signoria* (cat. no. 13), and the lady with the fan appears again in Bellotto's Milanese *View of San Paolo Converso e Sant'Eufemia* and the *Castello Sforzesco* in Namešt. The artist presumably kept a notebook prior to 1740 containing a repertory of figures, which he referred to at various moments in his career. I would like to thank Doretta Davanzi Poli for her help in researching the costumes.

[23] Carlevaris 1703-4, nos. 62 e 63.

[24] Waagen 1854, vol. 3, p. 240. This is probably not the painting that Michael Pantazzi (Ottawa 1987, p. 21) cites as an autograph work by Bellotto and that W.G. Constable and J.G. Links catalogued as by Canaletto (Constable and Links 1989, vol. 2, no. 273; Links 1998, p.28, no. 273). The painting, once in the collection of Henry Temple, 2nd Viscount Palmerston, and now in the Museum of Fine Arts of Houston, Texas, is a nineteenth-century variant copy of cat. no. 9 in the present exhibition.

[25] For the Darmstadt drawing, see Kozakiewicz 1972 vol. 2, p. 26; no. 27; Bleyl 1981, p. 22, no. 12; Kowalczyk 1988, vol. 2, no. 27; for the Paris drawing, Constable and Links 1989, vol. 2, discussed under no. 603.

[26] The *vedute* by Bellotto now at Castle Howard include the *Grand Canal from Ca' Foscari and Palazzo Moro-Lin to the Carità* (London 1990, no. 43; York 1994, note to no. 32; Succi, in Mirano 1999, pp. 52, 72); *Piazzetta looking towards the Libreria* (cat. no. 3); *Campo Santo Stefano* (cat. no. 4); *Bucintoro on Ascension Day* (London 1990, p. 96, note to no. 43; York 1994, p. 16; Succi, in Mirano 1999, p. 52, fig. 32).

[27] Constable and Links 1989, vol. 2, nos. 171 and 236 (d); Kowalczyk 1999, pp. 84-85; Succi, in Mirano, pp. 63-64, figs. 46, 47.

[28] Constable and Links 1989, vol. 2, no. 133; Kowalczyk, in Venice 1995, p. 443, note to no. 162; sale, Christie's, London, December 1995, lot 75; Kowalczyk 1996, vol. 2, pp. 5-7, no. 3; Kowalczyk 1996b, p. 80; Links 1998, no. 133; Succi, in Mirano 1999, p. 27, fig. 2. The identification of this painting as by Bellotto, which I proposed for the first time in the catalogue of the Venice exhibition, was courageously accepted by Christie's on the occasion of its sale in December 1995, even though at the time the attribution to the artist of a Venetian *veduta* that had previously been thought to be by Canaletto could have been seen as downgrading.

[29] Constable and Links 1989, vol. 2, no. 257 (b); sale, Christie's, London, 16 December 1998, lot. 78 (catalogue entry prepared by Charles Beddington in consultation with the present author); Kowalczyk 1998, p. 88.

[30] Succi, in Mirano, p. 62, fig. 44. Dario Succi's hypothesis is appealing, but it should be noted that, while the measurements of the paintings by Giambattista Cimaroli mentioned above as originating in the Castle Howard collection (note 1) correspond exactly to those in the Duthie inventory (1878; Castle Howard Archives, H2/1/11-12, nos. 478, 480), no painting from the collection listed in the nineteenth-century inventories has the same measurements as that formerly in the collection of Michael Hughes (23 × 36 inches).

[31] Constable and Links 1989, vol. 2, no. 257 (d). There are no known autograph replicas by Bellotto.

[32] London, Arthur Tooth, *The Venetian View Painters*, 1968, no. 18; Constable and Links 1989, vol. 2, no. 257 (b).

[33] Kozakiewicz 1972, vol. 2, p. 13, no. 9; Bleyl 1981, no. 19.

[34] Biblioteca del Museo Correr, Codice Gradenigo, 200, VII, cc. 12 and 17; Succi 1989, p. 142.

[35] See Pemberton-Pigott, in New York 1989-90, p. 60 ("As the demand for paintings generated by Joseph Smith increased, Canaletto brought his nephew Bernardo Bellotto into his studio. His technique began visibly to simplify."); Bomford and Finaldi 1998, p. 59.

The Freedom of a *Veduta* Painter: Bernardo Bellotto in Dresden

Gregor J.M. Weber

In 1747 Bernardo Bellotto, known in Germany and eastern Europe as Canaletto, arrived at the Saxon court of Augustus III, King of Poland and Elector of Saxony, to paint seventeen views of Dresden (Fig. 1), eleven of Pirna, five of the Fortress of Königstein, and other paintings including *capricci* and allegories, work that would occupy him through 1766. Not all of these paintings are housed in the Dresden Picture Gallery; the views of Königstein, for example, ended up in other collections as a result of the Seven Years War (1756-63). The war also forced Bellotto to stop working in Dresden for a period, during which time (between 1759 and 1761) he painted views of Vienna and Munich. Since both Augustus III and his plenipotentiary prime minister, Count Heinrich Brühl, died at the end of 1763 within a matter of weeks of each other, Bellotto was forced in the years following to obtain work at the Dresden Academy of Fine Arts, teaching the foundation courses in perspective where he also supervised the junior classes for landscape artists and architects. At the end of 1766 he asked for a period of leave to go to St. Petersburg, but he stopped on his way in early 1767 at the Polish court of King Stanislaus II Augustus Poniatowski, where in 1768 he became a court painter and spent the remainder of his career in the service of the king portraying the city of Warsaw, where he had settled.

Bellotto therefore spent almost twenty years working in Dresden, where no less than thirty-six paintings, including *capricci* and allegories, are gathered today in the Gemäldegalerie Alte Meister. Augustus III must have held the artist in high esteem, given the extremely generous salary he paid his court painter. Bellotto, moreover, provided the prime minister with a series of replicas of the royal *vedute*, many of which ended up in the collection of Catherine the Great of Russia (cat. nos. 45, 47, 50-52, 54, 61, 64), after the Brühl collection was broken up. For other clients, Bellotto painted reproductions of his views in smaller formats; he also published most of his subjects as impressive etchings.[1]

The earliest information regarding the completed paintings is to be found in the inventory of the royal art gallery, drawn up by Matthias Österreich between July and August 1754.[2] At that time Bellotto's paintings were not yet, however, among the paintings hanging in the gallery, but belonged to a small group of paintings "in store;" that is, held in the reserves. It is interesting to note that the paintings in store at the time were almost all modern Venetian paintings, whose final destination had obviously not yet been determined; the art gallery proper contained almost exclusively Old Masters.[3] At the time the reserves contained *vedute* of Venice by Bellotto's uncle, Antonio Canal, known as Canaletto, and by Luca Carlevarijs (1663/64-1730), landscapes by Marco Ricci, and other contemporary works Count Francesco Algarotti (1712-64) had commissioned from the Venetian artists Tiepolo, Pittoni, Piazzetta, Amigoni and Zuccarelli.[4] The largest group comprised twenty-two *vedute* by Bellotto (nos. 528-49), the titles for which can without exception be identified with the paintings by Bellotto that have come down to us.[5]

The series of large views is impressive: Bellotto favored a standard format of approximately 53 × 92 inches; only two paintings were executed in a different format, the two large, almost square *vedute* of the Kreuzkirche (see cat. no. 50) and the Frauenkirche.[6] As in the case of these two paintings, Bellotto tended to produce pairs of paintings, the subjects and compositions of which complemented each other. Among the *vedute* of Dresden are two panoramic views of the right bank of the Elbe (cat. no. 39; Fig. 1), two views of the old moats around the bastions (Dresden inv. nos. 609, 611), two of the Old Market (cat. no. 49; inv. no. 615) and two of the New Market (cat. nos. 46, 48). These paintings, plus another four views of Dresden, also of well-defined urban contexts, provide a rich and extensive repertory of views of contemporary Dresden, although Bellotto did not paint the city from every angle – there are no views of the city from the eastern side, for instance.

The many exhibitions and publications of Bellotto's work in the past century have helped his

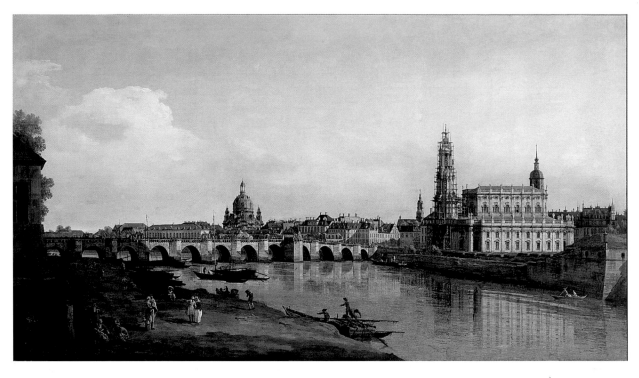

paintings to be valued as manifestoes of view painting. Today, the Dresden paintings epitomize the Augustan splendour of Saxony and have risen to the rank of historic and cultural documentation. Indeed his cities and landscapes, hills and houses are extremely reliable topographical records, illustrating the daily life of the streets and squares in a wealth of detail, with the skills of the raconteur. These paintings enable the viewer to virtually wander through Dresden and Pirna, to gaze on many of the same squares and buildings as Bellotto's contemporaries; in other words, they can stand in for the old cities, they have won the right to be considered faithful substitutes for the reality of a past time.

In his first view of Dresden, Bellotto clearly establishes his claim as a faithful delineator of the city, placing himself in the foreground of the painting as a witness to the reality of what lies before him (Fig. 2, cat. no. 39). The tradition of the artist incorporating himself into his composition had long been part of view painting: there is a view of Lunz dating from 1593 in which the painter Lucas van Valckenborch (1535-97) has placed himself in the foreground standing next to another figure (as in Bellotto's view) who points out to him a motif in the background.[7] The requirement for Bellotto's views to be truthful also surfaces in a warrant issued by the elector relating to Bellotto's records of Pirna. In 1753, the painter became interested in this town near the source of the Elbe with its imposing

castle, the Fortress of Sonnenstein. The warrant, certified by Count Brühl and dated 26 April 1753, instructed the local administrator Crusius not to "in any way obstruct" the court painter Bellotto "who has been charged with carrying out drawings of the situations of the surroundings of Pirna and further afield". A similar decree dated 30 May 1756, again certified by Count Brühl, refers to works "around the mountain fortress of Königstein".[8] It is therefore clear that those who commissioned work from Bellotto attributed great importance to the authenticity of the views and did not expect fanciful compositions, but rather verifiably and topographically exact records that faithfully reflected the actual situation, indeed that aspired to being real.

Even today, efforts are made to prove the authenticity of Bellotto's views and compare them to the original topographical sites. In Pirna, for example, which suffered much less destruction than Dresden during the last war, the cultural association "Canaletto Forum Pirna e.V." commissioned in 1998-99 a copy of the *Veduta of the Market Square in Pirna* to hang in the "Canaletto-Haus" (Canaletto's House, see cat. no. 56). In the publicity brochures of the local tourist information bureau, Bellotto's paintings have been placed alongside photographs of the city as it exists today. Similarly, most of the publications about the painter's Saxon *vedute* focus on the description of the topography and, above all, the monuments he painted. In addition the paint-

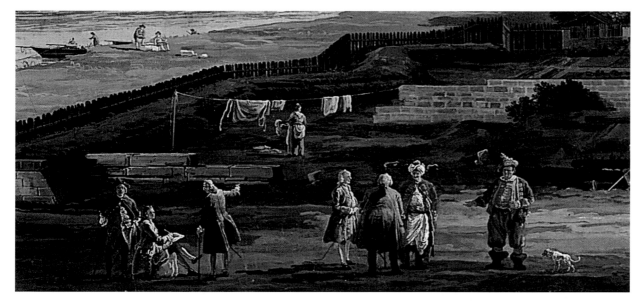

2. *Bernardo Bellotto,*
View of Dresden
from the
Right Bank of the Elbe
above the Augustus
Bridge (detail), *1747,
oil on canvas
(Gemäldegalerie
Alte Meister, Dresden)*

ings have been interpreted as documents recording civic history and popular traditions. In keeping with the elector's decrees of 1753 and 1756, Bellotto's art seems to be considered almost exclusively as a form of illustrated news, reporting times past.

In sharp contrast to the requirement that he faithfully record specific topographical sites, other paintings by Bellotto cannot be reconciled with historical reality. From the very beginning of the artist's career in Dresden, when he was creating what were to be his most famous views of the city, Bellotto painted two major *capricci*: in one he has placed a famous Dresden building, the Pavilion on the Bastion of Venus, among buildings of Roman and Venetian architecture; the other uses an etching of *A View of Dolo on the Brenta* by his uncle Canaletto to create an imaginary landscape, which also combines disparate buildings (cat. no. 44).[9] Bellotto executed these two *capricci* in the same large-format canvases of the Dresden, Pirna, and Königstein views.

Later, in the period following the Seven Years War, Bellotto painted *capricci* that summarized well-known motifs of Dresden and Pirna but are anything but "true" (Fig. 3). On the banks of a river stands an imposing Baroque domed church, which has elements of the church of Santa Maria della Salute in Venice, the Karlskirche in Vienna, and the Frauenkirche in Dresden; in the background is a cityscape with a majestic fortress similar to that of Sonnenstein in Pirna, and a Gothic church that is similar to the Marienkirche in Pirna, but seen as a mirror-image. In light of what people had come to expect from Bellotto the *vedutista*, such a capriccio with

imaginary and well-known motifs, one that crossed the boundaries of reality to represent things that had never been seen, was certain to take them by surprise. In a letter to Prospero Ricci in 1759, Count Algarotti spoke about this "new genre" that consisted of choosing a real place only to fill it with beautiful buildings taken from here and there or simply invented; in short, the fruit of imagination. The consequent improvement of the slavish imitation of nature by means of imagination, according to Algarotti, contributed to ennobling the art of the view painter. In this way, he continued, art and nature are united in such a way as to combine what the one possesses in terms of study and studied refinement and the other in terms of simplicity. Algarotti took as an example a painting by

3. *Bernardo Bellotto,*
Capriccio
with a Baroque church
and motifs of Pirna
(detail),
*c. 1765, oil on canvas
(Private collection,
Florence)*

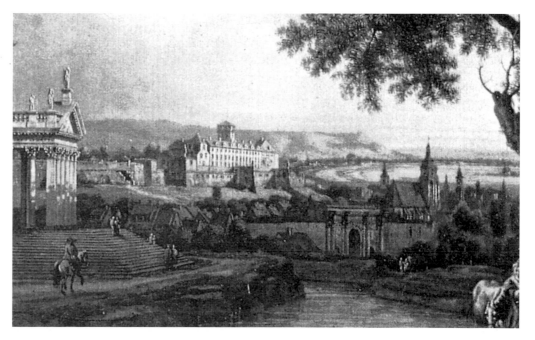

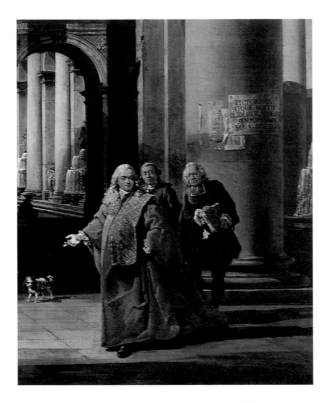

Canaletto, a view of the Grand Canal in Venice, but with the Rialto Bridge taken from a drawing by Palladio that had never actually existed.[10]

Bellotto himself took a stand regarding the capriccio. In about 1765, while he was still in Dresden, he painted a large invented architectural setting in which he appears in the foreground, but dressed as a noble Venetian procurator and therefore playing a role that he never had in life. On the large column behind Bellotto and his servants is a ripped and partially covered notice, the first lines of which are still legible (Fig. 4, cat. no. 85): "*Pictoribus atque poetis quidlibet audendi semper fuit aequa potestas*", a quotation of lines 9 and 10 of Horace's *Ars Poetica*: "Painters and poets have always had equal liberty to dare to do what they wanted".

Horace began his treatise on poetic art by commenting on paintings that, "futile as the dreams of the sick", put together the limbs of men and animals, absurd images of the imagination; therefore, like chimeras and sphinxes. In his next comment, however, the one Bellotto has used, the Latin poet mentions the equal degree of liberty enjoyed by both painting and poetry and he continues, "I know, and this favour I ask for myself and extend to others, not however to the point of joining fury and meekness, of coupling serpents with birds, and lambs with tigers … In short, a work of art may take any form, as low as it is complete and unitary". The quotation from Horace le-

gitimizes Bellotto's invented architectural elements, but at the same time limits them to representative verisimilitude, which is the only way to respect the required unity and completeness.[11]

This leads us to wonder how Bellotto, as a *vedutista*, went about exploring the gap between imagination and reality, whether he rigidly separated real views from imaginary ones, or whether he was able to reconcile the poetic licence of the painter with the objectivity of the chronicler. Did Bellotto also imbue his views of Dresden and Pirna with aspects of art, learning, and studied refinement (to repeat Algarotti's concepts)? While this may involve the introduction of unexpected motifs, it certainly involves making choices regarding certain artistic principles and certain pictorial refinements. Bellotto learned like any other painter to paint according to figurative conventions that were passed down to him and can still be seen today in the paintings of his teachers and predecessors. Knowledge of such models is necessary in order to discover the "art" in Bellotto's *vedute* that are so close to reality, in order to be able to identify both the conventional aspects as well as the surprisingly new and unusual ones.

The cities and landscapes represented in *veduta* painting must be recognizable. The artistic transformation therefore involves three main points: 1. the structure of the painting (composition, the angle and layout of the image, perspective, and so forth); 2. the light; and 3. the choice of accessory figures. We shall briefly discuss these individual aspects.[12]

In 1748 Bellotto added a pendant to his first view of Dresden – a view looking back at the city from below the Augustus Bridge (Fig. 1). This was to become the "classic" view of Dresden, dominated on the right by the Hofkirche, the Catholic court church, the bell-tower of which was missing in the previous view (cat. no. 43). In fact the bell-tower did not exist in 1748 and Bellotto referred to a copper engraving based, in turn, on the plans drawn up by the architect Gaetano Chiaveri. This is by no means a negligible falsification of the actual appearance of the church, however, as indicated by the scaffolding around the bell-tower, only actually completed in 1755. Bellotto added the bell-tower to other views, too, in which it occasionally appears out of proportion to the rest of the building. Although he certainly would not have decided independently to make such a critical adjustment to the skyline of

5. *Bernardo Bellotto,*
The New Market
of Dresden seen from
the Moritzstrasse,
c. 1750,
oil on canvas
(Gemäldegalerie
Alte Meister, Dresden)

the city, it is nonetheless revealing of the ease with which the "truth" of the views could be falsified. In contrast, what was omitted is more difficult to ascertain today.

On the other hand, Bellotto's figurative descriptions seem very authentic. In the painting, the Augustusbrücke spans the Elbe with its broad arches, forming at the same time the base for the buildings that comprise the "Brühlsche Terrasse". To the left looms the majestic dome of the Protestant Frauenkirche by George Bähr that offsets the Hofkirche. And in this very famous view of the city the apparently arbitrary overlapping of the individual buildings is much in evidence: the Hausmannturm (doorkeeper's tower) of the castle seems stuck against the chancel of the court church and one experiences difficulty in judging the distance to the bridge from the area below along the river bank. This lack of clarity, avoided by the Dresden view painters that preceded Bellotto mainly by means of what were almost bird's eye views, is one of the artist's most extraordinary technical feats. It is the skyline of the city and the overlapping of individual buildings against it that determines the overall effect, and not their portrayal from on high that makes them individually identifiable.

The realistic, apparently random, overlapping of buildings has often elicited the suggestion that Bellotto used a camera obscura to obtain his images. This precursor of the photographic camera was already quite widely used and G.J.S. Gravesande was not the first in 1711 to publish a booklet on the subject: *Usage de la Chambre Obscure pour le Dessein* (The Use of the Camera Obscura in Drawing). Contemporary reports tell us that Canaletto had learned how to use the camera obscura correctly; Michele Marieschi (1710-43) and Francesco Guardi (1712-93) are also thought to have employed it.[13] The principles are similar to that of a modern photograpic camera, except that the image in front of the lens was not projected onto a photosensitive film but onto an opaque glass or a sheet of parchment, onto which the artist could trace it in pencil. According to Helmuth A. Fritzsche, Bellotto drew the Zwinger in Dresden (cat. no. 53) with a camera obscura, reproducing slight inadvertent deviations in the right angles of the square not apparent in the architectural drawings, but which Fritszche verified by physically measuring the Zwinger.

Several drawings by Canaletto, and also some figures by Bellotto, have survived in which the outlines of the subjects have been executed in a shaky line, sometimes on a sheet divided into two parts to exactly the same scale, which can only be explained by the paper being moved while drawing with the camera obscura. A disadvantage of this equipment was the relatively small size of the image produced; therefore, the large-scale views could certainly not have been drawn at the same time unless they were reduced in size or done on several sheets placed side by

ately above it is not, since mathematically it should have an oval shape, like the dome Jan van der Heyden (1637-1712) depict once in a view of the Dam Square in Amsterdam (but quietly corrected thereafter). The distortion of the lantern on the roof of the town hall is only corrected when seen at very close quarters (Fig. 6). Bellotto therefore denies here, as in other paintings, the "mathematical" truth by painting a view that is realistic only according to the way we normally see things.

He employed the same principles when he decided to crop the views shown in his compositions, rigidly following the precepts of figurative art and the client's expectations of how a painting must be composed so that he could present a satisfactory, legible view with a proper sense of depth. In the course of the history of art certain genres have developed that followed these tried and tested principles rather than inventing totally new solutions based on personal experience. One of the preferred compositional schemes involved arranging a system of diagonal wedges, such as those employed by Jan van Goyen (1596-1650) in a view of Nijmegen (Fig. 7). The proximity of the site to the viewer is suggested by the figures in the boat moving over the water in the center of the painting. This is then echoed by another wedge with the view of the city, in which a dominant building – here the Valkhof – is outlined against the sky. Some boats follow the course of the river downstream, their ever diminishing sizes indicating the depth of the field. The precision with which Bellotto follows this scheme is surprising; it is very evident in his famous view of Dresden (Fig. 1), but his panoramas of Pirna (cat. no. 57) and even of Rome (cat. no. 25) show that he adopted the same approach. In each of the three views he also adds a high building at the far left of the painting, which being in the foreground connects with the margin of the painting at the point at which the image extends in depth. It it fairly doubtful that a building existed at precisely such a point in each of the three sites, so Bellotto composed one to satisfy his figurative and compositional needs.

Nor is it accidental that Bellotto follows this tried and tested scheme for his overall or panoramic views, whereas for the description of individual topographical sites within a town or city, single clusters of houses, for example, he achieves surprisingly innovative compositions. But here, too, Bellotto's creativity is not unlimit-

side and later glued together. The architectural drawings by Bellotto that have survived only show a linear structure with the most important features, no ornamentation, and no shading.

Another drawback of the image created by the camera obscura was a phenomenon Antonio Maria Zanetti the Younger mentioned in relation to Canaletto's methods: it was he who discovered that rigid observation of the rules of perspective produced errors, where scientific precision was at odds with common sense. Here he is certainly referring to the distortion of the outlines to produce an exact perspective that does not, however, correspond to what we normally see. Where the lateral distance from the vanishing point of the perspective is great, round forms appear eliptical. For example, the vanishing point in Bellotto's view of the New Market in Dresden (Fig. 5, cat. no. 48) is left of the center of the painting; the guardhouse made longer on the right is in keeping with the perspective, but the dome of the Frauenkirche that appears immedi-

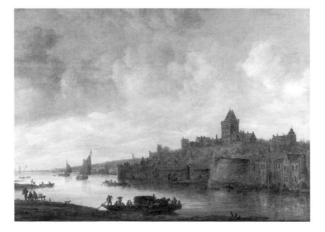

ed; the choice of where to crop an image was made according to established artistic and aesthetic principles and therefore, once again, based on models in the history of art. There were enough examples among Dutch painters of the seventeenth century that he could draw on for his urban views. For example, Bellotto's composition *The Kreuzkirche in Dresden* (Fig. 8; cat. no. 50), corresponds to a great extent to a precedent by Gerrit Berckheyde (1638-1698), *View of the Binnenhof in The Hague* (Fig. 9); in both views the façade of the imposing building occupies the right-hand side, while on the left a street continues into the distance, and further on the left the connection is made with the margin of the compositions by means of a narrow construction parallel to the frame. Similarly an area of shadow has been created in the front leading into the square in sunlight; at a similar point in both squares the scenes have been enlivened by the approach of a carriage from the right.[11]

The pendant of this painting by Bellotto is the *View of the Frauenkirche in Dresden* (Fig. 10); the title is a misnomer in that the subject is really the Rampische Gasse which continues into the distance, while the Frauenkirche stands foreshortened on the left. The composition may also have been based on a precedent of Gerrit Berckheyde's; in one of his paintings he depicts the fish market in Haarlem, on the left of which is the north transept of the church of St. Bavo towering above the other buildings (Fig. 11). The surprising size of the Haarlem cathedral confers on the painting a transient and incidental character and no more than the impression of a reliable description of reality; an impression exactly like Bellotto's Dresden paintings.

In all of Bellotto's paintings we find a pale strong lateral light, with shadows always running almost parallel to the lower edge of the painting. This phenomenon is strictly in keeping with the tradition of urban views; Bellotto was not the only one to use this sort of light, his Italian and Dutch predecessors worked in the same way. The only exception I know, the *View of the Dam and the Damrak in Amsterdam* by Jan van der Heyden, shows the light falling obliquely from above, an effect that makes the viewer dizzy.[15] So how did Bellotto work? Leaving aside the supposition that he only worked on his paintings when the sun was in the right position, it is very possible that he added this lateral light to the structure of his architectural drawings in his studio. It

8. *Bernardo Bellotto,* The Kreuzkirche, *Dresden, c, 1749-50, oil on canvas (Gemäldegalerie Alte Meister, Dresden)*

9. *Gerrit Berckheyde,* The Binnenhof in The Hague, *c. 1690, oil on canvas (Fundación Colección Thyssen-Bornemisza, Madrid)*

10. *Bernardo Bellotto,*
The Frauenkirche with
the Rampische Gasse,
c. 1751-52,
oil on canvas
(Gemäldegalerie
Alte Meister, Dresden)

ly freely invented, that acts as a second frame to the painting, creates depth, and draws the eye to the area in the light behind it. Luca Carlevaris, one of the Venetian *vedutisti* who preceded Bellotto, adopted this technique with masterly skill, but in a way that was divorced from reality; sometimes it would have taken a skyscraper rising out of the lagoon to justify the shadow effects the painter used (Fig. 12).[17]

The *View of the New Market in Dresden* by Bellotto (Fig. 5, cat. no. 48), with its dramatic succession of shadows and alternating areas of dark and light, is one of the finest examples of his theatrical use of illumination. The principles are the same used in landscape painting, where light and shade, and the height and depth of the separate areas of the scene alternate (Fig. 7). Bellotto's stratified method was necessary to create the effect of distance and depth with many overlapping dark and light areas, shadow areas in front of light areas. Accessory figures are therefore placed in the shade in front of lit areas and vice-versa, people in the light are placed in front of areas of shadow. The same applies to the side-scenes, the walls of the houses, where the artist's freedom to create shadows gives rise to some curious shapes. For example, on the façade of the Frauenkirche and on the paving below he invents the shadows of clouds with such clear outlines that one wonders how such dense broccoli-shaped clouds could stay up in the sky (Fig. 10). Nevertheless there is no need to question the way the light is achieved, it is so effective in rendering the distance between the houses in the light and the dark wall of the church. Dramatic portrayal, full of pictorial features, is much more important than the truth of the simple illustration.

Bellotto must certainly have often studied and drawn from life the accessory figures that fill his views. He faithfully reproduced the bustle in the market squares, the goods displayed in the shops, the carts and carriages. In his first view of Dresden the painter had even inserted a self-portrait in the company of other people, evidently members of court society (Fig. 2, cat. no. 39). In the 1748 pendant of this painting, now the classic view of Dresden, he portrayed with equal credibility a group of anonymous but fairly elegant visitors on the grass beside the Elbe (Fig. 1). The group on the far left, however, is surprising (Fig. 13): a poor family is grouped together in front of a simple wooden shack, a man in a brown coat leaning on a stick and, in front of

was therefore essentially up to him to decide to what extent to emphasize the plastic quality of the buildings and how to distribute the light to set off his scene. Light effects therefore counted among Bellotto's particular creative liberties; indeed, he did not hesitate in various paintings to show a clear light shining on Dresden and Pirna that could only have come from a sun positioned in the north, a light that was unnatural in Saxony (see Fig. 1). There were also precedents for this sort of artistic licence – in Canaletto's work, for example, where he shows the eastern façade of the church of Santi Giovanni e Paolo in Venice parallel to the frame, and uses the expedient of an imaginary sun in the north to create the lateral light that enlivens the façade of bricks.[16]

The lateral light obviously also creates bands of light on the flat surfaces, like the side-scenes on a stage, arranged alternately light and dark to create a sensation of depth. There is almost no painting by Bellotto in which he does not place in the foreground such an area of shadow, most-

him, a woman dressed in blue and red with a baby in her arms. Two figures have come up to the group, a boy and a young man who are kneeling at the feet of the woman. Until now the fact that these figures represent one of the most popular subjects in religious painting has been overlooked: the stable at Bethlehem with the holy family and the shepherds who came to adore the child, bearing gifts.[18] Perhaps Bellotto's intention in portraying this group was also perceived by other viewers. The simple scene in the shadow on the left is compositionally related to the Catholic court church lit by the sun on the right on the opposite bank of the Elbe. The iconographic plan of the church was developed according to Queen Maria Josepha's instructions; the main altar in the chancel was flanked by two side altars, one dedicated to Mary and the other to Joseph.[19] The allusion to the Holy Family was therefore intended either to underline their spiritual presence or as a reference to the building of the new church. A veiled criticism illustrating the difference between imperial ostentation and the poverty of Bethlehem was not something Bellotto would ever have dared to paint.[20]

In contrast to the Dresden paintings, the setting for the views of Pirna and Königstein is more bucolic with river valleys and vineyards, meadows and pastures. We encounter more peasants, travellers, carts, and river boats; we come across shepherds with their flocks at the edge of the road, in shallow water and in the fields. These pastoral motifs often recalled earlier art, such as the seventeenth-century Dutch Italianate genre paintings, more specifically the vigorous painting of Paulus Potter, although no direct example has been identified (Fig. 14, cat. no. 62).[21] It has not, however, been noted that some animals or even some groups of animals are identical in various paintings by Bellotto, not only in the *vedute* of Pirna, but also in the views of Königstein (cat. no. 65) in 1756-58 and in other paintings from his periods in Vienna and Munich (cat. nos. 66-70) between 1759 and 1761. In several views of Pirna, the same cow in profile turns up three times, although it also appears in a painting from the Viennese period with the view of Schloßhof at Marchegg. Consequently Bellotto must, for about eight years, have used concrete models such as other artists' drawings for the animals in his views.

The Dutch artist whose name is most closely linked in Bellotto's time to this genre of painting,

that is, Italian-influenced paintings with animals, is Nicolaes Berchem (1620-83). He belonged to the circle of painters that in the mid-seventeenth century produced picturesque landscapes with a Mediterranean light, peopled by Italian shepherds and shepherdesses riding on donkeys or mules, drowsing in the sun, sitting on the banks of a stream, or intent on crossing a ford. There was also a demand for Berchem's art in Italy. Indeed in the middle of the eighteenth century four large copper engravings taken from his models (or the drawings themselves) were published in Venice. They were supplemented by sheets in the same style by Francesco Zuccarelli (1702-88). They are all accompanied by a descriptive text in

13. *Bernardo Bellotto,*
View of Dresden
from the Right Bank
of the Elbe above the
Augustus Bridge
(detail), 1747,
oil on canvas
(Gemäldegalerie
Alte Meister, Dresden)

14. *Bernardo Bellotto,*
The Fortress of
Sonnenstein above
Pirna (detail),
c. 1753-55,
oil on canvas
(Gemäldegalerie
Alte Meister, Dresden)

Italian in the lower border referring to the search for Arcadia. On one sheet is written, "*Di quel terreno più vago a noi non cale*" (That more sought-after land does not attract us); on another, "*Senza pensier sol della Mandra ho cura*" (Without a care I look after my herd). Bellotto would certainly have been familiar with these engravings: a comparison with the animals depicted in his views reveals that he often drew upon the repertory of these sheets and transferred to his paintings animal and figural motifs exactly as he found them, but in new combinations, cows, goats, sheep, and even a shepherd[22]. The strange flock in the painting *The Fortress of Sonnenstein above Pirna* (cat. nos. 61, 62) is made up of a total of five sheep and a goat from the copper engraving *Di quel terreno*, as well as the cow and the shepherd from the *Senza pensier* sheet (Figs. 15,

16). It is curious that although Bellotto moved the grazing sheep from the shadow to full light on the left, he left the back of the animal as it was, slightly in shadow.

This use and re-working of others models was a common practice in painters' studios and was not in itself considered reprehensible; indeed, it was an indication of the painter's historical and artistic training. The quotation therefore served to underline the figurative scene or make some allusion to the content. In this case it seems clear that his new task of depicting "situations in the surroundings of Pirna and other places" allowed Bellotto to think not only of the required exactitude of his view, but also of earlier painting traditions, the particular forms and ways of depicting what he saw, and here in particular the pastoral landscape. This, however, is in turn connected with specific images that Nicolaes Berchem and – in Venice – Francesco Zuccarelli were largely responsible for developing. A citation of their art is therefore like the introduction of a certain chord in the overall orchestration of the pastoral painting. It was a figurative device that the seventeenth-century viewer would have understood (more easily than those of us in the present century) as the new link between "nature and art" championed by Algarotti. It was assumed that a connoisseur of art would be able to fully appreciate the artistically used quotation.

Bellotto was therefore quite free to use the repertory of the history of art, in this case involving the way he approached the artistic representation, although in other cases it involved the layout of the image, the organization of the composition and the light. But this only satisfied the requirements of his clients, who collected pictures because they were beautiful paintings and not because they depicted beautiful buildings. For this reason Bellotto's views did not encompass all aspects of the daily life of Dresden and Pirna, where there must also have existed a wealth of unattractive detail, of run-down areas, shady dealings and characters for him to depict. The concrete realization of the painting according to the above-mentioned artistic principles governing the structure of the image, the light, and the choice of figures, does, however, confer on the painting an idealizing quality that makes the view something more than the straightforward imitation of nature. It is Bellotto's artistic licence that reveals Dresden, Pirna and Königstein to us, exalted by his art.

[1] Bellotto's work in Saxony has been fully discussed by Kozakiewicz, 1972, Löffler 1985 (4th ed. 2000), Walther 1995, and Rizzi 1996.

[2] *Inventarium von der Königlichen Bilder Galerie in Dresden* (compiled by Matthias Oesterreich), Dresden 1754; see Lieber 1979, n. 359, Archiv der Direktion der Gemäldegalerie Alte Meister.

[3] There is a mention in the appendix to the gallery catalogue of 1765 of a single painting by Bellotto on show in the gallery (inv. 638), while the others are only given a brief mention: "*Outre ces Tableaux exposés sur les Parois, on y conserve encore plusieurs Perspectives de Dresde & de Pirna, peintes par Bernard Bellotto, dit Canaletto, d'autres par Alexandre Thiele…*". ("In addition to these paintings hanging on the walls, there are various other views of Dresden and Pirna, painted by Bernardo Bellotto, known as Canaletto, and others by Alexandre Thiele"), Dresden 1765, p. 244.

[4] Regarding Canaletto, see G.J.M. Weber in Columbus 1999, p. 202, note 2, and regarding Algarotti's "Kern moderner venezianischer Gemälde", see Weber 1996.

[5] The strange thing about the captions is that until then they had been linked to the wrong paintings in the various publications. For the first time this catalogue contained precise references to the textual citations.

[6] Approximately 196 × 186 cm, inv. 616, 617; 1754 inventory, nos. 528, 529. Rizzi 1996, nos. 30, 31.

[7] Oil on panel, 23.3 × 36 cm. Signed in the center: "1593 L V V", Städelsches Kunstinstitut und Städtische Galerie, Frankfurt/Main, Wied 1990, pp. 15, 30ff., 35, 49ff., 165, no. 63.

[8] Reproduced and transcribed correctly for the first time in Schmidt 2000, p. 39 ff.

[9] The first painting was found in the Residence castle in Dresden and was lost during the Second World War, Kozakiewiecz 1972, vol. 2, no. 245; Rizzi 1996, no. 82.

[10] Regarding Algarotti's letter, see Giovanni Bottari, *Raccolta di lettere sulla pittura, scultura ed archittetura*, VII, Milan 1822, pp. 427-36. See New York 1989-90, p. 220, note 4.

[11] Regarding Horace's ideas, see Müller Hofstede 1976-78, pp. 175-82.

[12] See Weber 2000a.

[13] Summarized from Fritsch 1936, pp. 151-98.

[14] Lawrence 1991, pp. 73-75, fig. 80.

[15] Cambridge, Mass., Fogg Art Museum, Harvard University Art Museum, inv. 1968.65. See The Hague and San Francisco 1990-91, pp. 273-79, no. 30.

[16] See New York, 1989-90, pp. 178-81, no. 45.

[17] Padua 1994, p. 242, no. 65. See ibid such as the shadows in the painting "*La Piazzetta verso la punta della Dogana*", p. 210, no. 41.

[18] In the etching Bellotto replaced the man standing with a man playing a musical instrument, who no longer represents Joseph but a shepherd. In the same vein it is interesting to note that in his etching of a view of Pirna, Bellotto left out a figure that could have caused a scandal if it had been exhibited to the public at large. See Rizzi 1996, no. I 2, I 16, and cat. 63. I would like to thank Jens Meinrenken of Berlin for discussing the painting with me.

[19] Seifert 1988, pp. 11-13.

[20] Putting saints in a contemporary setting was not at all unusual. Pieter Bruegel the Elder drew an adoration of the Magi in the snow, placing it on the left in a rural landscape (Reinhart Collection, Winterthur); extracts from the lives of the patron saints of a city, a country, or a sovereign are similarly illustrated. I am currently preparing a separate study of this group of figures by Bellotto.

[21] Pallucchini 1961a, p. 15; Menz 1963-64, p. 43; Walther 1986, p. 90; Walther 1995, p. 63; Rizzi 1996, p. 80, 132.

[22] See Weber 1998; Weber 2001.

Bellotto in Vienna and Munich

Martina Frank

In 1766 the Austrian statesman and patron, Prince Wenzel Anton von Kaunitz-Rietberg (1711-94) inaugurated the Kupferstichakademie in Vienna in order to "put an end to foreign supremacy" in the field of view painting.[1] A few years earlier Count Kaunitz (he was made a prince only in 1764) had been one of the principal private patrons of Bernardo Bellotto in Vienna. Between 1759 and 1760 Bellotto had painted for the count a view (Fig. 1) of his palace in the area "outside the walls" of Vienna in the Mariahilf suburb, west of the old town.[2] The view is a masterpiece, described with great precision and certainly composed according to the client's requirements. For decades Kaunitz had played a leading role in the foreign affairs of the Habsburg empire but he really came to the fore when he was appointed Austrian State Chancellor in 1753. He became and remained the closest confidant of Empress Maria Theresa (1717-80) and the man with chief responsibility for Austria's intellectual, political, and domestic development until 1792. The sources describe him as an able statesman but a vain man "with the failing that he could never walk in front of a mirror without stopping to look at himself and if he had the courage, he would probably use lipstick and beauty-spots".[3] Even if we strip this description of its witty, not to say malicious, intent, we are left with the image of a man aware of his own worth, of his physical attractiveness, and of his personal, political, and social standing. That said, it is not difficult to identify in the painting of the suburban palace, now in Budapest, a reflection of the character of Bellotto'patron.

The indisputable focus of the painting is the chancellor himself, shown standing on one of terraces in front of his "garden palace," and, not surprisingly, the palace itself, of which the spectator only obtains a glimpse at the extreme right of the composition. Kaunitz has taken up his position in front of the wall bordering the terrace in a pose that could perhaps be described as "mundane vanity," smiling for the "camera" (the painter and the viewer), his hands tucked casually into his coat. He is flanked on either side by two faithful "retainers," his secretary – the coattails of his livery jutting out at an angle as he bows respectfully and appears about to deliver a letter – and his little dog, head and tail raised towards its master, symmetrically balancing the servant's coat.

At the far left of the terrace await two other figures, one holding a tray and a glass. The central importance of Count Kaunitz is unequivocally highlighted. Directly behind and below him on the lower level is a tree-lined *allée* that continues in a straight line to a vanishing point in the distance. The light on the trees lining this walk falls from two opposing directions resulting in shadows on both sides of the path, as if Bellotto intended to link disparate and opposing elements, an effect which echoes the social disparity of the human group on the terrace. But this clear correlation between the human figures and the trees also imparts a certain ambiguity; why should the same formal means used to connect such disparate elements as the prince and his servants be adopted again for such minor elements as the trees in the background? Did Bellotto intend to suggest in a subtle fashion that the gap between the prince and his servants was not in fact insuperable? The only apparent difference between the servant on the left and his master is that the former is carrying a tray; in nearly every other way the poses are identical.

Even this highly unusual detail, which might at first seem to represent an ironic touch on the part of the artist, is in fact closely linked to the complex character of this enlightened aristocrat. It should be recalled that a few years later, at the height of Maria Josepha's reign, Kaunitz had a chapel built in the name of tolerance, with a pulpit for Catholics and another for Protestants. Bellotto may be seen in this view attempting to reconcile the need to paint for the chancellor an explicit celebratory portrait within the context of a traditional view painting, and, at the same time, to subtly communicate another, more human, less imperious, side of the personality of his patron.

The portrayal of the owner before a view of his property – essentially non-Italian in character

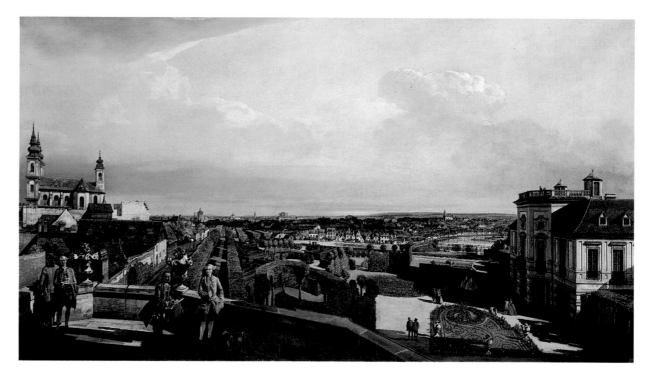

1. *Bernardo Bellotto,*
The Kaunitz-Esterházy
Palace and Gardens
in Vienna,
1759-60,
oil on canvas
(Museum of Fine Arts,
Budapest)

and certainly outside the tradition of Venetian *vedute* – was an innovation most satisfactorily realized by Bellotto in the Budapest picture and in a pair of paintings made for another leading patron of the arts associated with the imperial Habsburg court, Prince Joseph Wenzel von Liechtenstein (1696-1772).[4] In these views of his summer residence at Rossau with its large Baroque garden (1759-60; Liechtenstein Collections, Vaduz), there are also raised terraces that serve as a "stage" for the presentation of the patron. In the view of the garden, the figure of the prince is clearly outlined against a green "wall" of neatly-trimmed trees;[5] in the companion view of the palace from the side, he poses with his wife and another woman, as well as the seemingly ubiquitous dog.[6]

These brief observations are perhaps sufficient to broaden our appreciation of the paintings in question. In a previous discussion I attempted to show how these allusions to the physical presence and importance of a patron within a composition was not completely new to Bellotto, even in views of urban settings where the aim was quite different.[7] In the view of Lobkowitz Palace, a building that had recently changed ownership, an "animated" group stands out in the foreground on the right in contrast to the true protagonist of the painting; that is, the patrician building on the left. In this case the "stage" is the area in the foreground and one's attention is drawn to the group of people, whose

shadows fall in the opposite direction to that dictated by the actual lighting conditions. This tendency of Bellotto's to underscore the importance of human figures that are not just typical landscape *staffage* first appeared in paintings of the Dresden period and reaches a high point during the artist's stay in Vienna. Indeed documented studies of figures exist only for this period,[8] testifying to a definitive change in approach to satisfy (and this is a fundamental component of the significance of the Vienna-period paintings discussed above) the specific demands of his clients.

Bellotto's etching of a theatrical scene (Fig. 2) is also important in this context (and as a document of theatrical history). "*Le Turc Généreux*", a ballet based on the well-known opéra-ballet, *Les Indes Galantes*, by Jean-Philippe Rameau and choreographed by Franz Hilverding, was performed on 26 April 1758 in the Burgtheater in Vienna, on the occasion of the visit of the Turkish envoy Rasmi Ahmend Effendi.[9] Bellotto had not yet arrived in the Habsburg capital by the date of this first performance, although he must have attended a later one, and, as regards the reproduction of the scenography, obtained access to drawings and/or engravings by others.[10] His etching was more celebratory than documentary, having been commissioned not by the court but by Count Giacomo Durazzo, the impresario and lessee of the theatre. However, it is still noteworthy since it is the only known interior repre-

sentation in Bellotto's oeuvre and it was probably commissioned by Durazzo, who has been thought to be depicted in the lower box on the right-hand side of the proscenium.

Bellotto arrived in Vienna in January 1759. On 5 December of the previous year he had received a passport to travel from Dresden to Bayreuth. Although we have not been able to reconstruct the precise circumstances of this trip, Bellotto could not have failed to be impressed by the new margravial theatre in Bayreuth, built by Giuseppe Galli-Bibiena (1696-1756) in 1747-48. It is important to note how the careers of Bibiena and Bellotto intertwined. The two artists did in fact take almost identical routes but in opposite directions. In 1743 Bibiena left Vienna, where he was chief theatrical designer to the imperial court, for Dresden, then Dresden for Bayreuth in 1747. In 1748 he returned to Dresden, which he left for Berlin in 1754.[11] Bellotto left Dresden for Bayreuth (at least that seems to have been his intention) and then traveled from Bayreuth to Vienna. Perhaps the two Italians got to know one other in the Saxon capital and maybe it was Bibiena who told him about the "court of the muse" as a place where work was to be found. How Bellotto ended up in Vienna is not known, but it can be cautiously suggested that it was quite possibly the theatrical world that brought him there; this would also explain his unique engraving of "The Generous Turk."

Irrespective of the actual circumstances, it certainly was not an invitation from the Habsburg court that brought Bellotto to Vienna. It is tempting to see Bellotto responding initially to the demands of new private clients and patrons of the court such as Count Kaunitz and Prince Liechtenstein and revising his approach to view painting to include a new emphasis on his patrons within his compositions, flattering and aggrandizing them as if they were sitters in a traditional portrait. Only at a later stage was the court, and more probably Empress Maria Theresa herself, to become the final destination of many of his paintings. The thirteen large paintings recording the principal attractions of Vienna are very different from those commissioned by Bellotto's private clients and accord much more satisfactorily with his earlier Dresden *vedute,* so that a logical progression can be traced in the evolution of the two series.

Bellotto seems to have undertaken two different taks in the Vienna views; on the one hand, he documented many of the most important historical places of the city, depicting the Viennese going about their everyday affairs, and on the other, he celebrated and immortalized the imperial residences. A single rule, however, appears to have governed both types of view: a powerful criterion of objectivity, even within the variations of differing vantage points. The clearest example of this is found in the series of views of the palace of Schlosshof, two of which are included in the present catalogue (cat. nos. 66, 67). For obvious reasons, the device of the terrace as a stage for the celebratory portrait of the client appears neither in this series, nor is it used in the views of the castles of Schönbrunn and the Belvedere (Kunsthistorisches Museum, Vienna). Nor are we able to state with certainty that the group of views of the city and the palaces were commissioned directly by the empress; all that is certain is that she acquired them. The paintings were not listed in the imperial catalogues until 1881, when they appeared in the Enghert catalogue, probably because prior to this they were employed and considered as mere decorative appurtenances for furnishing rooms.[12]

It is curious that two of the three palaces documented (the Belvedere and the Schlosshof) are part of the legacy of Prince Eugene of Savoy (1663-1736), while only Schönbrunn can lay claim to a purely imperial background. The portrayal of the palace of Schönbrunn (Kunsthistorisches Museum, Vienna) also contains a significant reference to a recent historical episode, the announcement of the victory against the Prussians at Kunersdorf, won by the Austro-Russian troops on 12 August 1759. The painting records a specific occasion on 16 August, showing the empress and her courtiers standing on the balcony of the palace awaiting news of Austria's victory.[13] (Ironically, the events of the Seven Years War, which jeopardized the survival of the house of Habsburg-Lorraine, had previously affected Bellotto's life, costing him his house, his job, and forcing him to leave Dresden.) Perhaps the key to interpreting many of the individual views in the Vienna series lies precisely in this historical situation. The buildings with a link to Prince Eugene thus evoke a recent and glorious past, characterized mainly by the prince's victories over the Turks, which gave rise among other things to a new feeling of territorial security. The Belvedere has historically been seen as the symbol of new expansion to the east, while the castle

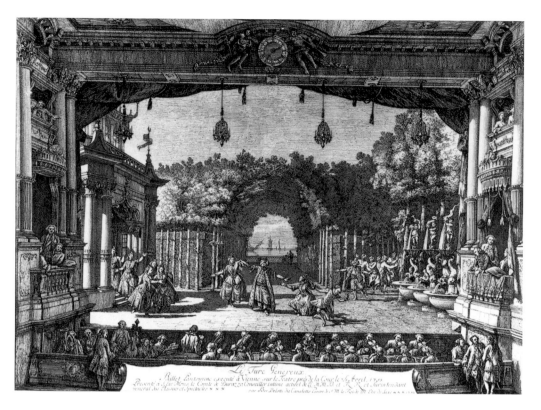

2. *Bernardo Bellotto,*
Le Turc Généreux,
1759, etching
(Kunsthistorisches
Museum, Vienna)

of Schlosshof is situated on the banks of the March, the river that has always marked the frontier. That one of the very rare happy moments in that period has been portrayed in one of the Schönbrunn paintings may be interpreted as a desire to imbue all the urban and suburban areas with a sense of faith in their continuity.

Bellotto's views dedicated to the city itself are no less historically charged and from this point of view they reinforce the significance of the whole series, which is to exemplify a Vienna (the capital and a symbol of the nation) eternally prosperous and safe. In his panorama of Vienna from the Upper Belvedere (Fig. 3) the gardens of Prince Eugene are laid out beside other gardens next to the Schwarzenberg Palace.[14] This area was not restricted to the court but had been open to the public since 1752. It has been noted on a number of occasions how Bellotto has modified, or rather "adjusted", the objective view of the site obtained with a camera obscura by changing the position of the separate buildings in relation to each other. In the center, the vertical rise of the bell-tower stands out above the other buildings; behind it rises the outline of the Leopoldsberg, the hill Jan Sobiesky's soldiers marched down to liberate Vienna from the Turkish siege in 1683. On the left is the Karlskirche, the votive church erected by Charles V, Maria Theresa's father, and balancing this on the right, in perfect symmetry,

is the dome of the Salesian convent, that is to say, the "feminine" pendant of the Karlskirche. At the vanishing point of the half-dark, half-light wedge bounded by the bushes and the edge of the flower-beds, stands the university's astronomical observatory, founded by Maria Theresa. The group of paintings depicting the city squares of Vienna is not strictly intended to document modern Vienna, or at least that does not seem to be its sole purpose. The real aim of the series appears to be to communicate the historical continuity of the sites depicted. The Freyung (Kunsthistorisches Museum, Vienna), with the Scottish church, refers back to the Babenberg dynasty and to a time in the twelfth century when Vienna became the capital and permanent residence. In the view of the Mehlmarkt (Flour Market), later the Neuer Markt (New Market), also in the Kunsthistorisches Museum, stands the simple church of the Capuchin monks, whose crypt had been the burial place of the Habsburgs since the early seventeenth century. In a view of the Universitätsplatz (Kunsthistorisches Museum, Vienna), the Jesuit college also stands out in its severity, its plain unadorned façade faces the church of the Dominicans, another symbol of Catholic Austria. In the background of the view can be seen the observatory of the old Jesuit university, while the new one appears in the view contrasting the "old" with the "new", portraying the façade of the Jesuit church and that of the university building, which Maria Theresa had had built by Nicolas Jadot.[15]

It is impossible to know whether Bellotto was forced to abandon a larger project of documenting Vienna when after two years he departed the city for Munich. Certainly some Viennese buildings that one would consider significant and important are missing, such as the Graben or the Hoher Markt. But perhaps some of the "highlights" were sacrificed and replaced with a reality that does justice not only to history but also to everyday life, precisely because the views for Maria Theresa are neither comparable nor intended to follow the traditional topographical city views of Vienna by such artists as Johann Adam Delsenbach (1687-1765) or Salomon Kleiner (1703-61) and because in them we find for the first time an image of a city based not on a series of individual architectural vignettes but, as we have suggested, on the principle of historical continuity.

Early in 1761, in a climate still dominated by the

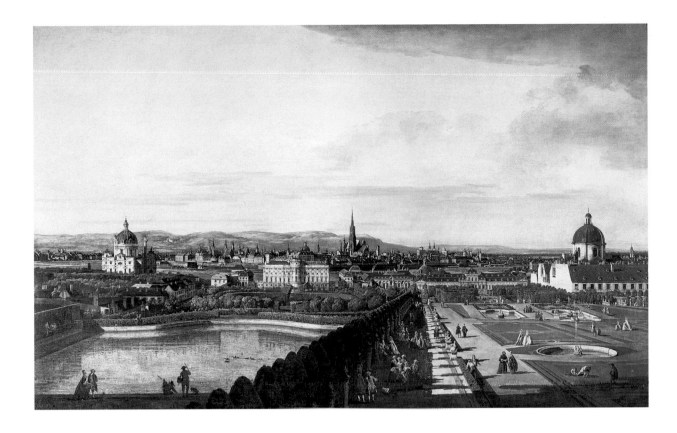

Seven Years War, Bellotto departed Vienna for Munich. He arrived there on 14 January, carrying a recommendation from Empress Maria Theresa praising the "*très belles*" paintings he had painted in the imperial capital. The letter was addressed to Princess Maria Antonia of Saxony, the empress's cousin, who had fled the previous year with her husband, Prince Frederick Christian, the eldest son of Augustus III, to the Munich court of her brother, Elector Maximilian III Joseph of Bavaria. Bellotto joined six other painters of the Saxon court at the "Black Eagle" hotel, perhaps an omen that his work in Bavaria would remain within the circle of Dresden clients and patrons.[16] Indeed, the three paintings executed for the antechamber of the residence (cat. nos. 69, 70), were mounted in frames bearing the coats of arms of Bavaria and Saxony. According to Gisela Barche, these coats of arms suggest that the paintings were given by the Saxon couple to Maximilian in gratitude for his hospitality to them,[17] and one is tempted to add that the above-mentioned letter from Maria Teresa was not so much a recommendation of employment as a grateful sovereign's way of "returning" the painter, a witness and interpreter of the anti-Prussian coalition's "good government", to his rightful court.

[1] Pötschner 1978, p. 46; for a more detailed discussion of the Academy's teachings, see Prange 1998, pp. 339-53.

[2] Szépmuvészeti Muzeum, Budapest (inv. 52.207); Rizzi 1995, p. 118, with previous bibliography.

[3] Ricci 1995, p. 118, for the complete description supplied by the legate Christoph Heinrich von Ammon. But for Kaunitz's character and his career including the appointments of "*Generalhofbaudirektor*" and patron of the Academy, see the recent study by Kroupa 1996.

[4] Built in 1690 for Johann Adam von Liechtenstein by Domenico Egidio Rossi and Domenico Martinelli (see Lorenz 1999, pp. 255-56, no. 24).

[5] Vaduz, Fürstlich Liechtensteinsche Gemäldegalerie, inv. 889; see Rizzi 1995, pp. 120-21, also for the earlier bibliography. In the right margin of the painting, aligned exactly with the portrait of the client, stands the villa of Peter von Strudel, founder of the Viennese Academy, which was transformed into a military hospital in 1759 during the Seven Years War (Koller 1993, p. 180).

[6] Vaduz, Fürstlich Liechtensteinsche Gemäldegalerie, inv. 887; Rizzi 1995, p. 121

[7] Frank 1989, p. 154.

[8] See the list of drawings in Rizzi 1995, pp. 169-73.

[9] The caption to the engraving reads: "*Le Turc Généreux. / Ballet Pantomine éxécuté à Vienne sur le Teatre près de la Cour, le 25. Avril, 1758. / Présenté à S. Ec. Mons. le Comte de Durazzo, Conseiller intime actuel de LL.M.M. I.I. et Surintendant Général des Plaisirs et Spectacles &.&.&. / par Ber: Belotti dit Canaletto Peintre de S.M. le Roi de Pol: Elec. de Saxe: &.&.&. 1759*". In addition to the bibliography cited by Rizzi 1995, p. 220, see above all Schindler 1976, pp. 27-29, as well as the recent description by Delneri 2000, p. 102, n. 23.

[10] Schindler's (1976, p. 25) analysis is correct: the aspect of the proscenium boxes does not correspond exactly to the real situation, suggesting that Bellotto, perhaps at the request of the client, "corrected" an element thought to be unsatisfactory.

[11] For information regarding Giuseppe Galli-Bibiena's movements see the catalogue of the recent exhibition in Bologna (edited by Deanna Lenzi and Jadranka Bentini, Venice 2000).

[12] The fact that the paintings did not appear in the catalogues of the imperial collections does not necessarily add weight to the opinion of Christian Ludwig Hagedorn, director of the Academy and galleries of Dresden from 1764, that Bellotto's views were at best useable as objects of interior decoration for the various castles. More relevant is the fact that in 1759-60 Johann Christian Brand, who later taught the landscape class at the academy, was commissioned to execute four views of the surroundings of Laxenburg, destined to be hung in the antechamber of the castle (Prohaska 1999, pp. 457-58, no. 193). At this point the information that eleven of the thirteen views by Bellotto were in the castle of Laxenburg becomes more significant; but unfortunately this information only dates from 1822.

[13] Vienna, Kunsthistorisches Museum, inv. 1666; Rizzi 1995, p. 122, for the inscription "*XVI. Augusti Anno M.D.CC.LIX./Prusso caesio ad Francofortum ab exercitu Russo-Austriaco*", and additional bibliographic references.

[14] Vienna, Kunsthistorisches Museum, inv. 1669; Rizzi 1995, p. 100.

[15] The university building, built in 1753, is also, due to its proximity to the Jesuit building, the most tangible evidence of the empress's reform of university education, the aim of which was to break free of the Jesuits' influence and involve the State to a greater degree (Weigel 1999, pp. 298-99).

[16] Barche, in Verona 1990, p. 156

[17] *Ibid.*

Bernardo Bellotto in Warsaw

Andrzej Rottermund

Bernardo Bellotto's modern biographers agree that the painter left Dresden "to seek his fortune" at the court of Catherine II, Empress of Russia, on account of the economic difficulties and diminution of his professional status in the Saxon capital.[1] Bellotto never reached St. Petersburg, however, because he interrupted his journey half-way, in Warsaw, where he found a favorable and positive professional situation at the court of the last Polish monarch, King Stanislaus II Augustus Poniatowski (1732-98). Here he spent the last fourteen years of his life and ensured the economic future of his wife and four children (a boy and three girls), as well as restoring a measure of the professional prestige he had lost in Dresden.[2] If we bear in mind that the artist had a fairly unstable and irrational character, and that he had difficulty forming interpersonal relationships, we may presume that his decision to remain in Warsaw was influenced by the strong role played by Italian artists at the Polish court. Each week the Polish sovereign organized lunches to which he invited numerous artists, with such a preponderance of Italians that the occasions became known as the "Italian lunches".[3] Bellotto collaborated with other artists in the so-called "Artistic Department", a royal organizational structure that was really quite progressive for the time. He received an annual salary of 400 ducats, as well as 150 for keeping his household, 120 for carriage and horses, 40 ducats for firewood, and probably another 120 ducats for his theatre expenses.[4]

Scholars of the Polish Enlightenment have always regarded Stanislaus Augustus's rule as a golden age of culture and art.[5] The sovereign was well-educated, he spoke foreign languages (including Italian), and as a diplomat he had traveled extensively in central and western Europe, where he met leading artists, writers, and philosophers. Following his coronation as king of Poland in 1764, he invited numerous European artists to his court, not only to realize ambitious artistic projects, but above all to help him to establish in Warsaw an academy of fine arts, centered on the artists assembled at the royal court. Despite three failed attempts to found such an academy (1766, 1778, and the late 1780s), the painting, sculpture, and architecture studios at the court of Stanislaus Augustus became a focal point for the education of young Polish artists. It was chiefly with these in mind that the king established his collections of painting and sculpture and his albums of drawings and illustrations. The king thus expressed his devotion to his mission in a letter to a writer and historian of the court: "For as long as I draw breath I will not cease to work for sowing the good seed in my homeland, although I know that I myself will not gather the fruits".[6]

In the sixteenth and seventeenth centuries Sarmatism had taken root in the Polish state and found fertile terrain in the old Polish nobility.[7] Although not an art-historical term, it has been used to describe artistic phenomena connected with the patronage of Polish nobles of the period. Politically, the exponents of Sarmatism promoted the idea of a republic of nobles with an elected king as first among equals, and strongly opposed absolutist tendencies, then popular in Europe. Consequently, its features included conservatism, traditionalism, xenophobia, religious zeal, and, finally, a deep conviction that the Polish political system was the best possible and that the mission of the Polish nation was to defend the Christian (especially Roman Catholic) world against the Eastern Orthodox, Protestant, and Islamic peoples.

The cultural life of the nobility was infused with the notion of the idealized figure of the land-owning Catholic noble as chivalrous knight and defender of the faith and the political system of the Republic of the Two Nations. Moreover, there was a predilection for tradition and the glorious past of the nation and of the lineage of the fabled valiant Sarmatians, who were believed to have been the ancestors of the Poles and to have lived north of the Black Sea in the time of the Roman Empire. Sarmatism was an all-embracing culture that even had an influence on everyday life, especially on the costumes of the nobility, who wore long robes of Persian origin made of precious silk, broad silk waist sashes, and fur caps (see cat. no. 76). Stanislaus Augustus firmly opposed this ideology and way of life, but when he attempted to enforce his own artistic projects and ideological programs, he was forced to reckon with the role of

traditional nationalistic principles in the life of the state. Although he was guided by his own political ambitions in drawing up the building plans for his official residences, for example, he also had to allow for the more traditional ideas of the nobility on state buildings. Ideological and political motives also had a bearing on the artistic forms of the works he commissioned: it would seem that the syncretism of form of the works of art produced within his immediate sphere of influence was an expression not so much of an uncertain artistic orientation as of a need to declare himself in favor of either tradition or modernity

1. *The Royal Castle, Warsaw, Senate antechamber (Canaletto Room), northwest wall*

2. *The Royal Castle, Warsaw, Senate antechamber (Canaletto Room), southwest wall*

according to the political situation in which the artistic statement was to be made – as in the successive plans for the reconstruction of the main body of the Royal Castle. Thus Stanislaus Augustus's reign saw the continuation of Baroque forms and mythological and allegorical symbolism as the conserving of an artistic canon acceptable to the nobility, and at the same time the introduction of more modern, classicizing forms as an expression of the king's personal, decidedly anti-Sarmatian and anti-conservative attitude

In the seventeenth and eighteenth centuries the royal court of the Republic of the Two Nations had an organizational structure similar to that of the other European courts, the only difference being the political roles allotted to the various powers. In fact, the power of the Crown was radically curtailed in favor of Parliament, which resulted in a weakening of the central state machinery; that is, legislative executive power. The Sarmatian ideology, flanked by that of the concept of "golden freedom", equality amongst nobles and an aversion to central power, contributed to a state of internal conflict and tension that hindered Poland from becoming an artistic capital of the magnitude of Dresden,

Munich, or Vienna. Nonetheless, despite the attempts of the nobility to limit the role of Poland's royal court, its importance in the eighteenth century was remarkable, thanks largely to the initiatives of the monarchs themselves, who never ceased to struggle to reinforce their own power and raise the prestige of their courts. The great power of the monarchs over the moguls was their ability to confer honors by the court, and this in part enabled them to raise Warsaw to the rank of residential city and center of power. Stanislaus Augustus also pursued this political strategy, maintaining the prominence of the court through its organizational powers and his activity as a patron, collector, and promoter of the arts. When Bernardo Bellotto arrived in Warsaw, the Republic of the Two Nations was undergoing a period of uncertainty: both domestic and foreign policy were unstable and the state had been weakened through internal tension. This situation degenerated into a civil war that lasted four years (1768-72), during which time there was an attempt to assassinate the king (1771) and which concluded in the first division of the Republic, in 1772. The Polish state lost part of its territories to Russia, Prussia and Austria, and the king a portion of his revenues. In the mid-1770s some political and social stability was recovered. During this period Stanislaus Augustus's optimism revived over the possibility of reinforcing the powers of the Crown, achieving the necessary State reform, and concluding interrupted artistic projects. But his hopes were very short-lived.

This socio-political climate provides a backdrop to Bellotto's artistic activity in Warsaw, where he lived from early 1767 until his death on November 17, 1780. The extensive correspondence left by the sovereign himself and the testimonies of persons close to the court present an image of Stanislaus Augus-

tus as a person who often established direct contact with artists and attempted to close the traditional distance between a monarch and his subjects.[8] The sovereign had a particularly close relationship with the painter Marcello Bacciarelli (1731-1818), who, in turn, looked after Bellotto and his family. The king wanted to know even the most minute details about the work undertaken by court artists, and he sought to impose his ideas not only on his "own" artists (Stanislaus Augustus employed the greatest array of European artists ever to visit the Polish royal court), but also attempted to commission works of art from famous artists outside Poland, such as François Boucher, Carle van Loo, Anton Raphael Mengs, and Antonio Canova.[9] When examining the works of Bernardo Bellotto during his time at the royal court in Warsaw, one should always bear in mind the dominant role the sovereign played in iconographical and compositional decisions which were intended to further his ideological and political aims.

Bellotto's stay in the Polish capital coincided with two important artistic architectural initiatives promoted by Stanislaus Augustus, the restructuring of his official residence, the Royal Castle (State Treasury property, begun in 1764 and completed in 1786), and the almost total reconstruction of Ujazdów Castle, just a few miles from the city center, built between 1766-71.[10] From the start of his reign in 1764, Stanislaus Augustus had always intended to establish a residence that could act as a substitute to the official dwelling during its restructuring and he opted for Ujazdów Castle, which was Crown property. This building needed modification to make it suitable for ceremonial functions and as a home. The design for the royal apartments, located on the first floor of the castle, included not only the queen's quarters but also numerous, richly decorated staterooms that could be reached by a sumptuous staircase.

The works of art produced under Stanislaus Augustus were to a large extent the result of close artistic collaboration. The assembled artists created first and most importantly an individual type of representative interior, whose artistic expression was frequently described as the "Stanislaus style." The "Stanislaus" interior was suffused by color, while the strikingly gilded architectural details formed a framework for painting that not only covered the ceilings but often filled the entire walls of halls. It was thus due to the programmatic requirements of the king and his architectural projects that Bernardo Bellotto found employ-

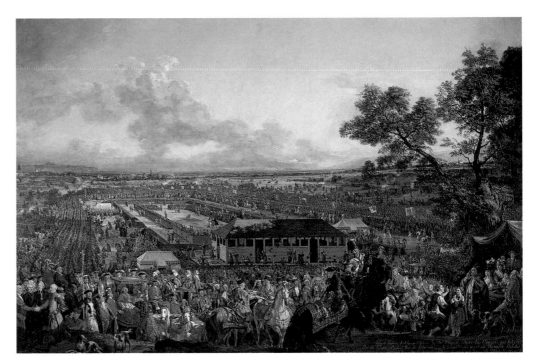

3. *Bernardo Bellotto,*
The Election of Stanislaus II
Augustus Poniatowski, *1778*
(The Royal Castle, Warsaw)

ment at Ujazdów Castle upon his arrival in Warsaw. Stefan Kozakiewicz's studies reveal clearly that Bellotto was entrusted with the decoration of the Great Hall, which subsequently bore his name, "*La Sale de Canaletto*"[11], although the scope and type of work is not entirely clear. We do not know whether the subjects of the frescoes were imaginary or actual views. What is certain is that Bellotto painted his first views of Warsaw and the series of sixteen views of Rome (based on the etchings by Giovanni Battista Piranesi) for Ujazdów. The series dates to 1768-69 although some paintings were also done in 1767 and 1770. Bellotto was aided with these views of Rome by his son Lorenzo, who collaborated with his father from 1764 until Bellotto's death in 1770.[12] Judging from the precedents of Piranesi's etchings, most of the paintings were conceived in pairs; for instance, a painting entitled the *Capitol with the Church of Santa Maria d'Aracoeli* was the companion of *The Staircase of Piazza di Spagna*; similarly, an *Interior of the Basilica of San Paolo fuori le mura* was paired with a *Ceremony in the Basilica of St. Peter*. That the painting *Krakow Outskirts seen from Sigismund's Column* (1767-68) was the companion of a *Roman Forum seen from the Capitol*, is established by the similarity of their compositions, emphasis on color, and the keys describing the contents of the two paintings, respectively.[13]

By the end of 1770, the king owned eighteen paintings by Bellotto (which were definitely part of the decor at Ujazdów Castle).[14] The castle's walls had been designed to accomodate the paintings that

would be hung there, and this project influenced the decor of the wood-panelled walls for the Senate antechamber in the Royal Castle, where the paintings, which were of remarkable dimensions, were later taken. In fact, in 1777, the views of Warsaw and of Rome were hung in the Royal Castle. The reason the king had chosen Rome as the subject for the interior decoration of part of Ujazdów Castle in the 1760s is quite clear – ancient art was then a point of reference for all court artists. The use of etchings by Piranesi reflected the taste of the monarch, the ambience of his court, and of the other European courts. After 1772 (the year of Poland's first division) the Republic of the Two Nations was confronted with a new political situation. The sovereign advanced general state and political changes and initiated a new architectural program. In reality, the concept of Warsaw as "a new Rome" was taking shape, and this new role for the city began to find expression in the writings of the enlightened ideologists of the time, such as Hugo Kollataj, who argued that "The Republic of Poland should also have its Rome, its principal city".[15]

The internal tensions and conflicts of those years prevented the sovereign from completing his reconstruction of Ujazdów Castle so he turned his attention to the Royal Residence in Warsaw. As early as 1769-71 the southern wing of the building (destroyed by fire in 1767) was rebuilt and work went ahead on the rooms of the State (Marble Room) and Royal apartments. In 1772-75 the Royal Chamber was furnished, while in 1774 work began on furnishing three rooms of the State apartments, the Senate Antechamber (the "Canaletto Room"), the Chamber of Audience, and the Chapel.

The inventoried drawings, architectural designs, and receipts for work carried out all bear the date 1776 as the beginning of the project for the reorganization and furnishing of the Senate Antechamber.[16] The sumptuously elegant antechambers of the royal palaces held a special symbolic role and logistical function, for they led visitors in succesive stages to the presence of the king himself. The importance of the antechambers in the spatial hierarchy of the royal apartments was reflected in their rich structure and decoration, which would correspond to a precise political program of propagandistic content (the high-minded and lofty principles that inspire those who hold the reigns of power). Of the rooms that preceded the Chamber of Audience, the most important was the Senate an-

techamber, later called the Canaletto Room, and decorated with the series of views of Warsaw by Bellotto.

The year 1776 was a turning point for this important antechamber, whose physiognomy changed from a "Roman" chamber to a "Warsaw" chamber. It was in this very year, in fact, that the definitive project got under way for decorating the walls of the Senate antechamber (Figs. 1, 2) and the Warsaw paintings began to be executed in quick succession by Bellotto. At the end of 1777 twenty-two paintings were hung on the wood-panelled walls: "Twenty-two paintings, mainly views of Warsaw and its chief monuments, such as the Royal Castle, its buildings, churches and gardens, as well as Wilanów Palace and its surrounding area, were painted by Master Canaletto and hung on the *boiserie* walls of the Senate antechamber above the doors in special spaces..."[17]

In 1778 a new version of the *Election of King Stanislaus II Augustus Poniatowski* (Fig. 3) was realized, and it was intended as a major visual statement reinforcing the political and ideological function of the Senate antechamber. Both the first version of the *Election*, dated 1776 (National Museum, Poznan), and the second, which replaced it, depicted the election ceremony in the fields of Wola on the west side of Warsaw on 7 September 1764.[18] In the 1778 version that is now in the Royal Castle, however, modifications were made to the foreground of the painting where the Primate Wladyslaw Lubienski is shown as he advances at the head of a procession, followed by the Marshal of the Electoral Diet, the great Lithuanian writer Józef Sosnowski, and the Voivode of Plock, Józef Podoski, who is shown handing over the deed of election. A number of figures are clearly identifiable; for instance the members of the royal family and other personages linked to them (including Bernardo Bellotto and his three daughters). The painting was closely linked to the project of royal propaganda and one of the purposes of the painting's iconographical program was to convince the nation that Stanislaus Augustus's election as monarch of the Republic of the Two Nations was entirely legal and reflected the will of the people as proved by the popularity the king enjoyed with the nobility. The presence of the primate and of two priests in the painting serves to underscore the role and the participation of the clergy in the life of the nation, while the presence of civil servants and court officials in the foreground emphasize the function and the merits of a loyal political alliance.

Thanks to archival research it has been possible to reconstruct the original scheme of the paintings in the Senate antechamber and, undoubtedly, the painting described in 1797 and 1808 is the original.[19] This is proved by the organization of the compositions of the pictures as matching pairs. Only *The Church of the Holy Sacrament in the New Town, Warsaw* (cat. no. 92) and *Dluga Street, Warsaw,* appear to have been organized according to different principles. Bellotto created these works with a precise knowledge of where they would subsequently be hung. This is obvious from the perspective from which he painted them. Several paintings were clearly intended to be hung high in the ensemble and thus seen from below (*The Blue Palace, Warsaw,* and *The Reformate Church, Warsaw*); lower down would have been *Miodowa Street, Warsaw,* and *Dluga Street, Warsaw;* further down, *The Church of the Holy Sacrament, Warsaw,* and *The Holy Cross Church, Warsaw;* and, finally, at eye level, *Wilanów Palace from the Main Entrance* and *The East Front of Wilanów Palace from the Gardens.* The extremely high position of several paintings enabled Bellotto to paint scenes of human figures and animals with rather less attention to detail.

The handing down of power from one reigning dynasty to the next and the commitment to continue what had been started by their royal predecessors is the message communicated by the "portraits" of the six Warsaw churches, belonging to the congregations constituted in Poland by elective monarchs.[20] The emphasis laid on the religious activism, almost fervor, of the Polish monarchs, was dictated by the desire to ingratiate themselves with the strongly Catholic nobility. The views of the Wilanów residence, however, paid homage to Jan III, for Stanislaus Augustus was well aware of the force emanated by the personality and actions of this sovereign, so he exploited his predecessor's image to advance his own political propaganda. The need to contrast the inferences and insinuations regarding the origins of the sovereign and his lineage was the reason why the Warsaw views often include a family motif. On the one hand, the king showed the power and wealth of the Czartoryski family, from whom his mother descended (the Czartoryski properties at Wilanów and the Blue Palace); on the other, the genealogy of the Poniatowskis highlighted his father's rank, which (in his role as Castellan of Krakow) was that of first Lay Senator of the Republic of Poland. The king also commissioned the

paintings of all the buildings belonging to the Castellans of Krakow, successors to his father (the palace of Jan Klemens Branicki in Miodova Street, that of Jerzy August Mniszek in Senatorska Street, and the palace of Anton Lubomirski behind the Iron Gate). Just as the *Election of King Stanislaus II Augustus Poniatowski* symbolized the solidity of the State structure, the efficiency of the law and the triumph of the political system in the Republic of Poland, so the other paintings offered an image of Warsaw as the ideal city-state, a new Rome. From an ideological standpoint, the cycle of Warsaw views were intended to express the ideals of both the Enlightenment and Sarmatism: their concept of state structure, of power, and of monarchic duties, an absolute glorification of the monarch himself (as can be noted in the *View of Warsaw,* a companion painting to the *Election,* set high up on the opposite wall of the chamber).

The series of Warsaw views (twenty-six altogether) remains the most extraordinary artistic success of the last fourteen years of Bernardo Bellotto's life.[21] In the same period, however, he also undertook to paint *trompe l'oeil,* historical subjects, genre scenes, and portraits. Kozakiewicz has brought to light the principal stylistic features of the paintings of the artist's Warsaw period. In particular, we

4. *Bernardo Bellotto,* Prince Józef Poniatowski Receiving a Riding Lesson from Colonel Königsfels *(National Museum, Warsaw)*

should note that the paintings of that time are not just the result of the experiences of an artist in a new and unfamiliar (even exotic) environment, but also the consequence of the painter's personal artistic ambitions. Kozakiewicz observed of the views of Warsaw that they possess "a more diverse and spontaneous character than, for instance, the Saxon series with its consistently monumental formats".[22] The medium and small formats of many of these views enabled the artist to look, in Kozakiewicz's words, "as through a window, into the most intimate spatial enclaves of the city center, and at the same time diminished the formal, 'official' character typical of the earlier series." An example of Bellotto's new artistic tendency can be seen in the *View of Warsaw and the River Vistula from Praga* (cat. no. 88), although there are still strong links present with the European tradition, especially in the composition of the work.[23]

The realism in the scenes of everyday life is extraordinary. The figures take up much more space than in the Dresden, or Vienna, views, and far more frequently than before they are composed of groups of figures, always true to life. The streets and inhabitants of Warsaw spring to life in these scenes, and often compete with the architectural setting for attention. As Kozakiewicz put it, this growing tendency to attach greater importance to the figures in Bellotto's work "now reaches its final fruition: the colorful, picturesque life of the Polish capital attracted Bellotto to the genre with greater magnetism then ever".[24] The characteristic is even more noticeable in the series of small Warsaw cityscapes, particularly in *Miodowa Street, The Church of the Holy Sacrament* (cat. no. 92), and in medium-size paintings such as *Krakow Outskirts seen from Sigismund's Column* (cat. no. 87) and the *Palace of the Polish Republic* (cat. no. 91).

It has been calculated that the paintings of the Warsaw series contain about 3000 figures, half of whose professional or social rank are clearly identifiable. Of all the views of Warsaw, one painting, entitled *View of Wilanów Meadows* (cat. no. 89), is especially worthy of note for its artistic value and its large-scale dimensions. The painting is almost wholly dedicated to the landscape except for the presence of a number of large figures and animals and architectural elements in the foreground. This painting is a watershed in Bellotto's artistic activity. Here, a more natural layering of color and portrayal of the subject is accomplished, as well as a more ample use of the range of color, purer contrasts of chiaroscuro, and, in an atmosphere full of lyricism, we perceive the painter's pantheistic relationship with nature. Thanks to these new values, on which the artist based the composition of his works, the landscape differs from that of more conventional paintings by his predecessors and in many ways anticipates landscape painting of the nineteenth century.[25]

Several exhibitions in recent decades dedicated to the works of Bellotto have encouraged Italian art historians to reconsider the paintings of the Warsaw period.[26] The general tenor of this criticism is that the works reveal a diminution in artistic quality and lack "originality" (especially when compared to those of the Dresden period). Others, like Kozakiewicz and Alberto Rizzi, are of the opinion that it is more appropriate to speak of a "dissimilarity" when discussing the Warsaw period paintings. The new artistic environment, the personal role of King Stanislaus Augustus, and the lingering aesthetic ideals of the late Baroque in Poland have each exercised a strong influence on Bellotto's compositions and these factors should be kept in mind in evaluating the artist's views in and around Warsaw. One should also bear in mind the results of recent conservation and restoration interventions on the paintings of the Warsaw series following their return from Russia in 1922. These paintings had undergone a wax treatment that stripped them of the "luminosity" of their color. Restorers now believe that it was this treatment that rendered the paintings "different" in appearance from the earlier views and thus caused Italian experts to deride their "originality".[27]

In the Warsaw period Bellotto also tried his hand at historic subjects, which he had always avoided in the past. The two versions of the *Election of King Stanislaus II Augustus Poniatowski* and the *Entry of the Polish Emissary, Count Jerzy Ossolinski, into Rome* (National Museum, Wroclaw) were appreciated by his contemporaries and may be defined as

the most successful of the works of this genre. Bellotto did not attend the election of Stanislaus Augustus, but was informed of it and the processional entry into Rome of the envoy from the newly elected king of Poland to Pope Urban VIII in 1633 through historical accounts and written records. In these historical compositions, Bellotto emphasized the political significance of the respective scenes, no doubt according to the advice of the king and his aides. For this reason he used a compositional structure that imitated the archaic precedents of earlier illustrations of the election of Polish kings (Augustus II and Augustus III) and, in the case of Count Ossolinski's arrival in Rome, etchings and paintings of similar subjects.

In historical paintings and equestrian scenes such as *Prince Józef Poniatowski Receiving a Riding Lesson from Colonel Königsfels* (Fig. 4), Bellotto's talent as a portrait artist emerges forcefully. Most of his subjects can be identified and one is convinced that Bellotto included actual figures present at the court of Stanislaus Augustus in many of the Warsaw views.[28] In support of our theory, we include the phrase written on a plaque in the *Entry of the Polish Emissary, Count Jerzy Ossolinski, into Rome*: *AFIN DE REPRESENTER LE PLUS FIDELEMENT QUE POSSIBILE* [in order to represent the world as faithfully as possible...], which aptly summarizes Bellotto's artistic aspirations during his years in Warsaw.

[1] Palluchini 1961a, pp.18-19; Kozakiewicz 1972, vol. 1, pp. 153-54, 184; Rizzi 1991, pp. 7-8. For important archive material concerning Bellotto's move from Dresden to Warsaw, see Bassi 1979, pp. 175-89; Rizzi 1991, pp. 149-50.

[2] For Bellotto's work at the court of Stanislaus Augustus, see Wallis 1954; Venice 1955; Król-Kaczorowska 1966; Kozakiewicz 1972; Rottermund 1989; Rizzi 1991 and the exhibition catalogue, *Dresden and Warsaw in the work of Bernardo Bellotto Canaletto*, Warsaw 1964.

[3] Grzeluk 1983, pp.135-50; Rottermund 1989, p. 199.

[4] Kozakiewicz 1972, vol. 1, pp.184-85.

[5] For the artistic patronage of Stanislaus Augustus, see especially Tatarkiewicz 1919; Mankowski 1932; Mankowski 1976; Kwiatkowski 1983; Rottermund 1992; and a brief account by Rottermund in *The Dictionary of Art*, vol. 25, pp. 211-13.

[6] Naruszewicz 1959, p. 42.

[7] See Maciejewski 1977, pp. 638-45, for an extensive explanation of Sarmatian ideology; for a briefer account see also Jan Bialostocki, in *The Dictionary of Art*, vol. 27, pp. 842-43.

[8] Warsaw National Library, code: ind. BN.III.3289, "Listy artystów do Bacciarellego z lat 1764-1793"; ind. BN.III.3291,"Korespondencja Marcello Bacciarellego z królem a lat 1781-1785"; ind. BN.IV.3292,"Papiery Marcello Bacciarellego z lat 1771-1793."

[9] Rottermund 1992, p.25; Kaczmarzyk 1970.

[10] Kwiatkowski 1983, pp. 71-82; Rottermund 1989, pp. 84-91, 104-208.

[11] Kozakiewicz 1972, vol. 1, pp.154-58.

[12] Kozakiewicz 1960, pp.140-57.

[13] Rottermund 1989, pp.112-14. The paintings of the Roman series are today scattered in various museums and private collections, see Kozakiewicz 1972, vol. 1, pp. 303-17; Rizzi 1991, pp. 22-29.

[14] Rizzi, 1991, p.22, is in error when he states that the author considered only twelve pieces when talking of the hypothetical layout reconstructed for the paintings in Warsaw Ujazdowski Castle. He has neglected the other sixteen on a Roman theme (see Rottermund 1989, pp. 113-14).

[15] Kollataj 1954, vol. 2, pp. 9-11.

[16] Rottermund 1989, p. 112.

[17] Czartoryskich family library in Cracovia, code: ind. 909, cat. 34, "Expens pieniezny…na…Reparacja …Pokoiu Senatorskiego…w roku 1777 zakonczony". In this period only sixteen of the twenty-two paintings hung in the Senate antechamber *boiserie* can be considered Polish subjects and, considering the size of the paintings, only four of the six large-size ones could have been used to decorate the room. In short, only fourteen "Polish" paintings were a part of the Senate antechamber decor. The Warsaw series of cityscapes was completed by the eight paintings of the Roman series.

[18] Regarding free election compare Chroscicki, pp. 635-38.

[19] We formulated a reconstruction of the original layout of the paintings in the Senate antechamber (Canaletto Room) using the information found in Warsaw Royal Castle inventory dated 1797 (Central Archive of the Ancient Deeds of Warsaw, Archives of Prince Józef Poniatowski and Maria Teresa Tyszkiewiczowa, code 203), in the inventory dated 1808 (Central Archive of the Ancient Deeds of Warsaw, Imperial Palace Administration, no code). The 1808 inventory is that which offered the most information regarding the original layout of Bellotto's paintings.

[20] Hulsenboom 1984, p. 89.

[21] Of the twenty-six views of Warsaw, twenty-two are now in the Senate antechamber of the Royal Castle (this does not include the *Election of King Stanislaus II Augustus Poniatowski*, which we consider a historic painting). In the Warsaw National Museum there are two painting: *View of Warsaw from the terrace of the Royal Castle* and *View of Ujazdów and Lazienki*. Two works were lost, however: a view of Sigismund's Column and the king inspecting one of the burnt-out wings of the Royal Castle (Fig. 5) and one vaguely defined as a view of the Square beyond the Iron Gate. At the moment, in the Senate antechamber there are twenty-three paintings, including the *View of Sigismund's Column from Zjazd* (hung above the chapel door 1922).

[22] Kozakiewicz 1972, vol. 1, p. 167.

[23] Rottermund 1999, p. 17.

[24] Kozakiewicz 1972, vol. 1, p. 169.

[25] Pallucchini 1965, p.84; Kozakiewicz 1972, vol. 1, p. 173.

[26] Martini 1964, p.98; Vicenza 1986, p.27; Verona 1990, p. 44.

[27] In 1999-2000, seven paintings in the Warsaw Royal Castle collection, on display in this exhibition, were examined by Castle conservation experts, led by Pawel Sadlej. Pawel Sadlej and his team edited the information contained in the catalogue.

[28] Rizzi 1991, p.70, identifies the figures depicted on horseback in the *View of Wilanów Meadows* as Prince Józef Poniatowskie and his sister Teresa z Poniatowskich Tyszkiewiczowa.

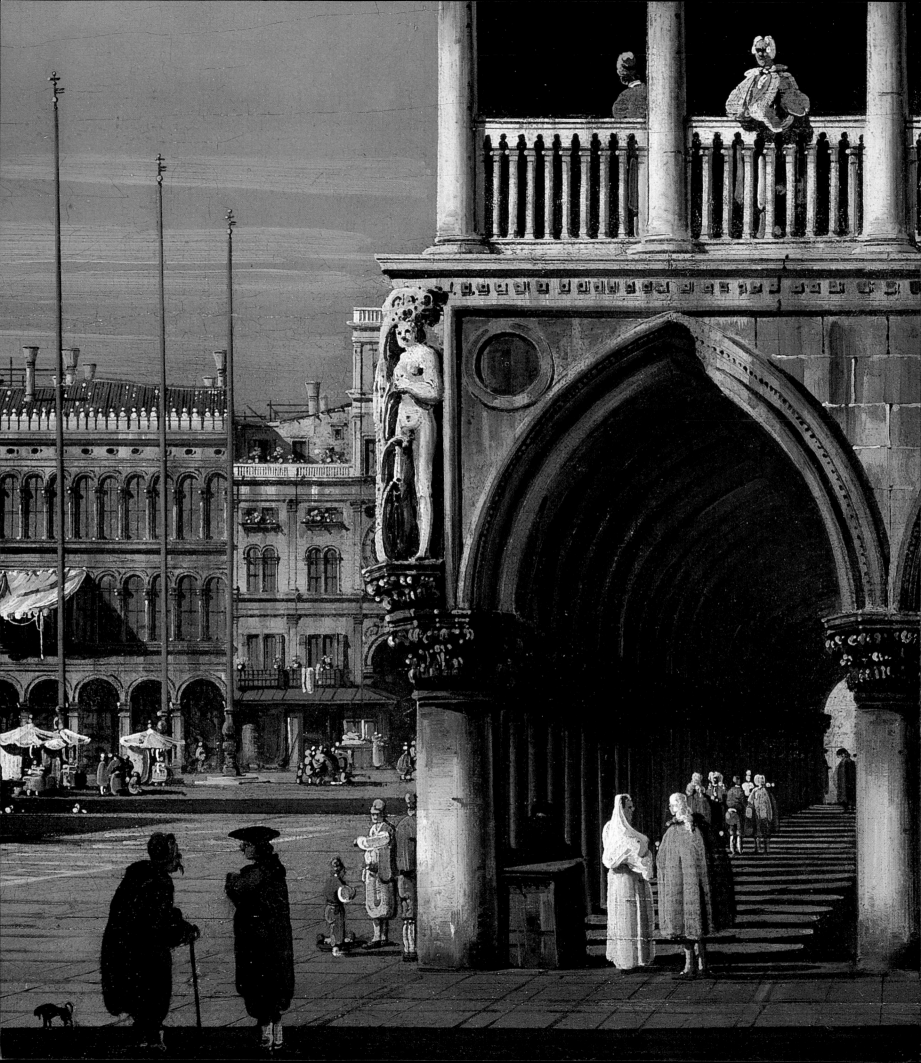

Venice

1. *The Grand Canal from the Church of Santa Croce and the Convent of Corpus Domini, Venice*

1738-39
Oil on canvas
23 1/2 × 36 1/4 inches
(59.7 × 92.1 cm)
The National Gallery, London

Provenance: George Salting (1835-1909), London, by October 1900; Salting Bequest, 1910 (No. 2514).

Exhibitions: London 1910, no. 7; London, York, and Swansea 1998-99, no. 8.

Bibliography: Levey 1956, p. 20; Constable 1962, vol. 2, p. 300, no. 262 (c) ("coarsely painted, and at best a studio piece"); Levey 1971, pp. 47-48 ("not typical of Canaletto's style at any period"); Constable and Links 1976, vol. 2, pp. 319-20, no. 262 (c); Constable and Links 1989, vol. 2, pp. 319-20, no. 262 (c); Baker and Henry 1995, p. 92 ("a pastiche in Canaletto's manner, perhaps executed after his death"); Bomford and Finaldi 1998, p. 26 (as by a follower of Canaletto, after 1768); Kowalczyk 1998, pp. 84-85, 88; Succi 1999, pp. 33-34, 37.

In addition to several masterpieces by Canaletto, the collections of the National Gallery, London, contain a number of paintings of particular interest for the study of eighteenth-century Venetian view painting. Among these is this painting of the upper reaches of the Grand Canal facing Santa Croce, recently recognized as the work of the young Bellotto and a rare example of his style and technique during his period of apprenticeship in Canaletto's studio. The painting complements topographically a splendid view of the Grand Canal with San Simeone Piccolo by Canaletto in the same collection.[1]
The painting was mentioned for the first time in 1900 as a

"View on the Grand Canal by Canaletto" (with a purchase price of £550 against an evaluation of £750) in the diary of the collector George Salting (now preserved at the National Gallery), among the "pictures in my rooms", together with a pair of views of the Piazza di San Marco by Canaletto, purchased in 1886, and a number of *capricci* by Francesco Guardi. Salting's interest in Venetian view painting is further borne out by the presence in his collection of numerous drawings by Canaletto, carried out at various stages in his career, including two sheets later attributed to Bellotto, purchased by the British Museum in 1910.[2]
Although this view of Grand Canal from the Church of Santa Croce and the Convent of Corpus Domini has been in one of the most prestigious British collections for almost a hundred years and reproduced in many publications, the negative opinion of the picture expressed by Michael Levey ("too clumsy to have come from Canaletto's studio at any date") and followed in subsequent National Gallery's catalogues, has resulted in the dismissal of the work by almost all later scholars. Stefan Kozakiewicz failed to cite the painting, not even in the context of a discussion of a similar view at Castle Howard, and Constable considered it "a school piece".
Following the inclusion of the painting in the recent exhibition *Venice through Canaletto's Eyes* (London, York, and Swansea 1998-99), scholars recognized the cold and silvery light and descriptive incisiveness as prominent features of Bellotto's youthful manner, notwithstanding the elementary quality of the overall pictorial language. It is evident that the painting bears no relation to a drawing by

Canaletto in Windsor Castle, as suggested by Levey, even less with a print by Antonio Visentini as Constable was inclined to think, but in fact is based on a compositional drawing by Bellotto (ill.) in the Hessisches Landesmuseum, Darmstadt.[3] The painting differs from the drawing in the length of the oblique shadow on the façade of the church, the height of the campanile of San Geremia in the distance, to which the artist wanted to give more prominence, the boats on the right where room has been made for an additional gondola, and a change in the position of one of the rowers in the flat-bottomed boat in the center.
Apart from such commonplace "adjustments," the painting faithfully follows the broad compositional indications of the sketch, which was probably carried out by Bellotto under Canaletto's supervision while he worked on the similar Windsor Castle sheet. The architectural details are "drawn" as they are in the sheet, with the aid of a ruler; the light is distributed in the same way, the tiles of the roofs are drawn in a similar fashion, the imperfections in the wall of the convent of Corpus Domini on the left and the façade of the church on the right are indicated with little comma marks. As in the drawing, which in this particular detail corresponds only with the Windsor sheet, the two long windows are missing from the church, although they appear in all the other depictions of the place, and can be traced back through Canaletto's documentary sketches, one of the twenty-four views of Venice by the artist at Woburn Abbey, painted for John, 4th Duke of Bedford (1710-71); one of the twenty-one views belonging to Sir Robert Grenville Harvey of Langley Park, Slough; to a

Bernardo Bellotto, The Grand Canal from the Church of Santa Croce and the Convent of Corpus Domini, *Venice (Hessisches Landesmuseum, Darmstadt)*

painting by Bellotto – formerly at Castle Howard – that follows the same composition.[4]
The figures, in particular the ones in the boat, described with wavy lines in the Darmstadt drawing, anticipate their rendition in the painting with patches of impasto painting. The vertical division of the composition into four equal parts, marked out on the sheet with ruler and pencil – an aid typically used by the artist to maintain the proportions and distances indicated in the drawings in his paintings – is transferred exactly to the canvas, as is the height of the horizon, marked by a line for half its length to make it stand out. These correspondences and their elementary character confirm the precise preparatory function of the drawing and suggest that the painting must date from about the same time, early in Bellotto's career, definitely much earlier than 1740 when the two paintings for Marshal Schulenburg were completed.[5]
Bellotto's inexperience can be seen in his simplified approach to the various techniques (even though they were techniques that had already been widely explored by Canaletto in the canvases painted for the Duke of Bedford between 1732 and

1736) and in the way he built up the perspective, uncertain about how to place the churches of Santa Lucia and the Scalzi within the composition, and in the fairly rigidly depicted sequence of houses between the Croce and San Simeone Piccolo. The evident awareness of Canaletto's working procedures confirms the workshop provenance of the National Gallery composition, but the way of using them is typical of Bellotto's later work: the careful application of paint in layers, the exact drawing of the architectural details with the tip of the paintbrush, the paint slightly raised on the surface of the walls, the precise indications of reflections in the water, heavily outlined in places, all strengthened by an already highly individual sense of colour and an unusual studied changeable quality of light. The techniques and handling seen here, in addition to confirming the painting as Bellotto's work, enable us to understand how it evolved. The geometrical precision with which he reproduces the reflection of the church in the water anticipates the scrupulous observation of similar details that the artist painted in his later years, such as the reflections of the Hofkirche and the Sonnenstein fortress

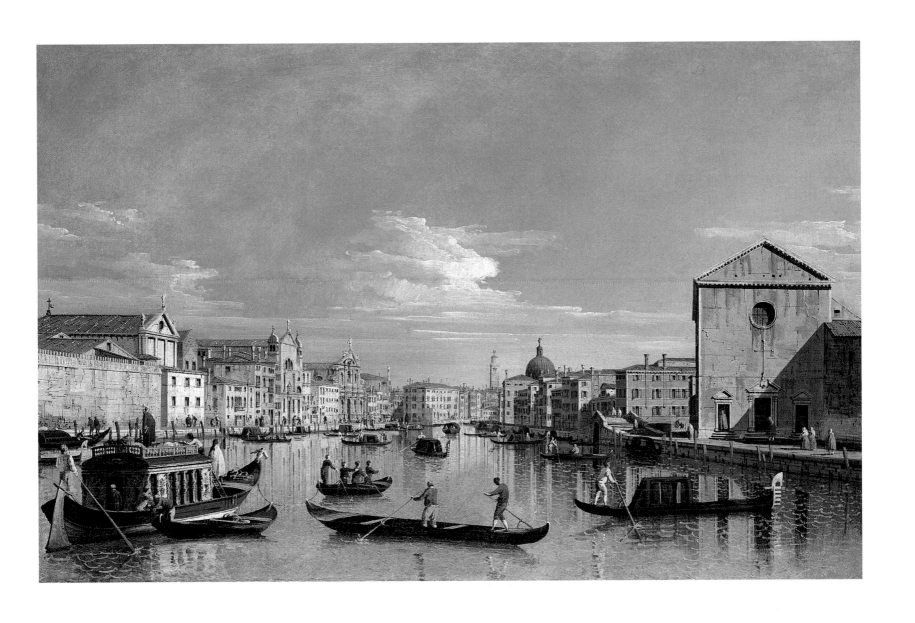

Venice

Studio of Canaletto, The Grand Canal from the Church of Santa Croce to San Geremia, *Venice (National Gallery, London)*

Prospectus ab Sede S. Crucis ad P. P. Discalceatos.

Antonio Visentini, The Grand Canal from the Church of Santa Croce and the convent of Corpus Domini, *Venice, etching*

their technically superficial description, far different from Bellotto's faithful replication of Canaletto's manner of painting.[7] Only the handling and construction of the figures are close to those in the present painting. The existence of NG 1885 and 1886 could indicate that the former Salting painting may have originally been accompanied by a pendant picture of San Simeone Piccolo, for which there is a preparatory drawing, once in the artist's estate, now in the Metropoltan Museum of Art, New York.[8]

The same imitator also executed a pair of views in the same format depicting the Grand Canal at Santa Croce and the Fondamenta di Santa Chiara looking towards the Lagoon, which in 1964 were with the Galleria Bellini, Florence.

Bożena Anna Kowalczyk

[1] Constable and Links 1989, vol. 2, no. 259.
[2] Parker 1948, under nos. 26, 76.
[3] Parker 1948, no. 16; Levey 1971, pp. 47-48; Constable and Links 1989, vol. 2, p. 319; Kozakiewicz 1972, vol. 2, pp. 18-19, no. 18.
[4] Nepi Scirè 1997, pp. 86-89; Constable and Links 1989, vol. 2, nos. 263, 262, and 262 (b), reproduced by Succi 1999, p. 53, pl. 34.
[5] See my essay in the catalogue, pp. 3-4.
[6] Levey 1971, pp. 45-46, nos. 1886, 1885;Constable and Links 1989, vol. 2, nos. 264, 320
[7] Kowalczyk 1998, pp. 88-91.

(cat. nos. 42, 57) in his views of Dresden and Pirna.

Michael Levey noted similarities between this painting and two smaller, squarish views in the National Gallery of, respectively, the Grand Canal at Santa Croce (NG 1885) and San Simeone Piccolo (NG 1886), purchased in 1860 as part of the Paris collection of Edmond Beaucousin, as by Jacopo Marieschi, later thought to be by Michele Marieschi, and still later as by Francesco Tironi.[6] In my opinion, the present view of the Grand Canal from the Church of Santa Croce and from the Convent of Corpus Domini differs from these two pictures not only in its higher quality, as Levey has already noted, but also in the considerable differences in technique and style that exclude any possibility of the latter having been painted by the same artist. The different training in the techniques of *veduta* painting by the artist of the two "quadrotto" views is confirmed by direct examination of the original: compared with Bellotto's work, these paintings clearly differ in

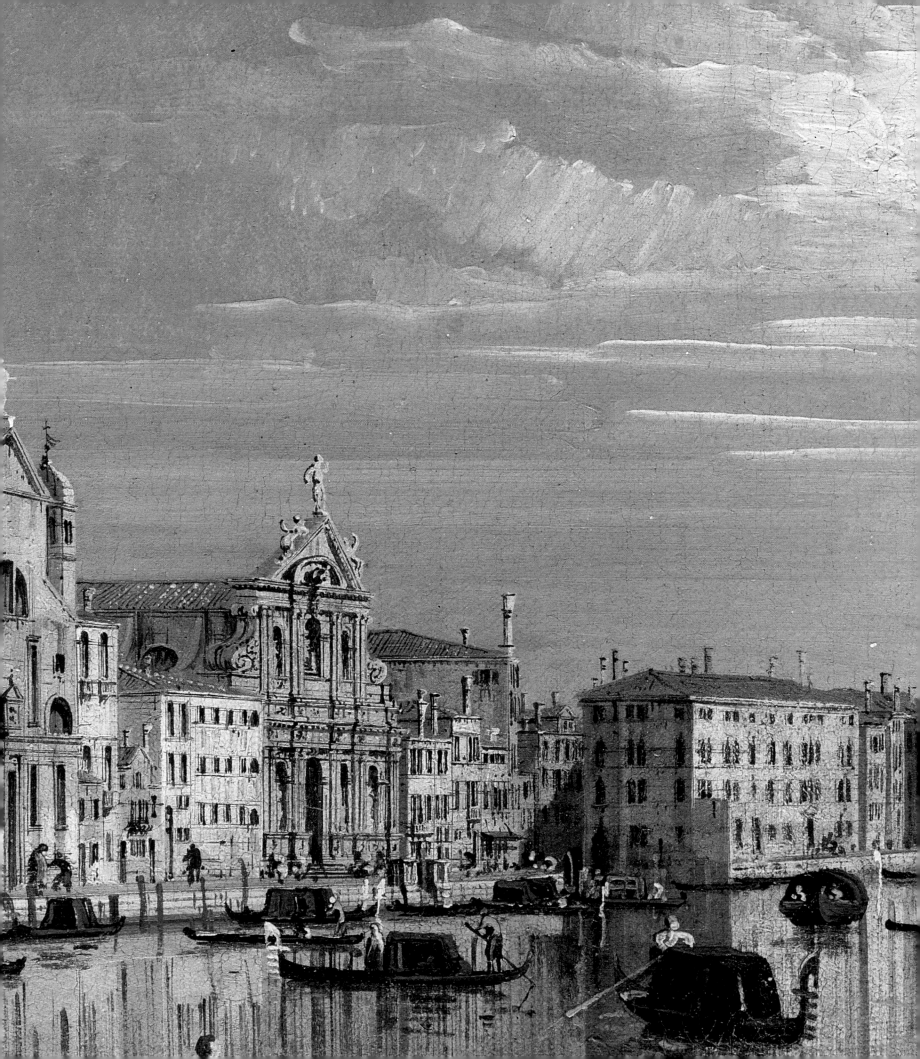

2. *View of the Campo and Church of Santa Maria Formosa, Venice*

1740-41
Oil on canvas
24 × 36 3/8 inches
(61 × 92.4 cm)
Private collection

Provenance: Bought in London about 1900 by Max Michaelis; thence by family descent; acquired in 1991 by Harari and Johns, London; from whom acquired by the present owner in 1992.

Bibliography: Kowalczyk 1995b, p. 73; Kowalczyk 1996a, vol. 2, pp. 15-16, no. 15; Kowalczyk 1996b, pp. 83-84, 89, n. 54; Kowalczyk 1998, p. 84; Links 1998, no. 280**, pp. 28-29 (as by Canaletto, c. 1730-35); Succi 1999, p. 62.

The Campo Santa Maria Formosa with its parish church by the most accomplished and original architect of early Renaissance Venice, Mauro Codussi (c. 1440-1504), later embellished by a fanciful façade and campanile in the seventeenth century, was depicted as the traditional site of "*feste e cazze*" (entertainment and tricks) in the prints of Luca Carlevaris (1663-1730), Domenico Lovisa (1690-1750), and Michele Marieschi (1710-43).[1] The drawings and paintings produced by Canaletto and Bellotto over a ten-year period further add to our knowledge of the site and record the changes to the area over time, such as the installation of a new well-head and new paving, which unfortunately being of relatively minor urbanistic importance are not documented in the city archives.

The present view, thought to be by Canaletto when it was acquired in 1991 by Derek Johns and Philip Harari, was later recognized as the work of Bellotto and constitutes a great addition to the known views of the *campo*.[2] The work under

way on the paving in the foreground of the painting has led to the belief that it predated a version of the composition by Canaletto owned by the Duke of Bedford at Woburn Abbey, where the paving of the square appears in good order, and postdated a similar view attributed to Canaletto in the collection of the Earl of Cadogan (ill.) where the pavement appears in need of repair.[3] Although these considerations exclude any possibility of an attribution to Bernardo Bellotto, the style provides unmistakable clues that suggest further investigation of the circumstances is necessary.

The parapet around the well, which has an eighteenth-century cylindrical shape today but is not accurately documented,[4] points to other conclusions. It appears octagonal in the print by Luca Carlevaris and remains so in the documentary drawings made by Canaletto in the early 1730s,[5] in the Duke of Bedford's painting (c. 1735; ill.) and in the print by Michele Marieschi, published in 1741-42 but probably engraved at the end of the 1730s. Bellotto depicts it in its new cylindrical shape with decorative garlands, and hints at its newness in the whiteness of the marble. The paving, some of which has been lifted in order to examine the hydraulics of the well, has not yet been replaced. It is depicted relaid only in a painting by Canaletto, now in a private collection, which was definitely completed before 1742, the year in which the engraving by Antonio Visentini (1688-1782) was published, as well as another view of the *campo* by Canaletto held in a private English collection.[6]

In the view belonging to the Earl of Cadogan the parapet has the same cylindrical shape and the paving has apparently

been replaced in the surrounding area, although only one of the paving stones around the area of the well appears to be in Istrian stone. In the left-hand part of the campo the "liston," or promenade, is in brick, a feature that does not appear in any other view of the square. Can this difference be attributed to the same imaginative impulse that led Michele Marieschi to depict a herring-bone pattern in the paving of his beautiful etching?

While the Earl of Cadogan's painting is certainly not by Canaletto and clearly does not date from the 1730s, it does share characteristics with Bernado Bellotto's style in the period between the creation of his views of the Campo Santi Giovanni e Paolo (cat. no. 7) and the view of Dolo along the Brenta (cat. no. 12) and its measurements are very close to those of the artist's Roman views. It is interesting to note how faithful the painting is to Canaletto's sketches in the depiction of the dome of the church, showing the long window visible behind the tympanum, completely missing from the present painting, and in the Palazzo Donà on the far left, with its fine portal surmounted by a bas-relief, of which only a glimpse can be seen in the other depictions of the place.[7] On the right, the Cadogan painting is in agreement with the present painting in depicting the corner of a house that does not appear in the documentary sketches. The way the direction of the light is reversed is also typical of the young artist, perhaps to affirm his artistic independence, and he uses this technique both in his paintings and in his drawings. The figures – in particular the woman with two buckets in the foreground, her eyes marked out in black, and posed in an agitat-

Bernardo Bellotto, View of the Campo and Church of Santa Maria Formosa, *Venice (Earl of Cadogan, Scotland)*

Canaletto, View of the Campo and Church of Santa Maria Formosa, *Venice (The Bedford Estates, Woburn Abbey)*

Bernardo Bellotto, View of the Campo and Church of Santa Maria Formosa, *Venice (Hessisches Landesmuseum, Darmstadt)*

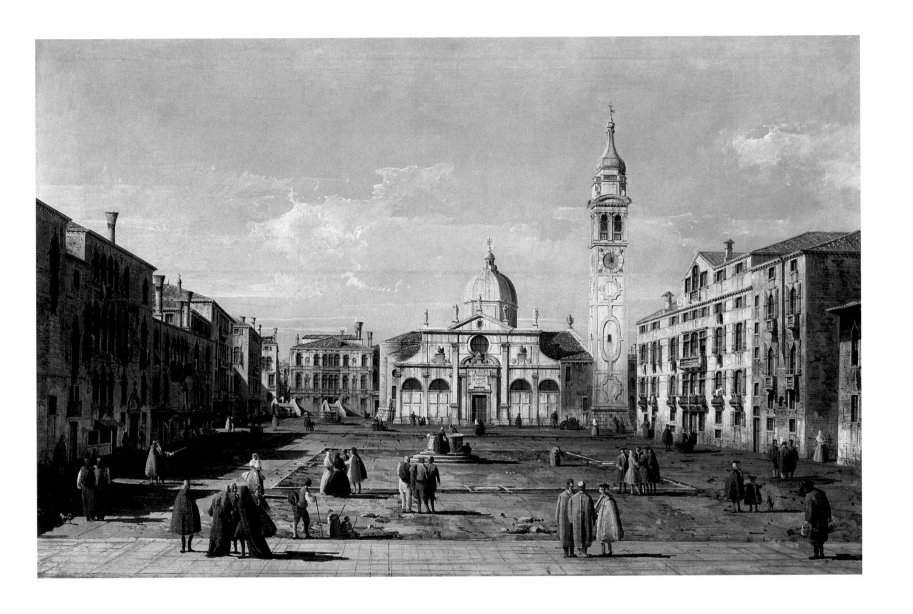

Venice

edly unnatural manner – clearly herald similar figures in the Dresden views.

The Campo Santa Maria Formosa was studied in two drawings by Bellotto, one (ill.) in the Hessisches Landesmuseum, Darmstadt. The other, very similar, probably later, more accurate and with a more sharply contrasted chiaroscuro effect, is at Windsor Castle, still attributed to Canaletto and thought to be the original of the Darmstadt drawing.[8] Also in the Royal Collection at Windsor is a version by Canaletto of the same view, with different figures and more diffused light.[9] In the present painting, Bellotto faithfully adheres to the two preparatory drawings, but increases the depth and length of the shadows, as was his practice. He also pays more attention to the figures, organizing them into distinct groups around the campo, which has been disrupted by the work in progress. He animates the composition with various hues of brown, ochre and black, with the odd spot of lilac, cobalt blue, and crimson. The figures are part of a "lesser" Venice, immobile but fascinating in this evocative atmosphere, unintentionally highlighted by the stylized rigidity of the perspective and the conventional lighting. The houses are described with great clarity but – in comparison with the Earl of Cadogan's painting – in a fairly "graphic" style, especially the fully illuminated parts, such as the façade of Santa Maria Formosa, on which the scrolls are clearly depicted and surmounted by the portraits of the Cappello family, the principal benefactors of the church. These stylistic features and the silvery tones suggest this view of the Campo Santa Maria Formosa is closer to the Campo Santo Stefano at Castle Howard (cat. no. 3).[10] The belief that this painting and a view of the Grand Canal from Palazzo Flangini to San Marcuola – which until its sale at Christie's, London, on 16 December 1998 (lot 78) had been part of the collection of Max Michaelis' nephew – may both have originally belonged to the series executed for Henry Howard, is supported by their appearance on the antiques market at the same time as the collection was sold.[11]

Bellotto's special interest in the Campo Santa Maria Formosa is easily explained: Situated between his home in Santa Marina and Canaletto's house at San Lio in Corte Pierina, it was also the parish of his wife, Elisabetta Pizzorno, and their marrige is recorded in the archives of the church of Santa Maria Formosa on 5 November 1741.

Bożena Anna Kowalczyk

[1] Carlevaris 1703-4, no. 31; Lovisa 1717; and Marieschi 1741-42.
[2] Kowalczyk 1995b and 1996b.
[3] Constable and Links 1989, vol. 2, nos. 278, 279.
[4] Rizzi 1981, p. 118.
[5] Nepi Scirè 1997, pp. 115-23, especially pages 122-23.
[6] Constable and Links 1989, vol. 2, no. 280; Visentini 1741-42, Pars Terza, VIII; Links 1998, no. 280*.
[7] Nepi Scirè 1997, p. 120.
[8] Kozakiewicz 1972, vol. 2, no. 22, and Bleyl 1981, no. 15; Parker 1948, no. 38.
[9] Parker 1948, no. 39.
[10] Kowalczyk 1996b, p. 83.
[11] Constable and Links 1989, vol. 2, no. 257 (b), and Succi 1999, p. 62.

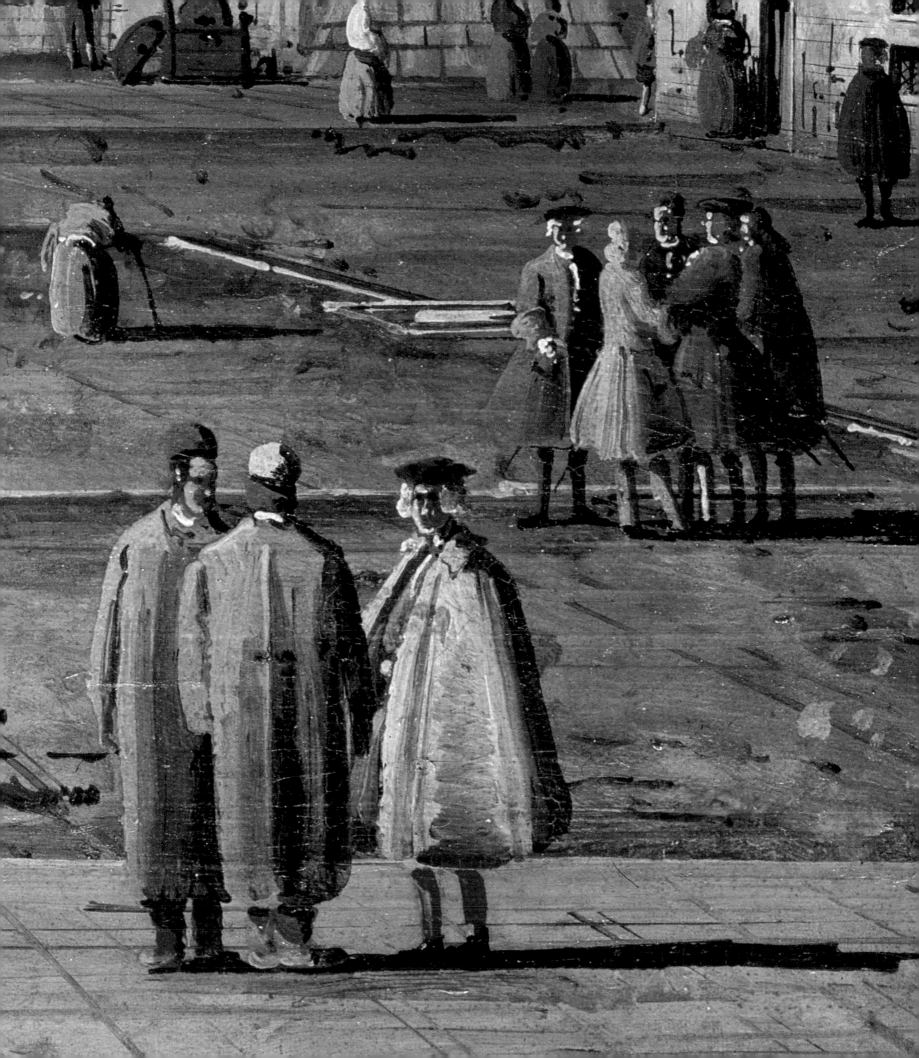

1740
Oil on canvas
23 1/2 × 35 1/4 inches
(59 × 89.5 cm)
The Castle Howard Collection, York

Provenance: One of the Venetian views acquired by Henry Howard, 4th Earl of Carlisle (1694-1758) during his visit to Italy in 1738-39; thence by descent at Castle Howard.

Exhibitions: Kingston-upon-Hull, London 1967, no. 6; London 1990a, p. 43; York 1994, no. 32; Padua 1994, no. 87.

Bibliography: Clovis Whitfield, in London 1990a, pp. 94-96; Hugh Brigstocke, in York 1994, pp. 12-16, 34; Succi, in Padua 1994, pp. 54, 267; Kowalczyk 1995a, p. 301; Kowalczyk 1996a, vol. 2, p. 12, no. 17; Kowalczyk 1996b, pp. 73, 76; Succi 1999, p. 52.

This painting and the following view of the Piazzetta toward the Libreria (cat. no. 4) formed part of a large group of more than forty Venetian views by Canaletto, Bellotto, and others, that were commissioned or assembled by Henry Howard, 4th Earl of Carlisle (1694-1758), during or just after his second visit to Italy between 1738 and 1739. Some of paintings commissioned in Venice had already arrived in Yorkshire through the agency of Antonio Maria Zanetti the Elder, by June 1740. The employment of Zanetti for this purpose in place of the English resident, Consul Smith, was unusual and probably connected with the purchase of the pictures (mostly now dispersed) not by Canaletto himself. In any case it did result in Henry Howard acquiring several fine paintings by Bellotto executed at a moment when the artist was still

strongly influenced by his uncle. The paintings by Canaletto that he acquired included one of the true masterpieces of eighteenth-century Venetian view-painting, *View of the Bacino di San Marco* (Museum of Fine Arts, Boston), commissioned during his second trip to Italy and executed immediately after in 1739.[1] This was followed by other paintings that regularly made their way to England until about 1742-43, the date of the two Canalettos from Castle Howard, now in the National Gallery of Art, Washington.[2]

There is no precise documentation to help reconstruct the sequence of this series of *vedute*, apart from the letter from Zanetti to Howard, dated 3 June 1740, in which he mentions that he has dispatched to England several canvases by an unknown *vedutista*.[3] Apart from the three afore-mentioned pictures by Canaletto and two (of the same dimensions as the Washington canvases) destroyed in a fire of 1940, of which only archival photos remain, eighteen were by Michiele Marieschi, confirmed by a hand-written list kept in the Castle archives, and two were by Giambattista Cimaroli.[4] Of the remaining fifteen paintings, six are definitely by Bellotto: the ones on show in this exhibition, two still at Castle Howard, depicting the Grand Canal from Palazzo Foscari and Moro Lin and the Bucintoro leaving the Molo, and two – recently confirmed as being by Bellotto and with documentation regarding their provenance – the *Entrance to the Grand Canal with Santa Maria della Salute* and the *Ponte di Rialto from the North*, formerly owned by Victor Lyon, Geneva, now in the Musée du Louvre.[5] A further six canvases, destroyed by fire, were

Bernardo Bellotto, View of the Campo Santo Stefano, *Venice (Hessisches Landesmuseum, Darmstadt)*

probably also by Bellotto, as can be deduced from photographs dating from the early twentieth century in the Castle Howard archives.[6]

If Marieschi and not Bellotto was the "*bon homme*" Zanetti mentions in his letter as having sold his *vedute* for twenty-five gold coins, there would be no documentary connection between Bellotto's chronology and Castle Howard. In any case, given the style of these pieces, it can be assumed that when the letter was written in mid-1740, the *Bucintoro in partenza dal Molo il giorno della Sensa* had been finished for some time and that the view of the Campo Santo Stefano exhibited here and that of the Piazzetta toward the Libreria (cat. no. 4) date from the same year.

In the late 1960s, when Stefan Kozakiewicz was putting the final touches to his monograph on Bellotto, this beautiful painting was entirely over-

looked, although it had been shown in 1967 as attributed to the artist in exhibitions at Kingston-upon-Hull and in London. It was later exhibited at the Walpole Gallery, London, in 1990 and in York in 1994, together with the view of the Piazzetta toward the Libreria at the exhibition, *Masterpieces from the Yorkshire Houses*, before being shown in Padua in *Luca Carlevarijs e la veduta veneziana del Settecento*, where it represented unequivocally a work by Bellotto, an exceptional example of his style in the early 1740s.

Whereas Canaletto created compositions of great novel charm and beauty for the Earl of Carlisle, Bellotto drew his subjects from views Canaletto had previously painted for such prestigious British collectors as John, 4th Duke of Bedford, and Joseph Smith. In this painting Bellotto uses the composition of the Campo Santo Stefano painted in 1734-35 for the Duke of

Bedford, engraved by Antonio Visentini for the series published in 1742.[7] In keeping with Canaletto's usual procedures, the sketches made of the site were used for a compositional drawing at Windsor Castle and probably also by Bellotto for a sheet now in the Hessisches Landesmuseum, Darmstadt, as well as for this painting at Castle Howard.[8] Canaletto's preliminary sketches made on the site, which have not survived, must have been similar to the ones made for the view of the Campo Santa Maria Formosa and other paintings in the Bedford series, annotated in the artist's sketchbook now in the Gallerie dell'Accademia, Venice.[9]

Bellotto, however, subtly modified the earlier compositional precedents for this painted view, working on it first in the drawing with hatching in Darmstadt and later with a surer touch in the painting itself. Whereas in his view of the Campo Santa Maria Formosa

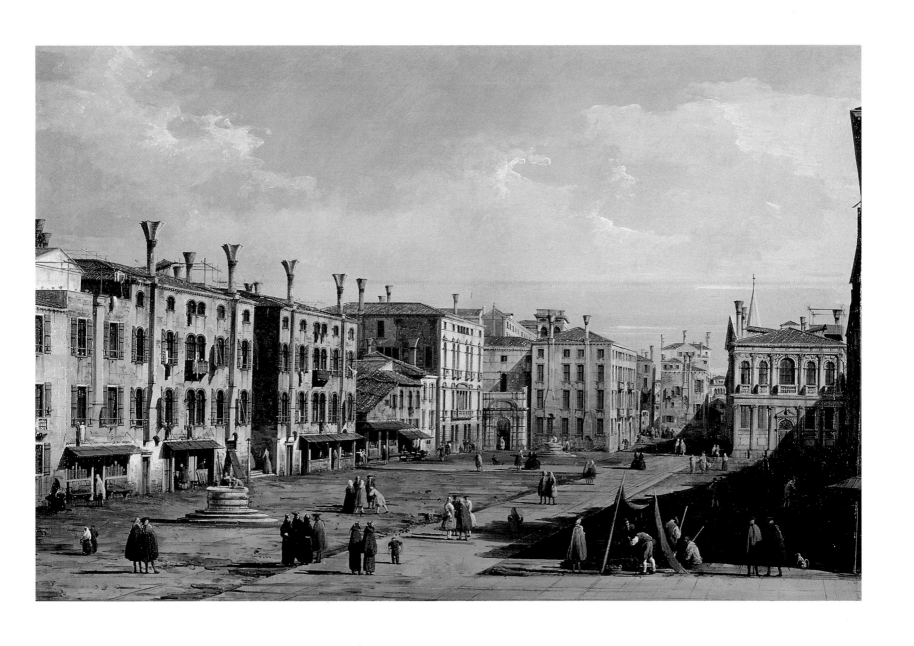

(cat. no. 2) Bellotto faithfully reproduces Canaletto's composition for Woburn Abbey – leaving out, as in his two drawings and as his teacher had done, a good part of the Gothic Palazzo Donà on the left (it would only appear in a later view of the Campo painted for the Earl of Cadogan and reproduced on page 46) – in the present painting the artist adds a large portion of the first house on the left, only partially depicted by Canaletto. He describes it accurately with its chimneys, roof terrace and a shop on the ground floor. In the Windsor drawing this same house has an additional section in respect to the Woburn Abbey painting, but in his drawing Bellotto adds a further part, as far as the second chimney. On the verso is a charcoal sketch of the house with the roof terrace that he has inserted into this painting.

In contrast to the rather romantic view of the Campo Santo Stefano by Canaletto at Woburn that depicts an unpaved Venetian square with a scattering of anonymous figures, Bellotto presents us here with a rigorous perspective view, a clearly defined architectural site bathed in a more uniform light with clearly defined alternating shadows. His view is broader, enabling him to add to the foreground a horizontal strip of paving. But the *campo* appears much narrower with the augmented dimensions of the architecture which has been defined with precision and characterized by rows of windows, open shutters and balconies all perfectly aligned, creating an almost geometrical relief. Even in this "perspective view" the artist manages to transmit the charm and beauty of a Venetian scene, with the silvery tone that pervades the view, the various shades of beige of the houses, and the long shadow falling on the right, which enables him to accent the figures in the light. The figures are particularly accurate, painted with a soft brush, and interestingly grouped together. While the fruit seller with his makeshift tent is a new element to the traditional repertory of views of the site, the pair of Capuchin monks were almost *de rigeur*.

Between the church of San Vidal, the façade of which is heavily foreshortened, and the Palazzo Cavalli stands a shabby little house. This must have been the "marble workshop" of San Vidal or the "*casotto di tagliapietra*" (the stonecutter's house) owned by the Rezzonico family, as indicated in the cadastral records of 1712 and 1740 and later in the Napoleonic land register.[10] In the summer of 1725 the marble-worker moved to the Campo San Vidal to face the facade of the church in marble. Canaletto depicted this scene in one of his early masterpieces, the *Campo S. Vidal and Santa Maria della Carità* (1725, National Gallery of London).[11]

No other views of the Campo Santo Stefano are known to have been done by either Canaletto or Bellotto, but Stefan Kowakiewicz mentions a *veduta* attributed to the nephew, taken from the opposite direction, looking towards the church of Santo Stefano. In 1886 it belonged to the J. P. Heseltine collection.[12]

Bożena Anna Kowalczyk

[1] Constable and Links 1989, vol. 2, no. 131; see also Bettagno 1983, pp. 226-28.
[2] Constable and Links 1989, nos 50, 154; Bowron, in De Grazia and Garberson 1996, pp. 24-31.
[3] Scarisbrick 1987, p. 96.
[4] *See my essay in this catalogue,* p. 12.
[5] Kowalczyk 1998, pp. 84-85; Succi 1999, pp. 63-64; and Constable and Links 1989, vol. 2, nos. 171, 236 (d).
[6] Succi 1999, pp. 53-54.
[7] Constable and Links 1989, vol. 2, no. 284; Visentini 1741-42, Pars Terza, VII.
[8] Parker 1948, no. 41; Kozakiewicz 1972, vol. 2, no. 21; Bleyl 1981, no. 16.
[9] Constable and Links 1989, vol. 2, no. 278; for the sketchbooks, see Pignatti 1958; Nepi Scirè 1997.
[10] Kowalczyk 1998, p. 94.
[11] Constable and Links 1989, vol. 2, no. 199.
[12] Kozakiewicz 1972, vol. 2, no. Z 248.

4. *View of the Piazzetta di San Marco with the Libreria Sansoviniana, Venice*

1740-41
Oil on canvas
23 1/4 × 35 1/4 inches
(59 × 89.5 cm)
The Castle Howard Collection, York

Provenance: One of the Venetian views acquired by Henry Howard, 4th Earl of Carlisle (1694-1758) during his visit to Italy in 1738-39; thence by descent at Castle Howard.

Exhibitions: York 1994, no. 33; Padua 1994, no. 86.

Bibliography: Constable 1962, vol. 2, p. 212, no. 70 (by an imitator of Canaletto); Constable and Links 1976, vol. 2, pp. 219-20, no. 70; Constable and Links 1989, pp. 219-20, no. 70; Clovis Whitfield, in London 1990, p. 96; Hugh Brigstocke, in York 1994, pp. 12-16, 72 Succi, in Padua 1994, pp. 54, 266-67; Kowalczyk 1996a, vol. 2, pp. 10-11, no. 8; Kowalczyk 1996b, p. 74; Succi 1999, p. 52.

Jacopo Sansovino's (1486-1570) architectural masterpiece, the Libreria Sansoviniana, or Library (1535-37), praised by Palladio as "the richest and most ornate building since ancient times," embellishes numerous scenes of the Piazzetta, the Molo, and the Bacino di San Marco. Surprisingly, a frontal view only appears in the late 1730s in a painting by Canaletto, one of a series executed between 1739 and 1740 for Thomas Brand of the Hoo, Kimpton, Hertfordshire, and later in the collection of Viscount Hampden, Alton, Hampshire, where it is now together with a view of the Grand Canal from the Palazzo Corner to the Palazzo Contarini dagli Scrigni.[1] Two other *vedute* in the same series, *Campo Santi Giovanni e Paolo* and *Piazza San Marco from the Campo San Basso*, that had for some time been missing from the collection, were put up for sale at Christie's London on 13 December 2000 (lots 104 and 105).[2]

As Bellotto had done in the view of the Campo Santi Giovanni e Paolo (cat. no. 7), which replicates one of the views in the Brand series, here the artist confidently transforms Canaletto's composition and gives it a rigidly organized perspective. The Library is set further back, the composition is invaded by shadow in the foreground, its lines of perspective established on the left by the columns of Saint Mark and Saint Theodore and the white line of Istrian stone set in the paving, and on the right by the side of the Loggetta and the the Campanile with its oblique shadow in the square. The lines of perspective governing the Bacino, which appears narrower because the Dogana and the Redentore have been brought forward, and the square, which is wider, meet at a central point behind the building to give depth to the scene. There is no such compositional tension in Canaletto's painting. In Bellotto's view the Library is much more clearly defined (even the base of the steps stands out clearly), while the roof of the Procuratie Nuove has definitely been lowered and the row of statues on the balcony stand out more prominently against the sky and take on a more important compositional role. The marble decoration has been described with meticulous attention to detail in an effort to show every column, capital and sculpture in detailed relief.

The same rigor has been applied to the description of the figures milling about the Piazzetta. Here they are not randomly scattered about as in Canaletto's version but gathered in quite distinctive small groups, each of which, as always in Bellotto's work, adds its own episode to the overall narrative. Even the puppet-theatre in Canaletto's painting has been decisively changed: a large group of spectators are crowded round the platform, the booth itself is very high, while the outline of the actor in silhouette is small; the shadow of the platform on the paving is sharply outlined. Such artistry was to be even more apparent in the puppet-theatre in the later view of the Piazza della Signoria in Budapest (cat. no. 13).

The charm of Bellotto's scenes lies in the contrast between his rigidly imposed perspectives and his exceptional ability to create an intense and unusual atmosphere by means of skillful manipulation of light, shade, and color. Here the monochrome tone of the buildings, built up in subtlest shades of beiges and browns, paling to an almost white sandy colour in the stippling on the second floor of the Library, stands out against both the dark grey-blue sky and the leaden-grey water of the Bacino to create a poetic atmosphere. By setting the foreground pavement in shadow against which the figures in the full light are emphasized, Bellotto highlights, in a manner reminiscent of Vermeer, the effect of sunlight falling on the Piazzetta.

Not a single preparatory drawing for this composition by either Bellotto or Canaletto has survived: Bellotto's, which definitely existed, must have been similar to a dynamic and incisive sketch in Darmstadt of the Procuratie Nuove that is filled with very similar figures.[3] The drawn composition, dated by Kozakiewicz between 1736 and 1740 (but which was more probably made in 1740), bears similarities to the present painting – the view is frontal and the square before the principal building is bounded on the side by the line of the flagpole. A

Canaletto, The Piazzetta looking toward the Libreria
(Viscount Hampden, Alton, Hampshire)

similar compositional layout was used in a view of the Piazzetta toward the Palazzo Ducale, formerly in the Spitzer collection, that was inspired by a print of Luca Carlevaris. Stylistically very similar is its pendant view of the Bacino di San Marco from the Piazzetta to this portrayal of the Piazzetta and the Libreria. We know that the two ex-Spitzer paintings must have been completed by the end of November 1740 (or shortly thereafter) when they are mentioned in the Schulenburg papers, but they may have been painted at the beginning of 1740 or slightly earlier. This view of Piazzetta and the Libreria could have been executed in the second half of 1740, after the *Campo Santo Stefano* (cat. no. 3) at Castle Howard.

Whereas Bellotto did not return to this composition, Canaletto reworked the painting for Thomas Brand on his return from London in 1755, reducing the view over the Bacino and filling the square with figures.[4] W.G. Constable described the first of these versions as "The type of painting sometimes attributed to Bellotto, but characteristic in details of Canaletto" and noted the similarities to the present painting, which he considered the work of an imitator.

Bożena Anna Kowalczyk

[1] Constable and Links 1989, vol. 2, nos. 69, 193.
[2] Constable and Links 1989, vol. 2, nos. 306 and 40.
[3] Kozakiewicz 1972, vol. 2, no. 2; Bleyl 1981, no. 6.
[4] Constable and Links 1989, vol. 2, nos. 71,72.

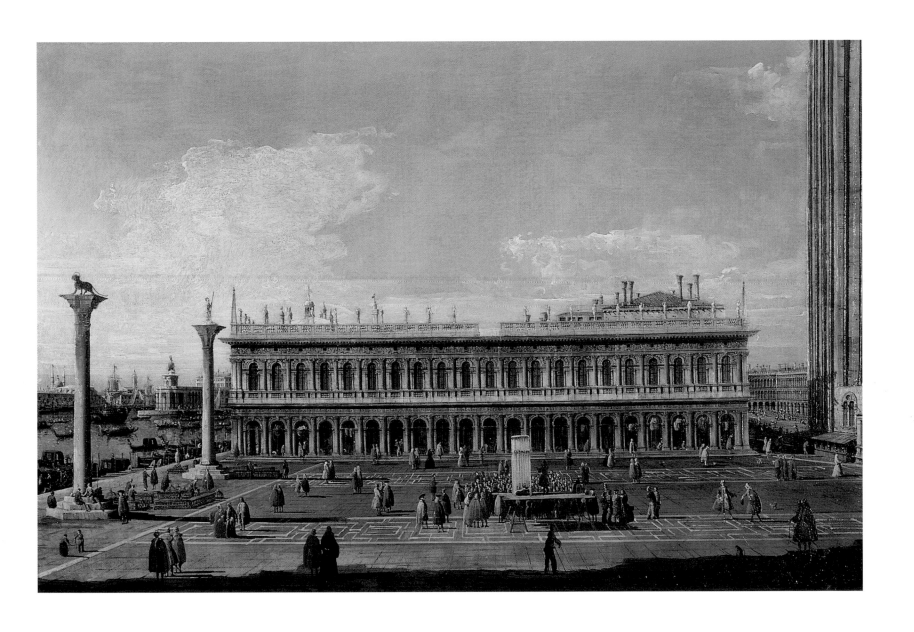

5. *View of the Rio dei Mendicanti and the Scuola di San Marco, Venice*

c. 1741
Oil on canvas
16 1/2 × 23 5/8 inches
(41.9 × 59.9 cm)
Gallerie dell'Accademia, Venice

Provenance: Girolamo Manfrin, Venice; acquired in 1856 (inv. no. 494).

Exhibitions: Paris 1919, no. 6; Rome 1945, no. 53; Zaragoza 1990, no. 82; Verona 1990, no. 1; Venice 1995, no. 74.

Bibliography: Ruskin 1888, vol. 1, part ii, ch. vii, p. 109; Constable 1962, vol. 2, p. 312, no. 291 (attributed to Canaletto); Moschini Marconi 1970, p. 5, no. 7; Kozakiewicz 1972, vol. 1, pp. 25-26, vol. 2, p. 20, no. 23; Links 1973, p. 107; Camesasca 1974, p. 87, no. 4; Constable and Links 1976, vol. 2, p. 332, no. 291; Links 1977, p. 52; Links 1982a, pp. 102-103; Mucchi and Bertuzzi 1983, p. 89; Nepi Scirè and Valcanover 1985, p. 95, no. 45; Constable and Links 1989, vol. 2, p. 332, no. 291; Links 1990, p. 660; Nepi Scirè in Belgrado 1990, no. 26; Pedrocco in Zaragoza 1990, no. 82; Marini, in Verona 1990, pp. 52-53; Succi, in Padua 1994, p. 55; Links 1994, pp. 69-70; Kowalczyk, in Venice 1995, p. 306; Kowalczyk 1996a, vol. 2, p. 13, no. 16; Kowalczyk 1996b, p. 73; Links 1998, p. 29, no. 291 (as Canaletto with Bellotto "likely to have played a large part in the painting").

The fact that the painting is mentioned in the famous Venetian collection of Girolamo Manfrin at the end of the eighteenth century suggests that it was commissioned by a local patron.[1] Bellotto is mentioned in the Manfrin inventory drawn up by his advisor, Pietro Edwards, and there can be no doubt that the citation refers to this painting since the label with the collector's name is still attached to the back of the original canvas. The accuracy of Edward's attribution, of which no account has been taken in later discussions of the work, is surprising and could derive from his knowledge of the painting's history.[2] Ignored by Hellmuth Allwill Fritzsche, the author of the first monograph on Bellotto, the painting was generally accepted as by Bellotto only in 1958, after it had been cleaned. But W.G. Constable always maintained the ascription to Canaletto, and J.G. Links, although ready to accept that "Bellotto is likely to have played a large part in the painting of the picture", found it inconceivable that younger painter was capable of composing it and argued that Canaletto must have it out for his pupil's benefit or have been responsible for a lost painting of which the painting in the Galleria dell'Accademia is a copy.[3]

The compositions of Bernardo Bellotto's first works often take up Canaletto's ideas and compositions (and, occasionally, anticipate them), understandable in the context of their collaborative efforts in the workshop. Only in rare instances, such as here, does the younger artist initiate completely original views, probably motivated by the requirements of the commission. This view of the Rio dei Mendicanti complements a view of the site looking south chosen by Canaletto for one of four early *vedute* formerly in the Liechtenstein collection and now in Ca' Rezzonico.[4] The presence of these paintings by master and pupil in Venetian public collections provides an exceptional opportunity to compare and contrast the personal approach of each to the requirements of topographical view painting at an early stage in their respective careers.

Before undertaking the broader, more common view of the Campo Santi Giovanni e Paolo now in Springfield (cat. no. 7), Bellotto undertook this unusual view of the square, placing greater emphasis on the Palazzo Dandolo on the right and the houses opposite spread out along the Rio, but making sure to include the splendid façade of the Scuola di San Marco, which he describes in great detail, and other prominent features of the site such as the Ponte del Cavallo and the campanile and dome of San Michele in the distance. Bellotto's vantage point for the composition may be explained by the fact that the central focus of our attention is the palazzo where a charming woman with a fan, attentively depicted with her white high-laced shoes and accompanied by a man with a wig and black cloak, emerges from the open door and awaits a gondola. But it has not been possible to get further into the circumstances of the commission than the fact that the Palazzo Dandolo was inhabited in 1740 by the four Dandolo brothers, sons of the late Antonio, Marco, Andrea, Enrico and Maria Dandolo in Dolfin.[5]

Bellotto was obviously deeply absorbed in this commission, attempting to create the illusion of reality for every detail – the naturalness of the shadows, where rays of light glance off the cornices thrown into relief; the reflections on the windows of the Scuola di San Marco; the signs of age on the wall at the right edge of the canvas, full of cracks and overgrown with vegetation. He is greatly concerned with creating a fascinating and seductive pictorial narrative and does not pass over any opportunity to add to the rich pictorial fabric. The composition is extremely rigid, "photographic" or "perspectival", but the essentially experimental nature of the light, warm on the façade of the Scuola and the Palazzo Dandolo, cold and contrasting on the houses along the Rio, results in a lively and perfectly balanced description, which relies on the rich paint – carefully applied in heavy or light layers with the tip of the brush to create the illusion of relief, with broad vertical brush-strokes on the walls, horizontal strokes on the complex sky – and the highly elaborate water with its great variety of hues of green, shading to yellow and black. To impart the illusion of reality Bellotto adopts with great skill the full repertory of Canaletto's techniques, but with such mastery and freedom that the work can be appreciated as emblematic of the exceptional skills of Canaletto's pupil. The work was produced some time before his visit to Rome, probably at the beginning of 1741.

It is difficult to specify the most brilliant passages of the painting. The lower parts of the houses on the left in deep shadow, where the dark greys and reds are interrupted by the narrow grooves of incisions that allow us to see clearly Bellotto's careful preparation of the composition, or the upper floors that stand out in the strong leaden light? Or, the palazzo Dandolo, a study in the sophisticated use of color, mellow beige at the top, rendered more intense by very thin layers of ochre, with brown and olive green at the bottom, and brown grids to mark the doors, windows and cornices positioned according to the incisions in the wet paint? The façade of the Scuola di San Marco is depicted using a special technique (also employed by Canaletto) of applying thin paint delicately with the tip of the brush, which is also used in the slightly later *Santa Maria della Salute from Campo Santa Maria del Giglio* in the Fitzwilliam Museum, Cambridge.[6] This technique is also used on those parts of the figures and their clothing that are shown in full light.

Many versions of this composition exist in copies that can be distinguished from one other and provide an interesting diversity of stylistic approaches and handling.[7] Many of these paintings appear to date from the very last years of the eighteenth and the early nineteenth centuries. These works, although generically defined as "school of Canaletto," all emulate Bellotto's personal artistic style and manner of painting. The final generation of eighteenth-century Venetian *vedutisti* – Francesco Zanin, Vincenzo Chilone (1758-1839), Giovanni Migliara (1785-1837) – had the opportunity of studying and imitating this intense pictorial narrative, highly representative of the technique developed by Canaletto, and embellished by Bernardo Bellotto; an "academic textbook" of *vedutismo* at its height.

Bożena Anna Kowalczyk

[1] For Manfrin, see Haskell 1980, pp. 379-81.
[2] Biblioteca del Seminario Patriarcale. Venice, Mss. 788.13.
[3] Links 1994, p. 70.
[4] Constable and Links 1989, vol. 2, no. 290; see Ruth Bromberg, in London and Washington 1994-95, no. 134.
[5] Archivio Stato di Venezia, Dieci Savi alle decime in Rialto, redecima 1740, b. 318, nos. 596, 628, 745.
[6] Kozakiewicz 1972, vol. 2, no. 7.
[7] These include the painting formerly in the Foresti collection, Milan (Constable and Links 1989, vol. 2, under no. 291); one sold at Sotheby's, London, 13 July 1977, lot 110; one from the Vittorio Zurla collection (1947); and a version of unknown date, attributed by Giuseppe Fiocco to Vincenzo Chilone (44 × 65 cm). Another larger, exact copy (50.7 × 80.7 cm), entered the Staatsgalerie Stuttgart in the mid-nineteenth century together with 250 paintings from the Venetian collection of Michelangelo Barbini, painter and art dealer, later G.B. Breganze, Vicenza (see Kozakiewicz 1972, vol. 2, no. Z251; Gardner 1998, pp. 79-80).

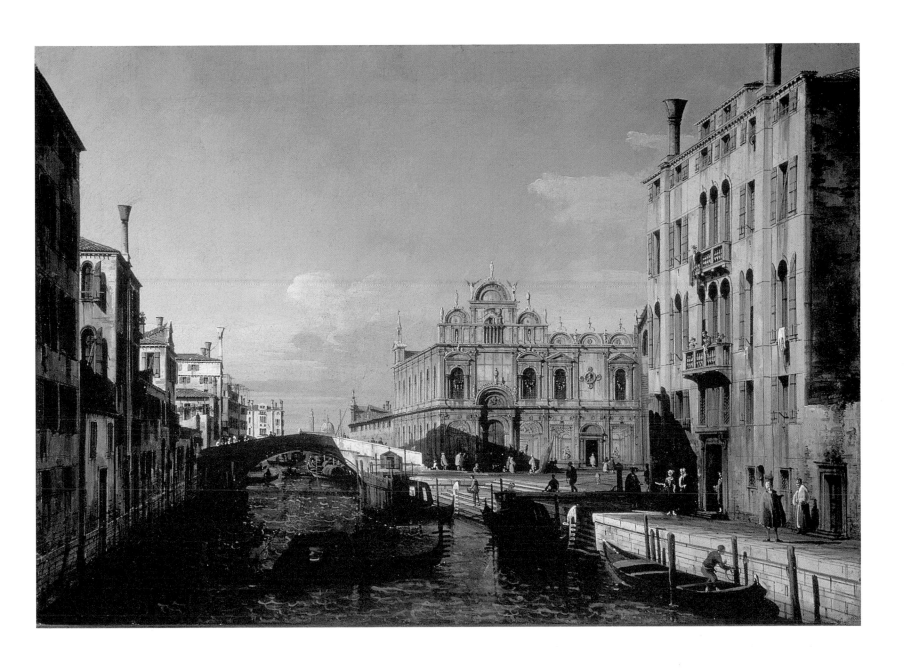

6. *Santa Maria dei Miracoli and the Apse of Santa Maria Nova, Venice*

c. 1741
Oil on canvas
16 1/8 × 26 inches
(41 × 66 cm)
Niedersächsisches Landesmuseum, Landesgalerie, Hannover (on loan from the Fritz Behrens Foundation)

Provenance: Count Gregory Stroganov (1829-1910), Rome; Camillo Castiglioni, Vienna; sale, Frderick Muller & Co., Amsterdam, 17-20 November 1925, lot 28 (unsold); sale, Ball and Graupe, Berlin, 28-29 November, 1930, no. 30; sale, Sotheby's, New York, 9 June 1983, lot 155 (as Bellotto), bought by Richard Green; P. & D. Colnaghi, London.

Exhibitions: Venice 1929, no. 13; London, Burlington Antiques Fair, 1983; Hannover 1985, no. 1; Hannover and Düsseldorf 1991-92, no. 4.

Bibliography: Muñoz 1911, vol. 2, p. 46; Falke 1930, p. 20, no. 30; Pallucchini 1960, p. 222; Constable 1962, vol. 2, p. 409, no. 464 (attributed to Canaletto); Pignatti 1966, pp. 219-20; Kozakiewicz 1972, vol. 1, pp. 25-26; vol. 2, p. 83, no. 105 (as Bellotto); Links 1973, p. 107; Camesasca 1974, p. 89, no. 14; Constable and Links 1976, vol. 2, p. 441, no. 464; Grohn, in Hannover 1985, p. 22; Constable and Links 1989, vol. 2, p. 441, no. 464; Trudzinski 1989, p. 51; Horn, in Hannover and Düsseldorf 1991-92, p. 96; Kowalczyk 1996, vol. 2, p. 13, no. 19; Links 1998, p. 43, no. 464.

Count Gregory Stroganoff (1829-1910), a member of the renowned Russian family of collectors and patrons of the arts who lived in Rome, had in his collection of European paintings several eighteenth-century Venetian works, including two late *capricci* by Francesco Guardi.[1] Antonio Muñoz, who compiled the inventory of the collection, confidently atributed this "*belle vue de l'Église de Santa Maria dei Miracoli à Venise, prise par derrière*" to Bernardo Bellotto because of its "*tonalité un peu sombre des couleurs dans les architectures,*" adding "le ciel est clair". Before 1925 the painting had been acquired by Camillo Castiglioni in Vienna, who owned two other apaintings by Bellotto, *Paduan Capriccio with a Bridge* (Fundación Colección Thyssen-Bornemisza collection, Madrid) and a *Landscape Capriccio with Ancient, Medieval, and Classical Architectural Motifs* (cat. no. 84), as well as a version attributed to Bellotto of the *Capriccio with a Colonnade* (Gallerie dell' Accademia, Venice) by Canaletto.[2]
Stefan Kozakiewicz supported the attribution of the present painting to Bellotto, although he had not actually seen the canvas in the original. According to Constable, the painting, which was not mentioned at all by Hellmuth Allwill Fritzsche, was similar to Bellotto's work in the tone and in the manner of painting the figures in the right-hand corner, while "in other respects the handling is typical of Canaletto". J.G. Links published it as "attributed to Canaletto". As in the case of the *View of the Rio dei Mendicanti and the Scuola di San Marco* (cat. no. 5) and other works previously considered to be by Canaletto, Bellotto's "Canalettian" style continued for a long time to be confused with the style and technique of the master himself. On the other hand, the rather early date suggested for the work by Kozakiewicz, "about 1740", is at odds with the skillful execution and maturity of the composition.
In Bellotto's topographical repertory this *veduta* that in Kozakiewicz's opinion "was

clearly intended to be taken … real," occupies a very special place. To alter reality and interpret it with imagination was a common practice among view painters; but here the very layout of the city has been transformed into what Kozakiewicz called an "architectural capriccio". In order to represent the church of Santa Maria dei Miracoli – which seems to have been ignored by Canaletto and other view painters of the eighteenth-century – more attractively, the artist has moved back the houses surrounding it and made the canal running alongside it broader, opening up the view of the canal as far as the lagoon and a domed church on an island, which is probably San Giorgio Maggiore, and not San Michele in Isola as mentioned in the catalogue of the Castiglioni sale. There is a clear allusion to the bell-towers of San Giorgio and Santa Maria Formosa in the one that the artist depicted close to the houses; it is a convincing blend of shapes in carefully balanced counterpoint to the apse of the church. The church of Santa Maria dei Miracoli, designed by Pietro Lombardo (1435-1515), consecrated in 1489, and often referred to as "a jewel of the Venetian Renaissance", is ingeniously placed by Bellotto in a new setting shaped by the play of light and shadow, although it appears without its sculptural bas-relief decoration, medallions and reliefs between the arches, or the ornamental frieze in the upper part. The depiction of these delicate Renaissance embellishments clearly did not fit in with the artist's aim; it is in the richly faded colours of the intonaco of the apse of Santa Maria Nova at the right that Bellotto creates the most pictorially intense section of the painting.
There, the irregular and lively

brush strokes – influenced by Canaletto but much denser, creating a relief effect – create varying hues and colors, while the black dots and dark lines suggest the irregularities and cracks in the wall. The black shadow of the roof is also sharply defined, and the windows stand out clearly. The depiction of the altar, where the shapes of the Virgin and Child have been barely suggested with light and colour, is also typical. The quality of the brushwork and handling suggests the painting was executed in the period just before Bellotto departed for Rome, between the view of the *Rio dei Mendicanti and Scuola di San Marco* (cat. no. 5) and his view of the *Grand Canal with Santa Maria della Salute from Campo Santa Maria del Giglio* in the Fitzwilliam Museum, Cambridge.[3]
The melancholy figures – isolated groups situated at intervals, figures seeming lost in thought on the bridge, in front of the church and in the foreground, where a scrawny dog, outlined against the light, accompanies two bedraggled servants – perhaps allude to a situation or circumstance known only to the artist or the unknown recipient of the painting.
There are no known versions, pendants, or preparatory drawings of this painting.

Bożena Anna Kowalczyk

[1] Morassi 1973, vol. 1, pp. 459-60, 469, nos. 805, 858.
[2] Kozakiewicz 1972, vol. 2, no. 109; Falke 1930, p. 20, no. 29.
[3] Kozakiewicz 1972, vol. 2, no. 7.

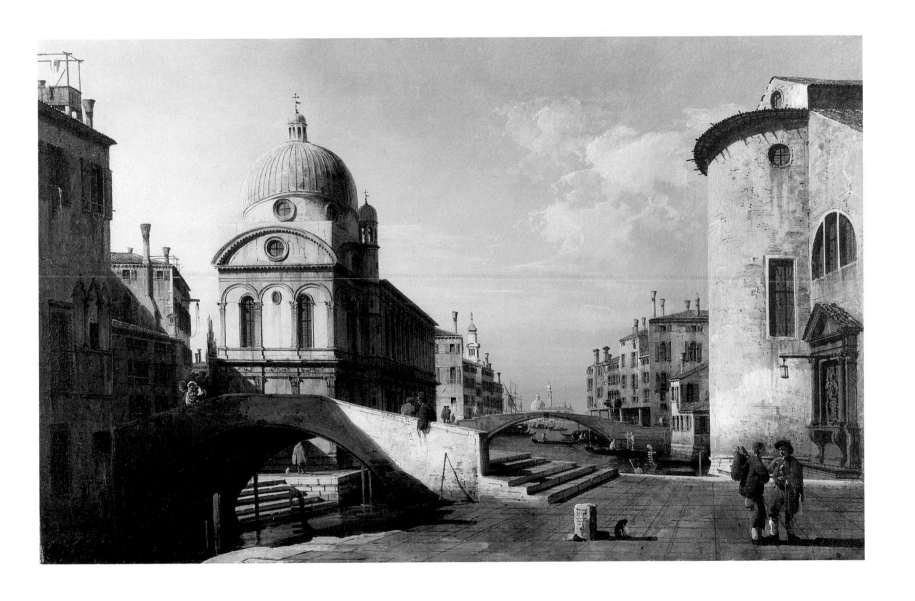

c. 1741
Oil on canvas
24 × 38 3/4 inches
(68 × 98.4 cm)
Museum of Fine Arts,
Springfield, The James Philip
Gray Collection, inv. 36.03

Provenance: Thomas Agnew &
Sons, London; Grand Duke Pa-
vel Romanov, Tsarskoye Selo,
near St. Petersburg; inherited
by his widow, Princess Palej; sa-
le, Christie's, London, 21 June
1929, lot 18; M. Knoedler &
Company, London; Marshall
Field, Chicago, 1929; exchanged
for another painting, through
Agnew's in 1930; purchased by
the museum in 1936 (36.03).

Exhibitions: Springfield 1934,
no. 8; Wilmington 1935, no. 29;
Saint Louis 1936, no. 6; Cam-
bridge 1938; Bloomington
1939, no. 7; Detroit and India-
napolis 1952-53, no. 2; Cam-
bridge 1956, no. 20; Boston
1958; Pittsfield 1960, no. 4.

Bibliography: Parker 1948, p. 37,
under no. 40; Pallucchini 1960,
p. 222; Pallucchini 1961b, pp. 7,
9; Constable 1962, vol. 2, p. 319,
no. 307 (a) and I; Kozakiewicz
1972, vol. 1, pp. 21, 25, 26, vol. 2,
pp. 20, 25, no. 24; Constable and
Links 1976, vol. 2, no. 307 (a)
and I; Bleyl 1981, p. 24, no. 20;
Bettagno 1986, pp. 19-20; Con-
stable and Links 1989, vol. 2, p.
340, no. 307 (a) and I; Bettagno
1990, p. 16; Succi, in Padua
1994, p. 52; Kowalczyk 1995a,
pp. 299, 344, no. 164; Bowron,
in De Grazia and Garberson
1996, pp. 10, 12-14; Kowalczyk
1996a, vol. 2, pp. 6, 14-15, no.
21; Kowalczyk 1996b, pp. 72, 85;
Bettagno 1998, p. 13; Kowalczyk
1998, p. 71; Kowalczyk 1999, pp.
199, 210, n. 79; Succi 1999, pp.
33, 37, 39.

This painting and the prepara-
tory drawing on which it is
based, signed and dated 8 De-

cember 1740, are important ref-
erence points in the early career
of Bernardo Bellotto. The draw-
ing at Darmstadt has been ana-
lyzed in depth to discern the dif-
ferences in style and composi-
tion between it and a similar
sheet by Canaletto, made for
Consul Smith, prior to one of
the paintings in the group of
four commissioned in Venice by
Thomas Brand (c. 1717-70) of
Hoo, Kimpton, Hertfordshire,
during a trip made in 1738-39.[1]
On the other hand, the Spring-
field painting has tended until
recently to be excluded from
Bellotto's Venetian period due to
a lack of stylistically similar
pieces, although its attribution
to the artist by Constable in the
1930s has for years been the sub-
ject of much discussion. Only
now can this work be seen as the
young artist's most important
undertaking. Here, as in the ac-
curate preparatory drawing in
Darmstadt, he distills the experi-
ence of his very early years and
sets down the fundamentals of
his future development. The
precise date of the drawing and
its connection with the Thomas
Brand series, probably carried
out between 1739 and 1740, en-
able us to fix a date for the paint-
ing towards the middle of 1741
and establish its chronological
precedence over both the pair of
views of Florence painted for the
Marchese Vincenzo Riccardi
(cat. nos. 13, 14) – which repre-
sent a further development of
his early style – and that of the
Grand Canal from Palazzo
Flangini to Palazzo Vendramin
Calergi sold recently in London.[2]
It is interesting to trace Bellot-
to's involvement in Canaletto's
working process, particular
evidence of which is to be
found in the series commissio-
ned by Thomas Brand. Of the
four Canaletto views, two (re-
presenting the Campo Santi
Giovanni e Paolo and the Li-
breria) were followed by "per-

sonalized" versions by Bellotto;
a third (representing the Grand
Canal from Palazzo Corner to
Palazzo Contarini dagli Scri-
gni) has been very faithfully
captured by the younger artist
in a picture that recently tur-
ned up on the art market; whi-
le the fourth, probably the late-
st in the series, depicting the
Piazza di San Marco from
Campo San Basso, reveals the
direct participation of Bellotto
in the painting of architectural
passages from the Procuratie
Nuove to the house in the
Campo San Basso.[3]
The Brand series, later inherited
by Viscount Hampden, must ha-
ve remained for some time in the
house of Joseph Smith: two pain-
tings were to have been engraved,
the views of Campo Santi Gio-
vanni e Paolo and the Grand Ca-
nal from Palazzo Corner della Ca'
Grande to Palazzo Contarini de-
gli Scrigni. Of these, Antonio Vi-
sentini, in keeping with the usual
practice, made two outline
drawings, one in the Museo Cor-
rer, Venice, the other more accu-
rately defined with hatching, now
in the British Museum, but only
the latter – and not Bellotto's re-
plica, as J.G. Links believed – was
published in Visentini's *Prospec-
tus Magni Canalis Venetiarum* of
1742.[4] Drawings by Canaletto
and Bellotto are also known to be
connected with three composi-
tions in the series – those for the
Libreria are missing. The Spring-
field painting therefore belongs
to a creative process in the con-
text of the workshop in which
Bellotto was completely involved.
The composition of the Spring-
field painting, which faithfully
follows the Darmstadt drawing,
derives from the drawing by Ca-
naletto and not the painting for
Thomas Brand, which, compa-
red with the drawing, broadens
the Rio dei Mendicanti in the
background, opening up the
view to the lagoon (an ingenious
idea, already adopted more than

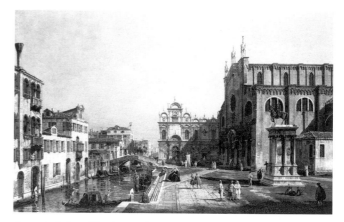

Bernardo Bellotto, The Campo di SS. Giovanni e Paolo, *Venice
(National Gallery of Art, Washington)*

ten years earlier in a view of the
campo painted by Canaletto for
Stefano Conti) raises and com-
plicates the line of the shadow
on the facade of the Scuola di
San Marco, and makes the Col-
leoni equestrian monument big-
ger. Bellotto here asserts his in-
dependence, adapting with a su-
re hand the Canaletto composi-
tion that is his model: he raises
the horizon, pushes the main
buildings into the distance as if
seen through a telescope, and
extends the horizontal view,
creating a more ample fore-
ground. He replaces Canaletto's
delicate diffused light, barely
veiled by transparent clouds,
with a series of strong shafts of
sunlight and sharply defined
shadows. He introduces an area
of shadow that falls across the
immediate foreground of the
campo, creating the effect of a
stage, at the edge of which his
elongated figures are portrayed
in the light. The same device was
employed in the view of the
Piazzetta and the Libreria acqui-
red by Henry Howard for Castle
Howard (cat. no. 4).
It is typical of Bellotto that he
renders the architectural features
in great detail. The façade of the
church, shown in perspective,
has three and not four niches on
the right of the fifteenth-century
door, correcting Canaletto's

inaccuracy, which was repeated
by Antonio Visentini in the
drawings cited above. But it
would appear that the decision
to eliminate the small altar on
the side of the church, visible
behind the Colleoni monument,
was dictated by compositional
requirements. In all his views of
the *campo*, Canaletto preferred
to limit the view on the right as
far as the monument.[5] Bellotto,
however, decided to depict the
low house alongside the church,
moving it to the left so that he
could also fit in part of the apse
of the church because these ele-
ments were essential to the ove-
rall effect of his rigid composi-
tion of light and shade.
In Bellotto's later version of the
view in the National Gallery of
Art, Washington, the clearly de-
fined, sharp, diagonal shadows
have been replaced by more sof-
tly defined areas of light and
shadow.[6] Even the manner of re-
presenting the paving of the
campo differs in the two ver-
sions. In the Springfield pain-
ting, as in the Darmstadt
drawing, two areas separated by
a white line in Istrian stone are
clearly visible. On the left-hand
side the stone paving is in a bet-
ter state of preservation, wheras
the right-hand side is covered
with grass, with the odd paving
stone showing. In the Washing-

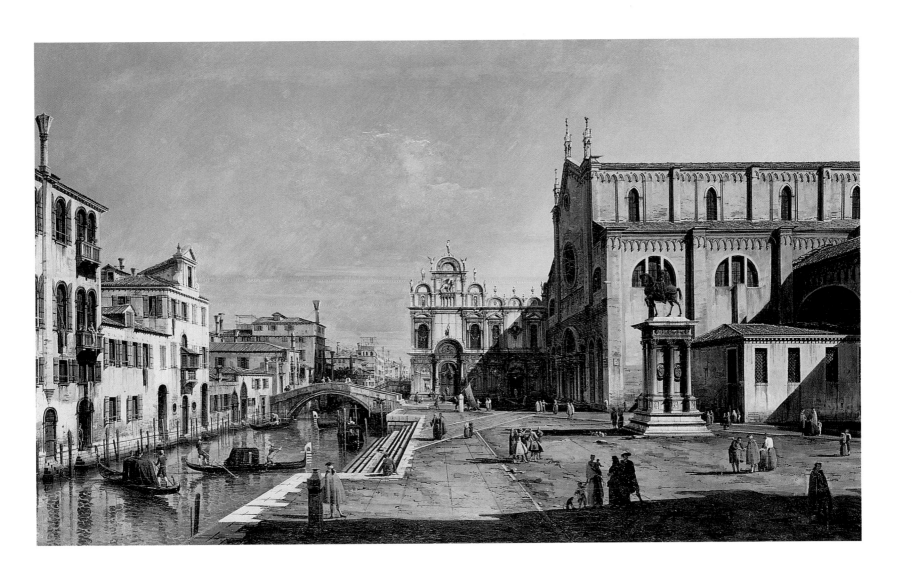

Bernardo Bellotto, The Campo di SS. Giovanni e Paolo, *Venice (Hessisches Landesmuseum, Darmstadt)*

Antonio Visentini, The Campo di SS. Giovanni e Paolo, *Venice (British Museum, London)*

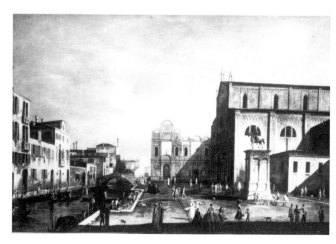

Anonymous, The Campo di SS. Giovanni e Paolo, *Venice (formerly Bordoni Bisleri collection, Milan)*

ton painting, this area is in an even more advanced state of decay. In the Hampden painting by Canaletto and in the drawing by Visentini the situation is similar with the paving-stones visible throughout the area, although partly covered with grass. Only Bellotto depicts the white dividing line that extends into the distance beyond the liston to reach the point where the oblique shadow of the church highlights the entrance to the Scuola di San Marco, the focal point of the composition. This is an ingenious compositional expedient that emphasizes the perfectly constructed interplay of light and perspective in the view, adding to its beauty and sense of movement.

The grey-green tones and the cold atmosphere are a variation of Bellotto's range of metallic greys and colder greens, of dawn, moonlight or evening light and recall the Grand Canal from Palazzo Flangini to Palazzo Vendramin Calergi cited above. They anticipate the view of Dolo along the Brenta (cat. no. 12). The blue sky is typical in its diagonal preparation, but it is particularly dark; very fine lively black lines describe the architectural details; Bellotto's efforts to create light effects are as elaborate as the description of the walls, comprising thickly applied yellow and pale red paint, grey shadows and brushstrokes of white. The figures are given a particular mannered treatment involving elaborate description: some are based on Canaletto's figures but shown in more natural poses, others are decidedly eccentric, such as the group of tourists in the middle of the *campo* with their cicerone or guide, their clothes in more sophisticated colours of blue, violet and amaranth, and sharply outlined.

The rich complexity of this early composition by Bellotto attrac-

ted the attention of many imitators of Venetian art in the second half of the eighteenth century, suggesting that the picture remained in the city at least until about 1800 and that it was probably a Venetian commission. Photographs of these copies are found in the Fototeca Pallucchini in the Fondazione Giorgio Cini, Venice; Kunsthistorisches Institut, Florence; and the Witt Library, London. The provenance of a late eighteenth-century replica put up for sale by Sotheby's in Munich, 18 July 1992 (lot 17), has been traced through a print reproduction kept in the Witt Library to the nineteenth century (when it came from the Mosselman collection) and the Burat sale at the Petit Palais in Paris, 28-29 April 1885 (lot 29).

Bellotto's composition is so striking that other painters emulated his layout of perspective and light, introducing different and more numerous figures, as seen in the painting of the Bordoni Bisleri collection and in a smaller version with a procession through the square, sold at Christie's, London, 11 December 1992 (lot 25), attributed to Francesco Tironi. The artist responsible for the version in Viscount Rothmere's collection must have been a Venetian contemporary of Bellotto's. This painting is mentioned by W.G. Constable and Stefan Kozakiewicz, who, on examining the photograph, thought it very similar to the Springfield painting, although in light of the "mediocre workmanship of the architecture" not by Bellotto.[7]

Bożena Anna Kowalczyk

[1] For the drawing, see Kowalczyk 1995a, no. 164, and Pignatti 1966, pp. 223-24.
[2] Christie's, London, 16 December 1998, lot 78, entry by Charles Beddington.
[3] Constable and Links 1989, vol. 2, nos. 306, 69, 193 (a), 40. The pain-
ting on the art market was with Partridge, London, in 1997.
[4] Links 1998, no. 193* and Visentini 1741-42, Pars Secunda X.
[5] See his first version now in Dresden; Constable and Links 1989, vol. 2, no. 306.
[6] Bowron, in De Grazia and Garberson 1996, pp. 9-14.
[7] Konody 1932, p. 34; Constable and Links 1989, vol. 2, no. 307 (a) 5; Kozakiewicz 1972, vol. 2, no. Z 252.

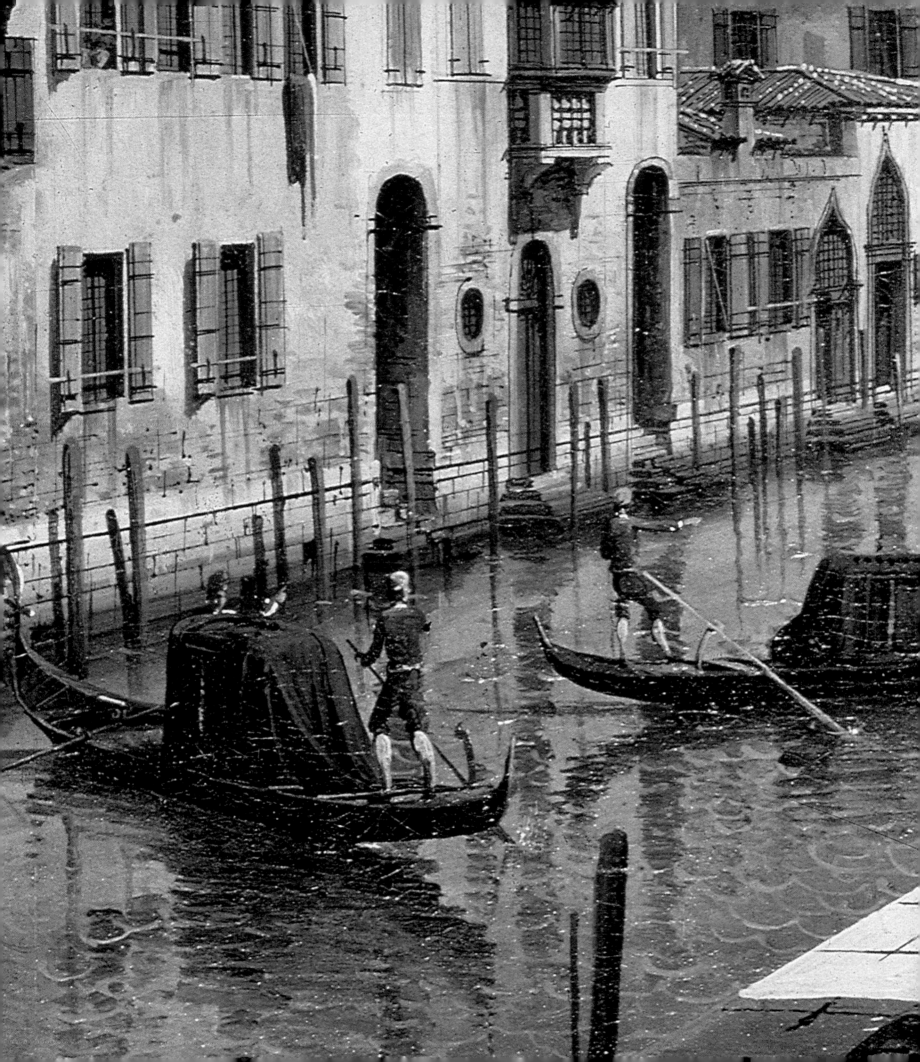

8. *View of the Grand Canal with Santa Maria della Salute from the Campo Santa Maria del Giglio, Venice*

1743-44
Oil on canvas
53 1/4 × 91 1/4 inches
(135.5 × 232.5 cm)
The J. Paul Getty Museum,
Los Angeles

Provenance: William, 2nd Earl of Craven, Combe Abbey, Warwickshire (documented 1831-66); George Grimston, 3rd Earl of Craven (1866-83); William George Robert, 4th Earl of Craven (1883-1921); Cornelia, Duchess of Craven (1921-61), Hamstead Marshall, Berkshire; sale, Sotheby's, London, 29 November 1961, lot 41, bought by Julius H. Weitzner; Robert Lehman, New York; Newhouse Galleries, New York, 1991; from whom purchased by the museum in 1991 (91.PA.73) in exchange for a painting by Canaletto (Links 1998, no. 160*).

Exhibitions: Birmingham 1831, no. 126; Birmingham 1842, no. 58; Manchester 1857, no. 826; London 1863, no. 59.

Bibliography: Waagen 1854, vol. 3, p. 219; Scharf 1857, p. 69; Waagen 1857, p. 69; Combe Abbey 1866, no. 8; Murray 1899, p. 7; Combe Abbey 1909, pp. 794-804; Graves 1913, vol. 1, pp. 144-45; Constable 1962, vol. 2, p. 259, no. 180 (as Canaletto); Pallucchini 1966, p. 324; Goodison and Robertson 1967, vol. 2, p. 14; Puppi 1968, p. 102, no. 134 A; Barry Hannegan in Chicago, Toledo, and Minneapolis 1970-71, p. 54; Kozakiewicz 1972, vol. 2, pp. 13, 419, no. Z 117; Constable and Links 1976, vol. 2, p. 273, no. 180; Nancy Coe Wixom, in Cleveland 1982, p. 318 (as Canaletto); Corboz 1985, vol. 2, p. 634, P 234; Constable and Links 1989, vol. 2, p. 273, no. 180; Boucher 1991, p. 1 (as "the last major large-scale painting by Canaletto to have been on the market"); Los An-

geles 1992, p. 151, no. 35 (as Canaletto); Kowalczyk 1995a, p. 443, no. 163; Kowalczyk 1996a, vol. 2, pp. 18-19, no. 35; Kowalczyk 1996b, pp. 83, 89; Jaffé 1997, p. 38, no. 19 (as Bellotto, c. 1740); Los Angeles 1997, p. 38 (as Bellotto); Links 1998, p. 19, no. 180.

Bellotto's view looks toward the opening of the Grand Canal onto a distant vista that includes the Riva degli Schiavoni and the Bacino di San Marco. In the left foreground, the façade of the Palazzo Pisani-Gritti presents an elegant backdrop to the mundane activities of the *campo* bank. Across the canal, the façade of the Abbey of San Gregorio rises above a row of houses. The view of the opposite bank is dominated one of the most imposing architectural landmarks of Venice, by Baldassare Longhena's (1596-1682) church of Santa Maria della Salute, built in thanksgiving for the deliverance of the city from the plague of 1630. To the left of the church are the Seminario Patriarcale and the Dogana, the marine customs house. The bell tower and dome of San Giorgio Maggiore can be seen rising above the Dogana.

In an account of his visit to Combe Abbey, Warwickshire, in 1768, Horace Walpole made no mention of the painting nor of the view also thought to be by Canaletto and usually considered its pendant, the *View of the Piazza di San Marco looking Southwest* (Cleveland Museum of Art).[1] Neither Thomas Pennant nor the anonymous author of *Beauties of England and Wales* who, at the end of his tour of the house in 1814, observed: "The above are the rooms usually submitted to the inspection of the curious. The more private appartements are, likewise, uniformly adorned by productions of the noble art".[2] Only George

Scharf in 1853 and, a year later, Gustave Waagen, who informs us that he organized his visit very carefully and was given the opportunity of seeing the "two Canalettos" among other paintings at Combe Abbey, cited the works. (Both paintings had, however, previously been shown in exhibitions at Birmingham by William, the 2nd Earl of Craven.) When the Combe Abbey views appeared at Sotheby's in 1961 (as by Canaletto), the differences between the two paintings were markedly noted by one anonymous observer who hailed enthusiastically the view of the Grand Canal as "a vigorous vision of a busy city … with a marked sense of composition," but thought Canaletto in the view of the Piazza di San Marco to have "dallied over one of his impeccable representations that verge on stereotyped painting".[3] At the sale, the Los Angeles painting brought £40,000, the Cleveland view £25,000. The view of the Piazza di San Marco in Cleveland has been accepted for some time as the work of Bernardo Bellotto[4], while the painting now in Los Angeles, in spite of doubt having been cast on Canaletto's authorship as early as 1967 in a catalogue of paintings in the Fitzwilliam Museum, Cambridge, which defined it as a "workshop" painting[5], has nonetheless persistently been attributed to Canaletto because of its exceptional quality and differences in style and handling from the pendant. As recently as 1998, J.G. Links listed the Getty Museum painting as by Canaletto, although he revised its date of execution from the early 1730s to "a period when Bellotto was active in the studio".[6]

The explanation for the difference between the Los Angeles and Cleveland paintings seems to be that they were done at different moments and that work-

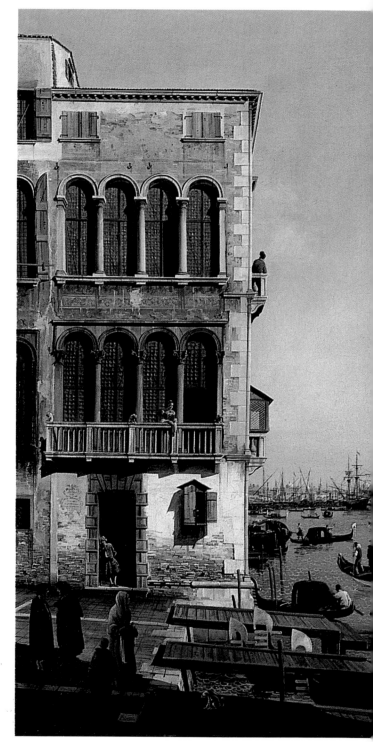

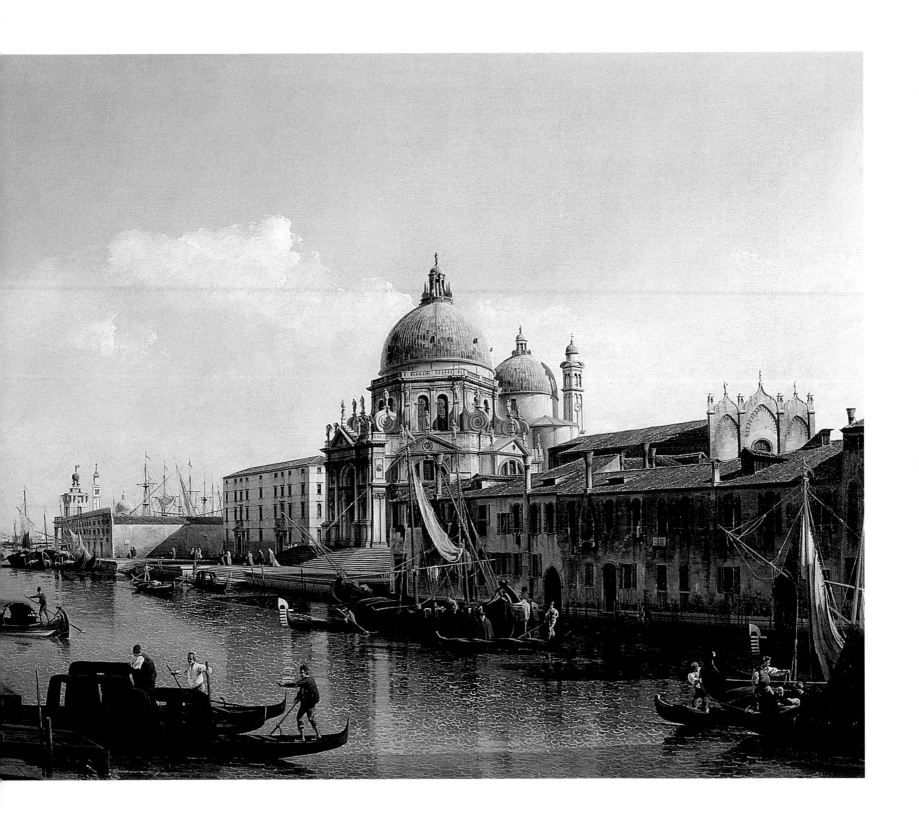

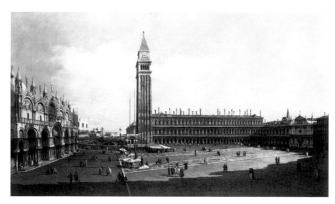

Bernardo Bellotto, View of the Piazza di San Marco looking Southwest
(The Cleveland Museum of Art, Leonard C. Hanna, Jr., Fund)

Bernardo Bellotto, View of the Grand Canal with Santa Maria della Salute from the Campo Santa Maria del Giglio *(Hessisches Landesmuseum, Darmstadt)*

shop intervention has affected each in varying degrees. The canvases were probably the largest the artist had undertaken to date and the results are uneven. There are precedents in Canaletto's work for such a situation: two large canvases by the older artist painted for the Conte di Colloredo, a view of the Grand Canal looking Northeast from near the Palazzo Corner-Spinelli to the Rialto Bridge (Gemäldegalerie Alte Meister, Dresden) and a pendant view of the Bacino di San Marco with Count Colloredo entering the Doge's Palace (National Trust, Upton House, Warwickshire), are also quite different with respect to style and composition.[7] The subjects of the Los Angeles and Cleveland paintings were

first undertaken by Bellotto in a smaller format in the *Grand Canal with Santa Maria della Salute from the Campo Santa Maria del Giglio* in the Fitzwilliam Museum, Cambridge, one of seven Venetian paintings identified by Stefan Kozakiewicz as by the artist, and in *Saint Mark's Square Looking Towards the Procuratie Nuove,* formerly in the collection of Captain Cecil Samuel, more or less the same size as the Cambridge canvas and the immediate predecessor of the Cleveland version; although indisputably by Bellotto, the latter remains attributed to Canaletto.[8]
Both compositions were prepared on the basis of autograph drawings that came from the artist's estate: the view of the Pi-

azza di San Marco was preceded by sketches now in the Rijksmuseum, Amsterdam, and in the Hessisches Landesmuseum, Darmstadt[9]; that of the Grand Canal with Santa Maria della Salute from the Campo Santa Maria del Giglio was carefully prepared on the basis of another sheet at Darmstadt, a precise study of light and shade executed in 1740-41.[10]
The details of the drawing match the Los Angeles painting closely and every element has been faithfully transferred to the canvas. But other, smaller, autograph versions of this view – the Fitwilliam Museum painting and two others, completed later, probably in 1743-44, formerly owned by Otto Hirsch, Frankfurt, and Mrs. J. A. Stewart, respectively[11]– also reproduce the composition accurately with differences in the position of the boats, figures and other details. The Grand Canal is depicted as wider in the painting than in the drawing – the wall beside the monastery of the Somaschi monks (now a seminary, the Seminario Patriarcale) is longer. The view of the Riva degli Schiavoni is much more distant in the painting and rendered unusually atmospheric; the clear, transparent water is shot through with subtly applied reflections and shadows, partly following the drawing but with a lighter touch that does not appear in any of the other versions of the composition.
The only version of the Grand Canal composition by Canaletto, formerly owned by Commander David Heber-Percy, and in the Fitzwilliam Museum, Cambridge, since 1992,[12] is probably later than Bellotto's version in the Fitzwilliam; the figures and boats are arranged differently, but in its elongated format and in the proportions of the water, sky and buildings it is closer to the Los Angeles painting than to

other compositions by Bellotto. The Fitzwilliam stands out from the others for its delicate light, greatly simplified areas of chiaroscuro, and the pictorial elements, always very complicated and complex in Bellotto's work. The church of Santa Maria della Salute appeared in Canaletto's repertory right from the start of his career. It was not, however, until he was working with Bellotto that he decided to paint the church from the Campo Santa Maria del Giglio, from the same perspective as the print by Luca Carlevaris,[13] but also including an accurate glimpse of a portion of the side of the Palazzo Pisani-Gritti and the campo before it. The composition was very successful among the Venetian *vedutisti* and the same view was adopted by various artists over the years including Francesco Albotto and the Master of the Langmatt Foundation.[14] The inspiration for these artists was definitely the painting by Bellotto in Cambridge, which must have belonged in a Venetian collection in the eighteenth century. The view in the Museo del Settecento Veneziano, Cà Rezzonico,[15] has more in common with the Darmstadt drawing than the Los Angeles painting, indicating the closeness of this modest unknown *vedutista* to the Canaletto-Bellotto workshop. Another version, sold at Sotheby's, London, 15 December 2000 (lot 90), with its pendant view of the Molo and the Riva degli Schiavoni with the Doge's Palace, stylistically difficult to place because of the poor state of conservation, is so similar to the view of the Grand Canal from Ca' Rezzonico to the Palazzo Balbi, in the Musée des Beaux Arts, Lyons[16], that the possibility that it may also be by Bellotto should not be excluded.
The exceptional size of the two paintings from Combe Abbey did not allow the artist to

achieve either the compositional unity of the two Turin views of 1745 (cat. nos. 33, 34) or the charming atmosphere of the views of Verona at Powis Castle (cat. no. 37) and on loan to the National Gallery of Edinburgh.[17] The faithfulness to the drawings made between 1738 and 1741, the repetition of the distribution of light and shade, and the indecisiveness regarding the choice of figures (in the Los Angeles painting Bellotto has used at least three different figural "types", which differ from those in the Cleveland pendant), combined with masterful interpretation and descriptive maturity, suggest a date for the painting after the artist's visit to Rome and shortly before his departure for Lombardy in 1743-44. The pendant view of the Piazza di San Marco could have been executed between 1742 and 1743. The barely visible bronze gate of the Loggetta fixes the earliest date as 1742, the year in which the gate was erected by Antonio Gai, and even though there is a certain coldness about the work as a whole, there are also details of great artistry: some of the figures in the foreground, such as the group of gentlemen wearing tricorne hats, have been executed with a very sure hand, and are already similar to the figures in the Turin and Dresden *vedute.* The crowd surrounding the puppet-theatre, those in the Piazzetta, and the distant figures in the gondolas are just black outlines, as in the view of Dolo (cat. no. 12), which probably dates from the beginning of 1743.
Bellotto was attracted by a variety of picturesque details in the façade of the Palazzo Pisani-Gritti, which he emphasized in the Los Angeles painting. These include the two rows of sixteenth-century mullioned windows, the panes sparkling with reflected light, the colored frieze on the façade, the street tabernacle, the

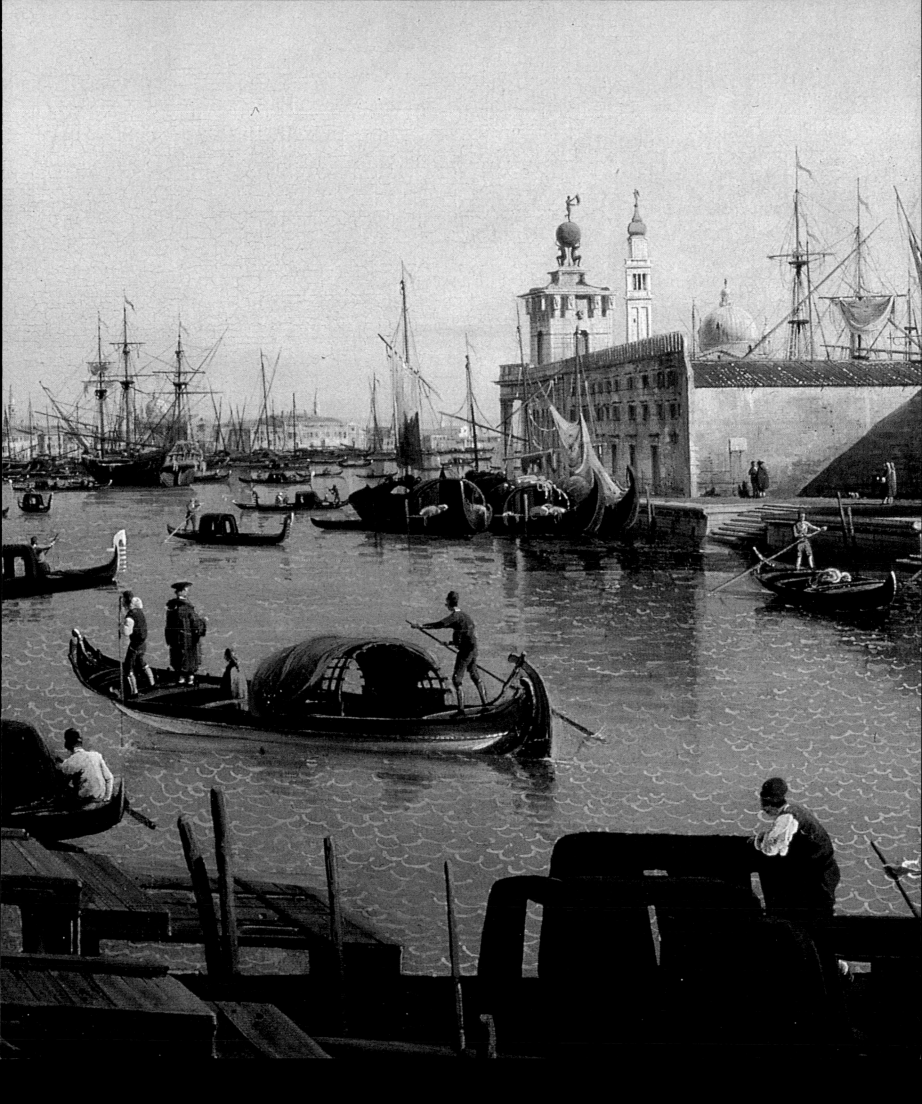

Bernardo Bellotto, View of the Piazza di San Marco looking Southwest *(detail; The Cleveland Museum of Art, Leonard C. Hanna, Jr., Fund)*

Bernardo Bellotto, View of the Grand Canal with Santa Maria della Salute from the Campo Santa Maria del Giglio *(formerly Mrs. J. A. Stewart, New York)*

placard on the wall, rough-hewn stones, and decorative brickwork. Canaletto, on the contrary, softened the impact of the light and shade and paid less attention to the windows of the palace in his version of the composition. The representation of the palace

is almost identical to that in the Fitzwilliam Museum painting and in the Darmstadt drawing, but the façade appears taller – the door is higher, the space between the two floors has been increased, making the floral decoration of the frieze more visible (the goth-

ic façade on the Grand Canal was once decorated with frescoes by Giorgione [1476/8–1510]), the mullioned windows are narrower, making them more imposing (compared with the height of the maidservant); the little tabernacle, as in the drawing, has one shutter open throwing a prominent shadow onto the white stuccoed wall; the form of the notice, which has an ill-defined border in all the other versions (and is not included at all in Canaletto's views of the site), is drawn here with precision – two superimposed ovals, surmounted by two eagles side by side – but its meaning has not been determined.

In several details the church of the Salute matches the Darmstadt drawing better, whereas in others it corresponds to the Fitzwilliam Museum work. But the marvellous sculptural quality of this Baroque church, the clear and accurate depiction of every architectural detail, the strong contrasts of chiaroscuro ranging from strong sunlight to deep shadow, anticipate similar elements in Bellotto's Dresden views such as the Frauenkirche (cat. no. 48). The old convent of San Gregorio (now altered by the Palazzo Cenedese built in the nineteenth century) provides the artist with an opportunity to represent aged and damp walls in shadow by applying overlapping brushstrokes of browns, greys, oranges, and very narrow incisions to mark the window ledges. The figural types and the manner in which Bellotto painted them vary considerably in the Getty painting. This exhibition affords a unique opportunity to study and compare the painting alongside other autograph works. The charming maid and the elegant young man at the door – very dashing in his white wig and grey-blue coat with shiny buttons, left open to reveal his red breeeches – correspond to the sort of figures Bellotto was

doing after his visit to Rome. The changes are more pronounced in these figures than in those of the gondoliers (the one in the center, while highly realistic, recalls the figures in the two views of Florence in the Beit collection, Russborough[18]), and the heavy stocky quite unrealistic figures close to the *traghetto*, which are not typical of Bellotto's types, are found in only one of the paintings in the Mills collection, Ringwood, Hampshire, a view of the entrance to the Grand Canal with the Salute.[19]

Other figures – the paunchy man in the boat on the right, the one in the adjacent *sandalo*, and the gondolier in the center balancing on the gondola, turn up again with much the same faces, body types, and color of clothing in Canaletto's *Canal Grande con San Simeone Piccolo* in the National Gallery, London.[20] This suggests that they were done from the same drawings, such as those in the Kupferstichkabinett, Berlin,[21] and perhaps also that both artists worked on these paintings at the same time, thus supporting the idea that Canaletto's masterpiece in London is the pendant of the *Entrance to the Canal Grande with Santa Maria della Salute*, painted for Joseph Smith, and signed and dated 1744.[22]

Bożena Anna Kowalczyk

I am very grateful to Dawson Carr, Jennifer Helvey, and Jean Linn for sending me a complete bibliography of the painting, containing interesting information, which could not be added at the page-proof stage. In particular, I would like to mention George Scharf's (1857) comments on the Manchester exhibition, in which two Canalettos from Combe Abbey were shown. He noted that "Lord Craven still holds the painter's receipt for two of the Venetian scenes (826 and 827) given to his ancestor". There was also another, smaller Venetian view of the Rialto bridge in the Combe Abbey

collection that is mentioned in the 1866 inventory. For the citation of additional inventories of Combe Abbey, see the Italian-language catalogue of this exhibition, *Bernardo Bellotto 1722-1780*, Venice, 2001, pp. 64-68.

[1] Walpole 1868, p. 63. For the pendant, see Constable and Links 1989, vol. 2, no. 53, and Cleveland 1982, pp. 316-18.
[2] Pennant 1783, pp. 181-89; *Beauties of England and Wales*, pp. 50-57.
[3] L'*Espresso*, 10 December 1961, p. 27.
[4] Pignatti 1981, pp. 548-49; Chong 1993, p. 8.
[5] See Goodison and Robertson 1967.
[6] Links 1998, p. 19, no. 180.
[7] Constable and Links 1989, nos. 208, 144; see Kowalczyk, in Venice 2001, no. 56.
[8] Kozakiewicz 1972, vol. 2, no. 8; Constable and Links 1989, vol. 2, note on no. 53; sold, Sotheby's, London, 5 July 1989, lot 74.
[9] Kozakiewicz 1972, vol. 2, nos. Z 25, 3.
[10] Kozakiewicz 1972, vol. 2, no. 9.
[11] Kozakiewicz 1972, II, n. 8; Constable and Links 1989, vol. 2, no. 180 (a); sold, Christie's, New York, 11 January 1995, lot 25, as "a newly-recognized work of Bellotto's early maturity datable to c. 1742."
[12] Constable and Links 1989, vol. 2, no 180 (aa).
[13] Carlevaris 1703, no. 5: *Altra veduta della Salute.*
[14] Toledano 1988, V. 15; Succi 1989, no. 41, p. 260.
[15] Kozakiewicz 1972, vol. 2, no. Z 147.
[16] Kozakiewicz 1972, vol. 2, no. 11.
[17] Kozakiewicz 1972, vol. 2, no. 101.
[18] Kozakiewicz 1972, II, nos. 52 and 56.
[19] Constable and Links 1989, vol. 2, no. 147.
[20] Constable and Links 1989, vol. 2, no. 259.
[21] Constable and Links 1989, vol. 2, nos. 837 (1) and (2).
[22] Constable and Links 1989, vol. 2, no. 174; Kowalczyk 1998, p. 81.

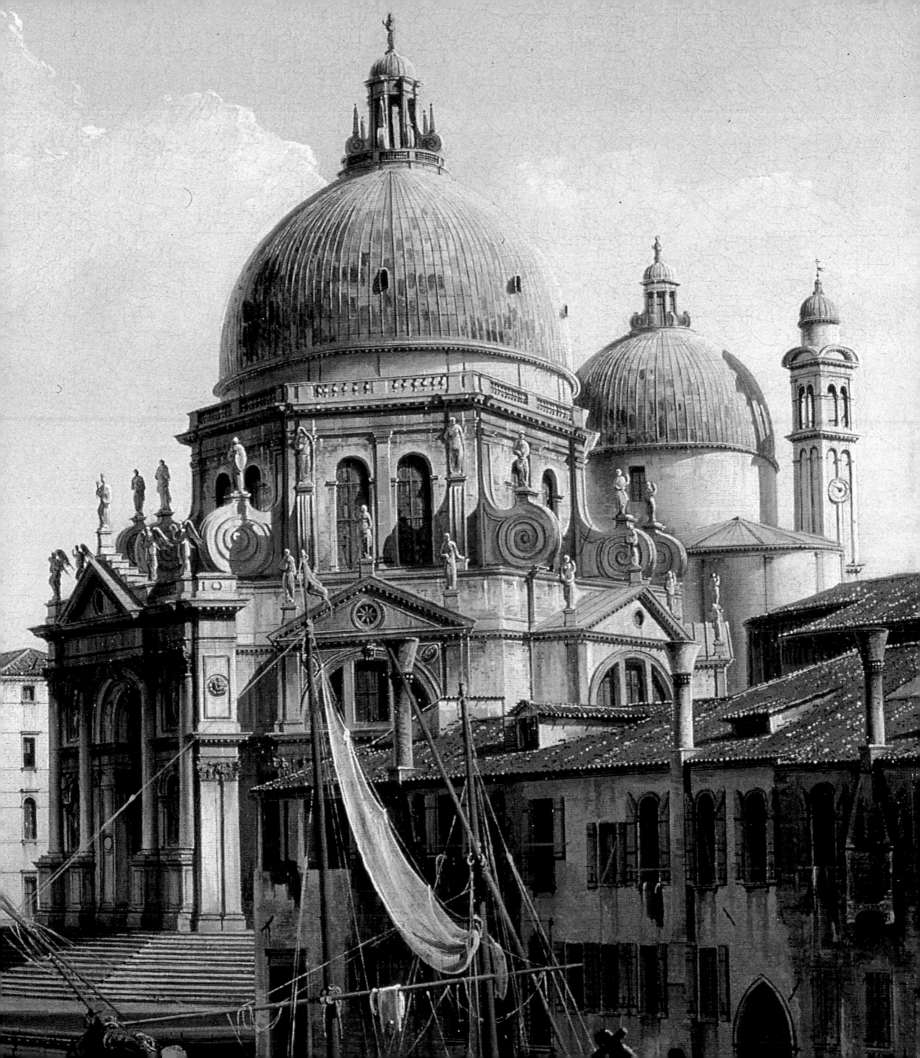

c. 1743
Oil on canvas
59 5/8 × 47 3/4 inches
(151.5 × 121.5 cm)
National Gallery of Canada, Ottawa

Provenance: Bouchier Cleeve, Foots Cray Place, Kent, until 1760; his daughter, Elizabeth Cleeve, who married in 1765 Sir George Yonge, Bt., Foots Cray Place; his sale, White's, London, 24 March 1806, lot 28; John Parker, 2nd Baron Boringdon (later 1st Earl of Morley), Saltram, Devon; thence by family descent; sale, Christie's, London, 1 June 1860, lot 111; Sir John Hardy, 1st Bt., Dunstall Hall, Burton-on-Trent, Staffs.; thence by descent to Major Bertram Hardy; sale, Christie's, London, 1 August 1929, lot 41; Savile Gallery, London; from whom purchased by the museum in 1930 (no. 3719).

Exhibitions: London 1930, no. 1; Ottawa 1931, no. 4; Montreal 1942, no. 120; Detroit and Indianapolis 1952, no. 9; Amsterdam 1953, no. 24; Brussels 1953, no. 23; Toronto, Ottawa, and Montreal 1964-65, no. 27; Winnipeg 1971 (no. cat.); Vancouver 1983, no. 6.

Bibliography: Dodsley 1761, vol. 2, p. 315; Martyn 1766, 1, p. 36; Borenius 1929, pp. 481; Parker 1948, p. 34, under no. 29; Constable 1962, vol. 2, p. 211, no. 272 (as Canaletto); Boggs 1964, pp. 150-51; Pignatti 1966, pp. 222-23, 226-27, 229 (as Bellotto); Pignatti 1967a, pp. 2-3; Pignatti 1967b, pp. 23; Zampetti 1967, no. 85 (note), p. 188; Puppi 1968, p. 122, no. 358; Fredericksen-Zeri 1972, p. 42 (as Canaletto); Kozakiewicz 1972, vol. 1, pp. 65-68, vol. 2, p. 447, Z 261; Levey 1973, pp. 615-16 (as perhaps Canaletto); Links 1973, p. 107; Valcanover 1973, p. 335; Camesasca 1974, p. 88, no. 9; Pignatti 1976, p. 82; Constable and Links 1976, vol. 2, p. 218, under no. 67 (as Canaletto); Young 1977, p. 65; Pignatti 1979, p. 46; Links 1981, p. 56; Corboz 1985, I, p. 390, fig. 393; Pantazzi, in Ottawa 1987, pp. 19-24 (with additional references); Constable and Links 1989, vol. 2, no. 272, p. 325a; Young 1977, p. 107; Binion 1990a, p. 29; Succi 1994, p. 51; Kowalczyk 1995a, pp. 300-301; Kowalczyk 1995b, p. 76; Kowalczyk 1996a, vol. 2, pp. 20-21, no. 36b (1); Kowalczyk 1996b, p. 85; Pallucchini 1996, pp. 494-95; Succi 1999, pp. 23-24, 71.

Of the 103 views of Venice engraved by Luca Carlevaris at the beginning of the eighteenth century, two depict the Arsenale, or shipyard: *Veduta esteriore delle Porte dell'Arsenale* and *Altra Veduta delle Porte dell'Arsenale*.[1] Some decades later, Canaletto, Bellotto, Marieschi and Visentini, followed by still other painters and engravers, took inspiration from these two engravings. Some of the works of art created by these artist were connected with the patronage of Fieldmarshall Johann Matthias von der Shulenburg (1661-1747), the aristocratic German soldier who had gloriously defended the interests of Venice, the Serenissima. He became one of the major art collectors in the city when he purchased eighty paintings from the collection of the last dukes of Mantua in 1724. One of the four marble lions close to the Arsenal gate was erected in 1716 in memory of the conquest of Corfu, in which Schulenburg played a leading role, and a few days after his death, on 1 April 1747, the Senate decided to erect a funerary monument in his memory. It was duly executed by Giovanni Maria Morleiter and placed in the Arsenal courtyard in 1756.[2] When the receipt for "… four

views, two paintings of San Marco and two of the Arsenale" was found among the extensive archives of the Schulenburg with a note indicating "Canaletto's nephew" as the author, Alice Binion connected the paintings with four canvases divided between the National Gallery of Ottawa and the Mills collection, Ringwood, Hampshire.[3] The paintings had generally been accepted as the work of Bellotto following a long- drawn-out critical deliberation that began in 1966 with Terisio Pignatti's pioneering identification of Bellotto as the artist responsible for the four views, an attribution that most experts in Canaletto and Bellotto strongly disagreed with at the time.[4] Now that Bellotto's early career is better documented and understood, the paintings noted in the Schulenberg archives have been traced to the nineteenth-century collection of Baron Fédéric Spitzer. These included two smaller views of San Marco executed in the manner of Canaletto, but already quite distinctive in their handling. The other two, views of the Arsenale, have been lost, but one was probably very similar to the present view and based on the same print by Luca Carlevaris, *Altra Veduta delle Porte dell'Arsenale*.

The reconstruction of the eighteenth-century provenance and history of the Ottawa paintings (cat. nos. 9, 10) by Michael Pantazzi,[5] suggest that they were not painted for a Venetian client. The two paintings are first mentioned in 1760, as works by Canaletto, in the fine collection of Bouchier (or Bourchier) Cleeve (1722-60) of Foots Cray Place, Kent. The collection included *vedute* by Carlevaris and Marieschi, in addition to the famous *Caccia ai tori in Piazza San Marco*, by Canaletto and Giovanni Battista Cimaroli, now in the collection of Peter Jones,

Chester.[6] There is no documentary evidence that Cleeve made a trip to Italy, but it is possible that the two Ottawa views were procured by Joseph Smith, as were the two paintings by Salvador Rosa, *Diogene e Democrito*, now in the Staten Museum for Kunst, Copenhagen, purchased from the Cecilia Grimani Sagredo collection by the English consul before 1752.[7]
The fact that only the two Ottawa views and not the paintings in the Mills collection, Ringwood, found their way into the Cleeve collection may be because they were conceived solely as pendants and not as a series of four as Terisio Pignatti had suggested in 1966. The two views, representative of the political and military power of Venice, executed in a vertical format unusual in Venetian *vedutismo*, were certainly painted as the result of a specific commission. An English commission for a work representing the Campo dell'Arsenale may seem strange, although in 1734-35 Canaletto executed a view of the Porte dell'Arsenale for the Duke of Bedford one of twenty-four views of Venice now at Woburn Abbey.[8] It should be noted that the date of this painting is very close to that of the splendid view of the Riva degli Schiavoni looking toward the East, destined for the Schulenburg collection and purchased in 1736 for 120 gold coins, and now in Sir John Soane's Museum, London.[9] Bouchier Cleeve, a famous financial expert, reveals in a pamphlet published in London in 1756 a strong professional interest in the navy and the merchant navy, thus providing a fascinating insight into his possible motives in obtaining a view of the Arsenal, the seat of the Venetian Republic's naval power.[10]
In the view of the Arsenal, Bellotto reveals a capacity as a *vedutista* to place his art in the ser-

vice of particular political and cultural ideals, as he was to do in his later years at the European courts. The Arsenal, the vast secret shipyard on which the fortunes of the Republic had rested for centuries, lies behind the two entrances: the large, severe monumental gate, erected in the reign of Doge Pasquale Malipiero (1460) by the architect Antonio Gambello and the canal entrance for ships and boats, flanked by two towers and closed off by a gate. Foreigners not allowed to cross this threshold could only marvel at the historic and symbolic significance of the gates of the Arsenal. Bellotto renders the atmosphere of the site superbly. Within an area of deep shadow, he focuses the sunlight on the marble statues, the powerful lions sent from Athens by Francesco Morosini, the Peloponnesian (1687), as symbols of his victory at Morea (as is the tall bronze pylon in the centre, cast by Gianfranco Alberghetti, 1693) and the eight mythological statues, highlighting their beauty and paying much attention to their description so that they appear more real and human than the strangely static figures in the square. The imposing wrought-iron balustrade stands out in marked contrast to the white marble. Between the two towers at the entrance we are given a glimpse of the masts of a ship; the small, picturesque oratory of the Madonna dell'Arsenale (demolished in 1809), with its large windows sparkling in the light and its flaking plaster brings the view back to Venetian dimensions.
No drawings for the composition by Bellotto have survived, nor are there any other autograph paintings extant. All the known views of this site – including the lost Schulenburg canvas – are in horizontal format, including a nineteenth-cen-

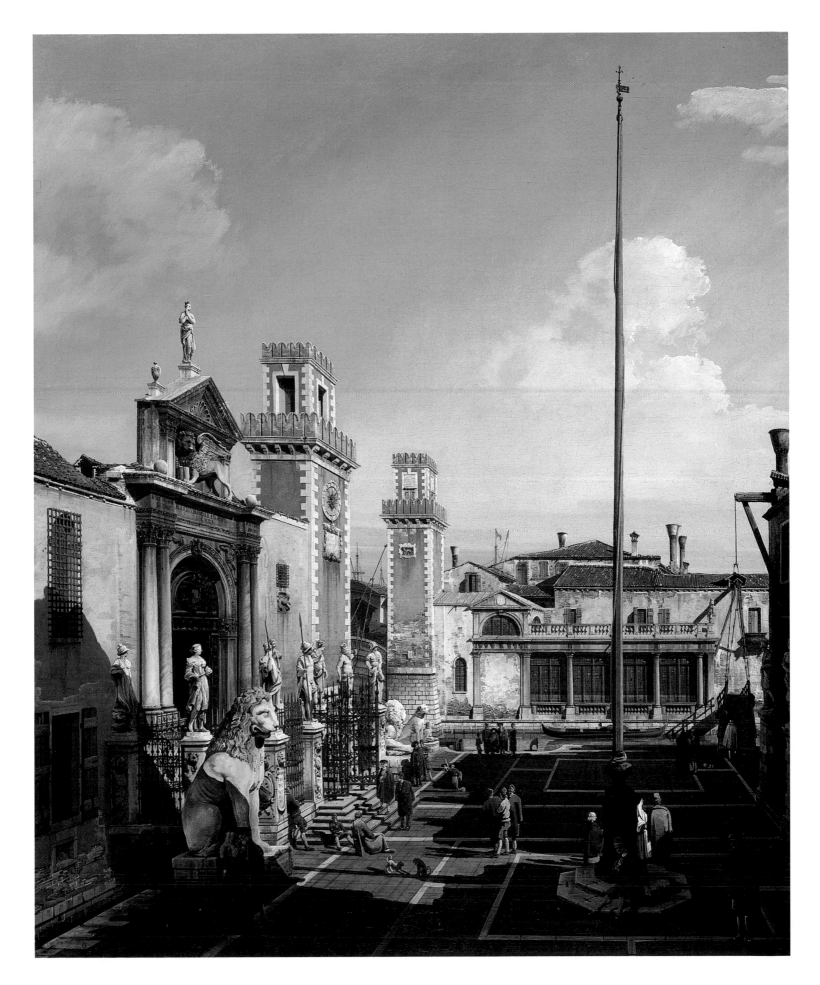

tury copy of the present painting, formerly in the Henry Temple, 2nd Viscount Palmerston, and now in the Museum of Fine Arts, Houston, in which the view has been extended in almost the same way as the print by Michele Marieschi.[11] The Marieschi print, published in 1741, has the addition of a procession in the square and the outline of a ship between the two towers. A similar image of the Arsenale that forms the background to the letter A in the Pasquali edition of *Istoria d'Italia* by Guicciardini of 1738 is also in a square format.[12]

The view of the Porte dell'Arsenale was studied by Canaletto in the sketchbook now in the Gallerie dell'Accademia, Venice, made in preparation for the Woburn Abbey painting and also used in a Windsor Castle drawing with stippling.[13] Bellotto was familiar with both the previous engravings of the site as well as Canaletto's drawings, as the drawings in the Hessisches Landesmuseum, Darmstadt, and the Custodia Fondation, Paris, reveal, although the latter is thought to be by Canaletto.[14]

The Ottawa paintings are exceptional in the repertory of Bellotto's early work for the determination and courage with which the artist undertakes such innovative compositions complete with large figures; painting on a grand scale, with the architectural features in the foreground and the surface of the walls seen at close quarters. The challenges of depicting restricted city squares, dominated by imposing architecture, such as the Campo dell'Arsenale, were present in the Dresden commissions of the views of the Frauenkirche and again in the views of Viennese.[15] Large architectural elements in the foreground appear also in the architectural capriccio in the Galleria Nazionale di Parma (cat. no. 35).

The date of 1740-42 suggested by Terisio Pignatti for the Ottawa canvases was advanced to 1743 by Michael Pantazzi, citing the similarities with the two Roman views, *The Porta Santo Spirito* and *The Arch of Titus* (cat. nos. 22, 23), dated 1742-44 by Kozakiewicz.[16] In these views, as in *Santa Maria d'Aracoeli and the Capitol* at Petworth House (cat. no. 20), finished before the summer of 1743, the artist employs the same compositional means of dramatic areas of deep shadow in the foreground to impart greater relief to the areas in the light. The elongated, melancholy-looking figures inhabiting the campo were executed using the same technique used for the figures in *the View of Dolo on the Brenta* (cat. no. 12): dots of pure colour, dry parallel brushstrokes, clear-cut edges on the clothing, faces rendered with touches of black.

Bożena Anna Kowalczyk

[1] Carlevaris 1703-4, nos. 62, 63.
[2] Livan 1742, p. 21, with the date 20 aprile 1756.
[3] Binion 1990a, pp. 119-120; Binion 1990b, pp. 27-29; for the paintings in the Mills collection, see Constable and Links 1989, vol. 2, nos. 56 and 147.
[4] See especially the references to Constable, Links, Kozakiewicz, and Levey cited above.
[5] Pantazzi, in Ottawa 1987, pp. 19-24.
[6] Watson 1953, p. 206; Constable and Links 1989, vol. 2, no. 361.
[7] Pantazzi 1987, p. 20.
[8] Constable and Links 1989, vol. 2, no. 271.
[9] Constable and Links 1989, vol. 2, no. 122; Binion 1999b, p. 29.
[10] The title of the booklet is *His Majesty's Royal Bounty: or, a Scheme for keeping in his Majesty's Service such number of Seamen, that upon the breaking out of a War, or when Required for any particular Service* (London, 1756), and the first line reads: "As nothing tends so much to the Good of these Kingdoms as the Encouragement of our Navigation…"
[11] Constable and Links 1989, vol. 2, no. 273; Links 1998, no. 273.
[12] It is not known to which of the two engravings by Carlevaris the painting mentioned by Waagen as in the William Roscoe collection, Liverpool, corresponds ("The entrance to the Arsenal at Venice, with the lions"), described by him as "… a good picture by Bernardo Bellotto, and not by Canaletto;"Waagen 1954, III, p. 240.
[13] Nepi Scirè 1997, pp. 109-13; Parker 1948, no. 29.
[14] Kozakiewicz 1972, II, no. 27; C/L 603, note.
[15] Kozakiewicz 1972, II, n. 179.
[16] Kozakiewicz 1972, II, nos. 72 and 74.

10. *View of the Piazzetta looking toward San Marco, Venice*

c. 1743
Oil on canvas
59 1/2 × 48 inches
(151 × 122 cm)
National Gallery of Canada,
Ottawa

Provenance: Bouchier Cleeve, Foots Cray Place, Kent, until 1760; his daughter, Elizabeth Cleeve, who married in 1765 Sir George Yonge, Bt., Foots Cray Place; his sale, White's, London, 24 March 1806, lot 29; John Parker, 2nd Baron Boringdon (later 1st Earl of Morley), Saltram, Devon; thence by family descent; sale, Christie's, London, 1 June 1860, lot 112; Sir John Hardy, 1st Bt., Dunstall Hall, Burton-on-Trent, Staffs.; thence by descent to Major Bertram Hardy; sale, Christie's, London, 1 August 1929, lot 42; Savile Gallery, London; from whom purchased by the museum in 1930 (no. 3720).

Exhibitions: London 1930, no. 2; Ottawa 1931, no. 5; Toronto a1937, no. 26; Toronto 1944, no. 1; Detroit and Indianapolis 1952, no. 8; Toronto, Ottawa, and Montreal 1964-65, no. 26; Venice 1967, no. 85 (as Bellotto).

Bibliography: Dodsley 1761, vol. 2, p. 313; Martyn 1766, 1, p. 36; Borenius 1929, p. 481; Constable 1962, vol. 2, p. 211, under no. 67 (as Canaletto); Boggs 1964, pp. 150-151; Pignatti 1966, pp. 222-23, 226-27, 229 (as Bellotto); Pignatti 1967a, pp. 2-3; Pignatti 1967b, pp. 23 (as Bellotto); Links 1967, p. 457; Puppi 1968, p. 122, no. 359; Fredericksen-Zeri 1972, p. 42 (as Canaletto); Kozakiewicz 1972, vol. 1, pp. 65-68, vol. 2, p. 404, no. Z 241 (as Canaletto); Levey 1973, pp. 615-16 (as perhaps Canaletto); Links 1973, p. 107; Valcanover 1973, p. 335 (as Bellotto); Camesasca 1974, p. 88, no. 9; Pignatti 1976, p. 82; Constable and Links 1976, vol.

2, p. 218, under no. 67 (as Canaletto); Young 1977, p. 65; Pignatti 1979, p. 46; Links 1981, p. 56; Corboz 1985, vol. 1, p. 390, fig. 393; Pantazzi, in Ottawa 1987, pp. 19-24 (with additional references); Constable and Links 1989, vol. 2, no. 272, p. 325; Young 1977, p. 65; Binion 1990a, p. 29; Succi 1994, p. 51; Kowalczyk 1995a, pp. 300-301; Kowalczyk 1995b, p. 76; Kowalczyk 1996a, vol. 2, pp. 20-21, no. 36b (2); Kowalczyk 1996b, p. 85; Pallucchini 1996, pp. 494-95; Succi 1999, pp. 23-24, 71.

This view of the Piazzetta is unique in the repertory of Venetian eighteenth-century view painting. The vertical elements of Saint Mark's Column in the foreground, the corner of the Doge's Palace, and the Campanile, powerfully dominate this majestic scene. Both in its originality and in its connections to Canaletto's visual repertory, the painting represents the high point in the collaboration between the two artists. Bellotto knew Canaletto's views from the Molo looking towards the Procuratie Vecchie and the Clocktower, all rendered markedly horizontal and panoramic by the absence of Saint Mark's Columns. Among the very few Canaletto drawings kept by the younger artist is the perspective sketch without figures for the Woburn Abbey painting, dated July 1732, now in the Hessisches Landesmuseum in Darmstadt;[1] there are no known versions of this view by Bellotto. Canaletto painted a similar view in the early 1740s, now in the Norton Simon Museum of Art.[2] But only one painting in the series of four *vedute* of San Marco executed for Joseph Smith and engraved by Antonio Visentini, signed and dated 24 October 1743, now in the royal collections of Wind-

Canaletto, The Piazzetta looking toward the Procuratie Vecchie and the Torre dell'Orologio
(The Royal Collection, Windsor Castle)

sor Castle[3], is similar to the Ottawa painting with regard to the direction of the fall of light and the vantage point. The light falls from the opposite direction in the other works, and the view was taken from opposite the corner of the Doge's Palace in order to portray the portico, the row of arches alternating with the shadows of the pilasters, in all its length. This unusually artful effect emphasizes the connection between the two paintings that were perhaps derived from the same drawings or diagrammatic sketches.[4]
Saint Mark's column appears in Canaletto's painting, but positioned further left, and although he alters and "adjusts" the real view, as the view painters were in the habit of doing, he includes the side of the church and the Clocktower exactly as they appear seen from the viewpoint of the Molo. In order to fit the view into the vertical format, Bellotto's composition eliminates a large section of the square, bringing the Doge's Palace closer to the

Campanile. Only the very long, slightly slanting shadow of Saint Mark's column alludes to a continuation of the view.
Similar connections and changes suggest the two paintings were done at the same time, as suggested by Michael Pantazzi.[5]
There is a sketch in black chalk of the side of the church, as it appears in the Windsor Castle painting by Canaletto, on the verso of one of Bellotto's sheets that was later used for a Lombard drawing, *Mulino ad acqua e ponte*, private collection.[6] The principal figures in this painting also derive from drawings by Bellotto. The central group around the birdcages was the subject of a study in one of the sheets in the series attributed to Canaletto, but undoubtedly by the younger artist[7], and the young servant carrying two baskets is identical to a figure that appears in one of Bellotto's Roman *vedute*, *Trinità dei Monti e la scalinata di Spagna*, current whereabouts unknown.[8] There is an insistent quality, unusual in Canaletto, about the lozenge-

shaped decoration of the Doge's Palace, very similar to Bellotto's method of painting, and exactly like this Ottawa view. In this exchange of reciprocal influences the figures in the Ottawa painting are particularly revealing of the way the two artists influenced each other: the gentleman with the tricorne hat and the man in Eastern dress are identical to figures Canaletto placed in the view of the *Molo con la colonna di San Teodoro*, formerly owned by Albertini, now in the Castello Sforzesco in Milan[9], definitely earlier than 1742, because it was engraved by Antonio Visentini in the series for the *Prospectus Magni Canalis Venetiarum* (*Pars Secunda*, 12). A similar silhouette of a gentleman was to appear in the *Mercato Nuovo di Dresda visto dalla Moritzstrasse* in the Gemäldegalerie of Dresden (cat. no. 48), while the two figures on the right were to be reused in the *Piazza del Mercato di Pirna* in the Gemäldegalerie Alte Meister, Dresden, and in all its versions (cat. no. 56), as in the

Venice

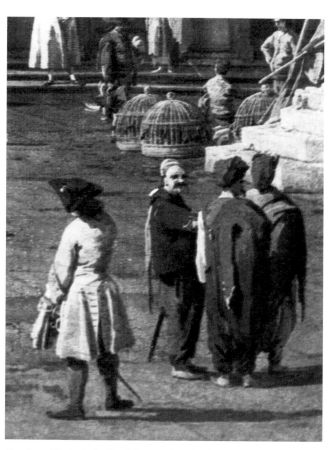

Canaletto, The Molo looking West, *Venice, (detail; Collezioni Civiche d'Arte, Milan)*

cold light that highlights the power of the architecture, and the solidity of the figures combine to create a painting that is not unlike the views of Turin done in 1745 (cat. nos. 33, 34).

Bożena Anna Kowalczyk

[1] Constable and Links 1989, vol. 2, nos. 64, 551.
[2] Constable and Links 1989, vol. 2, no. 66.
[3] Constable and Links 1989, vol. 2, no. 68.
[4] Pantazzi, in Ottawa 1987, pp. 23-24.
[5] Pantazzi, in Ottawa 1987, pp. 23-24.
[6] Constable and Links 1989, vol. 2 no. 712; sale, Sotheby's, 5 July 2000, lot 67.
[7] Constable and Links 1989, vol. 2, no. 840**; see my essay in this catalogue, p11.
[8] Kozakiewicz 1972, vol. 2, no. 81.
[9] Constable and Links 1989, vol. 2, no. 95.
[10] Kozakiewicz 1972, vol. 2, no. 216; Pantazzi, in Ottawa 1987, p. 24.
[11] Pignatti 1966.
[12] 1987, p. 24.

preparatory drawing in the National Museum of Warsaw.[10]

The two Ottawa paintings were recognized as Bellotto's work by Terisio Pignatti and considered part of a series of four, including the two views in the collection of Major J. Mills, Ringwood, Hampshire.[11] The evident differences in the proportions of the architectural elements and figures and in the compositions themselves – the Ottawa ones are highly innovative, the Mills ones inspired by the canvases executed by Canaletto for Joseph Smith in the first half of the 1720s – could, according to Terisio Pignatti, be put down to the difficulties of an emerging artist, while for Michael Pantazzi it pointed out the separate eighteenth-century history of the two pairs.[12] The Mills paintings also differ in their stylistic results and they do not have the same compositional tension. The two Ottawa paintings have the characteristics of Bellotto's style just before he left Canaletto's workshop – still a profoundly "Canalettian" technique, but interpreted with subtlety: the double parallel lines incised between the pilaster strips in the campanile to enhance the representation of the walls are identical to the lines Canaletto normally used, and the distinctive narrow brushstrokes outlining the marble slabs above the arches of the Doge's Palace to make them seem thicker. The crystal-clear quality of the description, the way every detail stands out, the

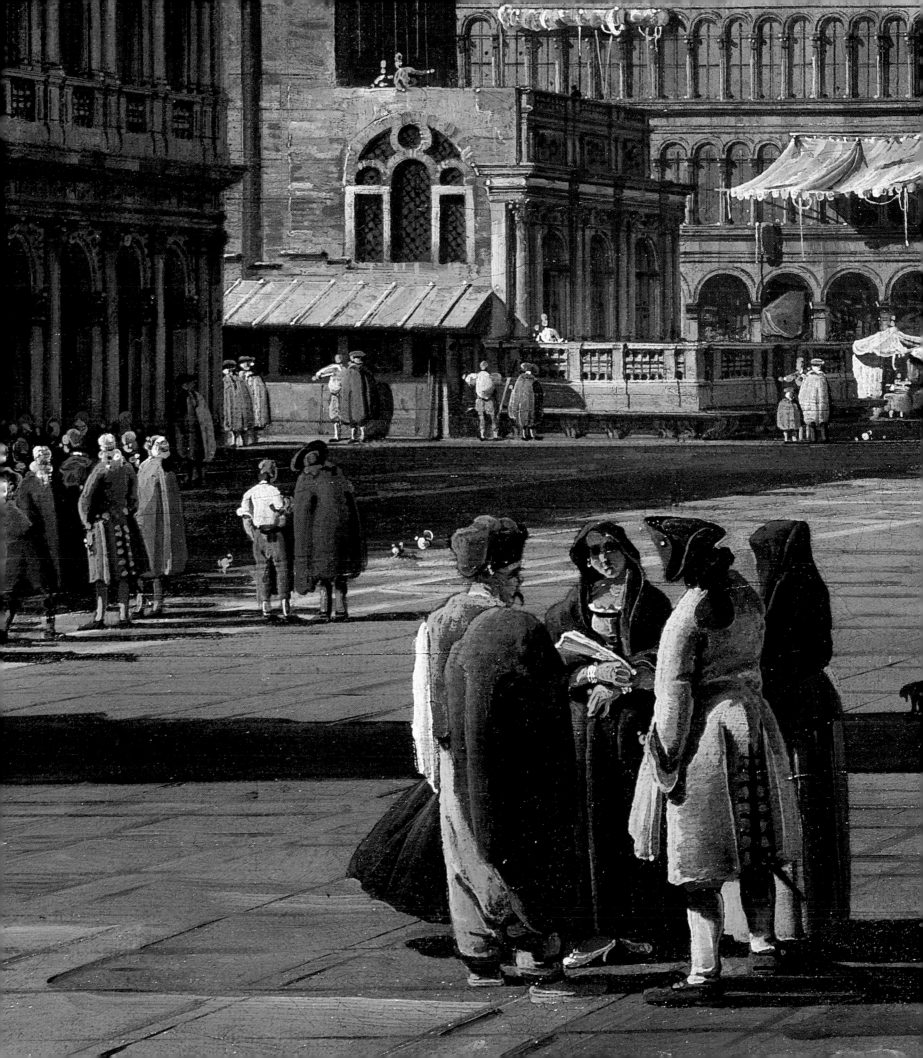

c. 1740
Oil on canvas
29 1/4 × 50 3/4 inches
(74.3 × 128.8 cm)
Private collection

Provenance: Edmund Higginson (née Barneby; 1802-71), Saltmarshe, Herefordshire, England; purchased in 1860 by Col. the Hon. Edward Gordon Douglas Pennant (1800-86), later 1st Baron Penrhyn of Llandegai, Penrhyn Castle, Gwynedd, Wales, and thence by inheritance.

Bibliography: Douglas Pennant 1902, no. 31.

This view shows a stretch of the Grand Canal particularly rich in Baroque and Neo-Palladian buildings. On the right is Domenico Rossi's (1678-1742) sparkling white facade of 1709-10 of the newly rebuilt church of Sant' Eustachio, known in Venetian dialect as San Stae, surmounted by the sculptor Antonio Corradini's (1668-1752) statues of the Redeemer, Faith, and Hope. Against its far flank is the small Scuola dei Tiraoro e Battiloro (the guild of the gold drawers and beaters) of 1711, and beyond the Palazzo Coccina Giunti Foscarini Giovanelli is the magnificent Baroque facade of Baldassare Longhena's (1596-1682) Ca' Pesaro, begun in 1652 and now site of the Gallery of Modern Art. The painting only hints at the presence of two small houses which separate this from the Palazzo Corner della Regina (in the depiction of which significant liberties have also been taken), reconstructed in 1724-27 by the same Domenico Rossi and clearly intended to rival the Ca' Pesaro, then nearing completion. The view stretches beyond to the Fabbriche Nuove di Rialto.
The subject was treated by Canaletto in two paintings measuring approximately 18 1/2 ×

30 5/8 inches (47 × 78 cm) and datable to the second half of the 1730s. One, now in a London private collection, is from the series of twenty once owned by Sir Robert Grenville Harvey of Langley Park, Slough.[1] The other, sold at Christie's, London, 4 July 1997 (lot 120) and now in an American private collection, is of a slightly later date and is that engraved by Antonio Visentini for the 1742 edition of the *Prospectus Magni Canalis Venetiarum*.[2] In this the viewpoint is raised from that of a man standing in a gondola to a level perhaps eighteen feet above the water level, and the foreground boats and figures and the clouds are entirely different.
The exhibited painting, for which Alice Douglas Pennant followed the traditional attribution to Canaletto with the observation "This picture had always been called a Canaletto, but like many works so named is perhaps by his nephew, Belotto [sic]," has since been completely overlooked, its high quality being entirely obscured until recent cleaning. The point of departure is clearly the earlier of Canaletto's two depictions of the view, which it follows quite closely in details such as the two gondola prows in the lower left corner, the poses of the two gondoliers in the left foreground and those of the two others in the moored gondola beyond, as well as, to a degree, in the form of the cloud bank above Ca' Pesaro. The sense of the monumentality of the buildings provided by the low viewpoint is further enhanced by the painting's considerably larger size. It is in no sense, however, a copy, numerous details revealing a fresh examination of the subject. While strongly Canalettesque, and illuminated by the same cold light which characterises Canaletto's style at the end of

the 1730s, the handling is unmistakably Bellotto's.
His is the juicy impasto, the calligraphy of the ripples in the water, the texturing of the brickwork at lower left and right, and the back-lighting of the boats and figures in the left foreground. The use throughout of incising to define the architectural forms and to catch the light, with the verticals carried on down (those marking the verticals of the dominant palazzi almost to the bottom edge) in order to play an important role in defining their reflections as well, is a hallmark of Bellotto's work at this moment in his development. Also characteristic of the artist's style in about 1740 are many of the figure and facial types, the latter with eyes in dark hollows set close together, the rendering of roof tiles in light and dark dots, the almost abstract patterning in horizontal striations of the distant clouds, and the impression that the boats sit on, rather than in, the water. Bellotto's youthfulness is particularly evident in the drawing of the urns in front of the church.
The provenance of the painting is, regrettably, unknown before it entered the collection of Edmund Higginson, one of the finest assembled in Britain in the nineteenth century. It is not recorded in the catalogue of Higginson's pictures published in 1842,[3] nor in the sales of sections of the collection held in 1846 and 1860.[4] There seems no reason to doubt, however, the statement of Alice Douglas Pennant that the work was purchased privately from Higginson by her grandfather, Col. the Hon. Edward Douglas Pennant, later 1st Lord Penrhyn of Llandegai, in 1860, presumably through the great Belgian dealer C. J. Nieuwenhuys, Lord Penrhyn's chief adviser and source of pictures. Also from Higgin-

son Lord Penrhyn acquired a Canaletto view of the Thames and Westminster from near the York Water Gate, which remains at Penrhyn Castle,[5] and a pair of Venetian views sold in 1924 and now in an European private collection, which has recently been attributed to Bellotto.[6] At the Saltmarshe sale of 1860 (lot 23) Nieuwenhuys purchased for Penrhyn another Canaletto which is apparently the impressive view of Piazza di San Marco still in the family collection.[7] Penrhyn's fine group of views was completed by a late Canaletto of the Piazza di San Marco sold in 1924 and now in the collection of Dr. Gustav Rau, and a Bellotto of Campo San Stin which is still at Penrhyn Castle.[8] The provenance of none of these paintings before Higginson and/or Penrhyn is known.
The exhibited painting would seem to have remained in Venice for a time, as a full-size copy recently on the art market shows in the far distance, though subsequently painted over, the campanile of the church of San Bartolomeo in the form which it took in 1754.[9] While that corresponds closely in small details of colour, both it and a smaller copy also recently on the market omit the sculptures on the pediment over the church door and the woman in the window on the far right, and include two additional figures in the right foreground.[10]

Charles Beddington

[1] Constable and Links 1989, vol. 2, p. 309, no. 246.
[2] Constable and Links 1989, vol. 2, p. 309, no. 246(a).
[3] Catalogue 1842.
[4] Christie's, London, 4-6 June 1846 and 16 June 1860. See also, Redford 1888, vol. 1, pp. 136-37.
[5] Douglas Pennant 1902, no. 40; Constable and Links 1989, vol. 2, pp. 417-18, no. 427(a).
[6] Constable and Links 1989, vol. 2,
pp. 232, 292, nos. 95(b) and 219(a); Kozakiewicz 1972, vol. 2, nos. Z 50 and Z 170; Succi, in Mirano 1999, pp. 39-40, figs. 20-1. Constable only gives the Higginson provenance for the second painting of the pair.
[7] Constable and Links 1989, vol. 2, p. 190, no. 9; the identification is stated as fact by Douglas Pennant 1902, no. 76, despite disparities in the size and description.
[8] Constable and Links 1989, vol. 1, p. 193, no. 17; Paris 2000-2001, no. 11, and Douglas Pennant 1902, no. 32, as Bellotto; Constable and Links 1989, vol. 2, p. 330, no. 286, as Canaletto.
[9] Constable and Links 1989, vol. 2, pp. 309-10, no. 246(d), as school of Canaletto; Kozakiewicz 1972, vol. 2, no. Z 213; Sotheby's, New York, 3 November 1983, lot 156, as follower of Canaletto; exhibited New York 1984, no. 28, as Bellotto; Bath 1987, no. 21, as Bellotto; London 1987, no. 13, as Bellotto; Pedrocco 1995, p. 55, colour pl. 66, as Bellotto. I am grateful to Bozena Kowalczyk for pointing out the detail regarding the campanile of San Bartolomeo.
[10] Oil on canvas, 15 × 26 inches (38 × 66 cm); from the collection of The Hon. P. Elliot (nineteenth century); sold (with a pendant) at Wingett's, Wrexham, Clwyd, Wales, 21 February 1990, as attributed to Bellotto, and subsequently with Rafael Valls Ltd, London.

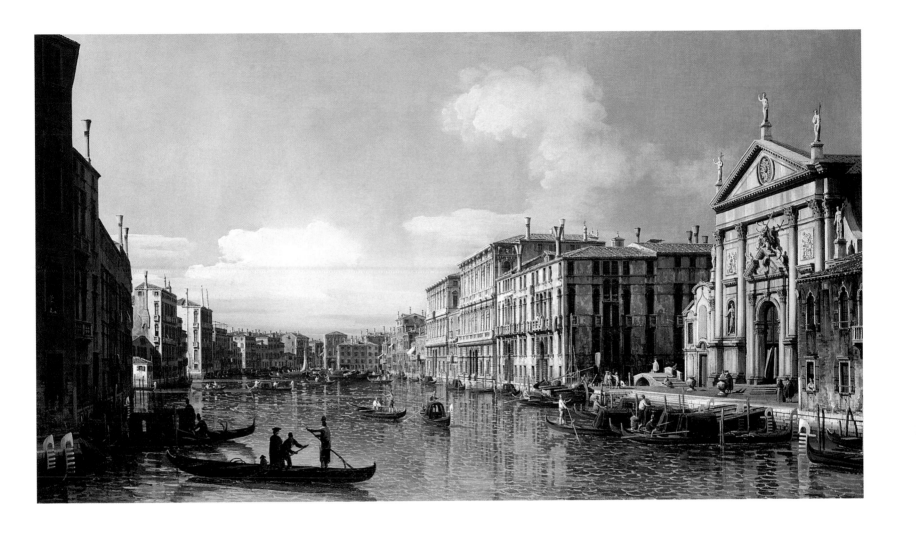

1742-43
Oil on canvas
23 3/4 × 37 1/4 inches
(60.5 × 94.7 cm)
Private collection

Provenance: N.F.D. Smith collection, 3 Grosvenor Place, London, 1899; Viscount Hambleden, Henley-on-Thames.

Exhibitions: London 1899; Bath 1987, no. 22; London 1987, no. 14; Oxford 1993, no. 3; Mira 1996, no. 10.

Bibliography: Watson 1954, p. 16; Constable 1962, vol. 2, p. 355, under no. 371; Kozakiewicz 1972, vol. 1, p. 25, vol. 2, p. 26, no. 29; Constable and Links 1976, vol. 2, p. 381, under no. 371; Links 1978, p. 438; Constable and Links 1989, vol. 2, p. 381, under no. 371; Baetjer and Links, in New York 1989-90, p. 206; Kowalczyk 1996b, vol. 2, p. 15, no. 22; Pedrocco, in 1996, p. 118; Succi 1999, p. 60.

In 1780 a painting described as "*un quadro con pittura rappresentante la veduta del Dolo con Soaza*" was in Venice in the house of Bortoli Filosi in the parish of Santa Maria Mater Domini.[1] There is no way of identifying it, but it is interesting to note that the owner, who had many other *vedute* in his collection, was a malmsey-wine merchant, as was his father, Angelo, before him.[2]
It is not surprising that the Venetian *vedutisti* frequented Dolo so assiduously, testimony of which is to be found in whole series of drawings, engravings and paintings. The small village situated on the Brenta was where the *burchiello* docked; it was a holiday village, a major port of call for river traffic, and a farming and trading centre. From here many roads led inland into the plain and the game-shooting re-

serves along the lagoon; these were much frequented since ancient times owing to the abundance of game there.[3]
Canaletto painted a view of Dolo (Ashmolean Museum, Oxford), in about 1728.[4] Almost fifteen years later he returned to the town in search of subjects for his etchings, including the one in which he depicted the river looking in the other direction, entitled *Al Dolo*, with the mills in the distance, the church of San Rocco (which had been erected in the interim, 1729) and the Palladian villa of Zanon-Bon (previously Andruzzi).[5] This villa, which perhaps had a special significance for the *vedutisti*, was depicted by Bellotto in the background, behind the boatshed, seen from the side, and in the light.
The present view, attributed to Bellotto by Francis Watson in 1954 as an example of his early work, is the only known topographical view by Bellotto of the area, he also executed two later painted *capricci* of the locks at Dolo with elements inspired by Canaletto's print *Le Porte del Dolo*, now in the Yale University Art Gallery, New Haven, and in the Gemäldegalerie Alte Meister, Dresden (cat. no. 44), respectively.[6] Canaletto was to return to the motif of his print at the end of his career, in a painting in the Budapest Museum of Fine Arts.[7]
It is interesting to note that the present view by Bellotto is not connected with the Oxford painting but with a version of the site, formerly in the collection of Walter Dunkels, England, and now in the Staatsgalerie Stuttgart, which has an identical perspective in the left-hand side and depicts an inn close to the moorings for the boats that is absent from the painting in the Ashmolean Museum.[8] The Stuttgart version,

Giovanni Battista Cimaroli (here attributed to), View of Dolo along the Brenta River (Staatsgalerie Stuttgart)

traditionally thought to be by Canaletto, in my opinion, marks the high point in the career of Giovanni Battista Cimaroli (1687-1771), the painter of river-side scenes on the Brenta *par excellence*. His work is recognizable in every detail, in the peculiarly defined leaves of the trees (a particular quirk of the artist's), the description of the houses, the stocky figures (a bit strange-looking as a result of the attempt to make them look like Canaletto's), the unusually fresh joyful atmosphere, and the constrasts of light and shade, cited by Constable as the reason why it was difficult to fit the painting chronologically into Canaletto's oeuvre. The date must be very close to that of the *vedute* Cimaroli painted for Castle Howard;[9] that is, the

early 1740s, by no mere coincidence close to the date of this painting.
Bellotto's interpretation of the site is so personal that it stands out clearly from his previous views. The artist imbues the composition with dramatic potential, in the state of disrepair of the peasants' houses and in the poverty and the shabbiness of the mills, emphasizing it by describing every single detail and using sharp contrasts of light and shadow. He transforms an idyllic image of the countryside frequented by noble tourists into a panoramic view of the village on the banks of the river, dominated by the mills. He accentuates its horizontal extension with the addition of the houses on the right. Here he accomplishes a virtuoso description of the walls,

partly in shadow, with brushstrokes of grey-green, yellow, pale red, and clearly delineated grooved edges. He also lowers the horizon so that the sky takes up more of the canvas than the architectural features; he inverts the direction of the light (a device he often used) in order to explore the cracks in the plaster of the houses on the left, the weeds that are growing on the nearby wall, and to augment, varying the intensity of the light, the depth of the perspective.
Bellotto focuses his descriptive energy on the houses on the weir, shaped by means of the strong contrast of light and shade. He has made a feature of the roofs seen from above, flooded in a silvery light, highlighted with black lines depicting the tiles, illuminated with

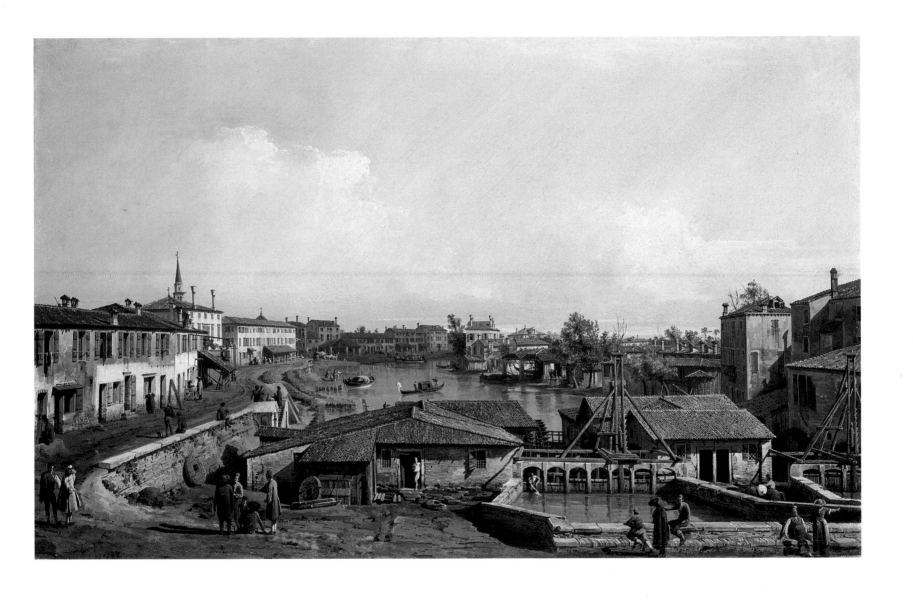

Venice

Canaletto, View of Dolo (Al Dolo), *etching*

points of light and with an infinite range of shades of grey. The figures that are the exactly the same in the Oxford and Stuttgart paintings are different here although arranged in a similar way. Each one is depicted as a solitary figure isolated in his or her own existence, wrapped in an atmosphere that only Bellotto could imagine. His highly personal style rendered with overlapping patches of colour, confirms, as does every other element in the painting worked on with perseverance, the date as being after the Rome visit. The controlled complexity of the composition suggests that it must be close to, or not much earlier than, the *View of Santa Maria d'Aracoeli and the Capitol* from 1743 (cat. no. 20).

In his mature work, Bellotto's enthusiasm for dramatic description was to be replaced by his efforts to attain harmonious and evocative atmospheres, such as *Pirna from the Boatmen's Village* (cat. no. 58), which in comparison with this early panoramic view by Bellotto reveals the level of compositional maturity he had attained. There is a definite conceptual parallel with an interesting view of Santa Maria dei

Servi, Venice, and its surrounding buildings, of which two versions ascribed to Bellotto but doubted by Kozakiewicz are known to exist. Bellotto may well have painted the lost original that inspired these works.[10]

There are no known replicas of the present painting: the painting attributed to the artist and similar to this view (Private collection, Bergamo; formerly in the Galleria Lorenzelli) is in fact a copy that post-dates the view by Cimaroli.[11] There is also a tenuous connection with Francesco Guardi, who may have been inspired by this painting to execute three works in the 1780s in the Worms collection, Paris, Gulbenkian Museum, Lisbon; and the Detroit Institute of Arts.[12]

Bożena Anna Kowalczyk

[1] Kowalczyk 2000a, note 78, p. 210.
[2] A.S.V., Dieci Savi alle Decime di Rialto, b. 316, no. 769.
[3] Lorenzetti 1975, p. 869.
[4] Constable and Links 1989, vol. 2, no. 371.
[5] Bromberg 1974, no. 4.
[6] For Canaletto's print, see Bromberg 1974, no. 6; Kozakiewicz 1972, vol. 2, no. 106.
[7] Dobos, in Atlanta, Seattle, and Minneapolis 1995, no. 53.
[8] Constable and Links 1989, vol. 2, listed under no. 371.
[9] See my essay in this catalogue, p. 11.
[10] Kozakiewicz 1972, vol. 2, nos. Z 273 and Z 274.
[11] Bergamo 1969, pl. XXXIX.
[12] Morassi 1973, vol. 1, pp. 434-35, nos. 669-71.

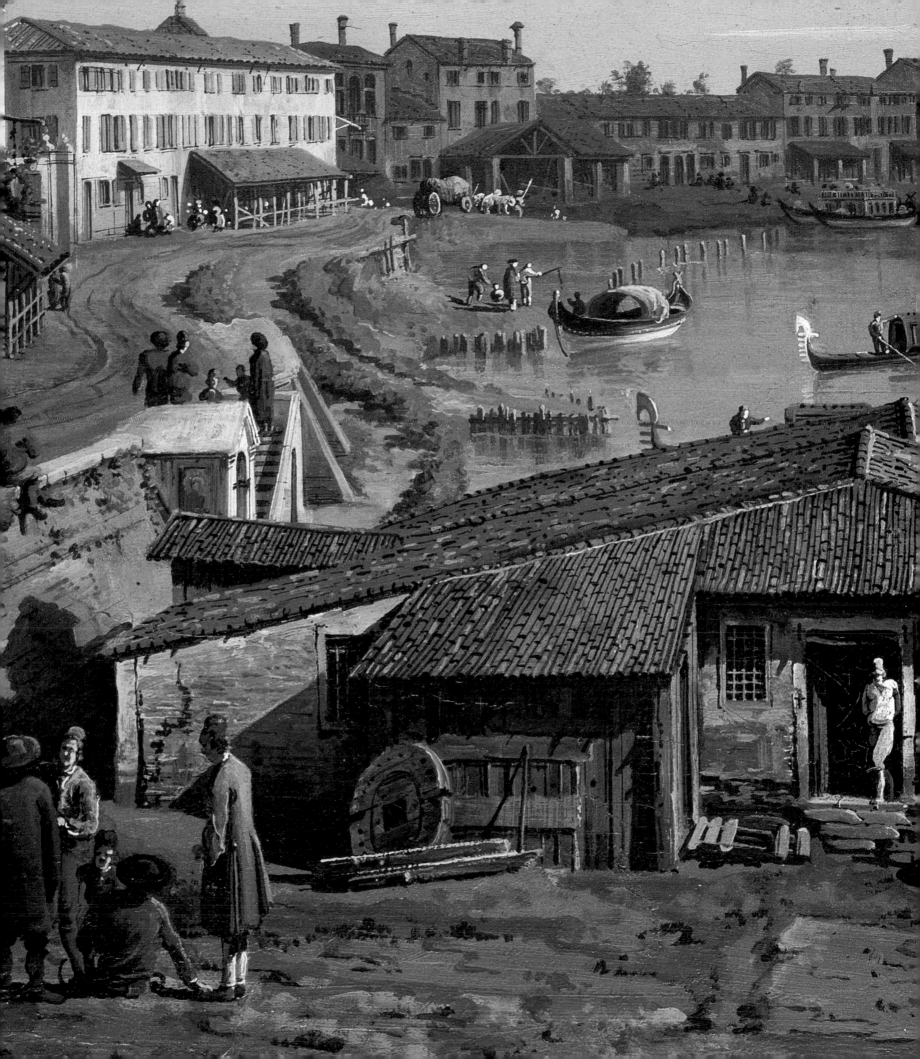

Tuscany, Rome

Tuscany, Rome

1742
Oil on canvas
24 × 35 3/8 inches
(61 × 90 cm)
Museum of Fine Arts, Budapest

Provenance: Marchese Vincenzo Riccardi, Florence 1752; Miklos Esterházy collection, Vienna, 1820; Paul Esterházy, Budapest, 1865; in 1871 to the National Gallery, Budapest (inv. 645).

Exhibitions: Vienna 1965, no. 2; Venice 1967, no. 92; Lugano 1985, no. 18; Florence 1994, no. 88; Frankfurt 1999-2000, no. 148.

Bibliography: Venturi 1900, p. 236; Ferrari 1914, p. 20; Meller 1915, p. 233; Fritzsche 1936, pp. 27, 105, no. VG 13; Pigler 1954, p. 50; Heinz 1965, pp. 44, 50, no. 2; Zampetti, in Venice 1967, p. 200; Pignatti 1966, pp. 219, 226, 228; Pignatti 1967b, pp. 3, 10; Zampetti 1971, p. 17; Kozakiewicz 1972, vol. 1, pp. 33-34, vol. 2, pp. 40-47, no. 57; Camesasca 1974, p. 89, no. 18; De Juliis 1981, pp. 61-62, 72; Chiarini, in Florence 1994, pp. 152-54; Gregori and Blasio 1994, pp. 201-9; Garas 1995, p. 40; Kowalczyk 1995a, p. 300; Kowalczyk 1996a, III, pp. 1-2, no. 37; Kowalczyk 1996b, p. 74; Pallucchini 1996, p. 497; Barkóczi, in Frankfurt 1999-2000, p. 368.

This painting, one of six Florentine *vedute* completed during a brief visit to Tuscany, probably in the spring of 1742, confirms that Bellotto had by then thoroughly mastered the skills of his art. The other paintings in the series are the view of the Arno from Ponte Vecchio looking towards the Ponte Santa Trinità (cat. no. 9), two pairs of pendants in the Fitzwilliam Museum (cat. nos. 15, 16) and in the Beit collection, Russborough.[1] Stefan Kozakiewicz grasped neither the significance of this group of Florentine views nor its importance in the evolution of the artist's work.[2] He maintained that the two Cambridge views were later works as explained by the artist's innovative treatment of the light; he also thought the figures in the Beit paintings were executed by a different artist, even though they are among the most representative examples of Bellotto's skill at representing the special character of a place in a compositional context. There is documentary evidence that the Budapest paintings were in Florence in 1752, in the collection of Marchese Vincenzo Riccardi, housed in the former Medici palace in via Larga.[3] It can be assumed that the other Florentine views were also commissioned for collections in the city, which enabled the Florentine *vedutista* Giuseppe Zocchi (c. 1711-67) to copy them.[4]

Canaletto's popularity among aristocratic Florentine collectors certainly helped his nephew, probably more than the visits to the city of either Gaspar Van Wittel or Paolo Anesi. In 1729, only one view by Canaletto, a view of the Grand Canal in the collection of the Marchese Gabburri, was exhibited in the cloister of the Santissima Annunziata, but at the next exhibition in 1737 there were a further three views of Venice (from the collections of the Marchese Gerini, Ferdinando de' Medici, and Filippo Branchi).[5]

When Bellotto reached Florence, Giuseppe Zocchi, newly returned from Venice, had been commissioned by Andrea Gerini to produce engraved of views of Florence and this major collection of subjects and motifs of the city was published in 1744.[6] Bellotto's two other pairs of Florentine views contain in fact precise references to Zocchi's work, in particular at a compositional level, suggesting that the two painters were in close contact. (One of the two Beit views, the Arno from the Vaga Loggia, is similar to the Florentine artist's engraving, whereas the Arno looking towards the Ponte alle Carraia in the Fitzwilliam Museum was preceded by two very similar sketches, a preparatory drawing by Bellotto and the same composition by Zocchi, which Bellotto kept among his drawings, now in Darmstadt).[7] What is striking about the two paintings in Budapest is their Venetian "look", which was first noted by Adolfo Venturi in 1900, causing him to comment upon "… the strange Florentine views given a Venetian interpretation by Bellotto".[8]

The view of the Piazza della Signoria is almost certainly the first work to be executed in Florence by Bellotto (to judge from quality of the work and the choice of subject) and was to serve as his introduction. Although he must have been more concerned than usual about the outcome, he deliberately decided to present himself as an avant-garde *veduta* painter and proceeded to create an impossibly complicated play of light and shade constructed stage by stage, alter distances and the proportions of buildings, and exaggerate the darkness of the shadows to demonstrate his descriptive skill, and he attached the same importance to the totally unreal figures as to the monuments and statues that decorated the piazza. The little street theatre, inspired by those that Carlevaris and Canaletto had set in their views of St. Mark's captures with an almost obsessive attention to detail the fascination and mystery that these theatrical shows in the square must have exerted upon contemporary passers-by.

Here Bellotto achieves the highest expression of his youthful poetics, a view that is at once realistic and mannered, conventional and personal, a kind of urban fairytale illustration. These subtleties risked being overlooked by contemporaries such as Nicolas Cochin, who offered his critical opinion on Bellotto's pictures during a visit to Florence in 1768, noting that the Riccardi collection contained "*deux vues de Florence par Gasparo delli Occhiali* [Gaspar van Wittel]": "*elles sont bien exécutés, mais les ombres en sont noircies & dures*".[9] The "harshness" of the shadows was in fact part of Bellotto's poetry: their edges in the *piazza* have been drawn with a ruler and incised and the clearly alternated shadows in the upper part of the Palazzo Vecchio had a precise decorative role as well as being functional. At least Cochin considered the Budapest pictures "well executed," which is faint praise. But it is only now that these *vedute* can be understood and evaluated as integral stages in the young artist's development. Each of the Venetian views predating the journey to Florence already contains, to a different degree, its own linguistic and stylistic characteristics as developed from the view of the Grand Canal from Santa Croce and the convent of Corpus Domini to San Geremia in the National Gallery, London (cat. no. 1) to a view of the Grand Canal from Palazzo Flangini, now in an American private collection.[10]

With its traditionally laid-out perspective, Bellotto's description is based on the usual technical methods, but applied here with great exactitude. Each palazzo in the square is differentiated not only by its architectural structure but by the way the light hits it, the quality of the plaster and the depth of the openings. The paint is applied with different kinds of brushes, very fine ones used to build up with a heavy or light stroke the various layers until the desired effect was achieved, broad brushes for the illuminated and smooth surfaces. The incisions in the wet paint are few and discreet, both those that mark out the lighted surfaces and those in shadow, while the architectural details are carefully drawn freehand with the tip of the brush in black, achieving, for example, incredible precision and delicate detail in the description of the façade of Palazzo Vecchio. Copies both of this painting and its pendant have been identified in an English collection; Marco Chiarini has suggested that one of them is the painting mentioned by Jadranka Bentini in the Fondazione Severi in Carpi.[11]

Bożena Anna Kowalczyk

[1] Kozakiewicz 1972, vol. 2, nos. 52, 56.
[2] Kozakiewicz 1972, vol. 1, p. 34.
[3] De Juliis 1981, p. 72.
[4] Kozakiewicz 1972, vol. 2, no. Z 311.
[5] Borroni Salvadori 1974, p. 72.
[6] *Scelta delle XXIV Vedute delle principali Contrade, Piazze, Chiese e Palazzi della Città di Firenze…*, Florence, 1744.
[7] Chiarini, in Verona 1990, p. 62, no. 6; and Kozakiewicz 1972, vol. 2 no. Z 313, and Chiarini, in Florence 1994, p. 160, under no. 94.
[8] Bettagno 1986, p. 20.
[9] Cochin 1769 (cited in the edition edited by Michel, 1991, p. 258).
[10] See my essay in this catalogue, pp. 9, 10, fig. 11.
[11] Kozakiewicz 1972, vol. 1, p. 221; Camesasca 1974, p. 89, nos. 17, 18; Chiarini, Florence 1994, no. 88; Bentini 1991, no. 65.

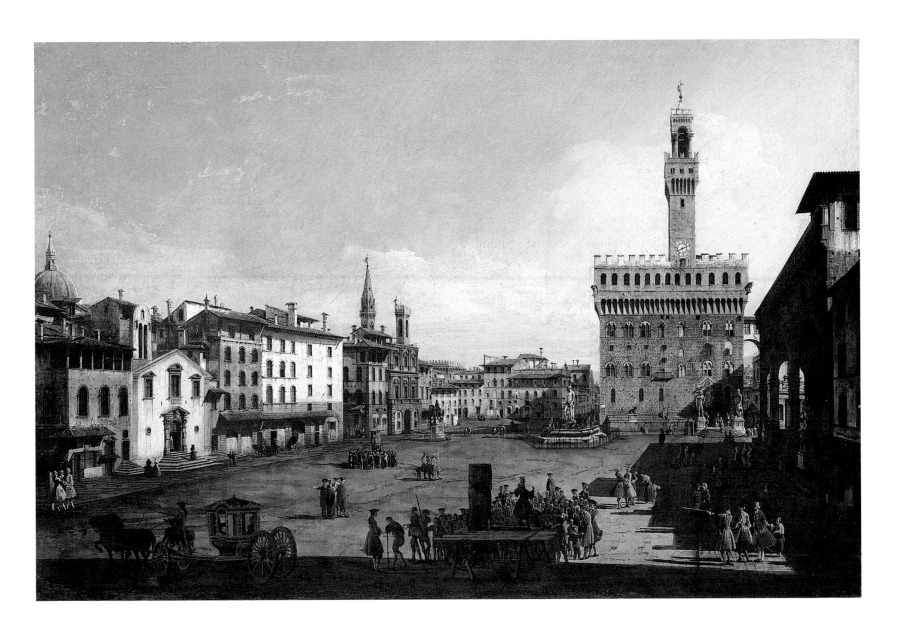

Tuscany, Rome

1742
Oil on canvas
24 3/8 × 35 3/8 inches
(62 × 90 cm)
Museum of Fine Arts,
Budapest

Provenance: Marchese Vincenzo Riccardi, Florence 1752; Miklos Esterházy collection, Vienna, 1820; Paul Esterházy, Budapest, 1865; in 1871 to the National Gallery, Budapest (inv. 647).

Exhibitions: Vienna 1965, no. 3; Venice 1967, no. 91; Lugano 1985, no. 19; Florence 1994, no. 89; Frankfurt 1999-2000, no. 149.

Bibliography: Venturi 1900, p. 236; Meller 1915, p. 233; Pigler 1967, no. 56; Garas 1968, p. 30; Pilo 1967, p. 275; Zampetti, in Venice 1967, p. 198; Kozakiewicz 1972, vol. 1, pp. 33-34, vol. 2, p. 38, no. 53; Camesasca 1974, p. 89, no. 17; De Juliis, 1981, pp. 61-62, 73; Chiarini, in Florence 1994, p. 154; Gregori and Blasi 1994, pp. 201-14; Garas 1995, p. 40; Kowalczyk 1995a, p. 300; Kowalczyk 1996a, vol. 3, pp. 1-2, no. 38; Pallucchini 1996, p. 495; Barkóczi, in Frankfurt 1999-2000, pp. 368-71.

Prince Miklos Esterházy (1756-1833) added greatly to the collection of his family, one of the wealthiest and most powerful in Hungary, acquiring paintings of the highest quality in Italy, France and Austria. This view of Florence and its pendant (cat. no 13), were probably added at the end of the eighteenth century, when the Riccardi collection was broken up. The Esterházy collection of 637 paintings was bought by the Hungarian state in 1870, forming the core collection of the National Gallery of Painting prior to the foundation in 1906 of the Museum of Fine Arts.[1] Before being transferred to Budapest, the magnificent collection of Italian, Dutch, and Spanish art was housed from 1815 to 1865 in the Kaunitz-Esterházy palace in Vienna which, by coincidence, Bernardo Bellotto had painted for Prince Wenzel Anton Kaunitz-Rietberg during his stay in Vienna in 1759-61. The view of the Kaunitz-Esterházy palace and gardens in the Viennese suburb of Mariahilf (Museum of Fine Arts, Budapest) is one of the most successful paintings Bellotto produced in Vienna.[2] Both of the Florentine *vedute* in Budapest were ascribed to Canaletto in the inventory of the Riccardi collection in 1752 and Nicolas Cochin in 1768 confused the author with Gaspar van Wittel but his description of "*ombres noircies & dures*" leaves little doubt that he was referring to the present paintings (see cat. no. 13). Attributed to Canaletto in the first hand-written catalogue of the old Esterhàzy gallery in Vienna of 1820, the pictures were recognized as Bellotto's in the 1871 catalogue of the Budapest Art Gallery.[3]
The stretch of river from the Ponte Vecchio to the Carraia bridge, barely visible below the piers of the bridge at Santa Trinità, must have particularly intrigued Bellotto, who also painted the scene looking from the opposite direction in one of the pendant views in the Fitzwilliam Museum, Cambridge (cat. no. 16). The major attraction of this painting lies in the jumble of houses huddled together on the left bank of the river, the rooflines, cornices, corbels, roofs and chimneys of which clearly fascinated and piqued the curiosity of Bellotto, who described their architectural features minutely. He was equally fascinated with the reflections on the surface of the river, seizing the most picturesque and intriguing aspects of the site such as the suspended apsidiole and campanile of San Jacopo sopr'Arno near the Santa Trinità bridge.
The principles of composition, perspective, and lighting governing the view do not differ greatly from those of the view of the Rio dei Mendicanti (cat. 5) or that of a view of the Grand Canal from Palazzo Flangini to Palazzo Vendramin-Calergi, now in a private collection.[4] As a result of the use of a camera obscura and his tendency to apply rigidly constructed perspectives in each view, Bellotto depicted the Arno like a Venetian canal; but the relief-like quality of the description, defined by strong light and shade constrast, with a suggestion of the effect of an aeriel view (in the distant houses, bridges and hills on the horizon) were new stylistic and expressive features. Everything he had learned from the production of his Venetian *vedute* is employed here in the manner of a virtuoso performance: the minute description of architectural detail, the precise reflections in the water, and the hint of a new confidence in the depiction of figures. With these two pendants the artist has created unique examples of his own style and the ability to apply the principles of Venetian view painting to other cities. Bellotto's increasing historical importance as a provider of topographical documentation is evident here in his record of the appearance of the buildings on the left bank of the river at Ponte Vecchio, most of which were destroyed during in 1944 by mines laid by the German army.[5]

Bożena Anna Kowalczyk

[1] Garas 1995, p. 40.
[2] Kozakiewicz 1972, vol. 2, no. 270; Barkóczi, in Atlanta, Seattle, and Minneapolis 1995, no. 55.
[3] Meller 1915, nos. 899 and 898, p. 233; in the 1871 catalogue, p. 27, nos. 56, 57.
[4] See my essay in this catalogue, pp. 9, 10, fig. 11.
[5] Chiarini, in Florence 1994, p. 154.

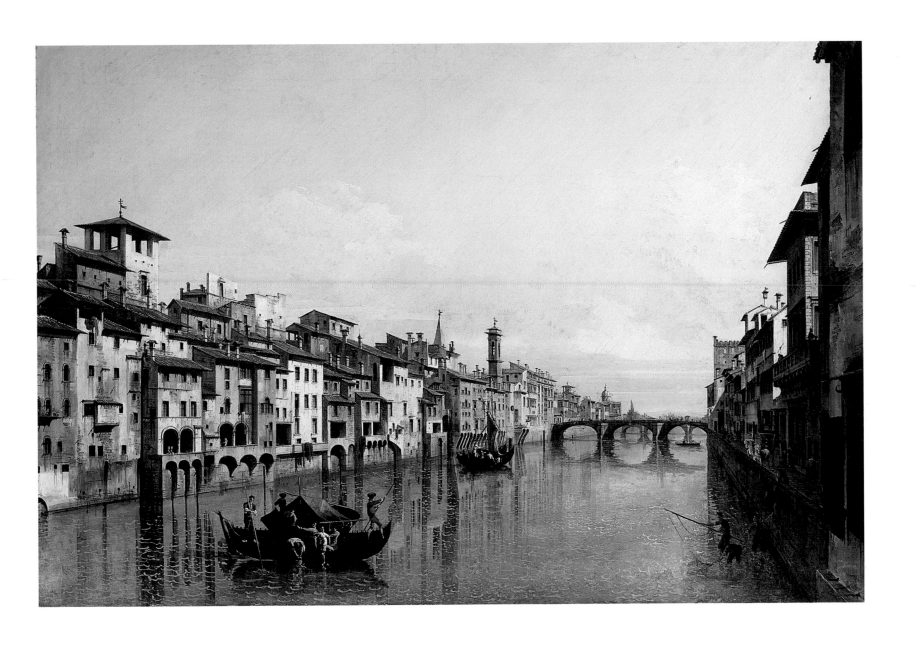

Tuscany, Rome

c. 1742-43
Oil on canvas
28 7/8 × 41 5/8 inches
(73.3 × 105.7 cm)
Lent by the Syndics of the
Fitzwilliam Museum,
Cambridge

Provenance: A. A. Vansittart, by
whom presented in 1876 to the
Fitzwilliam Museum (no. 192).

Exhibitions: Florence 1994, no.
90.

Bibliography: Fritzsche 1936,
pp. 27, 105, 134; Goodison and
Robertson 1967, p. 15, no. 192;
Kozakiewicz 1972, vol. 1, pp.
33-34, vol. 2, p. 41, no. 54 (with
previous references); Gregori
1983, pp. 245-48; Chiarini, in
Florence 1994, p. 156; Gregori
and Blasio 1994, pp. 204, 207;
Villis 2000, p. 81.

Bellotto's travels in central Italy
have been estimated as extend-
ing over several months within
the year 1742. It is generally ac-
cepted that the similarity be-
tween the artist's views of Flo-
rence and Lucca and the works
dating from before his departure
in Venice effectively confirms
that he visited both cities during
the tour of 1742, rather than at a
later period. For Kozakiewicz,
the maturation of style and
technique revealed in Bellotto's
Roman views indicates that he
visited Florence and Lucca on
his way to Rome, where he spent
the summer of 1742, rather than
on the return journey.[1]
Bellotto was not yet twenty
years old when he visited Flo-
rence, and his journey to central
Italy represented a first, impor-
tant step towards the creative
independence from his uncle
and teacher, Canaletto. Koza-
kiewicz summarized the conse-
quences of the young painter's
visit to Florence, a strange city
where for the first time he was
required to devise composition-
al schemata without Canaletto's
guidance: "It is hardly surpising
that he tried to apply the for-
mulae that he and his uncle had
worked out for Venetian sub-
jects in his new surroundings;
he favoured views of the Arno,
because they bore the greatest
similarity to views of the Grand
Canal and the Canale di Santa
Chiara, and his composition of
the view of the Piazza della Sig-
noria is modelled on the paint-
ings of the *campi* of Venice."[2]
Six views of Florence are general-
ly considered to be authentic
works by Bellotto: *View of the Pi-
azza della Signoria* (cat. no. 13),
*View of the Arno towards the
Ponte Vecchio* (cat. no. 14), a pair
of views of the Arno and the
buildings lining its banks (Beit
Collection, Russborough),[3] and
the present pair of views at Cam-
bridge. The enthusiasm for
Venetian view-painting in eigh-

teenth-century Florence among
local collectors and *cognoscenti*
was considerable. Francesco
Maria Gabburri (1676-1742), for
example, had exhibited in Flo-
rence in 1729 in the Chiostro SS.
Annunziata a "*veduta di Venezia*"
by Canaletto, and ten years later
a painting of the same designa-
tion was exhibited by one of the
Marchesi Gerini, Giovanni
(1685-1751) or Andrea (1691-
1760).[4] It is probable therefore
that the majority of Bellotto's
views were commissioned by lo-
cal collectors of landscape and
view painting, and Giuseppe de
Juliis has in fact suggested that
two views of "*Piazza Signoria
verso Palazzo Vecchio*" and
"*L'Arno dal Ponte Vecchio, verso il
Ponte a Santa Trinità*" described
in a 1752 inventory of the *cam-
era da letto* of Marchese Vincen-
zo Riccardi in Palazzo Medici-
Riccardi, are identical with Bel-
lotto's paintings at Budapest ex-
hibited here (cat. nos. 13, 14).[5]
The vantage point of the view
towards the Ponte Vecchio is on
the north side of the river, from
the embankment of Ponte Santa
Trinita, looking upstream across
to the Oltrarno, the area south
of the Arno. The campanile and
suspended apsis of San Jacopo
sopr'Arno are visible at the right
edge of the composition. (The
medieval houses to the left of
the church were blown up by the
Germans in 1944 to render the
Ponte Vecchio impassable.) On
the near bank, the greatly fore-
shortened houses along the
Lungarno Acciaioli are in shad-
ow. For Marco Chiarini, the
steeply angled lines of perspec-
tive reveal the influence both of
Bellotto's use of the camera ob-
scura and the compositional
procedures learned in the studio
of Canaletto. He suggested that
the view originated in a detailed
pen-and-ink sketch, now miss-
ing, similar to the drawing in the
Uffizi that is related to a compo-
sition of the pendant painting.[6]

The viewpoint of the compan-
ion picture is also near the
Ponte Santa Trinita – perhaps
because during the eighteenth
century it was the fashionable
place for a *passeggiata* – looking
downstream towards the north-
west. The Ponte alla Carraia,
constructed in wood on stone
piles in the thirteenth century,
was the second bridge to be
built over the Arno after the
Ponte Vecchio. On the right, the
houses along the Lungarno
Corsini are greatly foreshort-
ened; the view of opposite bank,
the Lungarno Guicciardini, is
much more expansive, stretch-
ing from the tower of Santo
Spirito rising above the houses
to the cupola of San Frediano in
Cestello beyond the bridge. This
composition was studied by
Bellotto in a pen-and-ink draw-
ing, now in the Uffizi, that was
probably made on the spot.[7]
The drawing reveals the signal
characteristics of Bellotto's
graphic style at this period with
vigorous hatched and cross-
hatched lines to indicate the fall
of light upon the scene and
clouds in the sky. In the subse-
quent painted composition, nu-
merous details have been al-
tered such as the time of day,
boats on the river, and the loca-
tion and number of the figures
on the quay at the right.
Kozakiewicz correctly observed
that the two Cambridge canvas-
es, "painted with greater assur-
ance and energy", were produced
later than the works in Budapest,
probably after Bellotto had left
the city, on the basis of drawings
such as the Uffizi sheet.[8] In the
Fitzwilliam views, Bellotto has
abandoned the practice of ren-
dering the surface of the water
with decorative crests on the
waves and instead indicates the
passage of the river much more
realistically; moreover, the fig-
ures are no longer lanky and stiff,
but are painted with greater im-
pasto with the point of the brush

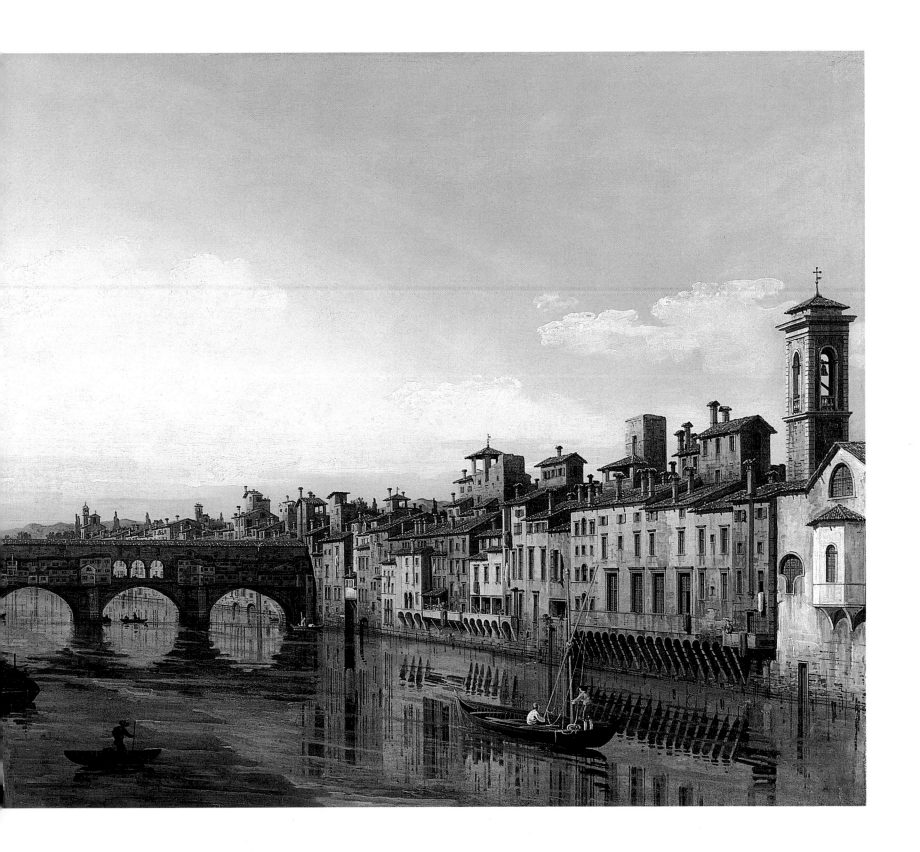

16. *View of the Arno towards the Ponte alla Carraia, Florence*

c. 1742-43
Oil on canvas
29 × 41 1/2 inches
(73.7 × 105.4 cm)
Lent by the Syndics of the
Fitzwilliam Museum,
Cambridge

Provenance: A. A. VanSittart, by whom presented in 1876 to the Fitzwilliam Museum (no. 195).

Exhibitions: Florence 1994, no. 91.

Bibliography: Fritzsche 1936, pp. 22, 105, no. VG 16; Goodison and Robertson 1967, p. 15, no. 192; Kozakiewicz 1972, vol. 1, pp. 33-34, vol. 2, p. 41-42, no. 55 (with previous references); Gregori 1983, pp. 245-48; Chiarini, in Florence 1994, p. 156; Gregori and Blasio 1994, pp. 204, 207; Villis 2000, p. 81.

and achieve much greater solidity and conviction than the earlier views. Although the artist has adhered to the strict rules of perspective taught by Canaletto, he shows increasing independence in his forceful contrasts of light and shade and more vibrant palette. The grayish-brown buildings, warmer in the roofs and greenish in the shadows, the green-gray water, and greenish-blue sky with slightly rosy clouds share much greater affinity with Bellotto's various views of Rome and even Verona (cat. nos. 37, 38) than his earlier views of Florence now in Budapest (cat. nos. 13, 14).

Edgar Peters Bowron

[1] Kozakiewicz 1972, vol. 1, p. 33.
[2] *Ibid.*
[3] Kozakiewicz 1972, vol. 2, nos. 52, 56, repro.; Verona 1990, nos. 3, 4, repro.; Florence 1994, nos. 92, 93, repro.
[4] De Juliis 1981, p. 61.
[5] De Juliis 1981, pp. 72-73, nos. 71, 83, both as Canaletto, with measurements identical to the Budapest paintings. De Juliis's suggestion that Bellotto gave the two little views to his host, Marchese Vincenzo, before his departure from Florence, would explain why the artist's name does not appear among the payments in the Riccardi inventory accounts.
[6] For a related view of Florence looking towards the Ponte Vecchio in the Museum of Fine Arts, Boston, see Kozakiewicz 1972, vol. 2, pp. 461, 463, no. Z 311, repro., and Chiarini, in Florence 1994, p. 156, who attributes the painting to Zocchi.
[7] Chiarini, in Verona 1990, pp. 62-63, no. 6, repro.; Chiarini, in Florence 1994, pp. 159-60, no. 94.
[8] Whether or not Bellotto in fact resided in Palazzo Medici-Riccardi during his brief visit to Florence and repaid his host, Marchese Riccardi, with the two little *vedute*, de Juliis' identification of these views with the Budapest canvases further encourages a chronology based on the stylistic differences between the two pairs; that is, Budapest earlier, Cambridge later, and almost certainly painted after the artist had left the city.

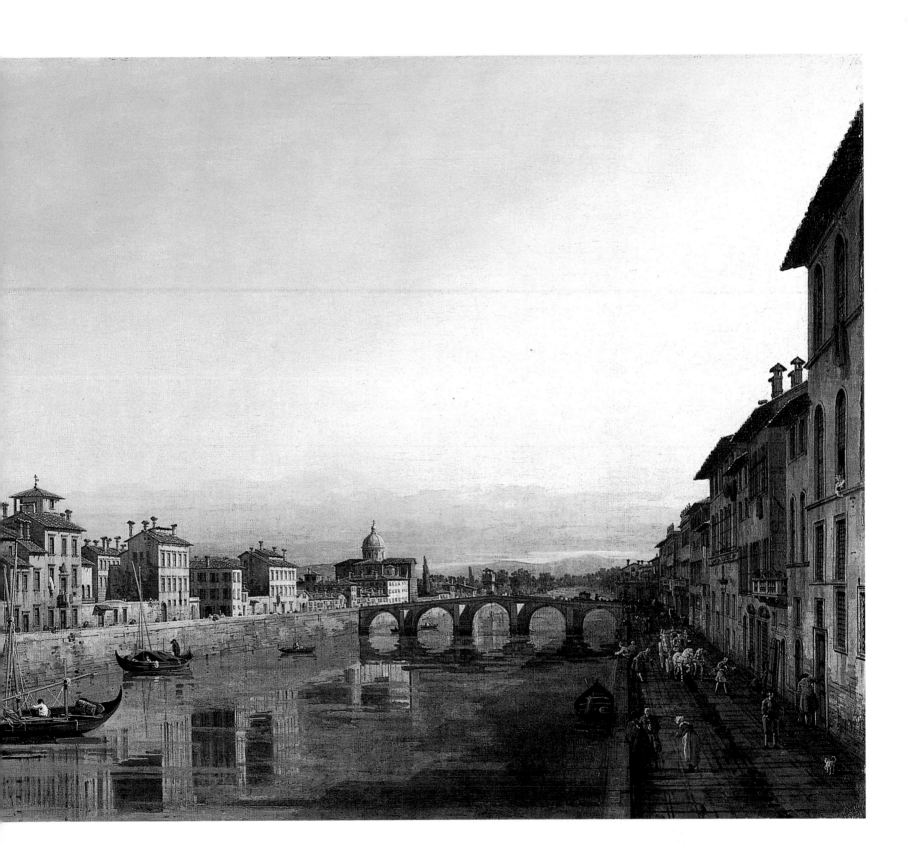

17. The Piazza San Martino, Lucca

1742
Oil on canvas
20 × 28 3/4 inches
(50.8 × 72 cm)
York City Art Gallery,
Presented by F. D. Lycett Green
through the National Art
Collections Fund, 1955.

Provenance: Sir William Agnew
(1825–1910), Rougham, Suffolk;
Sir George Agnew (1852–1941),
Rougham, Suffolk; F. D. Lycett
Green, Finchcocks, Goudhurst,
Kent; presented by him in 1955
through the National Art Collec-
tions Fund to the museum (no.
771).

Exhibitions: York 1955, no. 49;
Verona 1990, no. 7.

*Bibliography: Burlington Maga-
zine* 1944, pp. 257–8 (as Canalet-
to); Watson 1953, pp. 166, 169
(as Bellotto); Haskell 1956, pp.
296-300; York 1961, vol. 1, pp. 7-
8, no. 771; Kozakiewicz 1972,
vol. 1, p. 27, vol. 2, p. 47, no. 58;
De Seta 1990, p. 25; Honour, in
Verona 1990, p. 64, no. 7; Mari-
nelli 1993, pp. 83-4; Gregori and
Blasio 1994, pp. 201-14; Palluc-
chini 1995, p. 495; Kowalczyk
1996a, vol. 1, pp. 13, 36, no. 41.

The view looks east from a
house on the west side of the
Piazza San Martino towards
the cathedral with the cam-
panile on the right and part of
the Piazza degli Antelminelli to
the left. At the extreme left
edge of the composition is part
of the wall of the transept of
San Giovanni, with the Palazzo
Bernardi (Micheletti) and its
terraced gardens completing
that side of the square. The
anonymous author of a note in
the *Burlington Magazine* in
1944, who published the paint-
ing as by Canaletto, admired in
particular its extraordinary
sense of atmosphere, light, sil-
very tonality, and the handling
of certain details, such as the

women in their bright dresses
and the delicate white clouds
across the blue sky.
The connection of the view with
five drawings of Lucca in the
British Museum, once part of
the map collection of King
George III, where they are first
mentioned in 1819, led Francis
Watson to suggest the drawings
and the present painting were by
Bellotto, the result of a visit to
the city. Since Pietro Guarienti
makes no mention of such a vis-
it in an early biographical notice
of the artist, it is possible that
Lucca, like Florence, was just a
stop on Bellotto's trip to Rome
via Livorno, where the artist
recorded the Tacca monument
to Ferdinand I.[1] Documentary
evidence enables us to fix a date
for this brief visit – on the verso
of one of the Lucca sheets the
name of Pietro, Bernardo's
brother and assistant, is written
in the same colour ink. Their
working partnership came to an
end in Venice, 25 July 1742.[2]
The drawings made in Lucca are
sketches for paintings, complete
with descriptions of light and
shade fixing the limits of the ar-
eas in shadow and well-charac-
terised, if summarily executed,
outlines of the figures. The
drawing representing the cathe-
dral from the apse side is more
complete than the others, with
its accurate shading and clearly
defined sky. These were un-
doubtedly preparatory drawings
for a cycle of paintings of which
only the present work was fin-
ished or survives. On the basis of
the drawings, three paintings
were to have portrayed the areas
around the cathedral in order to
illustrate the urban situation of
the church, a very unusual ap-
proach in eighteenth-century
vedute; a fifth would have
recorded a view of the church of
Santa Maria Forisportam.
It would be particularly interest-
ing to know whence the idea for
this series originated, but there is

no documentation regarding
the commission. The dominant
interest in religious buildings
would seem to suggest an origin
for the commission in the eccle-
siastical world; a possible candi-
date is Archbishop Fabio Colle-
redo, originally from Friuli,
whose death on 15 November
1742 could explain why the se-
ries was not completed. Hugh
Honour in 1990 suggested a
more likely candidate, the the-
ologian Giovan Domenico
Mansi (1692-1769). He was a
member of one of the most im-
portant families in Lucca and a
man of character, as can be seen
from the portrait executed by
Pompeo Batoni (1708-87),
probably in 1764 on the occa-
sion of his being made an arch-
bishop by Clemente XIII[3]. Can
Mansi have had the idea of com-
missioning a Venetian *vedutista*
to paint views of the churches of
Lucca, perhaps in connection
with his *Diario sacro antico e
moderno delle chiese di Lucca,*
published in 1753? Two interest-
ing views of Venice come from
the Mansi collection (but it is
not known from which branch
of the family). They were paint-
ed in the early 1720s by a painter
who knew Canaletto well: *Canal
Grande dal campo San Vio* and
Molo con Palazzo Ducale, now in
a private collection in Paris.[4]
Two copies of the paintings
made by Canaletto for Stefano
Conti came from a collection in
Lucca, perhaps the same collec-
tion.[5]
A date in the latter half of 1742,
not long after the preparatory
sketch was done and before the
two views of the Arno, now in
the Fitzwilliam Museum, Cam-
bridge (cat. nos. 15, 16), fits in
well with the quality and charac-
ter of this painting in which the
influence of Bellotto's Venetian
views is still much in evidence.
This can be seen in the similari-
ty of the composition and in the
liveliness of the figures of the

type used in the view of the
Campo Santi Giovanni e Paolo in
Springfield (cat. no. 7), but al-
ready reminiscent, in the color-
ful figures on the right, of the
passage in Giuseppe Zocchi's
views of Florence. In the silvery
tone below the "Venetian" sky,
filled with strong vertical brush-
strokes and prominent clouds,
Bellotto very skilfully uses the
same stylistic approach in which
the technique lends itself well to
the artist's expressive sensitivity,
while the composition is ele-
gantly simple, a view with small
"corrections" from only one
point of view.
The subtlety with which the
chiaroscuro effects are achieved
confirm that the painting was ex-
ecuted after the *Piazza della Sig-
noria a Firenze* (cat. no. 13). The
elaborate layers of paint have
been cut into with a network of
incisions, the purpose of which is
to highlight the architectural de-
tails, make the surfaces of the
walls appear more realistic, and
give them substance. The metic-
ulous, almost shorthand codifi-
cation of the British Museum
drawing has been further cor-
rected and improved in the
painting: the façade of the cathe-
dral has the delicacy of lace; the
Palazzo Bernardi Micheletti –
with its hanging garden – the
simple nobility of a Tuscan
house; the artist delights in de-
scribing every brick in the church
of San Giovanni on the left and
manages to fit in the whole of the
door of the Oratorio della Mad-
dalena to render the details of the
shadow.
The painting in Bellotto's reper-
tory that is closest to this view in
spirit, atmosphere, and decora-
tive effect is a Lombard view of
1744, representing *Sant'Eufemia
and San Paolo Converso, Milan,*
in an Italian private collection,
where the surface is enlivened by
paint more thickly applied in
swift sure brushstrokes to define
the architectural details, making

them vibrate in the slanting rays
of light; in contrast, the light and
shade effects here seem unso-
phisticated.[6]

Bożena Anna Kowalczyk

[1] Guarienti 1753, p. 101; Watson
1953, p. 169.
[2] Mauroner undated [pre-1948], p. 1
and doc. 5, pp. 21-22; Marini 1993,
pp. 130-134, doc. 9, p. 138.
[3] Clark and Bowron 1985, pp. 297-
98, no. 280.
[4] Constable and Links 1989, vol. 2,
nos. 88(a), 187 (a).
[5] Constable and Links 1989, vol. 2,
230 and 304(note).
[6] Natale, in Pfäffikon and Geneva
1978, no. 167.

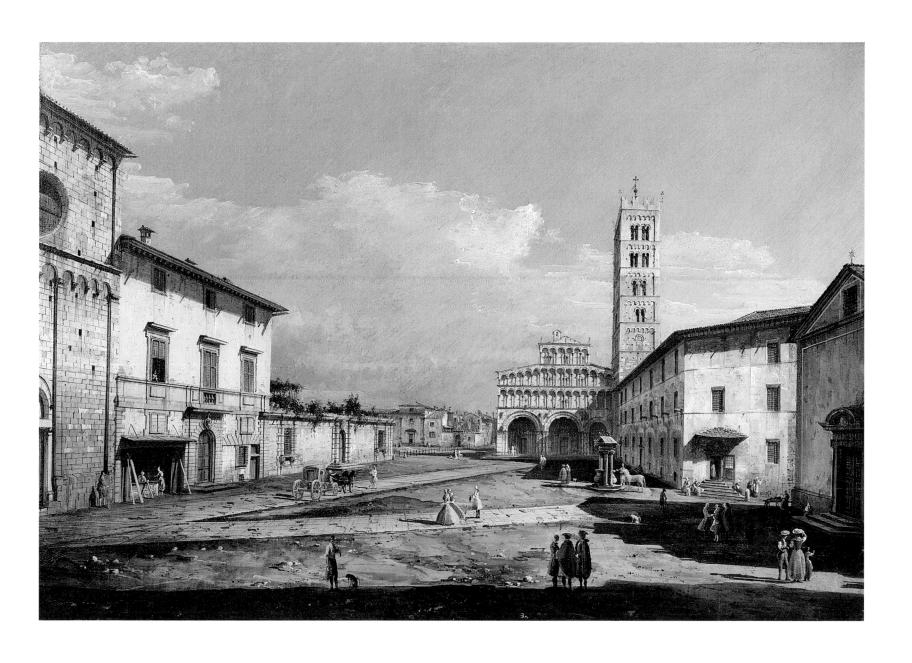

18. *The Roman Forum with the Temple of Castor and Pollux looking towards the Capitol*

c. 1742-43
Oil on canvas
24 1/4 × 38 inches
(61.5 × 96.5 cm)
Private collection

Provenance: Joseph Smith (c.1674-1770), Venice, where he served as British Consul 1744-1760; his widow, Elizabeth Smith, *née* Murray; purchased from her in June 1773 by Patrick Home (1728-1808), Lord Lieutenant and M.P. for the County of Berwick, of Paxton House, Berwickshire, Scotland, and by inheritance there to Miss Milne Home; with Knoedler, London, by whom purchased from her shortly after 1925; with Gaston Neumans, Paris, by whom purchased from Knoedler's, as by Bellotto, on 27 September 1928; on the art market, 1959; purchased by the present owner in 1999.

Bibliography: Hussey 1925, p. 451; Ashby and Constable 1925, pp. 208 and 288; Constable 1962, vol. 2, no. 279(b); Levey 1964, under nos. 417-18; Kozakiewicz 1966, p. 17; Vivian 1971, pp. 143-44, pls. 125-26; Kozakiewicz 1972, vol. 1, pp. 39, 222, fig. C 46; vol. 2, pp. 51-52, no. 69; Camesasca 1974, no. 24; Constable and Links 1976, vol. 2, nos. 379(b); Millar, in Venice 1982, p. 70, under no. 100; Constable and Links 1989, vol. 1, p. lxxxix; vol. 2, nos. 379(b) and p. 737; Brownell, in Verona 1990, p. 136; Levey 1991, pp. 48-49, under nos. 417-18; Succi, in Padua 1994, pp. 51 and 52, fig. 15; Hoff 1995, pp. 12, 13, note 6; Kowalczyk 1996, pp. 72, 80 and 88, note 8; Ingamells 1997, pp. 516 and 871; Links 1998, pp. 13-14, under no. 129(a), and 38, no. 379(b), pl. 273.

These paintings, long hidden in inaccessible private collections and never before publicly exhibited, are key components of the group of works executed by Bellotto as a direct result of his visit to Rome in 1742, but have never been accorded the significance which they deserve. Errors of identification propagated by Kozakiewicz and in the successive editions of the Canaletto catalogue by Constable and Links have contributed to their being overlooked.[1] Constable recognized the pair as "certainly by Bellotto" but thought that it had been split, confusing *The Roman Forum with the Temple of Castor and Pollux looking towards the Capitol* with a closely related painting sold at Sotheby's in 1955, exhibited by Arthur Tooth & Sons in the same year, and since untraced (see below).[2] Kozakiewicz repeated this mistake, blending the provenances of the exhibited painting and the Tooth version and illustrating the latter as his no. 69. Despite observing that "oddly enough the view from [the Paxton House] collection reproduced by Hussey looks more like [the exhibited painting]", he failed to draw the obvious conclusion.[3] Evidently working from two pairs of photographs of the paintings, one old, the second made when they were on the market in 1959, which he did not realize showed the same works, Kozakiewicz confused matters still further by illustrating them in his text volume as "probably by Canale". The Temple of Antoninus and Faustina is thus illustrated twice, described as two different paintings by different artists. This error was then assimilated by Links into his editions of Constable's catalogue. The exhibited pair of paintings emerges from this confusion as Bellotto's definitive statement on the subject of the Roman Forum.[4] The compositions of both

(but not the figures) derive, with only slight variations, from drawings made by Canaletto in Rome in 1719-20 and now in the British Museum.[5] The drawings form part of a group retained in Canaletto's studio which was well known to Bellotto, and other components of which were used by him as the basis for paintings.[6] That of the Temple of Antoninus and Faustina is followed even down to the detail of the coat-of-arms of Pope Clement XI (1700-21), even though Canaletto had himself presumably followed a print showing the building, transformed into the church of San Lorenzo in Miranda in 1602, without the upper half of its baroque facade. The paintings correspond even more closely, including the cloud formations, the figures and the colours of their clothing, with a pair of paintings of similar size in the collection of Her Majesty Queen Elizabeth the Queen Mother, which are either by, or largely by, Canaletto, and are also datable, on stylistic grounds, to the early 1740s. Those were not among the paintings acquired from Consul Joseph Smith (c. 1674-1770), Canaletto's great patron and agent, by King George III; they only entered the Royal Collection in 1946, the earliest recorded owner being Lord Caledon,[7] and their quality has been disputed.[8] The outstanding quality of the exhibited paintings raises the question of whether on this occasion Canaletto could have been following the lead of his young nephew.[9] It seems more likely, however, not least on account of the pronounced Canalettesque characteristics of the exhibited paintings, that the older artist was the protagonist. They may well have been intended to be sold as the work of Canaletto, and the opportunity for comparison offered by the

two pairs shows that Bellotto was already capable of surpassing his uncle in technical brilliance. A third version of the Temple of Antoninus and Faustina, once in the collection of the Earl of Sandwich, was last seen in a sale in Venice in July 1987;[10] also corresponding in details of colour, this would seem from reproductions to be a Canaletto studio replica of the Royal Collection painting. Canaletto himself used elements of the composition of the Forum looking toward the Capitol for the large upright painting, signed and dated 1742, executed for Consul Smith and now in the collection of Her Majesty the Queen.[11]

While Bellotto never repeated the composition of the Temple of Antoninus and Faustina, two other versions of the Forum looking toward the Capitol are known. That last recorded with Tooth in 1955 (already mentioned above) is particularly close to the exhibited painting and is presumably derived from it; differences are confined to such details as the shape of the piece of masonry at lower right, the angle of the boy's arm on the bucket on the rim of the fountain and the prominence of the stick resting diagonally across the left-hand first-floor window of the house directly behind the fountain.[12] The other variant, in the National Gallery of Victoria at Melbourne, is of far greater significance.[13] It is of a much larger size (34 1/4 × 58 1/4 inches) and, with the columns of the Temple of Castor and Pollux shown as more slender, there is a greater feeling of spaciousness and depth and the mood is more sombre. While the brick building on the left is shown, possibly more accurately, as at less of an angle, many of the buildings are simplified to heighten the sense of monumentality. These differences are more in line with Bellotto's per-

sonal artistic character and, although the Melbourne version cannot be far in date from the exhibited works, they serve to emphasize the Canalettesque qualities of the latter.

Neither Constable nor Kozakiewicz was aware that the exhibited paintings were owned by Consul Smith. Frances Vivian was the first to point out that they were acquired from Smith's widow by Patrick Home for the collection at Paxton House (where they remained until the 1920s). After building Paxton, Home had married in 1771 at the age of forty-three and subsequently spent six well-documented years in Italy, travelling and admiring and acquiring works of art.[14] In Venice in 1773 he met Smith's widow and bought from her twenty-five paintings, including views by Gaspar Van Wittel (1652/53-1736) and landscapes by Francesco Zuccarelli (1702-88), which he listed in his journal under 16 June 1773. Entry no. 13, "*Due Vedute di Roma … di Canaletti compagni*," refers to the exhibited paintings, while entry no. 14 records another pair, described as "*Due Vedute della piazza del San Marco*." "These are perhaps among the best views ever painted by Canaletti. He was long employed by Mr Smith & these were all retouched several times, as soon as any defects are discovered, one of them exhibits the Great Canal, Canal di Giudice … The other a more particular view of St Marks…". These other paintings, also sold in the 1920s as by Bellotto but subsequently considered the work of Canaletto, have recently emerged as even earlier works by Bellotto, copied from Canalettos of the 1730s.[15] A letter from Home to Colin Morison of 23 July 1775, after the arrival in Scotland of the paintings purchased from Mrs Smith, further demonstrates his naivety over artistic matters.[16]

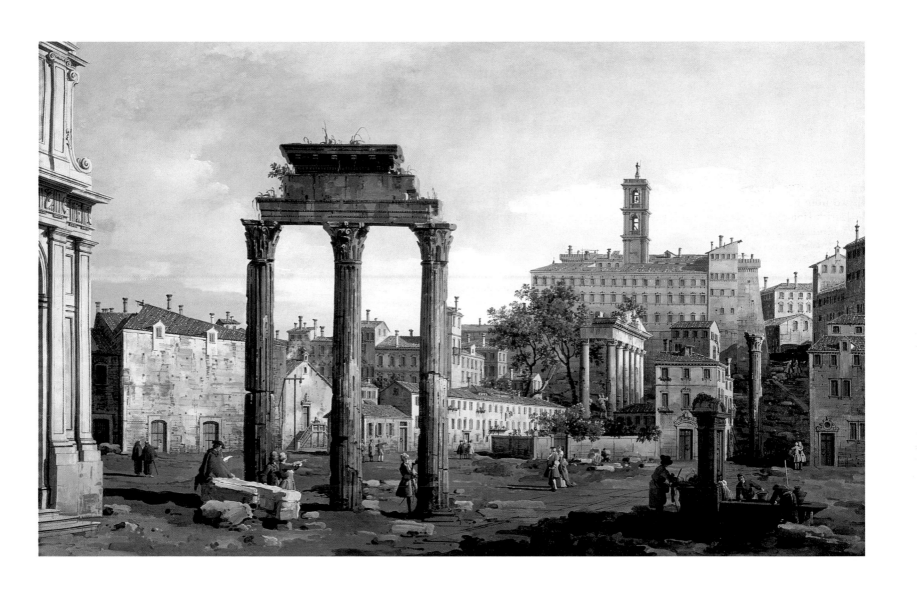

c. 1742-43
Oil on canvas
24 1/4 × 38 1/8 inches
(61.5 × 97 cm)
Private collection

Provenance: As for cat. no. 18.

Bibliography: Hussey 1925, p. 451, repro.; Ashby and Constable 1925, pp. 208 and 288; Constable 1962, vol. 2, no. 381(b); Levey 1964, under nos. 417-18; Kozakiewicz 1966, p. 17; Vivian, 1971, pp. 143-44, pls. 125-26; Kozakiewicz 1972, vol. 1, pp. 39, 222, fig. C 49; vol. 2, pp. 51-52, no. 71; Camesasca 1974, no. 25; Constable and Links 1976, vol. 2, no. 381(b); Millar in Venice 1982, p. 70, under no. 100; Constable and Links 1989, vol. 1, p. lxxxix; vol. 2, no. 381(b) and p. 737; Brownell, in Verona 1990, p. 136; Levey 1991, pp. 48-49, under nos. 417-18; Succi, in Padua 1994, pp. 51 and 52, fig. 15; Kowalczyk 1996, pp. 72, 80 and 88, note 8; Ingamells 1997, pp. 516 and 871; Links 1998, pp. 13-14, under no. 129(a), and 38, no. 381(b).

Home's journal is of great importance, however, in establishing the two pairs of paintings as the only works by Bellotto known to have been owned by Smith. The question of whether the consul purchased the several hundred paintings which he left in 1770 before or after his famous sale to King George III eight years earlier remains open. It seems most unlikely, however, that these paintings by Bellotto were not acquired by him at the time they were painted.

Charles Beddington

[1] They are not mentioned by Villis 2000, for instance.
[2] Constable 1962, vol. 2, pp. 360 and 361.
[3] Kozakiewicz 1972, vol. 1, p. 52.
[4] For three other, less successful, compositions, see Kozakiewicz 1972, vol. 2, nos. 67, 137, and 139.
[5] Constable and Links 1989, vol. 2, nos. 713 (224-5).
[6] See cat. no. 26.
[7] It is conceivable that they were purchased by James Alexander, 1st Baron Caledon (1730-1802), who visited Venice in 1777; see Ingamells 1997, pp. 12-13.
[8] Constable 1962, vol. 2, nos. 379 and 381; Levey 1964 and 1991, nos. 417-18, as Canaletto and studio; they were shown in London 1990, no. 1, after surface cleaning, which, in the opinion of Links (1998, p. 38), left "little doubt" that they are "mainly, if not wholly, by Canaletto". In those most of the skyline foliage is omitted.
[9] Levey 1994, nos. 417-18, sees Bellotto's influence in the Royal Collection versions.
[10] By Semenzato, lot 53; Constable 1962, vol. 2, no. 381(a), as Canaletto.
[11] Constable 1962, vol. 2, no. 378; Levey 1964 and 1991, no. 372; Briganti 1970, pl. 17.
[12] For a detail, see Briganti 1970, pl. 18.
[13] Constable 1962, vol. 1, no. 379(a), as Canaletto; Kozakiewicz 1972, vol. 2, no. Z-318, as possibly by Bellotto; Hoff 1995, pp. 12-13, as Bellotto.
[14] See Ingamells 1997, pp. 515-17.
[15] Constable 1962, vol. 2, nos. 129(a) and 135; Martini 1964, pls. 196-97 and 204-5.
[16] Ingamells 1997, p. 517.

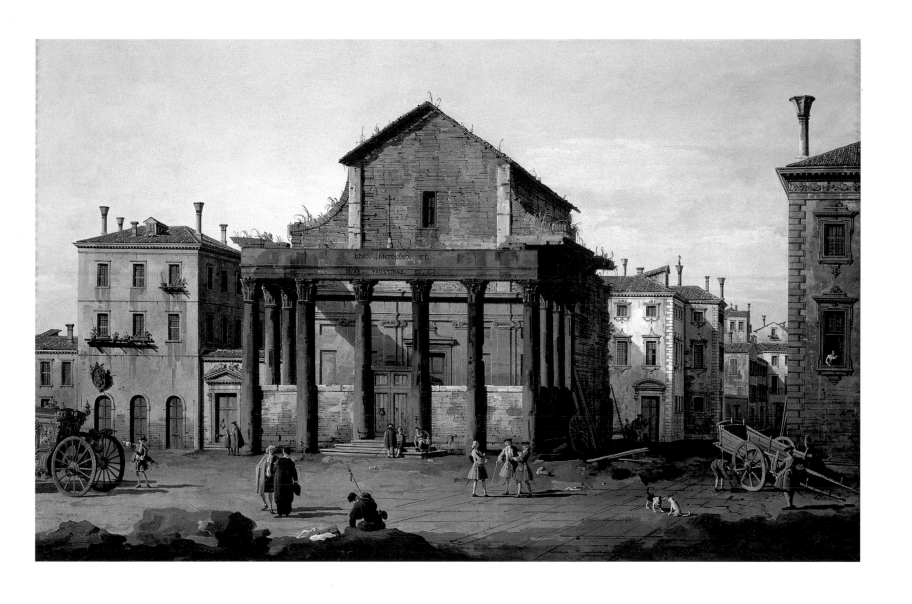

c. 1743
Oil on canvas
34 × 58 1/2 inches
(86.4 × 148.6 cm)
Petworth House,
The Egremont Collection
(The National Trust)

Provenance: Possibly acquired by Charles Wyndham, 2nd Earl of Egremont (1710-63), or, more probably, Percy Wyndham O'Brien, Earl of Thomond (1723-74), London;[1] by inheritance to his nephew, George O'Brien Wyndham, 3rd Earl of Egremont (1751-1837); thence by descent until accepted in lieu of death-duties in 1956 by H M Treasury, by which subsequently conveyed to the National Trust.

Exhibitions: London 1954, no. 7; London 1982, no. 5.

Bibliography: Collins Baker 1920, p. 13 (as Canaletto); Ashby and Constable 1925, p. 214 (as perhaps Bellotto); Fritzsche 1936, pp. 92, 94, 121; no. VG 163 (as Bellotto); Haskell and Levey 1958, p. 184, n. 27; Constable 1962, vol. 2, pp. 369-70, no. 398 (as attributed to Canaletto, but suggesting "the balance of possibilities favours [Bellotto's] authorship"); Kozakiewicz 1966, pp. 12-13 ("as Bellotto without reservations"); Kozakiewicz 1972, vol. 1, pp. 35, 37-38, vol. 2, pp. 55-56 (with previous references), no. 77; Busiri Vici 1976, p. 41; Bowron 1994, p. 30; Rowell 1997, p. 10; Villis 2000, pp. 76-77.

The only evidence of Bellotto's visit to Rome, other than his paintings and drawings, is the account of Pietro Guarienti, who knew the artist personally: "He was taught the principles of art by his uncle, Antonio Canal, and after having mastered these principles, began to imitate him with diligence. On the advice of his uncle he went to Rome to improve his style by drawing and painting the ancient ruins and the most beautiful views of that noble city."[2] It has been suggested that Bellotto's tour of Florence, Lucca, and Rome was financed by the Venetian publisher, Joseph Wagner (1706-80), but this cannot be proved.[3] There can be little doubt, however, that Bellotto was encouraged in this venture by Canaletto, who himself had visited Rome in 1719-20, accompanying his father, Bernardo, a painter of theatrical scenery, and working with him there on the sets for an opera by Scarlatti. Canaletto drew a number of views of the city, recorded in a sketchbook in the British Museum, with which Bellotto must have been familiar before going to Rome himself and is thought to have utilized in his own views of the city painted upon his return.[4]

Bellotto's central Italian journey is generally accepted as having extended over several months in 1742, the itinerary including stops at Florence and Lucca on the way to Rome.[5] Since Bellotto was almost certainly in Venice in the summer of 1743, most of the Roman views must date from 1743-44. Bellotto's principal Roman views, given the brevity of his residence in Rome, the unlikely possibility that he established a properly functioning studio there, and the increasing size of his canvases, were almost certainly painted in Venice.

This particular view of Santa Maria d'Aracoeli and the Campidoglio above ground level and to the right of the Cordonata was well-established in the sixteenth- and seventeenth-centuries by such graphic artists as Lieven Cruyl (1640-1720), Israel Silvestre (1621-91), and Giovanni Battista Falda (1643-78).[6] The broad flight of marble stairs on the left, built in 1348 as an offering in thanks for deliverance from a plague, leads to the bare brick façade of the medieval church of Santa Maria d'Aracoeli. The shallower Cordonata, which is flanked at the bottom by two Egyptian lions, rises obliquely across the lower part of the painting towards the Piazza del Campidoglio. The right half of the painting is filled with the Capitoline palaces: on the left, the Palazzo del Museo Capitolino; in the background, the Palazzo Senatorio; and on the right, the Palazzo dei Conservatori, seen from its end and partly concealed by the house at the edge of the painting.

At the top of the Cordonata are the antique statues of Castor and Pollux with their horses, the so-called Trophies of Marius, and statues of the Emperor Constantine and his son. The end of the left balustrade is terminated by a milestone of the Via Appia. The gilded bronze statue of Marcus Aurelius in the center of the Piazza is just visible behind the plinth of the statue of Pollux. On the right is the beginning of the Via delle Tre Pile, which rises beside the Cordonata and bends to the right where a coach ascends.

For a considerable portion of his Roman work, Bellotto made reference to the topographical engravings of others of the sites he was recording and in this instance he had the precedent of a drawing of the site made years earlier by Canaletto.[7] However, Bellotto inevitably constructed his own compositions, adapting perspective, varying light and shade, adding details, and introducing figures into the design on which he was working. Back in Venice, he based the Petworth composition on a pen-and-ink drawing now in Warsaw that he made on the spot in Rome.[8] The drawing contains annotations in the artist's hand concerning colors, intensity of tones, and the number of times certain details were to be repeated, and indicates the fall of light across the scene.

Bellotto viewed the site from an elevated point close to the right-hand lion at the base of the Cordonata, which he lengthened and made less steep than in reality. The façade of Palazzo Senatorio and its campanile are made smaller than they actually are in order to enlarge the Piazza del Campidoglio. Bellotto's other scenographic adjustments include a reduction in the size of the Palazzo del Museo Capitolino and an exaggeration of the perspective of its cornice and balustrade and a lengthening of the steps to the church of the Aracoeli.

The painting has been identified with a "*veduta del Campidoglio di Rome*" exhibited by Bellotto in the annual exhibition at the Scuola di San Rocco, Venice, on 16 August 1743.[9] A part of the Petworth view taken from a vantage point a little nearer to the foot of the Cordonata recurs in the *Capriccio with the Capitol*, Galleria Nazionale, Parma (repro. cat. no. 35).

Edgar Peters Bowron

[1] "*A view in Rome* by Canaletti" listed among the pictures in the Closet in the posthumous inventory taken of the Earl of Thomond's house in Dover Street, London, on 10 September 10 1774 may be identical with the Petworth painting; information from Alastair Laing, 23 December 1993.

[2] Orlandi and Guarienti 1753, p. 101, "*Per consiglio del zio portatosi a Rome fece uso del suo talento nel disegnare e dipingere le antiche fabbriche e le più belle vedute di quell' alma città.*"

[3] Michelangelo Muraro, in Florence 1953, p. 49, n. 93.

[4] Constable and Links 1989, vol. 1, pls. 130-32, vol. 2, pp. 559-63. For the attribution of these drawings to Canaletto, see Katherine Baetjer and J. G. Links, in New York 1989 90, p. 210, n. 2.

[5] Kozakiewicz 1972, vol. 1, pp. 33, 69-70; Marini 1991, p. 161.

[6] Bodart 1975, no. 294; see also Garms 1995, vol. 2, fig. C2. For Falda's view of the Capitol, see *Il Nuovo teatro delle fabriche et edificii in prospettiva di Roma moderna*, Rome, 1665-1669, pl. 10, from which the Palazzo del Museo Capitolino and Palazzo Senatorio appear to have been derived.

[7] Darmstadt, Hessisches Landesmuseum, AE 2186; Constable and Links 1989, vol. 1, pl. 132, vol. 2, p. 561, no. 238 (19).

[8] Kozakiewicz 1972, vol. 2, pp. 56-57, no. 78, repro.

[9] Haskell and Levey 1958, p. 184, n. 127, citing "Memorie di G. Zanetti," *Archivio Veneto*, XXIX, 1885, p. 145: "*De molti quadri, che soliono i più insigni pittori esporre ogni anno sopra la facciata della Scuola, soli due se ne videro in quest anno. L'uno, con veduta del Campidoglio di Roma, l'altro con le Chiovere di S. Gio. Evangelista di Venezia, ambidue di mano del nipote Antonio Canal, zio e nipote rinomatissimi per tal sorta di quadri.*" The authors argued that the Petworth painting was of a later date and thus could not be identified with the cited work.

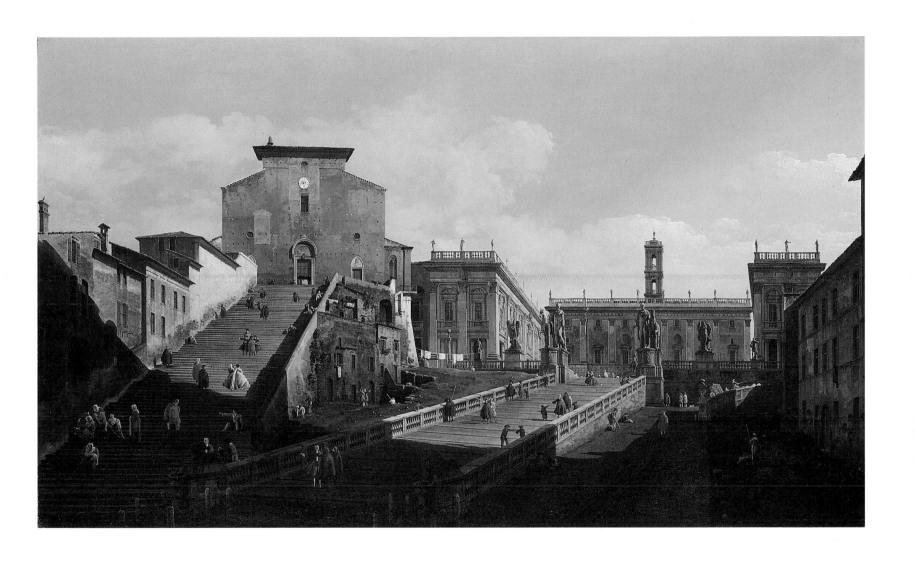

c. 1743-44
Oil on canvas
34 × 57 1/2 inches
(86.5 × 146 cm)
Kunstmuseum, Düsseldorf

Provenance: Saville family, Rufford Abbey, Nottinghamshire; sale, Christie's, London, 18 November 1938, lot 18; Sir Edmund Davis, Chilham Castle, Kent; Mrs. Thorneycroft Ryle, New York; her sale, Sotheby's, London, 27 November 1963, lot 96 (as Bellotto); Julius Weitzner, London; Hallsborough Gallery, London; purchased by the museum in 1964.

Bibliography: Constable 1962, vol. 2, pp. 373-74 no. 405 (as Canaletto, on the basis of a photograph); Kozakiewicz 1972, vol. 2, pp. 472, 476, no. Z 360 (as Canaletto, although "the execution of some of the figures in the foreground is reminiscent of the brushwork of the young Bellotto"); Marini 1991, p. 159 (as Bellotto); De Seta 1999, p. 87; Villis 2000, pp. 76, 78-80.

The Porto di Ripetta was built between 1703 and 1705, by order of Pope Clement XI, on the left bank of the River Tiber near Campo Marzio, where boats had landed since antiquity. By the fourteenth century the site had achieved prominence as the *ripetta* (literally "little bank") for smaller cargo boats that came downriver from Tuscany and Umbria. Under the direction of the architect, urban planner, and engraver, Alessandro Specchi (1668-1729), the construction of the Porto di Ripetta transformed a steep and rutted slope into a graded bank with ramps and steps that facilitated the unloading of grain, oil, wine, and wood arriving by river. Stone for the project was brought from the Colosseum, which had recently partly collapsed in an earthquake, and most of the construction was

completed by May 1704. The port was demolished in the late nineteenth century with the construction of the embankment walls of the Tiber and giant roadways (*lungotevere*) alongside.[1]

The Düsseldorf view, first published unequivocally as a work by Bellotto in 1991 by Marini, emphasizes the role of the Porto di Ripetta as a major pedestrian thoroughfare above its commercial significance. De Seta noted Bellotto's originality in depicting the port from a vantage point alongside the Tiber looking northward along the "Strada del Popolo" (today, via di Ripetta) rather than the more common view from the river. Both Gaspar Van Wittel (1652/53-1736) and Piranesi (1720-78), for example, depicted the port from the Tiber, highlighting the success of Specchi's graceful design with its magnificent double flight of curved steps and ramps rising more than fifty feet from the water to a formal piazza with a fountain in front of the church of San Girolamo.[2]

However, as the presence of the prominent, fashionably dressed couple in the foreground of the painting indicates, the scenic aspect of the quay had been greatly appreciated since the mid-seventeenth century. The embankment was an ideal retreat for a cool breeze from the river on a warm summer evening and a vantage point for the delightful and varied panoramas across the river of the vast meadows, the Prati di Castello, as well as the Castel Sant' Angelo and the dome of St. Peter's beyond. Indeed, as Tod Marder has written, "At the Porto di Ripetta the visitor could have enjoyed one of the few intentionally picturesque views of the Tiber ever monumentalized in the history of Rome."[3]

Bellotto has clearly utilized

Specchi's large engraving of 1707, or one of the many prints based upon it, for the articulation of the principal buildings on the right side of the quay.[4] These show, from right to left, the entrance to the Palazzo Borghese built for Prince Paolo Borghese in the 1670s by the architect Carlo Rainaldi (1611-91); the sixteenth-century façade of San Girolamo degli Schiavoni; and the bare façade of San Rocco before its neo-classical alteration in 1834 by the architect Giuseppe Valadier (1762-1839). The rooflines of the buildings to the right of San Girolamo have been regularized by Bellotto exactly as in Specchi's print, although in actuality they were irregularly spaced, uneven in height, and unequal in size. A comparison of these details to Piranesi's engravings and other eighteenth-century views of the site reveals that the buildings to the right of the church did not share an uninterrupted cornice and that, for scenographic reasons, Bellotto has manipulated the topography to obtain an orderly scansion of cornices and rooflines.[5] In the left foreground the low retaining wall which formed a courtyard to the Chapel of the Stevedores and Bargees is visible.

The steeply angled lines of perspective on both the right and left sides of the quay converge onto the keystone of the central arched window between the two portals on the principal façade of Specchi's customs house (*dogana*), completed in 1705. Bellotto follows Specchi's depiction of the *dogana* in the engraving of 1707 exactly but here, too, for pictorial purposes, he has taken liberties with the architectural details of the building. Although it appears symmetrical in the painted view in Düsseldorf, the structure was in fact L-shaped. Bellotto has eliminated the ungainly thicker arm along

the Via di Ripetta as well as a smaller section running from the street to the lowest level of the quay. The pediment above the balustrade has also been altered to appear more curvilinear and elegant.

The semi-circular façade of Specchi's ingenious staircase in front of the customs house is visible in the painting; at street level it was fitted with marble seats and balustrades. In the center is the Fontana dei Navigatori, formed by a mass of rough stones representing mountains supporting a star, which forms part of the Albani family crest, and two dragons from whose mouths issued water. The semicircle is terminated by two columns, carved in imitation of ancient Roman milestones, upon which were recorded the dates and heights of the Tiber's floods.

The Düsseldorf view of the Porto di Ripetta was paired with a view of Palazzo del Quirinale until 1963, sometime after which it is believed to have been destroyed by fire.[6]

Edgar Peters Bowron

[1] For the Porto di Ripetta, see Marder 1980, pp. 28-56, Johns 1993, pp. 183-85; Spagnesi 1997, pp. 48-60, repro.
[2] Briganti 1996, pp. 178-79, repro.; Johns 1993, fig. 105.
[3] Marder 1980, p. 28.
[4] Marder 1980, p. 35, fig. 10. For another, anonymous early-eighteenth century print, see Garms 1995, vol. 2, p. 41, fig. 308.
[5] Marder 1980, p. 36, figs. 13, 14.
[6] Kozakiewicz 1972, vol, 2, p. 472, no. Z345, repro., as Canaletto.

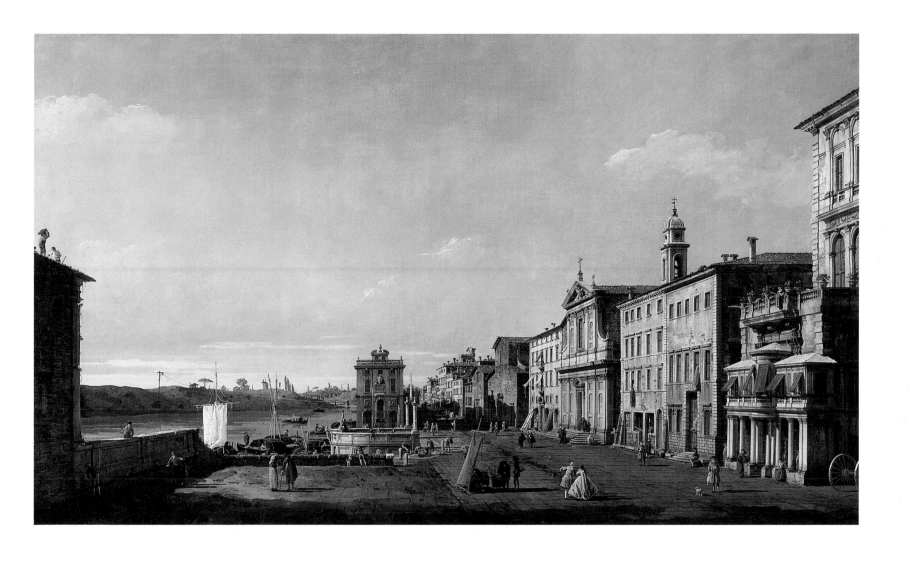

c. 1743-44
Oil on canvas
38 3/4 x 29 1/2 inches
(98.5 × 75 cm)
Private collection

Provenance: Probably acquired by Thomas, 5th Baron King (1712-79), London and Ockham Park, Surrey, by descent at Ockham through William, 8th Baron King, called Earl of Lovelace in 1838; Peter Malcolm, 4th Earl of Lovelace (1905-64); his sale, Sotheby's, London, 13 July 1937, lot 82 (as Bellotto); sale, in behalf of the Executry of Manon, Countess of Lovelace, Christie's, London, 10 December 1993, lot 60.

Bibliography: Constable 1962, vol. 2, p. 363, no. 386a ("the attribution to Bellotto is highly plausible"); Kozakiewicz 1972, vol. 2, p. 55, no. 74 (with previous references); Busiri Vici 1976, p. 39; Marini 1993, p. 131, n. 4; Bowron 1994, p. 31; Links 1998, p. 38, no. 386a (as Bellotto).

This view of the Porta Santo Spirito, together with a companion painting of the Arch of Titus (cat. no. 23), was not seen publicly for more than half a century until its appearance in 1993 at Christie's in London. Following cleaning, both works have emerged as among Bellotto's finest Roman views, remarkable for their descriptive exactitude, crisp handling, and powerful chromatic and tonal contrasts. The paintings are among the realistic views of Rome Bellotto painted in Venice following his return from the city, possibly when he was still sharing a studio with Canaletto. Lack of time renders it impossible that Bellotto should have executed very many of the known paintings of Roman motifs while he was actually there and, as Koza-

kiewicz has noted, the Roman views must have been completed by early in 1744, when the artist was in Lombardy.[1] Bellotto was often attracted by the natural theatricality of a topographical site such as the Porta Santo Spirito, which he exaggerated by adopting a close viewpoint, steep foreshadowing, and a wide angle of vision. Following the Sack of Rome in 1527, Paul III strengthened the southern tract of the Mura Leonine and in 1540 employed the architect Antonio da Sangallo (1484-1546) to design a new access to the *rione* of the Borgo, which immediately took the name of the nearby church of Santo Spirito in Sassia. The gateway was never completed, however, due to disagreements between the architect and Michelangelo, who had become the military consultant to the pope in 1545. In the painting, the Via dei Penitenzieri is shown leading into the Città Leonina. On the right, in the middle ground, the graceful campanile of the church, attributed to Baccio Pontelli (c. 1450-92), rises above the gate. At the extreme upper left edge of the canvas the casino of the seventeenth-century Villa Barberini is visible on one of the bastions erected in 1563 by Pio IV.
Most of the motifs Bellotto included in his Roman views, however, are also to be found in the paintings and drawings of earlier artists. He was certainly acquainted with the great mass of topographical prints that had been published in Rome in the sixteenth, seventeenth, and eighteenth centuries, and there can be no question that for both the realistic views and *vedute ideate* made after he left the city, he turned to these for guidance in depicting architectural details of a given site. There was a considerable amount of topographical material available for the

young artist to draw upon for detailed records of contemporary Rome which preceded Giuseppe Vasi's great compendium of the city's gates, squares, churches, convents, palaces, bridges, and villas, *Delle magnificenze di Roma antica e moderna* (1747-61), and Bellotto certainly utilized these sources in the creation of his own views of the Eternal City.[2] However, during his brief visit to the city in 1742, Bellotto also must have made numerous drawings of Roman motifs, of which only a mere fraction survive. Regardless of whether he had been sent to Rome by Canaletto to collect materials for their joint use or, as has been suggested, by the Venetian publisher and printmaker, Joseph Wagner (1706-80), to gather topographical data for a projected series of etchings, few drawings exist which appear to have been made with either of these purposes in mind.[3] Fortunately, a pen-and-ink study for the present view of the Porta Santo Spirito survives at Darmstadt and documents, in Kozakiewicz's words, Bellotto's "very personal vision of the buildings of Rome".[4] The sheet is typical of Bellotto's handling in his early drawings, marked by heavy hatching and a scratchy, all-over effect that nonetheless captures the salient topographical details of the scene.
Kozakiewicz's observation that "architecture is the protagonist of the Roman paintings and drawings to a degree which Bellotto only reached on exceptional occasions in earlier and future works," is borne out by both the painted and drawn views of the Porta Santo Spirito.[5] Clearly the portal made a deep impression on the artist, and in the Darmstadt drawing he concentrates on the site to the neglect of the day-to-day

life of the city. A pair of figures appears in the foreground, the principal function of which is to impart a sense of scale to the imposing arch behind. In the final version, however, Bellotto has enlivened the scene with a coach and horse, passers-by, and a man urinating against the wall in the lower left corner of the painting.
This view of the Porta Santo Spirito represents an important advance in Bellotto's technical proficiency and in the creation of a personal style, and its sophistication of handling and technique suggest that it was among the latest of the artist's realistic views of Rome when he was fast concluding his early stage of development. He is able to manipulate the *mis-en-scène* with great sophistication, lighting the space like a stage with pronounced areas of light and shade and leading the viewer by means of the alteration of areas of brightness and darkness to a point in the depths of the painting. The view and its companion also display Bellotto's tendency around 1744 to employ a deeper palette, his preference for increasingly brighter skies set with white clouds, and his use of a small red accent on the garments of his figures.[6]

Edgar Peters Bowron

[1] Kozakiewicz 1972, vol. 1, p. 38.
[2] See, for example, Vasi's own view of the Porta Santo Spirito in his *Delle magnificenze di Roma antica e moderna*, Rome, 1747, pl. 78.
[3] Kozakiewicz 1972, vol. 1, p. 35.
[4] Darmstadt, Hessisches Landesmuseum, AE 2240. Kozakiewicz 1972, vol. 1, p. 36; vol. 2, p. 55, no. 75, repro.; Bleyl 1981, p. 54, no. 42, repro.
[5] Kozakiewicz 1972, vol. 1, p. 36.
[6] Kozakiewicz 1972, vol. 1, pp. 37-38.

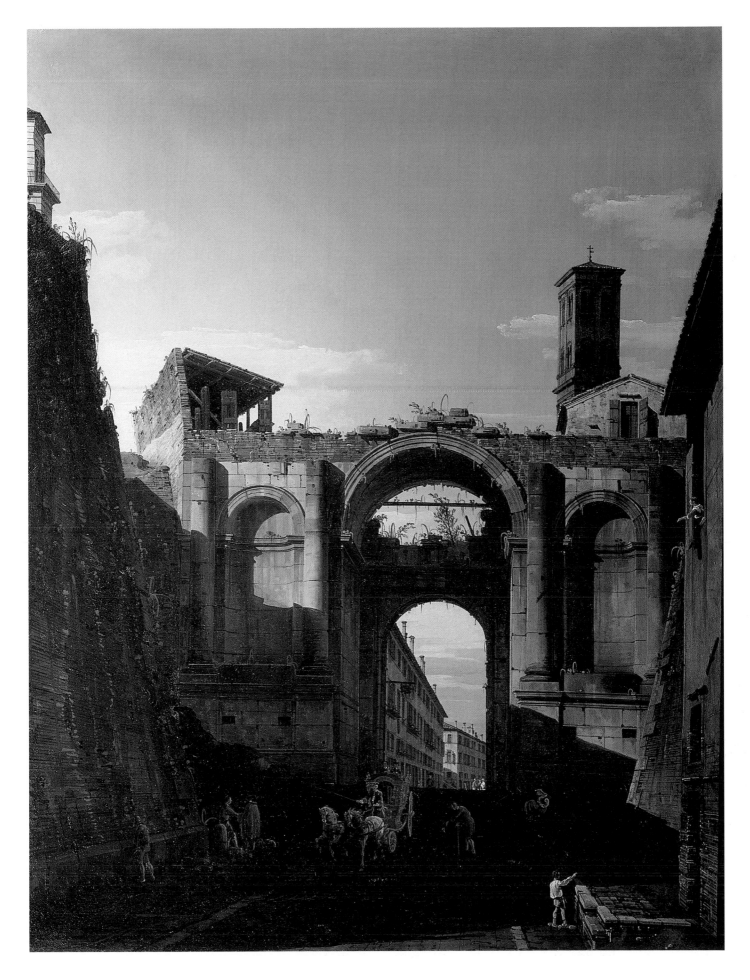

Tuscany, Rome

c. 1743-44
Oil on canvas
38 3/4 x 29 1/2 inches
(98.5 × 75 cm)
Inscribed on the arch:
.SENATVS./ POPVLVSQVE.
ROMANVS./
DIVO.TITO.DIVI.VESPASIANI
.F[ILIO]./ VESPASIANO.
AVGVSTO.
Private collection

Provenance: Probably acquired by Thomas, 5th Baron King (1712-79), London and Ockham Park, Surrey; by descent at Ockham through William, 8th Baron King, created Earl of Lovelace in 1838; Peter Malcolm, 4th Earl of Lovelace (1905-64); his sale, Sotheby's, London, 13 July 1937, lot 83 (as Bellotto); sale, in behalf of the Executry of Manon, Countess of Lovelace, Christie's, London, 10 December 1993, lot 60.

Bibliography: Watson 1954, p. 17; Constable 1962, vol. 2, p. 363, no. 386a ("the attribution to Bellotto is highly plausible"); Levey 1991, p. 14; Kozakiewicz 1972, vol. 1, p. 35, vol. 2, p. 55, no. 72 (with previous references); Marini, in Verona, 1990, p. 70; Marini 1993, p. 131, n. 4; Bowron 1994, p. 31; Links 1998, p. 38, no. 386a (as Bellotto).

Bellotto did not restrict his interests exclusively to the sights of modern Rome. This view of the Arch of Titus, with the wall of the former Farnese Gardens and Vignola's sixteenth-century garden wall and its imposing gate (now unfortunately demolished) and the columns and fragment of entablature of the Temple of Castor and Pollux beyond, is a notable example of his interest in Rome's classical heritage. Dominating the summit of the Sacra Via, the arch was erected in AD 81-82 in honor of the victories of Titus and Vespasian in the Judean War, which ended with the Sack of Jerusalem in AD 70. The view through the arch toward the Roman Forum was a prospect highly popular with artists from the sixteenth to the nineteenth centuries, most of whom, like Bellotto, chose a vertical composition that emphasized the monumental effect of the arch.[1] During the Middle Ages the Arch of Titus was incorporated into the fortress of the Frangipani family and had a room built into its upper story. Much of this structure was removed in the fifteenth century but the remains of the brickwork appear in Bellotto's painting. When the remnants of the medieval fortifications were removed during the restoration by the architect Giuseppe Valadier in 1821-22, the arch had to be taken down and reconstructed, with new sides, resulting in its radically different appearance today. Bellotto's view is topographically correct except for minor adjustments such as the inclusion of the third column of the remains of the Temple of Castor and Pollux, which would not be visible from this angle.[2] The Capitoline Hill and the medieval bell tower surmounting the Palazzo Senatorio, moreover, should be visible in the distance through the arch, as they appear in most eighteenth-century views of the site. The *Arch of Titus*, paired with a pendant view of the Porta Santo Spirito (cat. no. 22), was lost sight of for fifty years until its appearance in the sale room in 1993. The existence of a small oil sketch for the composition in the Accademia Carrara, Bergamo,[3] suggests that Bellotto employed a more elaborate sequence of stages in the evolution of his topographical view paintings than is usually assumed, and that other preparatory materials once existed for this work that are now lost. The handling of the sketch is free and rapid, the architecture indicated swiftly with the point of the brush, the figures freely described. The sky is broadly indicated with Bellotto's characteristic diagonal hatching and the clouds are quickly roughed in. Although numerous minor differences exist between the sketch and the final composition, there seems little reason to doubt that the Bergamo canvas was painted in Rome at the time visited Bellotto the site, and that the Lovelace *Arch of Titus*, more carefully finished, more vivid in coloration, and more sophisticated in its distribution of light and shade, was painted at a later date following the artist's return to Venice.

The similarities between Bellotto's composition and Canaletto's treatment of the site in a painting in the Royal Collection at Windsor, one of five large upright views painted in 1742, for Joseph Smith, has given rise to considerable discussion regarding the possibility of collaboration between the two painters at this moment.[4] If Canaletto in fact instigated Bellotto's visit to Rome in 1742, as is generally believed, in the opinion of many historians he also appears to have profited from the younger artist's experiences there. So closely is Canaletto's painting related to Bellotto's *Arch of Titus* in the treatment of the figures, the use of heavy shadows, and other aspects of the handling that the younger artist is thought to have swayed Canaletto's conception of the entire group.[5] Newly arrived from Rome with his memory of the topography fresh, Bellotto recorded and painted the triumphal arch more accurately than Canaletto, who almost certainly had not been to Rome after a visit in 1719-20, with his father, Bernardo Canale.

Michael Levey observed that the upper portion of the house adjoining the arch at the far left is treated in far more convincing detail in Bellotto's view, for example, and that Bellotto has transcribed the Latin inscription on the arch more accurately than Canaletto.[6]

On the other hand, probably very few of Bellotto's Roman views were necessarily painted in Rome. Most were painted in Venice, probably in Canaletto's studio, which Bellotto was still sharing, using his drawings made earlier on the spot. Levey believed that the two artists collaborated on some paintings at this period, and that in them Canaletto may have been stimulated and even influenced by his nephew.[7] The difficulty in accepting the influence of Bellotto on Canaletto's Roman views, however, is the date of the five paintings, 1742. Bellotto is recorded as having exhibited two paintings at the Scuola di San Rocco in August 1743, but he cannot have been back in Venice much before the autumn of 1742 at the earliest. The shared stylistic qualities of Canaletto's and Bellotto's paintings at this early date, the lack of atmosphere, stiff figures, and their visual "immediacy", for example, could just as easily have been transmitted to Bellotto from Canaletto rather than the other way round.[8]

Edgar Peters Bowron

[1] See Oehler 1997, p. 137; Briganti 1996, pp. 160-61.
[2] See Corboz 1985, vol. 1., fig. 57, for a photograph of this view made about 1865.
[3] Kozakiewicz 1972, vol. 2, p. 55, no. 73; Verona 1990, pp. 70-71, no. 10, col. repro.
[4] Constable and Links 1989, vol. 1, pls. 70-72; vol. 2, nos. 378, 382, 384, 386, and 390. See also the references in the following note.
[5] See Constable and Links 1989, vol. 1, p. 125; Kozakiewicz 1972, vol. 1, pp. 39-40; Levey 1991, p. 14; Links 1994, p. 136.
[6] Levey 1991, p. 14.
[7] *Ibid.*
[8] See note 5. It should further be noted that Canaletto could not have depicted the Arch of Titus with such precision from the Bergamo sketch alone, and that the various details of the arch are depicted slightly differently in each of the paintings by Canaletto and Bellotto.

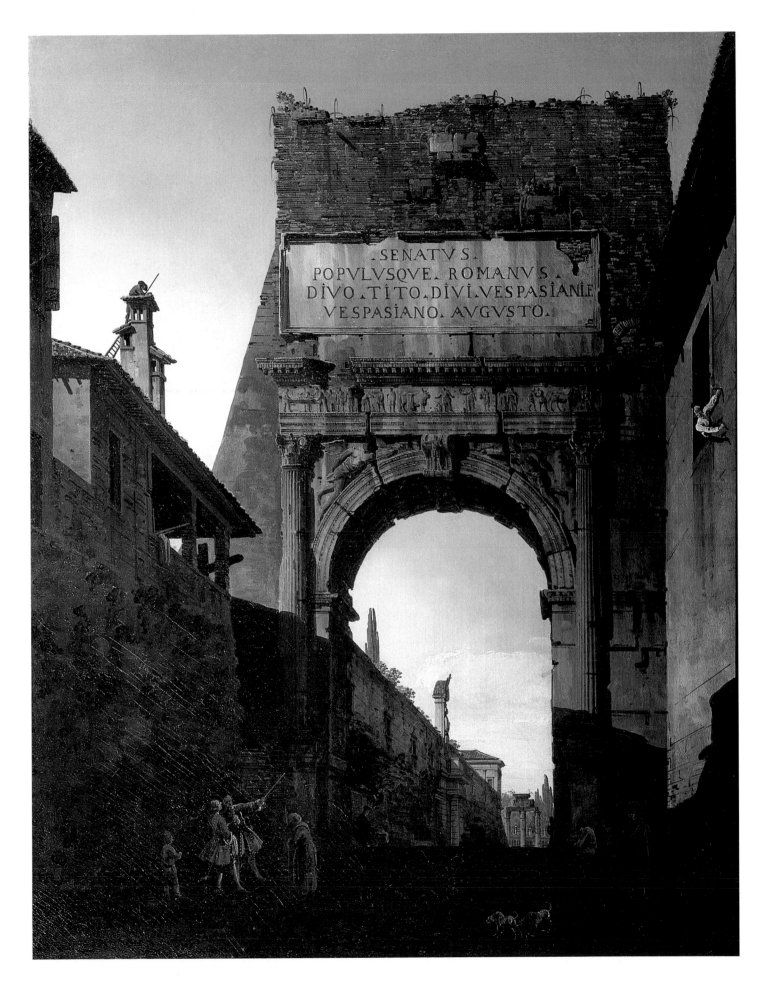

The inscription on the arch reads:

.SENATVS.
POPVLVSQVE. ROMANVS.
DIVO. TITO. DIVI. VESPASIANI F
VESPASIANO. AVGVSTO.

24. *View of the Tiber with the Castel Sant'Angelo and San Giovanni dei Fiorentini, Rome*

c. 1743-44
Oil on canvas
33 1/2 × 57 1/2 inches
(85.1 × 146.1 cm)
Toledo Museum of Art

Provenance: John Pemberton Heywood, Wakefield, England, c. 1800; by descent to Lt. Col. A. Heywood-Lonsdale (died 1976), Shavington Grange, Market Drayton, Shropshire; sale, Christie's, London, 2 July 1976, lot 59; Thomas Agnew & Sons, London, 1976, from whom purchased by the museum (no. 77.3) with funds from the Libbey Endowment, gift of Edward Drummond Libbey.

Exhibitions: Shrewsbury 1951, no. 3 (as Canaletto); London 1954, no. 39 (as Canaletto, but suggesting as by Bellotto); Liverpool, Walker Art Gallery, extended loan, 1958-76; London 1960, no. 184.

Bibliography: Voss 1955, p. 39 (as Bellotto); Watson 1955, p. 262 (as Bellotto); Constable 1962, vol. 2, p. 374, no. 407 (as attributed to Canaletto, but noting "the color and the handling of the lights is distinctly that of Bellotto"); Krönig 1961, pp. 403; Kozakiewicz 1972, vol. 1, p. 35, vol. 2, p. 51, no. 65 (with earlier literature); Busiri Vici 1976, pp. 39-40; Marini, in Verona 1990, p. 68; Marini 1991, p. 147, 159-61; Bowron 1994, pp. 29-30; Links 1998, p. 39, no. 407 (as Bellotto); Villis 2000, pp. 76, 80-81.

Hermann Voss was the first to argue conclusively in favor of this painting as a work by Bellotto and to connect it with the companion view of the Tiber in the Detroit Institute of Arts (cat. no. 25). Both paintings highlight the importance of river landscapes in Bellotto's work and his preference for local topographical sites that would accord with his training and development as

a Venetian *vedutista*. His selection of these particular sites along the Tiber was not accidental but rather intended to emphasize predominant features of the Roman urban topography, ancient and modern, pagan and Christian, imperial and papal. In the accounts of travelers to Rome, the Castel Sant'Angelo and St. Peter's have continually vied for attention, each conspicuous for its size, scale, and monumentality.[1]

The Toledo view is taken from a spot on the right bank of the Tiber near the Palazzo Salviati at the beginning of the via della Lungara, looking north-east with the river curving sharply to the right. On the far bank is the national church of the Florentines, San Giovanni Battista dei Fiorentini, with its dome by the architect Carlo Maderno (1555/56-1629) and choir at the west end, and a row of houses alongside the river. Various craft on the Tiber, including a floating mill, are depicted, and in the distance, brilliantly illuminated and situated nearly in the center of the composition, is the Castel Sant'Angelo.[2] The skillful contrasts of light and shade and the balance of shapes is highly theatrical, and indeed one writer has employed a theatrical metaphor to describe Bellotto's compositional organization.[3]

Thus, the house projecting at the left edge of the scene and the parapet running along the river serve to define the proscenium, on which various figures are illuminated before a shadowy backdrop. The elegantly dressed gentlemen appear on this stage and turn to admire the view before them which appears as if painted on a giant curtain.

Bellotto has chosen a vantage point favored by such sixteenth-and seventeenth-century graphic artists as Lieven Cruyl (1640-1720), Gomar Wouters (c. 1649-96), and Giovanni Battista Falda

(1643-78), one that was given definitive form in the gouaches and oils of Gaspar Van Wittel (1652/53-1736).[4] By the middle of the century this particular view had become a favorite of visitors on the Grand Tour and a familiar feature in the repertory of settecento Roman view painters, although few artists of the period could rival Bellotto's magical depiction of light and shade in the Toledo painting. If Bellotto has a weakness at this stage of his development, it is his figures, which continue to appear stiff and mechanical. Even so, the rôle of the staffage within the composition is carefully calculated and beautifully controlled down to the gesture of the *cicerone* pointing out a feature of the church on the opposite bank. The balanced and harmonious composition, assured perspective, bold palette of saturated greens and blues, contrasts of light and shade, and crystalline atmosphere of both the Toledo and Detroit views of the Tiber reveal a deeply personal idiom that heralds Bellotto's Dresden views for Augustus III, King of Poland and Elector of Saxony, a few years later.

Bellotto painted smaller versions of the Toledo and Detroit views that may have served the function of preliminary sketches.[5] These correspond closely to their respective larger compositions, but differ in incidental details such as the figures, watercraft, placement of clouds, and minor architectural features. Moreover, the two smaller canvases reveal a looser, even rougher handling that suggests that each may have preceded the larger, more carefully finished compositions. The brevity of Bellotto's residence in Rome and the unlikely possibility that he established a properly functioning studio there suggest that most, if not all, of the large Roman views presently in Detroit,

Toledo, Düsseldorf (cat. no. 21), Petworth (cat. no. 20), Melbourne, and elsewhere were executed after his return to Venice on the basis of drawings and small oil sketches he made in Rome and of prints and pictorial records of the city by others. Another preparatory source for the Toledo painting is a pen-and-ink drawing in the Hessisches Landesmuseum, Darmstadt, that emphasizes by means of idiomatic diagonal hatching the play of light and shade over the scene.[6] It is not at all clear, however, whether the drawing preceded the small oil as in the usual sequence of such preparatory materials or perhaps reveals an intermediary stage.

Edgar Peters Bowron

[1] For example, George Howard, *Six Months in Italy*, London, 1853, quoted by Scherer 1955, no. 202: "The most familiar view of Rome embraces the castle and the bridge of St. Angelo and the church of St. Peter's. A thousand times had I seen it in engravings, and it was with a peculiar feeling – half reconstruction and half surprise – that I beheld the real group in the smokeless air of a Roman December. The combination is so happy and picturesque that they appear to have arranged themselves for the especial benefit of artists, and to be good-naturedly standing, like models, to be sketched. They make a picture inevitable."
[2] For further discussion of the site, see Marini, in Verona 1990, pp. 159-60.
[3] Marini, in Verona 1990, p. 68.
[4] Marini 1991, p. 159; Briganti 1996, pp. 186-88, nos. 151-53, repro.
[5] Formerly, Barbara Piasecka Johnson Collection, Princeton, N.J.; Verona 1990, nos. 8, 9, oil on canvas, 48 × 71.5 cm; Marini 1991, p. 147.
[6] Inv. no. AE 2242; Kozakiewicz 1972, vol. 2, p. 51, no. 66, repro.; Bleyl 1981, p. 55, repro.

Tuscany, Rome

c. 1743-44
Oil on canvas
34 1/2 × 58 1/2 inches
(87.6 × 148.6 cm)
Detroit Institute of Arts

Provenance: George Folliott, Vicar's Cross, Chester, England; sale, Sotheby's, London, 14 May 1930, lot 58 (as Canaletto), bought by P. & D. Colnaghi, London; Jacob N. Heimann, New York, 1940; purchased by the museum (no. 40.166) with a gift of funds from Mr. and Mrs. Edgar B. Whitcomb, Detroit

Exhibitions: London 1930, no. 13 (as Canaletto); Toledo 1940, no. 13 (as Canaletto); Detroit and Indianapolis 1952-53, no. 3; Kansas City 1956, no. 4; Oberlin 1963, no. 17; Chicago, Toledo, and Minneapolis 1970-71, no. 14; Tokyo, Kyoto, and Ibaraki 1989, no. 38.

Bibliography: Richardson 1941, pp. 60-62; Constable 1962, vol. 2, p. 374-75, no. 407a ("in every respect a characteristic work by Bellotto"); Voss 1955, pp. 39, 46; Krönig 1961, pp. 403, 404, 406; Pignatti 1966, p. 219; Kozakiewicz 1972, vol. 1, pp. 35, 38, vol. 2, pp. 48-49, 51, no. 64 (with previous references); Giorgio Marini, in Verona, 1990, p. 66; Marini 1991, pp. 147, 149; Bowron, 1994, p. 28; Villis 2000, pp. 76, 80.

This magnificent view of the Castel Sant'Angelo, with St. Peter's in the distance, reveals clearly how proficient Bellotto had become by the age of twenty-one or twenty-two, and how rapidly his precocious talent for pictorial exactitude developed in the early 1740s. The vantage point is probably from a house near the Tor di Nona, demolished in 1892-93 together with the houses and palaces built directly over the river in the left foreground of the painting during construction of the Lungotevere.[1] In the distance, the fifteenth-century hexagonal tower of Santo Spirito in Sassia, the dome and façade of St. Peter's, the main wing of the Palazzo Apostolico, the church of Santa Maria in Traspontina, and the *nicchione* at the north end of the Cortile della Pigna are visible. On the right is the Castel Sant'Angelo, the massive cylindrical mausoleum begun by Hadrian in the AD 120s, with a marble statue of the archangel Michael by Raffaello da Montelupo (1504-66) on top. In general, Bellotto was remarkably accurate in his topography, but when necessary he took artistic license with minor details. Here, he has eliminated one of the two small arches at the right end of the bridge, the Pons Aelius, which Hadrian built to give access to his tomb and which was decorated in 1668 with angels carved by Gian Lorenzo Bernini (1598-1680) and his followers. Several insignificant elements of the fortifications on the riverbank have also been altered.

In Rome, Bellotto was influenced in his choice of views by those of the many *vedutisti* who preceded him, notably the great innovator and, for all practical purposes, inventor of view painting in eighteenth-century Italy, Gaspar Van Wittel (1652/3-1736). Vanvitelli (as he was known in Italy) deeply influenced the course of naturalistic view painting throughout Italy – his imaginative compositions, meticulous grasp of detail, and refinement of colour and tone set a standard for all practitioners of the genre in the next generation. Van Wittel's view of the Tiber and of the Castel Sant'Angelo, with the basilica of St. Peter's in the distance, for example, became the "classic" view of this site, although it had been a popular subject with artists from the late sixteenth century and continued as a favorite motif of artists and photographers well into the nineteenth.[2] His earliest painting of the Tiber with the Castel Sant'Angelo is dated 1683, but the scene was a staple of his topographical repertory, and he repeated the composition frequently thereafter.[3]

A comparison between Bellotto's view of the Castel Sant'Angelo and Van Wittel's reveals the Venetian's approach to the formal dynamics of the *veduta*. Painting on a canvas many times larger than the small sheets of parchment the Dutch painter typically employed, Bellotto reduced his composition to its essentials. His inherent sense of theater is revealed in the simplification of Van Wittel's breadth of view and reduction of his depth of field. By lowering the viewpoint – the horizon rises, characteristically, to about a third of the height of the painting – and compressing the composition within the area defined by the receding orthogonals of the banks of the Tiber, Bellotto achieved a harmony and balance that Van Wittel's scene conspicuously lacks. The foreground is limited to a few hundred feet of water terminated by Bernini's Ponte Sant'Angelo, which links the east bank of the river to the Castel Sant'Angelo on the opposite side. The prominence given to the Tiber emphasizes how strongly Bellotto's Venetian origins influenced his pictorial imagination and underscores the prominence of river landscapes throughout his career.

Bellotto's handling is characteristic of this moment in his career: the paint is applied with minimal impasto, visible primarily in the finest details and highlights. Most of the texture on the surface of the canvas results from perspective lines inscribed in the ground, delineating the principal edges and arches of the architecture. Looser brushstrokes are employed for the water, banks of the river, and the mottled embankment walls. The ground beneath the sky is white; the layer above is probably a light, cool blue, but now, with discoloration of the natural resin varnish, appears blue-green. The ground in the remainder of the picture is less easily visible, but may have been white covered with a light brown imprimatura.

The Detroit painting was first attributed to Bellotto by Hans Tietze in the exhibition, *Four Centuries of Venetian Painting*, Toledo, 1940. It was probably accompanied originally by a companion view of the church of San Giovanni dei Fiorentini with the Castel Sant'Angelo in the distance (cat. no. 24), for which see discussion of two smaller, related views.

Edgar Peters Bowron

[1] Marini 1991, p. 149, fig. 2.
[2] For selected sixteenth-century precedents, see Oehler 1997, pp. 125-26.
[3] Briganti 1996, pp. 178-81, nos. 126-36, repro.

c. 1743-44
Oil on canvas
24 5/8 × 38 5/8 inches
(62.5 × 98 cm)
Private collection

Provenance: Presumably acquired by Thomas, 5th Baron King (1712-79), and by descent at Ockham Hall, Surrey, through William, 8th Baron King, created Earl of Lovelace in 1838, to Peter, 4th Earl of Lovelace; his sale, Sotheby's, London, 13 July 1937, lot 128, as Canaletto (£800 to Tooth); with Arthur Tooth & Sons, London, from whom acquired in July 1942 by Mr, later Sir, Clifford Curzon, London; his posthumous sale, Christie's, London, 10 December 1982, lot 81 (to Richard Green); with Richard Green, London, from whom purchased by the present owner.

Exhibitions: London 1954-55 no. 155 (as Canaletto); Rome 1959, no. 124 (as Canaletto).

Bibliography: Parker 1948, pp. 51-52, under no. 109; Watson 1955, p. 262 (as Bellotto); Constable 1962, vol. 2, no. 400 (as Canaletto) and under nos. 713(241) and 727; Martini 1964, p. 250, note 214, fig. 208 (detail); Puppi 1968, no. 211; Briganti 1970, pl. 13 (detail); Kozakiewicz 1972, vol. 2, p. 472, no. Z 347 (as Canaletto); Links 1981, no. 181; Corboz 1985, vol. 2, no. P 319; Constable and Links 1989, vol. 2, pp. 400-401, no. 400 (as Canaletto); Pallucchini 1995, p. 492; Links 1998, p. 39, no. 400 (as Canaletto).

This unusual view shows the Piazza di San Giovanni in Laterano as transformed by the architect Domenico Fontana (1543-1607) for Pope Sixtus V. In the centre is the ancient Egyptian obelisk moved there from the Circus Maximus in 1588, with to the right the west facade of

the new Lateran Palace, and to the left the building housing the Scala Santa (both 1585-90). Only a small part of the benediction loggia (1588) fronting the north transept of the Basilica of San Giovanni in Laterano, the cathedral of Rome, is shown on the far right, while the ruins towards the left are of the Aqueduct of Nero.

This painting, here exhibited as the work of Bellotto for the first time, demonstrates with particular clarity how many of the artist's most distinguished early productions became – and remained – attributed to Canaletto. Francis Watson proposed nearly half a century ago that this and the Toledo view of the Tiber with the Church of San Giovanni dei Fiorentini (cat. no. 24) "must now, it seems, be restored to Bellotto", on account of the recurrence of "whip-like" reeds in both and in irrefutable works by the artist such as the Dublin view of Dresden from the right bank of the Elbe, above the Augustusbrücke, the Barlow *Capriccio with a Ruined Triumphal Arch and an Imaginary City beside a River*, and several of the Darmstadt drawings.[1] Constable, in notes made at the time of the 1937 sale,[2] observed of the painting that it represented a "Type that may be Bellotto and I think is – very like 82 and 83 in sale [cat. nos. 22, 23 in the present exhibition]," and, after seeing the painting in November of that year after cleaning, annotated a photograph, "I prefer Bellotto". By the time of the publication of his monograph in 1962, however, he had became wary of attributing Italian views to Bellotto and toned down his earlier opinion beyond recognition. The attribution to Canaletto has since remained unchallenged in print, being firmly endorsed by Martini, Puppi and Kozakiewicz, and retained for the 1982 sale. At

some stage the upper part of the characteristically thin Bellotto sky has been strengthened, the overpaint now darkened being clearly visible, presumably in order to make it look more like a typical Canaletto sky.

The origin of the misattribution of the painting to Canaletto lies in the sale of 1937 in which the Lovelace collection of view paintings was offered and largely dispersed. Previously unpublished and unrecorded, the view of the Lateran Palace was sold as part of "The Important Series of Pictures by Antonio Canale (Canaletto)" (lots 128-35)[3] rather than with the two paintings by Bellotto (lots 82-83 [cat. nos. 22, 23]), despite being smaller than any of the Canaletto paintings but in width identical to the height of the latter. Parker's observation that the composition depends on a drawing by Canaletto in the British Museum,[4] part of a series of twenty-three made in Rome in 1719-20,[5] of which a version is at Windsor,[6] has since been considered conclusive. Constable only hinted at Bellotto's possible use of his uncle's Roman drawings. Bellotto's use of those, one of which remained in his possession until his death, is now better understood, and no fewer than four other paintings by him are based on them.[7] The drawing at Windsor, which in the placing of the figures is intermediate between the British Museum drawing and the painting, would also seem, from its technique and distinctive cloud formations, to be the work of Bellotto,[8] although it differs from both in the proportions of the Lateran Palace and in the angle of the diagonal shadow across its façade.

More significantly, the painting reveals a fresh examination of the subject matter, for both drawings omit almost entirely the basilica, show no central gap

between Fontana's buildings or the hills beyond, and give the windows of the lower storey of the Lateran Palace imaginary pediments like those of the two upper storeys. Such corrections and alterations would have required prodigious feats of recall from Canaletto, who had not seen the site for decades. Bellotto's authorship is, in any case, beyond question. The sombre mood, the solidity of the blocks of architecture, the cold, wintry light, the colouring, predominantly in distinctive shades of brown and green, the texturing and the puppet-like figures are all characteristic, as are the striated, purple-tinged bands of the distant sky and, indeed, Watson's "whip-like reeds". The gentleman pointing with his cane at lower left parallels a figure *The Arch of Titus* (cat. no. 23), while the mannered elegance of the coach and horses is identical to that of the similar details in the a view of the Pantheon and the Piazza della Rotonda in the Dayton Art Institute, and in Lombard works by the artist.[9]

The confidence of the handling suggests a date after Bellotto's return from Rome to Venice. It is probable that it was Thomas, 5th Baron King (1712-79), rather than either of his brothers, Peter, 3rd Baron (1709-54) and William, 4th Baron (1711-67), who acquired the three paintings by Bellotto and commissioned the seven by Canaletto. It was certainly he who commissioned from Claude-Joseph Vernet (1714-89) a pair of marines dated 1767 and 1770,[10] and he is thus the only member of the family known to have taken an interest in the visual arts. Although no visit to Italy is recorded for him (or either of his brothers), he certainly sent his son on the Grand Tour, in 1769-70, and he alone married an heiress, Catherine Troye, known as "the Dutch heiress", in

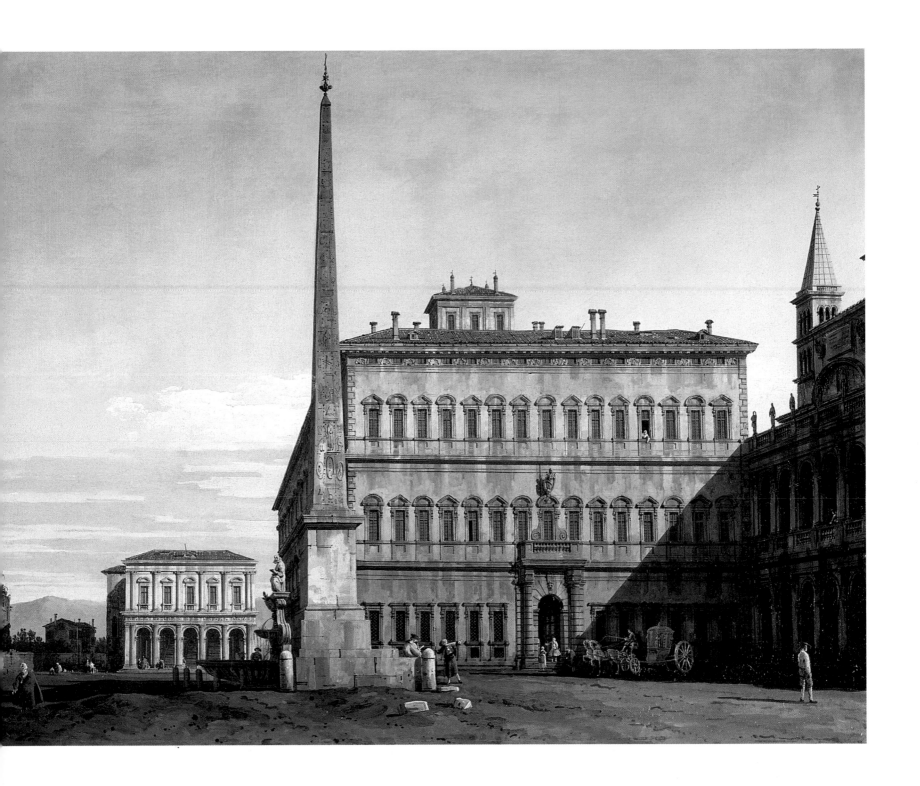

1734.[11] This would have provided him with the means to acquire or commission the three Bellotto paintings in Venice in the 1740s. Presumably, like the series of Canaletto views, these were originally displayed en suite in a room, which may well have been in King's London house rather than at Ockham.

Charles Beddington

64) that further proof is provided by the presence among the Canaletti of a capriccio of Eton, where the 5th Baron's son had been educated, is alas faulty, as the painting (Constable1989, vol. 2, no. 475), was inspired not by Eton but by St. Mary's Chapel near Guildford (and thus Ockham), as has kindly been pointed out to me by Christopher Wright.

[1] Kozakiewicz 1972, vol. 2, p. 108, no. 142; p. 100, no. 135; and Bleyl 1981.

[2] In the possession of the present writer.

[3] The other paintings, certainly by Canaletto, are Constable 1962, vol. 2, nos. 343, 367, 473-75, 478 and 504; six were reunited in New York 1989-90, nos. 75-80. Constable 1962, vol. 2, no. 475, now in the Museum of Fine Arts, Boston, is dated 1754 and it may be safely assumed that all were painted towards the end of Canaletto's period in England.

[4] Constable 1962, no. 713 (241). This was engraved by Giovanni Battista Brustolon (1712-96) in the 1780s.

[5] The authenticity of these drawings, often questioned, is re-affirmed, it is hoped definitively, in Venice 2001, nos. 1-13.

[6] Parker 1948, no. 109; Constable 1962, vol. 2, no. 727.

[7] Discussed by the present writer in Venice 2001, nos. 28, 29. The paintings include the pair of views in the present exhibition of the Roman Forum (cat. nos. 18, 19), the view of Santa Maria d'Aracoeli and the Capitol (cat. no. 20), and that of the Colosseum and the Arch of Constantine (Constable and Links 1989, vol. 2, no. 388*).

[8] As would the accompanying drawing of SS. Domenico e Sisto (Parker 1948, no. 110; Constable 1989, vol. 2, no. 724), likewise based on one of the Canaletto drawings in the British Museum.

[9] See the views of the churches of Sant' Eufemia and San Paolo Converso, Milan, and the Castello Sforzesco, Milan (Milan 1999-2000, nos. 1 and 4).

[10] Sale, Sotheby's, London, 13 July 1937, lots 114-15, and Christie's, London, 10 December 1993, lot 55.

[11] Ingamells 1997, p. 577. The suggestion of Francis Russell (1993, p.

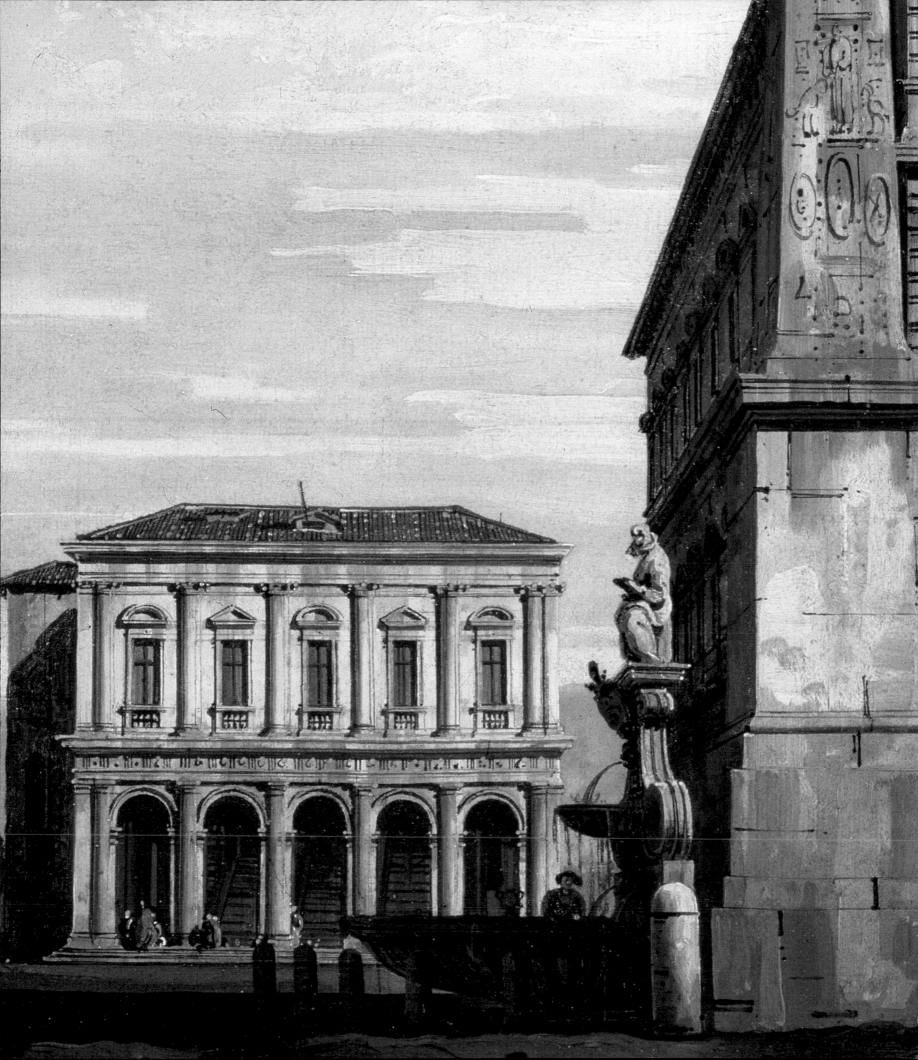

27. *Capriccio with a Ruined Triumphal Arch on the Banks of the Lagoon*

1743
Oil on canvas
16 × 19 1/4 inches
(40.5 × 49 cm)
Museo Civico, Asolo

Provenance: Bertoldi legacy, Asolo, 1910 (inv. 470).

Exhibitions: Venice 1946, no. 307; Lausanne 1947, no. 103; Venice 1967, no. 86; Munich 1987, no. 37; Verona 1990, no. 27; Zaragoza 1990, no. 27.

Bibliography: Pallucchini 1946, pp. 188-89; Pallucchini, in Lausanne 1947, p. 52; Parker 1948, p. 56, no. 133; Constable 1962, vol. 2, p. 416, no. 482; Martini 1964, p. 218; Zampetti, in Venice 1967, p. 190; Puppi 1968, p. 122, no. 363; Kozakiewicz 1972, vol. 1, p. 45, vol. 2, p. 88, no. 116; Camesasca 1974, p. 89, no. 16; Constable and Links 1976, vol. 2, p. 451, no. 483; Bleyl 1981, p. 37, no. 26; Steingräber, in Munich 1987, no. 37; Kowalczyk 1988, pp. 237-38, no. 49; Puppi 1988, p. 430, no. 27; Constable and Links 1989, vol. 2, pp. 450-51, no. 482; Marini, in Verona 1990, pp. 106-107; Nepi Scirè, in Belgrado 1990, p. 49; Pedrocco, in Zaragoza 1990, p. 86; Kowalczyk 1996a, no. 32; Pallucchini 1996, p. 496.

The background to this capriccio and its pendant (cat. no. 28) is to be found in a series of drawings that provide a repertory of ideas and motifs from which the artist could choose various elements and adapt them to new compositions. They provide an exceptionally complete documentation of the creative process and give an idea of the arduous preparatory work for the artist's etchings, recording his search for complex and attractive compositions, whimsical combinations of ruins, Paduan and rustic architecture, Palladian buildings, and lagoon landscapes. The se-ries comprises sketches from the artist's estate that are held by the Hessisches Landesmuseum, Darmstadt, and other sheets accurately finished with hatching or watercolour, collected by Joseph Smith and sold in 1763 to George III in a group of 143 pieces as by Canaletto.[1]
Of the two Asolo *capricci*, only the present composition was preceded by a preparatory study close to the final result, the Darmstadt line-drawing, *Capriccio with Ruins of a Triumphal Arch* (ill.), which established the principal compositional elements and the spatial relationships.[2] But the effects of light and shade in the composition – which was to be faithfully reproduced, treating the contrast of light and shade in more detail – seems to have been worked out in a drawing precisely shaded with watercolours at Windsor Castle, attributed to Canaletto.[3] In contrast to the unsure lines of the Darmstadt drawing, the Windsor composition is executed with confident, fluid lines in the manner of the Asolo painting. In Canaletto's and Bellotto's working methods an exchange of ideas and motifs was common, but very often Bellotto's drawing style is so close to Canaletto's that it is difficult to distinguish between the two, as often occurs with the paintings.
The idea of setting a motif between the aperture of an arch, already present in Marco Ricci's prints, was adopted by Bellotto in Rome, following the example of Gaspar Van Wittel, in the *vedute* with the Arch of Titus and the Porto Santo Spirito (cat. nos. 23, 22) and later in the *capricci*. It is a distinctive feature of the artist's work to have something connecting the foreground to the view seen through the arch as if alluding to deeper meanings. While in the Darmstadt and Windsor Castle drawings the opening in the ruin frames the Arch of Titus in the distance, in the painting of the Arch of Titus it is replaced by a Palladian church, of which only the upper part of the façade is visible. The church looks like San Francesco della Vigna and the ruin, which has a Roman appearance reinforced by a Christian patera, echoes the structural elements of the church in the peaceful timelessness of the lagoon.
The Masonic interpretation – suggested as Canaletto's by André Corboz[4] – is more clearly suggested by Bellotto in the two Asolo *capricci* by the presence of various symbols of the Lodge: the pyramid, grave-diggers, and pilgrims with sticks.
There are no other drawings as close to this pendant: *the Capriccio with the Ruins of a Rotunda* in Darmstadt has a composition that is not encountered in the Royal Library, Windsor Castle, but is made up of motifs to be found in various sheets in this collection; faithfully engraved, in one of the Italian etchings, it was successfully transformed to form a symmetrical pair with this painting.[5]

Bożena Anna Kowalczyk

Bernardo Bellotto, Capriccio with a Triumphal Arch in Ruins on the Bank of a Lagoon *(Hessisches Landesmuseum, Darmstadt)*

[1] Kozakiewicz 1972, vol. 2, nos. 114, 117, 119, 121; Parker 1948, nos. 125, 126, 133.
[2] Kozakiewicz 1972, vol. 2, no. 117.
[3] Parker 1948, no. 133.
[4] Corboz 1985, vol. 2, pp. 437-70.
[5] Kozakiewicz 1972, vol. 2, no. 119.

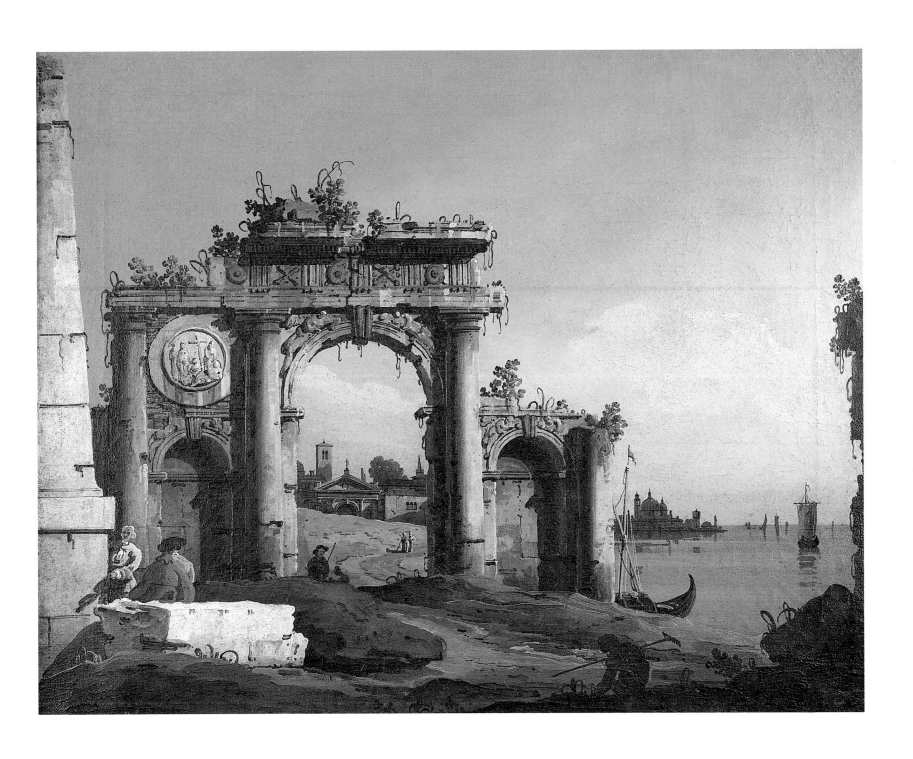

Tuscany, Rome

28. *Capriccio with the Ruins of a Roman Temple on the Banks of the Lagoon*

1743
Oil on canvas
16 × 19 1/4 inches
(40.5 × 49 cm)
Museo Civico, Asolo

Provenance: Bertoldi legacy, Asolo, 1910 (inv. 471).

Exhibitions: Venice 1946, no. 306; Lausanne 1947, no. 104; Gorizia 1988, no. 28; Verona 1990, no. 28; Zaragoza 1990, no. 28.

Bibliography: Pallucchini 1946, pp. 188-89; Pallucchini, in Lausanne 1947, p. 52; Parker 1948, p. 51, no. 106; Constable 1962, vol. 2, pp. 416-17, no. 483; Zampetti, in Venice 1967, p. 190; Puppi 1968, p. 122, no. 364; Kozakiewicz 1972, vol. 1, p. 45, vol. 2, p. 93, no. 118; Camesasca 1974, p. 89, no. 15; Constable and Links 1976, vol. 2, p. 451, no. 483; Bleyl 1981, p. 38, no. 27; Steingräber, in Munich 1987, no. 37; Kowalczyk 1988, pp. 237-38, no. 47; Puppi 1988, p. 430, no. 28; Constable and Links 1989, vol. 2, pp. 451, no. 483; Marini, in Verona 1990, pp. 108-109; Nepi Scirè, in Belgrado 1990, p. 49; Pedrocco, in Zaragoza 1990, p. 86; Kowalczyk 1996a, no. 32; Pallucchini 1996, p. 496.

With intuitive genius Rodolfo Pallucchini in 1946 attributed to Bellotto the two pendant capriccios in Asolo, the eighteenth-century provenance of which is unknown, but in all probability is Venetian. The attribution met with the general approval of later critics who rejected W.G. Constable's conviction, also held by J.G. Links, that the two pieces were "characteristic of one phase of Canaletto's work". According to Pallucchini, the works can be dated to the first half of the fifth decade of the eighteenth century when other similar paintings by Bellotto are known to have been executed "under the direct influence of his uncle Canaletto". This was the only critical judgement possible at that time in light of what was then known about Bellotto's early development.

Stefan Kozakiewicz suggested that the two *capricci* had been executed before the Rome visit, between 1740 and 1742, since there were no precise references to any knowledge of ancient Rome. This idea was accepted by Lionello Puppi, who envisaged "a period of productive collaboration" between uncle and nephew "close to 1740", and Giorgio Marini who thought they should be placed a little later in 1742, "as the maturity of the style and composition clearly indicate". Only Pietro Zampetti, analysing the composite nature (relating to Rome and the Venetian lagoon) of the topographical elements concluded that the works must "come after the Roman visit".[1]

A similar problem of pre- or post-Rome concerns a group of drawings (which the artist relied on for inspiration in the composition of his paintings) and a series of eight small Italian etchings for which the drawings had been prepared. The sheets executed in Rome can be distinguished by their very sure style and a heavier hand; this stylistic element suggests an earlier date for the preparatory sheets. In reality, the two Asolo *capricci* have never been valued for their draftsmanship but carefully compared with other paintings by the artist to confirm a date deduced from the topography.

The great harmony of these beautiful compositions lies in the light and shade effects and in the spatial organization in each pendant as well as in the overall symmetry. The flowing lines, with the graphic elements a thing of the past, reveal a much more mature expressive

Bernardo Bellotto, Capriccio with the Ruins of a Rotunda *(Hessisches Landesmuseum, Darmstadt)*

Bernardo Bellotto, Roman Forum with the Ruins of the Temple of Castor and Pollux
(detail, National Gallery of Victoria, Melbourne)

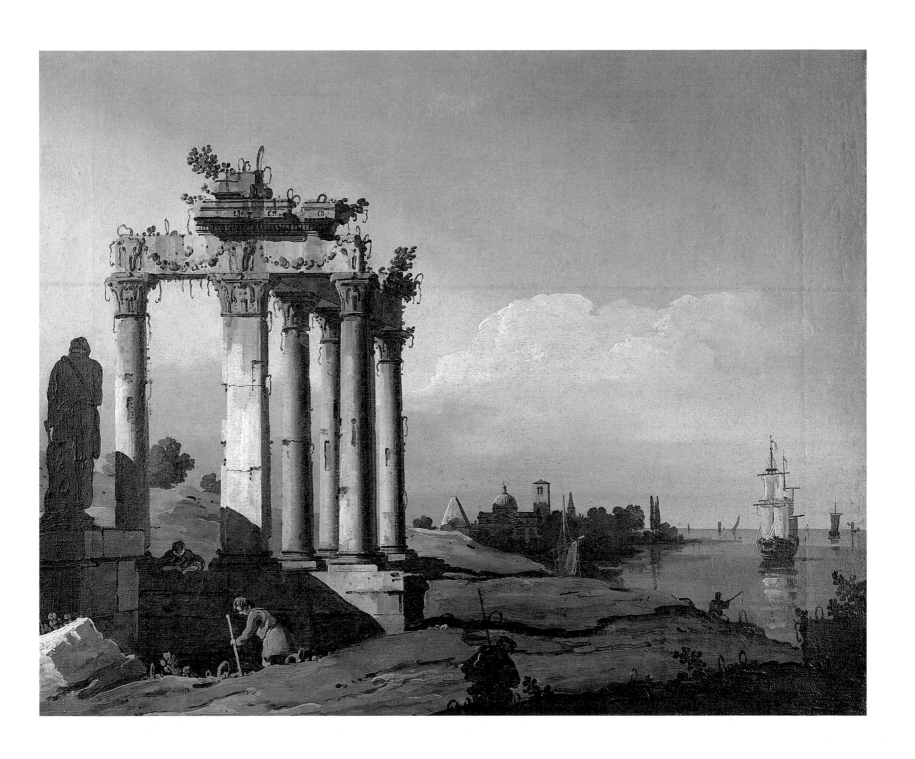

Tuscany, Rome

skill than in the Florentine views such as that of the *Piazza della Signoria* in Budapest. Among Bellotto's *vedute* of Roman ruins, the *Roman Forum with the Ruins of the Temple of Castor and Pollux* in the National Gallery of Victoria, Melbourne (ill.)[2] is particularly "Canalettian" in the subdued light, warm colours of the architecture, and the elegant figures; but it is already quite different from the views executed in Venice before the trip to Rome. The two Asolo *capricci* belong to the same period, before the departure for Lombardy, when the artist was experimenting with the new Roman subjects and gradually developing his own personal technique. The frequent use he made of incisions in the wet paint, a technique employed in the two Florentine *vedute* in the Fitzwilliam Museum, Cambridge (cat. nos. 15, 16), was replaced here by other techniques for showing how light hits the edges of architectural elements and their surfaces: with very fine brushstrokes of yellow and cadmium (as in the façade of the church seen through the arch in the pendant), layers of paint were built up until the desired effect was achieved. The unusual description of the landscape must have been produced in Rome, with broad, slightly oblique brushstrokes in various shades of beige, green and brown, the edges of which can be made out, so thick is the layer of paint, almost in relief. Dark brown in areas of deep shadow, at the edge of which weeds show up against the light and we see the ubiquitous stooping outline of a pilgrim with a tuft of hair and a long stick. As in the Melbourne painting, brushstrokes laden with white, but sparingly applied, describe the marble pieces in the foreground, while a soft style is used to draw the decora-

tions on the architecture and the sculptural quality of the structural elements, obtained by means of layers of transparent colour, both in shadow and in the light. Discreet use is made of incisions: to mark the edge of the illuminated outline in the shade of the column on the left of the central arch in the pendant, to make the light glance off the right-hand side of this arch, and to mark with a compass the curves of the arches. Although the range of colors is very limited, the shades are infinite, and the reds, oranges and blues of the figures, described with an almost rotary but sure movement of the brush, can be distinguished even though they have been toned down. The sky, across which are moving heavy oblique clouds, and which is livid white at the horizon, belongs to the post-Roman repertory, as does the water in various shades of green painted in parallel lines.

Among the various motifs of this composition, including the ruins of a Roman temple, a domed church and a Romanesque campanile, there is a statue of a soldier in the foreground; he is standing in shadow, a silent and impotent guardian. Statues of soldiers were often used to decorate the gardens of Venetian villas: there are two among the sculptures executed by Antonio Bonazza (1698-1763) for the Widmanns of Bagnoli in the early 1740s.[3] As early as the seventeenth century, statues of the company of the guards of the Venetian Republic stood along the avenues in the garden of the Villa Giustinian in Roncade and on the terrace close to the main entrance to the house.

Although the statue in this capriccio is not exactly like any of the ones in the villa the idea that the painter took his inspiration from one of them is ap-

pealing; the statues in front of the portico seen from the house have the same outline. This idea reinforces the possibility that the painter knew the Procuratore de Supra Marc'Antonio Giustinian, the owner of the villa at that time.[4]

Bożena Anna Kowalczyk

[1] Puppi 1988, p. 430; Marini 1990, p. 106; Zampetti, in Venice 1967, p. 190.
[2] Kozakiewicz 1972, vol. 2, no. Z 318.
[3] Gurian 1931, pls. 5, 6.
[4] Kowalczyk 1999.

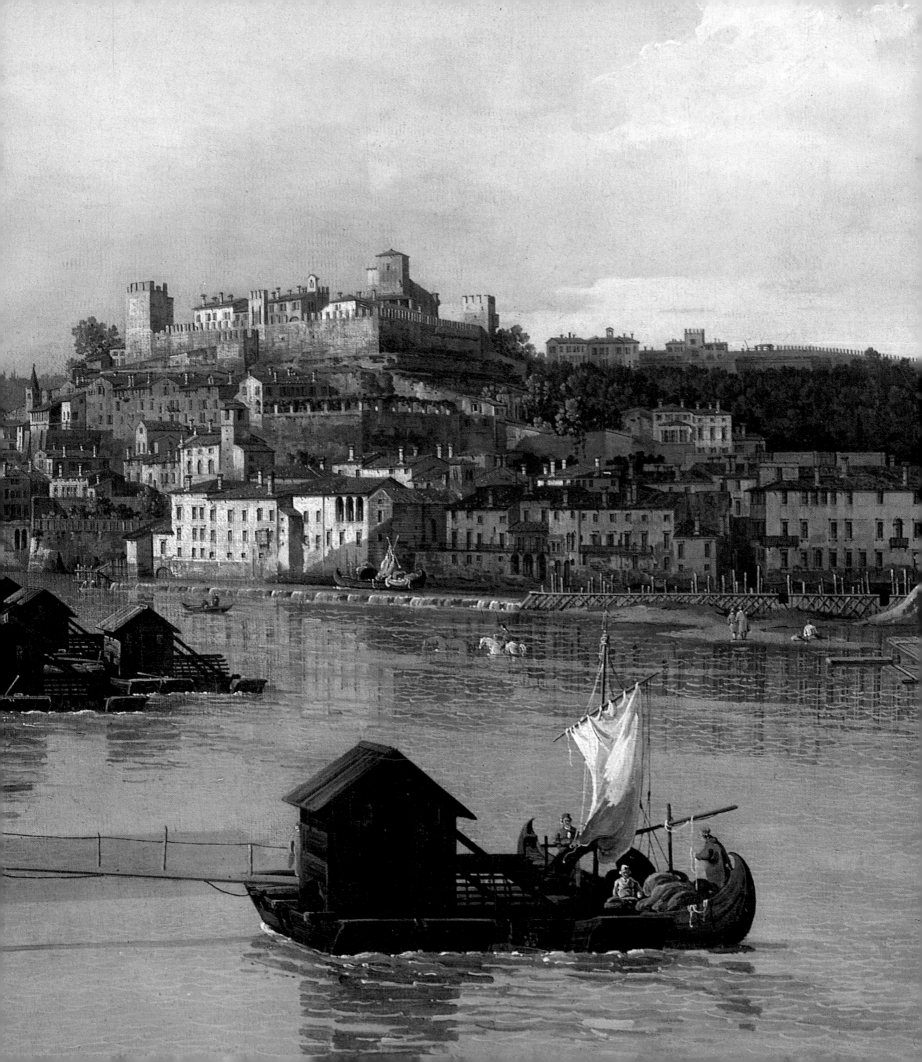

Lombardy, Turin and Verona

29. *View of Vaprio and Canonica, looking North-West from the West Bank of the Adda near the Confluence with the Brembo*

c. 1744
Oil on canvas
18 1/2 × 28 inches (47 × 71 cm)
Private collection, Milan

Provenance: The Dukes of Abercorn, Baron's Court, Northern Ireland; sold by the Abercorn Heirlooms Settlement, Christie's, London, 13 December 1991, lot 100 (to Richard Green); with Richard Green, London, from whom purchased by the present owner.

Exhibitions: London, Kenwood House, The Iveagh Bequest, on loan 1972-91; Milan 1999-2000, no. 7a.

Bibliography: Watson in London, Liverpool and York 1957, p. 25, note on no. 30; Kozakiewicz, in Dresden 1963-64, note on no. 70; Kozakiewicz, in Warsaw and Cracow 1964-65, note on no. 70; Kozakiewicz, in Vienna 1965, note on no. 95; Kozakiewicz, in Essen 1966, note on no. 64; Kozakiewicz 1972, vol. 2, pp. 60, 65, nos. 85, 86; Camesasca 1974, no. 50; Bleyl 1981, p. 60; Martini 1982, p. 539, note 292; Bettagno 1990, p. 16; Olivari, in Verona 1990, pp. 76, 78, 80, 82; Bona Castellotti 1991, p. 103, note 53; Kowalczyk, in Venice 1995, p. 310; Pallucchini 1996, p. 502; Briganti 1996, p. 253.

The twin towns of Vaprio and Canonica, between Milan and Bergamo at the confluence of the Rivers Adda and Brembo, were at a convenient distance from Milan to provide summer residences for members of the Milanese aristocracy. Vaprio in particular was one of the most popular beauty spots on the Adda. Leonardo da Vinci had spent much time there in the years 1507-13 as the guest of the family of his pupil Francesco Melzi, whose descendants still own the villa shown surrounded by cypress trees in both these paintings. A view similar to the first of the exhibited paintings was depicted no fewer than seven times by Gaspar Van Wittel (1682/83-1736), dated examples being of 1717, 1719 and 1722.[1]

The attractions of the place were noted by the French writer, Madame de Bocage, who stayed there in 1757, in a letter to her sister: "*une orangerie en terrasses qui s'etend le long du chateau, y regne sur un canal navigable pour tout le commerce de Milan; & trente pieds au dessous, chose rare, coule l'Adda, riviere qui n'est séparée du canal supérieur que par un mur de douze pieds d'épaisseur. Au bord de l'autre rive, s'élevent deux villages pleins de jolies maisons: au-delà une riche plaine, de bois & de riants côteaux menent en cercle l'oeil aux Alpes, dont le sommet couvert de neige entrêmelée de nuages, forme dans le lointain le plus admirable tableau.*"[2]

Eleven views of Lombardy by Bellotto are currently known, all generally assumed, despite stylistic variations, to have been painted in 1744. These include the pair of views of Gazzada in the Brera (cat. no. 31), a replica of one of those in the Kunsthaus, Zurich, and three views of Milan: the Castello Sforzesco (Castle of Námest, near Oslavou in the Czech Republic), the churches of Sant'Eufemia and

San Paolo Converso (Milan, private collection), and the Palazzo dei Giureconsulti and the Broletto Nuovo (Milan, Castello Sforzesco).[3] The remaining five paintings show Vaprio and Canonica, and include larger versions of both the exhibited paintings.[4]

The version of the view of Vaprio and Canonica looking north-west, now in a New York private collection, differs in the cloud formations, in the lower part of the sky having a purple tinge, in the elegant couple in the foreground being provided with a parasol, in there being two figures rather than one on the riverbank, and in being signed "*BERNARDO BELLOTTO DETo IL CANALETO*".[5] That of the second, formerly owned by Mario Crespi, Milan, and now in a Roman private collection, varies more strikingly, almost all the figures being different as well as the cloud formations, and the clouds and distant sky being tinged with the pink of sunset.[6] This was originally paired with a unique view taken from the other side of the river, now in the Metropolitan Museum of Art, New York.[7]

Drawings of all three of the Vaprio compositions are also known, those representing the Metropolitan Museum view and the present view looking south being at Darmstadt; that showing the view towards the north-west is at Warsaw.[8] Although the autograph status of inscriptions on these, questioned by Kozakiewicz,[9] is accepted by other scholars,[10] the information which they provide is not easily interpreted. While they describe each drawing as a "copy" of a painting, all the drawings have the appearance of being preparatory. The inscriptions on the Darmstadt drawings give the date 1744 and state that the corresponding

paintings were executed for Conte Antonio Simonetta;[11] while this is generally assumed to apply to the Metropolitan Museum and ex-Crespi pair, the drawing corresponds with the exhibited painting. The Warsaw drawing, on the other hand, corresponds not with the exhibited painting but with that in a New York private collection. Although the inscription states that the painting was in Dresden, it is recorded in the collection of Giuseppe Pozzobonelli (1696-1783), Archbishop of Milan, who was elected a cardinal in January 1744, along with the churches of Sant'Eufemia and San Paolo Converso, Milan.[12]

The original owner of the exhibited paintings remains unknown, although Antonio Melzi has been proposed as a possible candidate, and there is no evidence, other than stylistic, to establish their precedence or otherwise over the larger versions. Martini has pointed out, however,[13] that the larger version of the second view would be the only signed painting by Bellotto known before the view of Turin with the old Bridge over the Po (cat. no. 34), executed in the summer of 1745.

Charles Beddington

[1] Briganti 1996, nos. 326-32.
[2] Piquet 1762, vol. 3, pp. 142-43, quoted by Olivari, in Verona 1990, p. 76.
[3] Klemm 1988, pp. 148-49, no. 64; Milan 1999-2000, nos. 1, 4 and 5.
[4] Apart from the view of the Palazzo dei Giureconsulti and the Broletto Nuovo, Milan, which is in an upright format and measures 71 × 56 cm (28 × 22 inches), all of Bellotto's other Lombard views measure approximately 65 × 100 cm (25 5/8 × 39 3/8 inches).
[5] Purchased at Christie's, London, 3 December 1997, lot 90.
[6] Milan 1999-2000, no. 3.
[7] Milan 1999-2000, no. 2. The foreground figures in both these last paintings are by another hand.
[8] Verona 1990, nos. 14-15; Koza-
kiewicz 1972, vol. 2, no. 86.
[9] Kozakiewicz 1972, vol. 1, p. 61.
[10] See Olivari, in Verona 1990, p. 80.
[11] Simonetta had a magnificent summer home at Monasterolo.
[12] See Bona Castellotti 1991, p. 103. The pair was split in Christie's, London, sale, 30 November 1973, lots 100-101. Mariolina Olivari suggests, in Milan 1999-2000, p. 220, that the inscription may indicate that the exhibited pair was executed in Dresden.
[13] Martini 1982, p. 539, note 292.

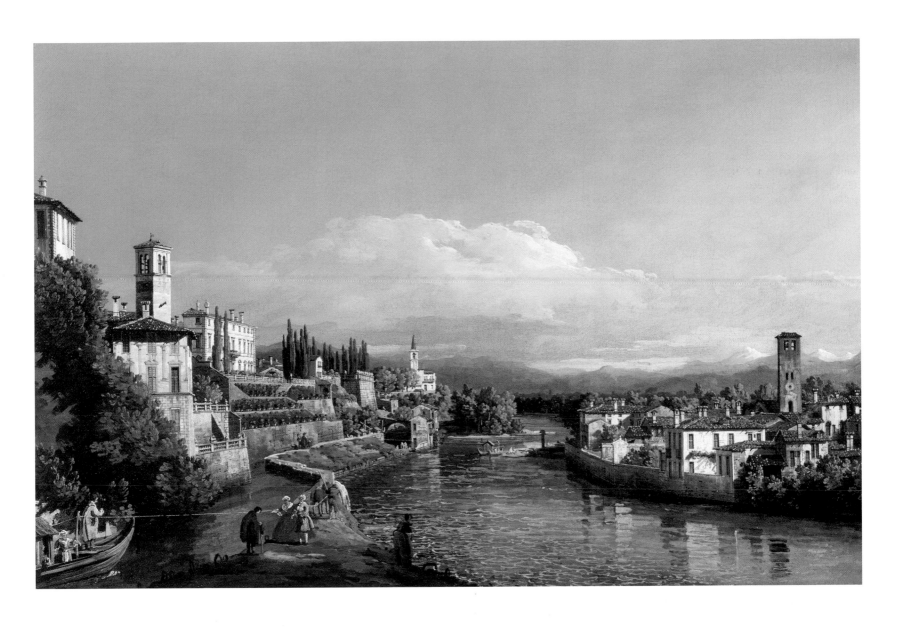

30. *View of Canonica and Vaprio, looking South from Monasterolo on the West Bank of the Adda*

c. 1744
Oil on canvas
18 1/2 × 28 inches (47 × 71 cm)
Private collection, Milan

Provenance: As for cat. no. 29.
Exhibitions: London, Kenwood House, The Iveagh Bequest, on loan 1972-91;
Milan 1999-2000, no. 7b.

Bibliography: Watson in London, Liverpool and York 1957, p. 25, note on no. 30 Kozakiewicz 1972, vol. 2, pp. 65, 66, nos. 88, 89; Camesasca 1974, no. 51; Bleyl 1981, p. 60, no. 48; Martini 1982, p. 539, note 292; Bettagno 1990, p. 16; Olivari, in Verona 1990, pp. 76, 78, 80, 82; Bona Castellotti 1991, p. 103, note 53; Kowalczyk, in Venice 1995, p. 310; Pallucchini 1996, p. 502; Briganti 1996, p. 253.

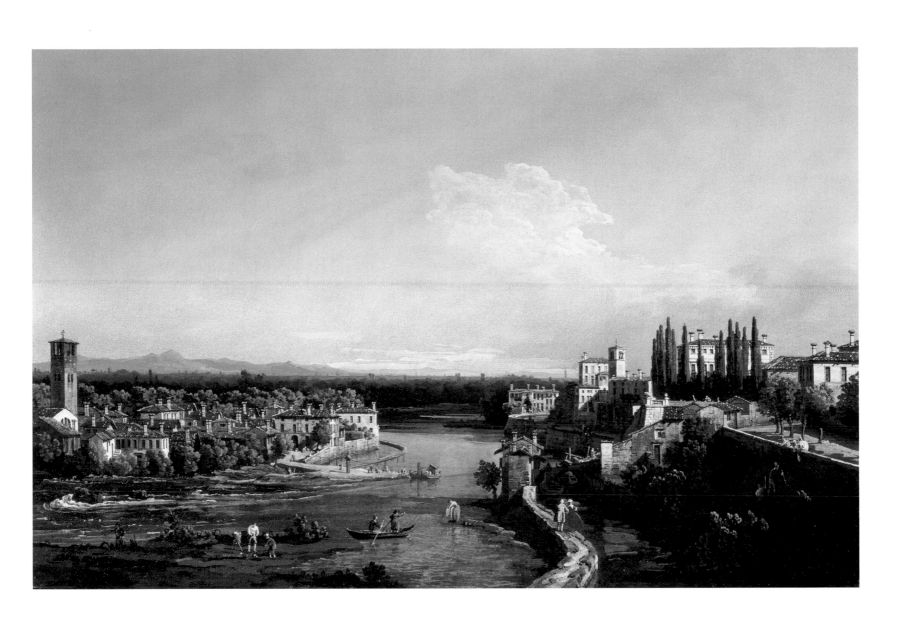

c. 1744
Oil on canvas
25 9/16 × 39 3/8 inches
(65 × 100 cm)
Pinacoteca di Brera, Milan

Provenance: Possibly commissioned by Giuseppe and Gabrio Perabò, Milan and Gazzada; acquired in 1831, probably from Alessandro Brison, Milan;[1] Pinacoteca di Brera, Milan (inv. no. 236).

Exhibitions: Venice 1929, no. 15; Venice 1967, no. 89; Verona 1990, no. 17; Milan 1999-2000, no. 6b.

Bibliography: Fritzsche 1936, pp. 27, 106, no. VG 21; Kozkiewicz 1972, vol. 1, pp. 42-43; vol. 2, p. 66, no. 90 (with previous references); Olivari, in Verona 1990, pp. 86-88; Olivari 1994, pp. 42-48; Olivari, in Milan 1999-2000, pp. 219-20 (with previous references); Kowalczyk 1999, pp. 196-98.

The most important of Bellotto's early Italian landscapes are generally thought to be his two views of Gazzada, near Varese, the one view showing the village itself with its church, the other the Villa Perabò.[2] Bellotto's excursions into the north Italian countryside awakened in him a genuine, deep feeling for the natural world, which would become increasingly evident in the later paintings. The contrasts of light and shade, intense color, crystalline atmosphere, and sensitivity to rural scenery in these works indicate a response to landscape that will invigorate his art for years to come. Kozakiewicz admired in particular Bellotto's views of Gazzada, which he praised as having been "painted under some peculiarly lucky star".[3]

In their subtle modulations of light and shade, and light palette, the Gazzada views reveal the artist as standing poised on the threshold of a new phase in his development. His attention has turned from the important cities, towns, and buildings that he previously painted to the humble cottages and farm buildings of a country village. The rural setting of Gazzada intrigued Bellotto, and one senses his genuine interest not only in the locale but in the people who live there and in their activities. From this point forward, Bellotto will show increasing interest in the daily life of ordinary people, urban and rural. Here he focuses on the comings and goings of pastoral folk at the end of the day – women gathering their laundry, laborers returning from the fields to the farmyard, and idlers gossiping in the warm afternoon sunlight.

Both views were probably painted in the studio from sketches and notes made on the spot. The vantage point of the village and little church of Santa Croce is relatively straightforward and is recognizable in present-day Gazzada; the view of the villa with the Alps and Monte Rosa in the distance is closer to a capriccio constructed with great mastery from fragments of reality imaginatively combined.[4] Bellotto's first-hand experience of nature at this moment encouraged him to develop a palette of greens, beige, cream, and yellow that he employed in his landscapes hereafter and with extraordinary effect in his depictions of the rural environs of Pirna (cat. nos. 57-62) and Königstein (cat. no. 65) a decade later. Numerous writers have observed that Bellotto's realism in the depiction of landscape precedes the interests, if not the methods, of the *plein-air* painters who visited Italy later in the century and anticipates the work of nineteenth-century landscape painters such as Corot.[5]

Bellotto painted the two views of Gazzada on different canvases, each in a slightly different manner: the *Village of Gazzada* is coarser in weave, the ground is applied more vigorously, and the *craquelure* more pronounced; the view of the Villa Perabò, painted on a finer canvas, is marked by a particularly "liquid" application of paint and greater subtlety of tonal contrast. Evidence of scoring has been detected in the delineation of the architectural lines of the villa, but otherwise the paintings appear to have been quickly and spontaneously painted with no substantial revisions or *pentimenti*.[6]

Bellotto's focus on landscape set him apart from Canaletto, who, in Italy at least, rarely undertook topographical views like this. Canaletto's principal concern was almost always a city's urban fabric, not the villa or village outside it. The textures of stone, soil, and vegetation and the reflections of water engaged Bellotto differently, and he was absorbed in their particularities in a way that his uncle never was. This view of Gazzada and its companion in the Pinacoteca di Brera are profoundly different from anything that Canaletto had painted to date, and in them Bellotto continues to distance himself from the older artist's style of painting by reliance on more precisely drawn architecture, heavier impasto, a bolder palette of saturated greens and blues, stronger contrasts of light and shade, and a colder tonality.

A replica of the *Village of Gazzada* in a slightly different format is at the Kunsthaus Zürich.[7]

Edgar Peters Bowron

1 For discussion of the probable provenance, see Olivari, in Verona 1990, p. 86; Olivari, in Milan 1999-2000, p. 220, and Kowalczyk 1999, pp. 196-98, with notes.

2 For the companion view of the Villa Perabò, later Melzi d'Eril, see Kozakiewicz 1972, vol. 2, p. 66, no. 91; Olivari, in Verona 1990, pp. 86-88, no. 18; and Olivari, in Milan 1999-2000, pp. 219-20, no. 6a.
3 Kozakiewicz 1972, vol. 1, p. 42.
4 Olivari, in Verona 1990, pp. 87-88.
5 Kozakiewicz 1972, vol. 1, p. 43.
6 Ibid.
7 Klemm 1988, pp. 148-49, no. 64, repro., oil on canvas, 69.5 × 90 cm.

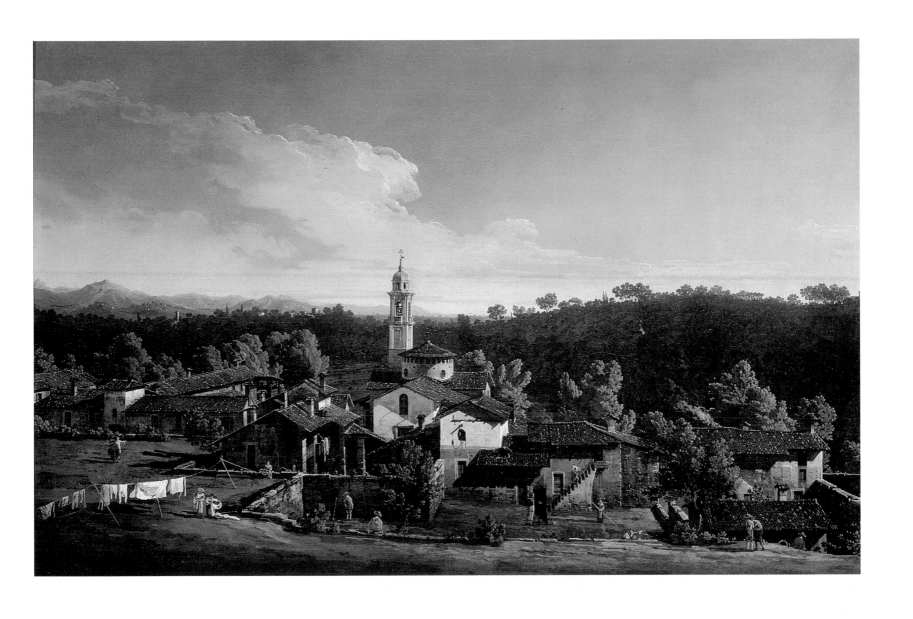

32. *Capriccio with a Triumphal Arch and a Town beside a River*

c. 1745
Oil on canvas
23 5/8 × 36 1/2 inches
(59.9 × 93 cm)
Columbia Museum of Art,
The Samuel H. Kress
Collection

Provenance: Private collection, England; sale, Caspari, Munich, 1930; Jacob M. Heimann, New York; Paul Drey, New York; from whom bought by the Samuel H. Kress Foundation, New York, 1948, and given in 1962 to the Columbia Museum of Art (no. 62.931).

Exhibitions: Munich 1930, no. 6; San Francisco 1938, no. 12; Poughkeepsie 1940, no. 4; Tucson 1951, no. 23, University of Arizona, Tucson, 1951-57 (extended loan); Museum of Fine Arts, Houston, 1958-61 (extended loan); Verona 1990, no. 11.

Bibliography: Fritzsche 1936, p. 105, no. VG 12; Contini Bonacossi 1962, p. 107; Kozakiewicz, 1972, vol. 1, p. 45, vol. 2, p. 100, no. 133 (with previous references); Shapley 1973, p. 169, no. K1589 (as attributed to Bellotto); Marini, in Verona, 1990, p. 72.

During his final years in Italy, Bellotto began to paint *vedute ideate* and landscape capriccios with architectural motifs, a genre that never ceased to attract him. The motifs that appear in these paintings are from the monuments, ancient and modern, that the artist had seen in Terra Firma, Padua, Rome, Turin, and Verona. The standard elements of which they are composed include rivers and bridges, ruined classical arches, buildings grouped in town-like clusters in the middle ground, and ranges of hills in the background. Landscape plays a prominent role in the setting of these fanciful

compositions and reflects the artist's study of natural scenery in Lombardy (cat. nos. 29-31). Kozakiewicz regarded the capriccios of Bellotto's last Italian years as a further development of the pictorial schema he had used in the two Asolo capriccios painted in the early 1740s (cat. nos. 27, 28). These compositions, in turn, developed from the fantasy pieces of Canaletto and the earlier explorations of the genre in Venice by Carlevaris and Marco Ricci.[1] The later Italian *capricci* such as the present view represent a significant advance over the earlier Asolo paintings, however, in their harmonious depiction of buildings and ruins, fluid, synthetic handling of water, earth, foliage, and sky, and vigorous and assured technique that approaches the same high technical standard as the realistic views of the same period.

Bellotto painted the subject of a triumphal arch and a town beside a river several times, of which the present painting is perhaps the finest example.[2] In this imaginary river landscape, an elegant triumphal arch clearly based on the Arch of Titus (see cat. no. 23) dominates the left half of the composition; the right half is given over to a wide fluvial plain and a river that winds towards the right bottom corner. In the middle ground, the river is crossed by a stone bridge that leads from a rotunda and medieval tower on the right to a group of houses with Venetian chimneys clustered on the side of a hill on the left. The skyline of the little village is dominated by a domed church and two towers, of which the one on the left resembles that of Santa Giustina in Padua and the one on the right that of the Carità in Venice.

This ideal landscape is a highly successful amalgam of assembled architectural motifs and

random landscape elements observed *en plein air*. The resultant mélange creates a convincing new view, leaving no hint that it is entirely a product of the painter's imagination. Restoration and cleaning of the painting in 1993, however, revealed several aspects of Bellotto's working methods and suggest a complicated genesis of the finished composition. He first painted the sky and the river in their entirety over a dark reddish-brown ground (visible in areas of paint loss, particularly the sky), and then applied the landscape features and foreground figures. He employed a straight edge for the lay-out of the architrave of the arch and inscription tablet, taking care to incise the horizontal lines directly into the paint layers below.

Several *pentimenti* are now visible to the unaided eye including a sloping hill at the left, a building at the right of the river, and a fisherman sitting on the bank with his back to the viewer. Infra-red reflectography confirmed these alterations to the original design and further revealed the presence of a fragment of the corner of a colonnade at the left that Bellotto subsequently painted over with a second layer of pigment in the sky and with several cypress trees. Evidently, he intended these columns to have been set behind the sloping hill in an arrangement similar to the ruined colonnade of the Temple of Vespasian that he inserted into another capriccio of approximately the same date.[3] Bellotto's method of composing, combining miscellaneous motifs that he undoubtedly observed from life and recorded and included in other paintings, such as the pair of oxen pulling a cart, present in one of the two views of Gazzada,[4] may explain the odd spatial rela-

tionship of the mill in the right foreground. Although intended to be perceived by the viewer as existing in space behind and below the figures in the left foreground, the structure appears curiously situated and oddly reduced in size, a discordant element within an otherwise impeccably organized composition.

Edgar Peters Bowron

[1] Kozakiewicz 1972, vol. 1, p. 45.
[2] Kozakiewicz 1972, vol. 2, nos. 132, 136, repro.
[3] Kozakiewicz 1972, vol. 2, pp. 104-105, no. 137, repro. The fisherman seated on the bank also appears in an imaginary river landscape of about the same date; see Kozakiewicz 1972, vol. 2, pp. 100 103, no. 135, repr. I am grateful to Jean Dommermuth for sharing with me her observations on Bellotto's materials and methods made during the cleaning of the painting at the Conservation Center of the Institute of Fine Arts, New York University, in 1993.
[4] Kozakiewicz 1972, vol. 2, p. 66, no. 91, repro.

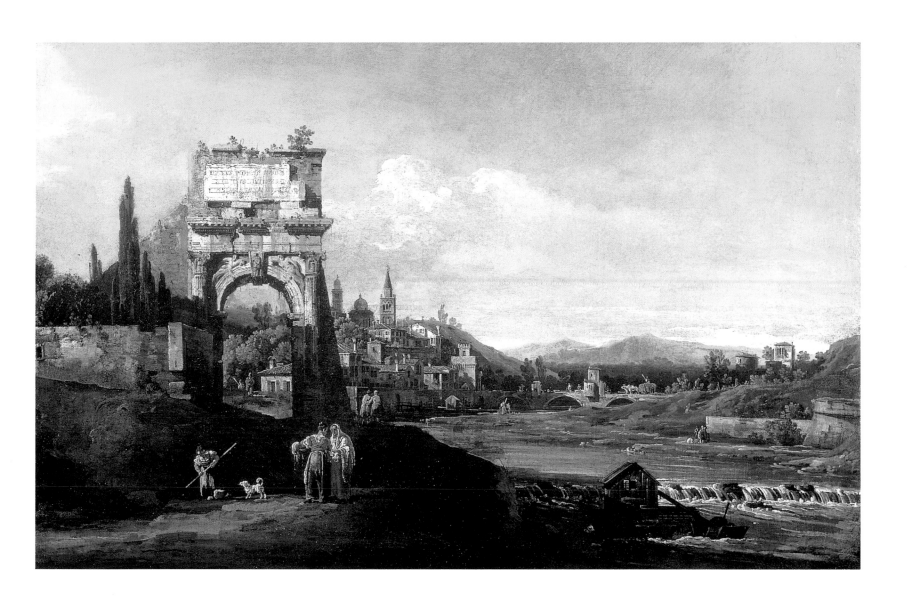

1745
Oil on canvas
50 × 64 1/2 inches
(127 × 164 cm)
Inscribed by a later hand at
the lower right: *BERNARDO
BELOTTO/ DT.º IL
CANALETTO. F.ᵉ*
Galleria Sabauda, Turin

Provenance: Commissioned by
Charles-Emanuel III (1701-
73), Duke of Savoy and King of
Sardinia, for 975 Piedmontese
lire; thereafter in the Turin roy-
al and state collections (inv. no
467).

Exhibitions: Venice 1929, no.
17; Turin 1956-57, no. 45; Mu-
nich 1958, no. 6; Vienna 1965,
no. 4; Verona 1990, no. 24; Am-
sterdam 1990-91, no. 32.

Bibliography: Fritzsche 1936,
pp. 27, 106, no. VG 25; Gabriel-
li 1971, pp. 72-73; Kozakiewicz
1972, vol. 1, pp. 43-44, vol. 2, p.
73, no. 92 (with previous refer-
ences); Mossetti and Romano,
in Verona 1990, pp. 98-101
(with additional references);
Bakker, in Amsterdam 1990-91,
pp. 196-97.

In the summer of 1745, Bellotto painted this pair of views of Turin for his first royal patron, Charles-Emanuel III (1701-73), Duke of Savoy and King of Sardinia. In the format of the paintings – both larger than anything he had painted before – the signature he affixed to one of them, and the inclusion of a self-portrait – his first, in which he has shown himself sketching in the company of a gentleman and a priest – Bellotto declared his artistic majority. The *Old Bridge over the River Po* is signed in large, carefully formed letters and has the nickname "*d° il Canaletto*" following his given name and surname. Bellotto had begun to use his uncle's name a few years earlier, on his earliest etchings, but only once before had he used it on a painting.[1] Bellotto's companion views of Turin are documented in the accounts of the Royal Household as having been painted for the king in 1745, the subjects representing a "*veduta di questo capitale verso li reali giardini e palazzo et altre adiacenze*" and a "*veduta di questa città*," respectively.[2] The first depicts an unusual view looking west from one of the bastions that formed part of the city's fortifications. On the left, in the middle ground, appears the garden façade of the Palazzo Reale and to its right, the west wing. The entire palace complex and the gardens are enclosed by the walls of the Bastion Verde, which is shown in the process of being repaired by workmen on scaffolding. The walls run diagonally into the depths of the picture, flanked by a moat, from the tower at the extreme left, called the Garritone. The opulent dome of the chapel of Santa Sindone and the campanile of the cathedral are visible above the palace roof. Beyond, the towers and domes above the skyline of athe old city are visible before a backdrop of the distant Alps.

The vantage point of the companion view looks south-west from a spot near the present-day church of the Gran Madre di Dio. Some of the houses of the Borgo del Po suburb appear on the left on the east bank of the river, with the Monte dei Cappuccini and Santa Maria del Monte behind. The foreground is dominated by the wood and stone bridge that leads across the river to the west bank, terminating in the Porta di Po, the entry to the center of the city. In the distance, at the left of center, the Castello del Valentino appears, and in the far distance, the Alps.[3] The Turin views conclude the development of Bellotto's early career and anticipate the strong perspective, mathematical precision, dramatic balances of light and shadow, and sophisticated coloring of the Dresden views. The composition of the *View of Turin with the Palazzo Reale*, which was not visible from a single vantage point, reveals the painter's ingenuity. From a viewpoint directly opposite the rampart of the city's fortifications Bellotto could see the Garritone to his left, but he almost certainly drew the view of the palace itself and the façade of the west wing from a vantage point in or near this tower.[4] He altered the actual point of view and has shown the façade of the western wing frontally in the final composition, rather than from an angle as it would have be seen. Boudewijn Bakker has observed another aspect of the powerful illusion of depth and varying distances Bellotto has achieved in this work: on the one hand, the strong linear perspective induces our eye to jump a considerable distance towards the Alps, on the other, all the buildings, even those in the distant background, are presented with equal clarity, as if captured by the zoom-lens of a camera.[5]

The fascination with daily life evident in so many of Bellotto's views of Dresden, Vienna, and Warsaw is present here. Bellotto has noted the scaffolding erected against the retaining wall for the masons who are repairing it and who have their mortar pit and supply of bricks in the meadow on the opposite side of the moat. The farmer's cart has apparently brought some material. The variety of figures painted into the composition, women doing their washing, for example, relieves what otherwise would have been an unenlivened topographical record. A dignified and elegantly dressed gentleman – a courtier or perhaps the king himself – draws his companion's attention to the restoration work in progress. In these years the king was in the midst of a large-scale programme of rebuilding and redecoration of the Palazzo Reale, and Bellotto's view may well contain a reference to one of these projects.[6] In these two views of Turin Bellotto found expression for his interests in both the depiction of architecture and of landscape, devoting one of the paintings to a large and imposing building and the other to modest houses on the edges of the city and their suburban environs and incorporating a vast landscape prospective into each. The Turin views represent a synthesis of Bellotto's youthful experiences, but in their strong contrasts of light and shade, increasingly vibrant coloring, particularly in the greens and blues, and in their combination of panoramic breadth and topographical detail, the paintings herald his large, realistic Dresden views. In terms of future patronage, Bellotto's commission to paint for the king of Sardinia and the reception of his work at the court of Turin held considerable importance.[7]

Edgar Peters Bowron

[1] *A View of Vaprio and Canonica, looking North-West*; sold, Christies', London, 3 December 1997, lot 90.
[2] Turin, Archivio di Stato, art. 217, 21 June and 17 July 1745; cited by Mossetti and Romano, in Verona 1990, p. 98.
[3] For further information on the topography of the site, see Griva 1993, pp. 411-16.
[4] Bakker, in Amsterdam, 1990-91, pp. 196-97.
[5] *Ibid.*
[6] For a resumé of the king's artistic and architectural patronage, see Pinto 1987, pp. 15-32.
[7] See Mossetti and Romano, in Verona 1990, pp. 98-99, with additional references.

1745
Oil on canvas
50 × 68 3/4 inches
(127 × 174 cm)
Signed at lower left:
*BERNARDO. BELLOTTO./
DT.^o IL CANALETTO/ F.^e*
Galleria Sabauda, Turin

Provenance: As for the pendant above (inv. no. 469).

Exhibitions: Florence 1922, no. 98; Venice 1929, no. 16; London 1930, no. 766; Paris 1935, no. 46; Venice 1967, no. 93; Verona 1990, no. 23; Venice 1995, no. 77.

Bibliography: Fritzsche 1936, pp. 13, 27, 106, no. VG 24; Gabrielli 1971, pp. 72-73; Kozakiewicz 1972, vol. 1, pp. 43-44, vol. 2, p. 73, no. 93 (with previous references); Mossetti and Romano, in Verona 1990, pp. 98-101 (with additional references); Bakker, in Amsterdam, 1990-91, pp. 196-97; Kowalczyk, in Venice 1995, p. 312.

1746
Oil on canvas
52 3/4 × 46 1/2 inches
(132.5 × 117 cm)
Galleria Nazionale, Parma

Provenance: Conte Stefano San-vitale, Parma; from whom pur-chased in 1835 as part of a series of four (inv. 238).

Exhibitions: Parma 1948, no. 231; Rome 1959, no. 65; Paris 1960-61, p. 226.

Bibliography: Parma 1852, no. 374; Ricci 1896, p. 358; Ferrari 1914, pp. 13-14, 20, 25; Ashby and Constable 1925, p. 213; Voss 1926, pp. 23, 25; Delogu 1930, p. 126; Fritzsche 1936, p. 123, no. VG 174; Voss 1937, p. 195; Quintavalle 1939, pp. 130, 143, no. 238; Delogu 1958, pp. 203-98; Pallucchini 1960, p. 222; Kozakiewicz 1966, pp. 17-19; Pignatti 1966, p. 219; Zampetti, in Venice 1967, p. 192; Koza-kiewicz 1972, vol. 1, pp. 38-39, vol. 2, pp. 94-95, no. 126; Came-sasca 1974, p. 94, no. 58; Fornari Schianchi 1982, pp. 194-97; Puppi 1988, pp. 219, 432-33; Succi 1988, p. 30; Marini, in Verona 1990, pp. 138-40; Kowalczyk 1995a, pp. 301, 308; Pallucchini 1996, pp. 498-99; Riccomini 1997, p. XXVII; Cat-tani 2000, pp. 66-67, no. 672, and pp. 60-66, no. 671.

The splendid series of four *capricci* in the National Gallery, Parma, to which this painting belongs, summarizes Bellotto's rich figurative repertory just prior to his departure from Italy, and exemplifies the train-ing he received in Canaletto's workshop combined with his own approach rich in original ideas, concepts, and execution. With a highly personal style and a perfectly honed technique that the artist was to use from now on, with slight variations and different emphases, Bellotto

scrupulously and painstakingly developed the skills learned in the workshop, distancing him-self completely from the world of the *vedute ideate* and *capricci* created by Canaletto. Bellotto does not invent buildings or landscapes, but rather assem-bles memories, notes and ele-ments of the real world. Com-pared with the images of Gio-vanni Paolo Panini and Marco Ricci, for example, the four Par-ma *capricci* reveal how close to and yet intellectually distant from his earlier ideas Bellotto was. The series, which was probably conceived as a group to decorate a specific room, comprises two pairs of different formats, vertical compositions containing Roman motifs (the pendant of this one is *Capriccio with the Capitol*[1] and horizon-tal, which are largely Venetian in tenor, *Capriccio with a City Gate* and *Capriccio with a Gate and a Tower*.[2]

He takes motifs already present in his Venetian, Paduan and Ro-man drawings and paintings, the elements of which are easily identifiable: the vertical pen-dant, for example, is a view of the Capitol as it appears in a drawing in the National Muse-um of Warsaw[3] and in the paint-ing at Petworth House (cat. no. 20); it is seen through the arch of a gate similar to the Porto Santo Spirito, studied in one of the Darmstadt drawings[4] and represented in a painting in a private collection (cat. no. 22). The ruins of the Temple of Cas-tor and Pollux are based on a view of the *Forum Looking to-wards Santa Francesca Romana* in a private collection, preceded by a fine Darmstadt drawing[5] and by two views of the *Forum Looking Towards the Capitol*, one in the National Gallery of Victo-ria in Melbourne[6] and another, smaller version executed for Joseph Smith and now in a pri-vate collection (cat. no. 18). The

Bernardo Bellotto (here attributed to), The Colosseum and the Arch of Constantine *(Private collection)*

origins of the fountain, here sit-uated closer to the temple, are similar; it also appears in other capricci, such as the one in the *Castel Sant'Angelo* in a private London collection.[7] The inspira-tion for the compositions of the very fine Melbourne and Smith paintings comes from a drawing made by Canaletto in his early years during a stay in Rome in 1719-20. The drawing is one of a series of twenty-three that were carefully kept in the workshop and comprised a good solid repertory of Roman subjects, used by Canaletto on his return from Rome and later on in the 1740s also by Bellotto. This group is now in the British Mu-seum in London, apart from one sheet, the *Capitol with Santa Maria d'Aracoeli*, conserved in the Hessisches Landesmuseum, Darmstadt.[8] One of the draw-ings, a view of the Colosseum with the Arch of Constantine[9] has not been translated directly to a painting but fragments of this monument appear in many invented Roman views and capricci, while all the later works, in which the Colosse-um

takes centre stage, are connected with Bellotto's name. A large painting in the royal collections has been attributed to him by Waagen,[10] although it is signed by Canaletto; Kozakiewicz and Levey agree with the theory that the workshop may have been in-volved and probably also Bellot-to.[11] Two further works, the drawing with the Colosseum of the Gabinetto Nazionale delle Stampe and one of the small pendants in the Galleria Borgh-ese, executed by Canaletto in the 1760s, have been associated with Bellotto.[12] Still awaiting a final decision is the painting of the *Colosseum and the Arch of Con-stantine*, put up for sale at Christie's, London, 8 July 1994, lot 10,[13] where the view and per-spective of the monument is similar to the one in the drawing by Canaletto in the British Mu-seum,[14] with the three crosses at the top, the small house and the hill with cypresses on the left-hand side and Constantine's Arch on the right. The Colosse-um in this painting, from 1743-44 – stylistically very close to the *San Giovanni in Laterano* in a

private collection (cat. 26) and with identical figures – is the im-mediate precursor of this Parma one.

In this series, exceptionally rich in ideas and embellishments, the *Capriccio with the Colosse-um* stands out for its coura-geous and atypical composi-tion, the only one that can be compared with Panini's compo-sitions. The monuments are placed in vaguely defined set-tings, and a succession of differ-ent levels of light and shade, starting from the deep shadow that invades the foreground, en-velops the fountain and fades out at the base of the columns of the portico of the Temple of the Dioscuri. Behind the Tem-ple the full glare of the light is shed over the Colosseum, pick-ing out the pyramid of Caius Cestius in the distance, and be-coming softer on the left-hand side of the Colosseum, where another area of shadow defines its shape.

Bellotto makes use of these in-tense and studied lighting-ef-fects to describe the structure and the substance of the monu-

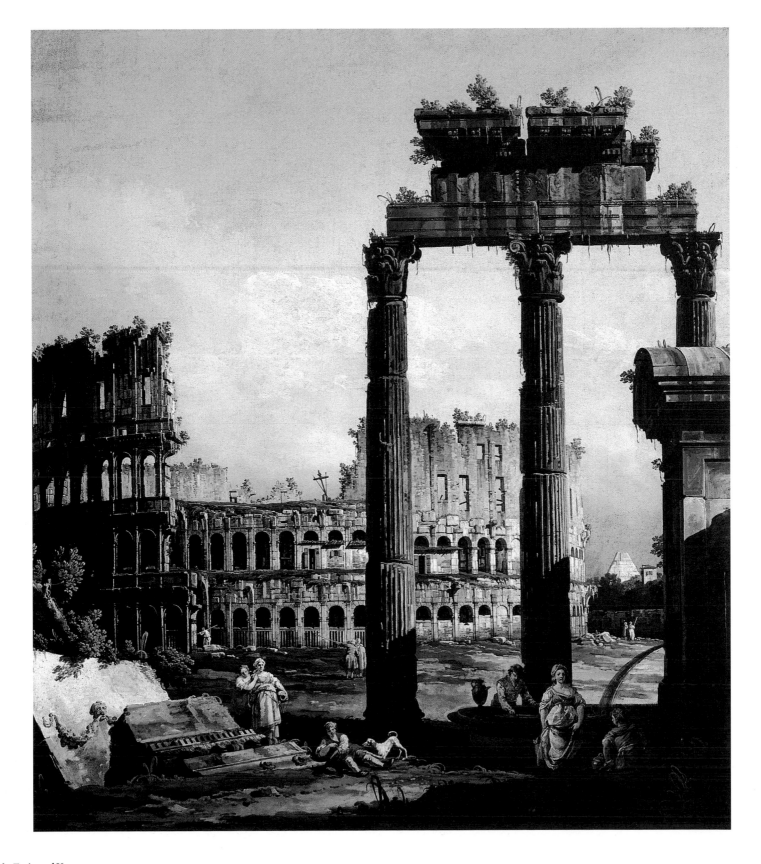

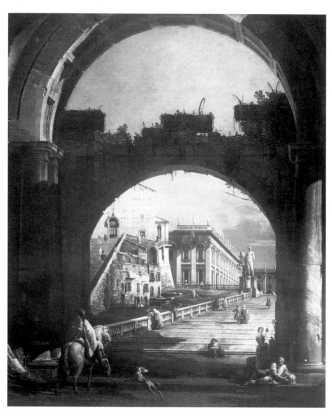

Bernardo Bellotto, Capriccio with the Campidoglio
(Parma, Galleria Nazionale)

uses in the cloak of the man wearing the cocked hat in the *Piazzetta Looking Northwards* in the National Gallery of Ottawa (cat. 10). The tourist and the guide close to the Colosseum are similar to the figures around the puppet theatre in the same Canadian painting. Evidently, the experience of the two pendants for Bouchier Cleeve, where large solid figures were used, adding to the power and the impact of the images, led the artist or the client to choose a different typology, better suited to the studied decorative nature of the series.

The four *capricci* were purchased in 1835 as attributed to Francesco Guardi from the collection of Count Stefano Sanvitale, as already mentioned by Ricci (1896), but have only recently been confirmed after much archival research.[17] Nothing is known about their history prior to this.

Bożena Anna Kowalczyk

ment. The technical skill acquired at this time allowed him to delight in painting the effects of the light glancing off the architectural details in relief, the fluting on the columns and the volutes on the capitals, created by very fine light-coloured brushstrokes, as were the decorative structures in the shadow of the Colosseum, while a ray of light over the fountain in shadow is barely indicated with an incision. The overlapping brushstrokes of varying shades of colour give the monuments density, as in the fountain, where every stone, border or decorative pilaster strip has its own precise relief.

Bellotto spent some years working to achieve these results. The two Ottawa *vedute* (cat. 9, 10) which, having established a connection with a dated painting by Canaletto in Windsor Castle,

can be dated to 1743,[15] already reveal a very similar technique and the same distinctly described details. Here the material is even denser, repeatedly gone-over and the skilled control of the compositional lighting effects seems more mature. It must have been executed after the one with two views of Turin (cat. 33, 34) and done at, or very close to, the time of his visit to the city, a hypothesis supported by the presence in one of the *cappricci* in the series of a Veronese topographical element, the north-west tower of Castelvecchio.[16]

The Arcadian figures in the two vertical pendants are considered to be by Bellotto in imitation of the ones executed by Francesco Zuccarelli in the horizontal format. The dry brushstrokes in relief that outline the legs of the seated boy are like the ones he

[1] Kowakiewicz 1972, vol. 2, no. 129.
[2] Kozakiewicz 1972, vol. 2, nos. 129 and 128.
[3] Kozakiewicz 1972, vol. 2, no. 78.
[4] Kozakiewicz 1972, vol. 2, no. 75.
[5] Kozakiewicz 1972, vol. 2, nos. 67 and 68.
[6] Kozakiewicz 1972, vol. 2, no. Z 318.
[7] Kozakiewicz 1972, vol. 2, no. 130.
[8] Constable and Links 1989, vol. 2, no. 713 (238).
[9] Constable and Links 1989, vol. 2, no. 713 (235).
[10] Waagen 1854, vol. 2, p. 355.
[11] Kozakiewicz 1972, vol. 2, no. Z 327; Levey 1991, pp. 17-18, no. 373.
[12] Constable and Links 1989, vol. 2, nos. 721 and 388.
[13] Constable and Links 1989, vol. 2, no. 388*.
[14] Constable and Links 1989, vol. 2, no. 713 (235).
[15] Pantazzi, in Ottawa 1987, pp. 23-24.
[16] Marini, in Verona 1990, pp. 138-40.
[17] Cattani 2000, pp. 60-61.

c. 1745
Oil on canvas
33 1/4 × 54 1/8 inches
(84.5 × 137.5 cm)
Inscribed at lower right
with an indistinct inventory
number: *122*
Fondazione Cassa di
Risparmio di Verona Vicenza
Belluno e Ancona, Verona

Provenance: Prince Alexis Orloff;
his posthumous sale, Galerie
Georges Petit, Paris, 29 April
1920, lot 7 (7,700 francs to Mar-
gossian); purchased soon after-
wards by a French private collec-
tor; sold by his children,
Christie's, London, 7 July 2000,
lot 84, where acquired by the pre-
sent owner.
Exhibition: Verona 1990, no. 32.

Bibliography: Kozakiewicz 1972,
vol. 1, p. 44, vol. 2, p. 74, no. 94
and under nos. 95-6; Camesasca
1974, no. 64; Bleyl 1981, p. 61, no.
49; Limentani Virdis 1990, pp. 35,
38; Brownell, in Verona 1990, pp.
116-18, no. 32 and under 33;
Links 1990, p. 661.

Verona clearly held a particular
appeal for Bellotto as a subject. It
had been painted on occasion by
Gaspar Van Wittel (1682/83-
1736) and Luca Carlevarijs
(1663/64-1730), and Bellotto
may have known a view executed
by Antonio Joli (1700-77) in 1735
for the German military com-
mander, patron, and collector,
Marshal Johann Matthias, von
der Schulenburg (1661-1747), a
resident of the city in the years
1742-47.[1] Although Verona is on-
ly sixty kilometers west of Venice
and had long been part of the
Venetian Republic, its picturesque
potential had been entirely over-
looked by Canaletto. Bellotto,
however, executed no fewer than
seven views of the city, all of un-
usually large size for paintings of
his Italian period. This is not the
only respect in which they antici-
pate the artist's achievements in

Northern Europe after his defini-
tive transfer there in April 1747.
The Verona views can be seen not
only as the culmination of his
Italian work, but also as the first
products of his maturity, includ-
ing as they do one of his greatest
masterpieces, the *View of Verona
with the River Adige from the
Ponte Nuovo* (cat. no. 37).
For that and the pendant *View of
Verona with the Ponte delle Navi,
looking Downstream*, now on
loan to the National Gallery of
Scotland at Edinburgh,[2] Bellotto
adopted the large format canvas
which he was to use for the rest of
his career for all his most impor-
tant urban views. As Stefan Koza-
kiewicz has pointed out, its width
was particularly well suited to the
depiction of the breadth of the
Adige, a prominent feature of all
his views of the city.[3] In the Ponte
delle Navi picture, Bellotto gives a
virtuoso display of the distinctive
characteristics of his style: use of
an unusual viewpoint, unifying
cold light, acute sense of texture
and lyrical atmosphere. The close
relationship between the Edin-
burgh and Powis pictures and
Bellotto's work in Northern Eu-
rope is further demonstrated by
full-size replicas of them in the
Gemäldegalerie Alte Meister at
Dresden (cat. no. 38).[4] Supplied
to Augustus III, King of Poland
and Elector of Saxony, in 1747-
48, these are possibly the first
paintings executed by the artist
after his emigration, as well as be-
ing his last views of Verona and
two of only three repetitions of
Italian compositions made by
him in the North.
The present view from the Re-
gaste San Zeno on the right bank
of the Adige towards the center
of Verona is dominated by the
imposing Castle of San Martino
in Aquario (the Castelvecchio)
and the adjoining Ponte di
Castelvecchio (Ponte Scaligero),
whose unity of design, similar
brick construction, and identical
Ghibelline forked battlements,

further enhances their apparent
scale. They were begun in 1354
by Cangrande II della Scala
(1332-59), one of the last mem-
bers of the della Scala (Scaligeri)
family to rule Verona as despots
in the manner of the Visconti in
Milan and the Este in Modena
and Ferrara. The dynasty's cen-
tury in power, 1277-1387, saw
the city expand manyfold and
was a golden age for building
and the visual arts. Completed in
1376, the castle and the bridge
were the last Scaligeri embellish-
ments to Verona. Their form re-
flects the increasing uncertainty
of the family's hold on the city,
which little more than a decade
after their completion was to
pass into the hands of the Car-
raresi of Padua, and subsequent-
ly the Visconti of Milan before
becoming part of the Venetian
Republic in 1405.
The castle is designed as a defense
as much against the city as against
the outside world, and a prime
function of the bridge, which was
for the Scaligeri's own exclusive
use, was to provide an escape
route in time of danger. The sky-
line is punctuated on the far left
by the church of Sant'Eufemia
and, beyond the bridge's three
unequal arches, by the eighty-
three meter high Torre dei Lam-
berti of the Palazzo del Comune
and the belfry of the church of
San Lorenzo. With the exception
of the floating mills in the fore-
ground, which did, however, re-
main a feature of the cityscape
until the beginning of the last
century, the view is relatively little
changed today. The castle has
been accurately restored and
since 1925 has housed the Museo
di Castelvecchio where the pre-
sent painting was exhibited in
1990, while the bridge was rebuilt
after its destruction in 1945.
The same qualities displayed in
the Edinburgh, Powis and Dres-
den views are evident to varying
degrees in Bellotto's three other
Veronese paintings, all of which

show the Castelvecchio and the
Ponte Scaligero. The exhibited
painting is the only one taken
from upstream. Hidden since
1920 in a French private collec-
tion, in which it survived attack
with a bayonet during the inva-
sion of Paris in 1940, it was on-
ly known to Kozakiewicz from
old photographs, but was redis-
covered in time to be included
in the 1990 exhibition. It is the
only view of Verona for which a
preparatory drawing survives,
in the Hessisches Landesmuse-
um, Darmstadt.[5] This accurate-
ly delineates the scene from its
single viewpoint and corre-
sponds closely with the paint-
ing, but shows rather more of
the house on the right and
omits the boatman on the left
and the two washerwomen on
the raft at lower right.
The painting was accompanied
until the Orloff sale in 1920 by a
pendant showing the same mon-
uments from downstream, which
has remained untraced since its
sale by Agnew's in 1934.[6] A vari-
ant of that painting, in the
Philadelphia Museum of Art, in-
corporates imaginary elements,
omitting altogether the river
bank to the left and including
prominently the whole of the
church of San Lorenzo, to which
is appended the apse of the Duo-
mo of Lucca, rising above a forti-
fied wall very like that of the
Castello Sforzesco in Milan.[7]
These Castelvecchio views are
not yet on the grand scale of the
Edinburgh and Powis paintings,
their compositions are less dra-
matic and the light less cold. The
corresponding enhancement of
the lyrical mood relates them to
Bellotto's pair of views of Turin
of 1744-45 in the Galleria Sabau-
da (cat. nos. 33, 34) and indicates
that they precede the larger pair.
Kozakiewicz and Penelope C.
Brownell both date the Philadel-
phia canvas to about 1745-46
and the present painting and its
pendant slightly earlier.[8]

Brownell's suggestion that they
"presumably date from the sec-
ond half of 1745, after the artist's
stays in Lombardy and Turin,
but the possibility that they were
executed in 1744 should not be
excluded" seems entirely con-
vincing.
Regrettably, nothing is known of
the provenance of *The Castelvec-
chio and the Ponte Scaligero,
Verona,* and its pendant before
the Orloff sale in 1920. The six-
ty-nine paintings in the sale cov-
ered all schools and included
several of distinction, notably
Canaletto's important early
*View of the Bacino di San Marco
from the Piazzetta, Venice,* in the
Museum Boymans van Beunin-
gen, Rotterdam.[9] The drawings
section on the second day con-
sisted predominantly of a previ-
ously unrecorded album of
ninety-six magnificent Tiepolo
drawings, many of them highly
finished presentation drawings.
Of none of Prince Orloff's pos-
sessions is any earlier prove-
nance known, and it may be as-
sumed that they had been in
Russia for some time before be-
ing exported on the eve of the
Russian Revolution.

Charles Beddington

[1] Christie's, London, 23 April 1993,
lot 53.
[2] Kozakiewicz 1972, vol. 2, no. 101.
[3] Kozakiewicz 1972, vol. 1, p. 44.
[4] Kozakiewicz 1972, vol. 2, nos. 99
and 102.
[5] Kozakiewicz 1972, vol. 2, no. 95;
Bleyl 1981, no. 49; Verona 1990, no.
33.
[6] Kozakiewicz 1972, vol. 2, no. 96.
[7] Kozakiewicz 1972, vol. 2, no. 97;
Verona 1990, no. 34.
[8] Kozakiewicz 1972, vol. 1, p. 44;
Brownell, in Verona 1990, p. 120.
[9] Constable and Links 1989, vol. 2,
no. 124.

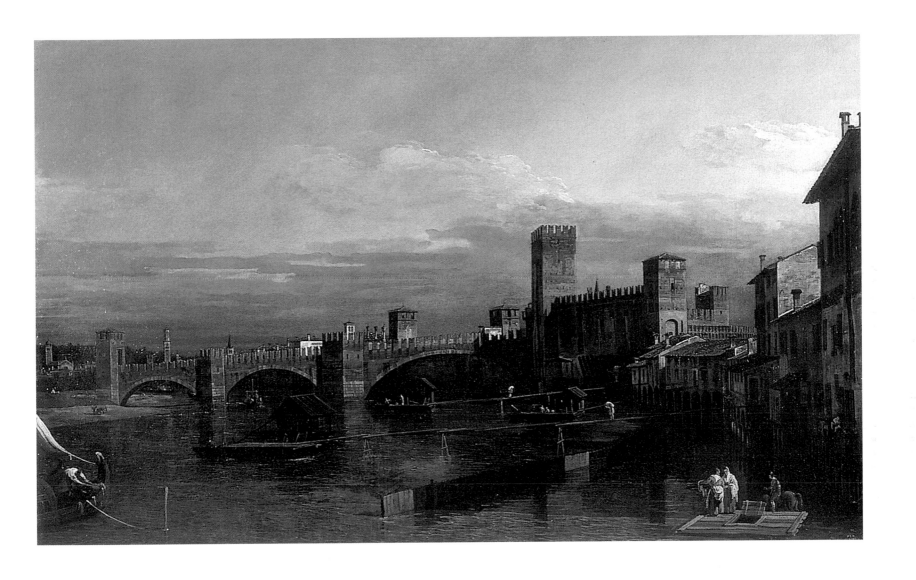

37. View of Verona with the River Adige from the Ponte Nuovo

c. 1745-47
Oil on canvas
52 1/4 × 91 inches
(132.5 × 231 cm)
Powis Castle, The Powis
Collection (The National Trust)

Provenance: Robert, 1st Baron Clive of Plassey (1725-74), by 1774, London; by descent to his son, Edward, 2nd Lord Clive, 1st Earl of Powis of the 3rd creation (1754-1839), who married the Powis heiress, Lady Henrietta Herbert, in 1784, London and Powis Castle; thence by descent; when Powis and the majority of its contents were transferred to the National Trust in 1952, the Bellotto remained in the ownership of the family; when offered for sale in 1981, its acquisition by the National Trust was made possible by grants from the National Heritage Memorial Fund and the National Art Collections Fund, and Grant-in-Aid administered by the Victoria & Albert Museum.

Exhibitions: London 1904, no. 68 (as Canaletto); London 1925, no. 21; London 1930a, no. 768; Manchester 1960, no. 113; London 1982, no. 6; Washington 1985-86, no. 193; London 1988-89, no. 90; London 1995-96, no. 30.

Bibliography: Von Hadeln 1930, pp. 20, 24; Fritzsche 1936, pp. 27-28, 106, VG 26 (provenance confused with that of the Courtauld picture); Kozakiewicz 1972, vol. 1, p. 44, vol. 2, pp. 79-80, no. 98 (with previous references); Brownell, in Verona 1990, pp. 124-29; Marini, in London and Washington 1994-95, pp. 428-29; Laing 1995, pp. 86-87.

From 1744 onwards, for the rest of the few years that he was to remain in Italy, Bellotto spent months at a time in Lombardy, Piedmont, and Verona, where he executed a large number of paintings on new subjects. In Verona, or shortly thereafter, he produced at least seven paintings of four different aspects of the city (cat. no. 36). The greatest of these river landscapes – and the last important pictures he painted in Italy – are a pair of complementary views of Verona seen from approximately the same point that creates the effect of a single huge panorama. One, the present view, is observed from the Ponte Nuovo, looking north up the River Adige towards the Visconti fortress of Castel San Pietro and the hills circled by medieval crenellated walls. The striking pendant view in the opposite direction, looking downstream towards the Ponte delle Navi, has been on loan for many years to the National Gallery of Scotland.[1] Together, these lyrical views achieve with their varied effects of light and crystalline atmosphere "the perfect harmony in a panoramic view of a city that was his goal."[2]

Verona's natural beauty had been admired since antiquity, and the prospect of the city's natural expanse exhibited here was a familiar point-of-view in topographical prints. In the eighteenth century, the view was commented upon by such distinguished visitors to the city as the Italian patron, collector, and writer, Francesco Algarotti (1712-64).[3] The scene is bathed in the clear light of a late summer afternoon under steely gray skies. The broad horizontal sweep of the composition permits the river to fill the whole of the foreground with its boats and floating mills and the shifting mirror-images of the houses on either side reflected on the water. To the left, on the west bank, is the unfinished brick façade and tower of Sant'Anastasia. At the extreme right edge of the canvas, on the east bank, is the Palazzo Fiorio della Seta, decorated with sixteenth-century frescoes.

The pair of Verona views at Powis and Edinburgh marks a breakthrough in Bellotto's ability to conceive and execute panoramic topographical views on a large scale. As one writer put it, referring to the size of these canvases, "From now on, seven feet was to become Bellotto's minimum width for his important townscapes, in itself, surely a mark of self confidence in a man not yet thirty years old."[4] The Verona views were half again as large as his previous largest canvases, and their horizontal shape provided the format that Bellotto was to use from then until the end of his life for all his most important urban views. The widening of his canvases made it possible for him to depict the broad river, with the buildings lining its banks and stretching away into the depths of the picture, to particularly good effect.[5]

A pen-and-ink record of the present painting is at Darmstadt. It corresponds to the composition in very nearly every detail of both the buildings and the figures and boats, and a network of lines in pencil over the sheet led Kozakiewicz to suggest that it served as a preparatory sketch employed to transfer the composition to a larger format.[6] More recent opinion inclines toward accepting the drawing as a record produced by the artist to document the composition for future reference. The sheet is inscribed "*copia del quadro dela Vista stando sun il ponte novo verso il castelo di Verona a Verona di Bernardo Belotto de:^tto il Canaletto per ingiltera*," which indicates an English buyer, most probably an English *milord* travelling in northern Italy on the Grand Tour.[7] Neither the identity of this patron nor the details of how the painting entered the collection of the 1st Lord Clive's collection in London late in the eighteenth century is known.[8]

So important were these panoramic views of Verona that Bellotto produced a second, virtual replica of each (cat. no 38), either in Italy shortly before his departure in 1747 for Dresden or shortly after arriving at the Saxon court of Augustus III, King of Poland and Elector of Saxony, where he had been appointed court painter.[9] There is little diminution in quality between the present picture and the Dresden version, and only slight differences of detail (the main one being the addition of an extra boat, drawn up alongside the foremost of the floating mills). The canvases were presented to the royal collection in 1748, possibly in honor of the new inspector of the Dresden gallery, the painter, writer, and connoisseur, Pietro Maria Guarienti (c. 1700-53), who was born in Verona. Guarienti had known Bellotto since 1745, and he has been thought to have been responsible for the painter's invitation to Dresden.

An excellent repetition of the Powis picture in the same dimensions, painted before 1771 by William Marlow (1740-1813), is in the Lee Collection of the Courtauld Institute, London.[10]

Edgar Peters Bowron

[1] Kozakiewicz 1972, vol. 2, pp. 80-81, no. 101, repro.
[2] Kozakiewicz 1972, vol. 1, p. 44.
[3] Verona 1990, p. 124.
[4] Links 1973, p. 108.
[5] Kozakiewicz 1972, vol. 1, p. 44.
[6] Darmstadt, Hessisches Landesmuseum, HZ 160; Kozakiewicz 1972, vol. 2, pp. 79-80, no. 100, repro.; Bleyl 1981, pp. 62 63, no. 50; Verona 1990, no. 36.
[7] See, however, the objections of Brownell, in Verona 1990, p. 124.
[8] Laing 1995, pp. 86-87: The first record of the picture is as A View in Verona by "Cannalletti," in a list of the 1st Lord Clive's pictures taken at his house in Berkeley Square between 1771 and 1774. The 1775 inventory places a price against it of £147, which translates into 140 guineas, suggesting a purchase in the salerooms, where guineas were the usual unit of bidding.
[9] Kozakiewicz 1972, vol. 2, pp. 77, 79-81, nos. 99, 102, repro.; Verona, 1990, nos. 35, 37.
[10] Kozakiewicz 1972, vol. 2, pp. 477-79, no. Z 369, repro.; Laing 1995, p. 87.

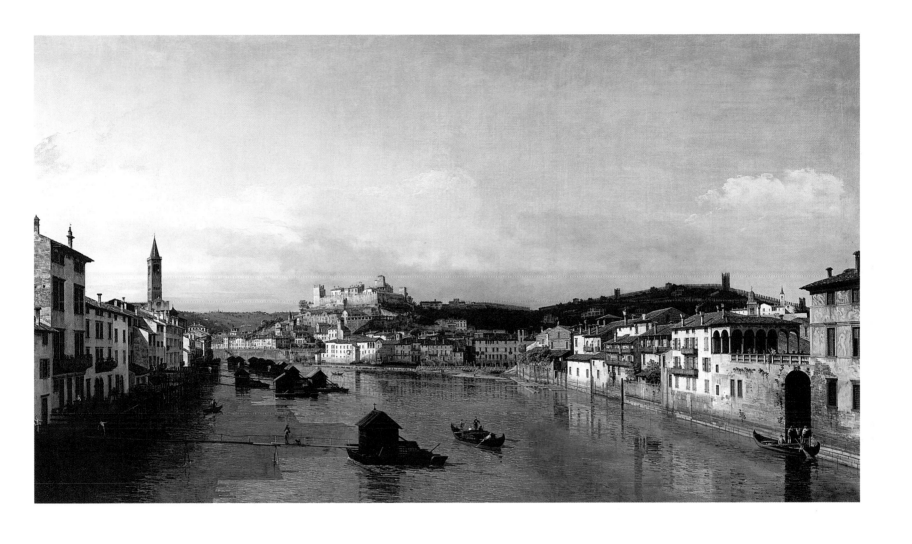

1747-48
Oil on canvas
51 1/2 × 91 1/4 inches
(131 × 232 cm)
Gemäldegalerie Alte Meister,
Staatliche Kunstsammlungen,
Dresden (604)

Provenance: First mentioned in the 1754 inventory of Dresden paintings, no. 544: "*Prospect* of a part of Verona, two castles, of *San Felice et San Pietro*, on canvas 4.8. 8.4."

Exhibitions: Dresden 1956, no. 604; Dresden 1963-64, no. 2; Warsaw and Cracow 1964-65, no. 2; Vienna 1965, no. 7; Essen 1966, no. 1; Venice 1967, no. 94; Verona 1990, no. 35; London and Washington 1994-95, no. 254.

Bibliography: Österreich 1754, vol. 1, no. 544; Posse 1929, p. 289, no. 60.; Fritzsche 1936, pp. 27, 52, 106, 130, no. VG 27; Kozakiewicz 1972, vol. 2, p. 79, no. 99 (with previous references); Camesasca 1974, p. 95, no. 66; Rizzi 1996, p. 239.

This view of Verona is taken from the Ponte Nuovo looking up the Adige towards Castel San Pietro and the medieval city walls in the hills. The broad bend in the river affords a lively view of the river bank and the many houses on it. On the far right the Palazzo Fiori della Seta stands out with its sixteenth-century frescoed façade, already showing marked signs of dilapidation. On the Adige are moored the black tar-covered windmills, and boats laden with goods are going to and fro. On both land and water the arrangement of the houses and boats creates a feeling of depth that is perfectly counterbalanced by the vastness of the river.
Bellotto chose a particularly attractive view for this composition, one already used by other artists, such as François Huret in

his copper engraving of 1648 and Dionigi Valesi (c. 1730-80) in 1747. However, when they first placed the Ponte Nuovo in the foreground in their works, as did Giambattista Cimaroli in a painting dating from approximately the time of Bellotto's *veduta*, the visual angle appears steeper, more limited, the city less extensive and grandiose.[1] Bellotto deliberately widened his depiction of the site, combining (quite unrealistically) in a single panorama separate views of the right and left banks, each taken from a different viewpoint.
The pendant of this painting (Gemäldegalerie Alte Meister, Dresden) shows the view in the other direction, looking downstream, with the Ponte delle Navi in the foreground.[2] Both paintings are generally considered to be replicas made by Bellotto of originals in the same format, one belonging to the National Trust at Powis Castle in Wales (cat. no. 37), the other on private loan to the National Galleries of Scotland in Edinburgh. With the regard to the present view, its differences from the Powis Castle painting lie chiefly in the arrangement of the boats on the Adige. A drawing in the Hessisches Landesmuseum, Darmstadt, shows these in the exact position they occupy in the Powis Castle painting, which corresponds to the inscription on the sheet: "Copy of the painting of View from the new bridge looking towards the castle of Verona in Verona by Bernardo Belotto known as Canaletto, for England."[3] It has not yet been discovered who the client in England was. The canvases are really too big to have been a souvenir bought by a tourist doing the Grand Tour; and in any case, Verona was a minor stop on the route and would have merited just a few days.
It is more probable that Bellotto received a commission from

England, where his uncle Antonio had been working since 1746 and could have served as an intermediary in the commission.[4] In this case, however, the first pair of views of Verona could date from 1746-47, or shortly before Bellotto left for Dresden in April 1747. He may therefore have painted the copies for Augustus III in Italy or when he was already in Dresden. It is unlikely that he painted them from preparatory drawings or from some similar *aide memoire* jotted down (as the Darmstadt drawing was). It is much more probable that Bellotto still had to hand the two primary versions from which to work before sending them off to England from Verona or Dresden. It is strange that these fine eighteenth-century views of Verona have never found their way to the city itself, and only in 1900 did copies of the Dresden paintings, executed by Otto Schneider for Agostino Zorzi, arrive in the Musei Civici of Verona.
Belotto's views of Verona are the largest paintings executed by him in Italy. Their format and harmony testify to the new heights the artist had reached in his work. The format was to become the standard one he would use for almost all the canvases he painted in Dresden: 4 feet 8 inches high by 8 feet 4 inches wide.

Gregor J.M. Weber

[1] See Verona 1990, pp. 128, 132, repro.; sale, Sotheby's, New York, 21 May 1998, no. 68, oil on canvas, 135.9 × 175.9 cm.
[2] Inv. no. 605; Kozakiewicz 1972, vol. 2, no. 102.
[3] Bleyl 1981, pp. 62, 63, no. 50; Brownell, in Verona 1990, pp. 128, 129, no. 36
[4] For further discussion, see the exhaustive study by Penelope C. Brownell, in Verona 1990, pp. 124-27.

Bernardo Bellotto, View of Verona with the Ponte delle Navi, *Gemäldegalerie Alte Meister, Dresden (605)*

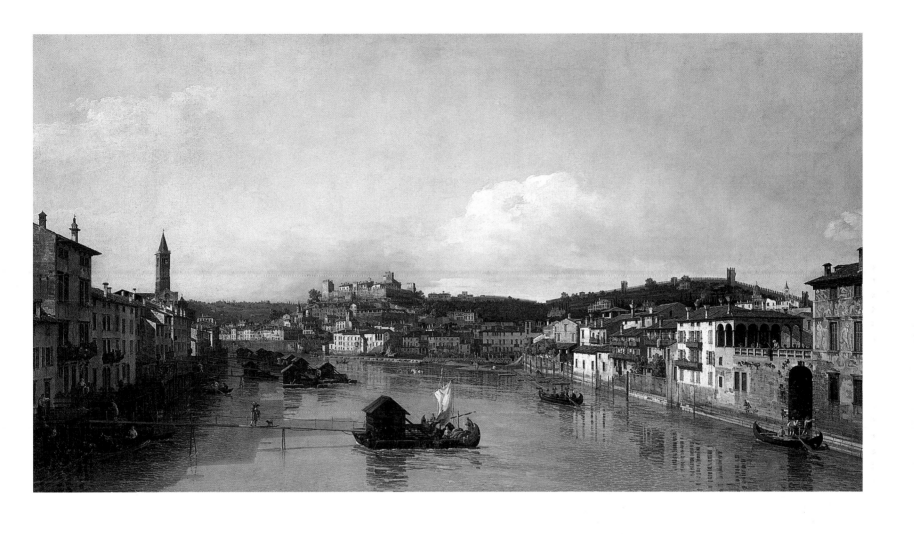

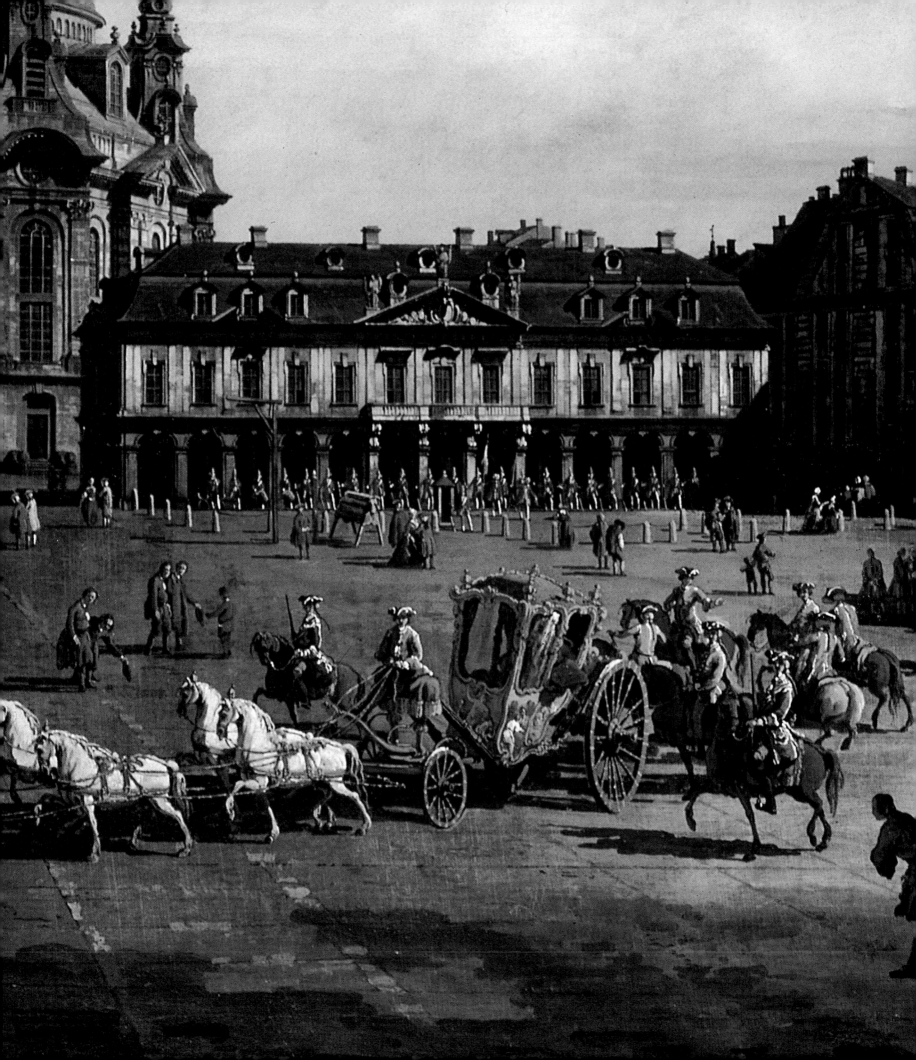

Dresden, Pirna and Königstein

39. Dresden from the Right Bank of the Elbe above the Augustus Bridge

1747
Oil on canvas
52 × 93 inches (132 × 236 cm)
Signed lower right on a block of stone: *BERNARDO. BELLOTTO / DETTO. CANALETO / F.ANNO 1747. IN. DRESDA*
Gemäldegalerie Alte Meister, Staatliche Kunstsammlungen, Dresden (602)

Provenance: First mentioned in the 1754 inventory of the Dresden paintings, no. 543: "*Prospect of Dresden, the Bridge, the Elbe and the Premier-Ministre*, Count *Brühl*, the gardens, on canvas 4.8. 8.4."

Exhibitions: Paris 1935, no. 47; Dresden 1963-64, no. 4; Warsaw and Cracow 1964-65, no. 4; Vienna 1965, no. 9; Essen 1966, no. 2; Venice 1967, no. 95; Venice 1986, no. 1; Munich 1990, no. 16; Warsaw 1997a, no. II 23.

Bibliography: Matthäi 1834, no. 41; Österreich 1754, vol. 1, no. 543; Posse 1929, p. 288; Fritzsche 1936, pp. 13-14, 38, 51, 53, 108-9, 170, no. VG 50; Lippold 1963, p. 26; Kozakiewicz 1972, vol. 1, pp. 84, 86, 89, 92, 100-102, 107; vol. 2, p. 107-8, no. 140 (with previous references); Camesasca 1974, no. 74; Löffler 1985, figs. 1-8; Walther 1992, p. 110; Walther 1995, pp. 23-25; Rizzi 1996, pp. 28-32, no. 1 (with additional references); Löffler 2000, figs. 1-8.

The definitive identification of the painting with the entry in the Dresden Picture Gallery's inventory of 1754 – as cited above – appears here in print for the first time. The reference to the garden of the prime minister, Count Heinrich Brühl, among the subjects of the painting might appear surprising; nevertheless, it was Bellotto himself who noted on the etching of the veduta in 1747: "*Perspective de la galerie, et du Jardin de son Excellence Mgr. / Le Comte de Brühl Premier Ministre…*"[1] He also mentions that the view was taken from the house of Councillor Hoffmann, the husband of the Venetian miniaturist Felicità Sartori (active 1728-60).

On the opposite bank of the Elbe the view ranges over a succession of houses and churches, framed on the right by the Augustus-brücke built by the architect Matthäus Daniel Pöppelmann (1662-1736). The dome of the Frauenkirche by George Bähr (1666-1738) on the far left looms above Count Brühl's art gallery, which is situated on the old bastion of Venus – the so-called gardens, today the "Brühlsche Terrasse" – alongside the library, the room overlooking the river and the Brühl palace. Beside these buildings are the Fürstenberg Palace, the Georgenbau of the castle, and the Catholic church of the court with the unfinished bell-tower.

This painting is rightly considered the first view of Dresden executed by Bellotto, who signed it in a particularly clear manner, putting his name in full, the date, 1747, and, the name of the site "in Dresden", the only such case among his Saxony vedute. This clearly indicates how aware he was of marking an important event in his own career, the beginning of a new creative phase, his admission to a major court. This awareness of his own place in history is also encountered in Bellotto's depiction of groups of figures, which he inserts in the middle of the lower edge of the painting: in a central position, against the backdrop of the city sits an artist who must be none other than Bellotto himself. His presence reinforces the information attached to his signature, doubly emphasizing the truthfulness of the view. Bellotto had represented himself in the same way in the summer of 1745 in a view of Turin, where he was accompanied by a corpulent priest and a younger man (cat. no. 34). In the

Dresden view, an elderly man dressed in green points out the scene before him, while another with a round reddish head is standing on the left behind him. We are unable to trace the historic origins of these figures or the ones further to the right. The Picture Gallery, however, traditionally identifies the corpulent man as the court painter Christian Wilhelm Ernst Dietrich (1712-74), who was also the inspector of the Royal Gallery, and the elderly man as Johann Alexander Thiele (1685-1752), Bellotto's predecessor as *vedutista* at the Dresden court. The gentlemen further to the right have been more or less definitely identified as the royal physician Filippo di Violante, the corpulent contralto Niccolò Pozzi, known as Niccolini, one of the Turks of the court and – a little off to one side – the court jester Fröhlich. Only this last figure can be recognized with any certainty from contemporary illustrations in which he appears dressed as he is here in the Austrian costume of the *Salzakammergut*.

There is also a pendant to this painting, the much more famous view of Dresden from the same bank of the Elbe but from a point downstream of the Augustus-brücke.[2] This painting of 1748 is almost a mirror image of the work seen here, to the extent that the diagonal lines of the flow of the river in the two paintings are symmetrical. While in the first case the Frauenkirche is situated on the far left and the court church is in the centre, in the other painting the relationship is the other way round, the Frauenkirche defines the centre and the court church dominates the far right, now furnished with a bell-tower that appears completed in the painting, although in reality it was not.

Gregor J.M. Weber

[1] Kozakiewicz 1972, vol. 2, p. 115, no. 144; Rizzi 1996, p. 197, no. I 1.
[2] Inv. no. 606; Kozakiewicz 1972, vol. 2, p. 116, no. 146.

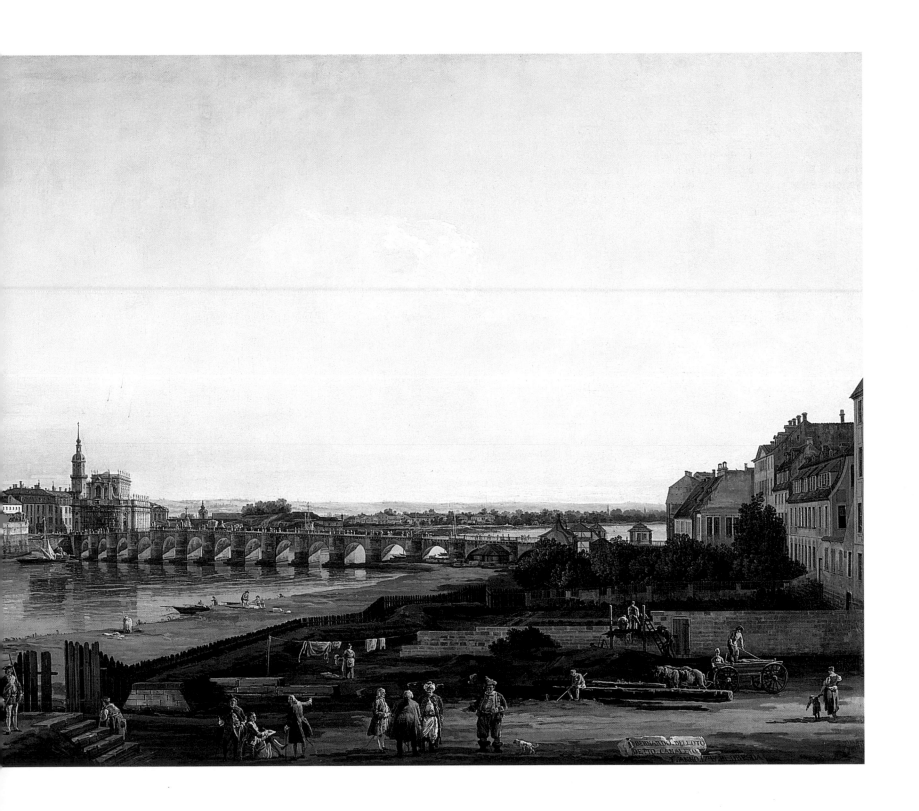

40. *View of Dresden from the Right Bank of the Elbe above the Augustus Bridge*

1747
Oil on canvas
51 1/2 × 91 5/8 inches
(130.8 × 232.7 cm)
Signed at lower left on a block of stone: *BERNARDO. BELLOTO/ DETTO. CANALETO/ F. ANNO 1747 DRESDA.*
North Carolina Museum of Art, Raleigh

Provenance: Commissioned by Graf Heinrich von Brühl (1700-63), Prime Minister of Electoral Saxony and Poland, and probably placed in his gallery in Dresden by the artist in 1747; Brühl estate, Dresden, 1763; Rt. Hon. Lord Hillingdon, Hillingdon Court, Uxbridge, England, by 1894; Hillingdon sale, Christie's, London, 3 May 1946, lot 43; Mrs. Warwick Bryant; her sale, Christie's, London, 23 June 1950, lot 67; David M. Koetser, New York, from whom purchased in 1952 by the North Carolina Museum of Art (52.9.145).

Exhibitions: London 1894, no. 107.

Bibliography: Stübel 1911, p. 476; Kozakiewicz 1967b, pp. 447-48; Kozakiewicz 1972, vol. 2, p. 108, no. 141 (with previous references); Barcham 1991, pp. 13-27; Ricci 1996, p. 32, no. 2.

In addition to the views of Dresden and Pirna that Bellotto painted for Augustus III, King of Poland and Elector of Saxony, he also produced a series of replicas for the collection of the king's prime minister, Count Heinrich Brühl (1700-63). This included thirteen views of Dresden and eight views of Pirna painted between 1747 and 1755, almost all in the same large format as the views that went to the royal collection. Owing to the outbreak of the Seven Years War in 1756, the series does not include any replicas of the Königstein views (cat. no 65). Brühl never paid Bellotto the agreed sum of 200 thalers for each painting, and the artist unsuccessfully brought suit against his heirs after the death of the count in 1763. Five years later, Catherine II (1729-96), Empress of Russia, purchased much of the Brühl collection with the result that fifteen of the surviving twenty views are in Alupka, Moscow, and St. Petersburg (cat. nos. 45, 47, 50-52, 54, 61, 64). The five remaining paintings, sold at Christie's in London in 1946 from Lord Hillingdon's collection, are in private collections in Italy and Spain and in the North Carolina Museum of Art.[1]

The majority of the replicas for Count Brühl reveal minor differences in the figures and in topographical details from the views in the royal collection and now part of the Dresden State Art Collections. In the present panorama of *Dresden from the Right Bank of the Elbe above the Augustus Bridge*, painted in the same year as the version for the king (cat. no. 39), Bellotto has eliminated the seated figure sketching in the foreground, traditionally supposed to be the artist himself, omitted a boat near the foreground embankment, and made the dome of the Frauenkirche more slender.

In the replica of *Dresden from the Left Bank of the Elbe below the Fortifications*, the tower of the Hofkirche is in scaffolding, as in the original painting of the subject (cat. no. 43), and few alterations have been made among the figures.

Recent conservation treatment and technical analysis of the Raleigh canvases provides significant information about Bellotto's methods, materials, and techniques.[2] The *View of Dresden from the Right Bank of the Elbe above the Augustus Bridge* was painted on a relatively light, fine canvas. A red-earth ground was used and this was primed with a pale-gray layer of white lead and fine black pigment in the upper two thirds of the composition, largely in the area reserved for the sky. The paint layers consist of pigments bound in oil, restricted to black, lead white, yellow ochre, burnt umber, Prussian blue, vermilion, and terre verde. Beginning with the sky, Bellotto applied his paint fluently with little impasto, varying considerably his touch and handling. Although he appears to have held in reserve an area for the dome of the Frauenkirche, he generally exploited the reflective properties of the gray imprimatura by brushing architectural details and features over this toned ground and reinforcing them in black with an extremely fine brush while adding highlights in a thicker opaque layer to establish solidity of form.

The architecture is rendered with a smooth, seamless handling that nonetheless conveys a variety of textures and building materials. Incised lines and thin ridges of paint along the edges of buildings reveal the use of mechanical aids to establish guidelines for the architecture and perspective. Bellotto used a compass, for example, to establish the contour of the dome of

the Frauenkirche and the arches of the Augustusbrücke. He employed a straight edge to render more accurately the windows in the Brühl Palace and to outline and delineate forms and details of other buildings.

Examination of the painting by X-ray radiography and infrared light does not reveal evidence of underdrawing or changes in the design, understandable in a repetition of a composition of such recent origin. Bellotto added his figures after the architecture and landscape had been substantially laid in, if not completely finished. These are highly individualized, particularly those in the foreground, and their garments are conveyed convincingly with weight and complexity. Bellotto's earlier formulaic depiction of water has been replaced by a much more naturalistic means of description, particularly in the ripples and reflections.

The *View of Dresden from the Left Bank of the Elbe below the Fortifications* is painted on a moderately thick red ground upon which a thinner beige layer composed of lead white and yellow ochre has been applied. A similar double ground was employed by the artist in a view of the Campo di SS. Giovanni e Paolo, Venice, c. 1743-47 (National Gallery of Art, Washington).[3] In this view of Dresden, Bellotto manipulated the beige imprimatura for a variety of visual effects, applying it more thinly in the sky to allow the red ground to show through and complement the subsequent layers of Prussian blue, leaving it more dense in the passages of landscape. The general sequence of the paint layers follows that of the other Raleigh canvas – the sky preceded the architecture and landscape, which in turn were painted before the figures and details such as the horses and wagon in the foreground.

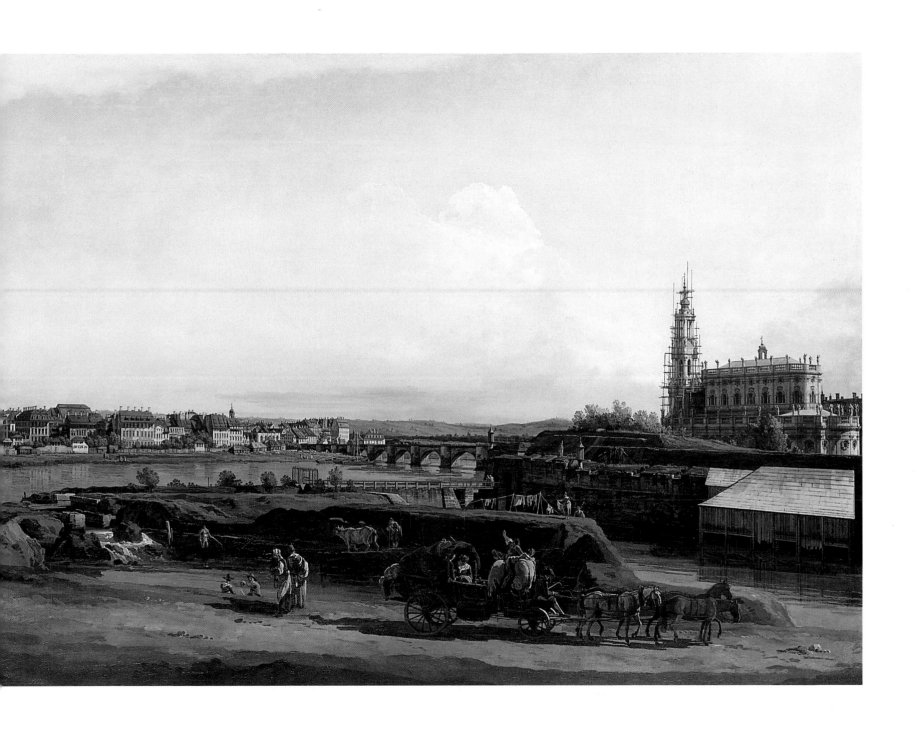

41. *View of Dresden from the Left Bank of the Elbe below the Fortifications*

1748
Oil on canvas
53 1/2 × 91 13/16 inches
(135.9 × 233.2 cm)
Signed bottom left on a block
of stone: [Bernar]*do Belloto
Detto/ Canaleto F An⁰: 1748.*
North Carolina Museum
of Art, Raleigh

Provenance: Commissioned by
Graf Heinrich von Brühl (1700-
63), Prime Minister of Electoral
Saxony and Poland, and proba-
bly placed in his gallery in Dres-
den by the artist in 1747; Brühl
estate, Dresden, 1763; Rt. Hon.
Lord Hillingdon, Hillingdon
Court, Uxbridge, England, by
1894; Hillingdon sale, Christie's,
London, 3 May 1946, lot 44;
Mrs. Warwick Bryant; her sale,
Christie's, London, 23 June
1950, lot 68; David M. Koetser,
New York, from whom pur-
chased in 1952 by the North
Carolina Museum of Art
(52.9.146).

Exhibitions: London 1894, no.
122.

Bibliography: Kozakiewicz 1972,
vol. 2, p. 127, no. 155 (with pre-
vious references); Barcham
1991, pp. 13-27; Ricci 1996, p.
40, no. 14.

The blue sky was thinly painted
with loose, rapid brushwork, the
broad diagonal strokes applied
from upper right to lower left;
clearly defined clouds were then
indicated by heavier impasto
with a wet-in-wet technique.
Bellotto largely completed the
entire sky before proceeding to
the remainder of the composi-
tion, holding in reserve an area
for the upper story of the
Hofkirche. (The textured paint
of the clouds and sky, however,
extends under the tower in scaf-
folding and other details of the
building.) The architecture was
generally painted in four stages:
a broad gray-brown underpaint
was first applied, lines were in-
cised into the wet paint with a
straight edge, establishing the
principal features of the build-
ings and the perspective, thin
dark pigment was used to delin-
eate the finer details; and col-
ored highlights were applied
last. The landscape was estab-
lished with a thin application of
gray-brown or olive paint and
worked up with a thicker ochre
and green layers. Although fig-
ures, boats, and other details in
the foreground were generally
painted over the completed un-
derstructure, a few of the larger
foreground figures were devel-
oped before the landscape was
entirely finished. The reclining
woman in the lower left corner,
for example, was painted over
the olive underpainting, but Bel-
lotto then applied a dark blue-
green, used extensively through-
out the landscape, around the
figure, covering slightly the
edges of her clothing.
Bellotto does not appear to have
used underdrawing, nor did he
undertake significant changes in
the design of the composition.
The few minor differences be-
tween the Raleigh and Dresden
versions appear to have oc-
curred during the course of exe-
cution. In the painting for
Brühl, for example, one of the

lead horses was initially shown
with its leg raised, not planted as
in the Dresden original, but the
artist changed his mind and the
detail was subsequently altered.
Edgar Peters Bowron

¹ Kozakiewicz 1972, vol. 1, pp. 85,
102-103, with additional references;
vol. 2, nos. 141, 147, 152, 155, 162,
165, 168, 171, 174, 177, 182, 186,
189, 194, 197, 201, 208, 212, 221,
226.
² I am exceedingly grateful to David
Findley, Chief Conservator, and
William P. Brown, Associate Con-
servator, North Carolina Museum
of Art, for sharing with me the re-
sults of their conservation treat-
ment and analysis of the paintings
conducted between 1998 and 2000
(letter of 18 December 2000).
³ Bowron, in De Grazia and Garber-
son 1996, p. 9.

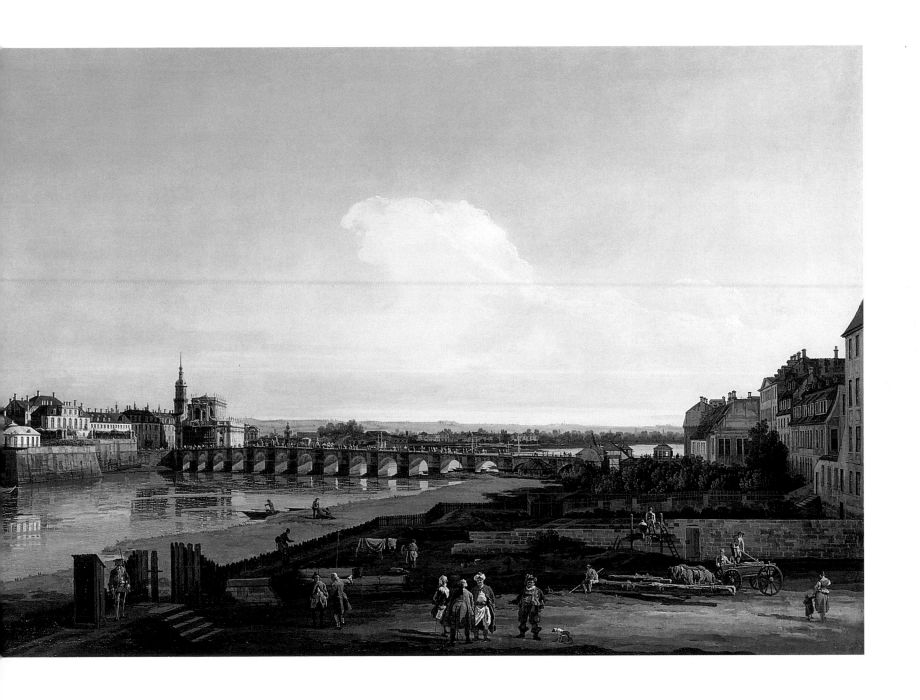

42. *Dresden from the Left Bank of the Elbe, the Palace on the Left, the Catholic Hofkirche Straight Ahead*

1748
Oil on canvas
52 3/8 × 92 1/2 inches
(133 × 235 cm)
Signed bottom left of center:
BERNARDº BELOTO DETTO/ CANALETTO. F.ANº. 1748.
Etching made by Bellotto in 1748.[1]
Gemäldegalerie Alte Meister, Staatliche Kunstsammlungen, Dresden (608)

Provenance: First mentioned in the 1754 inventory of the Dresden paintings, no. 539: "*Prospect of Dresden, part of the Castle, the new church and part of the bridge, on canvas. 4.8. 8.4.*"

Exhibitions: Dresden 1963-64, no. 7; Warsaw and Cracow 1964-65, no. 7; Vienna 1965, no. 12; Essen 1966, New Delhi 1984, no. 3; Vienna 1988, no. 2; Madrid 1998, no. 3; Bilbao 1998, no. 3; Columbus 1999, no. 3.

Bibliography: Matthäi 1834, no. 39; Österreich 1754, vol. 1, no. 539; Hübner 1856, no. 2180; Stübel 1923, pp. 17-18; Posse 1929, pp. 290-91; Fritzsche 1936, pp. 51, 53, 109, no. VG 55; Lippold 1963, p. 27; Kozakiewicz 1972, vol. 1, pp. 84, 86, 100, vol. 2, , p. 121-22, no. 151 (with previous references); Camesasca 1974, p. 97, no. 81; Löffler 1985, figs. 16-20; Walther 1986, p. 72; Walther 1992, p. 112; Walther 1995, p. 48, no. 13; Rizzi 1996, p. 38, no. 11 (with additional references); Citati 1996, p. 40; Löffler 2000, figs. 16-20.

The view ranges over the elevated Brühl Gardens on the Jungfernbastei – the modern Brühlsche Terasse toward the Palace Square and the Augustus Bridge. The square was created by razing the Elbe Gate and various other structures and dumping rubble around the piling to make room for the construction

of the Hofkirche. The church was built after plans by the Roman architect Gaetano Chiaveri (1689-1770), who began working in Dresden in 1737. Its upper storey is stepped back from the lower one; inside, the nave is circled by a twelve-foot-wide ambulatory that permitted Catholic processions in this Protestant city. The balustrades atop each of the two stories are adorned with ten-foot-tall figures of saints – seventy-eight in all – by the sculptor Lorenzo Mattielli (1688-1748) of Vicenza. The tower finally attained its full height of 280 feet in 1755. In his version of this painting for the prime minister, Count Brühl, Bellotto produced an accurate view of the structure as it appeared during the construction in 1748, its façade hidden behind dense scaffolding and the third story of the tower still missing.[2] In the present view made for the elector, Bellotto showed the finished tower as envisioned in the architect's plans but placed it behind scaffolding as though it were still under construction. In Bellotto's etching of the same view, also dated 1748, there is no trace of scaffolding.[3]

Portions of the elector's palace are visible on the left: the George Wing with its large gate and, behind it, the Moritz Wing with the Hausmann Tower above. Especially interesting is the view of the Augustus Bridge on the right, which was rebuilt between 1727 and 1731 by Matthäus Daniel Pöppelmann (1662-1736) and the city's master mason Johann Gottfried Fehre (1685-1753). Its piers were strengthened and their masonry raised to the height of the roadway, creating spacious resting places with benches. Balustrades and lanterns were then added, as Bellotto faithfully confirms. In the distance at the right edge of the painting is the Japanese Palace behind its

French gardens. Farther back we can follow the course of the Elbe downstream until it disappears from view in the vicinity of the Lössnitz Hills.

From the left appears the state carriage of Augustus III drawn by six horses, preceded by two horsemen and two attendants. Several bystanders are bowing to it, including two noblemen dressed in Polish national, to illustrate Augustus' two-fold role of elector of Saxony and king of Poland. This view and the one of the New Market with the art gallery (cat. no. 46) are the only two paintings in which Bellotto depicted the royal carriage, perhaps to underline the two most important building projects of Augustus III in Dresden, the restructuring of the art gallery and the building of the royal chapel.

Gregor J.M. Weber

[1] Kozakiewicz 1972, vol. 2, p. 122, no. 153.
[2] Kozakiewicz 1972, vol. 2, p. 122, no. 152; Rizzi 1996, p. 38, no. 12.
[3] Kozakiewicz 1972, vol. 2, p. 122, no. 153; Rizzi 1996, p. 199, no. 13.

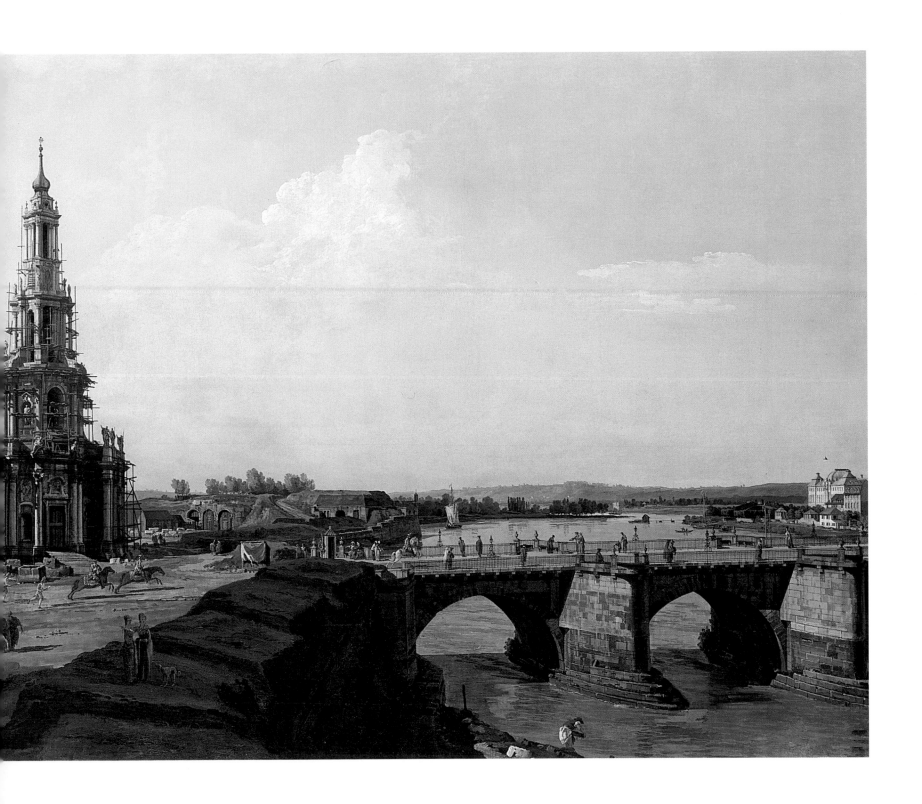

43. *View of Dresden from the Left Bank of the Elbe below the Fortifications*

1748
Oil on canvas
53 1/8 × 93 5/8 inches
(135 × 238 cm)
Signed at the lower left on a block of stone: *Bernardo Bellotto Detto/ Canaletto F.Anº. 1748.*
Etching made by Bellotto in 1748.[1]
Gemäldegalerie Alte Meister, Staatliche Kunstsammlungen, Dresden (607)

Provenance: First mentioned in the inventory of Dresden paintings in 1754, no. 545: "*Prospect of the new town of Dresden*, 4.8. 8.4."

Exhibitions: Prague, Brno, and Bratislava 1962-63, no. 8; Bucharest 1963, no. 14; Dresden 1963-64, no. 8; Warsaw and Cracow 1964-65, no. 8; Vienna 1965, no. 13; Essen 1966, no. 5; Venice 1967, no. 97; Venice 1986, no. 2; Vienna 1988, no. 1; Madrid 1998, no. 2; Bilbao 1998, no. 2; Columbus 1999, no. 2.

Bibliography: Matthäi 1834, no. 35; Österreich 1754, vol. 1, no. 545; Hübner 1856, no. 2176; Stübel 1923, pp. 14-16; Posse 1929, p. 290; Fritzsche 1936, pp. 53, 109, no. VG 54; Lippold 1963, p. 27; Kozakiewicz 1972, vol. 1, pp. 84, 86, 100-102, vol. 2, pp. 122, 127, no. 154 (with previous references); Camesasca 1974, p. 97, no. 79; Löffler 1985, figs. 21-25; Walther 1992, p. 112; Walther 1995, pp. 51, 52, no. 14; Rizzi 1996, p. 40, no. 13 (with additional references); Citati 1996, p. 44; Löffler 2000, figs. 21-25

Until recently no. 539 in the 1754 inventory has wrongly been thought to refer to this painting; but the description in the entry for no. 545 captures precisely the principal motif of the painting, a view of the new town on the opposite bank of the Elbe. Bellotto specifically mentions it in the title of his 1748 etching of the same scene: "*Perspective de La ville neuve, et du Palais de S.M. dit d'Hollande et des Environs de / La campagne de Loschúwitz…*"[2] Thus, the title that is normally given to this painting today is in fact misleading.

For this view Bellotto chose a spot on the left bank of the Elbe, looking downstream from the center of the town, at a point beyond the bastions of the old city walls. The moat, fed by the Elbe, continues to the right in front of the Luna Bastion and around the Zwinger, which is not visible in the painting. The elector's wine cellar was built into the wall behind the wooden structure with the two wheels. Again, the dominant feature of the picture is the Hofkirche, its tower still under construction. In his etching of this view, Bellotto left out the scaffolding. The tower lantern visible above the roof of the Hofkirche is actually part of the cupola of the Frauenkirche, farther upstream. Beyond the Augustusbrücke, on the opposite bank of the Elbe, lies the new town of Dresden, where wooden houses are still being constructed. At the end of the bridge, one can make out the Blockhaus, just then reaching completion. Its architect, Zacharias Longuelune (1669-1748), had originally envisioned a pyramid with steps above the square structure, topped by an equestrian statue of Augustus the Strong, but after his death it was decided to add a simple mezzanine story instead. At the left edge of the painting stands the Japanese Palace, which replaced the Dutch Palace, built in 1715. Augustus the Strong had acquired the latter structure in 1717, designating it as the home for his porcelain collection. The 884 page inventory of this "Little Porcelain Palace" from 1721 numbers thousands of pieces of porcelain from China, Japan, and Meissen. By 1738, the original structure had been expanded by the addition of three new wings and roofed in a manner reminiscent of Far Eastern architecture.

The city panorama actually takes up only a very narrow strip of the painting. None of Bellotto's other views of Dresden has such a strictly horizontal orientation. The painter has filled the broad band of the foreground with figures of country people, fisherman, and shepherds, some riding in a wagon, others resting or strolling about. Washing has been hung out on what is left of the outer wall. Bellotto has adopted elements from the pastoral landscapes of Francesco Zuccarelli (1702-88), notably the cow in the foreground, taken directly from one of the Venetian artist's paintings.[3] Later, in the foreground of his later views of Pirna and its environs and of Königstein (cat. nos. 59, 60, 61, 65), Bellotto would give even greater priominence to such idyllic and pastoral motifs.

Gregor J.M. Weber

[1] Kozakiewicz 1972, vol. 2. p. 127, no. 156.
[2] Kozakiewicz 1972, vol. 2, p. 127, no. 156; Rizzi 1996, p. 200, no. I 4.
[3] Pallucchini 1960, fig. 514; Weber 2001.

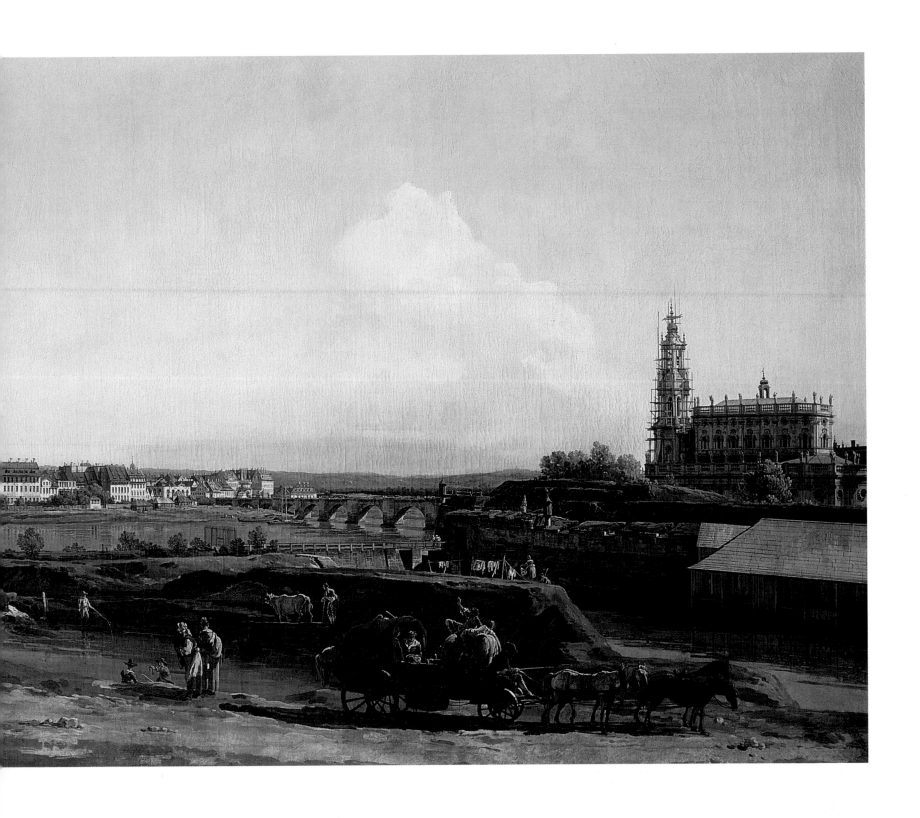

1748
Oil on canvas
52 × 91 3/8 inches
(132 × 232 cm)
Signed at lower left:
*BERNARDO./ BELOTO.
DETO. CANALETTO./ FE.
ANNO. 1748.*
Gemäldegalerie Alte Meister,
Staatliche Kunstsammlungen,
Dresden (603)

Provenance: First mentioned in the 1754 inventory of the Dresden paintings, no. 540: "*Prospect* of part of an Italian city, on canvas. 4.8. 8.4."

Exhibitions: Dresden 1956, no. 603; Dresden 1963-64, no. 1; Warsaw and Cracow 1964-65, no. 1; Vienna 1965, no. 6; Venice 1967, no. 96.

Bibliography: Matthäi 1837, no. 556; Österreich 1754, vol. 1, no. 540; Hübner 1856, no. 2165; Posse 1929, pp. 288-89; Fritzsche 1936, pp. 27-28, 107, no. VG 32; Voss 1937, pp. 197-98; Lippold 1963, p. 23; Pignatti 1966, pp. 221, 226-27; Pignatti 1967, pp. 1-4, 7; Kozakiewicz 1972, vol. 1, p. 86, vol. 2, p. 84, no. 107 (with previous references); Camesasca 1974, p. 95, no. 71; Walther 1986, p. 36; Rizzi 1996, p. 98, no. 81 (with additional references).

This Italian capriccio has several surprising aspects, not least the fact that Bellotto did not paint it in Italy, but – as confirmed by the signature and date – at the beginning of the Dresden period while he was working on his major views of the German city. And so he produced side by side realistic views and imaginary capricci, both in the large format of about 135 cm high by 235 cm wide.[1] The size and the subject were equally important to Bellotto's inspiration; for the composition he basically used a small etching of

Canaletto's, *Le Porte del Dolo*.[2] This view was executed during an overland journey that the two artists made together at the beginning of the 1740s. Bellotto copied the central motif, the oval-shaped basin of the locks at Dolo, halfway between Venice and Padua, from his uncle's etching as well as the corner house with a cartouche with coat-of-arms, hanging sign, and shrine on the wall containing a butcher's shop below. Bellotto also took from this source the low buildings just beyond the far wall of the basin, the motif of the figures on the wall, and the man steadying himself against the wall in the boat below. Nonetheless, the younger artist greatly expanded the whole composition beyond that of his source and added to the foreground on the right a platform with five steps leading to an entrance with large columns, reminiscent of ancient Roman temples. The building that extends into the middle distance has an imposing Mannerist façade with elements of the Fabbriche Nuovissime and the Procuratie Nuove in Venice. Finally, Bellotto draws the eye into the background of the painting where a splendid Palladian villa stands on the banks of the river. Canaletto had indicated the entrance to the sluice with a charming roof; Bellotto does away with this in favour of an open view of the Brenta, but he does however frame the composition with a mediaeval tower and the remains of a ruined bridge.
In order to increase the sense of depth to his composition, Bellotto adds areas of bright light and deep shadow. The dark area in the foreground is followed by the brightly lit area of the rear bulkhead, on which the figures on the right stand out in particular: a figurative procedure that is to be found in every detail of

the painting. For the same reason, Bellotto added a row of black chimney-pots in front of the light-coloured facade of the building opposite; it is apparent to the naked eye that these were added afterwards, because the finished painting of the building shows through the top layer of paint. Other *pentimenti* – for example, on the platform on the right – attest to Bellotto's efforts to revise and enhance his ideal view. A smaller variant of the present composition in the Yale University Art Gallery, New Haven, has been dated marginally earlier, about 1744-46; the composition nonetheless possess the same overall format as the larger Dresden painting, and it therefore remains an open question which painting preceded the other.[3]

Gregor J.M. Weber

[1] Another Venetian-Roman-Dresden capriccio with a house and a town beside a river, c. 1747-50, formerly in the Residenzschloß, Dresden, disappeared during the Second World War; Kozakiewicz 1972, vol. 2, p. 189, no. 245; Rizzi 1996, p. 99, no. 82.
[2] Bromberg 1974, pp. 67-71, no. 6.
[3] Kozakiewicz 1972, vol. 2, pp. 83-84, no. 106, 73.5 × 108.5 cm.

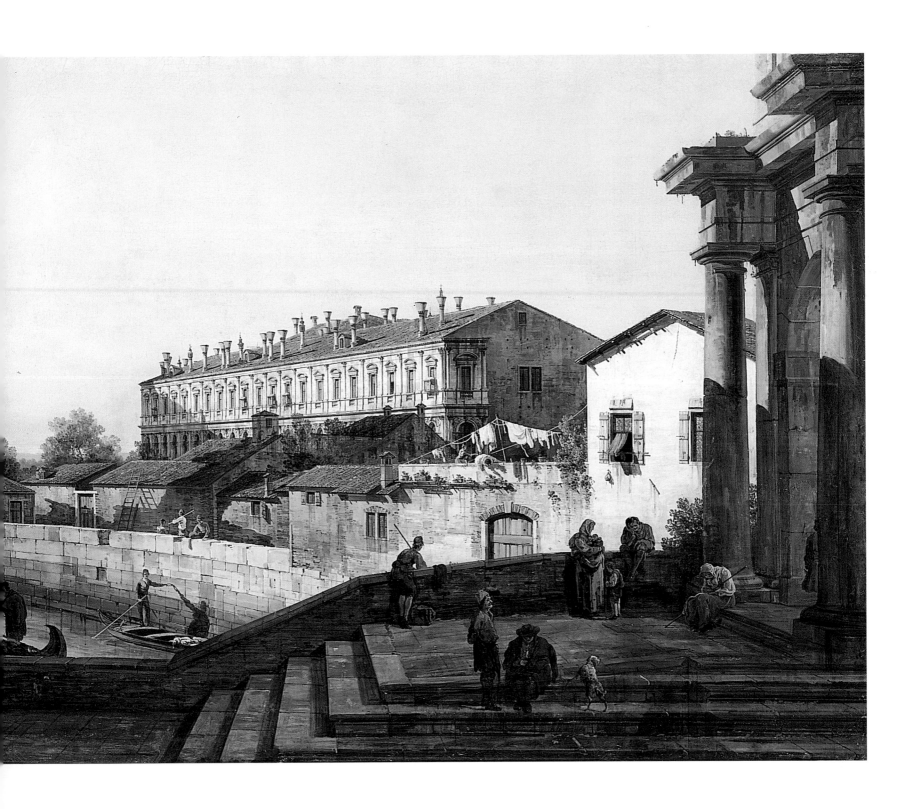

45. *The Old Fortifications of Dresden South of the Zwinger (the Saturn Bastion)*

1749-52
Oil on canvas
51 1/8 × 93 1/8 inches
(130 × 236.5 cm)
The State Hermitage Museum,
St. Petersburg (207)

Provenance: Part of the gallery of Count Heinrich Brühl (1700-63), Dresden, by 1752; acquired from his heirs by Catherine II (1729-96) of Russia in 1768; in the first half of the nineteenth century in the Tauride Palace, St. Petersburg; from 1863 in Gatchina Palace, near St. Petersburg; restored to the Hermitage in 1923.

Exhibitions: St. Petersburg 1923; Leningrad 1959, p. 10; Warsaw and Cracow 1964-65 (not in catalogue); Tokyo, Mie, and Ibaraki 1993-94, no. 39.

Bibliography: Staehlin, *Notes*, vol. 1, p. 374; vol. 2, p. 111; Minich 1773-83, vol. 1, pp. 149-50, no. 462; Hermitage 1774, p. 41, no. 462; Bernoulli 1780, p. 194; Hermitage 1797, vol. 1, p. 386, no. 2200; Hübner 1856, p 73; Hermitage 1859, no. 2919; Stübel 1911, p. 476; Fritzsche 1936, p. 110, no. VG 59; Hermitage 1958, p. 66; Fomichova 1959, pp. 9-10; Haskell 1963, p. 295; Kozakiewicz 1972, vol. 1, pp. 85, 100-102, vol. 2, p. 131, no. 162 (with additional references); Camesasca 1974, p. 98, no. 88; Hermitage 1976, p. 76; Levinson-Lessing 1985, p. 67; Fomichova 1992, p. 82, no. 48; Rizzi 1996, p. 46, no. 19.

The role of Count Heinrich Brühl at the Saxon court and his activity as a patron of the arts is depicted in the famous allegorical canvas by Giovanni Battista Tiepolo (1696-1770) – whose programme was devised by Count Francesco Algarotti (1712-64) – *Maecenas Presenting the Liberal Arts to Augustus* (c. 1743-44, The State Her-mitage Museum, St. Peters-burg). Brühl succeeded in invit-ing Bellotto to Dresden, assur-ing him of a good income and advantageous commissions and an appointment as "Peintre du Roi". When Bellotto executed the series of views of Dresden and Pirna for the king, he paint-ed similar views at the same time for his powerful patron, which went to make up the so-called "Brühl series". To recipro-cate the count's mediation, the artist painted pictures for him almost without asking for pay-ment. Only after Brühl's death on 28 October 1763 did Bellot-to, who was living in Dresden without any means, turn to the heirs of the prime minister, beg-ging them to give him 200 thalers per picture. This request could not be granted, given that the legacy of Count Brühl, who was inundated with debts, had been confiscated. Some time af-terwards the painter received a purely symbolic sum of money. As soon as the confiscation was reversed in 1768, Brühl's heirs began negotiations for the sale of the collection estimated at 105,000 thalers. Prince Belossel-skij, the Russian ambassador to Saxony managed to acquire the whole collection – which num-bered more than 600 paintings – for only 80,000 thalers.[1] Rizzi mistakenly informs us that "Catherine II of Russia pays Brühl's heirs 80,000 thalers for fifteen of the Saxon views paint-ed by Bellotto for the prime minister".[2] Even before Cather-ine II had given orders to nego-tiate with Brühl's heirs over the acquisition of the collection, Bernardo Bellotto had been in-vited to the empress's court. It is known that the artist accepted the invitation and in 1767 set off with his son on a trip to Russia, without, however, ever reaching St. Petersburg.
Having reached the Hermitage almost all of the paintings from the Brühl gallery were examined by the court restorer Lucas Pfandzeldt and probably by Catherine as well, as Jacob Staehlin informs us: "Many paintings in this very famous collection, probably, on the journey, when they were com-ing down the Elbe [Staehlin's annotation follows: "presum-ably deteriorated because they had been hidden in basements during the war"] being trans-ported to Lubeck, arrived in a terrible state, but thanks to the great skill of the court painter Pfanzeldt and Signor Martinelli, an Italian painter working in the palace of Count Razumovskij, they were restored. As we saw during the restoration of the aforesaid pictures from the gallery of Count Brühl, Her Majesty also became personally involved after the works were displayed in the new Hermitage Gallery, on a daily basis and sometimes for many hours and over a number of years. In this way the Empress succeeded in acquiring a deep knowledge of the famous and principal schools and the manners of cel-ebrated painters".[3]
For more than two centuries the Brühl series, being in Russia, was overshadowed by the bet-ter-known royal series in Dres-den and was not as appreciated as it deserved to be. Even today it is commonly thought that the pictures in the Hermitage is are smaller than those in Dresden.[4] In fact the canvases of both cy-cles are of identical dimensions. The Brühl series is not a copy of the royal one; it is an equivalent autograph version, to which the artist brings – albeit insignifi-cant – changes, first and fore-most in the small figures. The comparison of the two series made during the exhibitions in the years 1963-65 (Dresden, Warsaw and Vienna), allowed Kozakiewicz to confirm that the pictures also differentiate in terms of colour. In the Dresden paintings grey-brown shades dominate, while in those housed in St. Petersburg rose-pink and pale-blue colours pre-vail. Rizzi maintains that in the Hermitage works there is a "more lively chromatic range".[5] The view known as *The Old Fortifications of Dresden South of the Zwinger* is the companion of another picture, *The Zwinger Moat* in Dresden (Gemäldega-lerie Alte Meister, Dresden, inv. 609); both depict two bastions situated on opposite parts of a long wall. The two canvases be-long to the initial period of the artist's pictorial production both for the royal series and for the Brühl series of views of Dresden, whose subject was suggested by Bellotto's august commissioner. For these views the artist finds solutions of sim-ilar volumes – the compositions are defined on the one hand by the projection of a corner of the bastion (in this case the Saturn bastion) on the opposite bank of the moat, and on the other hand by the roofs of several buildings near the spectator. Among the panoramas of Dres-den executed by Bellotto this one stands out on account of its uncommon and in a certain sense, "Enlightenment," solu-tion: the foreground and back-ground of the painting are al-most totally immersed in a deep obscurity, underlined by a per-spective line positioned diago-nally, to create an intensity of contrasts of light and shade. The surface of the water glitters calmly without absorbing direct sunlight, but rather the intense-ly lit reflections of the fortress walls.
Behind the fort bathed in the morning light rise the buildings of the Opera House, the white building of the Adam house, and the massive dome of the Wilsche Tor. In the centre we can see the stone bridge that links the left bank to the Wils-druffer Tor. Rizzi notes that Bel-lotto includes some of his own additions in this view: "… the bell-tower of the Hofkirche that rises, disproportionately large, above the Opera House – takes on an artificial character in the pictorial *ductus*, given that at the time of the painting the part de-picted had not yet been built…"[6]
In the foreground, enveloped in shade, where Zwinger Strasse runs alongside the moat, rises a new building – as usual this vivid representation does not serve simply to animate the painting but gives life to addi-tional splashes of color in the chromatic solution of the work. The sun's rays that penetrate the houses here and there, now striking a group of builders, now the brightly coloured jack-et of a man who has stopped to talk, now the pale side of an obelisk – one of the milestones placed in Saxony by order of Augustus the Strong in 1722, on which was marked the time it took the mail carriage to reach the principal points of the King-dom. The view in Dresden dif-fers from the Hermitage com-position only in the absence, on the right, of the man leaning on the parapet and the dog barking at the women seated near the obelisk.
The Fishman collection in London contains a reduced version of the composition.[7]

Irina Artemieva

[1] Levinson-Lessing 1985, p. 260.
[2] Rizzi 1996, pp. 67, 238.
[3] Staehlin, *Notes*, I, p. 374.
[4] Cf. for example, Haskell, 1963, p. 295; Pallucchini, 1996, p. 508.
[5] Rizzi 1996, p. 19.
[6] Rizzi 1996, p. 46.
[7] Fomichova 1992, p. 82.

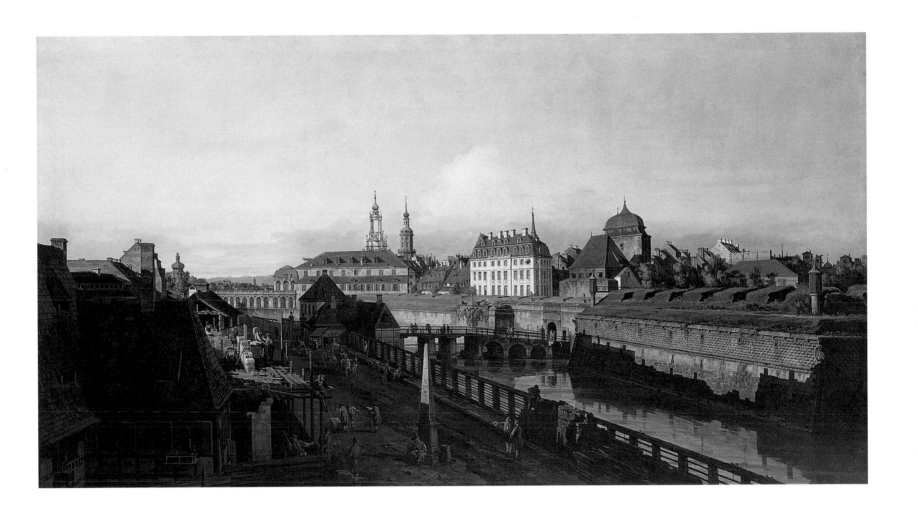

c. 1749
Oil on canvas
53 1/2 × 93 1/4 inches
(136 × 237 cm)
Etching made by Bellotto
dated 1749.[1]
Gemäldegalerie Alte Meister,
Staatliche Kunstsammlungen,
Dresden (610)

Provenance: First mentioned in the 1754 inventory of the Dresden paintings, no. 541: "*Prospect* of Dresden, the *Galerie* and the new market, behind the Pirnaische Gaße, on canvas. 4.8. 8.4."

Exhibitions: Moscow 1955, no. 610; Berlin 1955-56, no. 610; Dresden 1956, no. 610; Dresden 1963-1964, no. 12; Warsaw and Cracow 1964-65, no. 12; Vienna 1965, no. 17; Stockholm 1969, no. 228; Warsaw 1997a, no. II 24; Dresden 2000, no. 141.

Bibliography: Matthäi 1834, no. 45; Österreich 1754, vol. 1, no. 537; Hübner 1856, no. 2186; Stübel 1923, pp. 19-21; Posse 1929, p. 291; Fritzsche 1936, pp. 51, 53, 102, 111, no. VG 64; Lippold 1963, p. 27; Kozakiewicz 1972, vol. 1, pp. 84, 88, 92, 100-102, vol. 2, p. 132, no. 167 (with previous references); Camesasca 1974, p. 98, no. 89; Löffler 1985, figs. 38-42; Walther 1992, p. 113; Walther 1995, p. 42; Rizzi 1996, p. 50, no. 22 (with additional references); Löffler 2000, figs. 38-42.

In the background, the dome of the Frauenkirche, one of the most beautiful Protestant churches ever built, rises prominently. More than 300 feet in height, it was built between 1726 and 1743 by the Dresden master carpenter and architect George Bähr (1666-1738). At the rear of the Neumarkt, to the right of the church, opposite the guardhouse of the old town, soldiers are lined up to salute the royal cortège which is pass-

ing through the square in a procession of vehicles. Augustus III, seated in the first carriage drawn by six white horses, is greeted deferentially by several bystanders. The carriage has been depicted in front of the large building on the left, the Stallhof, the former stables, transformed by renovations in 1729-30 and 1744-46 into the magnificent Royal Gallery. Inside the gallery the paintings were hung side by side on walls nearly thirty feet high according to rigidly symmetrical rules. On the side lit by the high windows overlooking the street were the paintings of the North European school, while on the other side of the gallery, lit by windows overlooking the courtyard, were Italian masterpieces. The impression created by all these paintings arranged symmetrically on the walls must have been extraordinary, as indeed we know from the testimony of various illustrious visitors from Johann Joachim Winckelmann to Goethe.[2]

The painting of a square posed problems of a different order than the view of a city taken from the open perspective of a river. Indeed in this painting Bellotto referred more than in his earlier work to Dutch examples, such as the views of Job Berckheyde (1630-93) and his brother, Gerrit (1638-98), and Jan van der Heyden (1637-1712), who nearly a century before had depicted urban settings using similar artistic techniques. The spatial exploration of the square has been achieved by means of alternating light and shade on the houses jutting out and set back, but also by covering the surface with bands of light and shade. Bellotto often used the device of painting dark areas in the foreground that could be shadows created by clouds or buildings but, as a rule, are nothing more than a

compositional element in the spatial organization. Naturally other devices are added to these, such as the diagonal arrangement of the buildings on the side, in this case the art gallery. The pendant of this view shows the same square seen from the Moritzstraße, which, in this painting, is in the lower right-hand corner of the square (cat. no. 48).

Gregor J.M. Weber

[1] Kozakiewicz 1972, vol. 2, no. 169.
[2] Weber 1999, pp. 183-97.

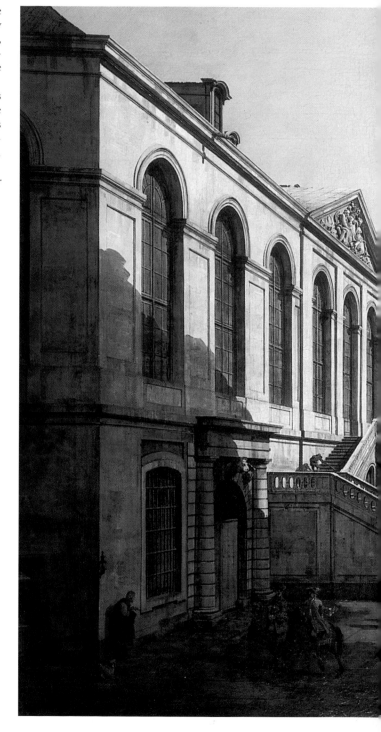

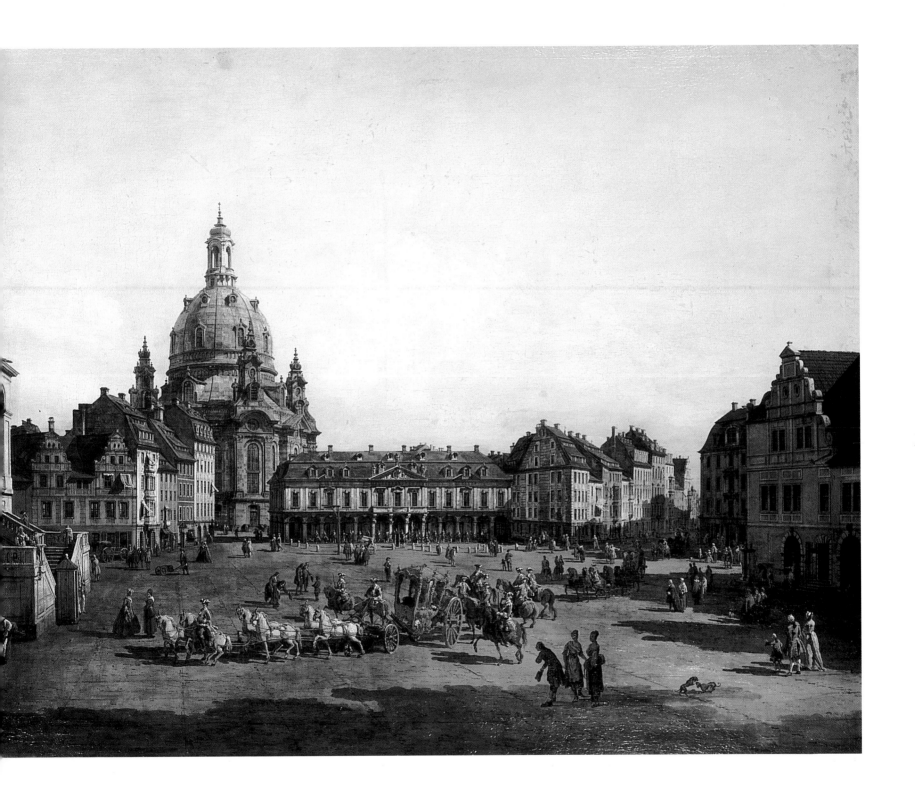

1749-52
Oil on canvas
53 7/8 × 93 1/8 inches
(134.5 × 236.5 cm)
The State Hermitage Museum,
St. Petersburg (204)

Provenance: Part of the gallery
of Count Heinrich Brühl (1700-
63), Dresden, by 1752; acquired
from his heirs by Catherine II
(1729-96) of Russia in 1768; in
the first half of the nineteenth
century in the Tauride Palace,
St. Petersburg; from 1863 in
Gatchina Palace, near St. Peters-
burg; restored to the Hermitage
in 1923.

Exhibitions: St. Petersburg 1923;
Venice 1998, no. 133.

Bibliography: Staehlin, *Notes*,
vol. 1, p. 374, vol. 2, p. 111;
Minich 1773-83, vol. 1, p. 195,
no. 607; Hermitage 1774, p. 53,
no. 607; Bernoulli 1780, p. 193;
Hermitage 1797, vol. 1, p. 353,
no. 2038; Hübner 1856, p 73;
Hermitage 1859, no. 2916; Stü-
bel 1911, p. 475; Fritzsche 1936,
pp. 53, 111, no. VG 65; Her-
mitage 1958, p. 66; Fomichova
1959, pp. 6, 7, 8, 28; Kozakiewicz
1972, vol. 1, pp. 85, 100-102, vol.
2, p. 135, no. 168 (with addition-
al references); Camesasca 1974,
no. 90; Hermitage 1976, p. 76;
Levinson-Lessing 1985, p. 67;
Fomichova 1992, p. 78, no. 44;
Rizzi 1996, p. 50, no. 23 (with
additional references).

*The New Market of Dresden Seen
from the Jüdenhof* is one of the
most sumptuous representa-
tions of the Saxon capital, and it
is not by chance that the artist
places at the center of the com-
position the royal carriage,
drawn by six horses and accom-
panied by a train of horsemen
driving over the Jüdenhof. The
variant in the Hermitage, ac-
cording to Kozakiewicz,[1] was ex-
ecuted a little later than the one
in Dresden, between 1749 and
1752. Even though it fully har-
monises with the royal series in
terms of composition, both
Kozakiewicz and later Rizzi
point out a difference in the
chromatic scale, compared to
the Dresden cycle.
This and all Bellotto's other
works are in a good state of
preservation. The last restora-
tion was in 1996.
 Irina Artemieva

[1]Kozakiewicz 1972, vol. 1, p. 85.

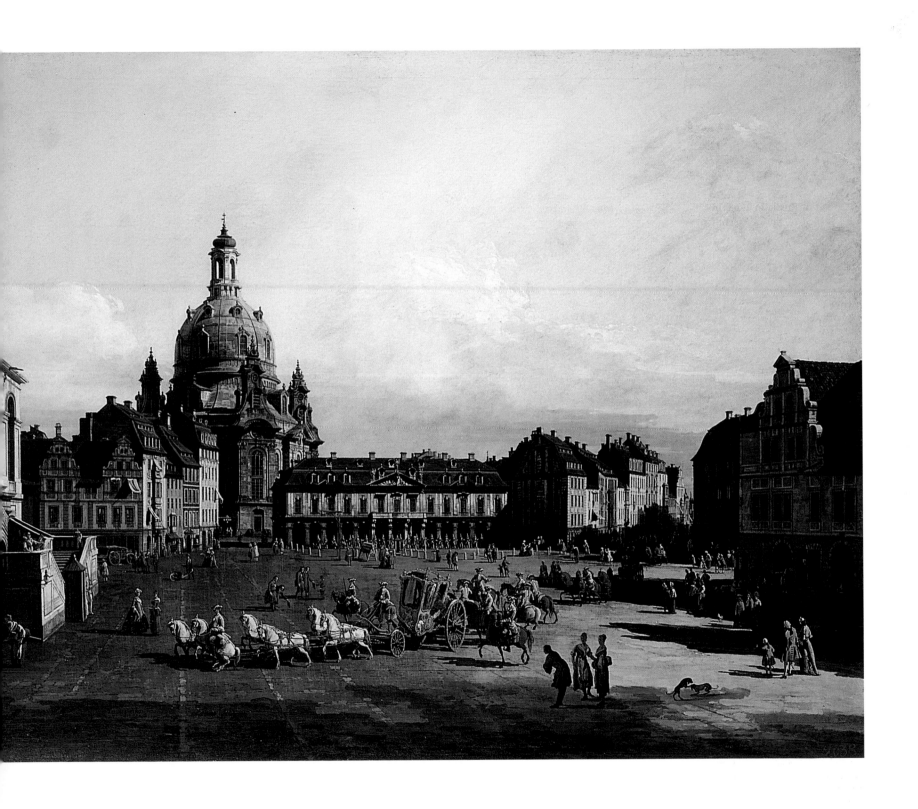

c. 1750
Oil on canvas
53 1/8 × 93 1/4 inches
(135 × 237 cm)
Etching made by Bellotto
dated 1750.[1]
Gemäldegalerie Alte Meister,
Staatliche Kunstsammlungen,
Dresden (613)

Provenance: First mentioned in
the 1754 inventory of the Dres-
den paintings, no. 537: "A simi-
lar one: [*Prospect* of Dresden]
from the new market, on can-
vas. 4.8. 8.4."

Exhibitions: Venice 1929, no. 18;
Berlin 1955-56, no. 613; Dres-
den 1956, no. 613; Dresden
1963-64, no. 13; Warsaw and
Cracow 1964-65, no. 13; Vienna
1965, no. 18; Essen 1966, no. 8;
Venice 1967, no. 98; Washing-
ton, New York, and San Francis-
co 1978-79, no. 6; Dresden
2000, no. 151.

Bibliography: Matthäi 1834, no.
43; Österreich 1754, vol. 1, no.
537; Hübner 1856, no. 2184;
Stübel 1923, p. 24-26; Posse
1929, p. 292; Fritzsche 1936, pp.
53, 111, no. VG 66; Lippold
1963, p. 27; Kozakiewicz 1972,
vol. 1, pp. 84, 88, 100-102, vol. 2,
p. 135, no. 170 (with previous
references); Camesasca 1974, p.
99, no. 97; Löffler 1985, figs. 43-
46; Walther 1992, p. 114;
Walther 1995, p. 44; Rizzi 1996,
p. 52, no. 24 (with additional
references); Weber 2000a, p. 22;
Löffler 2000, figs. 43-46.

This view of the New Market
provides and exact counterpart
to the painting of *The New Mar-
ket in Dresden Seen from the Jü-
denhof* (cat. no. 46), to which it
corresponds symmetrically in
terms of its composition and
perspective. The house with the
Renaissance gables, the Gewand-
haus, which in thc view from the
Jüdenhof can be seen on the far
right, is identifiable here on the
left-hand side completely in
shadow. It is the cloth ware-
house, built in 1591 by Paul
Buchner (1531-1607), where the
textile manufacturers sold their
cloth. Butchers and cobblers also
worked there, and there was a
room for social gatherings and
theatrical performances on the
upper floor. Bellotto does not
depict any of these activities and
instead portrays with the tip of
his brush a seller of paintings be-
low the wooden roof in the mid-
dle. In front of him in the shad-
ow on the left a large group of
people are standing watching a
performance by street singers,
some of whom are in costume.
In the far left is a fountain
crowned with a Victory statue,
commemorating the victory
over the Turks in Vienna, in
which the elector John George
III participated. The weekly mar-
ket took place around the foun-
tain; once the old market had
been cleaned up it could also
take place on Saturday evenings.
Bellotto depicts the market stalls
and figures in great detail.
The Alte Wache, the guardhouse
of the old town, built in 1715 by
Johann Rudolf Fäsch (1680-
1749), dominates the square on
the right-hand side; it was de-
stroyed in 1760 by Russian can-
non fire. Here, too, Bellotto's
faithful depiction of detail is re-
markable: in front of the guard-
house he shows the gallows and
the pillory in the form of a don-
key, on the pointed back of
which deserters were made to
"ride". Behind the guardhouse
the dome of the Frauenkirche
stands out against the sky and
one can make out several
roofers at work repairing it. Bel-
lotto does not subject the shape
of the dome to the perspective
of the whole composition, the
vanishing point of which is left
of centre, thus avoiding the dis-
tortion of its roundness into an
oval, which is mathematically
correct but unusual. Finally, in
the middle ground on the left,
Bellotto gives us a much fore-
shortened view of the north-
eastern side of the art gallery,
the facade of which is depicted
in the pendant.
In no other view of Dresden has
Bellotto created such wonderful
effects of light and shade; large
areas of shadow alternating to
great effect with areas in full
light. In this far-reaching com-
position he managed to trans-
mit the lively nature of the city
with the obliquely angled cor-
ner of the square and the busy
scenes of everyday life. In keep-
ing with the rules he had
learned for representing such
urban scenes, the light falls lat-
erally, which enables the painter
– as in all his other *vedute* – to
avoid any compositional insta-
bility deriving from shadows
that could appear askew to the
viewer.

Gregor J.M. Weber

[1] Kozakiewicz 1972, vol. 2, no. 172.

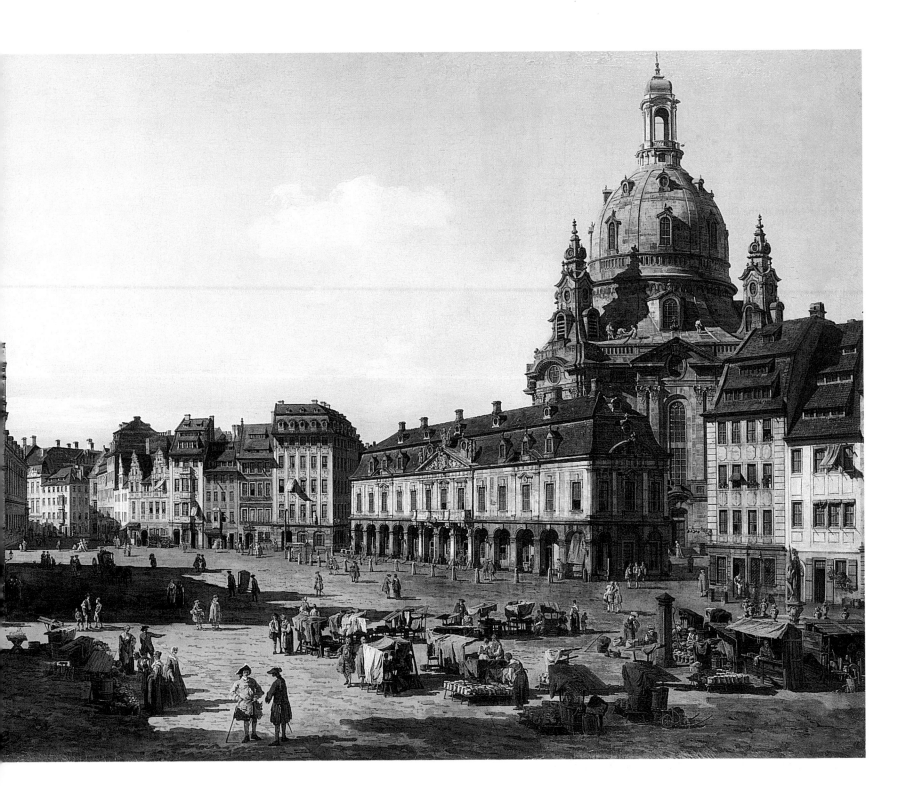

c. 1751
Oil on canvas
53 7/8 × 93 3/4 inches
(137 × 238 cm)
Etching made by Bellotto
dated 1752.[1]
Gemäldegalerie Alte Meister,
Staatliche Kunstsammlungen,
Dresden (614)

Provenance: First mentioned in the 1754 inventory of the Dresden paintings, no. 536: "*Prospect* of Dresden, the old market, seen from the Schößer-Gaße, on canvas 4.8. 8.4."

Exhibitions: Paris 1960-61, no. 228; Dresden 1963-64, no. 14; Warsaw and Cracow 1964-65, no. 14; Vienna 1965, no. 19; Essen 1966, no. 9; Stockholm 1969, no. 230; Venice 1986, no. 7; Munich 1990, no. 17.

Bibliography: Matthäi 1834, no. 32; Österreich 1754, vol. 1, no. 536; Hübner 1856, no. 2172; Stübel 1923, pp. 26-27; Posse 1929, pp. 292-93; Fritzsche 1936, pp. 53, 111, 157, 165-66, 168, no. VG 69; Lippold 1963, p. 28; Kozakiewicz 1972, vol. 1, pp. 84, 88, 100-102, vol. 2, p. 136, no. 173 (with previous references); Camesasca 1974, p. 99, no. 93; Löffler 1985, figs. 47-51; Walther 1992, p. 114; Walther 1995, p. 38; Rizzi 1996, p. 54, no. 26 (with additional references); Löffler 2000, figs. 47-51.

As with the New Market (cat. nos. 46-48), Bellotto also executed two views of the Old Market of Dresden. Given the almost rectangular layout of the square, however, he was able to paint the views from opposite sides. In this *veduta*, the viewer is looking from the north side at the south of the square, in the eastern corner of which can be seen the Seegasse. This is the very point the painter chose from which to take the second view, in which he looks back at the north side of

the square (repro.). Here, two streets lead onto the Old Market, the Schloßgasse in the western corner, and – four blocks to east – the Schößergasse. Matthias Österreich, who drew up the inventory of the Gallery in 1754, maintained that this second street was the painter's viewpoint, a supposition undoubtedly founded on his everyday familiarity with Dresden. Nevertheless, this lane comes out approximately in the middle of the north side of the square, while Bellotto's view is further west. But the view cannot have been taken from the Schloßgasse either, and Matthias Österreich's mistake can be explained as follows: Bellotto shows the square from a slightly elevated position, that is, from the first floor window of one of the townhouses beside the point where the Schloßgasse opens into the square; for the opposite view, his viewpoint must have been in a building on the corner of the Seegasse.

The Old Market was the heart of the old town of Dresden; the town hall stood here on the eastern side (identifiable on the right in the painting by the small bell-tower). It was built by Johann Christoph Knöffel (1686-1752) and the municipal masterbuilder Johann Gottfried Fehre (1685-1753) between 1741 and 1744. Facing it, at the far left in Bellotto's painting, stands the fountain of Justice, erected in 1653 by the sculptor Christoph Abraham Walther (1625-80); two elegant gentlemen dressed in grey are looking at it. The variously shaped town houses date from the sixteenth to the eighteenth centuries and almost all of them have shops with awnings on the ground floor. The oldest building was the penultimate one on the eastern side of the square at the left in the painting, in full light, which dated from 1481 and housed the Marienapotheke (the

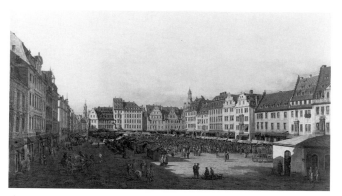

Bernardo Bellotto, The Old Market of Dresden seen from the Seegasse *(Gemäldegalerie Alte Meister, Staatliche Kunstsammlungen, Dresden, no. 615)*

pharmacy of Our Lady). A little further on, just to the left of center, is the Kreuzkirche, or Church of the Holy Cross, whose nave was built as a gallery between 1492 and 1499, while the unusual western part featuring the tower was only built between 1579 and 1584. The Kreuzkirch was destroyed by cannon-fire in 1760 during the Prussian attack on Dresden; Bellotto vividly depicted the demolition of the ruins in a memorable painting of 1765 (Gemäldegalerie Alte Meister, Dresden).[2]

As in the pendant, Bellotto exploits the strong light at sunset, slanting in from the western side to enliven the large square. The horizontal light also shapes the façades of the houses with their architectural friezes more effectively than would lighting from the front. Here, too, the way the sides of the square in shadow and those in full sunlight are angled enables Bellotto to clearly differentiate the reliefs of the houses.

Gregor J.M. Weber

[1] Kozakiewicz 1972, vol. 2, no. 175.
[2] Inv. no. 638; Kozakiewicz 1972, vol. 2, no. 297.

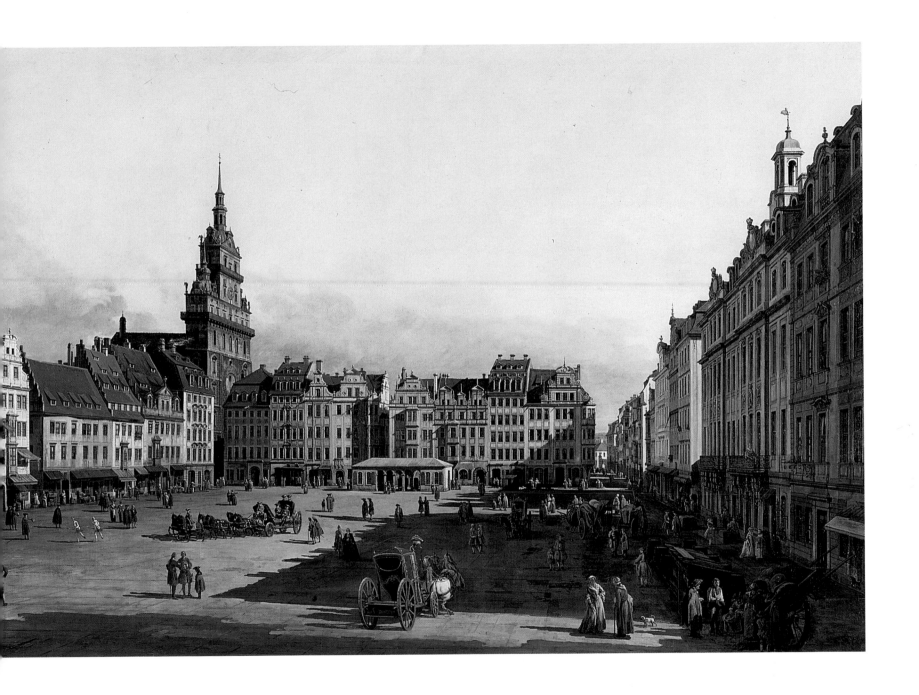

Dresden, Pirna and Königstein

1751-52
Oil on canvas
77 1/2 × 73 5/8 inches
(197 × 187 cm)
The State Hermitage Museum,
St. Petersburg (203)

Provenance: Part of the gallery of Count Heinrich Brühl (1700-63), Dresden, by 1752; acquired from his heirs by Catherine II (1729-96) of Russia in 1768; in the first half of the nineteenth century in the Tauride Palace, St. Petersburg; from 1863 in Gatchina Palace, near St. Petersburg; restored to the Hermitage in 1923.

Exhibitions: St. Petersburg 1923; Warsaw and Cracow 1964-65 (not in catalogue); Essen 1966, no. 13; Udine 1998, no. 37; Brussels 1998-99, no. 37.

Bibliography: Staehlin, *Notes*, vol. 1, p. 374, vol. 2, p. 111; Minich 1773-83, vol. 1, p. 160, no. 502; Hermitage 1774, p. 44, no. 502; Bernoulli 1780, p. 193; Hermitage 1797, vol. 1, no. 2201; Hübner 1856, p. 73; Hermitage 1859, no. 2914; Stübel 1911, p. 476; Fritzsche 1936, p. 68; Fomichova 1959, pp. 14-16; Haskell 1963, p. 295; Kozakiewicz 1972, vol. 1, pp. 85, 100-102, vol. 2, p. 148, no. 182 (with additional references); Camesasca 1974, no. 100; Levinson-Lessing 1985, p. 67; Fomichova 1992, p. 80, no. 46; Rizzi 1996, p. 60, no. 32; Artemieva 1998, no. 37.

This painting, like Bellotto's other works in the Hermitage collection, originates from the gallery of Count Heinrich Brühl, Prime Minister of Augustus III, King of Poland and Elector of Saxony. In his *Notes on the Fine Arts in Russia*, Jacob Staehlin includes in the *List of the most important pictures in the gallery set up by Her Majesty Empress Catherine II in the new Winter palace in Petersburg*:

"Canaletto. The Kreuzkirche in Dresden together with Kreuz-Gasse street. Painted by Canaletto from life in Dresden. Height 3 braccia 11 inches, width 3 braccia 7 inches. By the same – six views of Dresden and eight exceptional views of Elba in the vicinity of Pirna and in other places of equal size, namely, height 2 braccia 8 1/2 inches, width 4 braccia and 4 3/4 inches".[1] In the following years the picture in question did not undergo noteworthy restorations. The last intervention dates back to 1998; layers of yellowed paint and repaint, which were altering the chromatic range, were removed. It should be noted that this work by Bellotto is the only one of those preserved in the Hermitage executed on a canvas very rarely used by painters; the unusual weave has a thick warp utilised for the most part in decorative textiles, such as table-cloths and curtains. The particular workmanship of the canvas is distinctly visible through the paint layer.

Corresponding to the view of the Kreuzkirche in the royal series is a canvas of the same size depicting the Frauenkirche (both Gemäldegalerie Alte Meister, Dresden, 616, 617), missing from the Brühl series. In reality the true companion of this view is the famous representation of the ruins of the Kreuzkriche – destroyed on 19 July 1760 by Prussian bombardments – one of the most striking anti-military depictions in the history of art. In it one can detect the strong artistic influence concealed by the dispassionate semblance and the dry manner of Bernardo Bellotto.

The church of the Holy Cross – Kreuzkirche – was one of the predominant buildings in the Saxon capital: 96 meters high it was only surpassed by the Hausmannsturm of the Castle. Its construction began in 1491 on

the site of a church destroyed by a fire and was completed between the late fifteenth and early sixteenth centuries. In a square canvas the artist includes the austere and sober silhouette of a tower-shaped belfry, which differs from Italian church architecture and has obviously aroused the master's interest. The expressive pictorial means – primarily the light – are used by the artist mainly to bring out the buildings, which are principally rendered with contrasts of light and shade. As a result the depiction acquires a convincing documental force, from which any imprecision is excluded. In fact, in order to open up the façade of the Kreuzkirche to the spectator, the artist "frees" the square, by omitting several buildings in front of the church.[2] In the Hermitage painting the layout of the figures differs from their placement in the similar painting in Dresden, especially as regards those in the background. In the building on the left, for example, we can see an open window with a woman leaning out, and the arrangement of the windows has been altered with flowers.

Rizzi points out that this is the only subject for which both the drawing and the etching are known.[3] There are known to be replicas of smaller size in the Rothschild collection, London, the Stein collection, Paris, and the Kunsthalle, Hamburg.[4]

Irina Artemieva

[1] Staehlin, *Notes*, 1769, II, p. 111.
[2] Rizzi 1996, p. 60.
[3] Rizzi 1996, no. D 1; I 13.
[4] Fomichova 1992, p. 80.

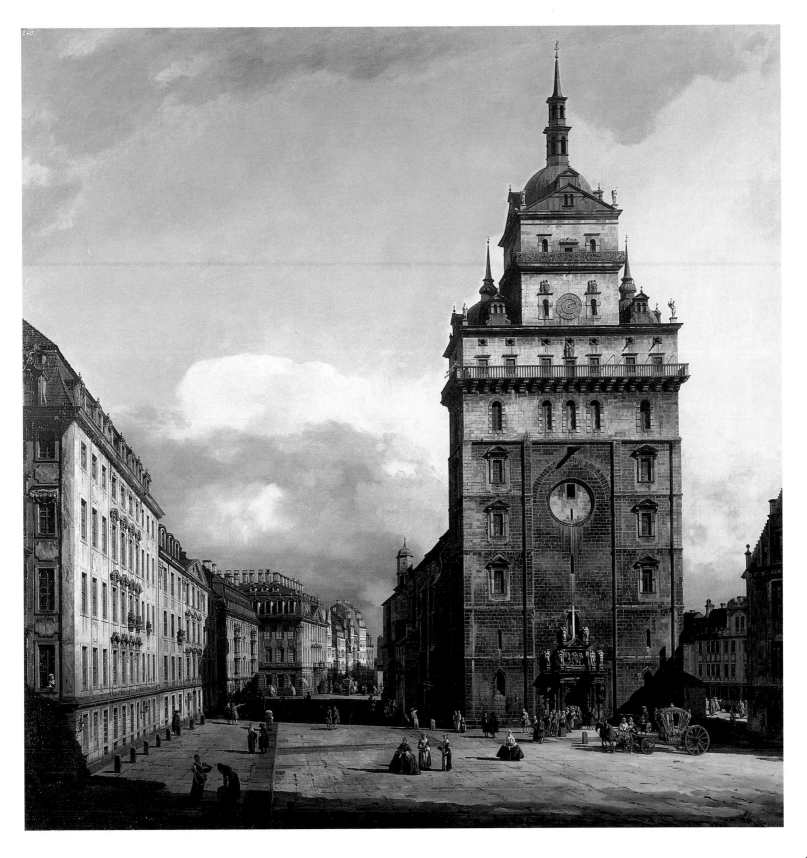

1751-52
Oil on canvas
53 × 93 1/8 inches
(134.7 × 236.5 cm)
The State Hermitage Museum,
St. Petersburg (202)

Provenance: Part of the gallery of Count Heinrich Brühl (1700-63), Dresden, by 1752; acquired from his heirs by Catherine II (1729-96) of Russia in 1768; in the first half of the nineteenth century in the Tauride Palace, St. Petersburg; from 1863 in Gatchina Palace, near St. Petersburg; restored to the Hermitage in 1923.

Exhibitions: Warsaw and Cracow 1964-65 (not in catalogue); Essen 1966, no. 15; Venice 1998, no. 133.

Bibliography: Staehlin, *Notes*, vol. 1, p. 374, vol. 2, p. 111; Minich 1773-83, vol. 1, pp. 156-57, no. 489; Hermitage 1774, p. 43, no. 489; Bernoulli 1780, p. 193; Hermitage 1797, vol. 1, p. 386, no. 2199; Hübner 1856, p 73; Hermitage 1859, no. 2924; Stübel 1911, p. 475; Fritzsche 1936, pp. 53, 110, no. VG 61; Hermitage 1958, p. 66, no. 202; Fomichova 1959, pp. 69, 11, 28; Kozakiewicz 1972, vol. 1, pp. 85, 100-102, vol. 2, p. 153, no. 186 (with additional references); Camesasca 1974, no. 91; Hermitage 1976, p. 76; Levinson-Lessing 1985, p. 67; Fomichova 1992, p. 78, no. 45; Rizzi 1996, p. 62, no. 34 (with additional references).

The painting depicts the market square of an old suburb of Dresden, situated on the right bank of the Elbe, previously called Old Dresden, which until the mid-sixteenth century had its own independent administration. In 1685 a great fire completely destroyed the district and subsequently this part of the city was radically rebuilt under Augustus the Strong. When these important changes were completed this area of the Saxon capital took the name of Neustadt (New City), and in the same period the name Old City (Altstadt) was applied to the districts on the left bank.

Many authors quite rightly find an analogy between the composition of *The Market Square in the New City* and *The Courtyard of the Zwinger* (cat. no. 54), executed using the same principle: a wide open empty space, very sunny in the middle, square in shape and bordered by a row of low buildings with no marked architectural points. Unlike the sumptuous façades in the *rocaille* style of the Zwinger, which remind us of a richly elaborate jewel, the modest buildings in the Neustadt market square imbue it with the atmosphere of a provincial town. In the centre of the square stands the equestrian monument to Augustus II, the work of the sculptor Ludwig Wiedemann. Behind the monument, in the distance, the Hauptstrasse is visible, at whose beginning on the left stands the heavy construction of the Dreikonigskirche, though without the bell-tower. The architectural complex of the Market Square is dominated by the old Town Hall, built in the years 1527-28.

The Hermitage composition convincingly confirms that the Brühl series is absolutely equivalent to the royal series. Bellotto undoubtedly executed this work shortly after the canvas now in Dresden (Gemäldegalerie Alte Meister, Dresden),[1] in that, in the interval of time that separates the two works, in the left-hand corner of the market square a new building is erected, next to another one with three storeys and a mansard. As has already been observed with regard to the views of Pirna, the provincial spirit of the place is conveyed by the artist with delicate good-natured humour in the series of vignettes reflecting characters from among the inhabitants of Neustadt; the two friends gesticulating to the right in the foreground are extremely expressive. We can also detect other details that indicate the differences between the variant in question and the painting in Dresden: on the left the male figure separating the scuffling dogs is missing, as are two figures on the right of the drinking fountain near the barrel.

Irina Artemieva

[1] Inv. no. 612; Kozakiewicz 1972, vol. 2, no. 185.

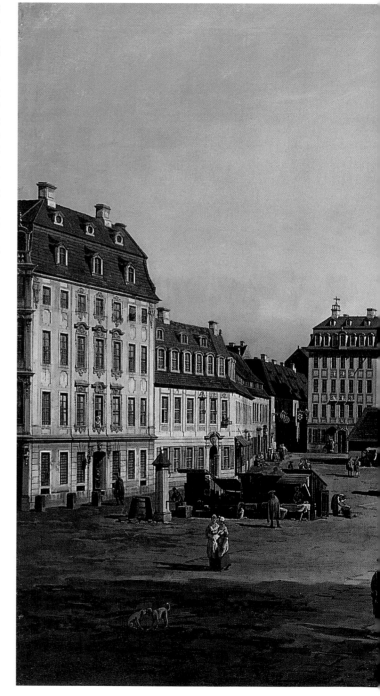

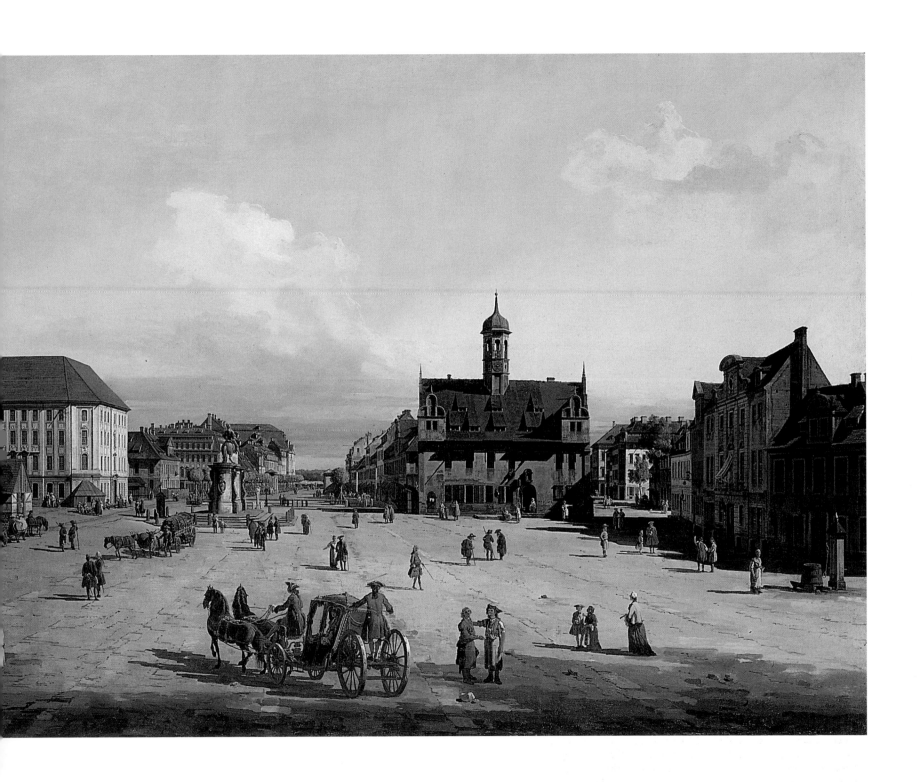

1751-52
Oil on canvas
52 3/8 × 93 1/8 inches
(133.5 × 236.5 cm)
The State Hermitage Museum,
St. Petersburg (211)

Provenance: Part of the gallery of Count Heinrich Brühl (1700-63), Dresden, by 1752; acquired from his heirs by Catherine II (1729-96) of Russia in 1768; in the first half of the nineteenth century in the Tauride Palace, St. Petersburg; from 1863 in Gatchina Palace, near St. Petersburg; restored to the Hermitage in 1923.

Exhibitions: Warsaw and Cracow 1964-65 (not in catalogue); Essen 1966, no. 11.

Bibliography: Staehlin, *Notes*, vol. 1, p. 374, vol. 2, p. 111; Minich 1773-83, vol. 1, p. 184, no. 576; Hermitage 1774, p. 51, no. 576; Bernoulli 1780, p. 196; Hermitage 1797, vol. 1, p. 354, no. 2041; Hübner 1856, p 73; Hermitage 1859, no. 2927; Stübel 1911, p. 476; Fritzsche 1936, pp. 53, 111, no. VG 72; Hermitage 1958, p. 67; Fomichova 1959, pp. 12, 13, 28; Kozakiewicz 1972, vol. 1, pp. 85, 100-102, vol. 2, p. 147, no. 177 (with additional references); Camesasca 1974, no. 96; Hermitage 1976, p. 76; Levinson-Lessing 1985, p. 67; Fomichova 1992, p. 78, no. 52; Rizzi 1996, p. 56, no. 29 (with additional references).

This painting is the companion to another view of the Old Market taken from the Schlossgasse, which is now in the Puskin Museum of Fine Arts in Moscow.[1] In actual fact, Bellotto does not confine himself to simply fixing a certain corner of Dresden, but attempts to find the best and most interesting solution at a pictorial level. Here we can see the crowded square on market day, with the stalls arrayed alongside the buildings lined up on either side of the Old Market. This allows the master to highlight the important role of the square in the life of the Saxon capital, by reanimating the monotony of the adjacent buildings. On the left, at the end of the Schlosstrasse rises the Hofkirche bell-tower, whilst in the right-hand corner, where the houses finish, the dome of the Frauenkirche is visible – these two vertical lines do not infringe upon the homogeneous architectural whole of the Market Square. The shadow that drags from the left-hand buildings along the line of stalls leaves the market area lit up: here we can detect the constant movement of the compact crowd, without the latter being broken up into individual figures. The indistinct low rumble and the gaily coloured people busy with their purchases are rendered by the artist with minute brushstrokes – using the so-called "pointillist" technique, a mode perfected and often used by Bellotto's uncle and teacher, Canaletto.[2]

The foreground in the half-light is used by the painter to execute a series of vignettes, among which the one in the centre stands out, showing a group of onlookers surrounding a ram whose worth its owner is boasting, whilst several urchins are trying to provoke the poor beast. In the Hermitage version, to the detriment of the one in Dresden, a barking dog has been added near the ram.

Irina Artemieva

[1] Inv. no. 2685; Kozakiewicz 1972, vol. 1, no. 174.
[2] Rizzi 1996, p. 56.

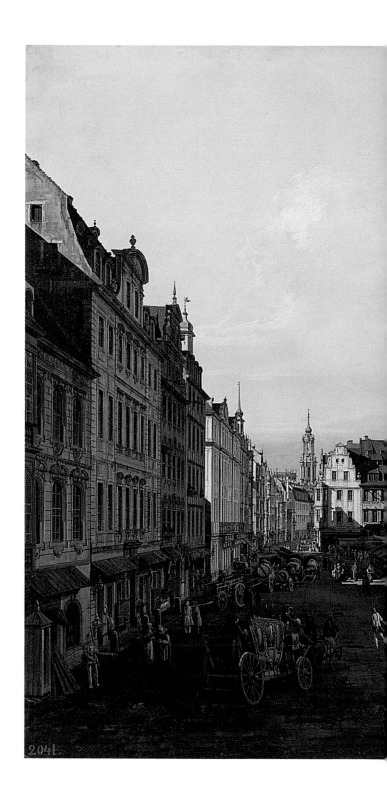

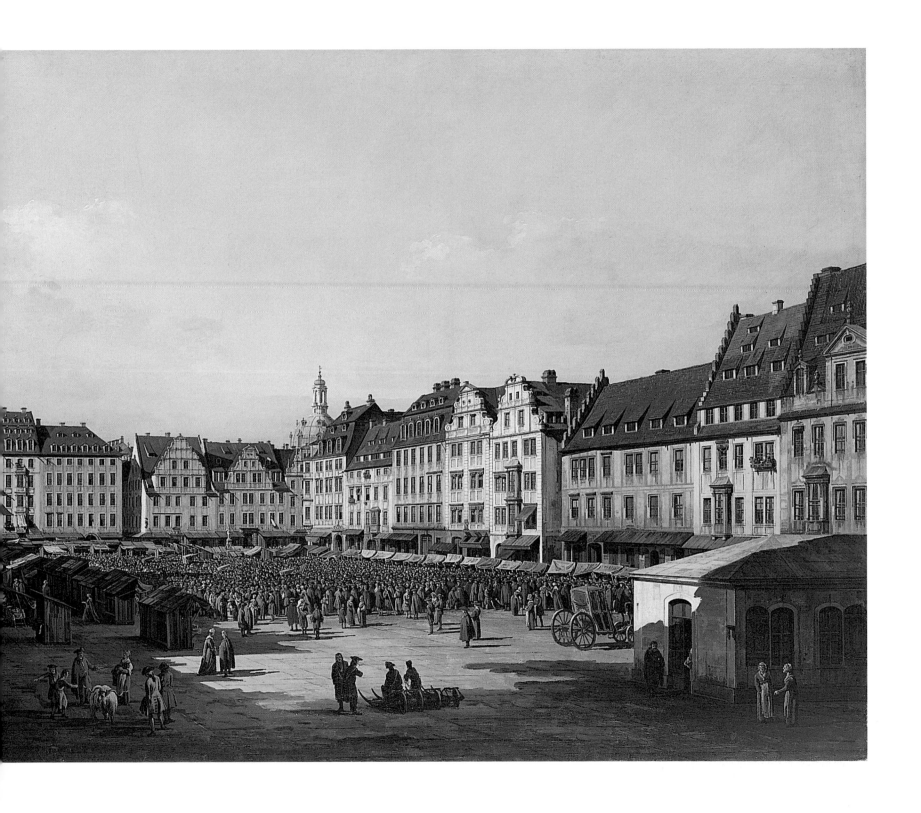

c. 1752
Oil on canvas
52 3/4 × 93 1/4 inches
(134 × 237 cm)
Etching made by Bellotto
dated 1758.[1]
Gemäldegalerie Alte Meister,
Staatliche Kunstsammlungen,
Dresden (629)

Provenance: First mentioned in
the 1754 inventory of the Dres-
den paintings, no. 532: "A simi-
lar one: [*Prospect*], of the
Zwinger, on canvas: 4.8. 8.4."

Exhibitions: Dresden 1963-64,
no. 11; Warsaw and Cracow
1964-65, no. 11; Vienna 1965,
no. 16; Venice 1967, no. 99; New
Delhi 1984, no. 2; Venice 1986,
no. 6.

Bibliography: Matthäi 1834, no.
42; Österreich 1954, vol. 1, no.
532; Hübner 1856, no. 2183;
Stübel 1923, pp. 30-31; Posse
1929, pp. 297-98; Fritzsche 1936,
pp. 53, 110, 157-65, 170, no. VG
62; Lippold 1963, p. 28; Koza-
kiewicz 1972, vol. 1, pp. 84, 100-
102, vol. 2, pp. 131-32, no. 164
(with previous references);
Camesasca 1974, p. 100, no. 101;
Löffler 1985, figs. 34-37; Walther
1992, p. 116; Marx and Weber
1992, p. 67; Walther 1995, pp.
32-35; Rizzi 1996, p. 48, no. 20
(with additional references);
Löffler 2000, figs. 34-37.

The Zwinger is one of the most
significant non-religious Baroque
buildings in Europe. Its name
(Zwinger means arena, a term
with military connotations) aris-
es from its location between the
fortification and the Residenz.
Initially, the Zwinger garden on-
ly had an orangery, but to mark
the occasion of the marriage of
the prince and future king, Au-
gustus III of Poland to the Aus-
trian archduchess Maria Josepha
in 1719, Augustus the Strong
transformed the place into a
splendid area for open-air festi-

vals, surrounded by six pavilions
connected by galleries. The
builder, Matthias Daniel Pöp-
pelmann (1662-1736), found a
suitable sculptor in Balthasar
Permoser (1651-1732), who
contributed a large number of
statues, fountains, vases and re-
liefs to the sculptural decora-
tion. The project also included
plans for further architectural
elements to be developed in var-
ious courtyards as far as the
Elbe, but lack of funds prevent-
ed their completion. Therefore,
in 1732 the courtyard was closed
on the north side by a wall made
initially in wood and later in
stone. The Gemäldegalerie (art
gallery) was built there between
1847 and 1855 according to the
plans of Gottfried Semper
(1803-79). From 1728, the pavil-
ions of the Zwinger housed the
collections of the art gallery and
the library. When Bellotto paint-
ed this view the period of the
grand royal festivities at the
Zwinger was over and the
carousels, masked balls, and
tournaments enlivened by fire-
works and ornamental foun-
tains long gone. Bellotto shows
it as an open space with a cart
drawn by oxen crossing it, al-
though it was still frequented by
interested visitors.
The painter's viewpoint was sit-
uated in the Wall Pavilion from
where, on the opposite side, in
the City Pavilion (Stadtpavil-
lon), the pendant view was tak-
en. On the left and right of the
painting only the corners of the
side pavilions can be made out,
while the two corresponding
buildings opposite are in full
view. Since the line of vision is
slightly to the left of the centre
only a small part of the tempo-
rary barrier closing off the
Zwinger in the north side is vis-
ible, while opposite a larger part
of the Langgalerie (the Long
Gallery) with the Kronentor
(Crown Tower) can be seen.
There was an old moat outside

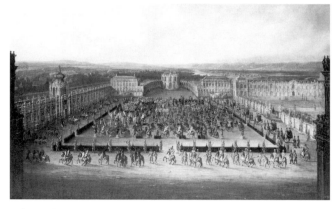

Johann Alexander Thiele, Procession of the "Caroussel Comique"
in the Zwinger *(Gemäldegalerie Alte Meister, Dresden, no. 3604)*

the south wall which Bellotto
depicted in another painting
(Gemäldegalerie Alte Meister,
Dresden).[2]
Beyond the outline of the
Zwinger can be seen other fa-
mous buildings of the city. On
the far left is part of the Residenz
with a Renaissance pediment,
the impressive Opera House,
built between 1664 and 1667,
which, from 1751, was used for
gala occasions. To the left of the
City Pavilion, the bell-tower of
the Kreuzkirche can be seen in
the distance, while, closer in on
the right, almost in the center of
the painting, is the roof of the
Sophienkirche with its many
dormer windows. Beside it and
behind the pavilion on the right
rises the Opera built by the ar-
chitect Matthäus Daniel Pöppel-
mann (1662–1736) in 1718-19.
Before 1725, Johann Alexander
Thiele (1685-1752) painted two
views of the Zwinger, one look-
ing towards the Kronentor and
the other seen from the City
Pavilion (Gemäldegalerie Alte
Meister, Dresden; see illustra-
tion). In both instances the
artist created the views from ar-
chitectural plans so that the
view is seen from above, from a
bird's-eye view. Bellotto's view
of the Zwinger, on the other
hand, was based on observa-
tion, which led Hellmuth Allwill
Fritzsche in 1936 to measure the

perspective layout of the paint-
ing. He found that in Bellotto's
painting the corners of the
Zwinger were not straight, but
slightly out of true, which is not
apparent in the plans but is clear
in the execution of the building.
According to this critic the mea-
surements proved that the
painter had used a camera ob-
scura and that he had trans-
ferred the outline to the large
format of the canvas.

Gregor J.M. Weber

[1] Kozakiewicz 1972, vol. 2, no. 163.
[2] Inv. no. 609; Kozakiewicz 1972, vol.
2, no. 157.

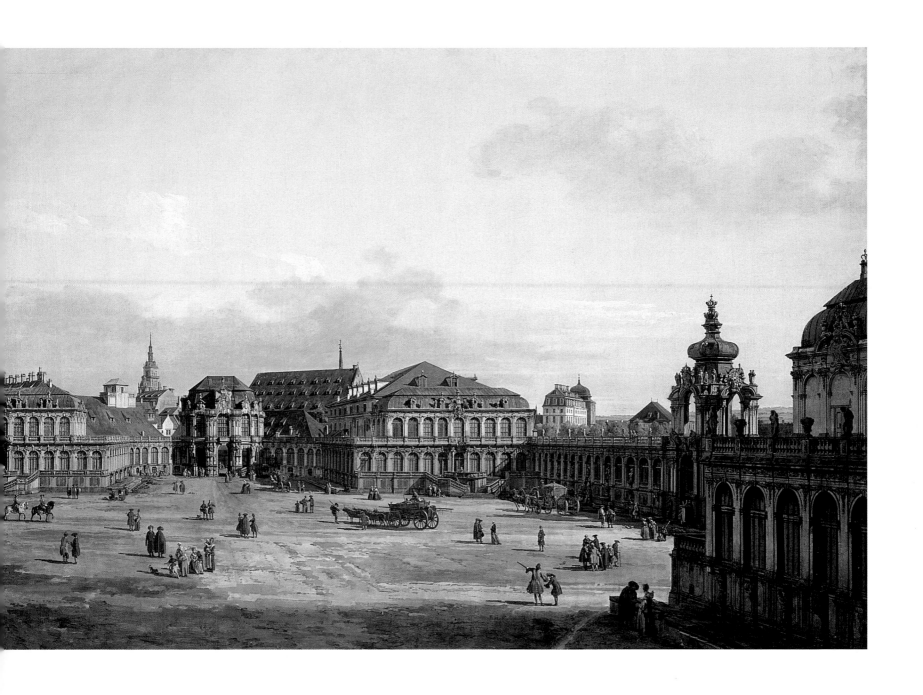

c. 1752
Oil on canvas
51 5/8 × 91 3/4 inches
(131 × 233 cm)
The State Hermitage Museum,
St. Petersburg (205)

Provenance: Part of the gallery of Count Heinrich Brühl (1700-63), Dresden, by 1752; acquired from his heirs by Catherine II (1729-96) of Russia in 1768; in the first half of the nineteenth century in the Tauride Palace, St. Petersburg; from 1863 in Gatchina Palace, near St. Petersburg; restored to the Hermitage in 1923.

Exhibitions: St. Petersburg 1923.

Bibliography: Staehlin, *Notes*, vol. 1, p. 374, vol. 2, p. 111; Minich 1773-83, vol. 1, pp. 237-38, no. 747; Hermitage 1774, p. 65, no. 747; Bernoulli 1780, p. 196; Hermitage 1797, vol. 1, p. 340, no. 1975; Hübner 1856, p 73; Hermitage 1859, no. 2927; Stübel 1911, p. 476; Fritzsche 1936, pp. 53, 110, no. VG 63; Hermitage 1958, vol. 1, p. 66, no. 205; Fomichova 1959, pp. 14, 17, 28; Kozakiewicz 1972, vol. 1, pp. 85, 100-102, vol. 2, p. 132, no. 165 (with additional references); Camesasca 1974, no. 102; Hermitage 1976, p. 76; Levinson-Lessing 1985, p. 67; Fomichova 1992, p. 81, no. 44; Rizzi 1996, p. 48, no. 21 (with additional references).

In the catalogue the work from the Hermitage is illustrated in its condition previous to the restoration carried out for the Houston exhibition. In our composition several small variations have been brought about with respect to the Dresden version (cat. no. 53), which can be detected exclusively in the small figures: on the left, the two men busy talking are missing, as is the figure of a gentleman with a stick in his hand next to a bowing manservant on his right.

Irina Artemieva

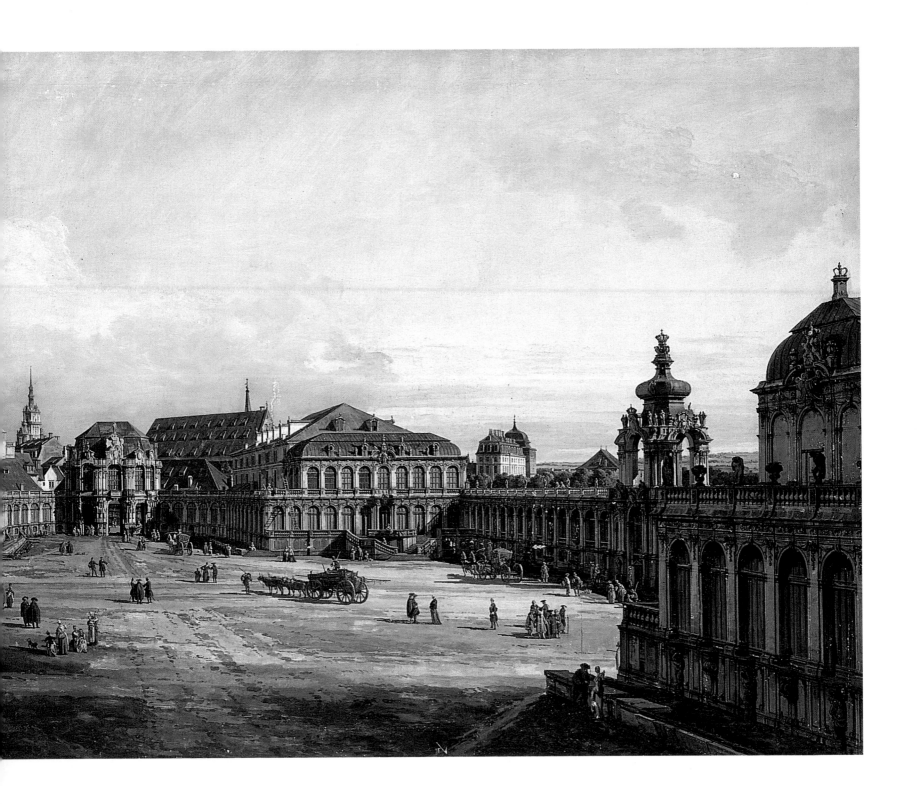

55. Dresden from the Right Bank of the Elbe above the Augustus Bridge

1751-53
Oil on canvas
37 3/8 × 65 inches
(95 × 165 cm)
Private collection

Provenance: Spahn collection, Dresden; bequeathed in 1778 to the Kurfürstliche Gemäldegalerie, Dresden; surrendered in 1926 to the Verein Haus Wettin, the trustees of the art collection of the former royal family of Saxony; sold in 1960 through H.M. Drey, London, to Huntington Hartford, New York; sale, Sotheby's, London, 24 March 1965, lot 92; bought by Leggat Bros., London; from whom purchased by a private collector, Atherton, California; art market, London, from whence acquired by the present owner.

Exhibitions: Huntington Hartford Gallery, New York (loan); California Palace of the Legion of Honor, San Francisco (loan); National Gallery, London (loan).

Bibliography: Hübner 1868, no. 2339; Fritzsche 1936, p. 77, no. 1d; Kozakiewicz 1972, vol. 1, pp. 85, 103; vol. 2, pp. 108, 115, no. 143 (with previous references); Camesasca 1974, p. 97, no. 77; Rizzi 1996, p. 33, no. 4; Weber 1999, p. 56.

Between 1751 and 1753, Bellotto executed smaller replicas of his first two large *vedute* of Dresden (cat. no. 39, and Gemäldegalerie Alte Meister, Dresden, no. 606[1]). Although the present painting was sold from the Gemäldegalerie in 1926 and is now in private hands, the pendant remains in Dresden.[2] As opposed to the large view painted for the royal collection, the smaller version of the pendant shows the Brühlsche Belvedere rebuilt (see illus.), thus giving us the

Bernardo Bellotto, Dresden from the Right Bank of the Elbe Below the Augustus Bridge, *c. 1751-53 (Gemäldegalerie Alte Meister, Dresden, no. 630)*

earliest date of 1751 for its execution. The painting on show here depicts the bell-tower of the royal chapel executed in a way that closely corresponds to the drawings done around 1753, which establishes a late date. If the painting had been executed after the completion of the building work in 1755, the tower woauld not appear with a round clock but a plaque with inscriptions, the opening on the third floor would be horizontal, and so forth. In both paintings the Brühl library appears with the addition of the second floor.

Bellotto made many changes in the figures in the foreground of the present composition: the artist's self-portrait is missing, and the two figures that were standing beside him are placed closer together, although in the same poses. One can only speculate as to why Bellotto eliminated his self-portrait. Perhaps he made this replica with the assistance of others and therefore the nature of the self-portrait as a "figurative signature" was no longer entirely valid.

Gregor J.M. Weber

[1] Kozakiewicz 1972, vol. 2, no. 146.
[2] Kozakiewicz 1972, vol. 2, no. 149; Columbus 1999, no. 1.

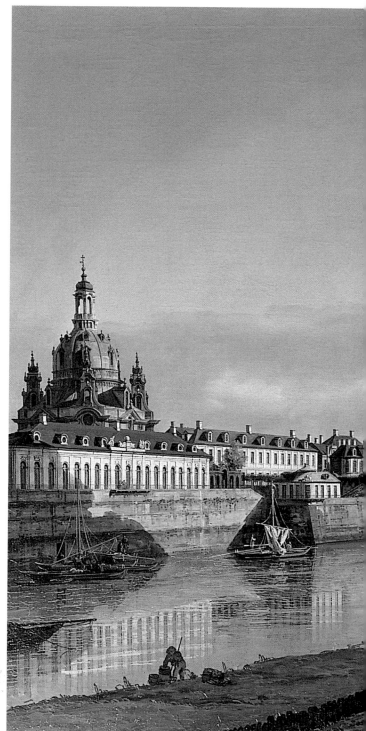

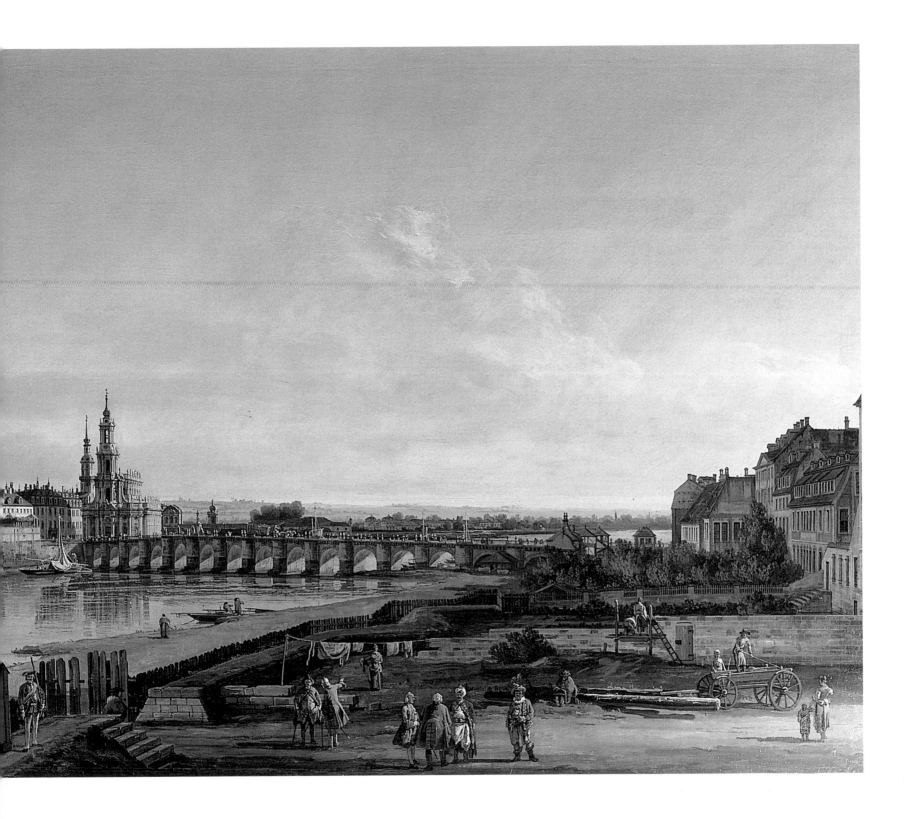

1753-1754
Oil on canvas
52 3/4 × 93 3/4 inches
(134 × 238 cm)
Gemäldegalerie Alte Meister,
Staatliche Kunstsammlungen,
Dresden (623)

Provenance: First mentioned in
the 1754 inventory of the Dres-
den paintings, no. 546:
"*Prospect* of *Pirna*, the market,
on canvas. 4.8. 8.4."

Exhibitions: Bucharest 1963,
no. 16; Dresden 1963-64, no.
25; Warsaw and Cracow 1964-
65, no. 25; Vienna 1965, no. 30;
Venice 1967, no. 106; Warsaw
1997b, p. 322, no. X 35; Dres-
den 1997-98, no. 112.

Bibliography: Matthäi 1834, no.
50; Österreich 1754, vol. 1, no.
546; Hübner 1856, no. 2193;
Posse 1929, p. 295; Fritzsche
1936, pp. 54, 103, 113, 157, no.
VG 85; Lippold 1963, pl. 41;
Kozakiewicz 1972, vol. 1, pp.
100-102, 108, vol. 2, pp. 166,
173, no. 211 (with previous ref-
erences); Camesasca 1974, pp.
9, 100, no. 107; Walther 1995,
pp. 73-75, no. 25; Rizzi 1996, p.
78, no. 56 (with additional ref-
erences); Schmidt 2000, pp. 48,
104-13.

The view of the market square
in Pirna is one of Bellotto's
most successful compositions,
of which there exist a series of
replicas in his hand and copies
by other painters. Bellotto took
the surviving drawing of this
subject – not a preparatory
drawing but a record of the fin-
ished painting – with him to
Warsaw. It is strange that only
the drawings of this work and
another view of Pirna (cat. no.
59) have survived, and that he
did not publish them as en-
gravings. Probably he made
new drawings of the paintings
only after 1761 when his house
in Dresden was destroyed, and

did not get round to producing
the engravings.[1]
This painting's fame is well de-
served. Bellotto must have con-
templated the rich blend of
modern and mediaeval archi-
tecture in this Saxon town with
the same thrill felt by explorers
of exotic lands. In Pirna he
found a place that offered a
wealth of figurative aspects. He
had already painted the Dres-
den markets, the empty rectan-
gle of the Old Market, which he
could enliven only by the addi-
tion of a multitude of accessory
figures (cat. no. 49), and the
busy New Market, in the ren-
dering of which he had to com-
press the art gallery within a
highly distorted lateral view
(cat. 48). In Pirna he found the
town hall isolated in the middle
of the square, an architectural
feature that still exists and
which can be seen to such effect
in only a few other cities such as
Breslau, Krakow, and Lemberg.
The foreshortened perspective
did not distort the proportions
of the building because Bellotto
managed to harmoniously rep-
resent both the Renaissance
pediments by depicting them
parallel to the painting. He then
balanced the pediments with
the tops and eaves of the sur-
rounding town houses. A fur-
ther successful device lay in the
proximity of the town hall to
the viewer, since it makes the
tower of the town hall seem
much bigger than the bell-tow-
er of the Marienkirche behind
it. The tops of the bell-towers
against the expanse of the sky
follow the perspective lines on
the ground, enhancing the de-
velopment of depth as they
draw the eye directly to the
Sonnenstein Fortress with the
Old Hall and the Luntenturm.
Thus the portrayal of the van-
ishing points is in dramatic
contrast to the flat motif paral-
lel to the plane of the tympana
of the houses.

At the far end of the square
stands an unusual house, the
façade of which, with its reticu-
lated tympanum, could do
with a good coat of paint. In
front of the house are some
market stalls with peasants
holding up their produce, de-
scribed in minute detail by Bel-
lotto with touches of colour. To
the right and left of the house,
streets continue into the dis-
tance. The street on the right,
in particular, has been de-
scribed by Bellotto with a
wealth of forms, colours, and
light and shade effects reminis-
cent of certain nineteenth-cen-
tury paintings, such as those of
Carl Spitzweg (1808-85).
The citizens of Pirna can still
identify with this view of their
town, especially as the market
square has remained largely
unchanged.
Recently, Christoph Wetzel
made a fine copy of it, of the
same dimensions, which now
hangs in the Canaletto-Haus
(Canaletto's house, the one
mentioned above with the
reticulated tympanum). Both
the citizens of Pirna and the
Historic Monuments Service
have found Bellotto's painting
particularly fascinating because
it splendidly documents the
appearance and the function of
the square; he describes the
butchers' stalls beside the town
hall, the public scales in its en-
trance, and the troughs in the
market fed by a system of water
pipes. All these aspects merit
discussion in detail as indeed
the two distinguished gentle-
men talking to a group of peo-
ple in the middle of the square
seem to be doing.
Gregor J.M. Weber

[1] See the convincing case made by
Schmidt 2000, p. 48.

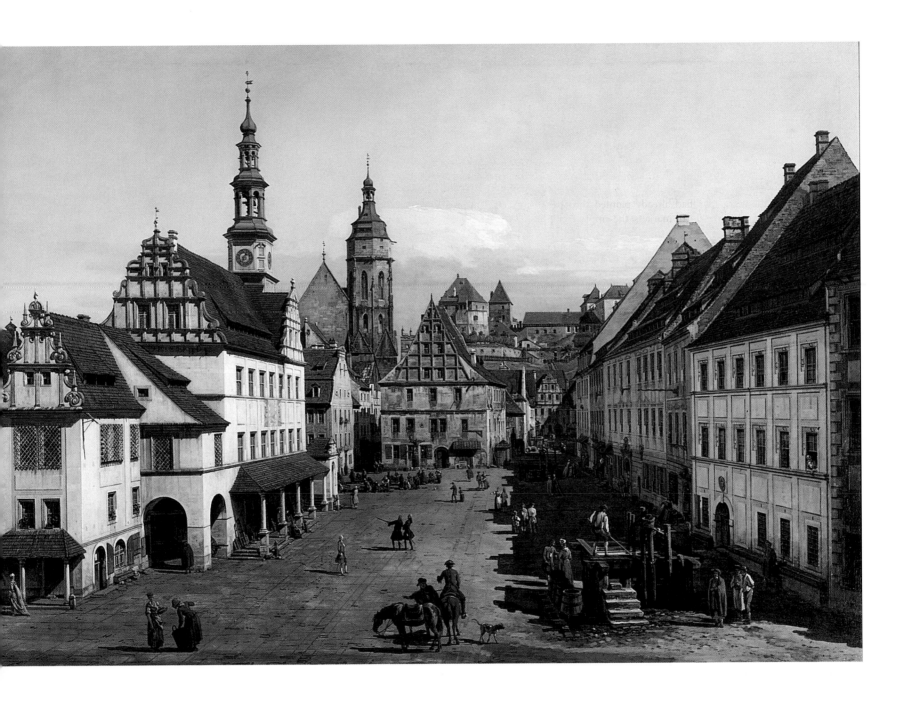

1753-55
Oil on canvas
53 1/4 × 92 7/8 inches
(135 × 236 cm)
Gemäldegalerie Alte Meister,
Staatliche Kunstsammlungen,
Dresden (627)

Provenance: The artist probably delivered the finished painting before 1756; first catalogued by Matthäi in 1834, no. 56.

Exhibitions: Dresden 1963-64, no. 30; Warsaw and Cracow 1964-65, no. 30; Vienna 1965, no. 35; Venice 1986, no. 18.

Bibliography: Matthäi 1834, no. 56; Hübner 1856, no. 2198; Posse 1929, p. 296-97; Fritzsche 1936, pp. 54, 112, no. VG 76; Lippold 1963, p. 30; Kozakiewicz 1972, vol. 1, pp. 84, 88, 100-102, vol. 2, pp. 161-62, no. 196 (with previous references); Camesasca 1974, p. 101, no. 115; Walther 1995, p. 64, no. 21; Rizzi 1996, p. 68, no. 41 (with additional references); Weber 2000a, pp. 19, 22; Schmidt 2000, pp. 64-69.

Within six years after his arrival in Dresden in 1747, Bernardo Bellotto had already painted fourteen views of the city, most of them in multiple copies. In 1753 he finally turned his attention to the smaller town of Pirna, about ten miles further up the river Elbe, with its imposing fortress, the Sonnenstein. So that the artist might make the necessary drawings of sites in Pirna and the vicinity undisturbed, the local magistrate, a man by the name of Crusius, was commanded by a decree from the royal chamberlain's office dated 26 April 1753, "to be in now way obstructive" and to facilitate his work "without the slightest hindrance".[1] Obviously great importance was placed on the accuracy of the paintings; these were not to be fictional

compositions but rather precise and verifiable reflections of the local topography. Bellotto had delivered eleven views of Pirna, in incredibly rapid succession, by the beginning of 1756. Four of them were already listed in the inventory of 1754.[2]

In 1747 and 1748 Bellotto had depicted Dresden from two viewpoints, one upstream and the other downstream of the city. It can be assumed that he went about his views of Pirna in the same way, and therefore this view must be one of the first ones he did. This painting would make an ideal pendant of the famous *View of Dresden from the Right Bank of the Elbe below the Augustus Bridge* (Cat. no. 40), the two compositions being remarkably similar – even the motif of the corner with the houses at the far left of the painting is the same. Here, too, the eye is drawn by the flow of the river to follow the whole outline of the city as far as the spurs of the sandstone hills of the Elbe in the background. The ferry in the middle of the river recalls Pirna's role as an ancient crossroads of trade, a meeting place of roads and waterways, a key feature of its commercial development in the Middle Ages.

At the center of the cityscape rises the Sonnenstein fortress, ever-present in the views of Pirna. The four bastions of the fortress stand out clearly aligned with the banks of the Elbe, and above – from left to right – the corner tower of the battery, the New Barracks of four floors and the Old Hall (Alte Kemnate). The market square in the town, of which Bellotto also executed a view (cat. 56), is to the right of the imposing bell-tower of the Marienkirche. The graceful tower of the town hall can just be glimpsed behind the tower of the Elbtor (the Elbe Gate). On the far right, the great roof of

the Klosterkirche with its unfinished bell-tower dominates the town's skyline. It was a typical Late Gothic hall church, as was Marienkirche.

On the banks of the Elbe, where a cart and a barge have been placed alongside each other, stands a strange archway bathed in light, but with no apparent function: perhaps it was the remains of what had been some sort of shelter close to the water. Johann Alexander Thiele (1685-1752) recognized the picturesque value of this ruined arch and used it in two engravings dated 1742 entitled, *The Old Gate of the Elbe at Pirna*. In Bellotto's time the gate had evidently been restored, but later, when Caspar David Friedrich drew it in 1800, it was once more showing signs of dilapidation; it was therefore a characteristic motif of the town. The accompanying figures in the foreground are also picturesque; they emphasize the bucolic nature of the surroundings of Pirna, as if the view of the town had been partly transformed into a pastoral landscape by such seventeenth-century painters as Nicolaes Berchem (1620-83) and Abraham Begeyn (1637/38-97).

Gregor J.M. Weber

[1] Kozakiewicz 1972, vol. 1, pp. 83, 101; Schmidt 2000, p. 39, repro.
[2] Österreich 1754, vol. 1, nos. 546-49; only the first painting can be identified as Gemäldegalerie inv. no. 623.

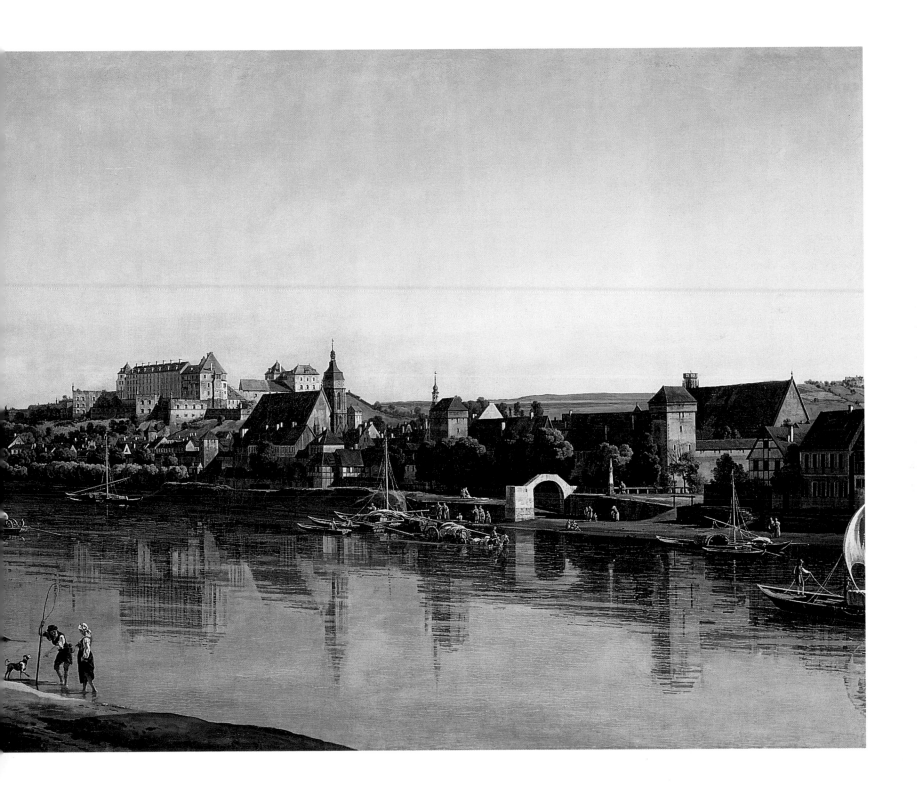

1753-55
Oil on canvas
53 1/2 × 93 1/4 inches
(136 × 237 cm)
Etching made by Bellotto
before 1763.[1]
Gemäldegalerie Alte Meister,
Staatliche Kunstsammlungen,
Dresden (626)

Provenance: The artist probably finished it before 1756; first catalogued by Matthäi in 1834, no. 55.

Exhibitions: Berlin 1955-56, no. 626; Dresden 1963-64, no. 29; Warsaw and Cracow 1964-65, no. 29; Vienna 1965, no. 34; Venice 1967, no. 105; Venice 1986, no. 19.

Bibliography: Matthäi 1834, no. 55; Hübner 1856, no. 2197; Posse 1929, p. 296; Fritzsche 1936, pp. 54, 112, 173, no. VG 82; Lippold 1963, p. 30; Kozakiewicz 1972, vol. 1, pp. 84, 100-102, vol. 2, p. 174, no. 217 (with previous references); Camesasca 1974, p. 103, no. 135; Walther 1995, pp. 60-61; Rizzi 1996, p. 76, no. 54 (with additional references); Weber 1998, pp. 50, 53, note 14; Schmidt 2000, pp. 86-93.

In the foreground is the old harbour which gave access on the right to the Elbe. This basin, however, only provided the barges with shelter during the winter; cargo ships anchored further down, above the customs house, visible at the right just before the river. This building still exists, as do many of the houses in Pirna. The view does not contain many famous buildings of the town; as always the fortress towers over the other buildings and the small lookout towers stand out clearly at the top of the ramparts. Beside it, partially hidden by the trees, the tower of the Marienkirche can be made out in among the houses.

The most alluring aspect of this view is, however, the row of simple cottages, part wood and part stone, represented parallel to the picture plane and all seen at relatively close quarters, with their sheds and latrines, old tools and wood-piles. Bellotto uses artistic license here in throwing these simple cottages into shadow even though they are in the center of the composition. The contrast with the *vedute* of the opulent buildings of Dresden (and later of Vienna and Munich) could not be greater: here the pictorial quality does not lie in the refined beauty of the object represented, but in the state of disrepair of a real unembellished model. Dutch painters in the seventeenth century were familiar with such effects, as the works of Albert Cuyp (1620-91), the depiction of simple peasant cabins in Rembrandt's (1606-69) drawings and Cornelius Decker's (before 1623-78) painting all testify to. Regarding such works, the Dutch painter and academician Gérard de Lairesse (1640-1711) examined in his art criticism whether refined or dilapidated subjects could be defined as "picturesque".[2]

Bellotto does not raise such questions, but restricts himself to painting a not very attractive aspect of Pirna, which he, nevertheless, manages to turn into an expression of the highest art. In his views of Dresden, Vienna, Munich or Warsaw he would never have been permitted the freedom to depict such subjects, but in Pirna he daringly added this view to the series of imposing large-scale *vedute*. He emphasizes the "Dutch" character of the view by introducing elements of genre: in the foreground the washing is being hung out to dry and a knotty willow behind the simple hut serves as a pole for the clothes line. Further to the right, a boat approaches its mooring and the boatman is shown throwing a rope to a boy on the river bank. On the far left, where the view shows in rapid succession the fortress, church, and timber store, a cowherd has brought his cattle down to the shallow water. Bellotto derived this group from an etching by Nicolaes Berchem (1620-83), published in Venice with the poetic title,"*Senza pensier sol della Mandra ho cura*" ("Untroubled by thought, I only look after my flock").[3]

Gregor J.M. Weber

[1] Kozakiewicz 1972, vol. 2, no. 219.
[2] Weber 1991, p. 130.
[3] Weber 1998, passim.

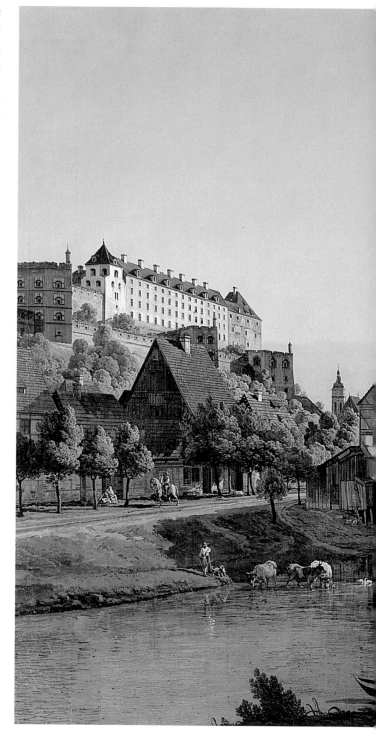

59. *Pirna from the Right Bank of the Elbe with the Main Road at Posta*

1753-55
Oil on canvas
53 1/2 × 95 1/4 inches
(136 × 242 cm)
Gemäldegalerie Alte Meister,
Staatliche Kunstsammlungen,
Dresden (619)

Provenance: The artist probably finished it before 1756; first catalogued by Matthäi in 1834, no. 46.

Exhibitions: Berlin 1955-56, no. 619; Dresden 1963-64, no. 21; Warsaw and Cracow 1964-65, no. 21; Vienna 1965, no. 26; Venice 1986, no. 17; Madrid 1998, no. 5; Bilbao 1998, no. 5; Columbus 1999, no. 5.

Bibliography: Matthäi 1834, no. 46; Hübner 1856, no. 2189; Posse 1929, pp. 294-95; Fritzsche 1936, pp. 54, 112, 173, no. VG 75; Kozakiewicz 1972, vol. 1, pp. 84, 88, 100-102, vol. 2, p. 161, no. 193; Camesasca 1974, p. 100, no. 111; Martini 1982, p. 84; Walther 1995, p. 62-63; Rizzi 1996, p. 66, no. 39; Weber 1998, pp. 50, 53, note 14; Schmidt 2000, pp. 80-85.

Most of Bellotto's paintings of Pirna show the town from a distance, always including the Sonnenstein fortress. In the present view the fortress rises majestically on the left above the town, which is spread out across the valley of the Elbe at its feet. The simpler houses next to the river below the fortress are part of a fishing village. Here a backwater served as a small harbor that provided work for a small community of fisherman and boatmen. For another of his Pirna views, Bellotto chose a vantage point quite close to this same row of houses (cat. no. 58). Comparing the two renderings of them, we see how very literal these paintings are. One wonders how Bellotto could have made

out the smallest details of the buildings situated on the opposite bank of the Elbe. If he did not use binoculars, he must have made a prior detailed study of the houses.

The skyline of the town itself is dominated by the towers of the Marienkirche and the town hall, which Bellotto made much taller than in his other views, taller with respect to their surroundings than they appear in actuality. In the square between the town buildings and the Elbe goods are piled up ready to be transported by river or road. There are large piles of sandstone brought from nearby quarries that were used in the buildings of Dresden. We know from contemporary sources that this square between the fishing village and the customs house was always a hive of activity, with goods being loaded and unloaded by boatmen and labourers with the help of mechanical lifting equipment. Bellotto instead portrays an almost deserted scene with the boats moored along the banks of the river.

In his views of Pirna, unlike those of Dresden, Bellotto emphasizes the bucolic surroundings. The river vallery and its vineyards, fields, and meadows become his main focus, green his dominant color. Here we find even more local figures, as well as travelers, wagons, freight barges, and cowherds with their cattle, either beside the road, standing in the shallow water, or grazing in the meadows. It is quite possible that in this view the artist wished to recreate the atmosphere of a summer Sunday morning (hence the central position of the Marienkirche in the painting), and by eliminating scenes of manual labour, he maintains the idyllic atmosphere of the painting.

The pastoral motifs in the Pirna views are reminiscent of earlier Netherlandish painting: quite specifically, Bellotto made use of a series of engravings depicting shepherds and flocks by Joseph Wagner (1706-80), published in Venice, in the manner of Nicolaes Berchem (1620-83).[1] The cattle in this view of Pirna are borrowed from two of these prints, the standing animal, for example, from a scene of a small herd standing in water. The same animal reappears, together with two more cows and a cowherd, in the painting of the boatmen's village just outside Pirna (cat. no. 58). Identifying these and other long-unrecognized borrowings helps to demonstrate how Bellotto capitalized on pastoral landscape conventions in his views of Pirna in order to capture the serenity of this countryside with its broadly flowing river.

Gregor J.M. Weber

[1] Weber 1998, passim.

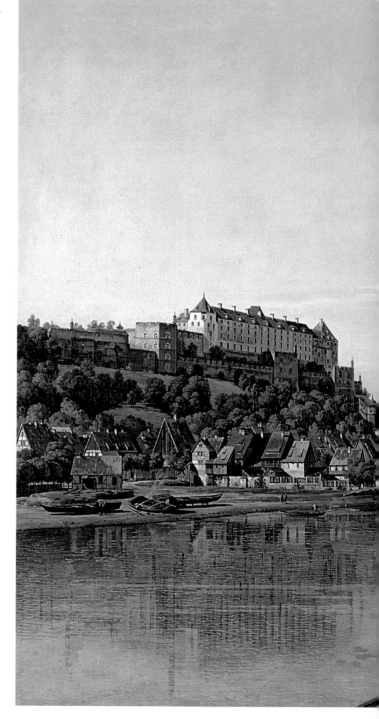

1753-55
Oil on canvas
52 3/8 × 92 1/8 inches
(133 × 234 cm)
Etching made by Bellotto
in 1763.[1]
Gemäldegalerie Alte Meister,
Staatliche Kunstsammlungen,
Dresden (625)

Provenance: The artist probably completed the painting before 1756; first catalogued by Matthäi in 1843, no. 52.

Exhibitions: Dresden 1963-64, no. 27; Warsaw and Cracow 1964-65, no. 27; Vienna 1965, no. 32; Essen 1966, no. 19; Venice 1986, no. 24; Madrid 1998, no. 6; Bilbao 1998, no. 6; Columbus 1999, no. 6.

Bibliography: Matthäi 1834, no. 52; Hübner 1856, no. 2196; Posse 1929, p. 296-97; Fritzsche 1936, pp. 54, 112, no. VG 83; Lippold 1963, p. 30; Kozakiewicz 1972, vol. 1, pp. 84, 100-102, II, vol. 2, pp. 179-80, no. 225; Camesasca 1974, p. 103, no. 130; Walther 1995, pp. 78-79; Rizzi 1996, p. 82, no. 65; Schmidt 2000, pp. 134-41.

This view of Pirna is from the Sonnenstein fortress looking down onto the valley of the Elbe. The painter positioned himself on the west rampart in front of the commandant's residence and near the oldest of the fortress's structures. The complex was expanded in the sixteenth century under the electors Moritz and Albert. Three bastions on the Elbe side, the new commandant's residence, and the north-east battery tower followed in the seventeenth century under Johann Georg II. In 1736-37, in the reign of Augustus III, the new Elbe barracks was added. The oldest surviving component was the polygonal keep – razed in 1859 – whose towering mass Bellotto

has depicted on the right. The Hornwerk rampart below it was built in 1701. The two-story structure in the corner in front of the keep housed a tavern that is mentioned as early as 1768 and still stands today, with the addition of another floor. The steeply angled projecting roof this side of the tavern – a boy has climbed partway up it – sheltered the so-called Klappe. This was the exit from a steep underground staircase leading up into the fortress from the street. The town below, much of which is already in shadow as the late-afternoon sun is low in the sky, is dominated by the Marienkirche, the same church, here quite close, that is so prominent in the previous painting (cat. no. 59).

Our knowledge of nineteenth-century Romantic painting, which evokes mediaeval ideals in the representation of feudal castles, makes Bellotto's view seem quite modern, a far cry from the aesthetics of the Rococo with its exaltation of an imaginary bucolic life. Bellotto describes in a surprisingly objective manner the original fifteenth-century building, the way it blends in with the rock on which it stands, and its rough beauty in comparison to the squat, Late Gothic hall church in the town below. It would have been impossible to include such a building in his imaginative architectural *capricci*, but here Bellotto made it the key motif of the painting.

Bellotto has built up his composition out of interlocking groups of buildings and abrupt changes of level in the landscape. These are underscored by a constant alternation of sunlit and shadowy elements, which also creates depth and relief and makes for any number of picturesque smaller scenes. One such picture within a picture is the glimpse of the Elbe with a

solitary sailboat. The figures in the foreground suggest that life at the fortress is untroubled. Mothers watch their children, a soldier peers in through the tavern window, another soldier, somewhat more dishevelled, stands daydreaming next to a heavy cannon overgrown with grass. Clearly no one here has any notion of what the Prussians have in store for them. The Seven Years War will break out in 1756, bringing dramatic political, social, and economic changes to Saxony.

Gregor J.M. Weber

[1] Kozakiewicz 1972, vol. 2, no. 229.

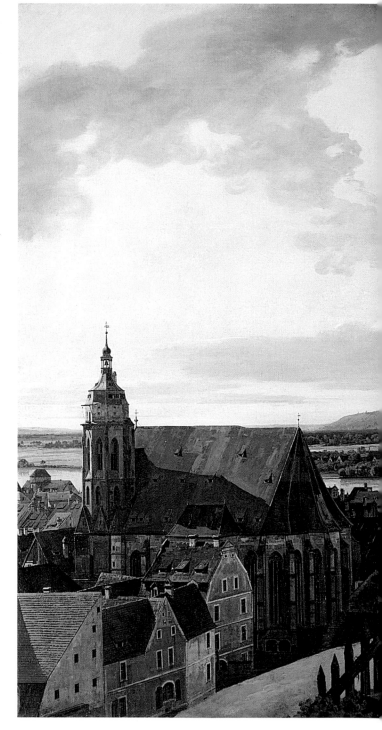

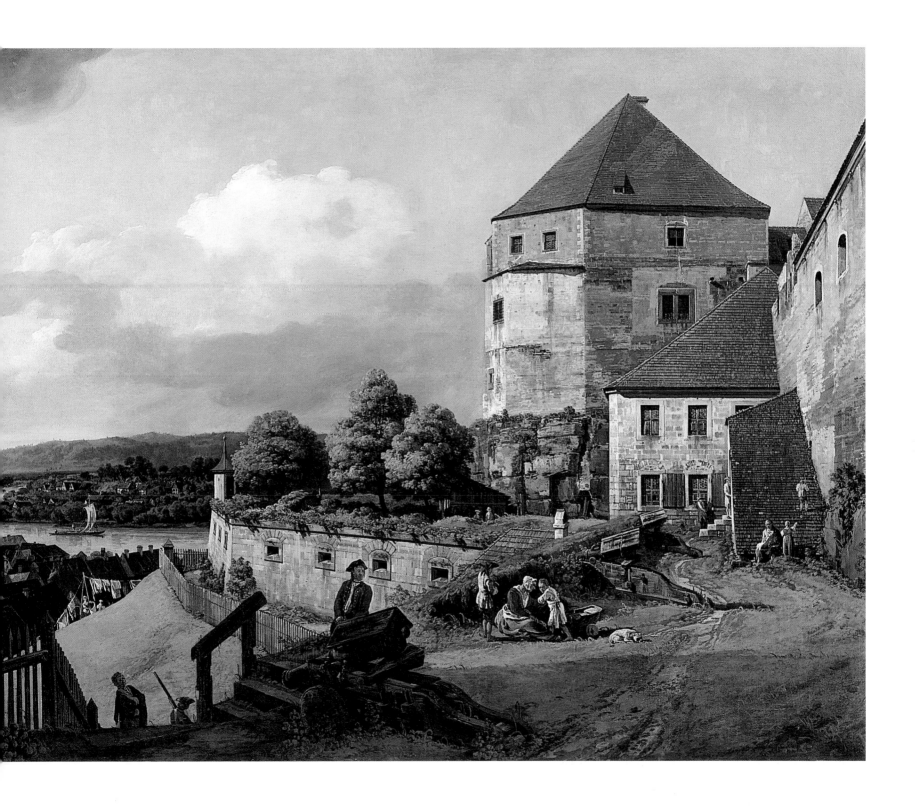

61. *The Sonnenstein Fortress from above Pirna*

1753-55
Oil on canvas
52 3/4 × 93 1/4 inches
(134 × 237 cm)
The State Hermitage Museum,
St. Petersburg (209)

Provenance: Part of the gallery of Count Heinrich Brühl (1700-63), Dresden, by 1752; acquired from his heirs by Catherine II (1729-96) of Russia in 1768; in the first half of the nineteenth century in the Tauride Palace, St. Petersburg; from 1863 in Gatchina Palace, near St. Petersburg; restored to the Hermitage in 1923.

Exhibitions: St. Petersburg 1923; Leningrad 1959, p. 10; Warsaw and Cracow 1964-65 (not in catalogue); Tokyo, Mie, and Ibaraki 1993-94, no. 40; Udine 1998, no. 39; Brussels 1998-99, no. 39.

Bibliography: Staehlin, *Notes*, vol. 1, p. 374, vol. 2, p. 111; Minich 1773-83, vol. 1, pp. 135-36, no. 413; Hermitage 1774, p. 37, no. 413; Bernoulli 1780, p. 196; Hermitage 1797, vol. 2, p. 1, no. 2276; Hübner 1856, p. 73; Hermitage 1859, no. 2924; Stübel 1911, p. 475; Hermitage 1958, vol. 1, p. 66, no. 209; Fomichova 1959, pp. 20, 22-28; Kozakiewicz 1972, vol. 1, pp. 85, vol. 2, p. 179, no. 221 (with additional references); Camesasca 1974, no. 127; Hermitage 1976, p. 76; Levinson-Lessing 1985, p. 67; Fomichova 1992, p. 84, no. 50; Rizzi 1996, p. 80, no. 62; Schmidt 2000, pp. 120-22.

This version from the Brühl collection is identical to the one in the royal series (cat. no. 62) except for minor alterations in the poses and gestures of the foreground figures.
Of all Bellotto's views of Pirna this one is particularly interesting on account of the fact that here the urban features are reduced to a minimum. The car-riage setting off towards the entrance of the Fortress of Sonnenstein does not disturb the idyllic Arcadian atmosphere: the shepherd with his flock in the foreground, the verdant hill of densely planted trees and in the distance, the fascinating panorama of the Elbe plain waning in the twilight shadows.
Several smaller replicas of the composition exist in a private collection, Munich, a private collection in the United States (on loan to the National Gallery of Art, Washington), and in the Wadsworth Atheneum, Hartford (cat. no. 81).[1]

Irina Artemieva

[1] Kozakiewicz 1972, vol. 2, nos. 222, 223.

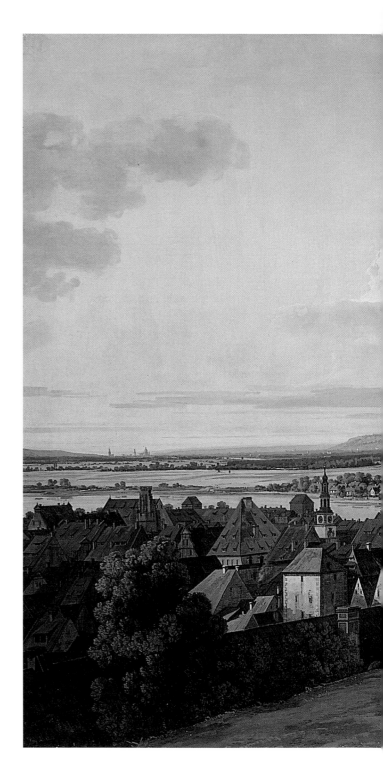

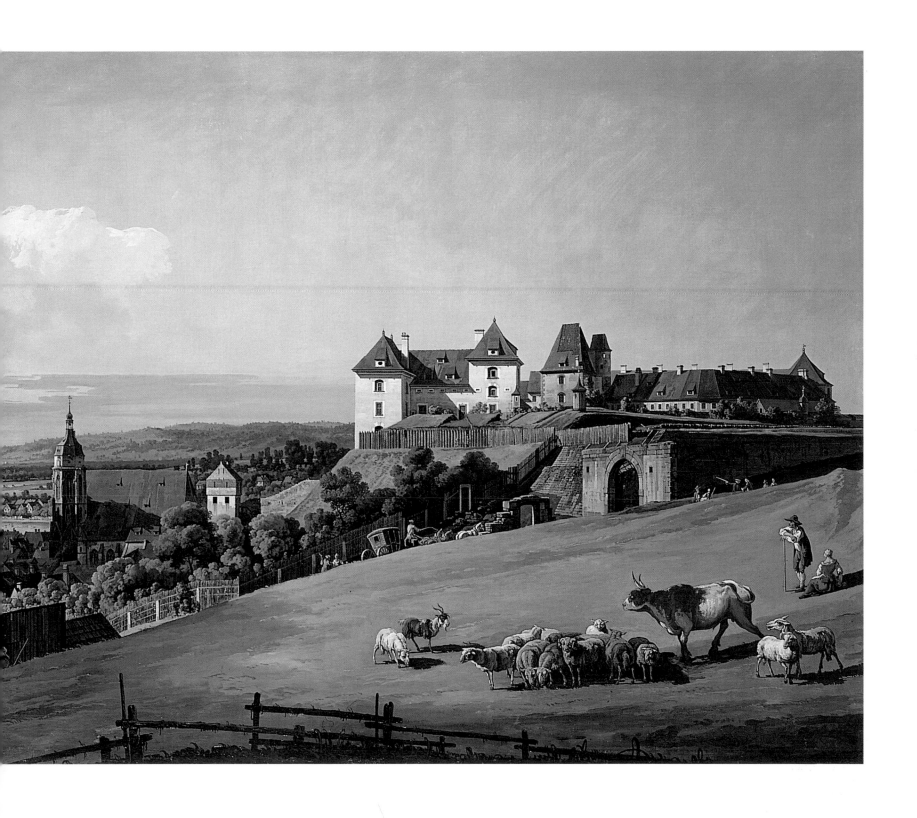

c. 1753-55
Oil on canvas
52 × 92 1/2 inches
(132 × 235 cm)
Etching made by the artist
before 1763.[1]
Gemäldegalerie Alte Meister,
Staatliche Kunstsammlungen,
Dresden (620)

Provenance: The artist probably finished the painting before 1756 and placed it in the royal collection shortly thereafter; first catalogued by Matthäi in 1834, no. 48.

Exhibitions: Dresden 1963-64, no. 22; Warsaw and Cracow 1964-65, no. 22; Vienna 1965, no. 27; Stockholm 1969, no. 231; Venice 1986, no. 23.

Bibliography: Matthäi 1834, no. 48; Hübner 1856, no. 2190; Posse 1929, pp. 294-95; Fritzsche 1936, pp. 58, 113, no. VG 84; Lippold 1963, p. 30, plate 37; Pallucchini 1965, p. 77; Kozakiewicz 1972, vol. 1, pp. 84, 88, 100-102; vol. 2, pp. 174, 179, no. 220 (with previous references); Camesasca 1974, p. 103, no. 126; Martini 1982, p. 84; Walther 1995, p. 66 ff., no. 22; Rizzi 1996, p. 80, no. 61 (with additional references); Weber 1998, pp. 47, 50, 53, note 14; Weber 2000a, p. 26 ff.; Schmidt 2000, pp. 120-25.

In this *veduta*, Bellotto chose the view from the Hausberg that overlooks the fortress and continues on down through the town and beyond as far as the Elbe valley and Dresden, the spires of which are just visible in the distance. On the left is the eastern part of the Kreuzkirche, then the castle tower and the dome of the Frauenkirche, which covers the bell-tower of the royal chapel. Bellotto has of course exaggerated the real size of the buildings, which would not otherwise be recognizable at such a distance.

The fortress is seen here from the south side, with the commander's quarters (dating from c. 1670), followed by the late-mediaeval towers, the one set furthest back being the Luntenturm. In front of the fortress a carriage is making its way up the steep road from Pirna to the Königstein fortress. It is about to go under a strange archway, standing on its own in the landscape, that must have been part of an older building. While Bellotto shows the distant hills still bathed in the last of the day's sun, the city is already immersed in shadow. Only on the odd building, such as the roof of the Marienkirche, can the sun still be seen to shed its horizontal rays. On the far left, standing out clearly against the outline of the town are the roof and bell-tower of the Klosterkirche. In about 1470 an octagonal addition, richly embellished with Gothic decorative motifs, was built onto the rectangular base of the bell-tower. The unfinished tower was decorated at the top by a balustrade with tracery. Bellotto used a daring composition for this view: below the wide expanse of sky which occupies approximately half of the painting, unfolds the landscape, which is divided into two triangles by a diagonal line. On one side is the smaller area of the roofs and fields along the Elbe; on the other is an almost monotonous expanse of brilliant green meadows. This wedge is enlivened by a solitary herd of sheep with shepherds who are enjoying the last rays of sun in the open air. The fields on the Hausberg were set aside for animal grazing, and all the butchers in the town put their animals out to pasture on them. Bellotto's representation, however, goes beyond the straightforward observance of this custom. Once again, in his depiction of the flock he borrows

from the copper engravings of Joseph Wagner (1706-80) made from Nicolaes Berchem's (1620-83) original paintings. He took the oxen and the flocks of sheep from one engraving, the individual sheep and the goat came from two others. His views of Pirna were thus infused with the atmosphere of the pastoral landscapes of old, of which there were many examples, mostly Dutch, in the royal art gallery.

The unusual composition of the painting does, however, create another effect: on the left, the *veduta* is inconclusive, in the sense that it remains completely open to the level of the valley. The gestures and poses of some of the figures suggest they are looking in that direction, but it is above all the shepherd who is gazing, lost in thought, into the distance, thus taking in the whole of Bellotto's vista. This figure is reminiscent of the later landscapes of Dresden by Caspar David Friedrich (1774-1840) and Ludwig Richter (1803-84), that invite the viewer to really look into the painting.

Gregor J.M. Weber

[1] Kozakiewicz 1972, vol. 2, p. 179, no. 224.

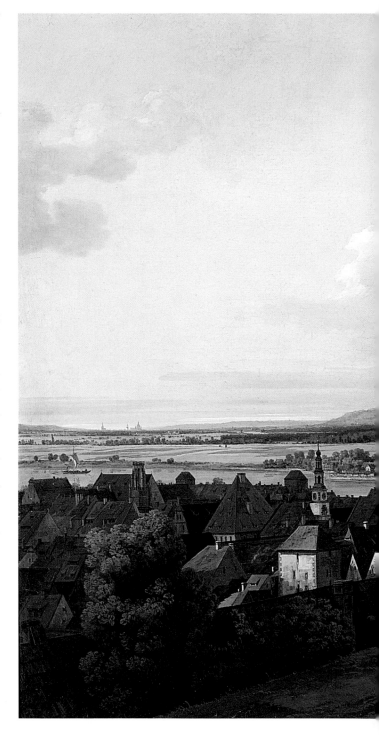

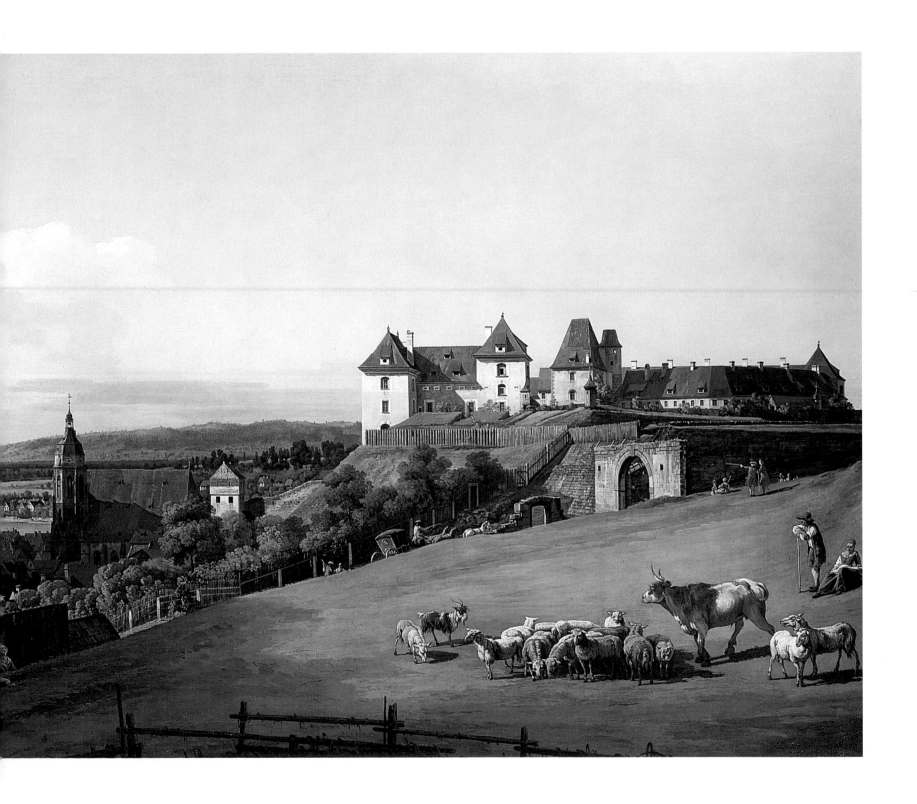

1753-55
Oil on canvas
52 × 92 1/2 inches
(135 × 235 cm)
Etching made by Bellotto before 1763.[1]
Gemäldegalerie Alte Meister, Staatliche Kunstsammlungen, Dresden (621)

Provenance: The artist probably finished this painting before 1756 and placed it in the royal collection thereafter; first catalogued by Matthäi in 1834, no. 49.

Exhibitions: Dresden 1963-1964, no. 23; Warsaw and Cracow 1964-65, no. 23; Vienna 1965, no. 28; Venice 1986, no. 21.

Bibliography: Matthäi 1834, no. 49; Hübner 1856, no. 2191; Posse 1929, p. 295; Fritzsche 1936, pp. 54, 112, no. VG 79; Kozakiewicz 1972, vol. 1, pp. 84, 100-102; vol. 2, p. 162, no. 200 (with previous references); Camesasca 1974, p. 101, no. 118; Walther 1995, pp. 70-72, no. 24; Rizzi 1996, p. 70, no. 45 (with additional references); Schmidt 2000, pp. 98-103.

This is one of the few views of Pirna in which Bellotto shows us the town and its streets at such close quarters. The subject in this case is the "Dohnaische Tor" (or Dohna Gate) on the far left where in another view he had placed the "Obertor" of the town (Gemäldegalerie Alte Meister, Dresden).[2] Bellotto used the composition of this painting, with its symmetrical diagonals that disappear into the depths of the image, once more in the view of *The Breitegasse of Pirna with Milestone* (Gemäldegalerie Alte Meister, Drresden).[3] Here too the setting was on the outskirts of the town at a crossroads.
Beside the Dohnaische Tor, the Breite Gasse stands diagonally to it to form the open area that

Bellotto has depicted in the foreground. From an elevated position we can see a long boundary wall adjacent to the road, behind which the city walls can be seen beyond the moat. Between two trees on the left stands the tower of the 1718 town hall and to the right of this the Marienkirche is silhouetted against the evening sky. The sun is still shining on the side of the fortress facing us and its buildings are clearly aligned: on the left are the bastions of the lower building and the Hornwerk, above is the massive outline of the Old Hall. Close to this is the castle taproom and the Klappe, which are one behind the other in the *Pirna from the Sonnenstein Fortress* (cat. no. 60). The right side of the fortress consists of the commander's quarters and the wall that continues round behind the town, reinforced by the White Tower and the Tower of the Upper Gate. The highest building is the Luntenturm (the Fuse Tower) looming above the fortress with its hip roof. The tower was built in 1469-70 and two spiral staircases were added to the side to replace an earlier building. Up until the middle of the seventeenth century the main entrance to the castle was through the ground floor of the tower. Its appearance here is important in that the building was unsafe and part of it had to be demolished in September 1755 to the height of the cornice of the adjacent circular wing. The fact that Bellotto depicted it as it was before the demolition suggests that his views were done no later than 1755.
There are only a few figures in the foreground, giving the impression of a quiet evening rather than the usual daytime buzz of activity around a city gate. The figures also serve to give a sense of depth to the open space as he places them ran-

domly in the sunlight and in the shade. The only person of rank seems to be the horseman with the red cloak on the white horse. In the etching Bellotto made of the painting sometime before 1763, he changed the horse's position, showing it rearing with its front hooves in the air.[4] In the engraving (and in the smaller painted copies) he left out one of the figures, a man urinating against the wall, beside the garden gate.[5] Bellotto obviously thought this image, which he found in the Dutch pastoral painting of David Teniers (1610-90), Adriaen von Ostade (1610-85) and other seventeenth-century painters, was unsuitable in an image that was to have a much wider audience.

Gregor J.M. Weber

[1] Kozakiewicz 1972, vol. 2, p. 165, no. 204.
[2] Inv. no. 624; Kozakiewicz 1972, vol. 2, pp. 165-66, no. 207.
[3] Inv. no 622; Kozakiewicz 1972, vol. 2, p. 165, no. 205.
[4] Kozakiewicz 1972, vol. 2, p. 165, no. 205.
[5] Kozakiewicz 1972, vol. 2, p. 165, no. 204, repro.; Rizzi 1996, p. 214, no. I 16.
[6] Kozakiewicz 1972, vol. 2, p. 165, no. 205.
[7] Kozakiewicz 1972, vol. 2, pp. 162, 165, nos. 202, 203.

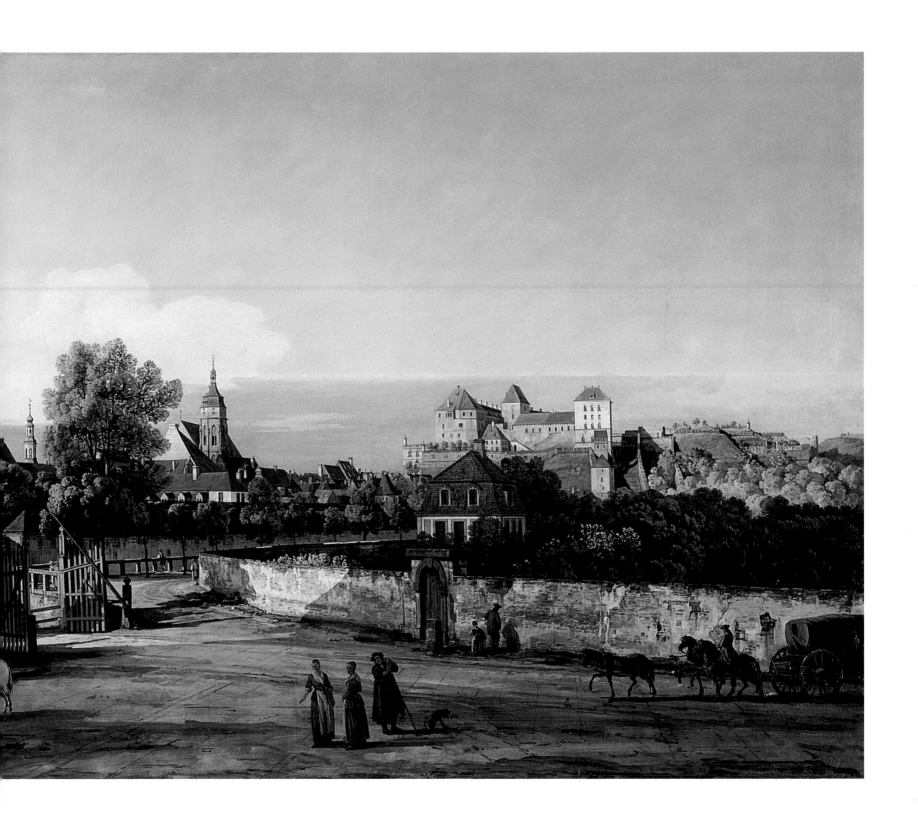

1753-55
Oil on canvas
52 3/4 × 93 1/4 inches
(134 × 237 cm)
The State Hermitage Museum,
St. Petersburg (213)

Provenance: Part of the gallery of Count Heinrich Brühl (1700-63), Dresden, by 1752; acquired from his heirs by Catherine II (1729-96) of Russia in 1768; in the first half of the nineteenth century in the Tauride Palace, St. Petersburg; from 1863 in Gatchina Palace, near St. Petersburg; restored to the Hermitage in 1923.

Exhibitions: St. Petersburg 1923; Warsaw and Cracow 1964-65 (not in catalogue); Tokyo, Mie, and Ibaraki 1993-94, no. 40; Udine 1998, no. 39; Brussels 1998-99, no. 39.

Bibliography: Staehlin, *Notes*, vol. 1, p. 374, vol. 2, p. 111; Minich 1773-83, vol. 1, p. 148, no. 456; Hermitage 1774, p. 40, no. 456; Bernoulli 1780, p. 196; Hermitage 1797, vol. 1, p. 395, no. 2245; Hübner 1856, p 73; Hermitage 1859, no. 2930; Stübel 1911, p. 476; Hermitage 1958, vol. 1, p. 67, no. 213; Fomichova 1959, pp. 20, 24, 27, 28; Kozakiewicz 1972, vol. 1, pp. 85, 100-102, vol. 2, p. 162, no. 201 (with additional references); Camesasca 1974, no. 119; Hermitage 1976, p. 76; Levinson-Lessing 1985, p. 67; Fomichova 1992, p. 81, no. 44; Rizzi 1996, p. 70, no. 46 (with additional references); Artemieva, in Udine 1998, p. 34 no. 39; Schmidt 2000, pp. 98-103.

The painting replicates the composition of a similar view from the royal series (cat. no. 63) but is distinguished, as in the other works commissioned from Bellotto by Count Heinrich Brühl, by a more accentuated use of shades of colour. The setting sun creates vivid pictorial passages ranging from the crepuscular tints amid the thick shadows in the foreground to the far off sunny hills and the very delicate pale-blue sky. In the views of Pirna the tiny figures acquire a more important role, compared to the showpiece pictorial versions of the city of Dresden. It seems that the painter found it amusing to jot these comic vignettes down on the canvas: whilst in the Dresden picture the solitary horseman in a red cloak is strutting along the road, in the Hermitage canvas the horse is going at full gallop, while the little dog following and barking amuses the loiterers.
Kozakiewicz cited several two smaller replicas of the composition.[1]

Irina Artemieva

[1] Kozakiewicz 1972, vol. 2, nos. 202, 203.

1756-57
Oil on canvas
52 1/2 × 92 3/4 inches
(133 × 235.7 cm)
National Gallery of Art,
Washington

Provenance: Commissioned by
Augustus III, King of Poland
and Elector of Saxony (1696-
1763); Henry Temple, 2nd Vis-
count Palmerston (1739-1802),
London; Henry John Temple,
3rd Viscount Palmerston (1784-
1865), who gave it, perhaps to
pay a debt, to William Lygon, 1st
Earl Beauchamp (1747-1816),
Madresfield Court, Worcester-
shire; thence by inheritance to
Else, Countess Beauchamp; sale,
Sotheby's, London, 11 Decem-
ber 1991, lot 18; Bernheimer
Fine Arts Ltd. and Meissner Fine
Art Ltd., London, 1991-93, from
whom purchased by the muse-
um with the Patrons' Permanent
Fund (1993.8.1).

Exhibitions: Dresden, Albert-
inum, Staatliche Kunstsamm-
lungen, 1991; New York 1992;
London and Washington 1994-
95, no. 256; Venice 1995, no. 79;
Washington 2000-2001, pp. 42-
43.

Bibliography: "Catalogue of Pic-
tures," c. 1800, n. p. (as in the
Dressing Room and described
as a "View of Keenigsteen: Can-
naletti" and valued at £250);
"Pictures in Stanhope Street," c.
1804, n.p., (as "Cannaletti Kon-
ingstein £105"); Scharf 1875, p.
10; Bowron 1993, pp. 1-14, figs.
1, 2, 10; Walther 1995, pp. 84-85;
Rizzi 1996, p. 88, repr. pp. 89-91;
Bowron, in De Grazia and Gar-
berson 1996, pp. 14-18; Schmidt
2000, pp. 146-151.

The painting is one of five large
views of an ancient fortress near
Dresden commissioned from
Bellotto by Augustus III, King of
Poland and Elector of Saxony.
The panorama encompasses a
broad expanse of the pic-
turesque, craggy landscape
known as Saxonian Switzerland,
which Bellotto invested with a
monumental quality rarely seen
in eighteenth-century Italian
painting. The great castle of
Königstein sits atop a mountain
that rises sharply from the Elbe
River valley, hundreds of feet be-
low. In the distance on the left is
the Lilienstein, one of the promi-
nent sandstone formations scat-
tered across the countryside.
Bellotto's boldly contrived de-
sign hinges upon the equilibri-
um between the fortress on its
rock massif and the towering ex-
panse of the sky on the left; the
interplay between the broad, dis-
tant vista stretching to the hori-
zon and the wealth of detail in
the complex of fields and paths;
and, at the extreme edges of the
composition, the equipoise be-
tween the Lilienstein and, on the
right, the curving road leading to
the castle. The fortress occupies
the apex of a bold triangle; cold,
remote, and forbidding, it is set
off by its sheer height and weight
from the staffage in the fore-
ground below.
The human figures and animals,
representatives of everyday life,
temper the heroic mood of the
painting and create a melan-
cholic, pastoral atmosphere.
Their presence mitigates the
dominance of the fortress,
which appears to exist in a realm
of eternal repose where time and
change are unknown. Whether
or not Bellotto intended these
rustic figures to give the land-
scape allegorical or symbolic
meaning, their importance is
underscored by the fact that they
are larger in scale and far more
closely integrated into the land-
scape than in almost any of the
artist's other topographical *ve-
dute*. (As in the views of Pirna –
cat. nos. 58, 59, 62 – Bellotto has
derived several of the animals
from contemporary prints after
Nicolaes Berchem [1620-83].[1])

To provide a clearer under-
standing of the magnitude and
complexity of the fortress,
which over the centuries has
served the Saxon kings and elec-
tors as a refuge in times of un-
rest and a stronghold for their
archives, treasury, and art col-
lections and covers nearly twen-
ty-four acres, Bellotto also pro-
duced four additional views:
two in the collection of the Earl
of Derby at Knowsley Hall, Lan-
cashire, showing the exterior of
the castle from the north and
south; and two, now in the City
Art Gallery, Manchester, from
within the walls.[2] Bellotto's
views of Königstein thus com-
prise an unusually complete
pictorial record of one of Eu-
rope's more dramatic examples
of fortress architecture, with
considerable iconographic and
documentary information of
value to historians.
Bellotto began working at
Königstein, twenty-two miles
south-east of Dresden, in the
spring of 1756. He was issued a
warrant from Augustus III ad-
dressed to Crusius, the bailiff
(*Amtmann*) of Pirna, requiring
him and other officials to assist
the artist in his work in and
around the castle.[3] The five
views of Königstein, executed on
canvases of the same size and
format, were obviously intended
to complete the earlier views of
Dresden and Pirna painted for
the king and placed in the Stall-
gebäude, the wing of the royal
palace that housed the painting
collection after about 1731. Bel-
lotto's progress at Königstein
was abruptly interrupted, how-
ever, when Frederick the Great
of Prussia opened hostilities in
the Seven Years War by invading
Saxony in August 1756. Follow-
ing the surrender on 10 October
of 17,000 Saxon troops at the
foot of the Lilienstein, Augustus
III, who had been encamped
with his sons at Königstein, left
the castle on 20 October and fled

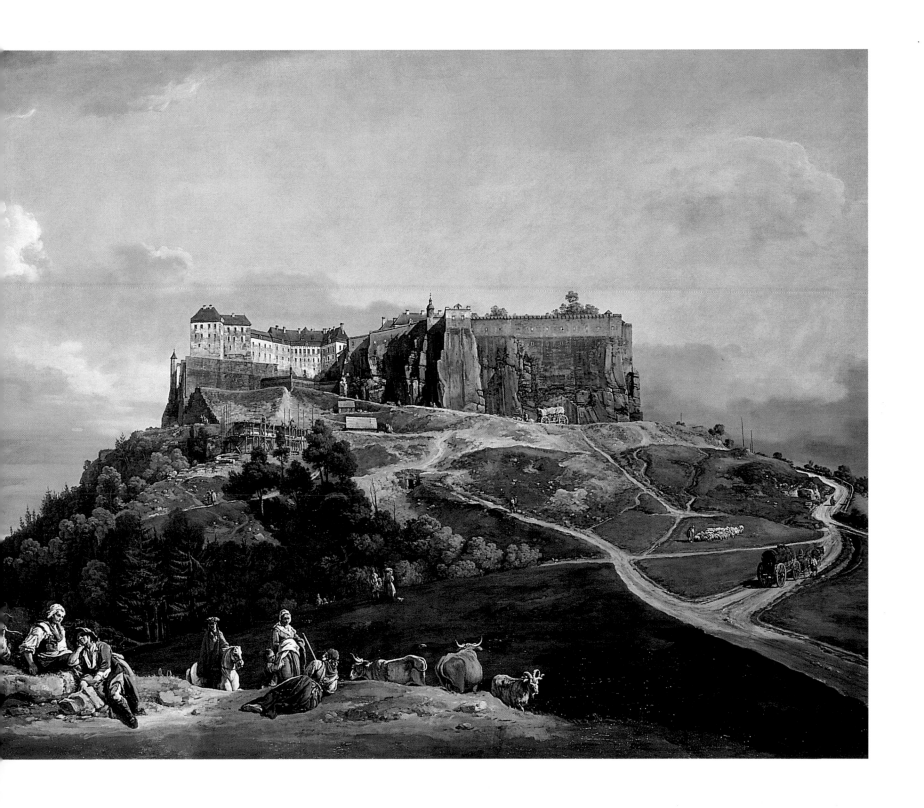

to the safety of Warsaw. One can only speculate on the degree to which Bellotto was himself traumatized by these events. It is known that in 1758 when Dresden was occupied by the Prussians, he departed the capital for Vienna. Kozakiewicz summarized the situation created by these events as follows: "He must have been at Königstein, making the preliminary drawings for the paintings completed later, from the spring of 1756 to the early autumn; any later date is ruled out by the fighting and the Prussian occupation of the castle. The continuity of his work for the court must have been disturbed by the precarious position in which the royal family and the capital were placed. Whether the many calls on the treasury permitted the whole of his original, high salary to be paid to him is not certain, although there exists a receipt from him for the first quarter of 1758. The four [Kozakiewicz was unaware of the existence of the National Gallery painting at the time he was writing in 1972] large views of Königstein, which he must have painted in 1756 and 1757, never reached the royal collection.[4]

One reason is the disarray of the royal picture collection itself. On 7 September 1756 the picture galleries in the royal palace were locked and the key given to Queen Maria Josepha, who remained at Dresden. When the queen died in 1757, the crown prince took charge of the key. The galleries remained closed, and in September 1759 were largely emptied and their contents dispatched to the fortress of Königstein for safekeeping.[5] For all practical purposes the Dresden picture galleries ceased to function, so it is not surprising that Bellotto found it difficult to complete his remaining obligations to the court. It may be assumed that during the period

before he left Dresden for Vienna, Bellotto accepted a variety of non-royal commissions and produced replicas and etchings of earlier paintings for ordinary paying customers, but precisely when and where he completed the Königstein canvases is unknown.

Included among the etchings Bellotto made of his views of Dresden, Pirna, and Königstein is the National Gallery's painting. The print is a large folio and is captioned in French, with the coat-of-arms of the elector of Saxony in the lower margin. Bellotto probably produced the print between 1763 and 1766, and made several minor changes of detail: the castle rock appears higher than in the painting, the scaffolding on the lower slope has been removed, and the tree in the foreground has denser foliage.[6] A reduced replica of the painting, evidently autograph, was in the Galerie Liechtenstein, Vienna, until about 1945 and then in a private collection in Zürich until at least 1965.[7] A nineteenth-century copy is recorded at Hradec Castle, Opávy, Czechoslovakia.[8]

Edgar Peters Bowron

[1] See Weber 1998, passim.
[2] Kozakiewicz 1972, vol 2, pp. 184, 189, nos. 233, 235, 238, 241, repro.; for further discussion, see Bowron 1993, pp. 4-7, figs. 4-7, repro. color; Rizzi 1996, pp. 92-97, nos. 72, 74, 75, 79, repro. color.
[3] Kozakiewicz 1972, vol. 1, p. 83.
[4] Ibid.
[5] Menz 1962, pp. 52-54.
[6] Kozakiewicz 1972, vol. 2, p. 183, no. 232, repro., and vol. 1, pp. 104-106, for a discussion of the etchings of Bellotto's first Dresden period.
[7] Kozakiewicz 1972, vol. 2, p. 183, no. 231, repro.
[8] Kozakiewicz 1972, vol. 2, p. 514, no. Z 506, repro.

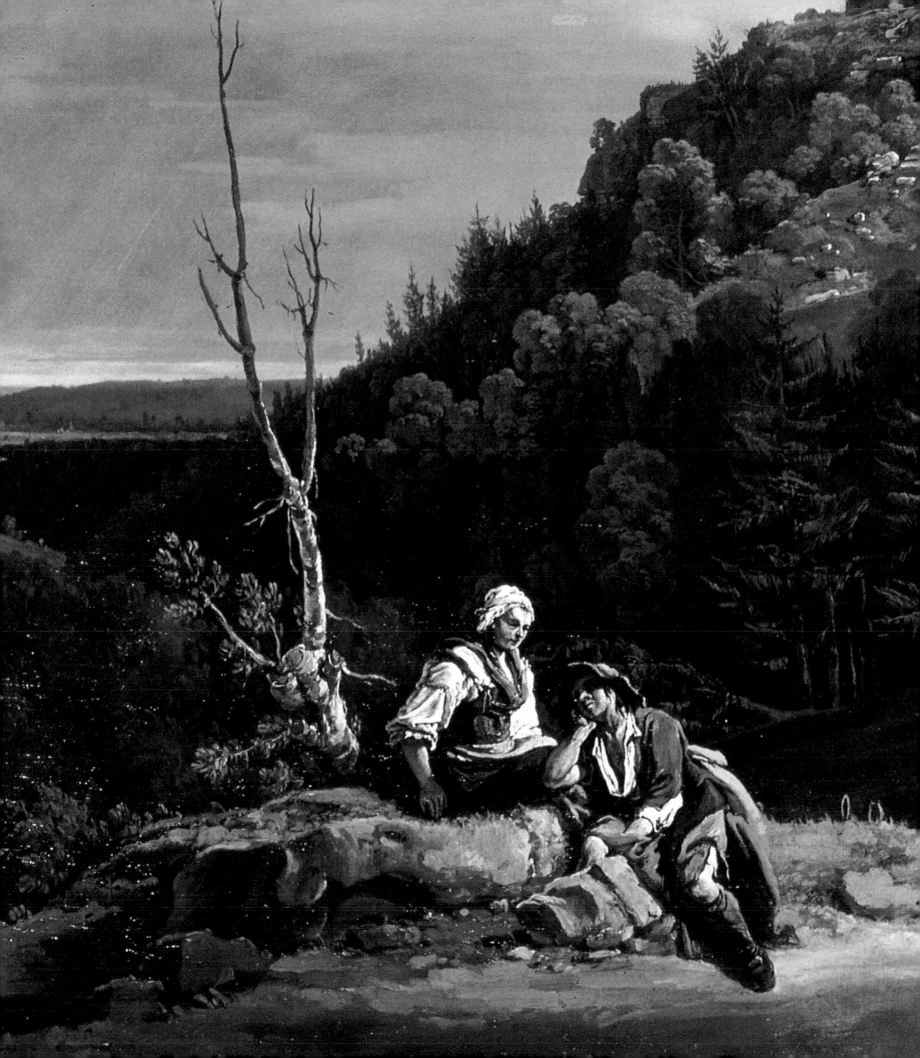

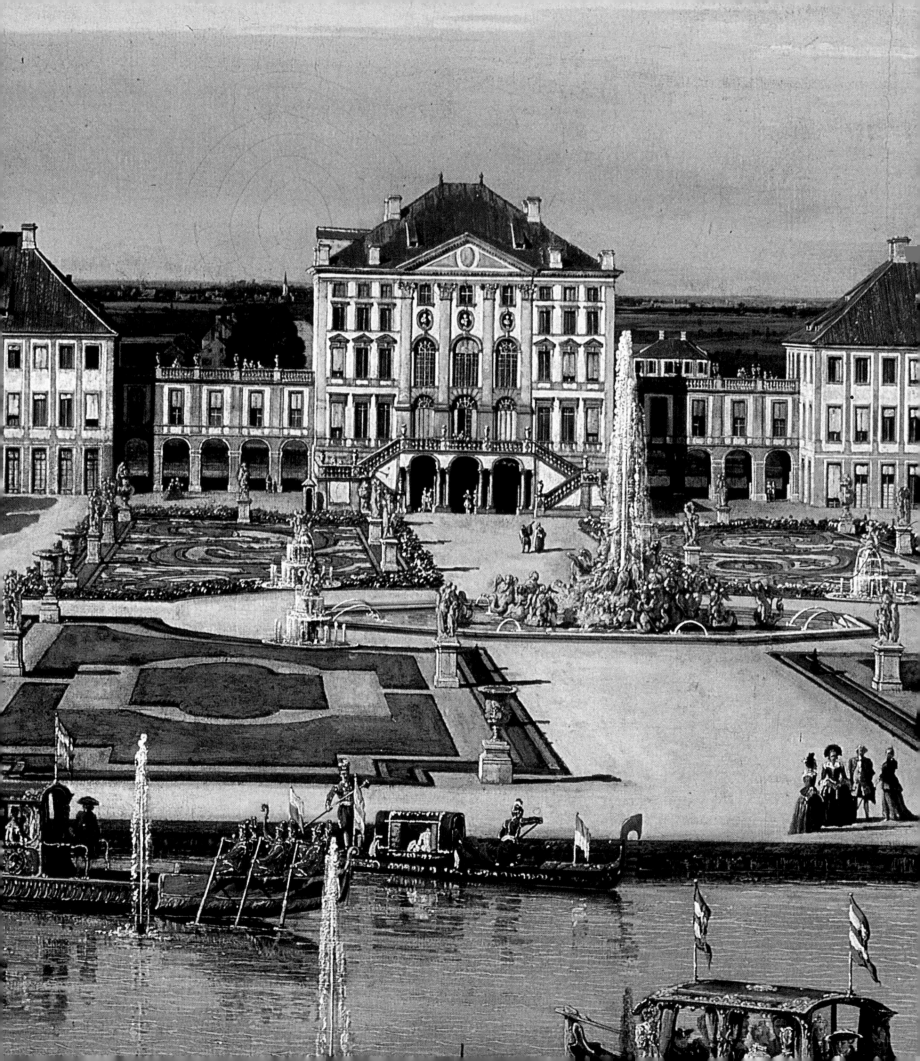

Vienna and Munich

66. *The Imperial Summer Palace of Schlosshof, near Marchegg, from the North*

1759-60
Oil on canvas
53 1/2 × 93 3/4 inches
(136 × 238 cm)
Gemäldegalerie,
Kunsthistorisches Museum,
Vienna (1675)

Provenance: Commissioned or purchased by the Empress Maria Theresa (1717-80) and thereafter in the possession of the Austrian imperial family, hanging in various palaces; in 1890 transferred to the Kunsthistorisches Museum, property of the nation from 1919.

Exhibitions: Vienna 1964, no. 93; Warsaw and Cracow 1964-65 (not in catalogue); Vienna 1965, no. 59; Essen 1966, no. 32.

Bibliography: Engerth 1881, no. 119; Fritzsche 1936, p. 114, no. VG 97; Trost 1947, pp. 11-12, 25, 28, no. 17; Heinz, in Vienna 1965, pp. 21-24, 29, 59-60, 113; Kozakiewicz 1972, vol. 1, pp. 114, 117, 119, vol. 2, p. 224, no. 285 (with previous bibliography); Camesasca 1974, no. 159; Knofler 1979, p. 118; Zava Boccazzi 1983, p. 76; Rizzi 1990, p. 74; Rizzi 1991, pp. 378-79; Rizzi 1996, p. 130, no. 107 (with additional bibliography).

As in the case of the group of canvases dedicated to the squares of Vienna, those depicting the imperial castles, that is, two views of Schönbrunn and three of Schlosshof (Kunsthistorisches Museum, Vienna), are characterized by similar dimensions.[1] The difference lies in the proportions, however, since the views of Schlosshof are wider and provide a more extensive elaboration of the landscape. Three canvases document Schlosshof castle and its park near the River March, while a fourth is dedicated to a site in the immediate vicinity, the ruined fortress of Theben (cat. no. 67), situated on the opposite banks of the March.

The palace of Schlosshof was restored between 1725 and 1729 by Johann Lukas von Hildebrandt (1668-1745), under the auspices of Prince Eugene of Savoy (1663-1736), and in 1730 the gardens were also refurbished. The entire complex was sold in 1755 to Empress Maria Theresa (1717-80) by the prince's heir. In 1760, the sovereign added another story and this modified completely the line of the Baroque modernization, consequently the images painted by Bellotto have assumed exceptional documentary value. His first view of the palace records the courtyard of honor, the second shows the terraced gardens on the eastern side, in both, only minor hints of the surrounding countryside are provided. Seen from the north, however, Schlosshof presents a totally different aspect. The present view provides a true comparison between interior and exterior, the world of the aristocratic and that of the peasant. The castle, whose monotonous flank seems to continue *ad libitum*, is far more impressive compared to previous views, and, vice versa, the garden no longer appears so monumental and grandiose. Now it is certainly a *hortus conclusus*, a snippet, resembling the Kräutergarten at Königstein. Bellotto highlights the isolation of his subject, something he carefully avoided or at least mitigated in the view of Prince Wenzel Kaunitz's Palace in the Mariahilf Suburb of Vienna (Szépmüvészeti Múzeum, Budapest).[2]

It is also worth mentioning once more – since the world of gardens and palaces is a novelty in Bellotto's repertoire, as has been repeatedly emphasized – how the painter has prepared various formal solutions for coping with this genre. So we must return to the commemorative type of view. In the view for Kaunitz, the residence's monumental architecture and its park appeared sacrificed to a perspective distortion of the garden. This loss was, however, compensated by the introduction of a new compositional fulcrum, ordered around the figure of the patron, which becomes the center of another line of perspective acting as a bridge between the aristocratic island and the town, just as his palace finds a correspondence in an ecclesiastical building.

For this view of Schlosshof, however, Bellotto chose an external and detached view, and a desolate strip of land replaces the scenic terrace. The boundary walls form an element of continuity with the earthworks that support the terraces, which in turn are reminiscent of elements of military architecture; that is, a bastion with handles. No organization of the garden can be perceived, on the other hand, and in fact the lack of "correct" perspective has in some way robbed it of its sense and made it an element that intrudes on the landscape, impeding the view over the plain, the river, and the hills with the ruins of Theben.

Martina Frank

[1] Kozakiewicz 1972, vol. 2, nos. 280, 281, 282, 284, 285.
[2] Kozakiewicz 1972, vol. 2, no. 270.

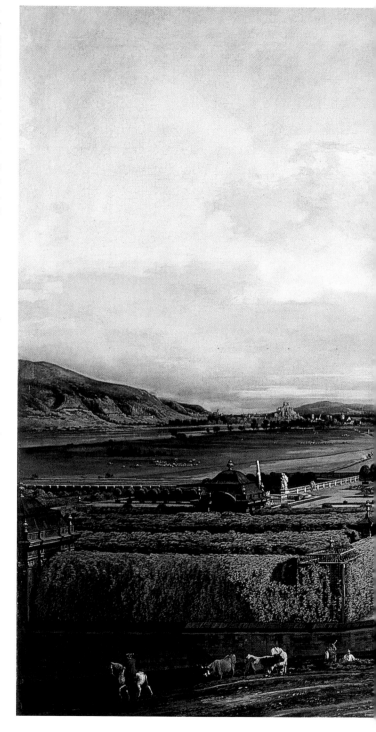

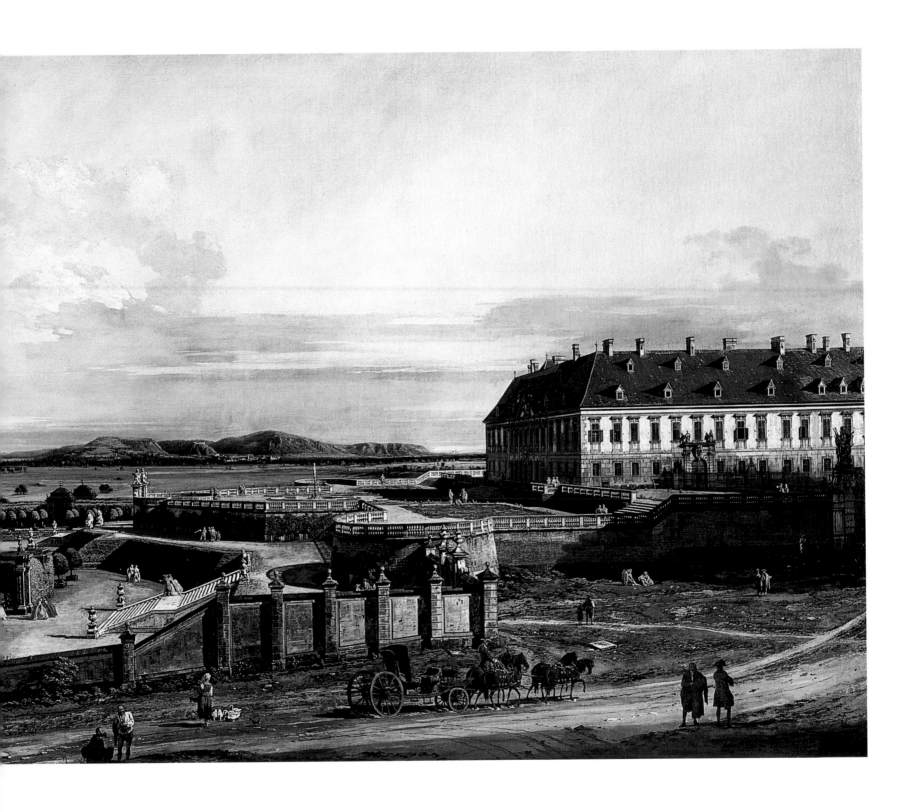

1759-60
Oil on canvas
53 7/8 × 85 inches
(137 × 216 cm)
Gemäldegalerie,
Kunsthistorisches Museum,
Vienna (1676)

Provenance: Commissioned or purchased by the Empress Maria Theresa (1717-80) and thereafter in the possession of the Austrian imperial family, hanging in various palaces; in 1890 transferred to the Kunsthistorisches Museum, property of the nation from 1919.

Exhibitions: Warsaw and Cracow 1964-65 (not in catalogue); Vienna 1965, no. 60; Essen 1966, no. 33.

Bibliography: Engerth 1881, no. 120; Fritzsche 1936, p. 114, no. VG 100; Trost 1947, p. 12; Lippold 1963, p. 31; Heinz, in Vienna 1965, pp. 21-24, 59-60; Kozakiewicz 1972, vol. 1, pp. 114, 117-19, vol. 2, pp. 224, 227, no. 286 (with previous references); Camesasca 1974, no. 160; Knofler 1979, p. 121; Rizzi 1990, p. 66; Rizzi 1991, pp. 379-80; Bowron 1994, p. 368; Rizzi 1996, p. 132, no. 108.

The painting may be considered the counterpart of Schlosshof seen from the north (cat. no. 66). In the latter, the Baroque residence is fully in the foreground whereas here we see it on the opposite bank of the March. The division of the painting into two parts is accentuated by the central position of a tree as decrepit as the buildings that surround it: on the left, the tall spur with the medieval castle, whose illuminated walls are silhouetted against a sky of storm clouds. On the right the sky is light yellow, and the vista is an infinite landscape. The foreground is in the shade and acts as a unifying element.

Here Bellotto returns to the use of a compositive matrix similar to that of the commemorative views, which is manifested chiefly in the introduction of a sort of stage for human figures. The family of gypsies that stands out starkly from the dark triangle formed by the tent is portrayed in a traditional pose but it is the monumentality of the figures that is unusual, especially if we think that they are not actually even in the foreground, but separated from it by a bare expanse. We are forced to make a comparison with the view of the Fortress of Sonnenstein seen from Dresden (Gemäldegalerie Alte Meister, Dresden), painted between 1753 and 1755. In the present, later view the foreground is animated by a group of peasants who act simply as a go-between for the spectator's attention towards the castle and the valley in the background, and they are easily relegated to a picturesque dimension. The Theben gypsies are even more appropriately included in that dimension, so the element of solemnity that undoubtedly characterizes them is even more significant and contributes to sealing the dramatic tension of the painting.

Martina Frank

1759-60
Oil on canvas
45 5/8 × 59 7/8 inches
(116 × 152 cm)
Gemäldegalerie,
Kunsthistorisches Museum,
Vienna (1654)

Provenance: Commissioned or purchased by the Empress Maria Theresa (1717-80) and thereafter in the possession of the Austrian imperial family, hanging in various palaces; before 1850 to the Belevedere Gallery; in 1890 transferred to the Kunsthistorisches Museum, property of the nation from 1919.

Exhibitions: Zurich 1946-47, no. 282; Amsterdam 1953, no. 20; Vienna 1965, no. 47; Schaffhausen 1953, no. 99; Brussels 1953-54, no. 18; Warsaw and Cracow 1964-65 (not in catalogue); Vienna 1965, no. 47; Vienna 1966, no. 229.

Bibliography: Krafft 1849, p. 159; Engerth 1881, no. 109; Tietze 1931, pp. 405-06; Fritsche 1936, p. 115, no. VG 103; Trost 1947, pp. 15, 22-23, nos. 5, 27, 30, 31; Heinz, in Vienna 1965, pp. 21-24, 29, 59-60; Kozakiewicz 1972, vol. 1, pp. 114, 116, vol. 2, p. 201, no. 260 (with previous references); Camesaca 1974, no. 147; Knofler 1979, pp. 29, 32; Zava Boccazzi 1983, p. 80; Rizzi 1990, pp. 32, 96; Rizzi 1992, pp. 269-70; Rizzi 1996, p. 106, no. 88 (with additional references).

Bellotto dedicated six views to the squares of Vienna (Kunsthistorisches Museum, Vienna), and as the paintings are all of a similar size, we may suppose that they were conceived as the elements of a series.[1] In this series the Freyung square is depicted twice: a second view from the opposite standpoint, the north-west, focuses on the façade of the "Scots" church (Schottenkirche.[2] They also represent contrasting images of daily life: the painting exhibited focuses on the animation of a market day in the town center, whilst the other illustrates a procession from the church to the neighboring convent and brusquely halts, almost a freeze-frame of the daily routine.

Generally his compositions of Vienna's square employ a diagonal, which begins at the top left and leads down to bottom right, with the intention of separating the sunny areas from the shady, but also pointing in a precise direction. Here Bellotto proposes, as he also does in the view of the university square,[3] a variation of the slim strip of foreground left in the shadows, which is his way of "leading" us into the place he is painting. Hence the market scene here is enacted mainly in a non- illuminated area and gradually flows into the play of light and shade that are also a feature of the main element – the Schottenkirche.

If the painting exhibited here enjoys a more favorable reaction than its companion depicting the procession, it is without doubt attributable to topographic details. The Freyung is an irregular shape and has a slight slope, seeming to be either a meeting point for a number of streets, or just a simple widening of the road. Bellotto has been able to exploit this difficult situation to the full, using the side access on the eastern section to create a solid framework of perspective for the rectangular Schottenkirche complex, which thrusts forward, wedge-shaped. Its main prospect is the church's lateral illuminated façade that constitutes the "natural" continuation of the right hand side. In this way the place's various qualities – crossroads, amphitheater, rest and business area – are all highlighted.

Martina Frank

[1] Kozakiewicz 1972, vol. 2, nos. 260, 262-64, 267, 269.
[2] Kozakiewicz 1972, vol. 2, no. 262.
[3] Kozakiewicz 1972, vol. 2, no. 267.

1761
Oil on canvas
52 × 92 1/2 inches
(132 × 235 cm)
Bayerische Verwaltung
des Staatlichen Schlösser,
Gärten und Seen,
Residenzmuseum, Munich

Provenance: Commissioned in 1761 by the Elector Maximilian III Joseph (1727-77) and thereafter in the possession of the electoral, later royal, family in the Residenz and other royal palaces; transferred to the Königliche (later Alte) Pinakothek before 1828; after 1918, property of the Bavarian state and placed on public exhibition in the Residenz; after 1945, in Nymphenburg Palace; returned in 1966 to the Residenzmuseum.

Exhibitions: Munich 1901, p. 19; Vienna 1965, no. 63.

Bibliography: Fassmann 1770, no. 320; Fritzsche 1936, pp. 69, 116, no. VG 119; Kozakiewicz 1972, vol. 1, pp. 120-21, 127, vol. 2, pp. 233-34, no. 294 (with previous references); Barche, in Verona 1990, pp. 156, 158; Rizzi 1996, pp. 140-41, no. 113 (with additional references).

The painting is one of three large views, one of Munich and two of Nymphenburg, painted by Bellotto for Elector Maximilian III Joseph (1727-77) and intended for one of the rooms in the electoral palace, the Residenz; for the details of the commission, see cat. no. 70. A masterpiece of perspective construction, and in Rizzi's words, a work of "Handelian joyousness," the present view depicts the west face of the Nymphenburg Palace, the extensive summer residence of the Bavarian elector, who had recently overseen the alteration and redecoration of several of its rooms. The view is described by Koza-

kiewicz as "taken from an imaginary, high vantage point, somewhat to the north of the axis of symmetry, so that there is a very slight degree of foreshortening. The main building, flanked by the galleries that join it to the pavilions, rises in the deeper middle ground, just left of center; further wings and minor buildings are visible on either side, partly concealed by the dense trees in the park."[1] The formal gardens are laid out in front of the palace in a pattern of parterres and walks; the fountain with a Flora group by Wilhelm de Groff (c. 1680-1742) is in the center. The gaily decorated boats and gondolas on the pool in the foreground, with attendants dressed in blue and white, the Bavarian national colors, may record the festivities organized by the elector in September 1761 honoring the visit of his cousin, Elector Karl Theodor (1724-99) of the Palatinate, both of whom are visible at the lower right.[2] The four richly colored gondolas, together with their gondoliers, were in fact brought from Venice and attest to the charm and fascination the Venetian gondola held for the courts of Europe.[3] The towers of the Theatinerkirche and Frauenkirche above the Munich skyline are visible in the distance at the right, and in the distance farther to the right snowcapped mountains may be seen.
Kozakiewicz has noted the importance of the three views as the first examples of architectural painting in the grand style produced in Munich, and their influence upon the local tradition of topographical painting.[4] The two views of Nymphenburg, in particular, mark a new phase in Bellotto's approach to the representation of palaces and gardens in a wider landscape background. Even more than in his earlier views of Dres-

den and Vienna, Bellotto created a powerful impression of space in the park landscape and in the expanses of sky. He achieved this by conceiving the views from an imaginary high viewpoint, which in reality could not have been reached by any spectator, and through an artificially constructed perspective. For this reason, the Nymphenburg paintings represent a radical departure from all of Bellotto's earlier views of topographical subjects employing an actual vantage point.[5]
William Barcham has further observed Bellotto's manipulation of the site in order to formalize and monumentalize the appearance of the palace buildings. In comparison with the view of Munich, both views of Nymphenburg are much more rigidly controlled. In the view of the palace from the gardens, even though the central allée is shown off axis and the parterre gardens recede to the left, the façade of the central building is shown entirely frontally with the result that its formal entrance now bears an iconic relationship to the scene before it. Indeed, Bellotto has emphasized this adjustment by placing the central fountain's enormously high jet of water exactly where the effect of perspective and recession would be most prominent and by diminishing the deep shadow on the wing extending to the right.[6] In spite of these subtle pictorial alterations, Bellotto's description of the park and buildings of Nymphenburg was so meticulous that when the exterior of the palace was being restored, his paintings were consulted as guides to the original coloring.[7]
A reduced replica in the National Gallery of Art in Washington records the present composition almost exactly except for the omission of minor figures.[8] Despite these small departures, the

quality and handling of the Washington version suggests that it is substantially the work of Bellotto himself with the assistance of a member of his studio. In 1766 Franz Xavier Jungwierth (1720-90) made an engraving of the view of Munich in imperial folio format.[9]

Edgar Peters Bowron

[1] Kozakiewicz 1972, vol. 2, pp. 233-34.
[2] Fritzsche 1936, p. 69.
[3] Ricci 1996, p. 140.
[4] Kozakiewicz 1972, vol. 1, pp. 120-21.
[5] William L. Barcham, letter of 24 June 1993, National Gallery of Art curatorial files, cited by Bowron, in De Grazia and Garberson 1996, pp. 22, n. 9.
[6] *Ibid*.
[7] Hager 1960, p. 42.
[8] Kozakiewicz, 1972, vol. 2, p. 234, no. 295, repro., as a work of collaboration, possibly by Lorenzo Bellotto; Bowron, in De Grazia and Garberson, 1996, pp. 19-22, repro.
[9] Nagler, 1835-52, vol. 6, p. 509, no. 29.

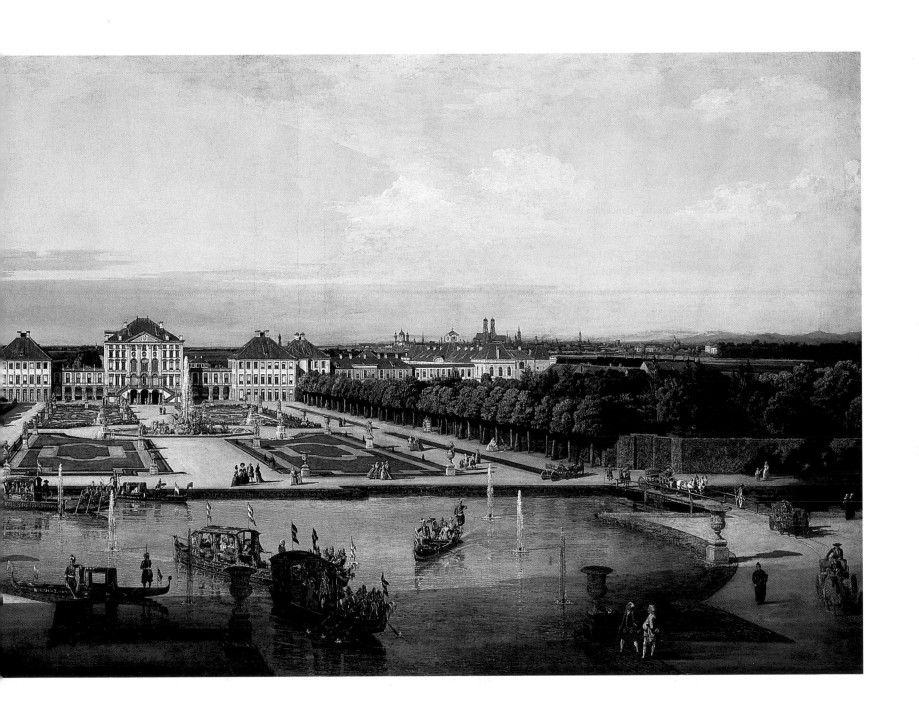

1761
Oil on canvas,
52 × 92 1/2 inches
(132 × 235 cm)
Bayerische
Staatsgemäldesammlungen,
Residenzmuseum, Munich

Provenance: Commissioned in 1761 by the Elector Maximilian III Joseph (1727-77) and thereafter in the possession of the electoral, later royal, family in the Residenz and other royal palaces; transferred to the Königliche (later Alte) Pinakothek before 1828; after 1918, property of the Bavarian state and placed on public exhibition in the Residenz; after 1945, in Nymphenburg Palace; returned in 1966 to the Residenzmuseum.

Exhibitions: Munich 1901, p. 38; Vienna 1965, no. 61.

Bibliography: Fassmann 1770, no. 321; Fritzsche 1936, pp. 69-70, 116, no. VG 115; Kozakiewicz 1972, vol. 1, p. 120, vol. 2, p. 228, no. 290 (with previous references); Barche, in Verona 1990, pp. 156-61; Rizzi 1996, pp. 134-36, no. 109 (with additional references); Rottermund 1998, pp. 9-19.

Little documentary evidence exists in relation to Bellotto's visit to Munich in 1761. Empress Maria Theresa commended the artist to Princess Maria Antonia of Saxony in a letter of 4 January 1761, and Bellotto left Vienna for Munich shortly thereafter, arriving on 14 January in the company of six other painters who had formerly worked for the court of Dresden.[1] The princess and her husband, Prince Frederick Christian, the eldest son of Augustus III, Bellotto's Dresden patron, were staying in Munich at the court of her brother, Elector Maximilian III Joseph of Bavaria. Bellotto would have known the royal couple from his years in Dresden, but it is uncertain whether he went to the Bavarian court in response to an invitation or of his own accord, hoping to obtain commissions from the elector upon the recommendation of the princess.[2]

During Bellotto's brief visit to Munich – he presumably returned to Dresden, shortly before the end of 1761 or in January 1762 – he produced three large, carefully executed views of Munich and Nymphenburg for Elector Maximilian III Joseph, intended for one of the rooms in the electoral palace, the Residenz. The subjects were this panorama of Munich from the village of Haidhausen, and two views of the Wittelsbachs' summer residence, Nymphenburg, one from the approach from the city,[3] the other from the garden side (cat. no. 69). Shortly after the Elector's succession in 1745, a suite of living rooms had been constructed for the new ruler and his wife, Maria Anna, on the upper floors of the Residenz. In 1760-63 the rooms were redecorated by François de Cuvilliés (1695-1763), and the three canvases were installed in the second anteroom, which served as one of the elector's dining rooms. The room was an intimate *petit souper*, limited to a few persons, which functioned also as a waiting room during the day. The view of Munich was placed on the central wall, opposite a window; the views of Nymphenburg Palace were placed on a corresponding side wall, their steep perspectives converging on the painting in the center and unifying the three views.[4] This ensemble predates and anticipates Bellotto's compendium of panoramas of Warsaw in the so-called "Canaletto Room" in the Royal Castle there. The view of Munich across the Isar River is taken from the south-east from the village of Haidhausen. (The painting is often alternatively entitled *A View of Munich from Gasteig Hill.*) On the near bank in the foreground is the Auer Tor (demolished in 1860),[5] tollhouse, and related buildings, and a gate at the head of the Isarbrücke, which was begun in 1759, two years before the painting. The long, narrow island in the middle of the river almost entirely conceals the water beyond it. On the far bank is the tollhouse and Isartor at the end of the bridge and, beyond, the Rote Türm. The city of Munich, dominated by the towers and domes of its principal buildings, stretches from the center of the painting to the right edge. The skyline is dominated at the right of center by the Frauenkirche, with its familiar twin towers crowned with round caps, and the towers of the old Rathaus, the Heiliggeistkirche, and the Peterskirche. Farther to the right is the spire of the Salvatorkirche, the dome and the twin towers of the Theatinerkirche, and the little spire of the Residenz.

Rizzi has commented upon the *staffage*, which relieves the documentary character of the view. The larger figures are organized into two principal groups, the more conspicuous and brightly lit at the left, consisting of a woman dressed in traditional Bavarian costume, a little girl frightened by a dog, and an old man on his knees, perhaps in response to the bell announcing the time for Angelus. Three of the figures in shadow at the lower right are shown in prayer, probably before a chapel or outdoor tabernacle located beyond the edge of the canvas. They are accompanied by a seated elderly man and a corpulent friar, a reminder of the predominant Catholic constitution of the city. A reduced replica in the National Gallery of Art in Washington records the present composition almost exactly except for the omission of minor figures.[6] Despite these changes, the quality and handling of the Washington version suggest that it is substantially the work of Bellotto himself with the assistance of a member of his studio. Andrzej Rottermund recently published another reduced replica of the Munich view which he considers to have been largely painted by Bellotto in the years 1762-67, during his second residence in Dresden.[7] In 1766 Franz Xavier Jungwierth (1720-90) made an engraving of the view of Munich in imperial folio format, which was later reproduced in other formats.[8] In the print the disposition of the figures corresponds closely to the Washington version, suggesting the possibility that the engraving was made after the replica rather than from the original in the Residenz.

Edgar Peters Bowron

[1] Kozakiewicz 1972, vol. 1, p. 120; Barche, in Verona 1990, pp. 156, 161, n. 1.
[2] See Barche, in Verona 1990, p. 156, for the suggestion that the three Munich views by Bellotto were gifts from the Saxon court to their Bavarian hosts.
[3] Kozakiewicz 1972, vol. 2, pp. 233, no. 292, repro.
[4] Barche, in Verona 1990, p. 156.
[5] Rizzi 1996, p. 134, noted the existence of a Hanfstaengel photograph of the Auer Tor taken five years before its demolition from the same vantage point and at the same time of day as Bellotto's view and the strong affinities between the "realism" of each.
[6] Bowron, in De Grazia and Garberson 1996, pp. 19-22, repro.
[7] Rottermund 1998, pp. 9-19, figs. 3-8, 10.
[8] Nagler 1835-52, vol. 6, p. 509, no. 27. On the importance of the the view of Munich and its subsequent use in diplomas, etc., see Barche, in Verona 1990, pp. 156-61.

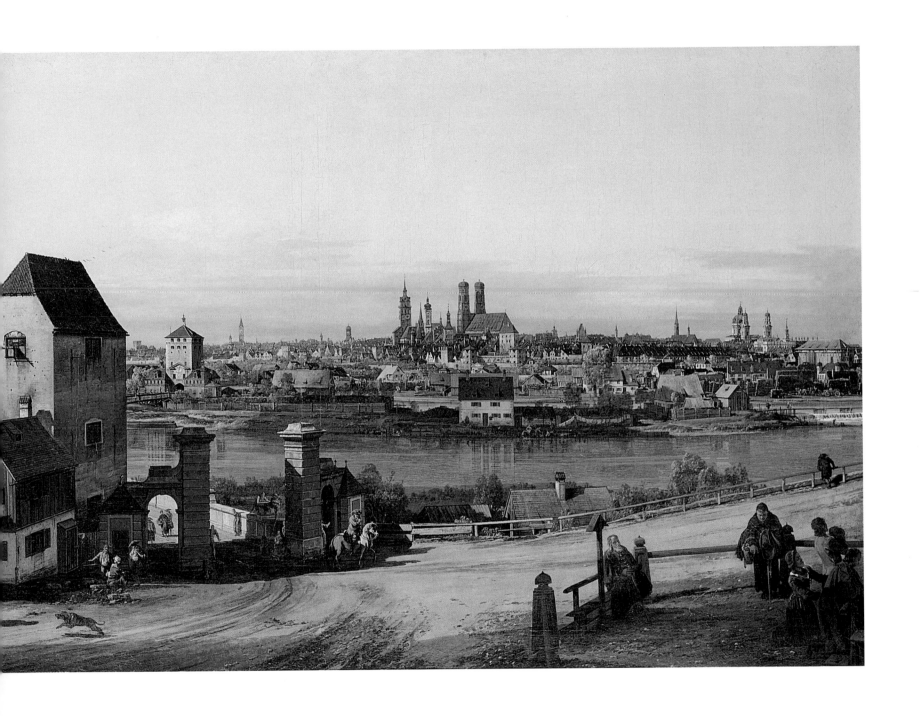

The Second Dresden Period: *Capricci* and *vedute di fantasia*

1760-65
Oil on canvas
18 7/8 × 31 5/8 inches
(48 × 80.5 cm)
Private collection

Provenance: Sale, Stuttgart, Herdle and Peters, 28-29 April 1870, lot 129; Jacob Klein, Frankfurt am Main; his sale, Frankfurt, Frankfurter Kunstverein, 31 October 1911; Stephan von Auspitz, Vienna; Van Beuningen Collection, Rotterdam.

Exhibitions: London 1932, no. 25.

Bibliography: Kozakiewicz 1972, vol. 2, p. 174, no. 218 (with previous references); Camesasca 1974, p. 103, no. 136; Rizzi 1996, p. 76, no. 55; Schmidt 2000, pp. 86-90.

Here we have a reduced version of the Dresden painting exhibited as cat. no. 58. Bellotto often made use of this format for his later replicas, and only the paintings for the Prime Minister Count Heinrich Brühl had the same dimensions of the pieces for the royal series. It would not appear, however, that Bellotto made a version of this composition for Brühl. Similarly, as no replica of the view of the Breite Gasse, Pirna (Gemäldegalerie Alte Meister, Dresden) appears to have been made for Brühl, it may be that the count did not want copies of these particular views, which depicted the poor outskirts of the city.[1]
Kozakiewicz attributed this painting to Bellotto's second period in Dresden, when he painted only views and capriccios in a small format.
Gregor J.M. Weber

[1] For the original version in Dresden (205), see Kozakiewicz 1972, vol. 2, no. 205; for an autograph reduced replica in the Chicago Art Institute, see Kozakiewicz 1972, vol. 2, no. 206.

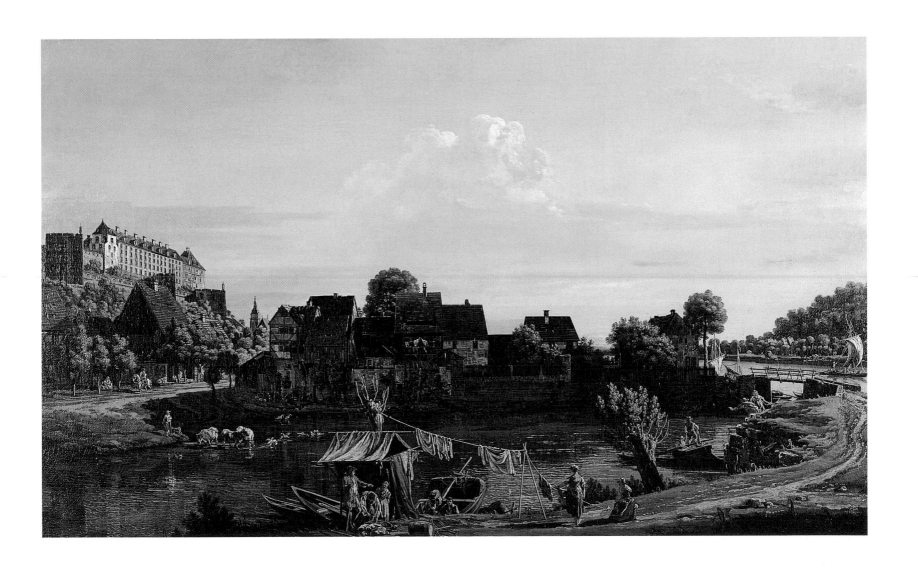

1762
Oil on canvas
42 7/8 × 60 3/4 inches
(109 × 154.5 cm)
Inscribed on the sheet held
in the dove's beak: *INCLINATA/
RESURGIT*; and on the lower
plinth: *MDCCLXII*
Gemäldegalerie Alte Meister,
Staatliche Kunstsammlungen,
Dresden (632)

Provenance: First listed in an inventory of the Dresden paintings made prior to 1841, no. 682, as "In the manner of L. Spada": "A seated female figure, dressed in white and green, her left hand resting on the coat-of-arms of the prince-elector of Saxony, addresses two elderly men in Polish costume standing next to her. Above the coat-of-arms, the date 1762;" in the Gemäldegalerie, Dresden, by 1860.

Exhibitions: Dresden 1963-64, no. 32; Cracow 1965, no. 32; Vienna 1965, no. 38; Warsaw 1997b, no. VII 18; Dresden 1997-98, no. 393.

Bibliography: Hübner 1868, no. 2323; Woermann 1887, p. 210; Stübel 1911, p. 478; Posse 1929, p. 298; Fritzsche 1936, pp. 56, 64, 70, 75, 100-102, 126, no. VG 193; Kozakiewicz 1972, vol. 1, p. 131, 142; vol. 2, p. 287-88, no. 362 (with previous references); Camesasca 1974, p. 107, no. 173; Rizzi 1994-95, p. 204; Rizzi 1996, pp. 162-63, no. 144.

For a lengthy period of time little was known of these two allegories except that they arrived in the picture gallery prior to 1860. Hübner did indicate, however, that both paintings had been taken from the reserves, which is now proved by an undated inventory of the reserve paintings, made before 1841.[1] At that time the attribution was uncertain; the vague hint at the manner of Leonello Spada (1576-1622) was without doubt due to the stylistic resemblance with another work painted by this artist in Dresden, *David with the Head of Goliath*, which also exhibits half figures with similar positions and physiognomies.[2] Both allegories appear again in an undated "Extract from the inventory of the Reserve paintings", which must have been drawn up in 1859 and contained a preliminary selection of paintings to be sold, used for decoration, or kept in the picture gallery. The names of Canaletto and Stefano Torelli (1712-84) were written with question marks, but fortunately there was also a note stating that the works were to be kept and displayed in the picture gallery in compliance with the resolution of 7 July 1860, taken by the appointed Commission. The inventory of the reserve paintings made prior to 1841 lists the two allegories together with another six paintings of the same size, all with the indication, "aus dem Haus-Marschall-Amte" (from the offices of the court marshal). These included three architectural capriccios by Bellotto (cat. no. 75), as well as three other allegories, one by Christian Wilhelm Ernst Dietrich (1712-74) and two by Charles Hutin (1715-76), both court painters during Bellotto's time in Dresden. Whilst the three capriccios went to the picture gallery on 7 July 7 1860, the Commission decided that the other three allegories were to be sold, which occurred on April 16 and May 13, 1861.

The inventory of the reserve paintings made prior to 1841 had erroneously identified the Bellotto architectural capriccios as views of Warsaw castle, which in turn led to a frequently-expressed conviction that the artist's allegories had been painted in 1762 for that castle. The reserve inventory indicates a destination in Dresden as the source, not the marshal's office (an administrative authority), but rather another building, still unknown, which belonged to the Prince-Elector. The five paintings by Bellotto that have come down to us all show the same curved format, which points to their inclusion in an architectural context; in this case, as overdoors.

The contents of Bellotto's allegories have still not been satisfactorily interpreted; only the first can be given a relatively convincing explanation: a female figure dressed in white, a pale blue cloak and a white and red plume on her helmet, holds a heraldic shield with the arms of electoral Saxony and thus could be a personification of Saxony, dressed as a bellicose Minerva. "Saxonia" points to the ground with her right hand and turns to a Polish nobleman in national costume; the head of a second Pole is visible between the two figures. On the right, a dove holds a sheet declaring "inclinata resurgit" ("that which has been beaten now rises again"); this is reinforced further by the palm branch (and not ears of corn as thought until recently!). Both devices constitute an explicit emblematic illustration: Nicolaus Taurellus exploited the same motif in 1602 to illustrate unbending virtue that cannot be beaten by unjust destiny.[3] As the oppression of the Seven Years War continued, although Poland was not involved, the inscription can only refer to Saxony, which will rise again (the palm) from the ground (gesture of the hand) and once again attain peace (dove). Given the union between Saxony and Poland under Augustus III, the message must also have involved the Poles (hence the presence of the two Polish noblemen).

The second allegory, *Ex Arduis Immortalitas*, cannot be interpreted with the same precision. A young man in armor and ermine indicates with a field-marshal's staff the inscription " Ex Arduis Immortalitas" (the way to immortality is through difficulty), which is incised on an impressive triumphal arch with rich relief decorations (trophies and victories). Behind the first figure, an old man in rich oriental costume holds aloft a single pearl; at the right, a dog has laid its paw on a ball, or globe, on which rests a crown. Kozakiewicz attempted to interpret the two figures as personifications of Austria and Russia, the former armed for war, the latter whose pearl symbolizes wealth. The globe and the crown would indicate the expansion of reigns; the dog, fidelity of trusted allies; and the triumphal arch, victory.

The figure in oriental costume without question represents the Turkish Grand Sultan, as he appears in the first illustration of the "*Recueil de cent Estampes representant differentes Nations du Levant...*", published by Ferriol in 1714, or in the 1719 German edition. Bellotto may well have had this illustration in mind, both because the book was in the royal library and also because the illustrations had been used to create at least ninety-four life-size figures that decorated the "Turkish Palace" in Dresden from 1719.[4] As in the pendant, therefore, the costume determined the personification of the country, indicating here the Ottoman Empire. The pearl in the Sultan's hand would appear to be a symbol of virtue and purity, a well-known attribute in portrait iconography.[5] The young captain in armor carries an ermine, as does the Sultan himself, and he has a white-and-red plume on his helmet. Perhaps his attribute is the crown in front of him, which indicates neither Saxony nor the kingdom of Poland, but is, in actual fact, Austria, since it is an Imperial Hapsburg crown, and this would also find heraldic correspondence in the colors of the feather. The dog, a symbol of fidelity and friendship, assures the stability of the crown on the unstable globe, which in turn is a symbol of changing destiny.[6]

By 1762, Saxony had been under Prussian occupation for six years. Its Austrian and Russian allies were fighting against Prussia, which in turn was trying to lure Turkey to its side in the war, but in vain since the Ottoman Empire had stipulated a peace treaty with Austria and Russia in 1739. The political message of the allegory may thus be that the uncertain destiny of war can be overcome with loyalty and pureness of spirit, and that finally trials and tribulations can open the door to victory (triumphal arch) and immortality (the inscription). As in the companion, we have a programmatic illustration that expresses the suffering and uncertainty of war, but envisages a happy ending.

The allegories of Hutin and Dietrich have not survived but it appears that they were also pictorial reflections on the themes of virtue and fame. The brief titles and imprecise descriptions found in the inventories hint vaguely that one Hutin painting personified the "Glory" of victory and the other undying

c. 1762
Oil on canvas
42 7/8 × 61 inches
(109 × 155 cm)
Inscribed on the cornice of the triumphal arch: *EX ARDUIS/ IMMORTALITAS*
Gemäldegalerie Alte Meister, Staatliche Kunstsammlungen, Dresden (633)

Provenance: First listed in an inventory of the Dresden paintings made prior to 1841, no. 681, as "In the manner of L. Spada": "Behind a young man in armor, whose left hand holds the scepter of command, stands a richly attired patriarch, holding a pearl above the head of a young man. Behind them rises a building with the inscription: 'ex arduis immortalitas'.

Exhibitions: Dresden 1963-64, no. 33; Warsaw 1964-65, no. 33; Vienna 1965, no. 39; Warsaw 1997b, no. VII 19; Dresden 1997-98, no. 394.

Bibliography: Hübner 1868, no. 2324; Woermann 1887, p. 210; Stübel 1911, p. 478; Posse 1929, pp. 298-99, no. 633; Fritzsche 1936, p. 56, 64, 72, 75, 100-102, 126, no. VG 194; Constable 1965, p. 64; Kozakiewicz 1972, vol. 1, p. 131, 142; vol. 2, p. 288, no. 363 (with previous references); Camesasca 1974, p. 107, no. 172; Rizzi 1994-95, p. 204; Rizzi 1996, pp. 162-63, no. 145.

"Fame", whilst the Dietrich seems to have represented Government legitimated by law.[7] Thus, Bellotto's allegories are part of a complex iconographic series, which was without doubt executed on commission and with a very precise plan in mind. Until this time Bellotto had never attempted such large figures in his paintings, so one is not surprised to learn that these works were thought to be the fruit of a collaboration with Torelli, Dietrich, or Marcello Bacciarelli (1731-1818). The technical analysis of the painting and the handling confirm, however, that the works are unequivocally and completely from the hand of Bellotto, who in fact created here large figures for the first time – actually quite stiff – with little landscape or architecture. Two additional large paintings depicting, respectively, the temple of Venus and a temple of Love, both exhibited in 1765 at Dresden Academy of Fine Art, have since completely disappeared.[8]

Gregor J.M. Weber

[1] The inventory (Lieber 1979, n. 365) is in the archives of the Gemäldegalerie Alte Meister, Dresden.
[2] Inv. no. 334; Posse 1929, p. 57; Marx and Weber 1992, p. 362.
[3] *Emblemata Physico-Ethica*, Nürnberg 1602, D 6: "Sursum deflexa recurret"; Henkel and Schöne 1967, column 196.
[4] See Dresden and Bonn 1995-96, pp. 267, 311, no. 362; Weber 2000b. None of these works has come down to us.
[5] See De Jongh 1975-76, pp. 69-97.
[6] With reference to the dog that holds the crown, cf. Guillaume de la Perrière's more complex emblem, *Le Théâtre des bons engins* […], Paris 1539, no. 92; Henkel and Schöne 1967, column 555ff.
[7] A separate study of the complete series of these paintings is being prepared by the author.
[8] Kozakiewicz 1972, vol. 2, nos. 360, 361; Rizzi 1996, nos. P 4, P 5.

1762
Oil on canvas
30 × 43 1/4 inches
(76 × 110 cm)
Inscribed at bottom right:
Canaletto. e … 1762.
Hamburger Kunsthalle,
Hamburg

Provenance: Karl Haberstock,
Berlin, 1924; purchased in 1925
by the Kunsthalle (inv. no. 645).

Bibliography: Fritzsche 1936, p.
65, 75, 100, 154, no. VG 188;
Lorentz 1955, p. 59, 71; Koza-
kiewicz 1960, pp. 145-46, 151;
Hamburg 1966, p. 39, no. 645;
Kozakiewicz 1972, vol. 1, p. 131,
138, 142; vol. 2, pp. 250, 253, no.
317; Camesasca 1974, p. 108, no.
179; Bowron 1994-95, p. 372;
Rizzi 1996, p. 155, no. 129

Following the outbreak of the
Seven Years War (1756-63),
Bellotto left Dresden in De-
cember 1758 to work in Vienna
and Munich, and he did not re-
turn to Dresden until the end
of 1761. There he found a city
sorely tried by the war and even
his own home had been de-
stroyed with everything he
owned. In the five years that
followed, Bellotto painted no
large-scale topographical views,
but rather – with few excep-
tions – fantasy landscapes and
architectural capriccios of
smaller dimensions. The excep-
tions include two realistic
views of the city destroyed by
the war, *The Ruins of the Old
Kreuzkirche* (Gemäldegalerie
Alte Meister, Dresden) and *The
Ruins of the Pirna Suburb of
Dresden* (Musée des Beaux-
Arts, Troyes); a view of Dres-
den from the New City end of
the Augustus Bridge (Staatliche
Kunsthalle, Karlsruhe); and an
Elbe valley landscape (cat. no.
86).[1] In April 1763, both King
August III and Count Brühl re-
turned from Warsaw, but they
both died in October of that

year. So the hope of important
commissions vanished and
Bellotto was offered only a post
at the Academy of Fine Art,
founded in 1764, as a teacher of
preliminary courses for the
lower classes in landscape and
architectural perspective.
The Hamburg painting is an
evident reference to Bellotto's
artistic production of this time,
for his architectural capriccios
were perfect examples for
teaching perspective. A sketch
for this painting, which defines
only the essential composition
lines, is to be found at the Na-
tional Museum, Warsaw.[2] A
partial reproduction of the
Hamburg painting, in the
Gemäldegalerie Alte Meister,
Dresden, derives from a series
of overdoors with curved
frames, made by Bellotto whilst
in the city, and includes an alle-
gory, also dated 1762.[3] This also
confers some reliability to the
dating of the Hamburg paint-
ing, carried out immediately
after the artist returned to
Dresden.
The artist's command of per-
spective allowed him to portray
in a credible and realistic man-
ner totally invented buildings
in picturesque views. Individ-
ual buildings are slotted into
others in a deliberately compli-
cated way, preventing a clear
perception of spaces, but at the
same time offering surprising
glimpses and effects of depth.
The strong realistic impression
of these works is enahnced by
the rich auxiliary figures, which
Bellotto prepared carefully us-
ing scale sketches that he then
used in the painting.[4] Amongst
these there are two Venetian
procurators and two ushers,
whose great shadows in the
foreground reinforce the sense
of depth compared to the fig-
ures on the light stairway,
which become ever smaller. On
both sides of the parapet at the
bottom of the staircase parapet

Bellotto has set the capricious
sculpture of a sphinx, straddled
by another, clownish figure,
decorated with garlands. The
statues at the upper sides of the
parapet – free of the oppressive
shade at the start of the stair-
case – are enormous Herculean
fighting figures, for instance a
figure of Hercules who raises in
the air Antheus, son of Mother
Earth.

Gregor J.M. Weber

[1] Kozakiewicz 1972, vol. 2, nos. 297,
301, 296.
[2] Inv. Rys. Pol. 2074; Kozakiewicz
1972, vol. 2, no. 319, repro.; Rizzi
1996, no. D 26.
[3] Kozakiewicz 1972, vol. 2, no. 318,
repro.
[4] The drawings of the two ushers
and of the figures on the stairway
correspond in size to the Dresden
version and not the Hamburg ver-
sion; see Rizzi 1996, nos. D27, D28.
It was not until Dresden that Bel-
lotto added, behind the man lean-
ing on the barrow, a girl in profile,
who bears a strong resemblance to
the famous "chocolate-maker" of
Liotard's pastel (Gemäldegalerie
Alte Meister, Dresden, inv. no. P
161, purchased in 1745).

The Second Dresden Period

c. 1762
Oil on canvas
40 1/2 × 57 1/2 inches
(103 × 146 cm)
Gemäldegalerie Alte Meister,
Staatliche Kunstsammlungen,
Dresden (636)

Provenance: Inventory of the reserve paintings made prior to 1841, nos. 674, 675 or 676 (from the Hausmarschallamt): "Canaletto. Views of the King of Poland and Elector of Saxony's castle in Warsaw"; in the Gemäldegalerie before 1855.

Exhibitions: Berlin 1955-56, no. 636; Dresden 1956, no. 636; Dresden 1963-64, no. 36; Warsaw and Cracow 1964-65, no. 36; Vienna 1965, no. 42; Essen 1966, no. 24; Cologne, Zurich, and Vienna 1996-97, no. 30; Bilbao 1998, no. 11.

Bibliography: Hübner 1856, no. 2171; Woermann 1887, p. 211; Stübel 1911, p. 478; Posse 1929, p. 300; Starzynski 1933, p. 107, 109; Fritzsche 1936, pp. 56, 65, 75, 100, 109, no. VG 185; Lippold 1963, p. 25, table 7; Kozakiewicz 1972, vol. 1, p. 139; vol. 2, pp. 259-60, no. 327 (with previous references); Camesasca 1974, p. 108, no. 182; Marx and Weber 1992, p. 116; Walther 1995, p. 93, no. 36; Rizzi 1996, p. 157, no. 132 (with additional references).

This capriccio has two pendants of the same shape and they come from the same source (Gemäldegalerie Alte Meister, Dresden).[1] Together with two allegories by Bellotto (cat. nos. 72, 73) and paintings by other authors, it is likely that the works, all of the same format, decorated a room, each hanging over a door.
One of the allegories is dated 1762, a date also found on the Hamburg version (cat. no. 74) of the Dresden capriccio.

About that time Bellotto created the impressive *Architectural Capriccio with a Self-Portrait in the Costume of a Venetian Nobleman* (cat. no. 85), where he included a quote from Horace's *Ars Poetica*: "Pictoribus atque poetis quidlibet audendi semper fuit aequa potestas" – "Painters and poets have always equal liberty to dare all they want". Thus Horace, an authoritative voice of antiquity, concedes to painters the same artistic license as poets, but – he concludes – they must always respect the completeness and the unity of the opus. As a painter faithful to urban views, Bellotto here takes a stance against the phenomenon of the totally free capriccio: architectural fantasy is permitted, but only in total respect of veracity and decor.
Bellotto gave this architectural fantasy a particularly complex structure: from the depth of a great gallery and then across a double archway in the center, an impressive staircase leads to a light-filled hanging garden, where the formal response to the gallery beneath is an enormous cupola of pruned trees. The dark foreground and middle areas confer quite a varied appearance to this capriccio, attributable to the chiaroscuro contrast.
The preparatory sketches for this composition and several auxiliary figures have also survived. Whilst the perspective lines are straight and drawn with extreme precision, the drawings of the figures seem to have been made by a shaky hand, with no shading, only an indication of the outlines and of the entire drawing. The knife-grinder on the left, who appears as a silhouette, was prepared in a drawing that measured 54.2 × 34 cm, and his size in the sketch corresponds exactly to the figure in the painting.[2] Preparatory drawings also exist for the mother with child and begging girl (once again resembling Liotard's "Chocolate-maker"; see cat. 74), in full light against a dark background, as well as other smaller figures and statues.

Gregor J.M. Weber

[1] Kozakiewicz 1972, vol. 2, nos. 318, 322.
[2] Rizzi 1996, p. 181-82, nos. D34, D35, D36.

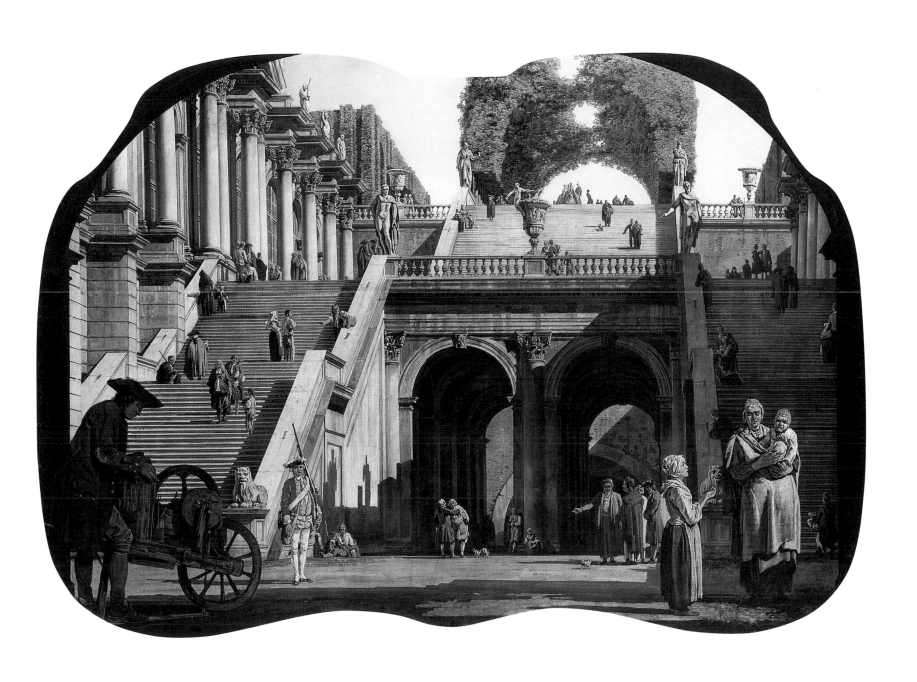

76. *Architectural Capriccio with a Portrait of Voivod Franciszek Salezy Potocki*

c. 1762-65
Oil on canvas
60 1/4 × 44 5/8 inches
(152.4 × 113.4 cm)
Signed at lower right: *Bernard. BELOTTO. DE. CANALETTO.*
El Paso Museum of Art, The Samuel H. Kress Collection

Provenance: Probably painted for Franciszek Salezy Potocki in Dresden, c. 1762-65; probably Potocki estates in the Ukraine until after c. 1918; Colonel Robert Adeane, Babraham Hall, Cambridge, England; sale, Christie's, London, 13 May 1949, lot 31 (as Bellotto); David M. Koetser, New York, from whom purchased by the Samuel H. Kress Foundation, New York, 1950 (K1691); given in 1961 by the Kress Foundation to the museum (61.1.50).

Exhibitions: Chattanooga 1952; Washington 1961-62, no. 5; Raleigh, Houston, Seattle, and San Francisco 1994-95, no. 43.

Bibliography: Suida 1951, pp. 166-67, no. 73; Kozakiewicz 1960, p. 147; Lorentz, in Warsaw 1964-65, pp. 15-16, 24; Kozakiewicz 1972, vol. 1, pp. 138-39, vol. 2, p. 263, no. 332 (with previous references); Shapley 1973, p. 166, no. K1691; Bowron 1994-95, p. 372; Shackelford, in Raleigh, Houston, Seattle, and San Francisco 1994-95, pp. 230-32; Rizzi 1996, p. 157, no. 133.

Bellotto's interest in a wide range of human types found expression in the occupations of the nobility and their families, as well as their servants and court officials, which he "caught in a measured, wordless narration".[1] The prominent juxtaposition in his paintings of the highest ranks of noble society with the lower classes led Kozakiewicz to ponder "whether this is the outcome of a deliberate objectivity on the artist's part, or whether his intention was a

kind of capriccio in social and human terms, instead of with the elements of landscape and architecture".[2] The El Paso capriccio, combining an imaginary palace courtyard in the Baroque style with relatively large, realistically portrayed genre figures in the foreground, is an evocative example of such a "social" capriccio.

The three richly dressed figures at the left have been identified as the powerful Polish nobleman, Voivod Franciszek Salezy Potocki (died 1772), his son, Stanislaw Szczesny (1752/53-1805), and a Cossack. Stanislaw Lorentz first identified the portraits, and on the basis of the boy's apparent age of approximately thirteen in 1765, he suggested that the painting was commissioned from between 1762 and 1764, during a visit to Dresden by Potocki.[3] On the basis of style and handling and comparison to two related paintings of about 1765 (cat. nos. 84, 85), Kozakiewicz extended the date slightly by about a year.

A wealthy landowner in the Ukraine, Potocki was allied with Count Heinrich Brühl (1700-63), Bellotto's patron during his first period of residence in Saxony, and stayed often in Dresden. Given the close relationships between Saxony and Poland at the time, it would not be unusual for Bellotto to introduce Poles in their national costume into a painting of the Dresden period, although this is the only known such portrait. The father, shaven and moustached, wears a red-orange mantle (*kontusz*) and a silk sash, while the son is dressed as a European, *à la francaise*, in a wig, chestnut suit, white stockings, and olive-green tailcoat. Behind them stands a Ukrainian Cossack in a high fur hat, traditionally identified as a retainer or servant.

Several writers have commented upon the striking contrast between the Potockis and the humble figures that surround them. These include a blind beggar at the extreme left, whose outstretched hand echoes the youthful Potocki's elegant gesture, and another boy and his father, a vendor of household utensils opposite. Another family appears in the middle ground, a poor father who stands beside his wife and child seated on the steps descending to the courtyard. Rizzi has explained the presence of the blind mendicant as an allusion to the dichotomy between the wealthy Poles and the often miserable state of the local citizenry in the aftermath of the Prussian bombardment of Dresden in July 1760. The humble peddler in the right foreground, depicted with the straightforward realism of Giacomo Ceruti (1698-1767), assumes a similar significance, his social and economic station further dramatized by the grandeur of the imagined architectural setting. The solemnity and enigmatic gravity of these figures has been described as disturbing, and "Equally disconcerting, indeed almost surreal, is Bellotto's repeated juxtaposition of the human visages with the carved stone masks that silently punctuate the foreground."[4]

The architectural setting provides one of the grandest contexts for any of Bellotto's ideal views, or *vedute ideate*, produced during his second stay in Dresden. The figures stand in the shade of an arcade that opens onto a courtyard terminating in a fountain with a marble Apollo and Daphne derived from Bernini's famous sculpture in the Villa Borghese. Behind, a flight of stairs lead to a palace surmounted by a balustrade and a pediment

with an ornamental relief. An arcade at the first-floor level reveals an ellipsoidal courtyard beyond, created by the wings of the palace, which appears in other compositions of approximately the same date (cat. nos. 74, 84, 85).

Restoration of the painting in 1993 revealed several aspects of Bellotto's handling and technique, the most interesting of which is his use of mixed media: the initial paint layers appear to have been executed in a different medium from those uppermost, enabling him to impart a richer texture to the surface. The underlayers were painted over a red priming layer in a smooth, thin coat of oil paint that is light and cool in tonality. The distant courtyard glimpsed through the arcade at the top of the stairs, for example, was painted exclusively in this manner. However, in many areas such as the broad palace façade stretching across the composition in the middle ground, Bellotto employed an additional layer of paint that is stiff and textured like stucco and contains an additive other than oil, such as glue or egg. The application of dark glazes to model and define the details of the architecture suggests the use of an aqueous medium. Numerous *pentimenti* have become visible with the increasing transparency of the paint layers over time and in scattered areas of pigment loss. These changes include alteration of the architecture at the extreme right edge of the canvas; a lowering of the areas of sky visible at the upper left, which originally stopped at the height of the balustrade of the palace façade in the center of the painting; and modifications to the dress of several figures. The clothing of two of the three figures under the arch at the left was changed; originally,

the man wore red breeches and the woman a low-cut bodice. The young Stanislaw Szczesny once held something in his outstretched hand, and Bellotto also made alterations in the costume of his father in the course of completing the composition.[5]

Edgar Peters Bowron

[1] Kozakiewicz 1972, vol. 1, p. 119.
[2] *Ibid.*
[3] Letter in the Kress archives, National Gallery of Art, Washington, 16 November 1955, cited by Shackelford, in Raleigh, Houston, Seattle, and San Francisco 1994-95, p. 232, nn. 2, 3. The identity of Potocki is confirmed by Domenico Cunego's engraving after Marcello Bacciarelli's portrait of the sitter, as Lorentz observed.
[4] Shackelford, in Raleigh, Houston, Seattle, and San Francisco 1994-95, p. 232.
[5] I am grateful to Dianne Modestini for sharing with me her observations on Bellotto's materials and methods made during the cleaning of the painting at the Conservation Center of the Institute of Fine Arts, New York University, in 1993.

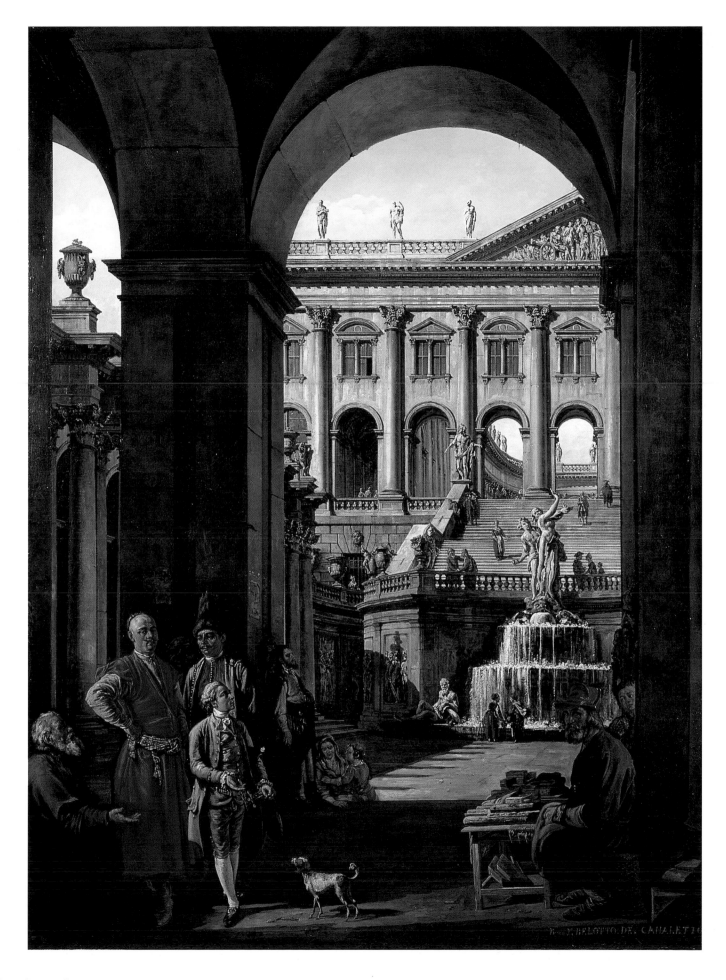

77. Architectural Capriccio with a Motif from the Senatorial Palace on the Capitol

c. 1762-66
Oil on canvas
25 5/8 × 18 3/8 inches
(65 × 46.5 cm)
Staatliches Museum, Schwerin

Provenance: Prior to 1836 in the Großherzogliche Gemäldegalerie, Schwerin; after 1945 in the Staatliches Museum (G 473).

Exhibitions: Dresden 1964-65, no. 17; Paderborn and Oldenburg 1996, no. 4.

Bibliography: Lenthe 1836, no. 87; Bode 1891, pp. 155-56, no. 53; Fritzsche 1936, pp. 100, 124, no. VG 184; Kozakiewicz 1972, vol. 1, p. 139; vol. 2, pp. 246, 249, no. 312 (with previous bibliography); Camesasca 1974, p. 109, no. 190; Rizzi 1996, p. 153, no. 125.

The two compositions were painted between 1762 and 1766, undoubtedly for private patrons, as is suggested by their relatively small formats and the fact that Bellotto had executed three examples of each composition, of which two pairs are included in this catalogue. The main pair now belong to Staatliches Museum Schwerin; the other is in the possession of the Staatlichen Schlösser und Gärten, Wörlitz (cat. nos. 79, 80). The fact that the locations where these paintings are to be found are both near to Dresden leads one to believe that they were commissioned directly from the artist.[1]

Here, on a small scale, Bellotto formulates his conception of the architectural capriccio. In the first composition, he frames the view using a round arch parallel to the picture plane, supported on the right by double columns. The interior space, thus framed, shows to the left a much-cropped façade of a building that resembles the Palazzo Senatorio on the Capitol in Rome. A gigantic external staircase leads to the main floor. The motif of arches is repeated in the background, but in the distance and far smaller. The auxiliary figures accompany the progressive changes in depth of the architecture, sometimes directing our glance with demonstrative gestures. In the companion view, Bellotto frames the composition with a single large arch that embraces the entire surface of the painting. The palace structure resembles the Stairway of the Giants in the Doge's Palace in Venice, but Bellotto does not include the decoration of the statues of Mercury and Neptune found there, and uses instead Rome's Capitoline Dioscuri. As W. G. Constable was the first to observe, in the composition of this painting

Bellotto probably employed a view of the Stairway of Giants painted by his uncle, Canaletto, but he transformed the Gothic forms with lavish Renaissance architecture and made the proportions of the stairs even more imposing.[2]

Here the painter's fantasy delineates architectonic worlds, but it is his mastery of artistic methods that endows them with realism. Bellotto's capriccios are always legible, for he avoids oppressive alienation, as occurred with Piranesi's famous Prison works. Stefan Kozakiewicz has connected this diktat of veracity and respect of decor with the new classicist ideas spreading in Dresden and propagated by the writings and teachings of Johann Joachim Winckelmann (1717-68), Anton Raphael Mengs (1728-79) and Christian Ludwig von Hagedorn (1712-80). Similarly, in 1759, Count Francesco Algarotti (1712-64) had written on the "new genre" of painting that consisted in endowing real places with lovely buildings from various localities but also with "ideal buildings". A confused depiction of space and unnatural architectural language would have been as foreign to Algarotti as they were to Bellotto. This latter's uncle, Canaletto, had divided his 1744 collection of views into just two groups: landscapes of real places and the other of imaginary places ("invented views"). So Canaletto avoided the "capriccio" concept, often considered in a negative fashion as a product of the imagination divorced from reality.[3]

It would be fantasy, however, for today's literature to declare Bellotto's paintings to be "a rigidly causal sequences of arrangements, re-arrangements and derivations" in the sense of a topic for discussion rich with content, that – in one of the

Schwerin paintings – leads to an "embryo" (the high round reliefs) and a first "couple of human beings" (at the balustrade), to the "repudiation" and so on … something that would obviously be intolerable from a purely speculative and iconographic point of view.[4]

Gregor J.M. Weber

[1] The third pair was split between two private collections; see Kozakiewicz 1972, vol. 2, nos. 309, 313; Rizzi 1996, nos. 123, 126. Preparatory drawings of the compositions are in the Hessisches Landesmuseum, Darmstadt, inv. nos. AE 2179, 2180; Kozakiewicz 1972, vol. 2, nos. 310, 314; Ricci 1996, nos. D24, D25.
[2] Constable 1962, vol. 2, p. 216.
[3] Cologne, Zurich, and Vienna 1996-97, p. 220 ff.
[4] Wandschneider 1996, pp. 31-34.

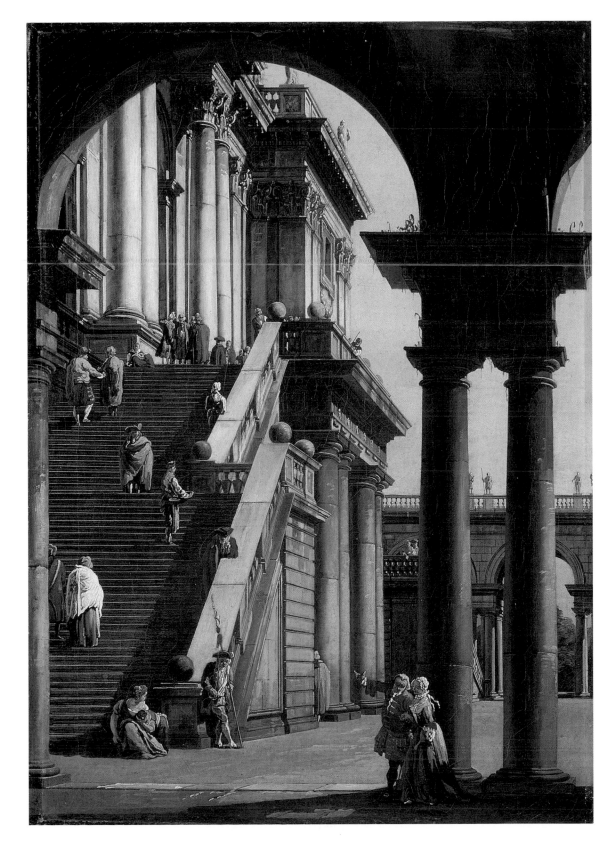

78. Architectural Capriccio with Motifs from the Palazzo Ducale and the Dioscuri from the Capitol

c. 1762-66
Oil on canvas
25 5/8 × 18 3/8 inches
(65 × 46.5 cm)
Staatliches Museum, Schwerin

Provenance: Prior to 1836 in the Großherzogliche Gemälde-galerie, Schwerin; after 1945 in the Staatliches Museum (G 472).

Exhibitions: Dresden 1964-65, no. 18; Paderborn and Oldenburg 1996, no. 3.

Bibliography: Lenthe 1836, no. 86; Bode 1891, pp. 155-56, no. 54; Fritzsche 1936, pp. 100, 124, no. VG 182; Kozakiewicz 1972, vol. 1, p. 139; vol. 2, p. 246, no. 308 (with previous references); Camesasca 1974, p. 109, no. 188; Rizzi 1996, p. 153, no. 122.

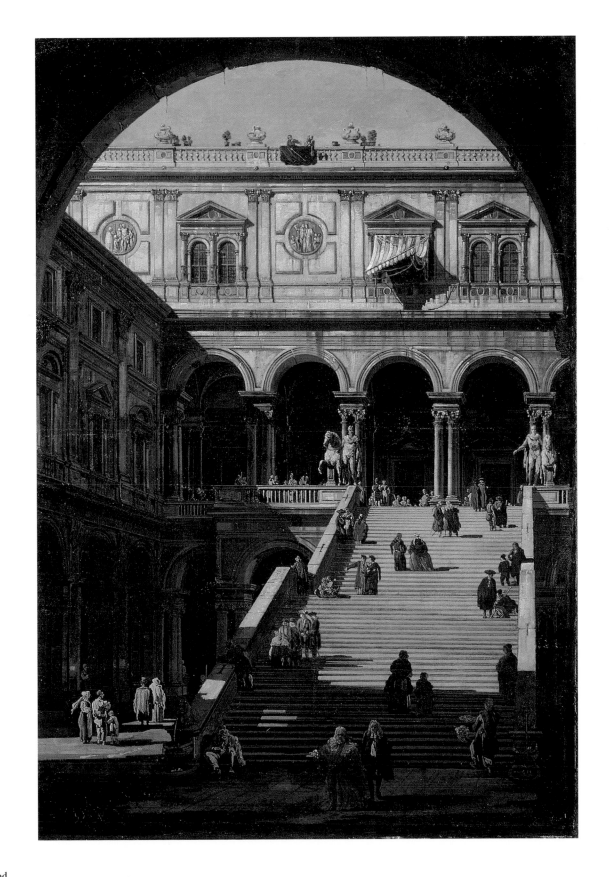

c. 1762-66
Oil on canvas
25 5/8 × 17 1/2 inches
(65 × 45 cm)
Kulturstiftung Dessau Wörlitz,
Dessau

Provenance: Possibly acquired directly from the artist for Leopold III Frederick, duke of Anhalt (1740-1817) by his artistic advisor, Friedrich Wilhelm Erdmannsdorf (1736-1800); Joachim-Ernst-Stiftung; Staatliche Schlösser und Gärten, Wörlitz (no. 1072).

Exhibitions: Dresden 1963-64, no. 37; Warsaw and Cracow 1964-65, no. 37.

Bibliography: Fritzsche 1936, pp. 75, 100, 124, no. VG 183; Lippold 1963, p. 26; Kozakiewicz 1972, vol. 1, pp. 136, 139; vol. 2, p. 246, no. 311; Camesasca 1974, p. 109, no. 191; Rizzi 1996, p. 153, no. 124.

80. Architectural Capriccio with Motifs from the Palazzo Ducale and the Dioscuri from the Capitol

c. 1762-66
Oil on canvas
25 5/8 × 17 1/2 inches
(65 × 46 cm)
Kulturstiftung Dessau Wörlitz,
Dessau

Provenance: Possibly acquired directly from the artist for Leopold III Frederick, duke of Anhalt (1740-1817) by his artistic advisor, Friedrich Wilhelm Erdmannsdorf (1736-1800); Joachim-Ernst-Stiftung; Staatliche Schlösser und Gärten, Wörlitz (no. 1075).

Exhibitions: Dresden 1963-64, no. 38; Warsaw and Cracow 1964-65, no. 38.

Bibliography: Fritzsche 1936, pp. 75, 100, 124, no. VG 181; Constable 1962, vol. 2, note on no. 81; Lippold 1963, p. 26; Kozakiewicz 1972, vol. 1, p. 136, 139; vol. 2, pp. 245-46, no. 307; Camesasca 1974, p. 109, no. 189; Rizzi 1996, pp. 152-53, no. 121.

For discussion of these and related compositions and preparatory drawings, see cat. nos. 77, 78.

1763
Oil on canvas
19 1/2 × 31 1/2 inches
(48.9 × 80.1 cm)
Inscribed with a brush on
the verso of the canvas: *Bern.*
Bellotto d. Canal/ dipinse 1763.
Wadsworth Atheneum,
Hartford, The Ella Gallup
Sumner and Mary Catlin
Sumner Collection

Provenance: Wolf Collection, Kassel; Julius Böhler, Munich, 1931; from whom bought by the museum in 1931 for $4200 from the Sumner Fund (1931.280).

Exhibitions: Munich 1931; New York 1932; Northampton 1932; Springfield 1933, no. 71; New York 1938, no. 30; New Haven 1940, no. 1; New York 1945-46, no. 22; Detroit and Indianapois 1952-53, no. 5; Hartford 1956, no. 3.

Bibliography: Constable 1963, pp. 10-11; Kozakiewicz 1972, vol. 2, p. 179, no. 223 (with previous references); Camesasca 1974, p. 103, no. 128; Cadogan, in Cadogan and Mahoney 1991, pp. 66-68; Rizzi 1996, p. 80, no. 64; Schmidt 2000, pp. 120-24.

The Atheneum painting is a smaller version of the view Bellotto made for the royal collection, now in the Gemäldegalerie Alte Meister, Dresden (cat. no. 62). About the same time, c. 1753-55, he produced a second version of the composition for Count Heinrich Brühl that is now in the Hermitage in St. Petersburg (cat. no. 61). This version, which is virtually identical in size to the royal version, shows very slight differences in the figures. Yet another version, of almost the same reduced dimensions as the Atheneum painting, is in a private collection in New York.[1]
Compared to the larger version in Dresden, Bellotto has here changed only the herd in the foreground and omitted the shepherd with his lady companion, as well as the large ox, shown in profile. He has substituted for them a shepherd on horseback seen from the rear and a cow with a calf. This latter group is copied from a composition by the Venetian pastoral landscape painter, Francesco Zuccarelli (1702-88), which Bellotto also used as a source for motifs in other paintings of the Dresden and Vienna period.[2] In the etching of the same view, Bellotto depicts the same cattle, but the shepherd on horseback is replaced by one on foot, with a stick over his shoulder.[3]

Gregor J.M. Weber

[1] Kozakiewicz 1972, vol. 2, p. 179, no. 222.
[2] See Rizzi 1996, nos. 13, 70, 108, 119; Weber 2001.
[3] Kozakiewicz 1972, vol. 2, p. 179, no. 224; Rizzi 1996, no. I 19.

82. *Architectural Capriccio with a Palace beside a Moat*

c. 1765
Oil on canvas
19 × 31 1/2 inches
(48.3 × 79 cm)
San Diego Museum of Art

Provenance: Exhibited at the Dresden Academy, 1766; Frits Lugt, Amsterdam; Van Diemen, Berlin, 1927; private collection, Germany; Vitale Bloch, Berlin, 1930; Frits Haussmann, Berlin, c. 1935; given in 1949 by the Misses Anne and Amy Putnam to the Fine Arts Gallery, San Diego (1949.68).

Exhibitions: Dresden, Academy of Fine Arts, 1766.

Bibliography: Weise 1765, p. 369; Posse 1930, pp. 166-67; Delogu 1935, p. 323-33; Fritzsche 1936, pp. 99-100, 123-24, no. VG 179; Kozakiewicz 1972, vol. 2, pp. 284, 287, no. 359; Barcham 1977, pp. 199-200; Rizzi 1996, p. 162, no. 143.

The capriccios of Bellotto's second Saxon period link him to the rising tide of taste across Europe for paintings, drawings, and prints with architectural fantasies as their subject. In Dresden itself changes in patronage, artistic theory, and cultural politics all contributed to Bellotto's renewed interest in the genre of inventive architectural capriccios. In enlightened and academic circles, straightforward topographical view-painting had always been a humble category, and the opinions of the new director-general of the arts at the Saxon court, Christian Ludwig von Hagedorn (1712-80), must have served as ominous directives to local artists to change their practices. For Hagedorn and idealizing critics and theorists of his ilk, "Works of art are enhanced only by the beauty of their invention".[1] This implied that the fantasy element in a

representation of a town or landscape was more highly prized than topographical accuracy; the combination of imaginary and/or real architecture within a picturesque setting more enthusiastically admired than descriptive exactitude; and creative license enjoyed greater esteem than mechanical aptitude.

Bellotto responded with a number of brilliantly painted architectural *capricci*, characterized by inventive combinations of Baroque and Neo-classical architecture and dazzling perspective effects. The severe, disciplined construction of the San Diego capriccio, the emphasis placed on perspective in the depiction of the buildings, and the introduction of relatively large foreground figures, comprise the characteristic features of the paintings of Bellotto's second Dresden period.[2] On the right bank of a broad moat Bellotto has conceived an ornate baroque palace, branching off in numerous wings and pavilions. In its position and in some of the architectural motifs it resembles the south side of the Dresden Zwinger, completed by Matthäus Daniel Pöppelmann (1662-1736), master architect of August the Strong's court, in 1714.

Posse was the first to note the specific inspiration for the architectural complex in the San Diego caprice – the Zwinger pavilion parallel to the Ostra-Allee, which Bellotto had previously recorded in a view for August III.[3] Although the elegant Baroque pavilions of the Zwinger and the city's ancient fortifications alongside the moat are clearly the inspiration for the present painting, Bellotto has nonetheless transformed his source almost beyond recognition. The Zwinger bridge, for example, has been altered from a single wooden walkway

to an imposing arcade incorporating a central opening that resembles the Kronentor, the latter standing in reality as the gateway to the pavilion itself. Bellotto has in fact constructed a purely imaginative architectural complex. In essence, nothing in the painting is "correct", except for the fundamental architectural unit of the Zwinger bay and the position of the palace alongside a river. Upon closer inspection, even the articulation of the walls of the main building and the long rows of arcaded windows reveal the strong influence of Venetian models, the Libreria Vecchia or the Procuratia Vecchia, for example. Bellotto clearly intended to combine fantasy and reality throughout the painting and, as Posse observed, right under the flight of stairs where the Opera was added to the Zwinger galleries during Bellotto's second Dresden period, tubs with orange trees stand on the open terrace, reminding the viewer of the original goal of the Zwinger building as an orangerie. Similarly, the construction on the left bank of the canal and the mountains in the distance (reminiscent of the Loschwitzer heights) enhance the fantasy of the scene.

Bellotto, like Canaletto before him, created an image that represents a specific site but, upon examination, engages the mind with its fanciful deviations from reality. There is a strong reminiscence in the San Diego architectural capriccio to the series of thirteen decorative "overdoors" Canaletto painted for Joseph Smith in 1742-44 depicting the "most admir'd Buildings at Venice, elegantly Historiz'd with Figures & Adjacencys to the Painter's Fancy".[4] Canaletto's capriccios for Smith such as *A Palladian Design for the Rialto Bridge*, 1742-

44 (Her Majesty the Queen), and another, painted for Francesco Algarotti, *A Palladian Design for the Rialto Bridge, with Buildings at Vicenza*, c. 1744 (Galleria Nazionale, Parma), boldly combine a variety of buildings and bridges reflected in the water below and establish a powerful precedent for Bellotto's *capricci* some twenty years later.

The group of figures in the bottom left-hand corner – the old man, the woman and pointing child – is largely identical to the group in Bellotto's *Architectural Capriccio with a Self-Portrait in the Costume of a Venetian Nobleman* at Warsaw (cat. no. 85).

Edgar Peters Bowron

[1] Hagedorn 1762, p. 154, quoted by.Kozakiewicz 1972, vol. 1, p. 137.
[2] Kozakiewicz 1972, vol. 1, p. 138.
[3] Kozakiewicz 1972, vol. 2, pp. 127-28, no. 157. For a photograph of the site, see Ermisch 1956, fig. 73.
[4] Links 1994, p. 150; for the architectural capriccios for Smith, see Levey 1991, p. 43, no. 408.

c. 1765
Oil on canvas
19.5 × 31 3/4 inches
(49.5 × 80.5)
Private collection

Provenance: R. Zahn, Plauen; sale, Hugo Helbing, Munich, 21 November 1917, lot 5, bought by A. S. Drey, Munich; Camillo Castiglione, Vienna; sale, F. Muller & Cie, Amsterdam, 17-20 November 1917, lot 29; Thomas Agnew & Sons, London, 1926; sale, Dorotheum, Vienna, 5 June 1931, lot 1; Galerie Sanct Lukas, Vienna, 1965.

Exhibitions: Vienna 1965, no. 44.

Bibliography: Haumann 1927, p. 79; Fritzsche 1936, pp. 65, 99-100, 124, 125, no. VG 180; Heintz, in Vienna 1965, p. 59; Kozakiewicz 1972, vol. 1, p. 138, vol. 2, p. 284, no. 358 (with previous references); Rizzi 1996, p. 161, no. 141.

The majority of Bellotto's paintings from his second Dresden period are *vedute ideate* and capriccios and these include several imaginary compositions with landscape settings. The artist had explored the genre in the years before his departure from Italy in such works as *Capriccio with a Triumphal Arch and a Town beside a River* (cat. no. 32) but, as Kozakiewicz has pointed out, those painted in the 1760s represent a new stage in his development. The later paintings are often characterized by the presence of architectural motifs from Dresden, Pirna, and Vienna, which are sometimes placed prominently in the foreground. In certain instances, Bellotto drew upon the compositional formats of the early imaginary Italian views; in others, he adopted elements derived from the panoramic views of Dresden. This hilly landscape is an imag-

inative mélange of architectural motifs that is constructed along a road that enters the composition from the lower left and emerges on the right over a single-span bridge above a river. In the background to the left of this diagonal is clustered a variety of ancient and modern classical buildings, some from eighteenth-century Dresden, including a section of the Zwinger. The ruins in the center of the composition almost certainly refer to the Prussian bombardment of Dresden in 1760. The arch of the bridge frames a view of a distant town, and the marble statue at one end appears to have been derived from a similar figure on the "Stone Bridge" in an earlier depiction of a view of the Karlskirche in Vienna.[1] On the right side of the road in the foreground are a number of rustic figures including a bearded old man squatting on the ground, the model for whom appears in a number of Bellotto's architectural and landscape capriccios of the period (cat. nos. 82, 85).

These prominent foreground figures are a conspicuous feature of the architectural and landscape capriccios of the second Dresden period and they often impart a melancholic character to his paintings. They are drawn from the daily life of contemporary Dresden and possess a distinct air of being portraits; they would certainly, irrespective of their humble social and economic station, have been recognizable by their contemporaries. Bellotto had often recorded the comings and goings of pastoral folk since his early views of the village of Gazzada (cat. no. 31), but with the unusual view of *The Ruined Castle of Theben* (cat. no. 67), featuring a family of gypsies before their tent, he began to include representatives of the

rural poor more conspicuously in his landscapes. The presence of the marginalized social classes is rare in eighteenth-century Italian painting, and Bellotto's figures bring to mind the work of Giacomo Ceruti (1698-1767), who sympathetically portrayed peasants, mendicants, and menial laborers. Like Ceruti's beggarmen, cripples, and wretches, the foreground figures here are presented with a rare and powerful objectivity.

This landscape capriccio is typical of Bellotto's handling and color in the second Dresden period: the impasto is pronounced and fluid, particularly in the depiction of figures and their garments; and the palette is vibrant, cool, and wider in range as a direct consequence of the greater variety of the costumes worn by the foreground figures. The painting characterizes the tension inherent in Bellotto's art in the second Dresden period; the balance, in Kozakiewicz's words, between "the fascination that the world of the imagination exercised on him, and his striving towards the faithful depiction of reality".[2]

A second version of the composition exists that includes changes in the foreground group of figures and that Kozakiewicz thought might in part have been painted by Bellotto's son Lorenzo was at Bern in 1968.[3]

Edgar Peters Bowron

[1] Günther Heinz, in Vienna 1965, p. 59; Kozakiewicz 1972, vol. 2, p. 200, no. 257, repro.
[2] Kozakiewicz 1972, vol. 1, p. 142.
[3] Kozakiewicz 1972, vol. 2, p. 284, no. 358a, repro.

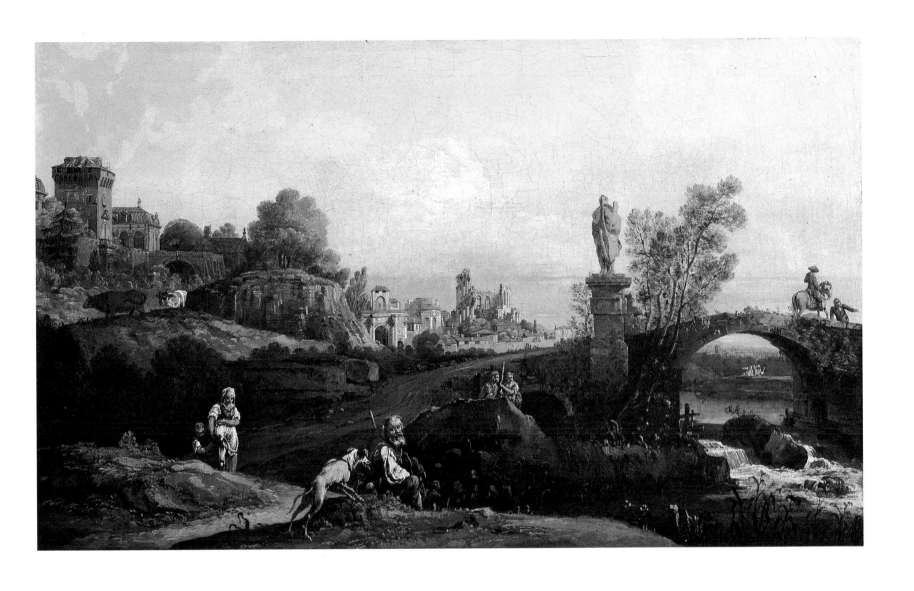

The Second Dresden Period

84. *Architectural Capriccio with Christ Driving the Money Changers from the Temple*

c. 1765-66
Signed at bottom right: *B. BELLOTTO DE. CANALETTO.*
Oil on canvas
60 1/4 × 44 7/8 inches
(153 × 114 cm)
The Royal Castle, Warsaw
(ZKW 3605)

Provenance: Probably taken from Dresden to Warsaw in 1767 and perhaps added in the same year to the collection of King Stanislaus Augustus Poniatowski (1732-98); by descent to Prince Joseph Poniatowski and still in Warsaw in 1819; A. A. Kosen, St. Petersburg, 1914; Krosnowski collection, St. Petersburg and Warsaw, after 1914; State Art Collections, Warsaw, 1920s; Royal Castle, Warsaw, 1929; National Museum, Warsaw (inv. 128669), from 1939; on loan to the Musée du Louvre, Paris, from 1961.

Exhibitions: Venice 1955, no. 29; Warsaw 1956, no. 16; London, Liverpool, and York 1957, no. 28; Rotterdam 1957, no. 28; Lublin 1960, no. 10.

Bibliography: Catalogue 1795, no 460; Ciampi 1839, p. 237, no. 35; Mankowski 1932, no. 460; Fritzsche 1936, pp. 65, 75, 100, no. VG 191; Lorentz and Kozakiewicz 1955, pp. 27, 34, 47, no. 29; Kozakiewicz 1972, vol. 1, p. 139, vol. 2, pp. 266, 275, no. 337 (with earlier references); Marini, in Verona 1990, p. 166; Rizzi 1990, p. 70; Rizzi 1996, pp. 159-160, no. 137 (with additional references).

The painting, Bellotto's only treatment of a religious subject (Matthew 21: 12-13) is a pendant to the *Architectural Capriccio with a Self-Portrait in the Costume of a Venetian Nobleman* (cat. no 85). The architectural setting complements the companion piece in its orientation with an arched doorway and

windows in the foreground opening onto an ellipsoidal courtyard, out of which a flight of steps leads up to a terrace. The lines of perspective converge steeply onto the heads of figures at the extreme lower-left and right edges of each painting, respectively, at about the height of the turbaned money changer in one and the bearded man in the other, linking the compositions spatially. The courtyard and the terrace are enclosed by arcades which appear to belong to a palatial building, and are surmounted by a classical pediment and a balustrade. The building in the background is similar to the left-hand half of an architectural fantasy painted as a *sopraporta* a few years earlier (cat. no. 75).

In the foreground, Christ, enraged at the sight of the Temple of Jerusalem turned into a market place for money changers and traders in cattle, sheep and pigeons, brandishes a makeshift whip of cords. Those around him recoil in astonishment, and the money changers at the right of the composition gather up their money and clutch their purses. Christ's outburst was the kind of dramatic act that invites a symbolic interpretation,[1] and the theme unquestionably held personal significance for Bellotto at a time in which he was struggling to survive professionally in the changed atmosphere of the Dresden court in the mid-1760s in the aftermath of the Seven Years War.[2]

The royal court, which had been Bellotto's main patron, was left without the funds previously used to support its stable of highly paid artists. Court patronage was largely replaced by the Academy of Fine Arts, established in 1764, which fostered philosophical debates on the purpose of art and the role of artists. The new Academy

and its director Christian Ludwig von Hagedorn (1712-80) greatly affected the course of Bellotto's professional status. He was refused a professorial chair at the Academy, and, following the intervention of the royal family, was made an aggregated member for perspective, the equivalent of tutor, and hardly a prominent post.[3] It was in this strained atmosphere that Bellotto painted this subject, a version of which along with its companion piece was exhibited at the Academy of Fine Arts in 1765.[4] The painting may therefore be understood both as a pictorial expression of Bellotto's frustration in a difficult new artistic climate and the message of revolt against the Dresden academic world that several scholars have read in the painting.[5]

The lofty academic style, faultless and exaggerated perspective, and inventive architectural settings of Bellotto's capriccios in these years are the result of the artistic, theoretical, and political changes at the Dresden court and can be regarded as an attempt on his part to conform to the opinion expressed by Hagedorn in 1762: "Works of art are enhanced only by the beauty of their invention. This is the means whereby an artist, in his creations, reaches out to the soul and speaks to the understanding. The mechanical aspect of art provides the imaginative aspect with a body, an exterior form to attract the eye. The heart wishes to be moved and the understanding to be flattered, but the eye wishes to be deceived."[6]

The importance to the artist of these paired compositions with their linked thematic messages is implied by the existence of three versions of the Warsaw self-portrait and two of Christ cleansing the Temple, the other of which is in a private collec-

tion in Milan.[7] This painting includes several variations among the figures from the present composition: the head of Christ is narrower and turned more to the front, and there is a basket of eggs beside the woman sitting on the steps. Both Warsaw paintings appear to share a possible provenance from the collection of Stanislas Augustus Poniatowski and therefore have been thought to have painted for the king shortly after the artist's arrival in Warsaw in January 1767.[8]

A preparatory pen-and-ink compositional drawing for the painting is at Darmstadt.[9] Two pen-and-ink drawings at Warsaw contain studies corresponding exactly in size and details to several of the figures in the painting such as Christ, the group at the lower left, and the figures in the left-middle group that include a man with a basket of pigeons on his head.[10]

Edgar Peters Bowron

[1] See Hall 1979, p. 70.
[2] For the situation at the Dresden court in these years, see Kozakiewicz 1972, vol. 1, pp. 131-34.
[3] Kozakiewicz 1972, vol. 1, p. 134.
[4] Kozakiewicz 1972, vol. 2, p. 265, citing Weise 1765, p. 369.
[5] For example, Marini, in London and Washington 1994-95, p. 430.
[6] Hagedorn 1762, p. 154, quoted by Kozakiewicz 1972, vol. 1, p. 137.
[7] Kozakiewicz 1972, vol. 2, p. 275, no. 338, repro.
[8] Marini, in London and Washington 1994-95, p. 430.
[9] Darmstadt, Hessisches Landesmuseum, AE 2246; Kozakiewicz 1972, vol. 2, p. 275, no. 339, repro.; Bleyl 1981, p. 68, no. 54.
[10] Kozakiewicz 1972, vol. 2, pp. 274-75, nos. 340, 341, repro.

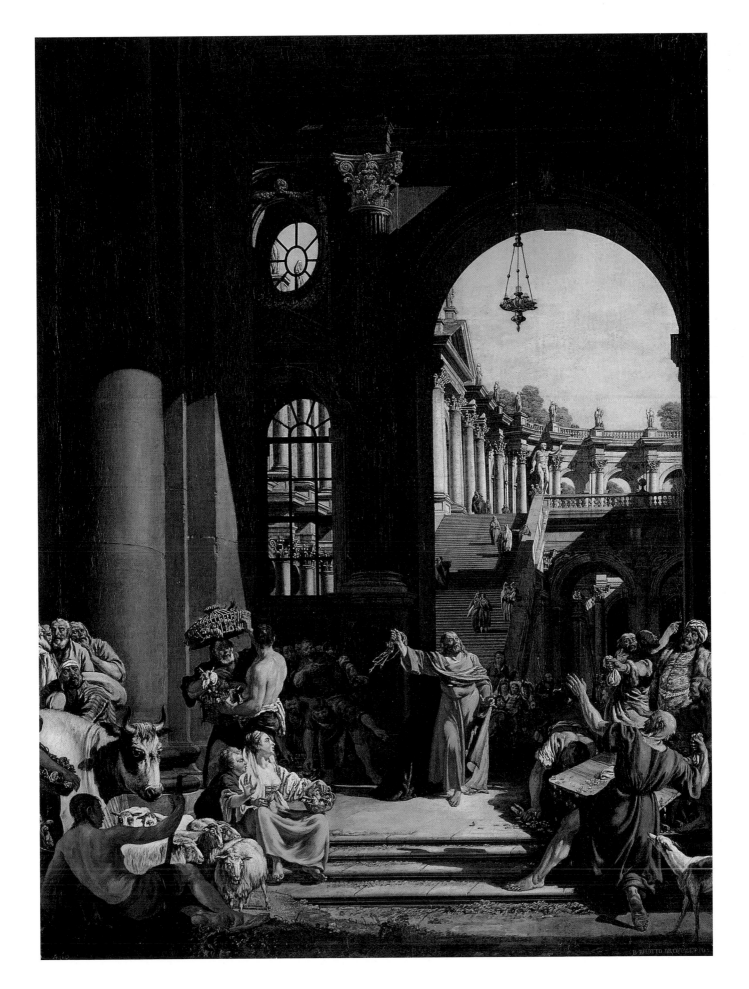

85. *Architectural Capriccio with a Self-Portrait in the Costume of a Venetian Nobleman*

c. 1765-66
Signed at bottom right: *B. BELLOTTO DE. CANALETTO.* Inscribed on theatrical posters on the pillar at right: *... / LENF ... / PROD .../ DE M. VO ... / SUIV ... /*; and: *PICTORIBUS / ATQUE POETIS/ QUIDLIBET AUDENDI/ SEMPER FUIT/ AEQUA POTESTAS/ . E ART POETICA LI...* ; the columns of the triumphal arch bear other partially legible posters: *MANDATO ... and RODOGUINE/ ... TRAGE ... / DE CORN ...*
Oil on canvas
60 1/4 × 44 7/8 inches
(153 × 114 cm)
The Royal Castle, Warsaw
(ZKW 357)

Provenance: Probably taken by the artist from Dresden to Warsaw in 1767 and perhaps added in the same year to the collection of King Stanislaus Augustus Poniatowski (1732-98); bequeathed in 1798 to Prince Joseph Poniatowski, Warsaw, and still there in 1819; A. A. Kosen, St. Petersburg, 1914; Krosnowski collection, St. Petersburg and Warsaw, after 1914; State Art Collections, Warsaw, 1920s; Royal Castle, Warsaw, 1929; on long-term loan to the National Museum, Warsaw, from 1939.

Exhibitions: Venice 1955, no. 30; Warsaw 1956, no. 15; London, Liverpool, and York 1957, no. 29; Rotterdam 1957, no. 29; Lublin 1960, no. 9; Dresden 1963-64, no. 39; Warsaw and Cracow 1964-65, no. 39; Vienna 1965, no. 43; Essen 1966, no. 25; Warsaw 1968, no. 26; Dresden 1968, no. 14; Prague 1968, no. 14; Budapest 1968, p. 11; Venice 1985, no. 15; Gorizia 1988, no. 30; Verona 1990, no. 47; London and Washington 1994-95, no. 257.

Bibliography: Catalogue 1795, no 461; Ciampi 1839, p. 237, no. 36; Mankowski 1932, no. 461; Fritzsche 1936, pp. 13-14, 65, 75, 100, no. VG 189; Lorentz and Kozakiewicz 1955, pp. 27, 34, 47, no. 30; Menz 1964, p. 86; Kozakiewicz 1972, vol. 1, pp. 138-40, vol. 2, pp. 263-64, no. 333 (with previous references); Puppi, in Gorizia 1988, pp. 221, 434-35; Marini, in Verona 1990, pp. 166; Rizzi 1990, pp. 38, 58-59, 122; Marini, in London and Washington 1994-95, pp. 429-30; Rizzi 1996, p. 158, no. 134 (with additional references).

This is the most familiar, and probably the latest in date, of three versions of an extraordinary self-aggrandizing self-portrait of Bellotto dressed in the crimson robes and golden stole of the Venetian nobility. In the foreground the artist steps forward with a gesture of proud display, as if presenting to the viewer this capriccio, a splendid example of his artistic capabilities and invention. He is attended by his faithful servant Checo (Francesco), and an elderly ecclesiastic carrying a folder, which Kozakiewicz suggested may contain sketches.[1] At the left, a young peasant boy points to Bellotto as if to encourage the viewer take note of the painter.

The fantastic architectural setting possesses the character of a grand theatrical set, and the pillar on the right and the columns of the triumphal arch bear posters advertising theatrical presentations. Bellotto's declamatory gesture both recalls paintings by official Venetian portrait painters and adds to the theatricality of the scene. This is heightened by the strong contrasts of light and shade that play across the deliberately complex architecture behind the artist and his retinue. The two-storied colonnade surrounds an interior courtyard based on elements of Jacopo Sansovino's Libreria Vecchia that is separated from the viewer by a triumphal gateway. The viewer is invited to look through the majestic arches and into a sharply receding space defined in great detail. The balustrade curving into the distance unites the whole and emphasizes the heroic scale of the palatial setting; its steeply angled lines of perspective exaggerate the depth of the courtyard, at the rear of which tiny figures move about. Bellotto's choice of subject for the pendant painting, the Cleansing of the Temple (cat. no. 84), is unusual and the thematic relationship between the two works has not been completely satisfactorily explained. The artistic credo implicit in the quotation from Horace's *Ars Poetica*, which appears in the guise of a theatrical advertisement posted on the large column at the right, holds the key to Bellotto's intention.[2] The famous motto proclaiming the liberty of the artist – *Pictoribus atque poetis quidlibet audendi semper fuit aequa libertas* ("Painters and poets have always had equal liberty to do the daring") – may have been intended as a declaration of aesthetic freedom against the new classicizing taste of Dresden artistic circles and an effort to satisfy the requirements of theoreticians and critics.[3]

It is probable that the message was intended for members of the Dresden Academy of Fine Arts, where versions of both pictures were exhibited in 1765.[4] At that date, following the death of Bellotto's patrons, Count Heinrich Brühl and Augustus III, court patronage was largely replaced by the Academy, which fostered philosophical debates on the purpose of art and the role of artists. Bellotto may have intended this imaginative and fanciful composition as a declaration of aesthetic freedom against the rising tide of academic classicism. The architectural *capricci* of Bellotto's last years in Saxony have been interpreted as an expression of compromise between his innate tendency toward realism and the decorative and idealized compositions favored by the artistic leaders at the Dresden court.[5]

It is not known which of the three self-portraits was exhibited with its companion piece, *Christ Driving the Money Changers from the Temple*, at the Dresden Academy in 1765. Kozakiewicz regarded the self-portrait formerly in the Chrysler collection as the earliest treatment of the composition, followed by a version now in a private collection in Milan.[6] The present version presumably followed shortly thereafter, although it has recently been dated to January 1767, when Bellotto left Dresden intending to travel to Russia by way of Poland, and therefore painted to impress Stanislas Augustus Poniatowski, King of Poland, to whom it was presented and at whose court in Warsaw the artist remained until his death.[7]

A preparatory pen-and-ink compositional drawing at Darmstadt corresponds to the Warsaw painting in the staffage, but is closest in other respects to the ex-Chrysler version.[8] A pen-and-ink drawing at Warsaw corresponds exactly in size and details to many of the figures in the painting such as the man seen from behind sitting on the ground to the left of the central pillar and the dog in the center foreground.[9] Some of the foreground figures appear again in other paintings of this period: the lady and nobleman seen from behind proceeding into the courtyard and the old woman seated with the pointing child appear in a view of Dresden of about 1765 (Staatliche Kunsthalle, Karlsruhe),[10] the group of the bearded old man, seated woman, and boy pointing towards the center of the scene appear almost identically in an architectural capriccio of 1765 (cat. no. 83).

Edgar Peters Bowron

[1] For the identification of Checo, the "aged domestic factotum" living in Vilnius in the early nineteenth century, who was questioned about Bellotto by Luigi Capelli, a professor at the University of Vilnius, on behalf of the scholar Sebastiano Ciampi, see Kozakiewicz 1972, vol. 2, p. 264.
[2] Kozakiewicz 1972, vol. 1, p. 140.
[3] Marini, in London and Washington 1994-95, p. 430.
[4] Kozakiewicz 1972, vol. 2, p. 265, citing Weise 1765, p. 369.
[5] Marini, in London and Washington 1994-95, p. 430.
[6] Kozakiewicz 1972, vol. 2, p. 265, no. 334a. The painting was purchased by Walter P. Chrysler, Jr., in 1976, placed on loan in that year to the Chrysler Museum, Norfolk, Virginia, and sold, Sotheby's, New York, 1 June 1989, lot 84 (now private collection, London). For the Milan version, see Kozakiewicz 1972, vol. 2, p. 265, no. 334, repro.
[7] Marini, in London and Washington 1994-94, p. 430
[8] Darmstadt, Hessisches Landesmuseum, AE 2174; Kozakiewicz 1972, vol. 2, pp. 265-66, no. 335; Bleyl 1981, p. 68, no. 53, repro.
[9] Warsaw, National Museum, Rys. Pol. 2094; Kozakiewicz 1972, vol. 2, p. 266, no. 336, repro.
[10] Kozakiewicz 1972, vol. 2, p. 266, no. 336, repro.

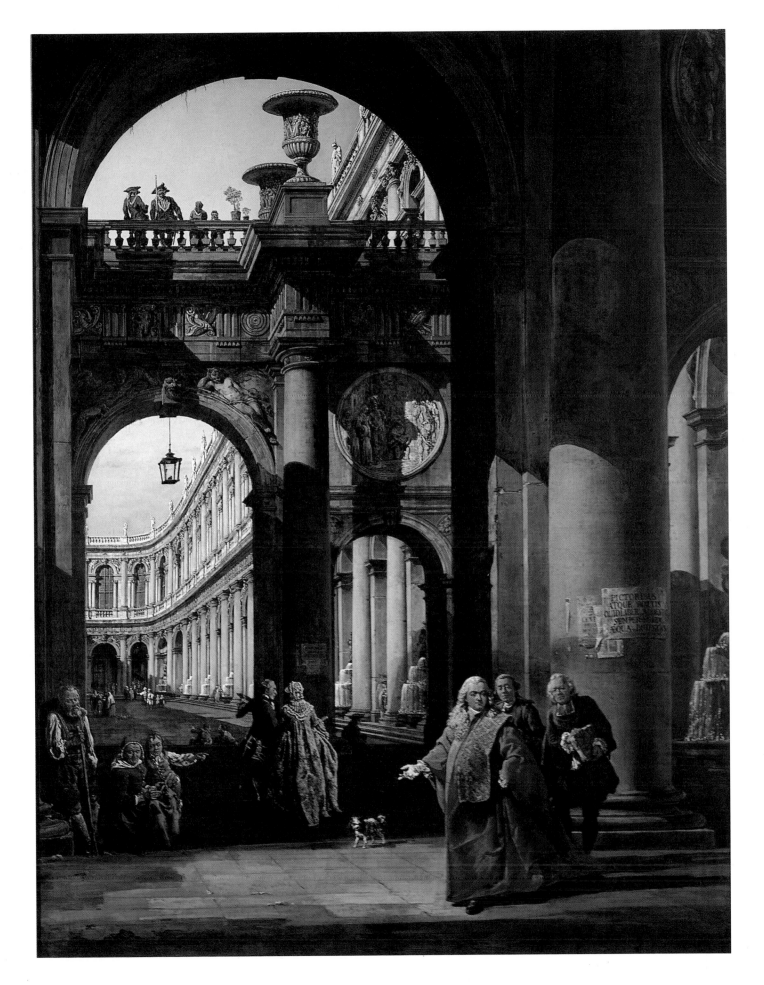

86. *View of Pillnitz and Pirna across the Valley of the Elbe*

c. 1766
Oil on canvas
41 3/4 × 53 3/4 inches
(105 × 136.5 cm)
Gemäldegalerie Alte Meister,
Staatliche Kunstsammlungen,
Dresden (638 A)

Provenance: Exhibited in the Dresden Kunstakademie in 1767; acquired for Schloss Pillnitz by exchange from Paul Cassirer, Berlin, in 1927.

Exhibitions: Dresden Academy of Fine Arts, 1767 (no catalogue); Warsaw 1997c, no. II 26; Madrid 1998, no. 8; Bilbao 1998, no. 8; Columbus 1999, no. 8.

Bibliography: Weise 1765-67, IV, part 1, p. 171; Fritzsche 1936, p. 127, no. VG 202; Kozakiewicz 1972, vol 1, p. 127, vol. 2, p. 242, no. 303; Rizzi 1994-95, pp. 197-212; Walther 1995, pp. 55-56, no. 16; Rizzi 1996, pp. 148-51, no. 119; Schmidt 2000, pp. 170-73.

This panorama takes in a broad sweep of the Elbe Valley from Pillnitz to the sandstone mountains of so-called Saxon Switzerland. At the far left we can see Schlöss Pillnitz at the foot of the Borsberg, with the architect Matthäus Daniel Pöppelmann's (1662-1736) vineyard church above it and to the right. Farther upstream come the villages of Söbrigen and Birkwitz, and above them on the far horizon stands Stolpen Castle. Back in the valley, in the center of the picture we can follow the windings of the Müglitz, which flows into the Elbe at Heidenau. Continuing to the right we discover the town of Pirna, with the Sonnenstein looming over it. On the horizon at this point appear the first of the dramatic peaks of Saxon Switzerland, among them the Königstein, its fortifications (cat. no. 65) picked out in bright sunlight. Bellotto's view of the Elbe Val-

ley is by no means realistic. He has combined various views – possibly with the aid of a map and even binoculars – into an expansive panorama with multiple perspectives. The procedure is the same as that employed by the Dresden landscape painter Johann Alexander Thiele (1685-1752) in his many views of the same valley that similarly exaggerate salient points and actually reduce greatly the distances between them.[1] Certain compositional devices and specific motifs are also reminiscent of Thiele's views – the tree cut off by the edge of the picture to the right, for example. Bellotto has nevertheless managed to interweave the various planes of the landscape more successfully and give the sunlit expanse a more atmospheric charm. At the same time, Bellotto also employed references to the landscapes of Francesco Zuccarelli (1702-88), with whom it is believed he worked in the early 1740s. From one of Zuccarelli's pastoral scenes, Bellotto quotes the central cow and calf, the tree stump and a dog running towards us in the foreground. The figures and the particular manner of painting foliage also hark back to Zuccarelli's style and handling.[2]

In 1767, a Bellotto landscape depicting "a delightful region as seen from Gamig" was exhibited at the Dresden art academy. The ancient estate of Gamig is north-west of Dohna,[3] on the eastern Erzgebirge's last hills before reaching the depression of the Elbe valley. From 1703 to 1830, the estate belonged to the Bose counts, holders of the hunting rights to the place and the fishing rights for Müglitz, as far as the confluence with the Elbe. It may well be that the description of the painting in 1767 refers to a place generally known on that

chain of mountains, but not actually referring to the painter's standpoint. Bellotto has effectively merged in a single painting – something that he was wont to do – several views, so that modern photographers are only able to capture one part of his landscape at a time.

It was long thought that the picture had been lost. However, in 1994 Alberto Rizzi was able to demonstrate that indeed this painting is that described in the contemporary records. And with this discovery, the painting that had long lain in storage or hung unnoticed at Schloss Pillnitz came to be appreciated as the most important masterpiece from Bellotto's last years in Dresden. By the time he painted it he had worked in Dresden for almost twenty years, interrupted only by his sojourns in Vienna and Munich from 1759 to 1761. In January 1767 Bellotto set out for St. Petersburg, but he broke his journey with a stopover in Warsaw. He ended up staying in Warsaw, where he became a principal painter in the court of King Stanislaus Augustus Poniatowski. This landscape, which Bellotto must have painted shortly before his departure, is closer in style to the paintings he executed in Warsaw than to those of his Dresden years, and therefore it stands on the threshold of a new creative period.

Gregor J.M. Weber

[1] See Columbus 1999, nos. 50-52.
[2] Weber 2001.
[3] For Gamig, see Columbus 1999, p. 74, n. 1.

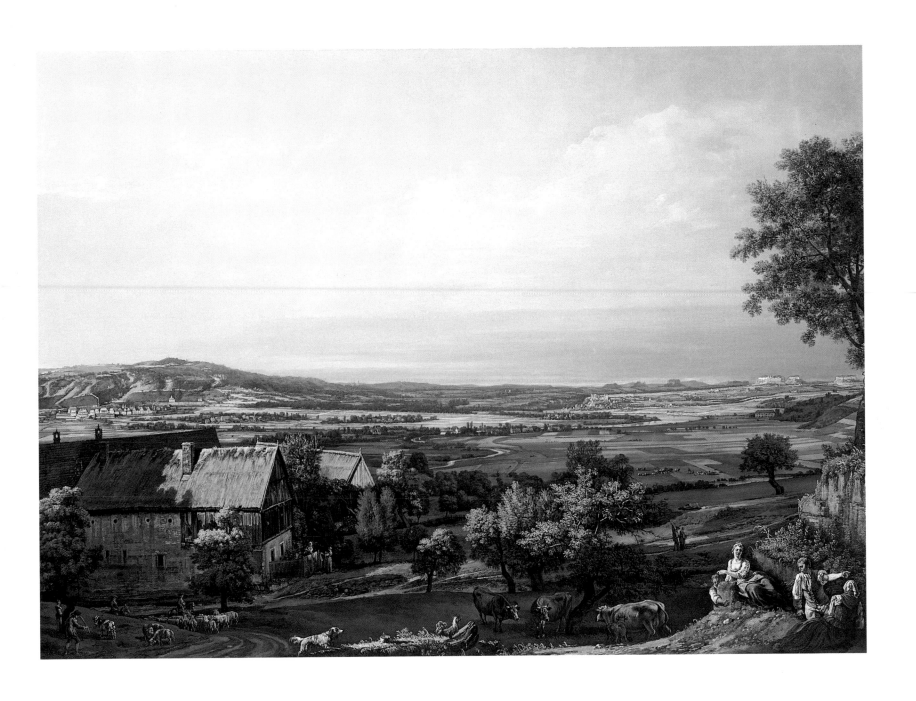

The Second Dresden Period

Warsaw

1767-68
Oil on canvas
44 1/8 × 67 inches
(112 × 170 cm)
Inscribed at the lower-right corner on a block of stone with a key to the buildings depicted in the painting: *Prospectus Warsawe,| Suburbiu Cracoviense, a Por | ta eiusde nominis delineatus | 1.Colonna cu Statua Pedestri Sigismundi III. | 2. Platea Senatorum |*
3. Teplu Monialiu S.:Francisci | 4. Basilica P.P Bernardinoru | 5. Capella Monialiu Carmeli discalceatarum | 6. Basilica P.P Carmeli discalceatorum | 7. Basilica S.Crucis | 8. Palatii principis Czartoryski palatini Russiae | 9. Palatium Comitis Małachowski | 10. Palatiu Episcoporu Cracoviensu;
and signed: *B. B. de Canaletto.*
The Royal Castle, Warsaw
(ZKW 449)

Provenance: Commissioned by King Stanislaus II Augustus Poniatowski (1732-98) for his private collection in Warsaw and probably exhibited at Ujazdów Palace between 1770-77; moved in 1777 to the Senate antechamber ("Canaletto room") in the Royal Castle, Warsaw, 1777-1807; in 1798 to the king's heir, Prince Joseph Poniatowski; in 1807 seized by order of Napoleon I and taken to Paris and hung in the Trianon and elsewhere; returned to Warsaw in about 1820 and hung in the Royal Castle; removed in 1832 by order of Nicholas I to Russia and hung in the Tauride Palace, St. Petersburg; later to Gatchina Palace, near St. Petersburg; Hermitage, St. Petersburg, 1832-1922; returned to the Royal Castle in 1922; transferred to the National Museum, Warsaw, in September 1939; confiscated by the Nazi authorities and removed to Germany, 1939-1945; reclaimed in 1945 and returned to Poland and hung in the National Muse-um, 1945-84; returned to the Royal Castle following reconstruction and exhibited in the Senate antechamber.

Exhibitions: Warsaw 1922, no. VII; Venice 1955, no. 4; London, Liverpool and York 1957, no. 4; Rotterdam 1957, no. 4; Warsaw 1958 (not in catalogue); Prague 1959, no. 4; Bordeaux 1967, no. 136; Warsaw 1962 (not in catalogue); Dresden 1963-64, no. 44; Warsaw and Cracow 1964-65, no. 44; Vienna 1965, no. 68; Essen 1966, no. 37; Chicago, Philadelphia, and Ottawa 1966-67, no. 66; Paris 1969, no. 163; London 1970, no. 207.

Bibliography: Mańkowski 1932, pp. 62, 150, 171, no. 430; Fritzsche 1936, pp. 88, 118, no. VG 136; Szaniawska 1967, pp. 285-316; Kozakiewicz 1972, vol. 1, pp. 333-34, vol. 2, pp. 333-34, no. 404 (with previous references); Rottermund 1989, pp. 113-14, 120; Rizzi 1991, pp. 32-37 (with additional references).

This is the first of the series of twenty-six views of Warsaw and the nearby palace at Wilanów, which were painted for King Stanislaus II Augustus Poniatowski (1732-98) between 1767 and 1780 and which are now, for the most part, in the Royal Castle, Warsaw. The title given to the painting in the 1795 catalogue of the king's collection is *Vüe de Varsovie prise de la porte de Cracovie* (A view of Warsaw from the Cracow Gate). The Cracow, or Krakow, Gate was part of the city's medieval fortifications and was one of the chief entrances to it. The front part, restructured at the end of the seventeenth century, was converted to the town hall from whose windows Bellotto painted his view, depicting the square in the Krakow's outskirts. In the years between the sixteenth and seventeenth centuries, when Warsaw was elected a royal residence, the outskirts of the Krakow became far more important. In fact, the ceremonial route began there and led from the Royal Castle towards Ujazdów Palace. The suburb became a kind of municipal forum, whose fulcrum is represented by the column with Sigismund III Wasa, set there in 1644.

The view looks south onto the principal subject of the painting, the street called the Krakowskie Przedmieście ("Kracow suburb"), which broadens in the foreground into a large square, known at the time as the Bernardine square. On the left is the Sigismund Column and the convent and the church of the Bernardine nuns, the oldest female monastic order in Warsaw. Their first home was built on the site between the fifteenth and sixteenth centuries. The church shown in the painting, dedicated to St. Claire, was built between 1609-17. When the nuns vacated the convent, this became the Conservatory of Music from 1819 to 1831, and it was here that Frederic Chopin studied from 1826-29. The church and the convent were demolished in 1843 and were then rebuilt thanks to the faithful illustration that Bellotto had left in the *View of Sigismund's Column from Zjazd Street* (Royal Castle, Warsaw)[1], which depicts the presbytery side of the church. The Bernardine church of St. Anne is next to this building, partly hidden by the column and in turn partly hiding the chapel of the Barefoot Carmelite nuns, seen from one side.

Most of the houses on the right-hand side of the street belong to ordinary citizens. The line of the façades is interrupted by the main entrance to the Malachowski Palace, which incorporates a street fountain in its structure. Visible at the far right of the composition is part of Senatorska street, which opens

Bernardo Bellotto, The Krakowskie Przedmieście from the Cracow Gate, Warsaw, 1771, etching

onto a view through to the Palace of the Bishops of Kracow in Miodowa street. The scaffolding poles lying in front of the group of houses in the distance at the left indicate that work is about to start on the erection of the house of Józef Seweryn Wasilewski, which appears, completed, in the engraving based on this painting, made three or four years later.[2] Dr. Wasilewski's house was started in 1767 and as the painting records a preparatory stage in the building, it can therefore be dated to that year or the following.

Bellotto's painting was commissioned by the king for Ujazdowski Castle as a complement to a painting dated 1769 and entitled *The Forum in Rome seen from the Capitol* (State Pushkin Museum of Fine Arts, Moscow).[3] The two works share a similar compositional structure, color, and a key that describes the buildings and the architectural elements depicted. However, when the present painting was exhibited in the Senate antechamber, the so-called "Canaletto room" in the Royal Castle, the artist asked for another of his works to be hung alongside, entitled *Outskirts of*

Krakow seen from Sigismund's Column (1774; Royal Castle, Warsaw).[4]

Scholars of Bellotto's work have believed that the present painting belonged to an earlier period in the artist's development since it is reminiscent of the emphasis on color and the conception of human and animal figures as decorative elements of the landscape that were employed in the paintings done in Vienna and in Dresden. Be that as it may, from his first view of Warsaw, Bellotto's great interest in the everyday life of the city emerges clearly and remains a significant feature of his final artistic period. In this busy point of the city, which the Krakow's outskirts were at that time, we can admire, for example, the variety of means of transport used by Polish moguls – in the foreground, a brougham; in the center, a berlin; and on the right, a ceremonial six-horse carriage.

Like all of Bellotto's views of Warsaw, the painting possesses enormous historical and documentary value. Several buildings in the view no longer exist and many others were radically

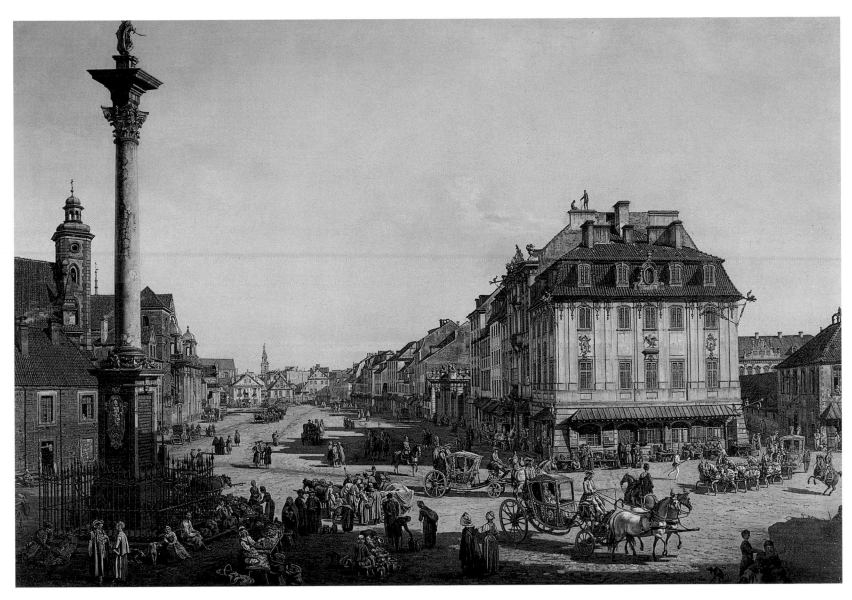

modified during the nineteenth century, when the structures between the Carmelite church and the Krakow outskirts were demolished to connect the latter with Miodowa Street. After the destruction of World War II, Bellotto's paintings were used in the rebuilding of the historic center of Warsaw. In this area of the city, for example, the Prazmowski House, the second house on the right from the square, and the nearest house, bestriding the corner, which belonged to a well-known merchant called John, were reconstructed with the aid of the painting.

Rizzi believes that Lorenzo, Bellotto's son, also worked on this painting and he sees the proof in the stereotyped human figures and the crudely drawn horse on the right of the painting.[5]

Andrzej Rottermund

[1] Kozakiewicz 1972, vol. 2, no. 407.
[2] Kozakiewicz 1972, vol. 2, no. 405.
[3] Kozakiewicz 1972, vol. 2, no. 384.
[4] Kozakiewicz 1972, vol. 2, no. 406.
[5] But see Kozakiewicz 1972, vol. 2, p. 334.

1770
Oil on canvas
67 7/8 × 102 3/4 inches
(172.5 × 261 cm)
Inscribed on the canvas that the artist is seen working on at the lower left: *Prospectus Varsaviae incipiendo de Villa/ nova usque ad Palatium Comitis Sa/ piehae cum inclusa parte Pragae trans/ flumen depictus per B.B. de Canaletto*, and above, to the right *A° 1770.*
The Royal Castle, Warsaw (ZKW 438)

Provenance: Commissioned by King Stanislaus II Augustus Poniatowski (1732-98) for his private collection in Warsaw and probably exhibited at Ujazdowski Castle between 1770-77; moved in 1777 to the Senate antechamber ("Canaletto room") in the Royal Castle, Warsaw, 1777-1807; in 1798 to the king's heir, Prince Joseph Poniatowski; in 1807 seized by order of Napoleon I and taken to Paris and hung in the Trianon and elsewhere; returned to Warsaw in about 1820 and hung in the Royal Castle; removed in 1832 by order of Nicholas I to Russia and hung in the Tauride Palace, St. Petersburg; later to Gatchina Palace, near St. Petersburg; Hermitage, St. Petersburg, 1832-1922; returned to the Royal Castle in 1922; transferred to the National Museum, Warsaw, in September 1939; confiscated by the Nazi authorities and removed to Germany, 1939-45; reclaimed in 1945 and returned to Poland and hung in the National Museum, 1945-84; returned to the Royal Castle following reconstruction and exhibited in the Senate antechamber.

Exhibitions: Warsaw 1922, no. 1; Venice 1955, no. 1; London, Liverpool and York 1957, no. 1; Rotterdam 1957, no. 1; Prague 1959, no. 5; Bordeaux 1967, no. 137; Warsaw 1962 (not in cata-

logue); Dresden 1963-64, no. 41; Warsaw and Cracow 1964-65, no. 41; Vienna 1965, no. 65; Essen 1966, no. 34; Chicago, Philadelphia, and Ottawa 1966-67, no. 65; Paris 1969, no. 162; London 1970, no. 208.

Bibliography: Mańkowski 1932, pp. 62, 150, no. 435; Fritzsche 1936, pp. 13-14, 88, 117, no. VG 129; Szaniawska 1967, pp. 285-316; Kozakiewicz 1972, vol. 2, pp. 318-22, no. 399 (with previous references); Wattenmaker, in Amsterdam and Toronto 1977, pp. 37-39; Rottermund 1989, pp. 113, 120-22; Rizzi 1991, pp. 38-45 (with additional references); Rottermund 1999, pp. 15-18.

The title of this work in the 1795 catalogue of King Stanislaus II Augustus Poniatowski's collection is *Vüe de Varsovie prise de Prague, le peintre s'y est peint avec son fils (*View of Warsaw from Prague, the artist has painted himself with his son*)*. In the foreground at left, the king is shown talking to Bellotto, who depicts himself at work on the view. The two men beside the easel are Bellotto's son, Lorenzo, and, probably, his son-in-law, the royal geographer, Herman Karl de Perthées, husband of Bellotto's eldest daughter, Giuseppina. The sovereign is depicted seated and to his right there is a figure that Rizzi calls "hajduk" (a historic term for a Polish infantryman in the seventeenth and eighteenth centuries), the aide-de-camp Henryk Butzau, killed by kidnappers during an attack on the king on 3 November 1771. The importance of the meeting between the king and the artist is emphasized by the presence of a division of royal guards on horseback, two carriages (a landaulet and landau) with six horses, several servants and two festively decorated boats. Bellotto's easel is set on the right bank of the River Vistula in the

suburb of Praga, and the small town of Golezedinów which had been the property of the king since 1767. On the extreme left is the Bernardine church dedicated to St. Andrew (which no longer exists) and the Loretto chapel. From this vantage point the artist painted the principal subject of his painting, the city of Warsaw on the further bank and the Vistula frontage of the Royal Castle, with the Sigismund Tower rising above it. To the right of the palace are visible the roofs, towers, and domes of the Old and New Towns. The buildings which lie to the left of the Royal Castle include the Krakowskie Przedmieście, or Cracow suburb (cat. no. 87), at that date the main thoroughfare of the city.
On the right-hand side of the view rise the steep escarpment of Warsaw, Sapiechów Palace, and the churches of the New Town: the Church of the Visitation of the Most Holy Virgin Mary, of St. Benno, the Sakramentki complex, the Dominican, the Pauline and the order of Pijarów churches along Długa Street. The Marshall's Tower spirals upwards, part of the fortifications (today only the lower floor survives). Further on there are the buildings of the Old City with its towers and roofs of the Jesuit church, the Collegiate of St. John and the Augustinian church. The view of the New Town was probably painted from another vantage point than that depicted in painting; shifted about ten meters from where Bellotto has set his easel in this view. The southern part of the city is also seen from a different perspective. The panorama is therefore the result of a carefully contrived scheme, intended to portray the city in its most attractive aspect yet creating an image that was as accurate as possible both from an architectural and compositional standpoint.

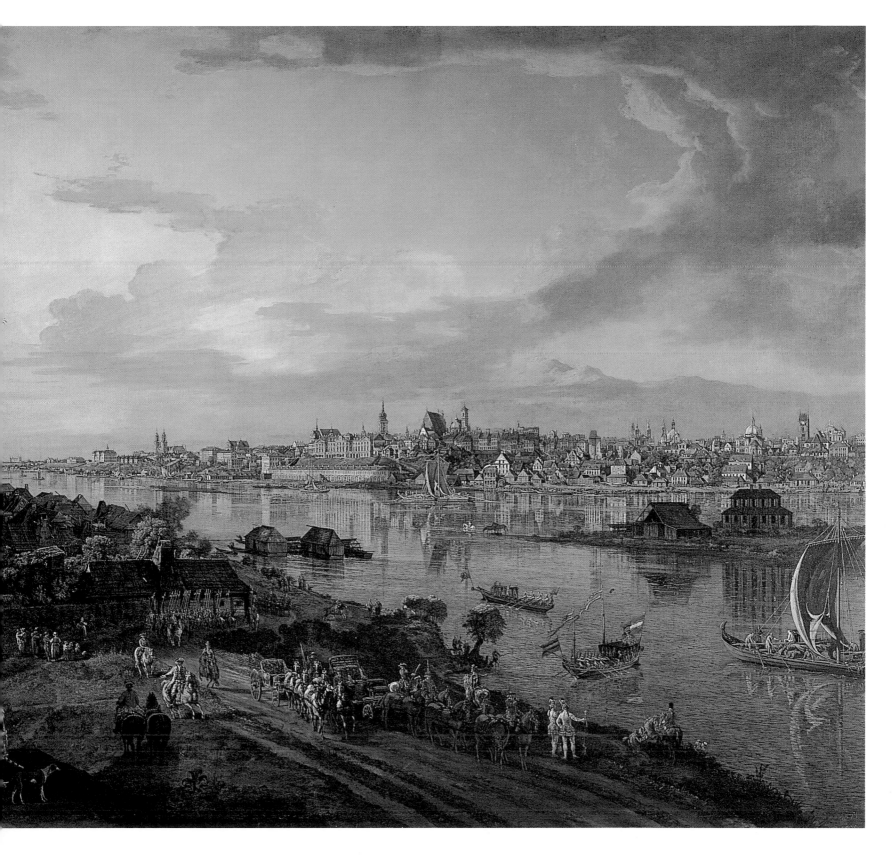

This view of Warsaw, the famous panorama of Vienna from the Upper Belvedere (1759-60; Kunsthistorisches Museum, Vienna)[1], and the view of Munich in this exhibition (cat. no. 70), demonstrate Bellotto's original approach to the genre of topographical view painting. Each of the three cities is depicted from the "outside," in the case of Munich and Warsaw from the far bank of the river, but within the city boundaries. In his approach to townscape painting, Bellotto was building on a foundation of thoroughly formulated Dutch seventeenth-century antecedents by such artists as Jan van der Heyden (1637-1712), as Richard J. Wattenmaker has observed.[2]

The fresh, yet intense, colors of the fine day are worthy of special attention. The atmosphere is emphasized by the chiaroscuro contrasts between the Praga bank in the shade and the profile of Warsaw in full light. The silence of nature is almost tangible, typical of that time of day, the peace disturbed only by a few sunlit glowering clouds. The rare artistic merit of this work makes it unique amongst those of the European landscape artists of the mid-1800s and a precursor of the era to come.

In 1772 Bellotto made an etching of this composition.[3] A smaller painted replica was part of a collection belonging to R. Przezdziecki, Warsaw, but this was lost during World War II. During restoration carried out in 1974-75, and again in 2000, it came to light that the painter had added a 5-6cm strip to the lower part of the painting.

Andrzej Rottermund

[1] Kozakiewicz 1972, vol. 1, no. 248.
[2] Wattenmaker, in Amsterdam and Toronto 1977, pp. 37-39.
[3] Kozakiewicz 1972, vol. 1, no. 400.

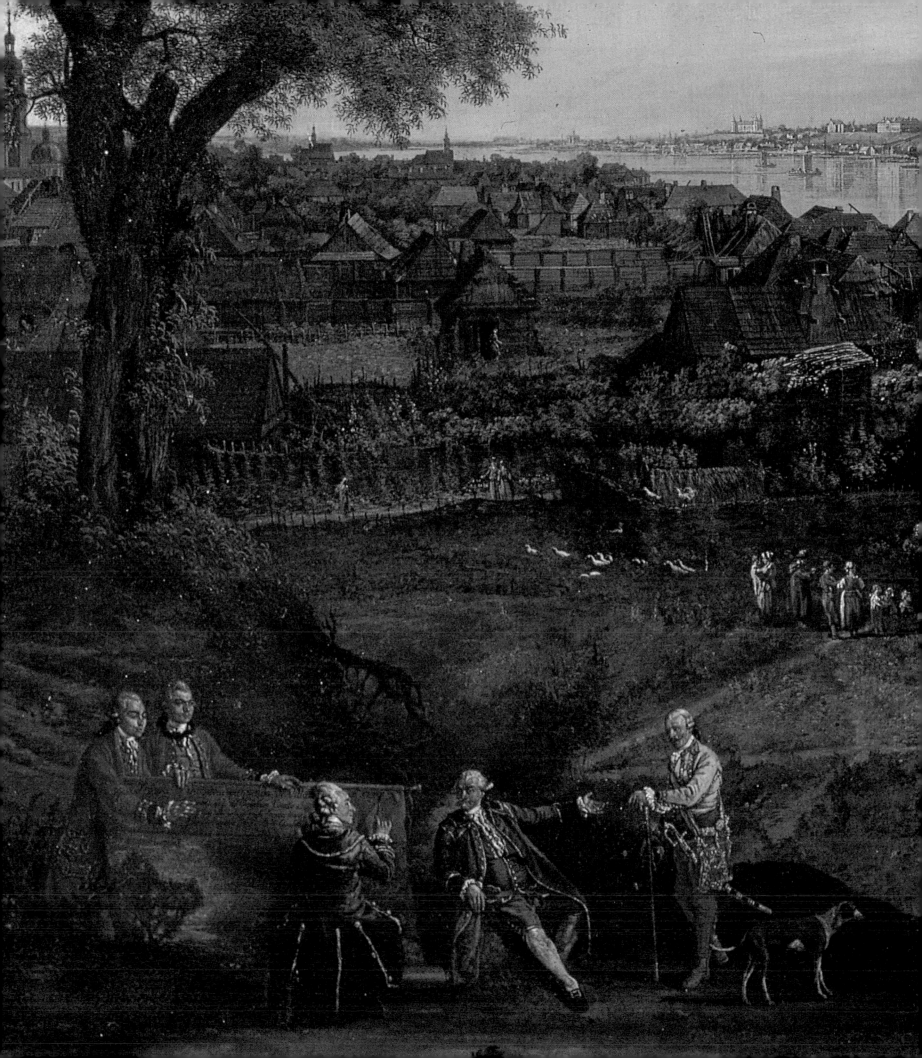

1775
Oil on canvas
68 1/8 × 96 7/8 inches
(173 × 246 cm)
The Royal Castle, Warsaw
(ZKW 452)

Provenance: Commissioned by King Stanislaus II Augustus Poniatowski (1732–98) for his private collection in Warsaw and probably exhibited at Ujazdów Palace between 1770-77; moved in 1777 to the Senate antechamber ("Canaletto room") in the Royal Castle, Warsaw, 1777–1807; in 1798 to the king's heir, Prince Joseph Poniatowski; in 1809 together with the majority of the paintings by Bellotto still in the Royal Castle sold to Frederick Augustus, King of Saxony and Grand Prince of Warsaw; remained in the palace until 1818 when transferred to the body responsible for the administration of the imperial palaces in Warsaw; removed in 1832 by order of Nicholas I to Russia and hung in the Tauride Palace, St. Petersburg; later to Gatchina Palace, near St. Petersburg; Hermitage, St. Petersburg, 1832-1922; returned to the Royal Castle in 1922; transferred to the National Museum, Warsaw, in September 1939; confiscated by the Nazi authorities and removed to Germany, 1939-45; reclaimed in 1945 and returned to Poland and hung in the National Museum, 1945-84; returned to the Royal Castle following its reconstruction and exhibited in the Senate antechamber.

Exhibitions: Warsaw 1922, no. XVII; Venice 1955, no. 44; London, Liverpool and York 1957, no. 20; Rotterdam 1957, no. 20; Prague 1959, no. 6; Warsaw 1962 (suppl. catalogue p. 60); Dresden 1963-64, no. 60; Warsaw and Cracow 1964-65, no. 60; Vienna 1965, no. 84; Essen 1966, no. 53; Chicago, Philadelphia, and Ottawa 1966-67, no. 74.

Bibliography: Mańkowski 1932, pp. 62, 171, no. 424; Fritzsche 1936, pp. 90, 95, 120, no. VG 154; Kozakiewicz 1972, vol. 1, pp. 171-73, vol. 2, p. 369, no. 423 (with previous references); Rottermund 1989, p. 120; Rizzi 1991, pp. 70-73, no. 22 (with additional references).

The title given in the 1795 catalogue of King Stanislaus Augustus' collection is *Vüe de Willanow prise de Belvedere* (A view of Warsaw from the Belvedere). The title offers a clear indication of the standpoint from which Bellotto painted the picture near the edge of the high escarpment on the southern side of Łazienkowski park. Here, during the 1730s, there was a building called the Belvedere (from 1769 to 1783 home of the royal majolica factory), from which there was a splendid view. The painting reveals an ample prospect to the south, encompassing the area that belonged to the Czartoryski family, and, on the distant horizon, the countryside of Wilanów with its church and palace. The terrain was first taken for sharecropping by King Augustus II in 1720, and used as the site of court festivities. Here, in 1732, the sovereign held the famous reception in honor of his daughter Anna Orzelska and it was also here that hunts and numerous parties were held in the large open space. Until World War I, military reasons ensured the area retained its rural aspect. (Warsaw was enclosed by fortified boundary walls.)

The chief buildings depicted in the panorama are the church of the Bernardine monks (dedicated to St. Anthony) and the houses of Czerniaków village, built to a design by the architect Tylman Gameren (1687-89), by order of the Grand Marshal of the Crown, Stanisław Herakliusz Lubomirski, one of seventeenth-century Poland's most important and influential personages. Known as the "Polish Solomon", he was a patron of the arts, a poet, a political writer, and playwright. When he died in 1702, he was buried in the church at Czerniaków. On the right-hand side of the painting is the north façade of the Immaculate Madonna church and the Baroque church of Santa Caterina in Słuzew (completely rebuilt in 1845-55).

Between the two trees on the right can be seen the villa of Duchess Izabela z Czartoryskich Lubomirska, built some years earlier (1772-74) and called "Mon Coteau" ("my hillside"). Several years later, in 1780, the villa was subjected to restructuring and in this instance Bellotto's painting has proven an invaluable record of the original aspect of the building. In the foreground the painter has depicted two figures on horseback that Alberto Rizzi has identified as the niece and nephew of the king, Maria Teresa z Poniatowskich Tyszkiewiczowa and Józef Poniatowski. Further to the right, the artist records with documentary precision a building complex, a group of elaborately dressed peasants (more likely to be aristocrats as peasants, as was fashionable at the time), and, in the center, cattle and sheep at pasture.

This beautiful painting is a fascinating, classical depiction of landscape, the fruit of Bellotto's studies of Dutch landscape painting and one of the most admired and famous paintings of the Warsaw period. Hellmuth A. Fritsche, author of the first monograph on Bellotto, underscored the artistic value of the Bellotto's deep and spacious prospects of rural scenery around Warsaw when he observed that "The clear air, the lofty skies give a dewy freshness to these landscapes, which anticipate the fundamental characteristics of the following century." Kozakiewicz emphasized further the importance of the landscapes of the Warsaw period, which "reveal Bellotto's right to be considered as a precursor of Romantic and early Realist landscape painting even more clearly than his earlier views: to the freshness with which he had long known how to treat distant scenery as it disappeared on the horizon, he now added realism, in the modern sense, in the representation of clusters of trees in the foreground and middle ground, where the maturity and mastery of the execution are reminiscent of some members of the Barbizon School."

Andrzej Rottermund

1777
Oil on canvas
33 × 42 1/4 inches
(84 × 107.5 cm)
The Royal Castle, Warsaw
(ZKW 443)

Provenance: Commissioned by King Stanislaus II Augustus Poniatowski (1732–98) for his private collection in Warsaw and probably exhibited at Ujazdów Palace between 1770-77; moved in 1777 to the Senate antechamber ("Canaletto room") in the Royal Castle, Warsaw, 1777-1807; in 1798 to the king's heir, Prince Joseph Poniatowski; in 1809 together with the majority of the paintings by Bellotto still in the Royal Castle sold to Frederick Augustus, King of Saxony and Grand Prince of Warsaw; remained in the palace until 1818 when transferred to the body responsible for the administration of the imperial palaces in Warsaw; removed in 1832 by order of Nicholas I to Russia and hung in the Tauride Palace, St. Petersburg; later to Gatchina Palace, near St. Petersburg; Hermitage, St. Petersburg, 1832-1922; returned to the Royal Castle in 1922; transferred to the National Museum, Warsaw, in September 1939; confiscated by the Nazi authorities and removed to Germany, 1939-45; reclaimed in 1945 and returned to Poland and hung in the National Museum, 1945-84; returned to the Royal Castle following its reconstruction and exhibited in the Senate antechamber.

Exhibitions: Warsaw 1922, no. IX; Venice 1955, no. 41; London, Liverpool and York 1957, no. 10; Rotterdam 1957, no. 10; Prague 1959, no. 8; Paris 1960-61, no. 230; Warsaw 1962 (suppl. catalogue p. 60); Stockholm 1962-63, no. 171; Dresden 1963-64, no. 50; Warsaw and Cracow 1964-65, no. 50; Vienna 1965, no. 74; Essen 1966, no. 43; Chicago, Philadelphia, and Ottawa 1966-67, no. 70.

Bibliography: Mańkowski 1932, p. 62, no. 439; Fritzsche 1936, pp. 88, 118, no. VG 141; Kozakiewicz 1972, vol. 2, pp. 349-50, no. 412 (with previous references); Rottermund 1989, pp. 120-22; Rizzi 1991, pp. 84-87, no. 26.

This picture was painted as a complement to the painting entitled *Długa Street*. In the Royal Gallery inventory it is listed as *Vue de la rue des Capucins, prise de la rue des Sénateurs*. This street, formerly Przeczna Street and Miodownicza Street, had been called Kapucynska Street in the eighteenth century, because of a Capuchin church and convent built there between 1683-92, whilst in the nineteenth century its original name was restored, in a slightly different form. The street had been mapped out in the fifteenth century, outside the walls of Old Warsaw and it connected two important urban nuclei, Długa Street, and Senatorska Street and the Royal Castle at the Palace of the Polish Republic. Its function made it one of Warsaw's most prestigious thoroughfares.

Bellotto copied his view from the window of the Pod Gwiazdą house, a small building along Miodowa Street, which was demolished in 1887 during work to widen the street as far as the Krakow suburb. The view opens on the left-hand side with the palaces of the bishops of Kracow, a corner building dated 1760-62. It was rebuilt several times during the nineteenth century, so that it lost its eighteenth-century appearance. After World War II, the building was reconstructed on the basis of Bellotto's painting. Alongside the Episcopal Palace is a far more sumptuous mansion built by the banker Piotr Tepper in 1774 to a design by the famous Polish architect, Efraim Szreger. This banker was one of Warsaw's most influential figures who financed even King Stanislas Augustus. In his home on Miodowa Street, Tepper had the offices of his bank and luxurious shops, whilst the third floor apartments were rented out. Scholars of architecture have defined the building as the first modern construction of civil use in which lodgings could be rented.

Beyond this building emerge the trees in the cemetery of the Capuchin church (dedicated to the Transfiguration of Christ). The church was built between 1684-96, founded by King Jan III Sobieski in gratitude for the victory obtained over the Turks in Vienna in 1683 (the king's heart is kept in a sarcophagus inside the church). Bernardo Bellotto was buried in this church in 1780, but the tomb has not survived.

The last palace visible at the end of the street is the Krasiński Palace (Palace of the Polish Republic) on Krsinski Square, where several dwellings and the carriageways of the Radziwiłłów (at that time property of the Czartoryskich family), Borchów, and Lelewelów houses can be identified. On the right-hand side of the street, in the foreground, is the mansion house of the Grand Commander-in-Chief of the Crown, Jan Klemens Branicki, and his wife Izabela, sister of King Stanislaus Augustus. Until 1771 Branicki was the Castellan of Krakow (the first lay senator of the Polish Republic), the role previously held by Stanislaus Augustus's father.

Scholars of Bellotto's works of the Warsaw period did not believe that the sculptures he painted on the top of the building really existed. Recent research has contradicted these critics, however, and confirms Bellotto's careful observation of the topographical details of the site. The doubts previously expressed by the scholars sprang from an analysis of iconographic material dating back to the period of the destruction of these buildings during the Kościuszko insurrection of 1794. Next to the Branickich Palace is the Szaniawskich Palace; further on is the Palace of Bishop Andrzej Stanisław Kostka Młodziejowski and in the background can be seen a glimpse of the Piarist convent (Collegium Nobilium) roof. The painting is considered one of the most technically successful views of Warsaw thanks to the color solutions and, above all, the realism of the scenes portrayed. The painting manifests an image of vital humanity and for the first time the details of daily life in the city rival in importance the architecture of the scene. The street's social function is highlighted by the presence of numerous vehicles, especially the elegant carriage with its six horses set in the foreground. Clearly visible inside is a magnate wearing the blue ribbon of the Order of the White Eagle on his chest. Nor is there a lack of attention to the other social classes: nobles, priests, monks, soldiers, merchants and even beggars. Among the most interesting and realistic vignettes are those of the two Jews chatting on the street and the seller of etchings on the corner of Senatorska Street. Bellotto makes especially sophisticated use of the perspective of rooflines and entrances to the buildings, in order to underline their importance, as in the case of the recently constructed Tepper mansion, and of the neoclassic and at that time, avant-garde, Palace of the Polish Republic, now the seat of the Treasury Commission Department.

Andrzej Rottermund

260

1778
Oil on canvas
45 5/8 × 64 5/8 inches
(116 × 164 cm)
The Royal Castle, Warsaw
(ZKW 454)

Provenance: Commissioned by King Stanislaus II Augustus Poniatowski (1732-98) for his private collection in Warsaw and probably exhibited at Ujazdów Palace between 1770-77; moved in 1777 to the Senate antechamber ("Canaletto room") in the Royal Castle, Warsaw, 1777-1807; in 1798 to the king's heir, Prince Joseph Poniatowski; in 1809 together with the majority of the paintings by Bellotto still in the Royal Castle sold to Frederick Augustus, King of Saxony and Grand Prince of Warsaw; remained in the palace until 1818 when transferred to the body responsible for the administration of the imperial palaces in Warsaw; removed in 1832 by order of Nicholas I to Russia and hung in the Tauride Palace, St. Petersburg; later to Gatchina Palace, near St. Petersburg; Hermitage, St. Petersburg, 1832-1922; returned to the Royal Castle in 1922; transferred to the National Museum, Warsaw, in September 1939; confiscated by the Nazi authorities and removed to Germany, 1939-45; reclaimed in 1945 and returned to Poland and hung in the National Museum, 1945-84; returned to the Royal Castle following its reconstruction and exhibited in the Senate antechamber.

Exhibitions: Warsaw 1922, no. X; Venice 1955, no. 11; London, Liverpool and York 1957, no. 11; Rotterdam 1957, no. 11; Warsaw 1962 (suppl. catalogue p. 527); Warsaw 1963 (not in catalogue); Dresden 1963-64, no. 51; Warsaw and Cracow 1964-65, no. 51; Vienna 1965,

no. 75; Essen 1966, no. 44; Chicago, Philadelphia, and Ottawa 1966-67, no. 71.

Bibliography: Mańkowski 1932, pp. 62, 171, no. 425; Fritzsche 1936, pp. 118, 121, nos . VG 133 and 159 (same painting given in error twice); Zanimirska 1971, pp. 415-418; Mossakowski 1972, p. 52; Kozakiewicz 1972, vol. 1, pp. 163, 168-69; vol. 2, pp. 350, 353, no. 413 (with previous references); Rottermund 1989, pp. 120-21; Rizzi 1991, pp. 90-93, no. 29.

In the 1795 catalogue of King Stanislaus Augustus's collection the painting is entitled *Vüe du Palais de la Commission*, thus emphasizing the state function of the building that dominates Krasiński Square. The palace belonged to the Krasiński family but after its purchase by the State Treasury in 1765 it became the seat of many important institutions of the Polish Republic, including the Commission for National Education, founded in 1773. The palace (which now houses the National Library) is the supreme secular achievement of the Dutch architect and painter active in Poland, Tylman van Gameren (1632-1706), built in 1689-95 for the voivode Jan Dobrogost Krasiński. The building was one of Warsaw's loveliest and most sumptuous and it stood out for its architecture and rich ornamentation, the work of the German sculptor, Andreas Schlüter (1659-1714). The sculptural decoration presented the triumphs of the legendary ancestors of the Krasiński family. The pediment relief visible from the square, for example, depicts a duel between Waleriusz and the Gallic commander, the statue of Marek Waleriusz Korwin above, and monuments to Pallas and Mars at the sides.
Jan Dobrogost Krasiński led a

spendthrift existence and organized chivalric tournaments in the courtyard of the palace that were famous throughout Warsaw. He was a passionate art collector who gathered in his home precious paintings including works by Rembrandt, Dürer, Correggio, and Rubens. Although his architectural projects were ambitious, he was usually unable to complete them. The palace looks upon an extensive square that did not achieve its final appearance until the 1770s, which explains the heaps of building materials and the traces of previous construction depicted in the left half of the composition. Of the original design for the square only a small dwelling (demolished in 1959) survived, in front of the palace, and it was from here that Bellotto established the vantage-point of the view.
The square is occupied by a religious procession passing from the church of the Piarist order and Długa Street in the background at the left. At its center is a revered statue (ill.) of the *Virgin of Mercy* (today in the Jesuit church in Swietojańska Street, Warsaw). The Virgin of Mercy was the patroness of Warsaw and traditionally invoked as protection from danger and calamities. Bellotto's scene assumes special importance if we reflect on the location of the painting in the Chamber of Audience (or Throne Room), a place with strong ideological significance. In Warsaw, the Virgin of Mercy was the object of fervent worship: on the second Sunday in May processions were held in her honor, setting off from the Piarist church to reach the Pauline church in Freta Street. (The baldachin with the statue is still carried today during the feast of Corpus Domini.)
Bellotto presents the religious

ceremony as an important event in the life of the city, evident from the great number of participants, members of religious congregations and high-ranking attendees in attendance with an extraordinary variety of carriages including berlins, broughams, and landaus, as well as ordinary onlookers and passersby.
The Palace of the Republic of Poland, Warsaw holds great documentary value since it captures an area of the city infrequently recorded in contemporary painting. In addition to the Piarist church in the background at left, Bellotto has carefully shown the adjacent building belonging to the priest Humański, the Piarist boarding-school known as the Collegium Nobilium, and the Capuchin church, He also shows the houses of Miodowa Street: the Kostancja z Jauchów Lelewelowa mansion, the Radziwill Palace (owned by the Lithuanian Grand Chancellor Fryderyk Michał Czartoryski at the time the painting was executed) with small roofs covering side alcoves, and, finally, the palace of the Lithuanian cupbearer, Joachim Potocki, with its typical curb-roof. Above the roof rise the towers of the Holy Cross church on the horizon, to the left looms the prominent roof of the Brühl mansion and, closer, the Załuski Library. Visible past the corner of the Krasiński Palace, in Długa Street, is the rear of the Karol Radziwill house.

Andrzej Rottermund

Early eighteenth century, Virgin of Mercy *(Jesuit Church, Warsaw)*

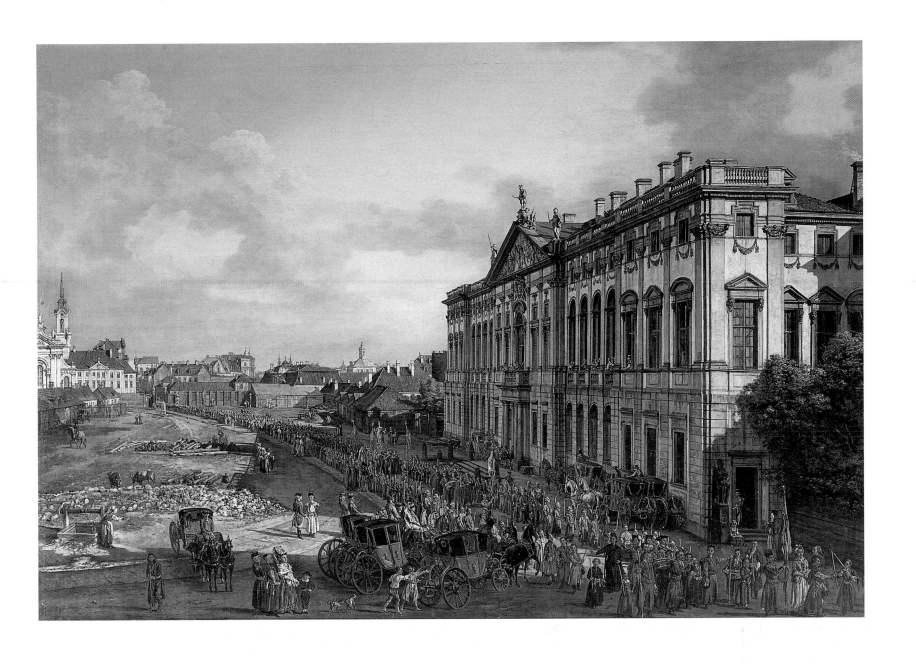

1778
Oil on canvas
33 1/8 × 41 3/4 inches
(84 × 106 cm)
The Royal Castle, Warsaw
(ZKW 445)

Provenance: Commissioned by King Stanislaus II Augustus Poniatowski (1732-98) for his private collection in Warsaw and probably exhibited at Ujazdów Palace between 1770-77; moved in 1777 to the Senate antechamber ("Canaletto room") in the Royal Castle, Warsaw, 1777-1807; in 1798 to the king's heir, Prince Joseph Poniatowski; in 1809 together with the majority of the paintings by Bellotto still in the Royal Castle sold to Frederick Augustus, King of Saxony and Grand Prince of Warsaw; remained in the palace until 1818 when transferred to the body responsible for the administration of the imperial palaces in Warsaw; removed in 1832 by order of Nicholas I to Russia and hung in the Tauride Palace, St. Petersburg; later to Gatchina Palace, near St. Petersburg; Hermitage, St. Petersburg, 1832-1922; returned to the Royal Castle in 1922; transferred to the National Museum, Warsaw, in September 1939; confiscated by the Nazi authorities and removed to Germany, 1939-45; reclaimed in 1945 and returned to Poland and hung in the National Museum, 1945-84; returned to the Royal Castle following its reconstruction and exhibited in the Senate antechamber.

Exhibitions: Warsaw 1922, no. VIII; Venice 1955, no. 18; London, Liverpool and York 1957, no. 18; Rotterdam 1957, no. 18; Bordeaux 1961, no. 143; Warsaw 1962 (suppl. catalogue p. 527); Dresden 1963-64, no. 58; Warsaw and Cracow 1964-65, no. 58; Vienna 1965, no. 82; Es-sen 1966, no. 51; Chicago, Philadelphia, and Ottawa 1966-67, no. 73.

Bibliography: Mańkowski 1932, pp. 62, 171, no. 438; Fritzsche 1936, p. 118, no. VG 140; Zanimirska 1971, pp. 415-18; Mossakowski 1972, p. 52; Kozakiewicz 1972, vol. 1, pp. 162, 168-69; vol. 2, pp. 363-64, no. 421 (with previous references); Rottermund 1989, p. 120; Kwiatkowski 1989, p. 144; Rizzi 1991, pp. 96-97, no. 31 (with additional references); Mączyński 1998, pp. 20-33.

In the 1795 catalogue of King Stanislaus Augustus's collection the painting is entitled *Vüe de l'eglise du St. Sacrement à la Ville neuve*. The picture was painted as a complement to another painting executed in the same year and entitled "The Holy Cross Church". Both views hung in a prominent position on the southern wall of the Senate antechamber, completely paneled in wood. The inventories of the Royal Castle of 1797 and 1808, suggest that the view of the church of the Holy Sacrament hung on the left and that of the Church of the Holy Cross on the right. Their positions, however, do not correspond to the rules of perspective governing the compositions of each of the paintings.
Among the most picturesque of Bellotto's Warsaw paintings, this view was taken from the second floor of a building on the southern side of the New Town square. The New Town that developed in the fourteenth and fifteenth centuries was one of eighteenth- century Warsaw's most ancient urban nuclei. Initially, the New Town buildings were constructed mostly of wood and the area's image changed only in the eighteenth century when majestic palaces and churches were built. Among the most prominent of these was the ecclesiastical complex of the Benedictine Order of the Incessant Adoration of the Most Holy Sacrament, otherwise known as the church of the Nuns of the Blessed Sacrament, which dominates the scene.
In 1687 King Jan III Sobieski's wife, Queen Maria Kazimiera, invited the religious order to Poland in compliance with the vow she had made in 1683 during her husband's campaign "so that the Almighty would bless her husband and concede him the grace of returning amongst those who fought the Muslims". The arrival of the Sacramentine sisters in the new convent was the most important religious event of the city during the seventeenth century. The queen entrusted the design of the complex to the Dutch architect and painter active in Poland, Tylman van Gameren (1632-1706). The construction encompassed several existing buildings, including the Kotowski Palace (1682-84) and the church of St. Casmir (1688-93). This group of churches and convents entirely fills the right-hand half of the painting. The decision to depict building projects so closely linked to the figure of King Jan III reflects the importance of this sovereign in King Stanislaus Augustus's literary and artistic program.
The church-convent complex that occupies the right side of the painting includes the convent behind the church, the former Kotowski Palace, never restored after the damage caused during the Second World War, and the Church of St. Casmir. In the distance at the right is visible the bell of the church of St. Benno, belonging to the German Confraternity. The church was built in 1646-49 to the designs of the court architect, Giovanni Battista Gisleni (1600-72). The bell tower, however, was added in about 1730. In the painting may also be seen, to the left of the Church of the Holy Sacrament, the older church of the Visitation of the Most Holy Virgin Mary, which was founded between 1409-11, with its early sixteenth-century Gothic tower partly hidden. On the left of the composition are the houses on the north side of the square, with part of the town hall (demolished in 1818) on the extreme left with porticoes on three sides to cover the market stalls. In the distance, on the left, we can see the most ornate building of that time, which belonged to the bourgeois Winniser family, as well as several Baroque-style houses. In the square itself the market is in full swing.
Bellotto's views of the Church of the Holy Sacrament and of Miodowa Street (cat. no. 90) are considered among the finest of the Warsaw period from a purely pictorial point of view and recall his views of Freyung in Vienna (cat. no. 68). The ability with which he describes the architecture of the site is no less striking than his talent for depicting the people and the animals which inhabit the square, and the sophistication with which he handles the play of light and shade across the scene is breathtaking. In the market scene, with its minute description of different types of livestock, farming implements, and goods for sale, we discern analogies with the works of the early Warsaw period. The obligatory presence of human and animal figures in the landscape paintings is here interpreted anew in a scene full of movement, variety, and subtlety.
During the Second World War, the New Town was almost entirely destroyed. Bellotto's painting was used as one of the principal topographical sources for the reconstruction of the church and convent between 1949 and 1955.

Andrzej Rottermund

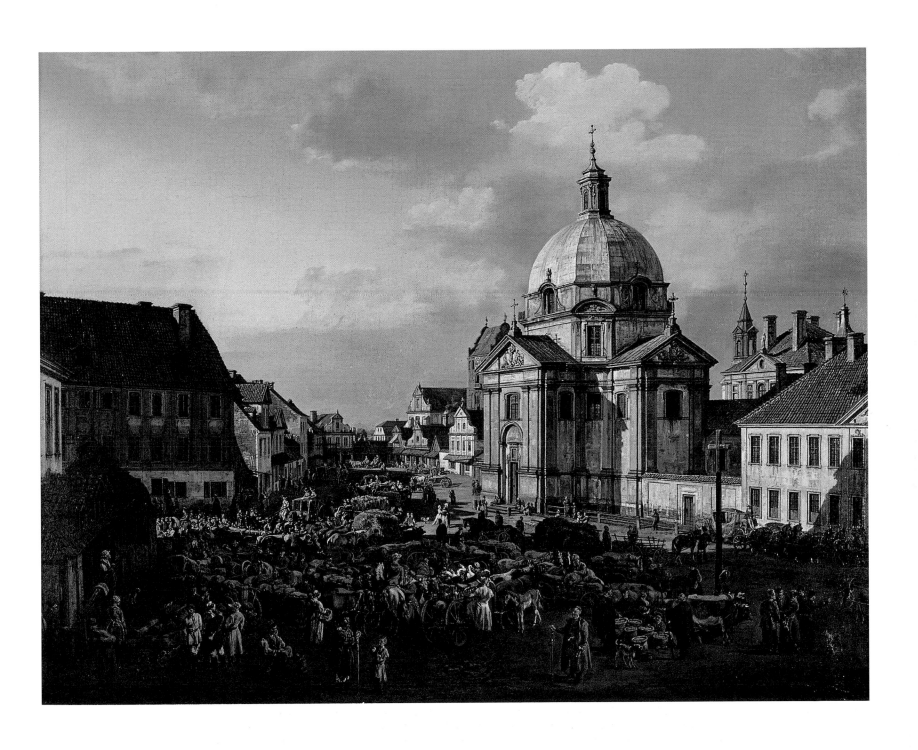

93. The Lubomirski Palace and Iron Gate Square, Warsaw

1779
Oil on canvas
45 5/8 × 64 5/8 inches
(116 × 164 cm)
The Royal Castle, Warsaw
(ZKW 455)

Provenance: Commissioned by King Stanislaus II Augustus Poniatowski (1732-98) for his private collection in Warsaw and probably exhibited at Ujazdów Palace between 1770-77; moved in 1777 to the Senate antechamber ("Canaletto room") in the Royal Castle, Warsaw, 1777-1807; in 1798 to the king's heir, Prince Joseph Poniatowski; in 1809 together with the majority of the paintings by Bellotto still in the Royal Castle sold to Frederick Augustus, King of Saxony and Grand Prince of Warsaw; remained in the palace until 1818 when transferred to the body responsible for the administration of the imperial palaces in Warsaw; removed in 1832 by order of Nicholas I to Russia and hung in the Tauride Palace, St. Petersburg; later to Gatchina Palace, near St. Petersburg; Hermitage, St. Petersburg, 1832-1922; returned to the Royal Castle in 1922; transferred to the National Museum, Warsaw, in September 1939; confiscated by the Nazi authorities and removed to Germany, 1939-45; reclaimed in 1945 and returned to Poland and hung in the National Museum, 1945-84; returned to the Royal Castle following its reconstruction and exhibited in the Senate antechamber.

Exhibitions: Warsaw 1922, no. XVI; Venice 1955, no. 13; London, Liverpool and York 1957, no. 13; Rotterdam 1957, no. 13; Warsaw 1962 (suppl. catalogue p. 527); Dresden 1963-64, no. 53; Warsaw and Cracow 1964-65, no. 53; Vienna 1965, no. 77; Essen 1966, no. 46; Paris 1969, no. 167.

Bibliography: Mańkowski 1932, pp. 62, 171, no. 1184; Fritzsche 1936, p. 118, no. VG 134; Sokołowska 1972, pp. 40-49; Kozakiewicz 1972, vol. 1, pp. 162-63, 168, vol. 2, pp. 353-54, no. 415 (with previous references); Rottermund 1989, pp. 120–21; Rizzi 1991, pp. 108-9, no. 36 (with additional references).

The title given in the 1795 catalogue of King Stanislaus Augustus's collection is *Vue du Palais Lubomirski derrière la grille de fer* (another copy of the catalogue adds *du jardin de Saxé*.) Rizzi believes the painting to be the companion to the view of the Palace of the Republic (cat. no. 91), but he does not give details regarding the location of the pair. The subject of the painting is closely related to the symbolic and ideological function of the "Warsaw Room", in which the king introduced bystanders to the homes of the Castellans of Krakow, successors to the office previously held by his father. In 1779, this role was conferred on Anton Lubomirski, owner of the building shown in the painting. Scholars of Bellotto have often wondered why, among the paintings of the Warsaw "series" there was not one entirely dedicated to the residence of the Wettinów dynasty kings, direct predecessors of Stanislaus Augustus on the throne of Poland, or of the palace of the Minister Count Heinrich Bruhl, which was of quite an original style. The obvious explanation is that it was the king and not the painter who chose the subjects of the paintings exhibited in the Senate Chamber, and the aforementioned buildings, together with many other interesting Warsaw constructions, were not held to be useful for the king's political and diplomatic purposes.

The painting offers a vista of the west side of the city, the location of the small, private urban nucleus of Wielopole. These kinds of areas were typical of Warsaw town planning and were called "jurydyki" and considered extraneous to the city's jurisdiction and administration. Wielopole was founded in 1693 by Ludwika Marianna de la Grange d'Arquien, widow of Jan Wielopolski, the Grand Chancellor of the Crown. The quarter hosted several mansions belonging to magnates and in 1730-33 several pavilions of the barracks. Wielopole was the home mainly for small artisans and merchants, and it did not have a good reputation because of the nearby barracks. Bellotto's view encompasses an ample prospect of this part of the city and is taken from the Mirów barracks (Crown Horse Guards Barracks) on the west side of the square, probably from the last row of buildings along the south side of the barracks. The largest building on the square, on the left, is the Lubomirski Palace, which was built in two phases. In the first, in about 1730, the central corpus was established, with the addition of a Baroque wing on the west side (in the foreground in this painting). Another, similar and symmetrical extension should have been added on the other side, but it was never completed. In 1791-93 the palace was totally refashioned in a Neo-classical style and turned by 80° compared to the axis of the city's old layout (the Saxon axis, or layout). It was completely rebuilt after the last war.

On the further side of the palace are modest houses and market stalls, which cluster round the so-called "Iron Gate" leading into the Saxon Gardens, and, rising above it, the Grand Salon. In the back-ground are various buildings in the western quarter of what was then the city center, including, from left to right, the turrets of the Reformate church (behind a house, immediately to the right of the Lubomirski Palace), the Brühl Palace (in the center of the painting, with corner pavilions and manasard roofs), the Saxon Palace (the west side of which can just be seen through the arches of the Grand Salon), and, on the extreme right, the towers of the Holy Cross church and the dome of the Protestant (Hapsburg Evangelical) church, which at that time was unfinished.

The observer of this painting will once again be struck by Bellotto's exceptional realism and his attention to such details of daily life as the washer-women and their laundry and the amusing confrontation of the dog and goat in the center of the square. This view of Lubomirski Palace and Iron Gate Square is the latest in date of the works in the exhibition and summarizes many of the features of the painter's Warsaw paintings including his seemingly nonchalant (but exceedingly subtle) use of linear perspective, brilliant employment of color, and, above all, his description of increasingly complex and detailed vignettes from the world around him.

Today the area of Warsaw depicted in the painting is much changed. In 1899-1902, buildings called Hale Mirowskie were constructed here. After World War II the western section of the Saxon Gardens was given over to modern housing complexes. These interventions radically modified the values of the city layout that was known as "the Saxon axis".

Bellotto had executed a painting that is listed in the royal catalogues with the title *Vue de la grille de fer, prise des casernes des Gardes à cheval* (View of the Iron Gate from the Horse Guards Barracks). Sadly, the painting is lost without a trace and it is therefore difficult to establish from which vantage point the view of Iron Gate Square was taken. The work is not mentioned in the list of paintings supplied by Bellotto to the royal collection from 1771 onwards, so it must have been completed before that date.[1]

Andrzej Rottermund

[1] Koazkiewicz 1972, vol. 2 no. 416.

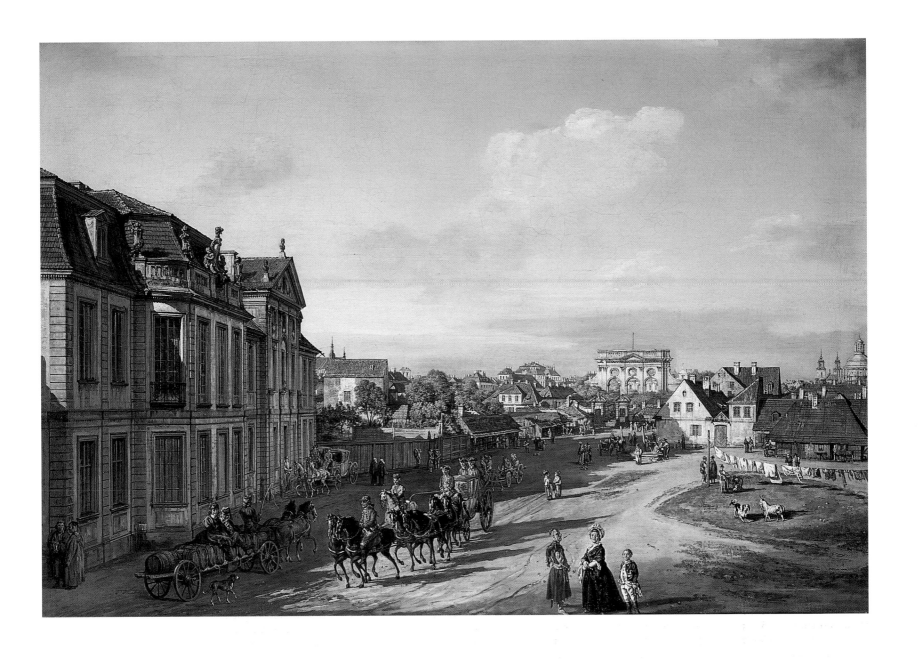

Family Tree

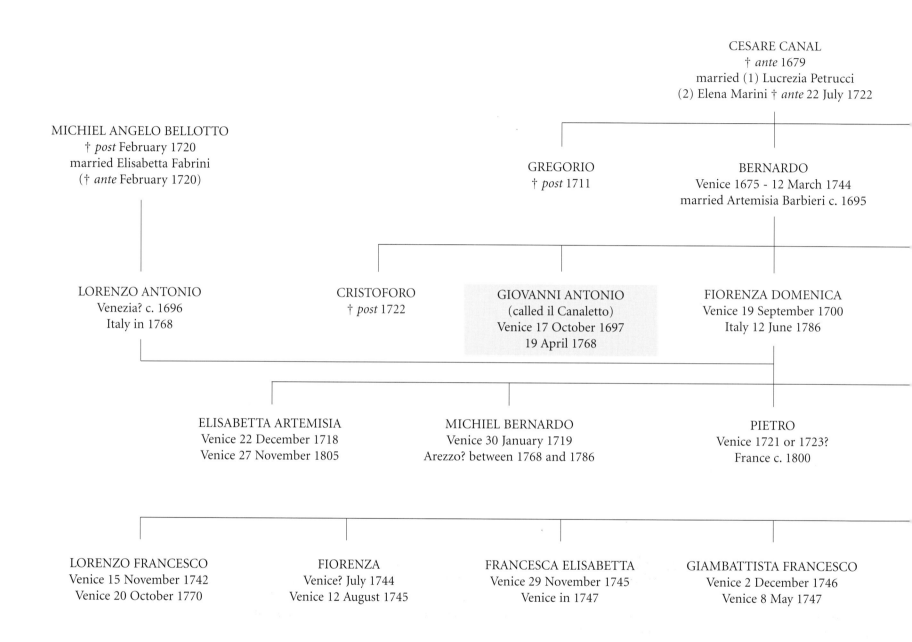

CESARE CANAL
† *ante* 1679
married (1) Lucrezia Petrucci
(2) Elena Marini † *ante* 22 July 1722

MICHIEL ANGELO BELLOTTO
† *post* February 1720
married Elisabetta Fabrini
(† *ante* February 1720)

GREGORIO
† *post* 1711

BERNARDO
Venice 1675 - 12 March 1744
married Artemisia Barbieri c. 1695

LORENZO ANTONIO
Venezia? c. 1696
Italy in 1768

CRISTOFORO
† *post* 1722

GIOVANNI ANTONIO
(called il Canaletto)
Venice 17 October 1697
19 April 1768

FIORENZA DOMENICA
Venice 19 September 1700
Italy 12 June 1786

ELISABETTA ARTEMISIA
Venice 22 December 1718
Venice 27 November 1805

MICHIEL BERNARDO
Venice 30 January 1719
Arezzo? between 1768 and 1786

PIETRO
Venice 1721 or 1723?
France c. 1800

LORENZO FRANCESCO
Venice 15 November 1742
Venice 20 October 1770

FIORENZA
Venice? July 1744
Venice 12 August 1745

FRANCESCA ELISABETTA
Venice 29 November 1745
Venice in 1747

GIAMBATTISTA FRANCESCO
Venice 2 December 1746
Venice 8 May 1747

CRISTOFORO
† *post* 1722

FRANCESCA MARINA
Venice 16 July 1703
Venice *post* 1786

VIENA FRANCESCA
Venice 6 June 1707
Venice 11 April 1778

GIOVANNI BATTISTA PIZZORNO
quondam Zorzi
† Venice *post* 1753

MARIA ELISABETTA
Venice c. 1724
† Warsaw 1785

BERNARDO
(called il Canaletto)
Venice 20 May 1722
Warsaw 17 November 1780

ARTEMISIA COSTANTINA
Venice 20 January 1724
Venice 29 January 1724

MARIA ANNA
HENRICA ISABELLA
Baptized Dresden
24 September 1748
Dresden 4 March 1750

MARIA JOSEPHA
FRIEDRICA
Baptized Dresden
4 August 1750
Warsaw 18 July 1789

ANTONIA FRIEDRICA
Baptized Dresden
26 July 1751
Dresden 27 November 1752

CHRISTIANA XAVERIA
Baptized Dresden
26 August 1752
Vilna? *post* 1805

THERESIA FRANCISCA
Baptized Dresden
2 November 1757
Vilna 1818

Bibliography

Amsterdam 1953
Amsterdam, Rijksmuseum, *Venetiaanse Meesters tekeningen, Prenten en Becken Ontstaan van 1480-1880,* ed. I.Q. van Regteren Altena, 1953.

Amsterdam 1990-91
Amsterdam, Rijksmuseum, *Painters of Venice: The Story of the Venetian 'Veduta',* ed. Bernard Aikema and Boudewijn Bakker, 1990-91.

Amsterdam and Toronto 1977
Amsterdam, Amsterdams Historisch Museum, and Toronto, Art Gallery of Ontario, *The Dutch Cityscape in the 17th Century and its Sources,* 1977.

Ashby and Constable 1925
Thomas Ashby and W. G. Constable, "Canaletto and Bellotto in Rome," *Burlington Magazine,* XLVI, 1925, pp. 207-14.

Atlanta, Seattle, and Minneapolis 1995
Atlanta, High Museum of Art; Seattle Art Museum; and Minneapolis Institute of Arts, *Treasures of Venice,* exhibition catalogue ed. by George Keyes, Istvan Barkóczi, and Jane Satkowski, 1995.

Baden 1994
Baden, Stiftung Langmatt Sidney and Jenny Brown, *Mythos Venedig: Venezianische Veduten des 18. Jahrhunderts,* ed. Gertrude Borghero, 1994.

Baker and Henry 1995
Christopher Baker and Tom Henry, *The National Gallery complete illustrated catalogue,* London, 1995.

Baltimore 1941
Baltimore, Johns Hopkins University, *Divertissements,* ed. G. De Bates, 1941.

Baltimore 1959
Baltimore Museum of Art, *Age of Elegance: The Rococo and its Effect,* ed. Adelyn D. Breeskin, George Boas, and James D. Breckenridge, 1959.

Barcham 1977
William L. Barcham, *The Imaginary View Scenes of Antonio Canal,* New York and London, 1977.

Barcham 1991
William L. Barcham, "Two views by Bernardo Bellotto: *View of Dresden with the Frauenkirche at Left* and *View of Dresden with the Hofkirche at Right,*" *North Carolina Museum of Art Bulletin,* XV, 1991, pp. 13-28.

Bassi 1979
Elena Bassi, "Notizie di artisti veneti nei carteggi del re Stanislao Poniatowski," *Archivio Veneto,* pp. 175-89.

Bath 1987
Bath, Victoria Art Gallery, *A Venetian Perspective,* London, 1987.

Bean 1975
Jacob Bean, *European Drawings recently acquired, 1972-1975* (Metropolitan Museum of Art), New York, 1975.

Beauties of England and Wales 1814
Beauties of England and Wales: or, Original Delineations, Topographical, Historical, and Descriptive, of Each County, London, 1814, vol. 15, pp. 50-57.

Belgrade 1990
Belgrade, Musée National, *La pittura veneziana del '700. Cultura e società nella Venezia del Settecento,* ed. Giovanna Nepi Scirè, Milan, 1990.

Bentini 1991
Jadranka Bentini, *La Fondazione Severi a Carpi, I: I dipinti,* Modena 1991.

Bergamo 1966
Bergamo, Galleria Lorenzelli, *Michele Marieschi 1710-1743,* ed. Antonio Morassi, Bergamo, 1966.

Bernoulli 1780
J. Bernoulli, *Reisen durch Brandenburg, Rommen, Preussen, Kurland, Russland, Poland,* 4 vols, Leipzig, 1780.

Bettagno 1983
Alessandro Bettagno, "In margine a una mostra," *Notizie da Palazzo Albani,* XII, nos. 1-2, 1983, pp. 222-28.

Bettagno 1986
Alessandro Bettagno, "Introduzione," in Venice 1986, pp. 17-30.

Bettagno 1990
Alessandro Bettagno, "Il Bellotto 'italiano,'" in Verona 1990, pp. 13-19.

Bettagno 1998
Alessandro Bettagno, "Bernardo Bellotto vedutista veneto-europeo," in Bilbao 1998, pp. 11-23.

Bilbao 1998
Bilbao, Museo de Bellas Artes, *Bernardo Bellotto en Dresde. En la Galería de Pinturas de Dresde,* ed. Harald Marx and Juan J. Luna, 1998.

Binion 1990a
Alice Binion, *La galleria scomparsa del maresciallo von der Schulenburg: Una mecenante nella Venezia del Settecento,* Milan, 1990.

Binion 1990b
Alice Binion, "I Bellotto di Schulenburg," in Verona 1990, pp. 27-29.

Birmingham 1831
Birmingham, Society of Arts, 1831.

Birmingham 1833
Birmingham, Society of Arts, *Catalogue of Pictures, Chiefly by the Old Masters of the Italian, Flemish, and Spanish Schools,* 1833.

Birmingham 1842
Birmingham, Society of Arts, 1842.

Bleyl 1981
Matthias Bleyl, *Bernardo Bellotto genannt Canaletto. Zeichnungen aus dem Hessischen Landesmuseum Darmstadt,* Darmstadt, 1981.

Bloomington 1939
Bloomington, *Central Illinois Art Exposition,* 1939.

Bodart 1975
Didier Bodart, *Dessins de la Collection Thomas Ashby à Bibliotheque Vaticane,* Vatican, 1975.

Bode 1891
Wilhelm von Bode, *Die Großherzögliche Gemälde-Galerie zu Schwerin,* Vienna, 1891.

Boggs 1964
Jean S. Boggs, "Canaletto in Canada," *Connoisseur,* CLVI, 1964, p. 150.

Bologna 2000
Bologna, Pinacoteca Nazionale, *I Bibiena: una famiglia europea,* ed. Deanna Lenzi and Jadranka Bentini, Venice, 2000.

Bomford and Finaldi 1998
David Bomford and Gabriele Finaldi, *Venice through Canaletto's Eyes,* London, 1998.

Bona Castellotti 1991
Marco Bona Castellotti, *I collezionisti a Milano nel 1700. Giovanni Battista Visconti, Gian Matteo Pertusati, Giuseppe Pozzobonelli,* Florence, 1991.

Bordeaux 1956
Bordeaux, Musée des Beaux-Arts, *De Tiepolo à Goya,* ed. Gilberto Martin-Méry, 1956.

Bordeaux 1961
Bordeaux, Musée des Beaux-Arts, *Trésors d'art polonais: chefs d'oeuvre des musées de Pologne,* 1961.

Borenius 1929
Tancred Borenius, "London (sales)," *Pantheon,* IV, 1929, pp. 481, 531.

Borenius 1931
Tancred Borenius, "Venetian Eighteenth-Century Painters in England," *Studio,* 1931, pp. 49-61.

Borroni Salvadori 1974
Fabia Borroni Salvadori, "Le esposizioni d'arte a Firenze dal 1674 al 1767," *Mitteilungen des Kunsthistorischen Institutes in Florenz,* XIX, no. 1, 1974, pp. 1-166.

Bortolon 1973
G. Bortolon, "Asterischi d1archivio per il Settecento veneziano," *Notizie da Palazzo Albani,* 1973, II, pp. 49-52.

Bossaglia 1984
Rossana Bossaglia, "*Veneziani in Lombardia, Lombardi a Venezia nel XVIII secolo,*" in *Venezia Milano. Storia civiltà e cultura nel rapporto tra due capitali,* Milan, 1984, pp. 129-76.

Boston 1958
Boston, Museum of Fine Arts, *Scenic Painters and Draughtsmen of 18th Century Venice,* 1958.

Boucher 1991
Isabel Boucher, "Getty Spends $22 million (with barter) in one week," *The Art Newspaper,* II, November 1991, pp. 1-2.

Bowron 1993
Edgar Peters Bowron, *Bernardo Bellotto: The Fortress of Königstein,* Washington, 1993.

Bowron 1994
Edgar Peters Bowron, "A Venetian Abroad: Bellotto and 'The Most Beautiful Views of Rome,'" *Apollo,* CXL, 1994, pp. 26-32.

Bowron 1994-95
Edgar Peters Bowron, "Bernardo Bellotto," in London and Washington, 1994-95, pp. 360-375.

Bowron 1995
Edgar Peters Bowron, "Un nuevo descubrimento: un *capriccio* arquitectònico de Bernardo Bellotto," *Anuario Museo de Bellas Artes de Bilbao,* 1995, pp. 13-19.

Briganti 1966
Giuliano Briganti, *Gaspar Van Wittel e l'origine della veduta settecentesca,* Rome, 1966.

Briganti 1968
Giuliano Briganti, *L1Europa dei Vedutisti,* Milan, 1968.

Briganti 1970
Giuliano Briganti, *The View Painters of Europe,* London, 1970.

Briganti 1986
Giuliano Briganti, "I Bellotto di Dresda," *Arte Veneta,* XL, 1986, pp. 304-8.

Briganti 1996
Giuliano Briganti, *Gaspar van Wittel,* 2nd ed. by Laura Laureati and Ludovica Trezzani, Milan, 1996.

Bromberg 1974
Ruth Bromberg, *Canaletto's Etchings,* London and New York, 1974.

Bromberg 1993
Ruth Bromberg, *Canaletto's Etchings,* 2nd ed., San Francisco, 1993.

Brussels 1953-54
Brussels, Palais des Beaux Arts, *La peinture vénitienne,* 1953-54.

Bucharest 1963
Bucharest, National Museum, *Espozitia de pictura a Galeriiror de Arta din Dresda secolele XV-XVIII,* 1963.

Budapest 1968
Budapest, Szépmüvészeti Múzeum, *Velencei Féstészet XV-XVIII. század*, 1968.

Budapest 1968
Budapest, Szépmüvészeti Múzeum, *Malarstowo Wenckie XV-XVIII W*, 1968.

Burlington Magazine 1944
"Canaletto in Lucca," *Burlington Magazine*, LXXXV, 1944, pp. 257-58.

Busiri Vici 1976
Andrea Busiri Vici, "In relazione all'opera romana di Bernardo Bellotto", *antichità viva*, XV, 1976, pp. 36-44.

Cadogan and Mahoney 1991
Jean K. Cadogan and Michael R.T. Mahoney, *Wadsworth Atheneum Italian Paintings, II: Italy and Spain Fourteenth through Nineteenth Centuries*, Hartford, 1991.

Cambridge 1938
Cambridge, Fogg Museum of Art, *Exhibition of Venetian Paintings and Drawings*, 1938.

Cambridge 1956
Cambridge, Fogg Museum of Art, *Venice Observed*, 1956.

Camesasca 1974
Ettore Camesasca, *L'Opera completa del Bellotto*, Milano 1974.

Carlevaris 1703-4
Luca Carlevaris, *Le Fabriche e Vedute di Venezia, disegnate, poste in prospettiva et intagliate da Luca Carlevaris*, Venice, 1703-4.

"Catalogue of Pictures," c. 1800
Southampton University Library Archives and Manuscripts, Broadlands Papers, BR 126/11, "Catalogue of Pictures belonging to Lord Palmerston in Hanover Square," c. 1800.

"Catalogue" 1842
A Descriptive Catalogue of the Gallery of Pictures collected by Edmund Higginson, Esq., of Saltmarshe, London, 1842.

Cattani 2000
R. Cattani, in *Galleria Nazionale di Parma. Catalogo delle opere. Il Settecento*, ed. Lucia Fornari Schianchi, Milano 2000, pp. 60-67.

Chattanooga 1952
Chattanooga, The George Thomas Hunter Gallery of Art, *Opening Exhibition*, 1952.

Chicago, Philadelphia, and Ottawa 1966-67
Chicago Art Insitute, Philadelphia Museum of Art, and Ottawa, National Gallery of Canada, *Treasures from Poland*, 1966-67.

Chicago, Toledo, and Minneapolis 1970-71
Art Institute of Chicago, Toledo Museum of Art, and Minneapolis Insitute of Arts, *Painting in Italy in the Eighteenth Century: Rococo to Romanticism*, ed. John Maxon and Joseph J. Rishel, 1970-71.

Chong 1993
Alan Chong, *European & American Painting in the Cleveland Museum of Art. A Summary Catalogue*, Cleveland, 1993.

Chróscicki 1989
Juliusz A. Chróscicki, "Golden Freedom: Diets and Free Elections of Polish Kings in the Sixteenth and Eighteenth Centuries," in *Acts of the XXVIth International Congress of the History of Art*, ed. Irving Lavin, vol. 3, University Park and London, 1989, pp. 635-40.

Ciampi 1830
Sebastiano Ciampi, *Notizie di medici, maestri di musica e cantori, pittori, architetti ed altri artisti italiani in Polonia e polacchi in Italia*, Lucca, 1830.

Ciampi 1839
Sebastiano Ciampi, *Bibliografia critica delle antiche reciproche corrispondenze*, 2 vols., Florence, 1839.

Citati 1996
P. Citati, "Bellotto a Dresda," *Cahiers d'Art*, IX, 1996, pp. 40-45.

Clark and Bowron 1985
Anthony M. Clark, *Pompeo Batoni. A Complete Catalogue of his Works*, ed. Edgar Peters Bowron, Oxford, 1985.

Cleveland 1982
Cleveland Museum of Art, *European Paintings of the 16th, 17th, and 18th Centuries: The Cleveland Museum of Art Catalogue of Paintings, Part Three*, Cleveland, 1982.

Cochin 1769
Charles Nicolas Cochin, *Voyage d'Italie: ou, Receuil de notes sur les ouvrages de peinture & sculpture, qu'on voit dans les principales villes d1Italie*, 2 vols, Paris, 1769.

Collins Baker 1920
C.H. Collins Baker, *Catalogue of the Petworth collection of pictures in the possession of Lord Leconfield*, London, 1920.

Collins Baker 1937
C.H. Collins Baker, *Catalogue of the principal pictures in the royal collection at Windsor Castle*, London, 1937.

Cologne, Zurich, and Vienna 1996-97
Cologne, Wallraf-Richartz-Museum, Zurich, Kunsthaus, and Vienna, Kunsthistorisches Museum, *Das Capriccio als Kunstprinzip. Zur Vorgeschichte der Moderne von Arcimboldo und Callot bis Tiepolo und Goya. Malerei-Zeichnung-Graphik*, ed. E. Mai, 1996.

Columbia 1962
Columbia, Museum of Art, *Art of the Renaissance from the Samuel H. Kress collection*, 1962.

Columbus 1999
Columbus, Museum of Art, *Dresden in the Ages of Splendor and Enlightenment. Eighteenth-Century Paintings from the Old Masters Picture Gallery. An exhibition from the Gemäldegalerie Alte Meister*, ed. Harald Marx and Gregor J.M. Weber, 1999.

Combe Abbey 1866
Catalogue of Pictures at Combe Abbey, Warwickshire. The Seat of William Earl of Craven, 1866.

Combe Abbey 1909
"Combe Abbey. I. Warwickshire. A Seat of the Earl of Craven," *Country Life*, CLXXVI, 4 December 1909, pp. 794-804.

Constable 1927
W.G. Constable, *Catalogue of Pictures in the Marlay Bequest, Fitzwilliam Museum*, Cambridge, 1927.

Constable 1962
W.G. Constable, *Canaletto. Giovanni Antonio Canal 1697-1768*, 2 vols, Oxford, 1962.

Constable 1963
W.G. Constable, "Vedute Painters in the Wadsworth Atheneum," *Wadsworth Atheneum Bulletin*, XIV, 1963, pp. 1-20.

Constable and Links 1976
W. G. Constable, *Canaletto. Giovanni Antonio Canal 1697-1768*, 2nd ed. by J. G. Links, 2 vols, Oxford, 1976.

Constable and Links 1989
W. G. Constable, *Canaletto. Giovanni Antonio Canal 1697-1768*, 3rd ed. by J. G. Links, 2 vols, Oxford, 1989.

Contini Bonacossi 1962
Alessandro Contini Bonacossi, *The Columbia Museum of Art: Art of the Renaissance from the Samuel H. Kess Collection*, 2nd ed., Columbia, 1962.

Corboz 1974
André Corboz, "Sur la prétendue objectivité de Canaletto," *Arte Veneta*, XXVIII, 1974, pp. 205-18.

Corboz 1985
André Corboz, *Canaletto. Una Venezia immaginaria*, 2 vols., Milan, 1985.

De Grazia and Garberson 1996
Diane De Grazia and Eric Garberson, eds., *Italian Paintings of the Seventeenth and Eighteenth Centuries. The Collections of the National Gallery of Art Systematic Catalogue*, Washington 1996.

De Jongh 1975-76
Eddy de Jongh, "Pearls of virtue and pearls of vice," *Simiolus*, VIII, 1975-1976, pp. 69-97.

De Juliis 1981
Giuseppe De Juliis, "Appunti su una quadreria fiorentina: la collezione dei marchesi Riccardi," *Paragone Arte*, XXXII, no. 375, 1981, pp. 57-92.

Delaney 1991
J.G.P. Delaney, "Charles Rickertts and the National Gallery of Canada," *Museum Management and Curatorship*, X, no. 4, 1991, p. 367.

Delogu 1930
Giuseppe Delogu, *Pittori veneti minori del Settecento*, Venice, 1930.

Delogu 1935
Giuseppe Delogu, "Berlino: Pittura italiana del '700 nella collezione Haussmann," *Emporium*, LXXXII, 1935, pp. 327-33.

Delogu 1937
Giuseppe Delogu, "Pitture italiane del '600 e del '700 a Vienna," *L'Arte*, XL, 1937.

Delogu 1958
Giuseppe Delogu, *Pittura veneziana dal XIV al XVIII secolo*, Bergamo, 1958.

De Seta 1990
Cesare De Seta, "Bernardo Bellotto vedutista e storiografo della civiltà urbana europea," in Verona 1990, pp. 20-26.

De Seta 1992
Cesare De Seta, "Bernardo Bellotto vedutista e storiografo della civiltà urbana Europea," in *Saggi in Onore di Renato Bonelli*, Rome, 1992, II, pp. 813-18.

De Seta 1999
Cesare De Seta, *Vedutisti e viaggiatori in Italia tra Settecento e Ottocento*, Turin, 1999.

Detroit and Indianapolis 1952-53
Detroit, Detroit Institute of Arts, and Indianapolis, John Herron Art Museum, *Venice 1700-1800. An Exhibition of Venice and the Eighteenth Century*, 1952-53.

Dodsley 1761
R. and J. Dodsley, *London and Its Environs Described. Containing an Account of Whatever is Most Remarkable for Grandeur, Elegance, Curiosity or Use, in the City and in the Country Twenty Miles round it*, London, 1761.

Douglas Pennant 1902
Alice Douglas Pennant, *Catalogue of the Pictures at Penrhyn Castle and Mortimer House in 1901*, Bangor, 1902.

Dresden 1956
Dresden, Gemäldegalerie, *Austellung der von der Regierung der UdSSR an die Deutsche Demokratische Republik übergebenen Meisterwerke*, 1956.

Dresden 1963-64
Dresden, Albertinum, and Gemäldegalerie Alte Meister, *Bernardo Bellotto gennant Canaletto in Dresden und Warschau*, ed. Stefan Kozakiewicz and Henner Menz, 1963-64.

Dresden 1968
Dresden, Staatliche Kunstsammlungen, *Venezianische Malerei 15. bis 18. Jahrhundert*, 1968.

Dresden 1987
Dresden, Staatliche Kunstsammlungen, *Matthaus Daniel Poppelmann 1662-1736. Ein Architekt des Barocks in Dresden*, 1987.

Dresden 1997-98
Dresden, Staatliche Kunstsammlungen, *Unter einer Krone. Kunst und Kultur der sächsisch-polnischen Union*, ed. Werner Schmidt, 1997-98.

Dresden and Bonn 1995-96
Dresden, Staatliche Kunstsammlungen, and Bonn, Kunst-und-Ausstellungshalle der Bundesrepublik Deutschland, *Im Lichte des Halbmonds. Das Abendland und der türkische Orient*, 1995-96.

Dresden 2000a
Dresden, Staatliche Kunstsammlungen, and Landesamt für Denkmalpflege Sachsen, *George Bähr. Die Frauenkirche und das bürgerliche Bauen in Dresden*, 2000.

Dresden 2000b
Dresden, Kupferstichkabinett, *Eine gute Figur machen. Kostüm und Fest am Dresdner Hof*, ed. C. Schnitzer and P. Hölscher, 2000.

Dublin 1957
Dublin, Municipal Gallery of Modern Art, *Paintings from Irish Collections*, 1957.

Enghert 1881
Eduard R. von Enghert, *Kunsthistorische Sammlungen des Allerhöchsten Kaiserhauses, Gemälde. Beschreibendes Verzeichnis: I. Bande, Italiensiche, spanische, und französischen Schulen*, Vienna, 1881.

England Displayed 1769
England Displayed. Being a new, Complete, and Accurate Survey and Description of the Kingdom of England and Principality of Wales, by a Society of Gentlemen, London, 1769.

Ermisch 1956
Hubert Georg Ermisch, *Der Dresdner Zwinger*, Dresden, 1956.

Essen 1966
Essen, Villa Hügel, *Europäische Veduten des Bernardo Bellotto gennant Canaletto*, ed. Stefan Kozakiewicz, 1966.

Essen 1986
Essen, Villa Hügel, *Barock in Dresden*,

1694-1763, Kunst und Kunstammlungen unter der Regierung des Kurfursten Friedrich August I. von Sachsen und Konigs August II. von Polen. . . und des Kurfursten Friedrich August II. von Sachsen und Konigs August III. von Polen . . ., 1986.

Fahy 1973
Everett Fahy, *The Wrightsman Collection, V: Paintings, Drawings*, New York, 1973.

Falke 1930
Otto von Falke, *Die Sammlung Camillo Castiglioni. Wien. Gemälde, Sculpturen, Möbel, Keramik, Textilien* [sale catalogue, Hermann Ball e Paul Graupe], Berlin, 1930.

Fassman 1770
Georg Benedikt Fassmann, *Catalogus über die in der Churfürstl. Residence zu München befindliche Gemälde verfasst worden im Jahr 1770*, Munich, 1770.

Ferrari 1914
Giulio Ferrari, *I due Canaletto. Antonio Canal, Bernardo Bellotto pittori*, Turin, 1914 (2nd ed. 1920).

Finberg 1938
Hilda Finberg, "The Lovelace Canalettos," *Burlington Magazine*, LXXII, 1938, pp. 68-71.

Fiocco 1929
G. Fiocco, "La pittura veneziana alla mostra del Settecento," *Rivista della Città di Venezia*, 1929, pp. 495-512, 529-44, 554-56, 562-81.

Florence 1922
Florence, Palazzo Pitti, *Mostra della pittura italiana del Seicento e del Settecento*, ed. Ugo Ojetti, Luigi Dami, and Nello Tarchiani, 1922.

Florence 1953
Florence, Gabinetto Disegni e Stampe degli Uffizi, *Mostra di disegni veneziani del Sei e Settecento*, 1953.

Florence 1994
Florence, Forte di Belvedere, *Firenze e la sua immagine: cinque secoli di vedutismo*, ed. Marco Chiarini and Alessandro Marabottini, 1994.

Fomichova 1959
Tamara D. Fomichova, *Vidy Drezdena i Pirny, architecturnyje Pejzazy Bernardo Bellotto*, (in Russian), Leningrad, 1959.

Fomichova 1992
Tamara D. Fomichova, *The Hermitage Catalogue of Western European Painting: Venetian Painting Fourteenth to Eighteenth centuries*, Florence, 1992.

Fornari Schianchi 1982
Lucia Fornari Schianchi, *La Galleria Nazionale di Parma*, Parma, 1982.

Frankfurt 1999-2000
Frankfurt, Schirn Kunsthalle, *Von Raffael bis Tiepolo. Italienische Kunst aus der Sammlung des Fürstenhauses Esterházy*, ed. Istvan Barkóczi, 1999-2000.

Fredericksen and Zeri 1972
Burton B. Fredericksen and Federico Zeri, *Census of Pre-Nineteenth-Century Italian Paintings in North American Public Collections*, Cambridge, Mass., 1972.

Fritzsche 1936
Hellmuth Allwill Fritzsche, *Bernardo Bellotto genannt Canaletto*, Burg bei Magdeburg, 1936.

Gabrielli 1971
Noemi Gabrielli, *Galleria Sabauda: Maestri italiani*, Turin, 1971.

Gambi and Gozzoli 1982
Lucio Gambi and Maria Cristina Gozzoli, *Le città nella storia d1Italia. Milano*, Rome and Bari, 1982.

Garas 1968
Klara Garas, *Eighteenth-Century Venetian Paintings*, Budapest, 1968.

Garas 1995
Klara Garas, "Collecting Venetian Painting in Central Europe," in Atlanta, Seattle, and Minneapolis, 1995, pp. 25-50.

Gardner 1998
Elizabeth E. Gardner, *A Bibliographical Repertory of Italian Private Collections*, ed. C. Ceschi and Katharine Baetjer, Vicenza, 1998.

Garms 1995
Jörg Garms, *Vedute di Rome dal medievo all'Ottocento. Atlante iconografico, topografico, architettonico*, 2 vols, Naples, 1995.

Garms 1999-2001
Jörg Garms, "Architectural painting: Fantasy and Caprice," in Stupinigi, Montreal, Washington, and Marseille 1999-2001, pp. 241-77.

Goodison and Robertson 1967
J. W. Goodison and G. H. Robertson, *Fitzwilliam Museum, Cambridge: Catalogue of Paintings, II: Italian Schools*, Cambridge, 1967.

Gore 1977
St. John Gore, "Three Centuries of Discrimination," *Apollo*, CV, 1977, pp. 346-57.

Gorizia 1988
Gorizia, Castello, *Capricci veneziani del Settecento*, ed. Dario Succi, 1988.

Gorizia 1989
Gorizia, Castello, *Michele Marieschi tra Canaletto e Guardi*, ed. Dario Succi, 1989.

Graves 1913
Algernon Graves, *A Century of Loan Ex-*

hibitions 1813-1912, 5 vols, London, 1913.

Gregori 1983
Mina Gregori, "Vedutismo fiorentino: Zocchi e Bellotto," *Notizie da Palazzo Albani*, XII, 1983, pp. 242-50.

Gregori 1988
Mina Gregori, "Ben tornato Bellotto," *Arte Documento*, II, 1988, pp. 172-73.

Gregori and Blasio 1994
Mina Gregori and Silvio Blasio, *Firenze nella pittura e nel disegno dal Trecento al Settecento*, Milan, 1994.

Griva 1953
Luigi Griva, "Scali fluviali sul Po nella Torino del Settecento," *Studi Piemontesi*, XXII, 1993, pp. 411-16.

Grzeluk 1983
I. Grzeluk, "Środy architektoniczne i malarskie, czyli obiady włoskie króla Stanisława Augusta," *Rocznik Muzeum Narodowego w Warszawie*, XXVII, pp. 135-50.

Gurian 1931
Giovanni Gurian, *Sopra sedici statue da giardino dello scultore padovano Antonio Bonazza*, Verona, 1931.

Hadeln 1930
Detlef von Hadeln, *Die Zeichnungen von Antonio Canal genannt Canaletto*, Vienna, 1930.

Hagedorn 1762
Christian Ludwig von Hagedorn, *Betrachtungen über die Mahlerey*, Leipzig, 1762.

Hager 1960
Luisa Hager, *Nymphenburg, Schloss, Park und Burgen: amtlicher Führer*, Munich, 1960.

The Hague 1966
The Hague, Mauritshuis, *In the Light of Vermeer. Jubilee-Exhibition Mauritshuis 1816-1966, Five centuries of Painting*, 1966.

The Hague and San Francisco 1990-91
The Hague, Mauritshuis, and The Fine Arts Museums of San Francisco, *Great Dutch Paintings from America*, ed. Ben Broos, 1990.

Hall 1979
James Hall, *Dictionary of Subjects & Symbols in Art*, New York, 1979.

Hamburg 1966
Katalog der alten meister der Hamburger Kunsthalle, 5th ed., Hamburg, 1966.

Hamburg 1993
Hamburg, Museum für Kunst und Gewerbe, *Pegasus und die Kunste*, ed. Claudia Brink and Wilhelm Hornbostel, 1993.

Hannover 1985
Hannover, Forum des Landesmuseum Hannover, *Von Cranach bis Monet. Zehn Jahre Neuerwerbungen 1976-1985*, 1985.

Hannover and Düsseldorf 1991-92
Hannover, Forum des Landesmuseum Hannover, and Düsseldorf, Kunstmuseum im Ehrenhof, *Venedigs Ruhm im Norden. Die grossen venezianischen Maler des 18. Jahrhunderts, ihre Auftraggeber und ihre Sammler*, ed. Meinolf Trudzinski and Bernd Schälicke, 1991-92.

Hartford 1956
Hartford, Wadsworth Atheneum, *Homage to Mozart*, 1956.

Haskell and Levey 1958
Francis Haskell and Michael Levey, "Art exhibitions in 18th century Venice," *Arte Veneta*, XII, 1958, pp. 179-85.

Haskell 1960
Francis Haskell, "Francesco Guardi as vedutista and some of his patrons," *Journal of the Warburg and Courtauld Institutes*, XXIII, 1960, pp. 256-76.

Haskell 1963
Francis Haskell, *Patrons and Painters. A Study in the Relations between Italian Art and Society in the Age of the Baroque*, London, 1963.

Haskell 1980
Francis Haskell, *Patrons and Painters. A Study in the Relations Between Italian Art and Society in the Age of the Baroque*, 2nd ed., New Haven and London, 1980.

Haumann 1927
Irene Haumann, *Das oberitalienische Landschaftsbild des Settecento (Zur Kunstgeschichte des Auslandes)*, Strasbourg, 1927.

Heinecken 1771
C.H. Heinecken, *Idée general d'une collection complete d'estampes*, Leipzig, 1771.

Heinz 1964
Günther Heinz, "Bemerkungen zu Bernardo Bellottos tätigkeit am Hof der Kaiserin Maria Theresia in Wien," in *Résumé der Wissenschaftlichen Konferenz Bernardo Bellotto*, Dresden 1964.

Heinz 1980
Günther Heinz, "*Die figürlichen Künste zur Zeit Josephs II*," in Vienna 1980, pp. 552-64.

Henkel and Schöne 1967
Arthur Henkel and Albrecht Schöne, *Emblemata. Handbuch zur sinnbildkunst des XVI. und XVII. jahrhunderts*, Stuttgart, 1967.

Hermitage 1774
[E Muenich], *Catalogue des tableaux qui se trouvent dans les Galeries et dans les Cabinets du Palais Impérial de Saint-Pétersbourg*, St. Petersburg, 1774.

Hermitage 1797
"Catalogue of the Paintings in the Imperial Gallery of the Hermitage, … compiled with the participation of F. I. Labensky," [in Russian], State Hermitage Museum Archives, f. 1. inv. VI-A, no. 85.

Hermitage 1859
"Inventory of Paintings and Ceiling Decorations under the Authority of the 2nd Department of the Imperial Hermitage, vols. 1-8, 1859-1929, State Hermitage Museum Archives, f. 1. inv. VI-B, no. 1.

Hermitage 1863
The Imperial Hermitage. Catalogue of Paintings [in Russian], St. Petersburg 1863.

Hermitage 1958
The State Hermitage. Department of Western European Art. Catalogue of Painting, Vol I [in Russian], Leningrad-Moscow, 1958.

Hermitage 1976
The State Hermitage. Western European Painting. Catalogue. Vol I., Italy, Spain, France, Switzerland [in Russian], Leningrad, 1976

Hoff 1995
Ursula Hoff, *European Painting and Sculpture before 1800 in the National Gallery of Victoria*, Melbourne, 1995.

Horace 1991
Quintus Horatius Flaccus, *Ars Poetica-Die Dichtkunst*, ed E. Schäfer, Stuttgart, 1980.

Hübner 1856
Julius Hübner, *Verzeichniss der Königlichen Gemälde-Gallerie .zu Dresden*, Dresden, 1856.

Hübner 1868
Julius Hübner, *Verzeichniss der Königlichen Gemälde-Gallerie zu Dresden*, 3rd ed., Dresden, 1868.

Hübner 1884
Julius Hübner, *Verzeichniss der Königlichen Gemälde-Gallerie zu Dresden*, 6th ed., Dresden, 1884.

Hulsenboom 1984
M. Hulsenboom, "De Warschause Vedute-Serie van Bernardo Bellotto /1721-1780/. Een iconologisch onderzoek," PhD dissertation, Catholic University of Nijmegen, 1984.

Hussey 1925
Christopher Hussey, "Paxton House, Berwickshire. A Seat of Miss Milne Home," *Country Life*, LVII, 21 March 1925, pp. 446-51.

Ingamells 1985
John Ingamells, *The Wallace Collection. Catalogue of Pictures, I, British, German, Italian, Spanish*, London 1985.

Ingamells 1997
John Ingamells, *A Dictionary of British and Irish Travellers in Italy 1701-1800, compiled from the Brinsley Ford Archive*, New Haven and London, 1997.

Ingelheim am Rhein 1987
Ingelheim am Rhein, Museum-Altes-Rathaus, *Kunst in Venedig. Gemälde und Zeichnungen 16.-18.Jh.- Arte a Venezia XVI-XVIII secolo. Dipinti e disegni*, ed. Patricia Rochard and François Lachenal, 1987.

Parma 1852
Inventario Generale delle opere di Pittura, Scultura, Ms., Soprintendenza per i Beni Artistici e Storici di Parma e Piacenza, 1852.

Jaffé 1997
David Jaffé, *Summary Catalogue of European Paintings in the J. Paul Getty Museum*, Los Angeles, 1997.

Jaroszewski 1971
T.S. Jaroszewski, *Pałac Lubomirskich*, Warsaw, 1971.

Johns 1993
Christopher M. S. Johns, *Papal Art and Cultural Politics. Rome in the Age of Clement XI*, Cambridge, 1993.

Kaczmarzyk 1970
D. Kaczmarzyk, "'Wenus opłakująca Adonisa', projekt rzeźby Stanisława Augusta zrealizowany przez Antonia Canovę," *Biuletyn Historii Sztuki*, XXXII, 1970, pp. 290-306.

Kansas City 1956
Kansas City, The Nelson Gallery and Atkins Museum, *The Century of Mozart*, 1956.

Kingston-upon-Hull 1967
Kingston-upon-Hull, Ferens Art Gallery, *Venetian Baroque & Rococo*, 1967.

Klemm 1988
Christian Klemm, *The Paintings of the Betty and David M. Koetser Foundation*, Dornspijk, 1988.

Klemm 1994
Christian Klemm, "Bernardo Bellottos 'Die Ruinen der Kreuzkirche in Dresden'. Eine 'Allegorie Réelle aus dem 18. Jahrhundert'," *Zuricher Kunstgesellschaft Jahresbericht*, 1994, pp. 83-89.

Knofler 1979
Monika J. Knofler, *Das Theresianische Wien. Die Alltag in den Bildern Canalettos*, Vienna, Cologne, and Graz, 1979.

Koller 1993
Manfred Koller, *Die Brüder Strudel: Hofkunstler und Grudner der Wiener Kunstakademie*, Innsbruck, 1993.

Kołłataj 1954
Hugo Kołłataj, *Listy Anonima i Prawo Polityczne Narodu Polskiego*, 2 vols, Kraków, 1954.

Konody 1932
Paul George Konody, *Works of Art in the Collection of Viscount Rothermere*, London, 1932.

Kowalczyk 1988
Bozena Anna Kowalczyk, "I disegni italiani del Bellotto," [tesi di laurea], Università degli Studi di Venezia, 1987-88 (Venice, 1988).

Kowalczyk 1995a
Bozena Anna Kowalczyk, "Bernardo Bellotto," in Venice 1995, pp. 298-305.

Kowalczyk 1995b
Bozena Anna Kowalczyk, "Il Bellotto veneziano nei documenti," *Arte Veneta*, XLVII, 1995, pp. 68-75.

Kowalczyk 1996a
Bozena Anna Kowalczyk, "Il Bellotto italiano,"[tesi di dottorato di ricerca], Università degli Studi di Venezia, VIII cycle, 1996.

Kowalczyk 1996b
Bozena Anna Kowalczyk, "Il Bellotto veneziano: 'grande intendimento ricercasi'," *Arte Veneta*, XLVIII, pp. 70-89.

Kowalczyk 1996c
Bozena Anna Kowalczyk, "Splendori del Settecento veneziano," *Venezia Arti*, X, 1996, pp. 133-36.

Kowalczyk 1998
Bozena Anna Kowalczyk, "I Canaletto della National Gallery di Londra," *Arte Veneta*, LIII, 1999, pp. 72-99.

Kowalczyk 1999
Bozena Anna Kowalczyk, "I primi sostenitori veneziani di Bernardo Bellotto," *Saggi e Memorie di Storia dell'Arte*, XXIII, 1999, pp. 189-218.

Kozakiewicz 1960
Stefan Kozakiewicz, "Lorenzo Bellotto, syn Bernarda i zagadnienie jego współpracy z ojcem," *Biuletyn Historii Sztuki*, XXII, 1960, pp. 140-57.

Kozakiewicz 1966
Stefan Kozakiewicz, "Il motivo Capitolino nell'arte de Bernardo Bellotto," *Bulletin du Musée National du Varsovie*," VII, 1966, pp. 11-20.

Kozakiewicz 1967a
Stefan Kozakiewicz, "L'eredità artistica e il rapporto con la realtà nella visione bel-

lottiana," in *Italia, Venezia e Polonia tra umanesimo e rinascimento*, Wroclaw, Warsaw, and Kraków, 1967, pp. 322-25.

Kozakiewicz 1967b
Stefan Kozakiewicz, "Eine Dresdener Ansicht von Bernardo Bellotto," *Pantheon*, XXV, 1967, pp. 445-52.

Kozakiewicz 1972
Stefan Kozakiewicz, *Bernardo Bellotto*, trans. Mary Whittall, 2 vols, London, 1972.

Kozakiewiczic 1976
Stefan and Helene Kozakiewicz, *Bernardo Bellotto 'Canaletto'*, Berlin and Warsaw, 1976.

Krafft 1849
Albrecht Krafft, *Verzeichniss der K.U.K. Gemälde Gallerie im Belvedere zu Wien*, 3rd ed., Vienna, 1849.

Krönig 1961
Wolfgang Krönig, "Geschichte einer Rom-Vedute," *Miscellanea Bibliothecae Hertzianae*, 1961, pp. 385-417.

Król-Kaczorowska 1966
Barbara Król-Kaczorowska, "Svolta dei lavori forniti alla corte di Varsavia ed altri documenti bellottiani," *Bulletin du Musée National de Varsovie*, VII, 1966, pp. 68-75.

Kroupa 1996
J. Kroupa, "Fürst Wenzel Anton Kaunitz-Riethberg. Ein Kunstmäzen und Curieux der Aufklärung," in *Staatskanzler Wenzel Anton von Kaunitz-Riethberg (1711-1794). Neue Perspektiven zu Politik und Kultur der europäischen Aufklärung*, ed. G. Klingenstein e F. Szabo, Graz and Esztergom, 1996.

Kwiatkowski 1983
M. Kwiatkowski, *Stanisław August. Król-Architekt*, Wroclaw, 1983.

Kwiatkowski 1989
M. Kwiatkowski, *Architektura mieszkaniowa Warszawy*, Warsaw, 1989.

Laing 1995
Alastair Laing, *In Trust for the Nation. Paintings from National Trust Houses*. London, 1995.

Lanzi 1795-96
Luigi Lanzi, *Storia pittorica della Italia*, 2 vols., Bassano, 1795-96.

Lausanne 1947
Lausanne, Musée Cantonal des Beaux-Arts, *Trésors de l'art vénitien*, ed. Rodolfo Pallucchini, 1947.

Lauts 1966
Jan Lauts, *Staatliche Kunsthalle Karlsruhe Katalog. Alte Meister bis 1800*, Karlsruhe, 1966.

Lawrence 1991
Cynthia Lawrence, *Gerrit Adriaensz.*

Berckheyde (1638-1698). Haarlem Cityscape Painter, Doornspijk, 1991.

Leningrad 1959
State Hermitage Museum, *European Landscape Paintings from the Seventeenth to the Twentieth Century* [in Russian], 1959.

Lenthe 1836
Lenthe, *Katalog der alten Schweriner Gallerie*, Schwerin 1836.

Levey 1956
Michael Levey, *National Gallery Catalogues: The Eighteenth-Century Italian Schools*, London, 1956.

Levey 1964
Michael Levey, *The Later Italian Pictures in the Collection of Her Majesty the Queen*, London, 1964.

Levey 1971
Michael Levey, *National Gallery Catalogues. The Seventeenth- and Eighteenth-century Italian Schools*, London, 1971.

Levey 1973
Michael Levey, "*Bernardo Bellotto* by Stefan Kozakiewicz [review]," *Burlington Magazine*, CXV 1973, pp. 615-16.

Levey 1986
Michael Levey, *National Gallery Catalogues. The Seventeenth- and Eighteenth-century Italian Schools*, 2nd ed., London, 1986.

Levey 1991
Michael Levey, *The Later Italian Pictures in the Collection of Her Majesty the Queen*, 2nd ed., London, 1991.

Levi 1900
Cesare Augusto Levi, *Le collezioni veneziane d'arte e d'antichità dal secolo XIV ai nostri giorni*, 2 vols, Venezia, 1900.

Levinson-Lessing 1985
Vladimir Levinson-Lessing, *Istoria Kartinnoi galerei Ermitazha (1764-1917)*, Leningrad, 1985.

Lieber 1979
E. Lieber, *Verzeichnis der Inventare der Staatlichen Kunstsammlungen Dresden. 1568-1945*, Dresden, 1979.

Limentani Virdis 1990
Caterina Limentani Virdis, "Bernardo Bellotto: *imago veritatis*," in Verona 1990, pp. 30-38.

Links 1967
J.G. Links, "The View Paintings Return to Venice," *Burlington Magazine*, CIX, 1967, pp. 453-58.

Links 1972
J.G. Links, *Townscape Painting and Drawing*, London, 1972.

Links 1973
J.G. Links, "Bellotto Problems," *Apollo*, XCVII, 1973, pp. 107-10.

Links 1977
J.G. Links, *Canaletto and his Patrons*, London, 1977.

Links 1978
J.G. Links, "Landscape and Townscape from the Grand Tour," *Apollo*, CVIII, 1978, pp. 434-39.

Links 1981
J.G. Links, *Canaletto. The Complete Paintings*, St. Albans, 1981.

Links 1982
J.G. Links, *Canaletto*, London, 1982.

Links 1990
J.G. Links, "Exhibition Review: Verona, Castelvecchio Museum. Bernardo Bellotto," *Burlington Magazine*, CXXXII, 1990, pp. 660-61.

Links 1994a
J.G. Links, "Canaletto's Venice," *Modern Painters*, VII, 1994, pp. 68-71.

Links 1994b
J.G. Links, *Canaletto*, 2nd ed., London, 1994.

Links 1998
J. G. Links, *A Supplement to W. G. Constable's Canaletto. Giovanni Antonio Canal 1697-1768*, London, 1998.

Lippold 1963
G. Lippold, *Bernardo Bellotto genannt Canaletto*, Leipzig, 1963.

Lódz 1972
Lódz, Muzeum Sztuki, *Canaletto-Bernardo Bellotto 1721-1780. Obrazy z Zamku Królewskiego w Warszawie*, 1972.

Löffler 1981
Fritz Löffler, *Das alte Dresden*, Leipzig, 1981.

Löffler 1985
Fritz Löffler, *Bernardo Bellotto genannt Canaletto. Dresden im 18. Jahrhundert*, Leipzig, 1985.

Löffler 2000
F. Löffler, *Bernardo Bellotto genannt Canaletto. Dresden im 18. Jahrhundert*, 4th ed., Munich, 2000.

London 1863
London, British Institution, *Catalogue of Pictures by Italian, Spanish, Flemish, Dutch, French, and English Masters*, 1863.

London 1871
London, Royal Academy of Arts, *Exhibition of the Works of the Old Masters*, 1871.

London 1894
London, Royal Academy of Arts, *Exhibition of works by the Old Masters and by Deceased Masters of the British School, Winter Exhibition*, 1894.

London 1899
London, *West Ham Free Pictures Exhibition*, 1899.

London 1904
London, Royal Academy of Arts, *Exhibition of works by the Old Masters and Deceased Masters of the British School, Winter Exhibition*, 1904.

London 1910
London, Thomas Agnew & Sons, *Catalogue of the Collection of Pictures and Drawings of the late Mr. George Salting*, 1910.

London 1925
London, Thomas Agnew & Sons, *The Magnasco Society. Catalogue of a loan exhibition of pictures of the XVII. & XVIII. Centuries*, 1925.

London 1929a
London, The Magnasco Society, *Catalogue of Oil Paintings & Drawings by Antonio Canal Known as Canaletto*, 1929.

London 1929b
London, P.& D. Colnaghi, *Paintings by Old Masters*, 1929.

London 1930a
London, Royal Academy of Arts, *Exhibition of Italian Art 1200-1900*, 1930.

London 1930b
London, Savile Gallery, *Canaletto and Guardi*, 1930.

London 1930c
London, P.& D. Colnaghi, *Exhibition of Paintings by Old Masters*, 1930.

London 1932
London, Thomas Agnew & Sons, *An exhibition of the Von Auspitz Collection of Old Masters by courtesy of Herr Walter Bachstitz*, 1932.

London 1954
London, Wildenstein, *The Petworth Treasures*, 1954.

London 1954-55
London, Royal Academy of Arts, *European Masters of the Eighteenth Century*, ed. Brinsley Ford, James Byam Shaw, and Francis J. B. Watson, 1954-55.

London 1957
London, Thomas Agnew & Sons Ltd., *European Pictures from an English County*, 1957.

London 1960
London, Royal Academy of Arts, *Italian Art and Britain*, 1960.

London 1968
London, Arthur Tooth & Sons Ltd., *The Venetian View Painters of the 18th and 19th Centuries*, 1968.

London 1970
London, Royal Academy of Arts, *1000 Years of Art in Poland*, 1970.

London 1978
London, P. & D. Colnaghi, *Pictures from the Grand Tour*, ed. Clovis Whitfield, 1978.

London, 1982
London, Wildenstein & Co., *Souvenirs of the Grand Tour. A Loan Exhibition of The National Trust Collections*, 1982.

London 1987
London, Harari & Johns, *Venice in Perspective*, 1987.

London 1988-89
London, British Museum, *Treasures for the Nation*, 1988-89.

London 1990a
London, Walpole Gallery, *Venetian Baroque & Rococo Paintings*, 1990.

London 1990b
London, Grosvenor House, British Antique Dealers' Association Fair, *Italy and the Grand Tour*, 1990.

London 1992
London, Dulwich Picture Gallery, *Stanislaus Augustus as Patron of the Arts*, 1992.

London 1995-96
London, National Gallery, *In Trust for the Nation*, ed. Alastair Laing, 1995-96.

London and Birmingham 1951
London, Whitechapel Art Gallery, and Birmingham, City Art Gallery, *Eighteenth-century Venice*, ed. Francis J. B. Watson, 1951.

London and Liverpool 1957
London, Whitechapel Art Gallery, and Liverpool, Walker Art Gallery, *Bernardo Bellotto 1720-1780. Paintings and drawings from the National Museum of Warsaw*, ed. Stanislaw Lorentz and Stefan Kozakiewicz, 1957.

London and New York 1979-80
London, Royal Academy of Arts, and New York, Metropolitan Museum of Art, *The Horses of San Marco*, 1979-80.

London and Washington 1994-95
London, Royal Academy of Arts, and Washington, National Gallery of Art, *The Glory of Venice: Art in the Eighteenth Century*, ed. Jane Martineau and Andrew Robison, 1994-95.

London, York, and Swansea 1998-99
London, National Gallery; York, City Art Museum; and Swansea, Glynn Vivian Art Gallery, *Venice through Canaletto's Eyes*, ed. David Bomford and Gabrielli Finaldi, 1998-99.

Longhi 1946
Roberto Longhi, *Viatico per cinque secoli di pittura veneziana*, Firenze, 1946.

Lorentz 1955
Stanislaw Lorentz, "I dipinti di Bernardo Bellotto," in Venice 1955, pp. 13-48.

Lorentz and Kozakiewicz 1955
Stanislaw Lorentz and Stefan Koza-

kiewicz, *Bellotto a Varsavia*, Venice and Milan, 1955.

Lorentz 1972
Stanislaw Lorentz, "Zamek Królewski w obrazach Canaletta i znaczenie tych obrazów dla odbudowy Warszawy," in Lódz´ 1972.

Lorenz 1999
Hellmut Lorenz, ed., *Geschichte der Bildenden Kunst in Österreich. Barock*, 4 vols, Munich, London, and New York 1999, Vol 4, pp. 255-56.

Lorenzetti 1975
Giulio Lorenzetti, *Venice and its Lagoon*, trans. John Guthrie, Triest, 1975.

Los Angeles 1992
"Acquisitions/ 1991," *The J. Paul Getty Museum Journal*, XX, 1992, pp. 100-75.

Los Angeles 1997
Masterpieces of the J. Paul Getty Museum: Paintings, Los Angeles, 1997.

Lovisa 1717
Domenico Lovisa, *Il Gran Teatro di Venezia ovvero descrizione esatta di cento delle più insigni prospettive e di altretante celebri pitture della medesima città*, 2 vols, Venice, 1717.

Lublin 1960
Lublin, Museum of Fine Arts, *Wystawa malarstwa pólnocno-wloskiego póznego baroku*, 1960.

Lüdke 1991
Dietmar Lüdke, *Hubert Robert (1733-1808) und die Brücken von Paris*, Karlsruhe, 1991.

Lugano 1985
Lugano, Villa Favorita, *Capolavori da musei ungheresi*, 1985.

Maciejewski 1977
J. Maciejewski, "Sarmatyzm," in *Słownik literatury polskiego Oświecenia*, Wroclaw, Warsaw, Kraków, and Gdansk, 1977, pp. 638-45.

Maczynski 1986
R. Maczynski, "Czy Canaletto fantazjował? Zagadka dekoracji rzeźbiarskiej warszawskiego palacu Branickich," *Kronika Zamkowa*, II, 1986, pp. 48-61.

R. Maczynski 1998
R. Maczynski, *Ulice Nowego Miasta*, Warsaw, 1998.

Madrid 1998
Madrid, Banco Bilbao Vizcaya, *Obras maestras del siglo XVIII en la Galería de Pinturas de Dresde. Creación y coleccionismo regio en Sajonia*, ed. Harald Marx and Juan.J. Luna, 1998.

Manchester 1857
Manchester, *Art Treasures of the United Kingdom*, 1857.

Manchester 1960
Manchester, City Art Gallery, *Works of Art from Private Collections*, 1960.

Mańkowski 1932
Tadeusz Mańkowski, *Galerja Stanislawa Augusta*, 2 vols, Lwów, 1932.

Mańkowski 1976
Tadeusz Mańkowski, *Mecenat artystyczny Stanislawa Augusta*, Warsaw, 1976.

Marder 1980
Tod A. Marder, "The Porto di Ripetta in Rome," *Journal of the Society of Architectural Historians*, XXXIX, 1980, pp. 28-56.

Marías 1999
Ferdinando Marías, "From the 'Ideal City' to Real Cities: Perspectives, Chorographies, Models, Vedute," in Stupinigi, Montreal, Washington, and Marseille 1999-2001, pp. 219-39.

Marieschi 1741-42
Michele Marieschi, *Magnifecentiores Selectioresque Urbis Venetiarum Prospectus*, Venice, 1741-42.

Marinelli 1990
Sergio Marinelli, "I *lumi* e le ombre della città del principe," in Verona 1990, pp. 39-50.

Marinelli 1993
Sergio Marinelli, "Aggiornamenti su Bellotto," *Arte Veneta*, 44, 1993, pp. 83-86.

Marini 1991
Giorgio Marini, " Il fiume e il castello: precisazioni sul viaggio romano di Bernardo Bellotto," *artibus et historiae*, XII, 1991, pp. 147-63.

Marini 1993
Giorgio Marini, " 'Con la propria industria e sua professione.' Nuovi documenti sulla giovinezza di Bellotto," *Verona illustrata*, VI, 1993, pp. 125-40.

Martini 1964
Egidio Martini, *La pittura veneziana del Settecento*, Venezia, 1964.

Martini 1982
Egidio Martini, *La pittura del Settecento veneto*, Udine, 1982.

Martyn 1766
Thomas Martyn, *The English Connoisseur: Containing an Account of Whatever is Curious in Painting, Sculpture, ecc., in the Palaces and Seats of the Nobility and Principal Gentry of England, both in Town and Country*, Dublin, 1766.

Marx 1994
Harald Marx, *Gemäldegalerie Dresden. Alte Meister. Führer*, Leipzig, 1994.

Matthäi 1834
Friedrich Matthäi, *Beschreibung der neu errichteten Sammlung vaterländischer

Prospekte von Alexander Thiele und Canaletto*, Dresden, 1834.

Matthäi 1837
Friedrich Matthäi, *Verzeichniss der Königlichen Sächsischen Gemälde-Gallerie zu Dresden*, Dresden, 1837.

Meller 1915
S. Meller, *As Esterházy képtár története*, Budapest, 1915.

Menz 1962
Henner Menz, *The Dresden Gallery*, New York, 1962.

Menz 1964
Henner Menz, "Bernardo Bellotto als Maler von Architekturphantasien," *Dresdener Künstblatter*, 8, 1964, pp. 86-91.

Meunich 1773-83
E. Muenich, "Catalogue raisonné des tableaux qui se trouvent dans les Galeries, Sallons et Cabinets du Palais Impérial a Saint Petersbourg, commencé en 1773 et continué jusqu'en 1783," State Hermitage Museum Archives, Saint Petersburg, f.1., inv. VI-A, no. 85., 2 vols, 1773-83.

Milan 1999-2000
Milan, Palazzo Morando Attendolo Bolognini, *La Milano del Giovin Signore. Le arti nel Settecento di Parini*, ed. Fernando Mazzocca and Alessandro Morandotti, 1999-2000.

Mira 1996
Mira, Villa Principe Pio, *Immagini della Brenta*, 1996.

Mirano 1999
Mirano, Barchessa di Villa Morosini, *Bernardo Bellotto detto il Canaletto*, ed. Dario Succi, 1999.

Montreal 1942
Montreal, Art Association, *Masterpieces of Painting*, 1942.

Morassi 1966
Antonio Morassi, "Profilo di Michele Marieschi," in Bergamo 1966, n.p.

Morassi 1973
Antonio Morassi, *Antonio e Francesco Guardi*, 2 vols, Milan, 1973.

Moschini Marconi 1970
Sandra Moschini Marconi, *Gallerie dell'Accademia di Venezia. Opere d'Arte dei secoli XVII, XVIII, XIX*, Roma, 1970.

Mossakowsi 1972
S. Mossakowski, *Palac Krasińskich*, Warsaw, 1972.

Mucchi and Bertuzzi 1983
L. Mucchi and A. Bertuzzi, *Nella profondità dei dipinti*, Milan, 1983.

Müller-Hofstede 1976-78
Julius Müller-Hofstede, "Ut pictura poe-

sis': Rubens und die humanistische Kunsttheorie," *Gentse Bijdragen tot de Kunstgeschiedenis*, XXIV, 1976-78, pp. 171-89.

Munich 1901
Munich, *Führer durch die kunst- und kuturgeschichtliche Austellung 'München im 18. Jahrhundert,'* 1901.

Munich 1930
Munich, Galerie Caspari, *Italienische Malerei, Venezianer des 16.-18. Jahrhunderts*, 1930.

Munich 1931
Munich, Julius Böhler, *Austellung altvenezianischer Malerei*, 1931.

Munich 1958
Munich, Residenz, *Europäisches Rokoko. Kunst und Kultur des 18. Jahrhunderts*, 1958.

Munich 1987
Munich, Kunsthalle der Hypo-Kulturstiftung, *Venedig Malerei des 18. Jahrhunderts*, ed. Erich Steingräber, 1987.

Munich 1990
Munich, Kunsthall der Hypo-Kulturstiftung, *Königliches Dresden. Hofische Kunst im 18. Jahrhundert*, 1990.

Munich 1995
Munich, Neue Pinakothek, *Polens letzter Konig und seine Maler Kunst am Hofe Stanislaw August Poniatowski, reg. 1764-1795*, 1995.

Muñoz 1911
Antonio Muñoz, *Pièces de choix de la collection du Comte Grégoire Stroganoff*, 2 vols., Rome, 1911.

Murray 1899
John Murray, *A Handbook of Warwickshire*, London, 1899.

Nagler 1835-1852
Georg Kaspar Nagler, *Neues allegemeines Künstler-Lexicon*, 22 vols, Munich, 1835-1852.

Naruszewicz 1959
A. Naruszewicz, *Korespondencja Naruszewicza 1762-1796*, ed. J. Platt, Wrocław, 1959.

Nepi Scirè and Valcanover 1985
Giovanna Nepi Scirè and Francesco Valcanover, *Gallerie dell'Accademia di Venezia*, Milano, 1985.

Nepi Scirè 1997
Giovanna Nepi Scirè, *Canaletto's sketchbook*, 2 vols, Venize, 1997.

New Delhi 1984
New Delhi, *Art Treasures from Dresden*, 1984.

New Haven 1940
New Haven, Yale University Art Gallery, *Eighteenth-Century Italian Landscape Painting and its Influence in England*, 1940.

New York 1932
New York, Kleinberger Galleries, *Italian Baroque Painting and Drawing of the Sixteenth, Seventeenth, and Eighteenth Centuries*, 1932.

New York 1938
New York, Metropolitan Museum of Art, *Tiepolo and his Contemporaries*, 1938.

New York 1945-46
New York, Brooklyn Museum, *European and American Landscape Painting*, 1945-46.

New York 1984
New York, Piero Corsini Inc., *Italian Old Master Paintings*, 1984.

New York 1989-90
New York, Metropolitan Museum of Art, *Canaletto*, ed. Katharine Baetjer and J.G. Links, 1989-90.

New York 1992
New York, Seventh Regiment Armory, *New York International Antique Dealers Fair*, 1992.

Northampton 1932
Northampton, Mass., Smith College Museum of Art, *Venetian Paintings from the Hartford Museum*, 1932.

Oberlin 1963
Oberlin, Allen Memorial Art Museum, *Youthful Works by Great Artists*, 1963.

Oehler 1997
Lisa Oehler, *Rom in der graphik des 16. bis 18. Jahrhunderts. Ein niederländischer Zeichnungsband der Graphischen Sammlung Kassel und seiner Motive im Vergleich*, Berlin, 1997.

Oesterreich 1754
Matthias Oesterreich, *Inventarium von der Königlichen Bilder-Galerie zu Dresden*, Dresden, 1754.

Oesterreich 1764
Matthias Oesterreich, *Beschreibung der Koniglichen Bildergalleri und des Kabinetts im Sans Souci*, Potsdam, 1764.

Oesterreich 1773
Matthias Oesterreich, *Description de tout l1interieur de deux Palais de Sans Souci, de ceux de Potsdam et de Charlottenburg*, Potsdam, 1773.

Ojetti, Dami, and Tarchiani 1924
Ugo Ojetti, Luigi Dami, and Nello Tarchiani, *La Pittura Italiana del Seicento e Settecento alla mostra del palazzo Pitti*, Milan and Rome, 1924.

Olivari 1990
Mariolina Olivari, in *Pinacoteca di Brera. Scuola Veneta*, Milan, 1990, pp. 63-67.

Olivari 1994
Mariolina Olivari, in *Dipinti del Settecento Lombardo e Veneto alla Pinacoteca di Brera*, Vigevano, 1994.

Olivari 1999
Mariolina Olivari, "Bellotto a Milano," in Milan 1999-2000, pp. 217-20.

Onofrio 1968
Cesare D'Onofrio, *Il Tevere e Roma*. Rome, 1968.

Orlandi and Guarienti 1753
Pellegrino Antonio Orlandi and Pietro Maria Guarienti, *Abecedario pittorico del M.R.P. Pellegrino Antonio Orlandi bolognese*, Venice, 1753.

Ottawa 1931
Ottawa, National Gallery of Canada, *Special Exhibition of Paintings by Old Masters Recently Acquired*, 1931.

Ottawa 1987
Myron Laskin, Jr., and Michael Pantazzi, eds, *Catalogue of the National Gallery of Canada, Ottawa: European and American Painting, Sculpture, and Decorative Arts*, 2 vols, Ottawa, 1987.

Oxford 1993
Oxford, Ashmolean Museum, *Hidden Treasures: Works of art from Oxfordshire Private Collections*, ed. Catherine Whistler, Christopher White, and Rosemary Baird, 1993.

Paderborn and Oldenburg 1996
Paderborn, Städtische Galerie in der Reithalle Schloss Neuhaus, and Oldenburg, Landesmuseum für Kunst und Kulturgeschichte, *Phantasie und Illusion. Städte, Räume, Ruinen in Bildern des Barock*, ed. Andrea Wandschneider, 1996.

Padua 1994
Padua, Palazzo della Ragione, *Luca Carlevarijs e la veduta veneziana del Settecento*, ed. Isabella Reale and Dario Succi, 1994.

Pallucchini 1960
Rodolfo Pallucchini, *La pittura veneziana del Settecento*, Venice and Rome, 1960.

Pallucchini 1961a
Rodolfo Pallucchini, *Die venezianische Malerei des 18. Jahrhunderts*, Munich, 1961.

Pallucchini 1961b
Ridolfo Pallucchini, *Vedute del Bellotto*, Milan, 1961.

Pallucchini 1965
Rodolfo Pallucchini, "L'arte del Bellotto," in *Venezia e la Polonia nei secoli dal XVII al XIX*, Venice and Rome, 1965, pp.65-85.

Pallucchini 1966
Rodolfo Pallucchini, "Considerazioni sulla mostra bergamasca del Marieschi," *Arte Veneta*, XX, 1966, pp. 314-25.

Pallucchini 1969
Rodolfo Pallucchini, "Appunti per il vedutismo veneziano del Settecento," in *Muzeum i Twòrca. Studia z historii sztuki i kultury ku czci prof. dr Stanislawa Lorentza*, Warsaw, 1969, pp. 141-55.

Pallucchini 1995
Rodolfo Pallucchini, *La pittura nel Veneto. Il Settecento*, vol. 1, Milan, 1995.

Pallucchini 1996
Rodolfo Pallucchini, "Bernardo Bellotto," in *La pittura nel Veneto. Il Settecento*, vol. 2, Milan, 1996, pp. 493-523.

Paris 1919
Paris, Palais des Beaux-Arts, *Venezia nei secoli XVIII e XIX*, 1919.

Paris 1935
Paris, Petit Palais, *Exposition de l'art italien de Cimabue à Tiepolo*, 1935.

Paris 1960-61
Paris, Petit Palais, *La peinture italienne au XVIIIe siècle*, ed. Francesco Valcanover, 1960-61.

Paris 1969
Paris, Petit Palais, *Mille ans d'art en Pologne*, 1969.

Paris 2000-01
Paris, Musée du Luxembourg, *De Fra Angelico a Bonnard: Chefs-d'oeuvre de la collection Rau*, ed. Marc Restellini, 2000-01.

Parker 1948
K. T. Parker, *The drawings of Antonio Canaletto in the collection of His Majesty the King at Windsor Castle*, Oxford, 1948.

Parker and Crawley 1990
K. T. Parker, *The drawings of Antonio Canaletto in the collection of Her Majesty the Queen at Windsor Castle*, with an apprendix by Charlotte Crawley, Bologna, 1990.

Parma 1835-43
Registro delle Lettere scritte dalla Direzione delle Gallerie e delle Scuole della Ducale Accademia di Belle Arti, ms., 1835-1843, Archivio dell'Accademia di Belle Arti di Parma.

Parma 1948
Parma, Galleria Nazionale, *Mostra parmense di dipinti noti ed ignoti dal XIV al XVIII secolo*, ed. Augusto Ottauiano Quintavalle, 1948.

Pedrocco 1995
Filippo Pedrocco, *Canaletto and the Venetian Vedutisti*, New York, 1995.

Pedrocco 1999
Filippo Pedrocco, "Biografia di Bernardo Bellotto," in Mirano, 1999, pp. 118-19.

Pennant 1783
Thomas Pennant, *The Journey from Chester to London,* Dublin, 1783.

Pfäffikon and Geneva 1978
Pfäffikon, Seedamm Kulturentrum, and Geneva, Musée d'art et d'histoire, *Art venitien en Suisse et au Liechtenstein,* ed. Georg Germann, 1978.

"Pictures in Stanhope Street," c. 1804
Southampton University Library Archives and Manuscripts, Broadlands Papers, BR 126/15, "Pictures in Stanhope Street and Hanover Square", c. 1804.

Pigler 1954
Andreas Pigler, *A Régi Képtár katalógusa, Országos Szépmüvészeti Múzeum,* Szövegrész, Budapest, 1954.

Pigler 1967
Andreas Pigler, *Katalog der galerie alter meister,* 2 vols, Budapest, 1967.

Pignatti 1958
Terisio Pignatti, *Il Quaderno del Canaletto alle Gallerie dell1Accademia,* Venezia, 1958.

Pignatti 1966
Terisio Pignatti, "Gli inizi di Bernardo Bellotto," *Arte Veneta,* XX, 1966, pp. 218-29.

Pignatti 1967a
Terisio Pignatti, "Bernardo Bellotto1s Venetian Period (1738-1743)," *Bulletin of The National Gallery of Canada,* 9-10, 1967, pp. 1-17.

Pignatti 1967b
Terisio Pignatti, "The Contemporaneity of the Eighteenth-century Venetian Vedutisti," *Art International,* XV, 1967, p. 23.

Pignatti 1979
Terisio Pignatti, *Canaletto,* Bologna, 1979.

Pignatti 1981
Terisio Pignatti, "Le prospettive impossibili del Canaletto e del Bellotto," in *Ars Auro Prior. Studia Joanni Balostocki sexagenario dicata,* Warsaw, 1981, pp. 543-49.

Pilo 1962
Giuseppe Maria Pilo, *Canaletto,* London, 1962.

Pilo 1967
Giuseppe Maria Pilo, "La mostra dei vedutisti veneziani del Settecento," *Arte Veneta,* XXI, 1967, p. 275.

Pinto 1987
Sandra Pinto, ed., *Arte in Piemonte, II: Arte di corte a Torino da Carlo Emanuele III a Carlo Felice,* Turin, 1987.

Piquet 1762
Anne Marie Lepage Piquet, Madame du Bocage, *Recueil des Oeuvres,* 3 vols., Lyon, 1762.

Pita Andrade and Borobia Guerrero 1992
Jose Manuel, Pita Andrade, and Maria del Mar Borobia Guerrero, *Old Masters: Thyssen-Bornemisza Museum,* Madrid, 1992.

Pittaluga 1947a
Mary Pittaluga, "Le incisioni di Bernardo Bellotto," *Arte Veneta,* I, 1947, pp. 263-75.

Pittaluga 1947b
Mary Pittaluga, *Acquafortisti veneziani del Settecento,* Florence, 1947.

Pittsfield 1960
Pittsfield, Berkshire Museum, *Works of Canaletto and Bellotto,* 1960.

Poughkeepsie 1940
Poughkeepsie, Vassar College Art Gallery, *Exhibition of Italian Baroque Painting of the Seventeenth and Eighteenth Centuries,* 1940.

Posse 1929
Hans Posse, *Die Staatliche Gemäldegalerie zu Dresden. Vollständiges beschreibendes Verzeichnis der älteren Gemälde. 1. Die romanischen Länder,* Dresden and Berlin, 1929.

Posse 1930
Hans Posse, "Eine Architekturphantasie Bernardo Bellottos über den Dresdener Zwinger," *Pantheon,* V, 1930, pp. 166-67.

Pötschner 1978
Peter Pötschner, *Wien und die Wiener landschaft. Spätbarocke und Biedermeierliche landschaftskunst in Wien,* Salzburg 1978.

Prague 1959
Prague, Národní Galerie v Praze, *Polské malírstvi od Canaletta k Wyspianskému ze zbírek Národniho Muzea ve Varsave,* 1959.

Prague, Brno, and Bratislava 1962-63
Prague, Brno, and Bratislava, *Z Drázdanské Galerie,* 1962-63.

Prague 1968a
Prague, Národní Galerie v Praze, *Benátské malìřstvì ze sbìrek Národniho Muzea ve Varšavé, Galerie Starých Mistru v Draźdanech, Muzea Výtvarných Umeni v Budapesti, Narodni Galerie v Pradze a dalsich cleskoslovenských a polských sbirek,* 1968.

Prague 1968b
Praga, Národní Galerie v Praze, *Venezianische Malerei 15. bis 18. Jahrhundert,* 1968.

Prange 1998
Peter Prange, "Die Wiener Kunstakademie zwischen Reform und Stagnation-zur Ausbildung von Malern in den Jahren 1766 bis 1812," in *Herbst des Barock,* ed. Andreas Tacke, Munich and Berlin, 1998, pp. 339-53.

Prohaska 1999
Wolfgang Prohaska, in *Geschichte der Bildenden Kunst in Österreich. Barock,* ed. Hellmut Lorenz, Munich, London, and New York, 1999, vol. 4, pp. 457-58.

Puppi 1968
Lionello Puppi, *L'opera completa del Canaletto,* Milan, 1968.

Puppi 1988
Lionello Puppi, "Una città che 'fabbricar potrebbesi' e una città negata. Divagazioni intorno a temi di 'capriccio architettonico' del Canaletto e del Bellotto," in Gorizia 1988, pp. 209-22, 430-35.

Quintavalle 1937
Armando Ottaviano Quintavalle, "Precisazioni e restauri nella riordinata galleria di Parma," *Bollettino d'Arte,* XXXI, 1937, pp. 210-37.

Quintavalle 1939
Armando Ottaviano Quintavalle, *La Regia galleria di Parma,* Roma, 1939.

Raleigh, Houston, Seattle, and San Francisco, 1994-95
Raleigh, North Carolina Museum of Art; Museum of Fine Arts, Houston; Seattle Art Museum; and The Fine Arts Museums of San Francisco, *A Gift to America: Masterpieces of European Painting from the Samuel H. Kress Collection,* ed. Margaret Rennolds Chase, 1994-95.

Redford 1888
George Redford, Art Sales, *A history of sales of pictures and other works of art,* 2 vols, London, 1888.

Ricci 1896
Corrado Ricci, *La R. Galleria di Parma,* Parma, 1896.

Riccomini 1997
Eugenio Riccomini, "Una visita alla Galleria Nazionale," in Lucia Fornari Schianchi, *Galleria Nazionale di Parma. Catalogo delle opere dall'Antico al Cinquecento,* Milano, 1997, pp. XIII-XXXIII.

Richardson 1941
E. P. Richardson, "Bellotto's View of the Tiber with Castel S. Angelo," *Bulletin of the Detroit Institute of Arts,* XX, 1941, pp. 60-62.

Riedel and Wenzel 1765
J.A. Riedel and C.F. Wenzel, *Catalogue des tableaux de la Galerie Electorale à Dresde,* Dresden, 1765.

Riedel and Wenzel 1765
Riedel and Wenzel 1771
J.A. Riedel and C.F. Wenzel, *Verzeichnis der Gemalde in der Churfurstlichen Gallerie in Dresden,* Leipzig, 1771.

Rizzi 1981
Alberto Rizzi, *Vere da pozzo di Venezia. I puteali pubblici di Venezia e della sua laguna,* Venice, 1981.

Rizzi 1990
Alberto Rizzi, *La Varsavia di Bellotto,* Milan, 1990.

Rizzi 1991
Alberto Rizzi, *Bernardo Bellotto Warschauer Veduten,* Munich, 1991.

Rizzi 1994-95
Alberto Rizzi, "Bernardo Bellotto: un ritrovato capolavoro del secondo periodo dresdense," *Atti dell'Istituto Veneto di Scienze, Lettere ed Arti,* CLIII, 1994-1995, pp. 197-212.

Rizzi 1996
Alberto Rizzi, *Bernardo Bellotto. Dresda, Vienna, Monaco (1747-1766).* Venice, 1996.

Rome 1945
Rome, Palazzo Venezia, *Mostra d'arte italiana a Palazzo Venezia,* 1945.

Rome 1959
Rome, Palazzo delle Esposizione, *Il Settecento a Roma,* 1959.

Rotterdam 1957
Rotterdam, Museum Boymans, *Bernardo Bellotto, Schilderijen en tekeningen uit het Nationaal Museum te Warschau,* ed. Stanislaw Lorentz and Stefan Kozakiewicz, 1957.

Rottermund 1989
Andrzej Rottermund, *Zamek Warszawski w epoce Oświecenia. Rezydencja monarsza-funkcje i treści,* Warsaw, 1989.

Rottermund 1992
Andrzej Rottermund, "Treasures of a Polish King. Stanislaus Augusts as Patron and Collector," in London 1992, pp. 23-26.

Rottermund 1998
Andrzej Rottermund, "Bernardo Bellotto's Unknown View of Munich," *artibus et historiae,* 38, 1998, pp. 9-19.

Rowell 1997
Christopher Rowell, *The National Trust: Petworth House, West Sussex.* London, 1997

Ruskin 1888
John Ruskin, *Modern Painters,* Kent, 1888.

Russell 1993
Francis Russell, "A Suffusion of Light," *Country Life,* 14 October 1993, p. 64.

Russell 1994
Francis Russell, "The Pictures of John, Fourth Duke of Bedford," *Apollo,* CXXVII, 1988, pp. 401-6.

Saint Louis 1936
Saint Louis, City Art Museum, *Special loan Exhibition, Venetian paintings, draw-*

ings, prints of the Eighteenth Century, 1936.

St. Petersburg 1923
St. Petersburg [Petrograd], State Hermitage Museum, *Exhibition of Italian Paintings of the Seventeenth and Eighteenth Centuries* [in Russian], 1923.

Salting 1900
George Salting, "Notebook," Ms. in National Gallery Archives, London, c. 1900.

San Francisco 1938
San Francisco, The California Palace of the Legion of Honor, *Exhibition of Venetian Painting from the Fifteenth Century through the Eighteenth Century,* 1938.

Sani 1988
Bernardina Sani, *Rosalba Carriera,* Turin, 1988.

Scarisbrick 1987
Diana Scarisbrick, "Gem Connoisseurship - the 4th Earl of Carlisle's correspondence with Francesco de Ficoroni and Antonio Maria Zanetti," *Burlington Magazine,* CXXIX, 1987, pp. 90-104.

Schaffhausen 1953
Schaffhausen, Museum zu Allerheiligen, *500 Jahre venezianische Malerei,* 1953.

Scharf 1857
George Scharf, *A Handbook to the Paintings by Ancient Masters in the Art Treasures Exhibition,* London, 1857.

Scharf 1875
George Scharf, *A Descriptive and Historical Catalogue of the Collection of Pictures at Knowsley Hall,* London, 1875.

Scherer 1955
Margaret R. Scherer, *Marvels of Ancient Rome,* New York and London, 1955.

Schindler 1976
O.G. Schindler, "Der Zuschauerraum des Burgtheaters im 18. Jahrhundert. Eine baugeschichtliche Skizze," *Maske und Kothurn,* XXII, 1976, pp. 20-53.

Schmidt 2000
Werner Schmidt, *Bernardo Bellotto genannt Canaletto in Pirna und auf der Festung Königstein,* Pirna, 2000.

Schubring 1905
Paul Schubring, *Moderner Cicerone, Berlin I, Das Kaiser-Friedrich-Museum,* Stuttgart, Berlin and Leipzig, 1905.

Seidlitz 1911
W. von Seidlitz, "Canaletto, eigentlich Bernardo Bellotto," in Thieme-Becker, *Allgemeines Lexikon der Bildenden Künstler von der Antike bis zur Gegenwart,* Leipzig 1911, pp. 487-89.

Seifert 1988
S. Seifert, "Das Bildprogramm der

Katholischen Hofkirche in Dresden, Kathedrale des Bistums Dresden-Meissen," in Vienna 1988, pp. 9-20

Shapley 1973
Fern Rusk Shapley, *Paintings from the Samuel H. Kress Collection. Italian Schools XVI-XVIII Century,* London, 1973.

Shrewsbury 1951
Shrewsbury Art Gallery, *Pictures from Shropshire Houses,* 1951.

Sirén 1902
Oswald Sirén, *Dessins et Tableaux de la Renaissance Italienne dans les Collections de Suède,* Stockholm, 1902.

Sokolowska 1972
A. Sokolowska, "Jurydyka Wielopole w Warszawie w świetle nieznanych planów Tylmana z Gameren," *Rocznik Warszawski,* XI, 1972, pp. 23-56.

Spagnesi 1993
Gianfranco Spagnesi, *Alessandro Specchi. Alternativa al Borrominismo,* Turin, 1993.

Springfield 1933
Springfield, Museum of Fine Arts, *Opening Exhibition,* 1933.

Springfield 1934
Springfield, Museum of Fine Arts, *Five Eighteenth-Century Venetians,* 1934.

Staehlin *Notes*
Konstantin V. Malinovskii, *Notes by Jakob Staehlin (1709-1785) on the Fine Arts in Russia* [in Russian], 2 vols., Moscow, 1990.

Starzynski 1933
J. Starzynski, "Rysunki Canaletta w Warszawskiem Muzeum Narodowem," *Biuletyn Historji Sztuki i Kultury,* II, 1933, pp. 99-111.

Staszewski 1981
J. Staszewski, "Polen und Sachsen im 18. Jahrhundert," *Jahrbuch für Geschichte,* 1991, XXIII, pp. 167-188.

Staszewski 1983
J. Staszewski, "Die sächsisch-polnische Union und die Umwand-lungsprozesse in beiden Landern," *Die Sächsische Heimatblatter,* 4, 1983, pp. 154-59.

Steingräber 1987
Erich Steingräber, "Vedute und Landschaft," in Munich 1987, pp. 87-93.

Stockholm 1969
Stockholm, Nationalmuseum, *Konstkatter från Dresden,* 1969.

Stübel 1911
Moritz von Stübel, "Der jüngere Canaletto und seine Radierungen," *Monatshefte für Kunstwissenschaft,* IV, 1911, pp. 471-501.

Stübel 1914
Moritz von Stübel, *Der Landschaftsmaler Johann Alexander Thiele und seine säch-*

sischen Prospekte (Aus den Schriften der Königlichen Sächsischen Kommission fur Geschichte), Leipzig and Berlin, 1914.

Stübel 1923
Moritz von Stübel, *Canaletto,* Berlin and Dresden, 1923.

Stupinigi, Montreal, Washington, and Marseille 1999-2001
Stupinigi, Palazzina di Caccia; Montreal Museum of Fine Arts; Washington, National Gallery of Art; and Marseille, Musée des Beaux-Arts, *The Triumph of the Baroque: Architecture in Europe, 1600-1750,* ed. Henry A. Millon, 1999-2001.

Succi 1989
Dario Succi, *Michele Marieschi tra Canaletto e Guardi,* Turin, 1989.

Succi 1994
Dario Succi, "Il giovane Bellotto," in Padua 1994, pp. 51-58.

Succi 1999
Dario Succi, "Bernardo Bellotto nell'atelier di Canaletto e la sua produzione giovanile a Castle Howard nello Yorkshire," in Mirano 1999, pp. 23-73.

Suida 1951
William E. Suida, *Paintings and Sculpture from the Kress Collection acquired by the Samuel H. Kress Foundation 1945-1951.* Washington, 1951.

Szaniawska 1967
W. Szaniawska, "Zmiany w rozplanowaniu i zabudowie Krakowskiego Przedmies´cia do 1773," *Biuletyn Historii Sztuki,* XXIX, 1967, pp. 285-316.

Szigethi 1991
Agnes Szigethi, in *Museum of Fine Arts, Budapest: Old Masters' Gallery. A Summary Catalogue of Italian, French, Spanish and Greek Paintings,* ed. Vilmos Tátrai, London and Budapest, 1991.

Tatarkiewicz 1919
W. Tatarkiewicz, *Rzady artystyczne Stanisława Augusta,* Warsaw, 1919.

Terpitz 1998
Dorothea Terpitz, *Giovanni Antonio Canal, genannt Canaletto 1697-1768,* Cologne, 1998.

Tietze 1931
Hans Tietze, *Wien. Kultur, Kunst, Geschichte,* Vienna and Leipzig, 1931.

Tokyo and Kyoto 1974-75
Tokyo and Kyoto, *Meisterwerke der Europäischen Malerei aus der Gemäldegalerie Alte Meister Dresden,* 1974.

Tokyo, Kyoto, and Ibaraki 1989-90
Tokyo, Bunkamura Museum of Art; Kyoto Municipal Museum of Art; and Ibaraki, Museum of Modern Art, *Master-*

pieces from the Detroit Institute of Arts, 1989.

Tokyo, Mie, and Ibaraki 1993-94
Tokyo, Tobu Museum; Mie Prefectural Art Museum; Ibaraki, Museum of Modern Art, *Italian Rennaissance and Baroque Art from the State Hermitage Museum,* 1993-94.

Toledano 1988
Ralph Toledano, *Michele Marieschi, l'opera completa,* Milan, 1988.

Toledo 1940
Toledo Museum of Art, *Four Centuries of Venetian Painting,* 1940.

Topinska 1974
M. Topinska, *Kościół Sakramentek,* Warsaw, 1974.

Toronto 1937
Toronto, Art Gallery, *Trends in European Painting,* 1937.

Toronto 1944
Toronto, Art Gallery, *Loan Exhibition of Great Paintings,* 1944.

Toronto, Montreal, and Ottawa 1954
Toronto, Art Gallery; Montreal, Museum of Fine Arts; and Ottawa, National Gallery of Canada, *Canaletto,* 1954.

Toronto, Montreal, and Ottawa 1964-65
Toronto, Art Gallery; Montreal, Museum of Fine Arts; and Ottawa, National Gallery of Canada, *Canaletto,* ed. W. G. Constable, 1964-65.

Trost 1947
Alois Trost, *Canalettos Wiener ansichten,* Vienna, 1947.

Trudzinski 1989
Meinolf Trudzinski, *Verzeichnis der ausgestellten Gemälde in der Niedersächsischen Landesgalerie,* Hannover, 1989.

Tucson 1951
Tucson, University of Arizona, *Twenty-five Paintings from the Collection of the Samuel H. Kress Foundation,* 1951.

Turin 1956-57
Turin, Palazzo Madama, *Seconda mostra dei capolavori della Galleria Sabauda,* 1956-57.

Udine 1998
Udine, Castello di Udine, *Capolavori nascosti dell'Ermitage. Dipinti veneti del Sei e Settecento da Pietroburgo,* ed. Irina Artemieva, Giuseppe Bergamini, Giuseppe Pavanello, 1998.

Valcanover 1973
Francesco Valcanover, "Il Bellotto di Kozakiewicz," *Arte Veneta,* XXVII, 1973, p. 335.

Valsecchi 1968
Marco Valsecchi, *Bernardo Bellotto,* Milan, 1968.

Vancouver 1983
Vancouver Art Gallery, *Masterworks from the Collection of the National Gallery of Canada*, 1983.

Venice 1929
Venice, Palazzo dei Giardini, *Il Settecento Italiano*, 1929.

Venice 1946
Venice, Museo Correr, *I Capolavori dei Musei veneti*, ed. Rodolfo Pallucchini, 1946.

Venice 1955
Venice, Palazzo Grassi, *Bellotto a Varsavia*, ed. Stanislaw Lorentz e Stefan Kozakiewicz, 1955.

Venice 1967
Venice, Palazzo Ducale *I vedutisti veneziani del Settecento*, ed. Pietro Zampetti, 1967.

Venezia 1982
Venice, Fondazione Giorgio Cini, *Canaletto: Disegni-dipinti-incisioni*, ed. Alessandro Bettagno, 1982.

Venice 1985
Venice, Ca' Rezzonico, *Varsavia 1764-1830. Da Bellotto a Chopin*, ed. Wojciech Fijalkowski, Marek Kwiatkowski, and Alberto Rizzi, 1985.

Venice 1986
Venice, Fondazione Giorgio Cini, *Le vedute di Dresda di Bernardo Bellotto. Dipinti e incisioni dai musei di Dresda*, ed. Alessandro Bettagno, Vicenza, 1986.

Venice 1990
Venice, Museo Correr, *I rami di Visentini per le vedute di Venezia del Canaletto*, ed. Giulio Lari, 1990.

Venice 1995
Venice, Museo del Settecento Veneziano-Ca' Rezzonico, Galleria dell'Accademia, and Palazzo Mocenigo, *Splendori del Settecento veneziano*, ed. Giovanna Nepi Sciré and Giandomenico Romanelli, 1995.

Venice 2001
Venice, Fondazione Giorgio Cini, *Canaletto prima maniera*, ed. Alessandro Bettagno and Bozena Anna Kowalczyk, 2001.

Venturi 1900
Adolfo Venturi, "I quadri di scuola italiana nella Galleria Nazionale di Budapest," *L'Arte*, III, 1900, pp. 185-240.

Verona 1990
Verona, Museo di Castelvecchio, *Bernardo Bellotto: Verona e le citta europée*, ed. Sergio Marinelli, 1990.

Vienna 1937
Vienna, Galerie Sanct Lucas, *Italienische Barockmalerei*, 1937.

Vienna 1964
Vienna, Gemäldegalerie der Akademie der bildenden Künste, *Garten und Park in Darstellungen der bildenden Kunst aus sechs Jahrhunderten*, 1964.

Vienna 1965
Vienna, Oberes Belvedere, *Bernardo Bellotto gennant Canaletto*, 1965.

Vienna 1966
Vienna, Historisches Museum der Stadt Wien, *Das barocke Wien. Stadtbild und Strassenleben*, 1966.

Vienna 1980
Melk, Stift Melk, *Österreich zur zeit Joseph II, zur Kaiser Josephs II*, 1980.

Vienna 1988
Vienna, Kunstlerhaus, *Ecclesia Triumphans Dresdensis: Christliche Kunst am Hofe der sachsischen Konige von Polen*, ed. Johann Lehner, 1988.

Villis 2000
Carl Villis, "Bernardo Bellotto's seven large views of Rome, c. 1743," *Burlington Magazine*, CXLII, 2000, pp. 76-81.

Visentini 1742
Antonio Visentini, *Prospectus magni canalis Venetiarum*, Venice, 1742.

Vivian 1971
Frances Vivian, *Il console smith, mercante e collezionista*, Vicenza, 1971.

Voss 1926
Hermann Voss, "Studien zur venezianischen Vedutenmalerei des 18. Jahrhunderts," *Repertorium für Kunstwissenschaft*, XLVII, 1926, pp. 1-45.

Voss 1937
Hermann Voss, "Beschprechung des Buches von H.A. Fritzsche, *Bernardo Bellotto genannt Canaletto*," in *Göttinger gelehrte Anzeigen*, CXCIX, 1937, 5, pp. 95-201.

Voss 1955
Hermann Voss, "Europäische Meister des 18. Jahrhunderts in der Royal Academy von London," *Kunstchronik*, VIII, 1955, pp. 37-40.

Waagen 1854
Gustave Friedrich Waagen, *Treasures of Art in Great Britain*, 3 vols., London, 1854.

Waagen 1857
Gustave Friedrich Waagen, *A Walk through the Art-Treasures Exhibition at Manchester*, London, 1857.

Wallis 1954
Mieczyslaw Wallis, *Canaletto, malarz Warszawy*, Warsaw, 1954.

Walpole 1868
"Horace Walpole's journals of visits to country seats," ed. Paget Toynbee, *The Walpole Society*, XVI, 1927-28, pp. 9-80.

Walther 1986
Angelo Walther, "Bernardo Bellotto a Dresda; Storia e sviluppo edilizio di Pirna. La Fortezza di Konigstein," in Venice 1986, pp. 31-102.

Walther 1988
Angelo Walther, in Vienna 1988, pp. 26-30.

Walther 1992
Angelo Walther, ed., *Gemäldegalerie Alte Meister Dresden. Katalog der Ausgestellten Werke*, Leipzig, 1992.

Walther 1995
Angelo Walther, *Bernardo Bellotto genannt Canaletto. Ein venezianer malte Dresden, Pirna und den Konigstein*, Dresden and Basel 1995.

Wandschneider 1996
Andrea Wandschneider, "Die Architekturphantasie," in Paderborn and Oldenburg 1996, pp. 26-41.

Warnke 1993
M. Warnke, "Quimeras de Fantasia," in Hamburg 1993, pp. 61-69.

Warsaw 1956
Warsaw, Muzeum Narodowe, *Wystawa malarstwa wloskiego w zbiorach polskich, XVII-XVIII w.*, 1956.

Warsaw and Cracow 1964-65
Warsaw, Muzeum Narodowe, and Cracow, Muzeum Narodowe, *Drezno i Warszawa w twórczosci Bernarda Bellotta Canaletta*, 1964-65.

Warsaw and Prague 1968
Warsaw, Muzeum Narodowe, and Prague, Narodni Galeri, *Malarstwo weneckie XV-XVIII w. ze zbiorów polskich oraz ze zbiorów Muzeum Sztuk Pieknych w Budapeszcie, Galerii Drezdenskiej, Galerii Narodowej w Pradze*, 1968.

Warsaw 1997a
Warsaw, Muzeum Narodowe, *Pod jedna Korona. 300-lecie unii Polsko-Saskiej. Królewskie zbiory sztuki w Dreznie*, ed. D. Syndram, E. Schwarm and K. Bäsig, 1997.

Warsaw 1997b
Warsaw, Zamek Kròlewski, *Pod jedna Korona. 300-lecie unii Polsko-Saskiej. Kultura i sztuka w czasach unii Polsko-Saskiej*, 1997.

Warsaw 1997c
Warsaw, Muzeum Palac w Wilanowie, *Louis de Silvestre 16/6-1/60. Francuski malarz dworu Augusta II e i Augusta III, obrazy ze zbiorow polskich*, ed. Irena Voisé, 1997.

Warsaw 1999
Warsaw, Muzeum Narodowe, *Serenissima. Swiatlo Wenecji. Dziela mistrzòw weneckich XIV-XVIII wieku ze zbioròw Muzeum Narodowego w Warszawie w swietle nowych badan technologicznych, historycznych i prac konserwatorskich*, 1999.

Washington, New York, and San Francisco 1978-79
Washington, National Gallery of Art; New York, The Metropolitan Museum of Art; and The Fine Arts Museums of San Francisco, California Palace of the Legion of Honor, *The Splendor of Dresden: Five Centuries of Art Collecting*, 1978-79.

Washington 1961-62
Washington, National Gallery of Art, *Art Treasures from America: An Anthology of Paintings and Sculpture in the Samuel H. Kress Collection*, 1961-62.

Washington 1985-86
Washington, National Gallery of Art, *The Treasure Houses of Britain*, 1985-86.

Washington 2000-2001
Washington, D.C., National Gallery of Art, *Art for the Nation: Collecting for a New Century*, 2000-2001.

Watson 1949
Francis J.B. Watson, *Canaletto*, London and New York, 1949.

Watson 1950
Francis J.B. Watson, "Notes on Canaletto and his Engravers," *Burlington Magazine*, XCII, 1950, p. 293.

Watson 1953
Francis J.B. Watson, "A group of views of Lucca by Bellotto," *Burlington Magazine*, XCV, 1953, pp. 166, 168-69.

Watson 1954
Francis J. B. Watson, *Canaletto (Master Painters)*, London and New York, 1954.

Watson 1955
Francis J.B. Watson, "Venetian Paintings at the Royal Academy 1954-55," *Arte Veneta*, IX, 1955, pp. 253-64.

Weber 1991
Gregor J.M. Weber, "Der Lobtopos des Œlebenden Bildes. Jan Vos und sein 'Zeege der Schilderkunst' von 1654," *Studien zur Kunstgeschichte*, 67, Hildesheim, **Zürich, New York, 1991.**

Weber 1993
Gregor J.M Weber, "Poetenhafer, Flugetel und Kunstlerparnass," in Hamburg 1993, pp.70-92.

Weber 1996
Gregor J.M. Weber, "Die Auftragsarbeiten Giovanni Battista Tiepolos für König August III," *Dresdener Kunstblätter*, 40, 1996, pp. 181-90.

Weber 1998
Gregor J.M. Weber, "Bernardo Bellotto,

Nicolaes Berchem und das pastorale Pirna," *Dresdener Kunstblätter*, 42, 1998, pp. 46-53.

Weber 1999
Gregor J.M. Weber, "The Gallery as Work of Art: The Installation of the Italian Paintings in 1754," in Columbus 1999, pp. 183-97.

Weber 2000a
Gregor J.M. Weber, "Bellotto's verbeterde werkelijkheid," *Kunstschrift*, 4, 2000, pp. 18-27.

Weber 2000b
Gregor J.M. Weber, "Alles getürkt. Die lebensgroßen Figurenbilder im Türkischen Palais Dresdens," in Dresden 2000, pp. 84-99.

Weber 2001
Gregor J.M. Weber, "Bernardo Bellotto und Francesco Zuccarelli," *Dresdener Kunstblätter*, 2001 (forthcoming).

Weise 1765-67
C. F. Weise, ed., *Neue Bibliothek der schönen Wissenschaften und freien Künste*, Leipzig, 1765.

Wied 1990
Alexander Wied, *Lucas und Maerten van Valckenborch (1535-1597 und 1534-1612): das Gesamtwerk mit kritischem Oeuvrekatalog*, Freren, 1990.

Wiesbaden 1935
Wiesbaden, Nassauisches Landemuseum, *Italienische Malerei des 17 und 18 Jahrhunderts*, ed. Hermann Voss, 1935.

Wilmington 1935
Wilmington Society of Fine Arts, April, 1935

Winkler 1989
Johannes Winkler, ed., *La vendita di Dresda Moderna*, 1989, pp. 27-57.

Winnipeg 1971
Winnipeg Art Gallery, *Opening Exhibition*, 1971.

Woermann 1887
Karl Woermann, *Katalog der Königlichen Gemäldegalerie zu Dresden*, Dresden, 1887.

Wrede 1988
M. Wrede, "Piwnica Watsona i 3pobudowy tarasowe2 Gordonów. Z badan´ nad skarpaœ wschodniaœ Zamku Królewskiego," *Rocznik Warszawski*, XXVII, pp. 81-111.

Wright 1976
Christopher Wright, *Old Master Paintings in Britain. An Index of Continental Master Paintings executed before c. 1800 in Public Collections in the United Kingdom*, London, 1976.

York 1955
York City Art Gallery, *Inaugural Exhibition. 1955. The Lycett Green Collection*, 1955.

York 1961
York City Art Gallery, *Catalogue of Paintings*, 2 vols, 1961.

York 1994
York City Art Gallery, *Masterpieces from Yorkshire Houses. Yorkshire families at Home and Abroad 1700-1850*, 1994.

Young 1978
Eric Young, "Pictures from the Grand Tour," *Connoisseur*, CXCIX, 1978, p. 211.

Zanetti 1743
G. Zanetti, "Memorie," *Archivio Veneto*, XV, 1885, XXIX, pp. 97 ff.

Zanimirska 1971
H. Zanimirska, "Genera kultu obrazu Nejświętszej Marii Panny łaskawej i rzeźby Matki Boskiej Passawskiej w Warszawie w 2. połowie XVII w.," *Biuletyn Historii Sztuki*, XXXIII, 1971, pp. 415-18.

Zaragoza 1990
Zaragoza, Palacio de la Lonja and Palacio de Sastago, *El Settecento Veneciano. Aspectos de la Pintura Veneciana del Siglo XVIII*, ed. Giandomenico Romanelli, 1990.

Zava Boccazzi 1983
Franca Zava Boccazzi, "Episodi di pittura veneziana a Vienna nel Settecento," in *Venezia Vienna*, ed. Giandomenico Romanelli, Milan, 1983.

Zocchi 1744
Giuseppe Zocchi, *Scelta delle XXIV Vedute delle principali Contrade, Piazze, Chiese e Palazzi della Città di Firenze . . .*, Florence, 1744.

Zumpe 1991
M. Zumpe, *Die Brühlsche Terrasse in Dresden*, Berlin, 1991.

Zurich 1946-47
Zurich, Kunsthaus Zurich, *Meisterwerke aus Österreich*, 1946-47.